PRÆTERITA

PRÆTERITA

The Autobiography of

JOHN RUSKIN

OXFORD UNIVERSITY PRESS

OXFORD NEW YORK

Oxford University Press, Walton Street, Oxford OX2 6DP

OXFORD LONDON GLASGOW
NEW YORK TORONTO MELBOURNE WELLINGTON
IBADAN NAIROBI DAR ES SALAAM CAPE TOWN
KUALA LUMPUR SINGAPORE JAKARTA HONG KONG TOKYO
DELHI BOMBAY CALCUTTA MADRAS KARACHI

Præterita *was first published in twenty-eight parts between 1885 and
1889. The present text, taken from the three-volume edition of
1899, was first published by Rupert Hart-Davis in 1949 and issued as
an Oxford University Press paperback in 1978
Reprinted 1983*

British Library Cataloguing in Publication Data

Ruskin, John
 Præterita.
 1. Ruskin, John — Biography
 2. Authors, English — 19th century — Biography
 I. Title
 828'.8'09 PR5263 78-40468
 ISBN 0-19-281253-X

*Printed in Great Britain by
The Thetford Press Limited
Thetford, Norfolk*

CONTENTS

INTRODUCTION

Præterita is the only one of Ruskin's writings intended
to give pleasure. When, after one of his lectures, a
member of the audience tried to tell him how much he
had enjoyed his works, Ruskin replied, "I don't care
whether you enjoyed them; did they do you any good?"
But in *Præterita*, as he tells us, he has written only of
what it gives him joy to remember. It was begun in
1885, soon after Ruskin's final resignation from the Slade
Professorship. Up to that date his writings had been
growing yearly more violent and bitter. His mounting
sense of evil, rumbling and flashing in the fitful numbers
of *Fors Clavigera*, had reached a crescendo in the last
Oxford lectures, which his friends had persuaded him to
abandon. And his rages were undoubtedly connected
with fits of what his biographers have called by the
unscientific, but adequate, name of brain fever. By 1885
Ruskin realised that the only hope for his sanity lay in
avoiding, as far as possible, those topics which brought
his mind to the boil. He had raged and prophesied in
vain. The world had followed its evil and crazy course,
and at last he felt powerless to alter it. *Præterita*, for
all its apparent ease and tranquillity, is an admission of
defeat.

But however carefully Ruskin avoided angry thoughts,
his attacks of brain fever continued, and became more
frequent during the next four years. *Præterita* was
written during the intervals between these attacks. At
first they had no effect on the consistency of his mind
during periods of calm. In fact Ruskin maintained that
they were positively restful, and wrote, "I did myself
much more real harm by three days steady work on the

axes of crystallisation in quartz, before my second illness began (1881) than I got during the illness itself from three weeks of the company of uninvited phantoms and the course of imaginary events." We know that some of the clearest and most consecutive passages of *Præterita* were written within a few weeks of a breakdown, notably the famous description of the Rhone on page 297. But as time went on and the attacks became more frequent, their effect can be felt. Towards the end of Book II there is a notable slackening of grasp. We are first aware of it towards the end of *The State of Denmark*; and in *L'Hotel du Mont Blanc*, where it is aggravated by causes to be mentioned later, we feel that the life of the book is over, and that the author is only filling in time. Ruskin himself was conscious that at any moment his faculties might leave him for ever, and for this reason he included in Chapter XII, *Otterburn*, some memories of the man whom he spoke of as his master, Thomas Carlyle. But once more he recovered, and was able to write the first three chapters of Part III, which, although they lack the crystalline focus of the first volume, are perfectly lucid and consecutive. In 1888 Ruskin made his last journey to Switzerland and to Venice; and in Paris, on the way home, he had a most serious attack, which left him almost powerless. It seemed to his friends that the final chapter of *Præterita* had been written; but Ruskin was determined to add one more, a tribute of love and thankfulness to his cousin, Joan Agnew (Mrs Arthur Severn), who had looked after him and his mother for over twenty years with perfect devotion, and was to continue doing so till his death in 1900. His biographer, W. G. Collingwood, has described how, as he made this final effort, Ruskin "seemed lost among the papers scattered on his table . . . and turned from one subject to another in despair." At last *Joanna's Care* was finished, and in its rambling,

inconsequent sentences, glowing with love and crumbling suggestions of poetry, we seem to be watching the dying embers of his genius: when suddenly a flame shoots up, as there pass before his eyes, with mysterious urgency, the fireflies at Fonte Branda. "*How* they shone! moving like fine broken starlight through the purple leaves. How they shone! through the sunset that faded into thunderous night . . . the fireflies everywhere in sky and cloud, rising and falling, mixed with the lightning and more intense than the stars." These are the last words which Ruskin wrote for publication, and Fors, the chance which is not a chance, has contrived that they should be a symbol of his life's work.

The pleasant temper of *Præterita* is reflected in its style. It appears to be written with perfect ease and candour: and to a certain extent this is true. Ruskin told Kate Greenaway that it was "much easier and simpler to say things face to face like that, than as an author." But the air of candour is also the result of conscious literary artifice. Ruskin's fits of insanity were common knowledge, and he rightly assumed that they would be made an excuse for dismissing his opinions, just as Van Gogh's madness was exploited by his early detractors. "Whenever I say anything they don't like," he wrote to his printer, "they all immediately declare I must be out of my mind; (so) the game has to be played neatly." This determination to prove that he was clear in the head helps to account for the relative simplicity of his style, a simplicity which was sometimes rather irksome to him. Speaking of his plan for *Dilecta*, he wrote to R. C. Leslie, "I shall be able to give pieces for reference out of diaries, and sometimes a bit of Fors-fashion talk—which will be a relief from the please-your-worship and by-your-leave style of *Præterita*." For Ruskin was naturally an eloquent man. "My dear Papa," he wrote, at the age

of thirteen, "I would write a short, pithy, laconic, sensible, concentrated, and serious letter if I could, for I have scarcely time to write a long one. Observe I say only 'to write,' for as to composition, 'tis nothing, positively nothing. I roll on like a ball, with this exception, that contrary to the usual laws of motion I have no friction to contend with in my mind and of course have some difficulty in stopping." As he grew up this flood of eloquence was controlled by rhetoric, by the study of Johnson and Byron, and, at a later stage, of Hooker; but a flood, a cataract it remained. It is curious to notice in *Præterita* that although he refers more than once to the success of his writings, he never mentions the chief cause to which that success was popularly attributed, his magnificent command of language. Round about 1860, when his interest shifted from art to society, his rich, elaborate style, with its crescendos swelling for half a page and ending in sunsets or mountain snows, was no longer to the point; but a new device of rhetoric offered itself in the style of Thomas Carlyle. Broken, ejaculatory, parenthetical, but with the vividness of one who thinks aloud and cannot restrain his indignation, this instrument was completely responsive to Ruskin's new needs; and it is in this style that he composed *Fors Clavigera*, and most of the Oxford lectures. An echo of it is still to be heard in *Præterita*,* greatly softened in the main, but regaining its original rhythmic force in those passages where Ruskin describes ludicrous or pathetic human beings, an exercise in which Carlyle himself had shown his greatest mastery. Such is the description on page 73 of the wretched Rowbotham; such, on page 190, are the memorable portraits of the Dons at Christ Church;

* The first two chapters being made up of extracts from *Fors*, written about fifteen years earlier, have a noticeably sharper accent than the rest of *Præterita*.

and an examination of these passages alone will dispel the idea that the style of *Præterita* is artless. It is indeed the work of an exceedingly accomplished craftsman. Ruskin tells us that his literary work was done "as quietly and methodically as a piece of tapestry. I knew exactly what I had got to say, put the words firmly in their places like so many stitches, hemmed the edges of chapters round with what seemed to me graceful flourishes, touched them finally with my cunningest points of colour, and read the work to Papa and Mama at breakfast next morning, as a girl shows her sampler." Careful examination of *Præterita* shows that it was written on the same principle. The sentences, to put it crudely, are far longer than they seem to be at first sight, and are packed full of subordinate images and associations. And when a touch of colour is needed, the hand which had woven the rich tapestries of Giorgione's Venice, or Turner's alpine storms, is seen to have lost none of its cunning. Only his supposed freedom of address has given him the opportunity of a new kind of grace, a graceful turning aside at the point where argument or description might become laboured, of which the Conversion of St Ranieri on page 323 is an exquisite example.

I have dwelt first on the style and temper of *Præterita*, because it is they which make us accept as true the account of his early life and surroundings. Mr Cook, whose edition of Ruskin's works is a model of fair-minded devotion, says that the frankness of the book "may well have come easily to an author who was little given to concealment, and who now, in his old age, had no reason for illusionment or disguise." But, in fact, this air of frankness is the result of art; for a great deal of Ruskin's character and experience has been purposely excluded from *Præterita*. When Kate Greenaway suggested illustrating it, Ruskin gracefully evaded the offer, saying, "You know

there's nothing in you of my grim side, and you never feel that it is there." Not that the self-portrait which he draws is by any means that of a simple character. Contrasting his youthful self with all that he was to become, he was tempted to feel that the Graduate of Oxford was "a little soppy and floppy tadpole little more than a stomach with a tail to it, flattening and wriggling itself up the crystal ripples." But elsewhere he showed a more correct understanding. He recognised that the upbringing which had brought him the gifts of peace, obedience and trust, had starved and atrophied his affections. There was no one with whom he could have ordinary human relationships, no one to love. Ruskin, in the same passage, gives as the consequence of this that "when affection did come it came with violence utterly rampant and unmanageable." But this is only half the truth. The other half is given in several other passages in *Præterita* where he refers quite candidly to his own lack of affection for other people, and the absence of any need for affection from them. He quotes as "much blamable and pitiable" the saying of Carlyle that "Not till here and there one is thinking of us, one is loving us, does this waste earth become a peopled garden." "My training," he says, "produced in me precisely the opposite sentiment." Such was the effect of being continually fussed over by his morbidly devoted parents. As for the parents themselves, "though I had no rightly glowing affection for either father or mother, yet as they could not well do without me, so also I found that I was not altogether comfortable without them." It astonished him that people should feel any love for him. "They might as well have got fond of a *camera lucida* or an ivory foot rule: all my faculty was merely in showing that such and such things were so; I was no orator, no actor, no painter but in a minute and generally invisible manner; and I couldn't bear being

interrupted in anything I was about." Should this be read as self-disparaging irony? Ruskin's letters, especially after 1860, seem to show a real warmth and capacity for friendship. Yet the general tone of Ruskin's self-analysis in *Præterita* is not ironical, but, on the contrary, is of an uncanny detachment, and at least one incident in Ruskin's life inclines us to accept it quite literally.

This is his marriage, the most remarkable of all omissions from *Præterita*. I say "remarkable" rather than "important" because one of the least attractive features of the whole episode is that, to Ruskin, it was entirely *un*important; and I could scarcely have written "remarkable," for it was never remarked on, had not a number of letters touching on Ruskin's marriage recently been published. Although these add little to what we can infer of his character from *Præterita* and in no way affect the main achievement of his life, the reader may well expect some information about an event, which, by normal human standards, should not have been omitted from an autobiography. When Ruskin says on one page that his affection, once aroused, was so violent as to be unmanageable, and on another that he was incapable of feeling affection at all, he is using the word in two senses. He was not capable of warm and steady devotion; but he was intensely susceptible to feminine charm. Was there ever an autobiography in which girls are more vividly remembered? Casanova's descriptions of women are often vague and generalised; but every girl Ruskin saw, from childhood onwards, was imprinted on his memory with all her particularities, and set down, after sixty years, as freshly as if she had just entered the room. There is still a tremor as he describes them, his Scottish cousins, the Domecq girls, Miss Wardell, Miss Lockhart, and Miss Tollemache, who, although he didn't succeed in getting within fifty yards of her, was the "light and solace" of

a whole winter in Rome. In a restricted sense of the word, he was always falling in love, and when he fell most violently in love with Miss Euphemia Gray, and her parents urged her to make a match of it, there was nothing in his knowledge of himself or of the world which could warn him to hold back. They were married in April, 1847, and Ruskin immediately discovered that the femininity which he adored was a creation of the fancy, the endowment of a fairy, not of a living woman. He shrank, as many sensitive men have done, from the physical act of love-making. And then, unfortunately, his fundamental selfishness and lack of warmth asserted itself. Since his wife was not the fairy queen, the child's dream of femininity, which he had anticipated, he could not be bothered with her. She became simply a nuisance. The marriage might have dragged out a long, unhappy life, if Effie had been a self-effacing girl like Joan Agnew, ready to fit in with the quiet middle-class ways of the Ruskin household. But she was a girl of spirit who loved society, and was not at all content to stay at home with old Mrs Ruskin, making jam and counting the linen. Moreover, the strain of her situation gave her nervous headaches and other indispositions, irritating equally in a fairy queen or a mother's help. With some notion that they should look like a young married couple, Ruskin took a house in Park Street, and Effie went into Society, where she appears to have shone; but Ruskin hated it, and whenever possible slipped back to work in his old study at Denmark Hill. No doubt he neglected her cruelly. These were the years of his greatest creative activity, the years of *The Seven Lamps*, and of *The Stones of Venice*. He was inspired. Ideas came pouring into his mind, demanding confirmation and expression. He began to realise that he had a message for the world more important than the superior excellence of Turner's painting. His experiences

in the Working Men's College and the study of Gothic Architecture both showed him where his mission lay. He must apply to social conditions the same analytical processes and the same moral standards which he had applied to landscape painting. To do this required the whole of his force; he "couldn't bear being interrupted in anything he was about," and instinctively he sought the peaceful, orderly way of life which he had evolved with his parents. They, of course, were delighted. Their wonderful genius son was the light of their lives, and the focus of every devoted second. Like many good, religious people in that unself-questioning age, they did not know when they were being wicked, and they automatically did all they could to win their son back to his old way of life. In so doing they behaved odiously to Effie, who, from her sensible, worldly, and not very subtle, point of view, seems to have acted with patience and dignity. In the end, Ruskin, enraged at this "interruption," and encouraged, we may suppose, by his parents, became positively, as opposed to negatively, cruel to her, and she very properly left him. The marriage was anulled, and she later married John Everett Millais. This was eminently successful, and Effie enjoyed the natural pleasures of a large family, a large house in Kensington, and a deer stalk in the Highlands, which, however, Millais could scarcely pay for, even by painting "Bubbles" and "Cherry Ripe." Meanwhile Ruskin wrote *Unto this Last*, which was generally considered the work of a madman.

Such is the unhappy story omitted from the chapter entitled *L'Hotel du Mont Blanc*, and from the rapid summary of the years 1850 to 1860 on page 449; and perhaps the fact that these chapters lose some clarity, and that *L'Hotel du Mont Blanc* consists of little more than extracts from Ruskin's diary, may be taken as an indication that the memory of his marriage was still slightly disturbing

to him. More likely the faltering of his narrative at this
point is due to an entirely different cause. For *Præterita*
omits something far more important in Ruskin's life than
Effie Gray, and that is his conversion, already referred to,
from a critic of art to a critic of society. Throughout
there is hardly a mention of social or economic conditions,
one of the very few being in an aside, revealing enough in
its context, on page 378. It is evident that the memory
of what Ruskin there calls "the political work which has
been the most earnest of my life," was emphatically not
among those things which it gave him joy to remember;
but was, on the contrary, all too likely to evoke the savage
and tormented state of mind which he wished to avoid:
and so it is excluded.

If *Præterita* were an autobiography like *The Prelude*
or *The Education of Henry Adams*, chiefly concerned with
self-discovery and spiritual evolution, this would be a
serious defect. But it is not a philosophic or a schematic
work. Ruskin was by nature an impressionist. This is
the side of his genius which was particularly sympathetic
to Proust, and there is ample evidence of it in *Præterita*.
Since childhood he had been in the habit of staring at
things and letting the impression sink in. He was, he
tells us, only interested in what was near him, or at least
clearly visible and present; and adds, "I suppose this is
so with children generally, but it remained—and remains
—a part of my grown up temper." *Præterita* is full of
things stared at, and Ruskin makes evident the kind of
impressions which he found most rewarding. As was
natural to a long, steady carpet gazer, he liked them to
be intricate and rich. In a passage written for the chapter
entitled *The Col de la Faucille*, but not printed in the
final version, he refers to "an idiosyncrasy which extremely
wise people do not share—my love of all sorts of filigree
and embroidery, from hoar frost to high clouds," and

admits that this, to a great extent, explains his love of flamboyant Gothic. It is, indeed, at the base of all his responses to art and nature, as we may see from the beautiful and crucial description of drawing an aspen tree in Fontainebleau (page 285), or the truly Proustian description of lying in the grass and "drawing the blades as they grew, with the ground herbage of buttercup or hawkweed mixed among them, until every square foot of meadow or mossy bank became an infinite picture and possession to me" (page 397).

As drawing is mentioned so frequently in *Præterita*, and obviously played an important part in Ruskin's early life, the reader may be glad of some estimate of his gifts as a draughtsman. In the early nineteenth century everybody drew. The practice did not imply artistic tastes or inclinations, any more than doing crossword puzzles implies a love of literature. Old Mr Ruskin drew, and his son followed his example as a matter of course. But it soon became apparent that John's imitations of Prout were unusually skilful, and they brought him such modest prominence as he achieved as an undergraduate. At the age of twenty-one he passed under the influence of David Roberts and the drawings done on the expedition to Italy of 1840 show that he could employ this style with great delicacy. They are still slightly mannered, albeit exceedingly well mannered; but in 1842 while drawing a piece of ivy on the road to Norwood, he suddenly realised that every form must be drawn exactly as it is, not improved by formula. This was the liberation of his true genius as a draughtsman, and thenceforward he developed a personal style. He recognised that his gifts were limited. He says more than once that he was incapable of invention, deficient in a sense of design, and apt to get so much involved in a passage of detail as to lose the structure of the whole. But even his passion for inscape

(and many of his drawings are remarkably like those of Gerard Manley Hopkins) was brought under control in the drawings of Venice, Verona and Abbeville, done from 1858 to 1880. These are (I take a long breath, and say it without qualification) some of the most beautiful architectural drawings ever executed. They are done with a combination of knowledge and love, sensibility and skill of hand, which makes almost all other attempts in the same kind seem mechanical, formulistic, or imprecise. In looking at them we begin to understand Ruskin's repeated claim that his chief merit was his power of analysis: by which he meant not scientific analysis (for, like the Brahmin, he would have destroyed all microscopes), but the power of scrutinising an object so patiently and so perceptively that he could reveal something of its true character which a hastier inspection, however adroit, would overlook.

So *Præterita* is the record of what this steady, analytic gaze had contemplated with pleasure, controlled and commented on by a moral consciousness. For although Ruskin has dropped his prophetic tone and has long ago outgrown his evangelical temper, his whole state of mind remains inherently moral. No perception of scene or character but is subordinate to his sense of right and wrong. Take, for example, his feelings for Switzerland. From his first sight of a Swiss Cottage and subsequent reflections on William Tell, to the last peaceful residence at the Trois Couronnes of Vevay, he makes it clear that the beauty of Switzerland was indissolubly connected with the supposed neatness, cleanliness, industry and protestant piety of the Swiss. In all this we may feel the influence of his parents, and it is notable that his great discoveries in the appreciation of Italian art date from the two journeys abroad which he made without them, in 1844 and 1858. In 1858, indeed, the narrow chill of Alpine

virtue was too much for him, and he turned with joy
to the sensual splendours of Paul Veronese and a military
band. But his feeling of the essential health of Switzer-
land was deep in his nature; and nothing in *Præterita*
is more vivid than the contrast between Naples and the
Alps; between "I knew, from the first moment when
my foot furrowed volcanic ashes, that no mountain form
or colour could exist in perfection when everything was
made of scoria, and that blue sea was to be little boasted
if it broke on black sand": and "I woke from a sound,
tired sleep in a little one windowed room at Lans-le-bourg,
at six of the summer morning, June 2nd, 1841; the red
aiguilles on the north relieved against pure blue—the
great pyramid of snow down the valley in one sheet of
eastern light. I dressed in three minutes, ran down the
village street, across the stream, and climbed the grassy
slope on the south side of the valley, up to the first pines.
I had found my life again;—all the best of it. Whatever
good of religion, love, admiration or hope had ever been
taught me, or felt by my best nature, rekindled at once."
How great a part of Ruskin's teachings lies in the contrast
between these two regions; a part, we may add, which
has been far from our way of thinking during the present
century, but which is none the less worth pondering and
relating to the confused æsthetic philosophy of today.

In contrast to the repeated ecstasies aroused by Switzer-
land are the slight and slighting references in *Præterita*
to Venice. Venice had been the subject of his greatest
work of art criticism, and had kindled his most eloquent
prose; it had inspired Turner and had produced the
painters of the Renaissance whom Ruskin most profoundly
and perceptively adored, Tintoretto, Paul Veronese, Car-
paccio and Bellini. Yet because Venice was a corrupt
city with a degraded population, he could write "all that
I did there was bye-work"; and had not the porter at the

school of St. Roch admitted him to see the Tintorettos,
he would have written *The Stones of Chamouni* instead of
The Stones of Venice. Tintoretto forced him into the
study of Venetian history; and "through that into what
else I have traced or told of the laws of national strength
and virtue. I am happy in having done this so that the
truth of it must stand; but it was not my own proper
work; and even the sea-born strength of Venetian paint-
ing was beyond my granted fields of fruitful endeavour."
This sentence shows us another and more important reason
why, in *Præterita*, Ruskin averts his eyes from Venice.
It was associated with the first consciousness of those social
and economic problems which were to become such a
torment to him. They had worn him out, and in his
exhausted state he felt that even Venetian painting was
beyond his strength. Like some great athlete in a wheeled
chair, the discoverer and supreme interpreter of Tintoretto
had to be content with Miss Kate Greenaway. He
wanted peace and health, and associated them with the
stones of Chamouni; he wanted order, certainty, and a
beauty which carried with it no commentary on human
life, and he found it in the contemplation of geological
specimens. "What a bishop was lost in him," lamented
old Mr Ruskin. "What a geologist was lost in me" is
the lament of his son.

I have not yet mentioned the features for which
Præterita is most often praised. There is the fascinating
account of Ruskin's upbringing, which every biographer
has paraphrased without gaining much advantage over the
original. There are the nostalgic descriptions of conti-
nental travel, the early starts, the evening walks, the
coaches and couriers and familiar inns. There is the
gallery of portraits, dons, tutors, cousins, old servants,
worthy, as Miss Thackeray said, of *Vanity Fair* or Jane
Austen. And there is the whole picture of middle-class

life in one of those respectable suburbs of London, which, as we pass through them to-day, seem so remote and impenetrable. Of these obvious excellencies I shall say a word only about the last. The Ruskins were typical of a section of Victorian society which plays relatively little part in the literature of the time, people who had risen by industry and thrift to a position of formidable respectability, but who remained conscious of not belonging to any definite stratum of society, and so lived in a proud, pious and slightly uncomfortable isolation. Mrs Ruskin would not let John play with his Croydon cousins because their father was a baker who lived over the shop; nor would she visit the Telford family in case she was made to feel inferior. The social graces were entirely absent, and with them the whole concept of taste. "The reader must have felt," says Ruskin, "that, though very respectable people in our way, we were all of us definitely vulgar people; just as my aunt's dog, Towzer, was a vulgar dog, though a very good and dear dog. Said reader should have seen also that we had not set ourselves up to have a taste in anything. There was never any question of matching colours in furniture, or having the correct pattern in china." Now the fact that in his youth and early manhood Ruskin was totally unaware of the concept of good taste seems to me exceedingly important. It is no accident that the three or four Englishmen whose appreciation of art has been strong enough and perceptive enough to penetrate the normal callosity of their country-men—Hazlitt, Ruskin, Roger Fry—have all come from philistine, puritanical homes. To be brought up in an atmosphere of good taste is to have the hunger for art satisfied at too early an age, and to think of it as a pleasant amenity rather than as an urgent need, as something to be taken for granted, rather than something to be striven for with the whole force of the spirit. Those who live

surrounded by beautiful works of art and architecture seem either to become impervious to them, like Oxford dons, or faddy and perverse, like museum officials. Ruskin recognised this when he wrote that a "great part of my acute perception and deep feeling of the beauty of architecture and scenery abroad was owing to the well formed habit of narrowing myself to happiness within the four brick walls of our fifty by one hundred yards of garden; and accepting with resignation the æsthetic external surroundings of a London suburb." And there was another consequence of his unæsthetic upbringing. Art is a long word which stretches from millinery to religion; and an exaggerated respect for taste inclines it towards the former. The religious seriousness of Ruskin's education made him assume that those works of architecture and design which moved him so deeply must have their roots in the same awful and eternal verities which had been hourly impressed upon his youthful mind. Even the evangelical bigotry of his mother's teaching was of value to him. Ruskin never doubted that he was one of the elect. Writing of his youthful reactions to a grotesque passage of protestant claptrap in Taylor's *Natural History of Enthusiasms*, he says, "I had already the advantage over its author, and over all such authors, of knowing, when I saw them, sincere art from lying art, and happy faith from insolent dogmatism." Perhaps this messianic confidence is contrary both to reason and to good manners. The civilised man of taste may claim that his preferences are entirely personal, and that he has neither the right nor the desire to force them on others. But no windows are opened, no horizons enlarged, no spirits set free by this wise indifference.

KENNETH CLARK

July, 1948

PRÆTERITA

AUTHOR'S PREFACE

I HAVE written these sketches of effort and incident in former years for my friends; and for those of the public who have been pleased by my books.

I have written them therefore, frankly, garrulously, and at ease; speaking of what it gives me joy to remember at any length I like—sometimes very carefully of what I think it may be useful for others to know; and passing in total silence things which I have no pleasure in reviewing, and which the reader would find no help in the account of. My described life has thus become more amusing than I expected to myself, as I summoned its long past scenes for present scrutiny:—its main methods of study, and principles of work, I feel justified in commending to other students; and very certainly any habitual readers of my books will understand them better, for having knowledge as complete as I can give them of the personal character which, without endeavour to conceal, I yet have never taken pains to display, and even, now and then, felt some freakish pleasure in exposing to the chance of misinterpretation.

I write these few prefatory words on my father's birth-day, in what was once my nursery in his old house,—to which he brought my mother and me, sixty-two years since, I being then four years old. What would otherwise in the following pages have been little more than an old man's recreation in gathering visionary flowers in fields of youth, has taken, as I wrote, the nobler aspect of a dutiful offering at the grave of parents who trained my childhood to all the good it could attain, and whose memory makes declining life cheerful in the hope of being soon again with them.

HERNE HILL,
10th May, 1885.

1

VOLUME I

CHAPTER I

THE SPRINGS OF WANDEL

[The reader must be advised that the first two chapters are reprinted, with slight revision, from Fors Clavigera, having been written there chiefly for the political lessons, which appear now introduced somewhat violently.]

1. I AM, and my father was before me, a violent Tory of the old school;—Walter Scott's school, that is to say, and Homer's. I name these two out of the numberless great Tory writers, because they were my own two masters. I had Walter Scott's novels and the Iliad, (Pope's translation,) for constant reading when I was a child, on week-days: on Sunday their effect was tempered by Robinson Crusoe and the Pilgrim's Progress; my mother having it deeply in her heart to make an evangelical clergyman of me. Fortunately, I had an aunt more evangelical than my mother; and my aunt gave me cold mutton for Sunday's dinner, which—as I much preferred it hot—greatly diminished the influence of the Pilgrim's Progress, and the end of the matter was, that I got all the noble imaginative teaching of Defoe and Bunyan, and yet—am not an evangelical clergyman.

2. I had, however, still better teaching than theirs, and that compulsorily, and every day of the week.

Walter Scott and Pope's Homer were reading of my own election, and my mother forced me, by steady daily toil, to learn long chapters of the Bible by heart; as well as to read it every syllable through, aloud, hard names and all, from Genesis to the Apocalypse, about once a year: and to that discipline—patient, accurate, and resolute—I owe, not only a knowledge of the book, which I find

5

occasionally serviceable, but much of my general power
of taking pains, and the best part of my taste in literature.
From Walter Scott's novels I might easily, as I grew older,
have fallen to other people's novels; and Pope might, per-
haps, have led me to take Johnson's English, or Gibbon's,
as types of language; but, once knowing the 32nd of
Deuteronomy, the 119th Psalm, the 15th of 1st Corin-
thians, the Sermon on the Mount, and most of the
Apocalypse, every syllable by heart, and having always a
way of thinking with myself what words meant, it was not
possible for me, even in the foolishest times of youth, to
write entirely superficial or formal English; and the
affectation of trying to write like Hooker and George
Herbert was the most innocent I could have fallen into.

3. From my own chosen masters, then, Scott and
Homer, I learned the Toryism which my best after-
thought has only served to confirm.

That is to say, a most sincere love of kings, and dislike
of everybody who attempted to disobey them. Only,
both by Homer and Scott, I was taught strange ideas
about kings, which I find for the present much obsolete;
for, I perceived that both the author of the Iliad and the
author of Waverley made their kings, or king-loving per-
sons, do harder work than anybody else. Tydides or
Idomeneus always killed twenty Trojans to other people's
one, and Redgauntlet speared more salmon than any of
the Solway fishermen, and—which was particularly a
subject of admiration to me—I observed that they not
only did more, but in proportion to their doings, *got* less
than other people—nay, that the best of them were even
ready to govern for nothing! and let their followers divide
any quantity of spoil or profit. Of late it has seemed to
me that the idea of a king has become exactly the contrary
of this, and that it has been supposed the duty of superior
persons generally to govern less, and get more, than any-

body else. So that it was, perhaps, quite as well that in those early days my contemplation of existent kingship was a very distant one.

4. The aunt who gave me cold mutton on Sundays was my father's sister: she lived at Bridge-end, in the town of Perth, and had a garden full of gooseberry-bushes, sloping down to the Tay, with a door opening to the water, which ran past it, clear-brown over the pebbles three or four feet deep; swift-eddying,—an infinite thing for a child to look down into.

5. My father began business as a wine-merchant, with no capital, and a considerable amount of debts bequeathed him by my grandfather. He accepted the bequest, and paid them all before he began to lay by anything for himself,—for which his best friends called him a fool, and I, without expressing any opinion as to his wisdom, which I knew in such matters to be at least equal to mine, have written on the granite slab over his grave that he was "an entirely honest merchant." As days went on he was able to take a house in Hunter Street, Brunswick Square, No. 54, (the windows of it, fortunately for me, commanded a view of a marvellous iron post, out of which the water-carts were filled through beautiful little trap-doors, by pipes like boa-constrictors; and I was never weary of contemplating that mystery, and the delicious dripping consequent); and as years went on, and I came to be four or five years old, he could command a postchaise and pair for two months in the summer, by help of which, with my mother and me, he went the round of his country customers (who liked to see the principal of the house his own traveller); so that, at a jog-trot pace, and through the panoramic opening of the four windows of a postchaise, made more panoramic still to me because my seat was a little bracket in front, (for we used to hire the chaise regularly for the two months out of Long Acre, and so

could have it bracketed and pocketed as we liked), I saw
all the high-roads, and most of the cross ones, of England
and Wales, and great part of lowland Scotland, as far as
Perth, where every other year we spent the whole summer;
and I used to read the Abbot at Kinross, and the
Monastery in Glen Farg, which I confused with "Glen-
dearg," and thought that the White Lady had as certainly
lived by the streamlet in that glen of the Ochils, as the
Queen of Scots in the island of Loch Leven.

6. To my farther great benefit, as I grew older, I thus
saw nearly all the noblemen's houses in England; in
reverent and healthy delight of uncovetous admiration,—
perceiving, as soon as I could perceive any political truth
at all, that it was probably much happier to live in a small
house, and have Warwick Castle to be astonished at, than
to live in Warwick Castle and have nothing to be aston-
ished at; but that, at all events, it would not make Bruns-
wick Square in the least more pleasantly habitable, to pull
Warwick Castle down. And at this day, though I have
kind invitations enough to visit America, I could not, even
for a couple of months, live in a country so miserable as
to possess no castles.

7. Nevertheless, having formed my notion of kinghood
chiefly from the FitzJames of the Lady of the Lake, and
of noblesse from the Douglas there, and the Douglas in
Marmion, a painful wonder soon arose in my child-mind,
why the castles should now be always empty. Tantallon
was there; but no Archibald of Angus:—Stirling, but no
Knight of Snowdoun. The galleries and gardens of
England were beautiful to see—but his Lordship and
her Ladyship were always in town, said the housekeepers
and gardeners. Deep yearning took hold of me for a
kind of "Restoration," which I began slowly to feel that
Charles the Second had not altogether effected, though I
always wore a gilded oak-apple very piously in my button-

hole on the 29th of May. It seemed to me that Charles
the Second's Restoration had been, as compared with the
Restoration I wanted, much as that gilded oak-apple to
a real apple. And as I grew wiser, the desire for sweet
pippins instead of bitter ones, and Living Kings instead
of dead ones, appeared to me rational as well as romantic;
and gradually it has become the main purpose of my life
to grow pippins, and its chief hope, to see Kings.*

8. I have never been able to trace these prejudices to
any royalty of descent: of my father's ancestors I know
nothing, nor of my mother's more than that my maternal
grandmother was the landlady of the Old King's Head in
Market Street, Croydon; and I wish she were alive again,
and I could paint her Simone Memmi's King's Head, for
a sign.

My maternal grandfather was, as I have said, a sailor,
who used to embark, like Robinson Crusoe, at Yarmouth,
and come back at rare intervals, making himself very
delightful at home. I have an idea he had something
to do with the herring business, but am not clear on that
point; my mother never being much communicative con-
cerning it. He spoiled her, and her (younger) sister, with
all his heart, when he was at home; unless there appeared
any tendency to equivocation, or imaginative statements,
on the part of the children, which were always unforgive-
able. My mother being once perceived by him to have
distinctly told him a lie, he sent the servant out forthwith
to buy an entire bundle of new broom twigs to whip her
with. "They did not hurt me so much as one" (twig)
"would have done," said my mother, "but I *thought* a
good deal of it."

* The St. George's Company was founded for the promotion of
agricultural instead of town life: and my only hope of prosperity
for England, or any other country, in whatever life they lead, is in
their discovering and obeying men capable of Kinghood.

9. My grandfather was killed at two-and-thirty, by trying to ride, instead of walk, into Croydon; he got his leg crushed by his horse against a wall; and died of the hurt's mortifying. My mother was then seven or eight years old, and, with her sister, was sent to quite a fashionable (for Croydon) day-school, Mrs. Rice's, where my mother was taught evangelical principles, and became the pattern girl and best needlewoman in the school; and where my aunt absolutely refused evangelical principles, and became the plague and pet of it.

10. My mother, being a girl of great power, with not a little pride, grew more and more exemplary in her entirely conscientious career, much laughed at, though much beloved, by her sister; who had more wit, less pride, and no conscience. At last my mother, formed into a consummate housewife, was sent for to Scotland to take care of my paternal grandfather's house; who was gradually ruining himself; and who at last effectually ruined, and killed, himself. My father came up to London; was a clerk in a merchant's house for nine years, without a holiday; then began business on his own account; paid his father's debts; and married his exemplary Croydon cousin.

11. Meantime my aunt had remained in Croydon, and married a baker. By the time I was four years old, and beginning to recollect things,—my father rapidly taking higher commercial position in London,—there was traceable—though to me, as a child, wholly incomprehensible,—just the least possible shade of shyness on the part of Hunter Street, Brunswick Square, towards Market Street, Croydon. But whenever my father was ill,—and hard work and sorrow had already set their mark on him,—we all went down to Croydon to be petted by my homely aunt; and walk on Duppas Hill, and on the heather of Addington.

12. My aunt lived in the little house still standing—

or which was so four months ago—the fashionablest in
Market Street, having actually two windows over the
shop, in the second storey; but I never troubled myself
about that superior part of the mansion, unless my father
happened to be making drawings in Indian ink, when I
would sit reverently by and watch; my chosen domains
being, at all other times, the shop, the bakehouse, and the
stones round the spring of crystal water at the back door
(long since let down into the modern sewer); and my chief
companion, my aunt's dog, Towzer, whom she had taken
pity on when he was a snappish, starved vagrant; and made
a brave and affectionate dog of: which was the kind of
thing she did for every living creature that came in her
way, all her life long.

13. Contented, by help of these occasional glimpses of
the rivers of Paradise, I lived until I was more than four
years old in Hunter Street, Brunswick Square, the greater
part of the year; for a few weeks in the summer breathing
country air by taking lodgings in small cottages (real
cottages, not villas, so-called) either about Hampstead, or
at Dulwich, at "Mrs. Ridley's," the last of a row in a
lane which led out into the Dulwich fields on one side,
and was itself full of buttercups in spring, and blackberries
in autumn. But my chief remaining impressions of those
days are attached to Hunter Street. My mother's general
principles of first treatment were, to guard me with steady
watchfulness from all avoidable pain or danger; and, for
the rest, to let me amuse myself as I liked, provided I
was neither fretful nor troublesome. But the law was,
that I should find my own amusement. No toys of any
kind were at first allowed;—and the pity of my Croydon
aunt for my monastic poverty in this respect was bound-
less. On one of my birthdays, thinking to overcome my
mother's resolution by splendour of temptation, she
bought the most radiant Punch and Judy she could find

in all the Soho bazaar—as big as a real Punch and Judy, all dressed in scarlet and gold, and that would dance, tied to the leg of a chair. I must have been greatly impressed, for I remember well the look of the two figures, as my aunt herself exhibited their virtues. My mother was obliged to accept them; but afterwards quietly told me it was not right that I should have them; and I never saw them again.

14. Nor did I painfully wish, what I was never permitted for an instant to hope, or even imagine, the possession of such things as one saw in toy-shops. I had a bunch of keys to play with, as long as I was capable only of pleasure in what glittered and jingled; as I grew older, I had a cart, and a ball; and when I was five or six years old, two boxes of well-cut wooden bricks. With these modest, but, I still think, entirely sufficient possessions, and being always summarily whipped if I cried, did not do as I was bid, or tumbled on the stairs, I soon attained serene and secure methods of life and motion; and could pass my days contentedly in tracing the squares and comparing the colours of my carpet;—examining the knots in the wood of the floor, or counting the bricks in the opposite houses; with rapturous intervals of excitement during the filling of the water-cart, through its leathern pipe, from the dripping iron post at the pavement edge; or the still more admirable proceedings of the turncock, when he turned and turned till a fountain sprang up in the middle of the street. But the carpet, and what patterns I could find in bed covers, dresses, or wall-papers to be examined, were my chief resources, and my attention to the particulars in these was soon so accurate, that when at three and a half I was taken to have my portrait painted by Mr. Northcote, I had not been ten minutes alone with him before I asked him why there were holes in his carpet. The portrait in question represents a very

pretty child with yellow hair, dressed in a white frock like a girl, with a broad light-blue sash and blue shoes to match; the feet of the child wholesomely large in proportion to its body; and the shoes still more wholesomely large in proportion to the feet.

15. These articles of my daily dress were all sent to the old painter for perfect realization; but they appear in the picture more remarkable than they were in my nursery, because I am represented as running in a field at the edge of a wood with the trunks of its trees striped across in the manner of Sir Joshua Reynolds; while two rounded hills, as blue as my shoes, appear in the distance, which were put in by the painter at my own request; for I had already been once, if not twice, taken to Scotland; and my Scottish nurse having always sung to me as we approached the Tweed or Esk,—

"For Scotland, my darling, lies full in thy view,
 With her barefooted lassies, and mountains so blue,"

the idea of distant hills was connected in my mind with approach to the extreme felicities of life, in my Scottish aunt's garden of gooseberry bushes, sloping to the Tay. But that, when old Mr. Northcote asked me (little thinking, I fancy, to get any answer so explicit) what I would like to have in the distance of my picture, I should have said "blue hills" instead of "gooseberry bushes," appears to me—and I think without any morbid tendency to think over-much of myself—a fact sufficiently curious, and not without promise, in a child of that age.

16. I think it should be related also that having, as aforesaid, been steadily whipped if I was troublesome, my formed habit of serenity was greatly pleasing to the old painter; for I sat contentedly motionless, counting the holes in his carpet, or watching him squeeze his paint out of its bladders,—a beautiful operation, indeed, to my

thinking;—but I do not remember taking any interest in Mr. Northcote's application of the pigments to the canvas; my ideas of delightful art, in that respect, involving indispensably the possession of a large pot, filled with paint of the brightest green, and of a brush which would come out of it soppy. But my quietude was so pleasing to the old man that he begged my father and mother to let me sit to him for the face of a child which he was painting in a classical subject; where I was accordingly represented as reclining on a leopard skin, and having a thorn taken out of my foot by a wild man of the woods.

17. In all these particulars, I think the treatment, or accidental conditions, of my childhood, entirely right, for a child of my temperament: but the mode of my introduction to literature appears to me questionable, and I am not prepared to carry it out in St. George's schools, without much modification. I absolutely declined to learn to read by syllables; but would get an entire sentence by heart with great facility, and point with accuracy to every word in the page as I repeated it. As, however, when the words were once displaced, I had no more to say, my mother gave up, for the time, the endeavour to teach me to read, hoping only that I might consent, in process of years, to adopt the popular system of syllabic study. But I went on to amuse myself, in my own way, learnt whole words at a time, as I did patterns; and at five years old was sending for my "second volumes" to the circulating library.

18. This effort to learn the words in their collective aspect, was assisted by my real admiration of the look of printed type, which I began to copy for my pleasure, as other children draw dogs and horses. The following inscription, facsimile'd from the fly-leaf of my Seven Champions of Christendom, (judging from the independent views taken in it of the character of the letter L, and

the relative elevation of G,) I believe to be an extremely early art study of this class; and as by the will of Fors, the first lines of the note, written after an interval of fifty years, underneath my copy of it, in direction to Mr. Burgess, presented some notable points of correspondence with it, I thought it well he should engrave them together, as they stood.

The noble knight Like a bold and daring hero then entered the valley where the Dragon had his abode who no sooner had sight of him but his lea thern throat sent forth a sound more

Bolton Abbey

Dear Arthur 24th Jan. 75

Will you kindly facsimile with moderate care, the above piece of ancient manuscript for Fors.

19. My mother had, as she afterwards told me, solemnly "devoted me to God" before I was born; in imitation of Hannah.

Very good women are remarkably apt to make away with their children prematurely, in this manner: the real meaning of the pious act being, that, as the sons of Zebedee are not (or at least they hope not), to sit on the right and left of Christ, in His kingdom, their own sons may perhaps, they think, in time be advanced to that respectable position in eternal life; especially if they ask Christ very humbly for it every day; and they always forget in the most naïve way that the position is not His to give!

20. "Devoting me to God," meant, as far as my mother knew herself what she meant, that she would try to send me to college, and make a clergyman of me: and I was accordingly bred for "the Church." My father, who—rest be to his soul—had the exceedingly bad habit of yielding to my mother in large things and taking his own way in little ones, allowed me, without saying a word, to be thus withdrawn from the sherry trade as an unclean thing; not without some pardonable participation in my mother's ultimate views for me. For, many and many a year afterwards, I remember, while he was speaking to one of our artist friends, who admired Raphael, and greatly regretted my endeavours to interfere with that popular taste,—while my father and he were condoling with each other on my having been impudent enough to think I could tell the public about Turner and Raphael,— instead of contenting myself, as I ought, with explaining the way of their souls' salvation to them—and what an amiable clergyman was lost in me,—"Yes," said my father, with tears in his eyes—(true and tender tears, as ever father shed,) "he would have been a Bishop."

21. Luckily for me, my mother, under these distinct impressions of her own duty, and with such latent hopes of my future eminence, took me very early to church;— where, in spite of my quiet habits, and my mother's golden vinaigrette, always indulged to me there, and there only, with its lid unclasped that I might see the wreathed open pattern above the sponge, I found the bottom of the pew so extremely dull a place to keep quiet in, (my best story-books being also taken away from me in the morning,) that, as I have somewhere said before, the horror of Sunday used even to cast its prescient gloom as far back in the week as Friday—and all the glory of Monday, with church seven days removed again, was no equivalent for it.

22. Notwithstanding, I arrived at some abstract in my

own mind of the Rev. Mr. Howell's sermons; and occasionally, in imitation of him, preached a sermon at home over the red sofa cushions;—this performance being always called for by my mother's dearest friends, as the great accomplishment of my childhood. The sermon was, I believe, some eleven words long; very exemplary, it seems to me, in that respect—and I still think must have been the purest gospel, for I know it began with, "People, be good."

23. We seldom had company, even on week days; and I was never allowed to come down to dessert, until much later in life—when I was able to crack nuts neatly. I was then permitted to come down to crack other people's nuts for them—(I hope they liked the ministration)—but never to have any myself; nor anything else of dainty kind, either then or at other times. Once at Hunter Street, I recollect my mother giving me three raisins, in the forenoon, out of the store cabinet; and I remember perfectly the first time I tasted custard, in our lodgings in Norfolk Street—where we had gone while the house was being painted, or cleaned, or something. My father was dining in the front room, and did not finish his custard; and my mother brought me the bottom of it into the back room.

24. But for the reader's better understanding of such further progress of my poor little life as I may trespass on his patience in describing, it is now needful that I give some account of my father's mercantile position in London.

The firm of which he was head partner may be yet remembered by some of the older city houses, as carrying on their business in a small counting-house on the first floor of narrow premises, in as narrow a thoroughfare of East London,—Billiter Street, the principal traverse from Leadenhall Street into Fenchurch Street.

The names of the three partners were given in full on

their brass plate under the counting-house bell,—Ruskin, Telford, and Domecq.

25. Mr. Domecq's name should have been the first, by rights, for my father and Mr. Telford were only his agents. He was the sole proprietor of the estate which was the main capital of the firm,—the vineyard of Macharnudo, the most precious hillside, for growth of white wine, in the Spanish peninsula. The quality of the Macharnudo vintage essentially fixed the standard of Xeres "sack," or "dry"—secco—sherris, or sherry, from the days of Henry the Fifth to our own;—the unalterable and unrivalled chalk-marl of it putting a strength into the grape which age can only enrich and darken,—never impair.

26. Mr. Peter Domecq was, I believe, Spanish born; and partly French, partly English bred; a man of strictest honour, and kindly disposition; how descended, I do not know; how he became possessor of his vineyard, I do not know; what position he held, when young, in the firm of Gordon, Murphy, and Company, I do not know; but in their house he watched their head clerk, my father, during his nine years of duty, and when the house broke up, asked him to be his own agent in England. My father saw that he could fully trust Mr. Domecq's honour, and feeling;—but not so fully either his sense, or his industry; and insisted, though taking only his agent's commission, on being both nominally, and practically, the head-partner of the firm.

27. Mr. Domecq lived chiefly in Paris; rarely visiting his Spanish estate, but having perfect knowledge of the proper processes of its cultivation, and authority over its labourers almost like a chief's over his clan. He kept the wines at the highest possible standard; and allowed my father to manage all matters concerning their sale, as he thought best. The second partner, Mr. Henry Telford, brought into the business what capital was necessary for

its London branch. The premises in Billiter Street belonged to him; and he had a pleasant country house at Widmore, near Bromley; a quite far-away Kentish village in those days.

He was a perfect type of an English country gentleman of moderate fortune; unmarried, living with three un-married sisters,—who, in the refinement of their highly educated, unpretending, benevolent, and felicitous lives, remain in my memory more like the figures in a beautiful story than realities. Neither in story, nor in reality, have I ever again heard of, or seen, anything like Mr. Henry Telford;—so gentle, so humble, so affectionate, so clear in common sense, so fond of horses,—and so entirely in-capable of doing, thinking, or saying, anything that had the slightest taint in it of the racecourse or the stable.

28. Yet I believe he never missed any great race; passed the greater part of his life on horseback; and hunted during the whole Leicestershire season; but never made a bet, never had a serious fall, and never hurt a horse. Between him and my father there was absolute confidence, and the utmost friendship that could exist without com-munity of pursuit. My father was greatly proud of Mr. Telford's standing among the country gentlemen; and Mr. Telford was affectionately respectful to my father's steady industry and infallible commercial instinct. Mr. Tel-ford's actual part in the conduct of the business was limited to attendance in the counting-house during two months at Midsummer, when my father took his holiday, and sometimes for a month at the beginning of the year, when he travelled for orders. At these times Mr. Telford rode into London daily from Widmore, signed what letters and bills needed signature, read the papers, and rode home again; any matters needing deliberation were referred to my father, or awaited his return. All the family at Wid-more would have been limitlessly kind to my mother and

me, if they had been permitted any opportunity; but my
mother always felt, in cultivated society,—and was too
proud to feel with patience,—the defects of her own early
education; and therefore (which was the true and fatal
sign of such defect) never familiarly visited any one whom
she did not feel to be, in some sort, her inferior.

Nevertheless, Mr. Telford had a singularly important
influence in my education. By, I believe, his sisters'
advice, he gave me, as soon as it was published, the illus-
trated edition of Rogers' Italy. This book was the first
means I had of looking carefully at Turner's work: and I
might, not without some appearance of reason, attribute
to the gift the entire direction of my life's energies. But
it is the great error of thoughtless biographers to attribute
to the accident which introduces some new phase of char-
acter, all the circumstances of character which gave the
accident importance. The essential point to be noted,
and accounted for, was that I could understand Turner's
work, when I saw it;—not by what chance, or in what
year, it was first seen. Poor Mr. Telford, nevertheless,
was always held by papa and mamma primarily responsible
for my Turner insanities.

29. In a more direct, though less intended way, his
help to me was important. For, before my father thought
it right to hire a carriage for the above mentioned Mid-
summer holiday, Mr. Telford always lent us his own
travelling chariot.

Now the old English chariot is the most luxurious of
travelling carriages, for two persons, or even for two
persons and so much of third personage as I possessed at
three years old. The one in question was hung high,
so that we could see well over stone dykes and average
hedges out of it; such elevation being attained by the old-
fashioned folding steps, with a lovely padded cushion
fitting into the recess of the door,—steps which it was one

of my chief travelling delights to see the hostlers fold up and down; though my delight was painfully alloyed by envious ambition to be allowed to do it myself:—but I never was,—lest I should pinch my fingers.

30. The "dickey,"—(to think that I should never till this moment have asked myself the derivation of that word, and now be unable to get at it!)—being, typically, that commanding seat in her Majesty's mail, occupied by the Guard; and classical, even in modern literature, as the scene of Mr. Bob Sawyer's arrangements with Sam,—was thrown far back in Mr. Telford's chariot, so as to give perfectly comfortable room for the legs (if one chose to travel outside on fine days), and to afford beneath it spacious area to the boot, a storehouse of rearward miscellaneous luggage. Over which—with all the rest of forward and superficial luggage—my nurse Anne presided, both as guard and packer; unrivalled, she, in the flatness and precision of her in-laying of dresses, as in turning of pancakes; the fine precision, observe, meaning also the easy wit and invention of her art; for, no more in packing a trunk than commanding a campaign, is precision possible without foresight.

31. Among the people whom one must miss out of one's life, dead, or worse than dead, by the time one is past fifty, I can only say for my own part, that the one I practically and truly miss most next to father and mother, (and putting losses of imaginary good out of the question,) is this Anne, my father's nurse, and mine. She was one of our "many," * (our many being always but few,) and from her girlhood to her old age, the entire ability of her life was given to serving us. She had a natural gift and speciality for doing disagreeable things; above all, the service of a sick room; so that she was never quite in her glory unless some of us were ill. She had also some

* Formerly "Meinie," "attendant company."

parallel speciality for *saying* disagreeable things; and might
be relied upon to give the extremely darkest view of any
subject, before proceeding to ameliorative action upon it.
And she had a very creditable and republican aversion to
doing immediately, or in set terms, as she was bid; so that
when my mother and she got old together, and my
mother became very imperative and particular about hav-
ing her teacup set on one side of her little round table,
Anne would observantly and punctiliously put it always
on the other; which caused my mother to state to me,
every morning after breakfast, gravely, that if ever a
woman in this world was possessed by the Devil, Anne
was that woman. But in spite of these momentary and
petulant aspirations to liberality and independence of
character, poor Anne remained very servile in soul all her
days; and was altogether occupied, from the age of fifteen
to seventy-two, in doing other people's wills instead of her
own, and seeking other people's good instead of her own:
nor did I ever hear on any occasion of her doing harm to
a human being, except by saving two hundred and some
odd pounds for her relations; in consequence of which
some of them, after her funeral, did not speak to the rest
for several months.

32. The dickey then aforesaid, being indispensable for
our guard Anne, was made wide enough for two, that my
father might go outside also when the scenery and day
were fine. The entire equipage was not a light one of its
kind; but, the luggage being carefully limited, went gaily
behind good horses on the then perfectly smooth mail
roads; and posting, in those days, being universal, so that
at the leading inns in every country town, the cry "Horses
out!" down the yard, as one drove up, was answered, often
instantly, always within five minutes, by the merry trot
through the archway of the booted and bright-jacketed
rider, with his caparisoned pair,—there was no driver's

seat in front: and the four large, admirably fitting and
sliding windows, admitting no drop of rain when they
were up, and never sticking as they were let down, formed
one large moving oriel, out of which one saw the country
round, to the full half of the horizon. My own prospect
was more extended still, for my seat was the little box
containing my clothes, strongly made, with a cushion on
one end of it; set upright in front (and well forward),
between my father and mother. I was thus not the least
in their way, and my horizon of sight the widest possible.
When no object of particular interest presented itself, I
trotted, keeping time with the postboy on my trunk
cushion for a saddle, and whipped my father's legs for
horses; at first theoretically only, with dexterous motion
of wrist; but ultimately in a quite practical and efficient
manner, my father having presented me with a silver-
mounted postillion's whip.

33. The Midsummer holiday, for better enjoyment of
which Mr. Telford provided us with these luxuries, began
usually on the fifteenth of May, or thereabouts;—my
father's birthday was the tenth; on that day I was always
allowed to gather the gooseberries for his first gooseberry
pie of the year, from the tree between the buttresses on the
north wall of the Herne Hill garden; so that we could not
leave before that *festa*. The holiday itself consisted in a
tour for orders through half the English counties; and a
visit (if the counties lay northward) to my aunt in Scotland.

34. The mode of journeying was as fixed as that of
our home life. We went from forty to fifty miles a day,
starting always early enough in the morning to arrive
comfortably to four o'clock dinner. Generally, therefore,
getting off at six o'clock, a stage or two were done before
breakfast, with the dew on the grass, and first scent from
the hawthorns; if in the course of the midday drive there
were any gentleman's house to be seen,—or, better still,

a lord's—or, best of all, a duke's,—my father baited the
horses, and took my mother and me reverently through
the state rooms; always speaking a little under our breath
to the housekeeper, major domo, or other authority in
charge; and gleaning worshipfully what fragmentary
illustrations of the history and domestic ways of the family
might fall from their lips.

35. In analyzing above, page 8, the effect on my mind
of all this, I have perhaps a little antedated the supposed
resultant impression that it was probably happier to live
in a small house than a large one.　But assuredly, while I
never to this day pass a lattice-windowed cottage without
wishing to be its cottager, I never yet saw the castle which
I envied to its lord; and although in the course of these
many worshipful pilgrimages I gathered curiously exten-
sive knowledge, both of art and natural scenery, afterwards
infinitely useful, it is evident to me in retrospect that my
own character and affections were little altered by them;
and that the personal feeling and native instinct of me had
been fastened, irrevocably, long before, to things modest,
humble, and pure in peace, under the low red roofs of
Croydon, and by the cress-set rivulets in which the sand
danced and minnows darted above the Springs of Wandel.

HERNE HILL ALMOND BLOSSOMS

36. WHEN I was about four years old my father found himself able to buy the lease of a house on Herne Hill, a rustic eminence four miles south of the "Standard in Cornhill"; of which the leafy seclusion remains, in all essential points of character, unchanged to this day: certain Gothic splendours, lately indulged in by our wealthier neighbours, being the only serious innovations; and these are so graciously concealed by the fine trees of their grounds, that the passing viator remains unappalled by them; and I can still walk up and down the piece of road between the Fox tavern and the Herne Hill station, imagining myself four years old.

37. Our house was the northernmost of a group which stand accurately on the top or dome of the hill, where the ground is for a small space level, as the snows are, (I understand,) on the dome of Mont Blanc; presently falling, however, in what may be, in the London clay formation, considered a precipitous slope, to our valley of Chamouni (or of Dulwich) on the east; and with a softer descent into Cold Harbour-lane * on the west: on the south, no less beautifully declining to the dale of the Effra, (doubtless shortened from Effrena, signifying the "Unbridled" river; recently, I regret to say, bricked over for the convenience of Mr. Biffin, chemist, and others); while on the north, prolonged indeed with slight depression some half mile or so, and receiving, in the parish of Lambeth, the chivalric

* Said in the History of Croydon to be a name which has long puzzled antiquaries, and nearly always found near Roman military stations.

title of "Champion Hill," it plunges down at last to efface itself in the plains of Peckham, and the rural barbarism of Goose Green.

38. The group, of which our house was the quarter, consisted of two precisely similar partner-couples of houses, gardens and all to match; still the two highest blocks of buildings seen from Norwood on the crest of the ridge; so that the house itself, three-storied, with garrets above, commanded, in those comparatively smoke-less days, a very notable view from its garret windows, of the Norwood hills on one side, and the winter sunrise over them; and of the valley of the Thames on the other, with Windsor telescopically clear in the distance, and Harrow, conspicuous always in fine weather to open vision against the summer sunset. It had front and back garden in sufficient proportion to its size; the front, richly set with old evergreens, and well-grown lilac and laburnum; the back, seventy yards long by twenty wide, renowned over all the hill for its pears and apples, which had been chosen with extreme care by our predecessor, (shame on me to forget the name of a man to whom I owe so much!)— and possessing also a strong old mulberry tree, a tall white-heart cherry tree, a black Kentish one, and an almost unbroken hedge, all round, of alternate gooseberry and currant bush; decked, in due season, (for the ground was wholly beneficent,) with magical splendour of abundant fruit: fresh green, soft amber, and rough-bristled crimson bending the spinous branches; clustered pearl and pendant ruby joyfully discoverable under the large leaves that looked like vine.

39. The differences of primal importance which I observed between the nature of this garden, and that of Eden, as I had imagined it, were, that, in this one, *all* the fruit was forbidden; and there were no companionable beasts: in other respects the little domain answered every

purpose of Paradise to me; and the climate, in that cycle
of our years, allowed me to pass most of my life in it. My
mother never gave me more to learn than she knew I
could easily get learnt, if I set myself honestly to work,
by twelve o'clock. She never allowed anything to disturb
me when my task was set; if it was not said rightly by
twelve o'clock, I was kept in till I knew it, and in general,
even when Latin Grammar came to supplement the
Psalms, I was my own master for at least an hour before
half-past one dinner, and for the rest of the afternoon.

40. My mother, herself finding her chief personal
pleasure in her flowers, was often planting or pruning
beside me, at least if I chose to stay beside *her*. I never
thought of doing anything behind her back which I would
not have done before her face; and her presence was there-
fore no restraint to me; but, also, no particular pleasure,
for, from having always been left so much alone, I had
generally my own little affairs to see after; and, on the
whole, by the time I was seven years old, was already
getting too independent, mentally, even of my father and
mother; and, having nobody else to be dependent upon,
began to lead a very small, perky, contented, conceited,
Cock-Robinson-Crusoe sort of life, in the central point
which it appeared to me, (as it must naturally appear to
geometrical animals,) that I occupied in the universe.

41. This was partly the fault of my father's modesty;
and partly of his pride. He had so much more confidence
in my mother's judgment as to such matters than in his
own, that he never ventured even to help, much less to
cross her, in the conduct of my education; on the other
hand, in the fixed purpose of making an ecclesiastical
gentleman of me, with the superfinest of manners, and
access to the highest circles of fleshly and spiritual society,
the visits to Croydon, where I entirely loved my aunt,
and young baker-cousins, became rarer and more rare:

the society of our neighbours on the hill could not be had
without breaking up our regular and sweetly selfish
manner of living; and on the whole, I had nothing
animate to care for, in a childish way, but myself, some
nests of ants, which the gardener would never leave un-
disturbed for me, and a sociable bird or two; though I
never had the sense or perseverance to make one really
tame. But that was partly because, if ever I managed to
bring one to be the least trustful of me, the cats got it.

Under these circumstances, what powers of imagination
I possessed, either fastened themselves on inanimate things
—the sky, the leaves, and pebbles, observable within the
walls of Eden,—or caught at any opportunity of flight into
regions of romance, compatible with the objective realities
of existence in the nineteenth century, within a mile and
a quarter of Camberwell Green.

42. Herein my father, happily, though with no definite
intention other than of pleasing me, when he found he
could do so without infringing any of my mother's rules,
became my guide. I was particularly fond of watching
him shave; and was always allowed to come into his room
in the morning (under the one in which I am now writing),
to be the motionless witness of that operation. Over his
dressing-table hung one of his own water-colour drawings,
made under the teaching of the elder Nasmyth; I believe,
at the High School of Edinburgh. It was done in the
early manner of tinting, which, just about the time when
my father was at the High School, Dr. Monro was teach-
ing Turner; namely, in grey under-tints of Prussian blue
and British ink, washed with warm colour afterwards on
the lights. It represented Conway Castle, with its Frith,
and, in the foreground, a cottage, a fisherman, and a boat
at the water's edge.*

* This drawing is still over the chimney-piece of my bedroom at
Brantwood.

43. When my father had finished shaving, he always told me a story about this picture. The custom began without any initial purpose of his, in consequence of my troublesome curiosity whether the fisherman lived in the cottage, and where he was going to in the boat. It being settled, for peace' sake, that he *did* live in the cottage, and was going in the boat to fish near the castle, the plot of the drama afterwards gradually thickened; and became, I believe, involved with that of the tragedy of Douglas, and of the Castle Spectre, in both of which pieces my father had performed in private theatricals, before my mother, and a select Edinburgh audience, when he was a boy of sixteen, and she, at grave twenty, a model housekeeper, and very scornful and religiously suspicious of theatricals. But she was never weary of telling me, in later years, how beautiful my father looked in his Highland dress, with the high black feathers.

44. In the afternoons, when my father returned (always punctually) from his business, he dined, at half-past four, in the front parlour, my mother sitting beside him to hear the events of the day, and give counsel and encouragement with respect to the same;—chiefly the last, for my father was apt to be vexed if orders for sherry fell the least short of their due standard, even for a day or two. I was never present at this time, however, and only avouch what I relate by hearsay and probable conjecture; for between four and six it would have been a grave misdemeanour in me if I so much as approached the parlour door. After that, in summer time, we were all in the garden as long as the day lasted; tea under the white-heart cherry tree; or in winter and rough weather, at six o'clock in the drawing-room,—I having my cup of milk, and slice of bread-and-butter, in a little recess, with a table in front of it, wholly sacred to me; and in which I remained in the evenings as an Idol in a niche, while my mother knitted, and my

father read to her,—and to me, so far as I chose to listen.

45. The series of the Waverley novels, then drawing towards its close, was still the chief source of delight in all households caring for literature; and I can no more recollect the time when I did not know them than when I did not know the Bible; but I have still a vivid remembrance of my father's intense expression of sorrow mixed with scorn, as he threw down Count Robert of Paris, after reading three or four pages; and knew that the life of Scott was ended: the scorn being a very complex and bitter feeling in him,—partly, indeed, of the book itself, but chiefly of the wretches who were tormenting and selling the wrecked intellect, and not a little, deep down, of the subtle dishonesty which had essentially caused the ruin. My father never could forgive Scott his concealment of the Ballantyne partnership.

46. Such being the salutary pleasures of Herne Hill, I have next with deeper gratitude to chronicle what I owe to my mother for the resolutely consistent lessons which so exercised me in the Scriptures as to make every word of them familiar to my ear in habitual music,—yet in that familiarity reverenced, as transcending all thought, and ordaining all conduct.*

This she effected, not by her own sayings or personal authority; but simply by compelling me to read the book thoroughly, for myself. As soon as I was able to read with fluency, she began a course of Bible work with me, which never ceased till I went to Oxford. She read alternate verses with me, watching, at first, every intonation of my voice, and correcting the false ones, till she made me understand the verse, if within my reach, rightly, and energetically. It might be beyond me altogether;

* Compare the 52nd paragraph of chapter iii. of *The Bible of Amiens.*

that she did not care about; but she made sure that as soon as I got hold of it at all, I should get hold of it by the right end.

In this way she began with the first verse of Genesis, and went straight through, to the last verse of the Apocalypse; hard names, numbers, Levitical law, and all; and began again at Genesis the next day. If a name was hard, the better the exercise in pronunciation,—if a chapter was tiresome, the better lesson in patience,—if loathsome, the better lesson in faith that there was some use in its being so outspoken. After our chapters, (from two to three a day, according to their length, the first thing after breakfast, and no interruption from servants allowed, —none from visitors, who either joined in the reading or had to stay upstairs,—and none from any visitings or excursions, except real travelling,) I had to learn a few verses by heart, or repeat, to make sure I had not lost, something of what was already known; and, with the chapters thus gradually possessed from the first word to the last, I had to learn the whole body of the fine old Scottish paraphrases, which are good, melodious, and forceful verse; and to which, together with the Bible itself, I owe the first cultivation of my ear in sound.

It is strange that of all the pieces of the Bible which my mother thus taught me, that which cost me most to learn, and which was, to my child's mind, chiefly repulsive —the 119th Psalm—has now become of all the most precious to me, in its overflowing and glorious passion of love for the Law of God, in opposition to the abuse of it by modern preachers of what they imagine to be His gospel.

47. But it is only by deliberate effort that I recall the long morning hours of toil, as regular as sunrise,—toil on both sides equal—by which, year after year, my mother forced me to learn these paraphrases, and chapters, (the

eighth of 1st Kings being one—try it, good reader, in a
leisure hour!) allowing not so much as a syllable to be
missed or misplaced; while every sentence was required
to be said over and over again till she was satisfied with
the accent of it. I recollect a struggle between us of
about three weeks, concerning the accent of the "of" in
the lines

> "Shall any following spring revive
> The ashes of the urn?"

—I insisting, partly in childish obstinacy, and partly in true
instinct for rhythm, (being wholly careless on the subject
both of urns and their contents,) on reciting it with an
accented *of*. It was not, I say, till after three weeks'
labour, that my mother got the accent lightened on the
"of" and laid on the ashes, to her mind. But had it taken
three years she would have done it, having once under-
taken to do it. And, assuredly, had she not done it,—
well, there's no knowing what would have happened; but
I'm very thankful she *did*.

48. I have just opened my oldest (in use) Bible,—a
small, closely, and very neatly printed volume it is, printed
in Edinburgh by Sir D. Hunter Blair and J. Bruce,
Printers to the King's Most Excellent Majesty, in 1816.
Yellow, now, with age, and flexible, but not unclean,
with much use, except that the lower corners of the pages
at 8th of 1st Kings, and 32nd Deuteronomy, are worn
somewhat thin and dark, the learning of these two chapters
having cost me much pains. My mother's list of the
chapters with which, thus learned, she established my soul
in life,* has just fallen out of it. I will take what in-

* This expression in Fors has naturally been supposed by some
readers to mean that my mother at this time made me vitally and
evangelically religious. The fact was far otherwise. I meant only
that she gave me secure *ground* for all future life, practical or spiritual.
See the paragraph next following.

dulgence the incurious reader can give me, for printing
the list thus accidentally occurrent:—

Exodus,	chapters	15th and 20th.
2 Samuel	,,	1st, from 17th verse to the end.
1 Kings	,,	8th.
Psalms	,,	23rd, 32nd, 90th, 91st, 103rd, 112th, 119th, 139th.
Proverbs	,,	2nd, 3rd, 8th, 12th.
Isaiah	,,	58th.
Matthew	,,	5th, 6th, 7th.
Acts	,,	26th.
1 Corinthians	,,	13th, 15th.
James	,,	4th.
Revelation	,,	5th, 6th.

And truly, though I have picked up the elements of a
little further knowledge—in mathematics, meteorology,
and the like, in after life,—and owe not a little to the
teaching of many people, this maternal installation of my
mind in that property of chapters, I count very confidently
the most precious, and, on the whole, the one *essential* part
of all my education.

And it is perhaps already time to mark what advantage
and mischief, by the chances of life up to seven years old,
had been irrevocably determined for me.

I will first count my blessings (as a not unwise friend
once recommended me to do, continually; whereas I have
a bad trick of always numbering the thorns in my fingers
and not the bones in them).

And for best and truest beginning of all blessings, I had
been taught the perfect meaning of Peace, in thought, act,
and word.

I never had heard my father's or mother's voice once
raised in any question with each other; nor seen an angry,
or even slightly hurt or offended, glance in the eyes of

either. I had never heard a servant scolded; nor even
suddenly, passionately, or in any severe manner, blamed.
I had never seen a moment's trouble or disorder in any
household matter; nor anything whatever either done in
a hurry, or undone in due time. I had no conception of
such a feeling as anxiety; my father's occasional vexation
in the afternoons, when he had only got an order for
twelve butts after expecting one for fifteen, as I have
just stated, was never manifested to *me*; and itself related
only to the question whether his name would be a step
higher or lower in the year's list of sherry exporters; for
he never spent more than half his income, and therefore
found himself little incommoded by occasional variations
in the total of it. I had never done any wrong that I
knew of—beyond occasionally delaying the commitment
to heart of some improving sentence, that I might watch
a wasp on the window pane, or a bird in the cherry tree;
and I had never seen any grief.

49. Next to this quite priceless gift of Peace, I had
received the perfect understanding of the natures of
Obedience and Faith. I obeyed word, or lifted finger,
of father or mother, simply as a ship her helm; not only
without idea of resistance, but receiving the direction as
a part of my own life and force, a helpful law, as necessary
to me in every moral action as the law of gravity in leaping.
And my practice in Faith was soon complete: nothing
was ever promised me that was not given; nothing ever
threatened me that was not inflicted, and nothing ever
told me that was not true.

Peace, obedience, faith; these three for chief good; next
to these, the habit of fixed attention with both eyes and
mind—on which I will not further enlarge at this moment,
this being the main practical faculty of my life, causing
Mazzini to say of me, in conversation authentically re-
ported, a year or two before his death, that I had "the most

analytic mind in Europe." An opinion in which, so far as I am acquainted with Europe, I am myself entirely disposed to concur.

Lastly, an extreme perfection in palate and all other bodily senses, given by the utter prohibition of cake, wine, comfits, or, except in carefullest restriction, fruit; and by fine preparation of what food was given me. Such I esteem the main blessings of my childhood;—next, let me count the equally dominant calamities.

50. First, that I had nothing to love.

My parents were—in a sort—visible powers of nature to me, no more loved than the sun and the moon: only I should have been annoyed and puzzled if either of them had gone out; (how much, now, when both are darkened!) —still less did I love God; not that I had any quarrel with Him, or fear of Him; but simply found what people told me was His service, disagreeable; and what people told me was His book, not entertaining. I had no companions to quarrel with, neither; nobody to assist, and nobody to thank. Not a servant was ever allowed to do anything for me, but what it was their duty to do; and why should I have been grateful to the cook for cooking, or the gardener for gardening,—when the one dared not give me a baked potato without asking leave, and the other would not let my ants' nests alone, because they made the walks untidy? The evil consequence of all this was not, however, what might perhaps have been expected, that I grew up selfish or unaffectionate; but that, when affection did come, it came with violence utterly rampant and unmanageable, at least by me, who never before had anything to manage.

51. For (second of chief calamities) I had nothing to endure. Danger or pain of any kind I knew not: my strength was never exercised, my patience never tried, and my courage never fortified. Not that I was ever afraid

of anything,—either ghosts, thunder, or beasts; and one
of the nearest approaches to insubordination which I was
ever tempted into as a child, was in passionate effort to
get leave to play with the lion's cubs in Wombwell's
menagerie.

52. Thirdly. I was taught no precision nor etiquette
of manners; it was enough if, in the little society we saw,
I remained unobtrusive, and replied to a question without
shyness: but the shyness came later, and increased as I
grew conscious of the rudeness arising from the want of
social discipline, and found it impossible to acquire, in
advanced life, dexterity in any bodily exercise, skill in any
pleasing accomplishment, or ease and tact in ordinary
behaviour.

53. Lastly, and chief of evils. My judgment of right
and wrong, and powers of independent action,* were left
entirely undeveloped; because the bridle and blinkers were
never taken off me. Children should have their times
of being off duty, like soldiers; and when once the obedi-
ence, if required, is certain, the little creature should be
very early put for periods of practice in complete command
of itself; set on the bare-backed horse of its own will, and
left to break it by its own strength. But the ceaseless
authority exercised over my youth left me, when cast out
at last into the world, unable for some time to do more
than drift with its vortices.

54. My present verdict, therefore, on the general tenor
of my education at that time, must be, that it was at once
too formal and too luxurious; leaving my character, at
the most important moment for its construction, cramped
indeed, but not disciplined; and only by protection innocent
instead of by practice virtuous. My mother saw this
herself, and but too clearly, in later years; and whenever

* *Action*, observe, I say here: in *thought* I was too independent,
as I said above.

I did anything wrong, stupid, or hard-hearted,—(and I have done many things that were all three,)—always said, "It is because you were too much indulged."

55. Thus far, with some omissions, I have merely re-printed the account of these times given in Fors: and I fear the sequel may be more trivial, because much is concentrated in the foregoing broad statement, which I have now to continue by slower steps;—and yet less amusing, because I tried always in Fors to say things, if I could, a little piquantly; and the rest of the things related in this book will be told as plainly as I can. But whether I succeeded in writing piquantly in Fors or not, I certainly wrote often obscurely; and the description above given of Herne Hill seems to me to need at once some reduction to plainer terms.

56. The actual height of the long ridge of Herne Hill, above Thames,—at least above the nearly Thames-level of its base at Camberwell Green, is, I conceive, not more than one hundred and fifty feet: but it gives the whole of this fall on both sides of it in about a quarter of a mile; forming, east and west, a succession of quite beautiful pleasure-ground and gardens, instantly dry after rain, and in which, for children, running down is pleasant play, and rolling a roller up, vigorous work. The view from the ridge on both sides was, before railroads came, entirely lovely: westward at evening, almost sublime, over softly wreathing distances of domestic wood;—Thames herself not visible, nor any fields except immediately beneath; but the tops of twenty square miles of politely inhabited groves. On the other side, east and south, the Norwood hills, partly rough with furze, partly wooded with birch and oak, partly in pure green bramble copse, and rather steep pasture, rose with the promise of all the rustic loveliness of Surrey and Kent in them, and with so much of space and height in their sweep, as gave them some fellowship

with hills of true hill-districts. Fellowship now incon-
ceivable, for the Crystal Palace, without ever itself attain-
ing any true aspect of size, and possessing no more sublimity
than a cucumber frame between two chimneys, yet by
its stupidity of hollow bulk, dwarfs the hills at once; so
that now one thinks of them no more but as three long
lumps of clay, on lease for building. But then, the
Nor-wood, or North wood, so called as it was seen from
Croydon, in opposition to the South wood of the Surrey
downs, drew itself in sweeping crescent good five miles
round Dulwich to the south, broken by lanes of ascent,
Gipsy Hill, and others; and, from the top, commanding
views towards Dartford, and over the plain of Croydon,—
in contemplation of which I one day frightened my
mother out of her wits by saying "the eyes were coming
out of my head!" She thought it was an attack of
coup-de-soleil.

57. Central in such amphitheatre, the crowning glory
of Herne Hill was accordingly, that, after walking along
its ridge southward from London through a mile of chest-
nut, lilac, and apple trees, hanging over the wooden palings
on each side—suddenly the trees stopped on the left, and
out one came on the top of a field sloping down to the
south into Dulwich valley—open field animate with cow
and buttercup, and below, the beautiful meadows and high
avenues of Dulwich; and beyond, all that crescent of the
Norwood hills; a footpath, entered by a turnstile, going
down to the left, always so warm that invalids could be
sheltered there in March, when to walk elsewhere would
have been death to them; and so quiet, that whenever I
had anything difficult to compose or think of, I used to
do it rather there than in our own garden. The great
field was separated from the path and road only by light
wooden open palings, four feet high, needful to keep the
cows in. Since I last composed, or meditated there,

various improvements have taken place; first the neigh-
bourhood wanted a new church, and built a meagre Gothic
one with a useless spire, for the fashion of the thing, at
the side of the field; then they built a parsonage behind it,
the two stopping out half the view in that direction.
Then the Crystal Palace came, for ever spoiling the view
through all its compass, and bringing every show-day,
from London, a flood of pedestrians down the footpath,
who left it filthy with cigar ashes for the rest of the week:
then the railroads came, and expatiating roughs by every
excursion train, who knocked the palings about, roared
at the cows, and tore down what branches of blossom they
could reach over the palings on the enclosed side. Then
the residents, on the enclosed side, built a brick wall to
defend themselves. Then the path got to be insufferably
hot as well as dirty, and was gradually abandoned to the
roughs, with a policeman on watch at the bottom.
Finally, this year, a six foot high close paling has been
put down the other side of it, and the processional excur-
sionist has the liberty of obtaining what notion of the
country air and prospect he may, between the wall and
that, with one bad cigar before him, another behind him,
and another in his mouth.

58. I do not mean this book to be in any avoidable way
disagreeable or querulous; but expressive generally of my
native disposition—which, though I say it, is extremely
amiable, when I'm not bothered: I will grumble elsewhere
when I must, and only notice this injury alike to the
resident and excursionist at Herne Hill, because questions
of right-of-way are now of constant occurrence; and in
most cases, the mere *path* is the smallest part of the old
Right, truly understood. The Right is of the cheerful
view and sweet air which the path commanded.

Also, I may note in passing, that for all their talk about
Magna Charta, very few Englishmen are aware that one

of the main provisions of it is that Law should not be sold; *
and it seems to me that the law of England might preserve
Banstead and other downs free to the poor of England,
without charging me, as it has just done, a hundred pounds
for its temporary performance of that otherwise un-
remunerative duty.

59. I shall have to return over the ground of these
early years, to fill gaps, after getting on a little first; but
will yet venture here the tediousness of explaining that my
saying "in Herne Hill garden all fruit was forbidden,"
only meant, of course, forbidden unless under defined
restriction; which made the various gatherings of each
kind in its season a sort of harvest festival; and which had
this further good in its apparent severity, that, although
in the at last indulgent areas, the peach which my mother
gathered for me when she was sure it was ripe, and the
cherry pie for which I had chosen the cherries red all
round, were, I suppose, of more ethereal flavour to me
than they could have been to children allowed to pluck
and eat at their will; still the unalloyed and long continuing
pleasure given me by our fruit-tree avenue was in its
blossom, not in its bearing. For the general epicurean
enjoyment of existence, potatoes well browned, green
pease well boiled,—broad beans of the true bitter,—and
the pots of damson and currant for whose annual filling
we were dependent more on the greengrocer than the
garden, were a hundredfold more important to me than
the dozen or two of nectarines of which perhaps I might
get the halves of three,—(the other sides mouldy)—or the
bushel or two of pears which went directly to the store-
shelf. So that, very early indeed in my thoughts of trees,
I had got at the principle given fifty years afterwards in
"Proserpina," that the seeds and fruits of them were for

* "To no one will We sell, to no one will We deny or defer, Right,
or Justice."

the sake of the flowers, not the flowers for the fruit. The
first joy of the year being in its snowdrops, the second,
and cardinal one, was in the almond blossom,—every other
garden and woodland gladness following from that in an
unbroken order of kindling flower and shadowy leaf; and
for many and many a year to come,—until indeed, the
whole of life became autumn to me,—my chief prayer
for the kindness of heaven, in its flowerful seasons, was
that the frost might not touch the almond blossom.

THE BANKS OF TAY

60. The reader has, I hope, observed that in all I have hitherto said, emphasis has been laid only on the favourable conditions which surrounded the child whose history I am writing, and on the docile and impressionable quietness of its temper.

No claim has been made for it to any special power or capacity; for, indeed, none such existed, except that patience in looking, and precision in feeling, which afterwards, with due industry, formed my analytic power.

In all essential qualities of genius, except these, I was deficient; my memory only of average power. I have literally never known a child so incapable of acting a part, or telling a tale. On the other hand, I have never known one whose thirst for visible fact was at once so eager and so methodic.

61. I find also that in the foregoing accounts, modest as I meant them to be, higher literature is too boastfully spoken of as my first and exclusive study. My little Pope's Iliad, and, in any understanding of them, my Genesis and Exodus, were certainly of little account with me till after I was ten. My calf milk of books was, on the lighter side, composed of Dame Wiggins of Lee, the Peacock at Home, and the like nursery rhymes; and on the graver side, of Miss Edgeworth's Frank, and Harry and Lucy, combined with Joyce's Scientific Dialogues. The earliest dated efforts I can find, indicating incipient motion of brain-molecules, are six "poems" on subjects selected from those works; between the fourth and fifth of which my mother has written: "January, 1826. This

book begun about September or October, 1826, finished about January, 1827." The whole of it, therefore, was written and printed in imitation of book-print, in my seventh year. The book is a little red one, ruled with blue, six inches high by four wide, containing forty-five leaves pencilled in imitation of print on both sides,—the title-page, written in the form here approximately imitated, on the inside of the cover.

HARRY AND LUCY

CONCLUDED

BEING THE LAST

PART OF

EARLY LESSONS

in four volumes

vol I

with copper

plates

PRINTED and composed by a little boy
and also drawn

62. Of the promised four volumes, it appears that (according to my practice to this day) I accomplished but one and a quarter, the first volume consisting only of forty leaves, the rest of the book being occupied by the aforesaid six "poems," and the forty leaves losing ten of their pages in the "copper plates," of which the one, purporting to represent "Harry's new road," is, I believe, my first effort at mountain drawing. The passage closing the first volume of this work is, I think, for several reasons, worth preservation. I print it, therefore, with its own divisions of line, and three variations of size in imitated type. Punctuation must be left to the reader's kind conjecture. The hyphens, it is to be noticed, were put long or short, to make the print even, not that it ever succeeds in being so, but the variously spaced lines here imitate it pretty well.

Harry knew very well-
what it was and went
on with his drawing but
Lucy soon called him aw-
ay and bid him observe
a great black cloud from-
the north which seemed ra
ther electrical. Harry ran
for an electrical apparatus which
his father had given him and the-
cloud electrified his apparatus positively

after that another cloud came which
electrified his apparatus negatively
and then a long train of smaller
ones but before this cloud came
a great cloud of dust rose from
the ground and followed the pos
itive cloud and at length seemed
to come in contact with it and
when the other cloud came
a flash of lightning was seen
to dart through the cloud of
dust upon which the negative
cloud spread very much and
dissolved in rain which pres
ently cleared the sky
After this phenomenon was over

and also the surprise Harry began
to wonder how electricity
could get where there was
so much water but he soon–
observed a rainbow and a-
rising mist under it which
his fancy soon transform
ed into a female form. He
then remembered the witch of
the waters at the Alps who
was raised from them by–
takeing some water in the-
hand and throwing it into
the air pronouncing some
unintelligable words. And
though it was a tale it-
affected Harry now when
he saw in the clouds some-
end of Harry thing
and Lucy like it.

63. The several reasons aforesaid, which induce me to
reprint this piece of, too literally, "composition," are—
the first, that it is a tolerable specimen of my seven years
old spelling;—tolerable only, not *fair*, since it was ex-
tremely unusual with me to make a mistake at all,

whereas here there are two (take*i*ng and unintellig*a*ble), which I can only account for by supposing I was in too great a hurry to finish my volume;—the second, that the adaptation of materials for my story out of Joyce's Scientific Dialogues* and Manfred, is an extremely perfect type of the interwoven temper of my mind, at the beginning of days just as much as at their end—which has always made foolish scientific readers doubt my books because there was love of beauty in them, and foolish æsthetic readers doubt my books because there was love of science in them;—the third, that the extremely reasonable method of final judgment, upon which I found my claim to the sensible reader's respect for these dipartite writings, cannot be better illustrated than by this proof, that, even at seven years old, no tale, however seductive, could "affect" Harry, until he had seen—in the clouds, or elsewhere— "something like it."

Of the six poems which follow, the first is on the Steam-engine, beginning,

* The original passage is as follows, vol. vi., edition of 1821, p. 138:—
"Dr. Franklin mentions a remarkable appearance which occurred to Mr. Wilke, a considerable electrician. On the 20th of July, 1758, at three o'clock in the afternoon, he observed a great quantity of dust rising from the ground, and covering a field, and part of the town in which he then was. There was no wind, and the dust moved gently towards the east, where there appeared a great black cloud, which electrified his apparatus positively to a very high degree. This cloud went towards the west, the dust followed it, and continued to rise higher and higher, till it composed a thick pillar, in the form of a sugar-loaf, and at length it seemed to be in contact with the cloud. At some distance from this, there came another great cloud, with a long stream of smaller ones, which electrified his apparatus negatively; and when they came near the positive cloud, a flash of lightning was seen to dart through the cloud of dust, upon which the negative clouds spread very much, and dissolved in rain, which presently cleared the atmosphere."

> "When furious up from mines the water pours,
> And clears from rusty moisture all the ores;"

and the last on the Rainbow, "in blank verse," as being of
a didactic character, with observations on the ignorant and
unreflective dispositions of certain people.

> "But those that do not know about that light,
> Reflect not on it; and in all that light,
> Not one of all the colours do they know."

64. It was only, I think, after my seventh year had
been fulfilled in these meditations, that my mother added
the Latin lesson to the Bible-reading, and accurately
established the daily routine which was sketched in the
foregoing chapter. But it extremely surprises me, in try-
ing, at least for my own amusement, if not the reader's, to
finish the sketch into its corners, that I can't recollect now
what used to happen first in the morning, except break-
fasting in the nursery, and if my Croydon cousin Bridget
happened to be staying with us, quarrelling with her which
should have the brownest bits of toast. That must have
been later on, though, for I could not have been promoted
to toast at the time I am thinking of. Nothing is well
clear to me of the day's course, till, after my father had
gone to the City by the coach, and my mother's household
orders been quickly given, lessons began at half-past nine,
with the Bible readings above described, and the two or
three verses to be learned by heart, with a verse of
paraphrase;—then a Latin declension or a bit of verb, and
eight words of vocabulary from Adam's Latin Grammar,
(the best that ever was,) and the rest of the day was my
own. Arithmetic was wholesomely remitted till much
later; geography I taught myself fast enough in my own
way; history was never thought of, beyond what I chose
to read of Scott's Tales of a Grandfather. Thus, as afore-
said, by noon I was in the garden on fine days, or left to
my own amusements on wet ones; of which I have farther

at once to note that nearly as soon as I could crawl, my
toy-bricks of lignum vitæ had been constant companions:
and I am graceless in forgetting by what extravagant
friend, (I greatly suspect my Croydon aunt,) I was after-
wards gifted with a two-arched bridge, admirable in fittings
of voussoir and keystone, and adjustment of the level
courses of masonry with bevelled edges, into which they
dovetailed, in the style of Waterloo Bridge. Well-made
centreings, and a course of inlaid steps down to the water,
made this model largely, as accurately, instructive: and I
was never weary of building, *un*building,—(it was too
strong to be thrown down, but had always to be *taken*
down,)—and rebuilding it. This inconceivable passive
—or rather impassive—contentment in doing, or reading,
the same thing over and over again, I perceive to have been
a great condition in my future power of getting thoroughly
to the bottom of matters.

65. Some people would say that in getting these toys
lay the chance that guided me to an early love of archi-
tecture; but I never saw or heard of another child so fond
of its toy bricks, except Miss Edgeworth's Frank. To be
sure, in this present age,—age of universal brickfield
though it be,—people don't give their children toy bricks,
but toy puff-puffs; and the little things are always taking
tickets and arriving at stations, without ever fathoming—
none of them will take pains enough to do *that*,—the
principle of a puff-puff! And what good could they get
of it if they did,—unless they could learn also, that no
principle of Puff-puff would ever supersede the principle
of Breath?

But I not only mastered, with Harry and Lucy, the
entire motive principle of puff-puff; but also, by help of
my well-cut bricks, very utterly the laws of practical
stability in towers and arches, by the time I was seven or
eight years old: and these studies of structure were farther

animated by my invariable habit of watching, with the closest attention, the proceedings of any bricklayers, stone-sawyers, or paviours,—whose work my nurse would allow me to stop to contemplate in our walks; or, delight of delights, might be seen at ease from some fortunate window of inn or lodging on our journeys. In those cases the day was not long enough for my rapturous and riveted observation.

66. Constantly, as aforesaid, in the garden when the weather was fine, my time there was passed chiefly in the same kind of close watching of the ways of plants. I had not the smallest taste for growing them, or taking care of them, any more than for taking care of the birds, or the trees, or the sky, or the sea. My whole time passed in staring at them, or into them. In no morbid curiosity, but in admiring wonder, I pulled every flower to pieces till I knew all that could be seen of it with a child's eyes; and used to lay up little treasures of seeds, by way of pearls and beads,—never with any thought of sowing them. The old gardener only came once a week, for what sweeping and weeding needed doing; I was fain to learn to sweep the walks with him, but was discouraged and shamed by his always doing the bits I had done over again. I was extremely fond of digging holes, but that form of gardening was not allowed. Necessarily, I fell always back into my merely contemplative mind, and at nine years old began a poem, called Eudosia,—I forget wholly where I got hold of this name, or what I under-stood by it,—"On the Universe," though I could under-stand not a little by it, now. A couplet or two, as the real beginning at once of Deucalion and Proserpina, may be perhaps allowed, together with the preceding, a place in this grave memoir; the rather that I am again enabled to give accurate date—September 28th, 1828—for the beginning of its "First book," as follows:—

"When first the wrath of heaven o'erwhelmed the world,
And o'er the rocks, and hills, and mountains, hurl'd
The waters' gathering mass; and sea o'er shore,—
Then mountains fell, and vales, unknown before,
Lay where they were. Far different was the Earth
When first the flood came down, than at its second birth.
Now for its produce!—Queen of flowers, O rose,
From whose fair coloured leaves such odour flows,
Thou must now be before thy subjects named,
Both for thy beauty and thy sweetness famed.
Thou art the flower of England, and the flow'r
Of Beauty too—of Venus' odrous bower.
And thou wilt often shed sweet odours round,
And often stooping, hide thy head on ground.*
And then the lily, towering up so proud,
And raising its gay head among the various crowd,
There the black spots upon a scarlet ground,
And there the taper-pointed leaves are found."

67. In 220 lines, of such quality, the first book ascends
from the rose to the oak. The second begins—to my
surprise, and in extremely exceptional violation of my
above-boasted custom—with an ecstatic apostrophe to
what I had never seen!

"I sing the Pine, which clothes high Switzer's † head,
And high enthroned, grows on a rocky bed,
On gulphs so deep, on cliffs that are so high,
He that would dare to climb them dares to die."

This enthusiasm, however, only lasts—mostly exhaust-
ing itself in a description, verified out of Harry and Lucy,
of the slide of Alpnach,—through 76 lines, when the
verses cease, and the book being turned upside down,
begins at the other end with the information that "Rock-
crystal is accompanied by Actynolite, Axinite, and Epi-
dote, at Bourg d'Oisans in Dauphiny." But the garden-

* An awkward way—chiefly for the rhyme's sake—of saying that
roses are often too heavy for their stalks.
 † Switzer, clearly short for Switzerland.

meditations never ceased, and it is impossible to say how much strength was gained, or how much time uselessly given, except in pleasure, to these quiet hours and foolish rhymes. Their happiness made all the duties of outer life irksome, and their unprogressive reveries might, the reader may think, if my mother had wished, have been changed into a beginning of sound botanical knowledge. But, while there were books on geology and mineralogy which I could understand, all on botany were then,—and they are little mended now,—harder than the Latin grammar. The mineralogy was enough for me seriously to work at, and I am inclined finally to aver that the garden-time could not have been more rightly passed, unless in weeding.

68. At six punctually I joined my father and mother at tea, being, in the drawing-room, restricted to the inhabitation of the sacred niche above referred to, a recess beside the fireplace, well lighted from the lateral window in the summer evenings, and by the chimney-piece lamp in winter, and out of all inconvenient heat, or hurtful draught. A good writing-table before it shut me well in, and carried my plate and cup, or books in service. After tea, my father read to my mother what pleased themselves, I picking up what I could, or reading what I liked better instead. Thus I heard all the Shakespeare comedies and historical plays again and again,—all Scott, and all Don Quixote, a favourite book of my father's, and at which I could then laugh to ecstasy; now, it is one of the saddest, and, in some things, the most offensive of books to me.

My father was an absolutely beautiful reader of the *best* poetry and prose;—of Shakespeare, Pope, Spenser, Byron, and Scott; as of Goldsmith, Addison, and Johnson. Lighter ballad poetry he had not fineness of ear to do justice to: his sense of the strength and wisdom of true meaning, and of the force of rightly ordered syllables,

made his delivery of Hamlet, Lear, Cæsar, or Marmion, melodiously grand and just; but he had no idea of modulating the refrain of a ballad, and had little patience with the tenor of its sentiment. He looked always, in the matter of what he read, for heroic will and consummate reason; never tolerated the morbid love of misery for its own sake, and never read, either for his own pleasure or my instruction, such ballads as Burd Helen, the Twa Corbies, or any other rhyme or story which sought its interest in vain love or fruitless death.

But true, pure, and ennobling sadness began very early to mingle its undertone with the constant happiness of those days;—a ballad music, beautiful in sincerity, and hallowing them like cathedral chant. Concerning which, —I must go back now to the days I have only heard of with the hearing of the ear, and yet of which some are to me as if mine eyes had seen them.

69. It must have been a little after 1780 that my paternal grandmother, Catherine Tweddale, ran away with my paternal grandfather when she was not quite sixteen; and my aunt Jessie, my father's only sister, was born a year afterwards; a few weeks after which event, my grandmother, not yet seventeen, was surprised, by a friend who came into her room unannounced, dancing a threesome reel, with two chairs for her partners; she having found at the moment no other way of adequately expressing the pleasure she took in this mortal life, and its gifts and promises.

The latter failed somewhat afterwards; and my aunt Jessie, a very precious and perfect creature, beautiful in her dark-eyed, Highland way,—utterly religious, in her quiet Puritan way,—and very submissive to Fates mostly unkind, was married to a somewhat rough tanner, with a fairly good business in the good town of Perth: and, when I was old enough to be taken first to visit them, my aunt

and my uncle the tanner lived in a square-built grey stone house in the suburb of Perth known as "Bridge-End," the house some fifty yards north of the bridge; its garden sloping steeply to the Tay, which eddied, three or four feet deep of sombre crystal, round the steps where the servants dipped their pails.

70. A mistaken correspondent in Fors once complained of my coarse habit of sneering at people of no ancestry. I have no such habit; though not always entirely at ease in writing of my uncles the baker and the tanner. And my readers may trust me when I tell them that, in now remembering my dreams in the house of the entirely honest chief baker of Market Street, Croydon, and of Peter—not Simon—the tanner, whose house was by the riverside of Perth, I would not change the dreams, far less the tender realities, of those early days, for anything I hear now remembered by lords or dames, of their days of childhood in castle halls, and by sweet lawns and lakes in park-walled forest.

Lawn and lake enough indeed I had, in the North Inch of Perth, and pools of pausing Tay, before Rose Terrace, (where I used to live after my uncle died, briefly apoplectic, at Bridge-End,) in the peace of the fair Scotch summer days, with my widowed aunt, and my little cousin Jessie, then traversing a bright space between her sixth and ninth year; dark-eyed deeply,* like her mother, and similarly pious; so that she and I used to compete in the Sunday evening Scriptural examinations; and be as proud as two little peacocks because Jessie's elder brothers, and sister Mary, used to get "put down," and either Jessie or I was always "Dux." We agreed upon this that we would be married when we were a little older; not considering it to be preparatorily necessary to be in any degree wiser.

* As opposed to the darkness of mere iris, making the eyes like black cherries.

71. Strangely, the kitchen servant-of-all-work in the house at Rose Terrace was a very old "Mause,"—before, my grandfather's servant in Edinburgh,—who might well have been the prototype of the Mause of "Old Mortality,"* but had even a more solemn, fearless, and patient faith, fastened in her by extreme suffering; for she had been nearly starved to death when she was a girl, and had literally picked the bones out of cast-out dust-heaps to gnaw; and ever afterwards, to see the waste of an atom of food was as shocking to her as blasphemy. "Oh, Miss Margaret!" she said once to my mother, who had shaken some crumbs off a dirty plate out of the window, "I had rather you had knocked me down." She would make her dinner upon anything in the house that the other servants wouldn't eat;—often upon potato skins, giving her own dinner away to any poor person she saw; and would always stand during the whole church service, (though at least seventy years old when I knew her, and very feeble,) if she could persuade any wild Amorite out of the streets to take her seat. Her wrinkled and worn face, moveless in resolution and patience, incapable of smile, and knit sometimes perhaps too severely against Jessie and me, if we wanted more creamy milk to our porridge, or jumped off

* Vulgar modern Puritanism has shown its degeneracy in nothing more than in its incapability of understanding Scott's exquisitely finished portraits of the Covenanter. In "Old Mortality" alone, there are four which cannot be surpassed; the typical one, Elizabeth, faultlessly sublime and pure; the second, Ephraim Macbriar, giving the too common phase of the character, which is touched with ascetic insanity; the third, Mause, coloured and made sometimes ludicrous by Scottish conceit, but utterly strong and pure at heart; the last, Balfour, a study of supreme interest, showing the effect of the Puritan faith, sincerely held, on a naturally and incurably cruel and base spirit. Add to these four studies, from this single novel, those in the "Heart of Midlothian," and Nicol Jarvie and Andrew Fairservice from "Rob Roy," and you have a series of theological analyses far beyond those of any other philosophical work that I know, of any period.

our favourite box on Sunday,—("Never mind, John,"
said Jessie to me, once seeing me in an unchristian state of
provocation on this subject, "when we're married, we'll
jump off boxes all day long, if we like!")—may have been
partly instrumental in giving me that slight bias against
Evangelical religion, which I confess to be sometimes
traceable in my later works; but I never can be thankful
enough for having seen, in our own "Old Mause," the
Scottish Puritan spirit in its perfect faith and force; and
been enabled therefore afterwards to trace its agency in
the reforming policy of Scotland, with the reverence and
honour it deserves.

72. My aunt, a pure dove-priestess, if ever there was
one, of Highland Dodona, was of a far gentler temper; but
still, to me, remained at a wistful distance. She had been
much saddened by the loss of three of her children before
her husband's death. Little Peter, especially, had been
the corner-stone of her love's building; and it was thrown
down swiftly:—white swelling came in the knee; he
suffered much, and grew weaker gradually, dutiful always,
and loving, and wholly patient. She wanted him one day
to take half a glass of port wine, and took him on her knee,
and put it to his lips. "Not now, mamma; in a minute,"
said he; and put his head on her shoulder, and gave one
long, low sigh, and died. Then there was Catherine;
and—I forget the other little daughter's name, I did not
see them; my mother told me of them;—eagerly always
about Catherine, who had been her own favourite. My
aunt had been talking earnestly one day with her husband
about these two children; planning this and that for their
schooling and what not: at night, for a little while she
could not sleep; and as she lay thinking, she saw the door
of the room open, and two spades come into it, and stand
at the foot of her bed. Both the children were dead
within brief time afterwards. I was about to write

"within a fortnight"—but I cannot be sure of remembering my mother's words accurately.

73. But when I was in Perth, there were still—Mary, her eldest daughter, who looked after us children when Mause was too busy; James and John, William and Andrew; (I can't think whom the unapostolic William was named after). But the boys were then all at school or college,—the scholars, William and Andrew, only came home to tease Jessie and me, and eat the biggest jargonel pears; the collegians were wholly abstract; and the two girls and I played in our quiet ways on the North Inch, and by the "Lead," a stream "led" from the Tay past Rose Terrace into the town for molinary purposes; and long ago, I suppose, bricked over or choked with rubbish; but then lovely, and a perpetual treasure of flowing diamond to us children. Mary, by the way, was ascending towards twelve—fair, blue-eyed, and moderately pretty; and as pious as Jessie, without being quite so zealous.

74. My father rarely stayed with us in Perth, but went on business travel through Scotland, and even my mother became a curiously unimportant figure at Rose Terrace. I can't understand how she so rarely walked with us children; she and my aunt seemed always to have their own secluded ways. Mary, Jessie, and I were allowed to do what we liked on the Inch: and I don't remember doing any lessons in these Perth times, except the above-described competitive divinity on Sunday.

Had there been anybody then to teach me anything about plants or pebbles, it had been good for me; as it was, I passed my days much as the thistles and tansy did, only with perpetual watching of all the ways of running water, —a singular awe developing itself in me, both of the pools of Tay, where the water changed from brown to blue-black, and of the precipices of Kinnoull; partly out of my own mind, and partly because the servants always became

serious when we went up Kinnoull way, especially if I wanted to stay and look at the little crystal spring of Bower's Well.

75. "But you say you were not afraid of anything?" writes a friend, anxious for the unassailable veracity of these memoirs. Well, I said, not of ghosts, thunder, or beasts,—meaning to specify the commonest terrors of mere childhood. Every day, as I grew wiser, taught me a reasonable fear; else I had not above described myself as the most reasonable person of my acquaintance. And by the swirls of smooth blackness, broken by no fleck of foam, where Tay gathered herself like Medusa,* I never passed without awe, even in those thoughtless days; neither do I in the least mean that I could walk among tombstones in the night (neither, for that matter, in the day), as if they were only paving stones set upright. Far the contrary; but it is important to the reader's confidence in writings which have seemed inordinately impressional and emotional, that he should know I was never subject to—I should perhaps rather say, sorrowfully, never capable of— any manner of illusion or false imagination, nor in the least liable to have my nerves shaken by surprise. When I was about five years old, having been on amicable terms for a while with a black Newfoundland, then on probation for watch dog at Herne Hill; after one of our long summer journeys my first thought on getting home was to go to see Lion. My mother trusted me to go to the stable with our one serving-man, Thomas, giving him strict orders that I was not to be allowed within stretch of the dog's chain. Thomas, for better security, carried me in his arms. Lion was at his dinner, and took no notice of either of us; on which I besought leave to pat him. Foolish Thomas stooped towards him that I might, when the dog instantly flew at me, and bit a piece clean out of

* I always think of Tay as a goddess river, as Greta a nymph one.

the corner of my lip on the left side. I was brought up
the back stairs, bleeding fast, but not a whit frightened,
except lest Lion should be sent away. Lion indeed had
to go; but not Thomas: my mother was sure he was sorry,
and I think blamed herself the most. The bitten side of
the (then really pretty) mouth, was spoiled for evermore,
but the wound, drawn close, healed quickly; the last use I
made of my moveable lips before Dr. Aveline drew them
into ordered silence for a while, was to observe, "Mama,
though I can't speak, I can play upon the fiddle." But
the house was of another opinion, and I never attained any
proficiency upon that instrument worthy of my genius. Not
the slightest diminution of my love of dogs, nor the slightest
nervousness in managing them, was induced by the accident.

I scarcely know whether I was in any real danger or
not when, another day, in the same stable, quite by my-
self, I went head foremost into the large water-tub kept
for the garden. I think I might have got awkwardly
wedged if I had tried to draw my feet in after me: instead,
I used the small watering-pot I had in my hand to give
myself a good thrust up from the bottom, and caught the
opposite edge of the tub with my left hand, getting not a
little credit afterwards for my decision of method. Look-
ing back to the few chances that have in any such manner
tried my head, I believe it has never failed me when I
wanted it, and that I am much more likely to be confused
by sudden admiration than by sudden danger.

76. The dark pools of Tay, which have led me into
this boasting, were under the high bank at the head of the
North Inch,—the path above them being seldom traversed
by us children unless at harvest time, when we used to go
gleaning in the fields beyond; Jessie and I afterward
grinding our corn in the kitchen pepper-mill, and knead-
ing and toasting for ourselves cakes of pepper bread, of
quite unpurchaseable quality.

In the general course of this my careful narration, I rebut with as much indignation as may be permitted without ill manners, the charge of partiality to anything merely because it was seen when I was young. I hesitate, however, in recording as a constant truth for the world, the impression left on me when I went gleaning with Jessie, that Scottish sheaves are more golden than are bound in other lands, and that no harvests elsewhere visible to human eyes are so like the "corn of heaven" * as those of Strath-Tay and Strath-Earn.

* Psalm lxxviii. 24.

CHAPTER IV

UNDER NEW TUTORSHIPS

77. WHEN I was about eight or nine I had a bad feverish illness at Dunkeld, during which I believe I was in some danger, and am sure I was very uncomfortable. It came on after a long walk in which I had been gathering quantities of foxgloves and pulling them to pieces to examine their seeds, and there were hints about their having poisoned me; very absurd, but which extended the gathering awe from river eddies to foxglove dells. Not long after that, when we were back at home, my cousin Jessie fell ill, and died very slowly, of water on the brain. I was very sorry, not so much in any strength of early affection, as in the feeling that the happy, happy days at Perth were for ever ended, since there was no more Jessie.

Before her illness took its fatal form,—before, indeed, I believe it had at all declared itself—my aunt dreamed one of her foresight dreams, simple and plain enough for any one's interpretation;—that she was approaching the ford of a dark river, alone, when little Jessie came running up behind her, and passed her, and went through first. Then she passed through herself, and looking back from the other side, saw her old Mause approaching from the distance to the bank of the stream. And so it was, that Jessie, immediately afterwards, sickened rapidly and died; and a few months, or it might be nearly a year afterwards, my aunt died of decline; and Mause, some two or three years later, having had no care after her mistress and Jessie were gone, but when she might go to them.

78. I was at Plymouth with my father and mother when my Scottish aunt died, and had been very happy with

my nurse on the hill east of the town, looking out on the bay and breakwater; and came in to find my father, for the first time I had ever seen him, in deep distress of sobbing tears.

I was very sorry that my aunt was dead, but, at that time, (and a good deal since, also,) I lived mostly in the present, like an animal, and my principal sensation was,—What a pity it was to pass such an uncomfortable evening —and we at Plymouth!

The deaths of Jessie and her mother of course ended our Scottish days. The only surviving daughter, Mary, was thenceforward adopted by my father and mother, and brought up with me. She was fourteen when she came to us, and I four years younger;—so with the Perth days, closed the first decade of my life. Mary was a rather pretty, blue-eyed, clumsily-made girl, very amiable and affectionate in a quiet way, with no parts, but good sense and good principle, honestly and inoffensively pious, and equal tempered, but with no pretty girlish ways or fancies. She became a serene additional neutral tint in the house-hold harmony; read alternate verses of the Bible with my mother and me in the mornings, and went to a day school in the forenoon. When we travelled she took somewhat of a governess position towards me, we being allowed to explore places together without my nurse;—but we gener-ally took old Anne too for better company.

79. It began now to be of some importance what church I went to on Sunday morning. My father, who was still much broken in health, could not go to the long Church of England service, and, my mother being evangelical, he went contentedly, or at least submissively, with her and me to Beresford Chapel, Walworth, where the Rev. E. Andrews preached, regularly, a somewhat eloquent, forcible, and ingenious sermon, not tiresome to him:—the prayers were abridged from the Church Ser-

vice, and we, being the grandest people in the congrega-
tion, were allowed—though, as I now remember, not
without offended and reproachful glances from the more
conscientious worshippers—to come in when even those
short prayers were half over. Mary and I used each to
write an abstract of the sermon in the afternoon, to please
ourselves,—Mary dutifully, and I to show how well I
could do it. We never went to church in afternoon or
evening. I remember yet the amazed and appalling sen-
sation, as of a vision preliminary to the Day of Judgment,
of going, a year or two later, first into a church by
candlelight.

80. We had no family worship, but our servants were
better cared for than is often the case in ostentatiously
religious houses. My mother used to take them when
girls, from families known to her, sister after sister, and
we never had a bad one.

On the Sunday evening my father would sometimes
read us a sermon of Blair's, or it might be, a clerk or a
customer would dine with us, when the conversation, in
mere necessary courtesy, would take generally the direc-
tion of sherry. Mary and I got through the evening how
we could, over the Pilgrim's Progress, Bunyan's Holy
War, Quarles's Emblems, Foxe's Book of Martyrs, Mrs.
Sherwood's Lady of the Manor,—a very awful book to
me, because of the stories in it of wicked girls who had
gone to balls, dying immediately after of fever,—and Mrs.
Sherwood's Henry Milner,—of which more presently,—
the Youth's Magazine, Alfred Campbell the young pil-
grim, and, though rather as a profane indulgence, per-
mitted because of the hardness of our hearts, Bingley's
Natural History. We none of us cared for singing
hymns or psalms as such, and were too honest to amuse
ourselves with them as sacred music, besides that we did
not find their music amusing.

81. My father and mother, though due cheques for charities were of course sent to Dr. Andrews, and various civilities at Christmas, in the way of turkeys or boxes of raisins, intimated their satisfaction with the style of his sermons and purity of his doctrine,—had yet, with their usual shyness, never asked for his acquaintance, or even permitted the state of their souls to be inquired after in pastoral visits. Mary and I, however, were charmed merely by the distant effect of him, and used to walk with Anne up and down in Walworth, merely in the hope of seeing him pass on the other side of the way. At last, one day, when, by extreme favour of Fortune, he met us in a great hurry on our own side of it, and nearly tumbled over me, Anne, as he recovered himself, dropped him a low curtsey; whereupon he stopped, inquired who we were, and was extremely gracious to us; and we, coming home in a fever of delight, announced, not much to my mother's satisfaction, that the Doctor had said he would call some day! And so, little by little, the blissful acquaintance was made. I might be eleven or going on twelve by that time. Miss Andrews, the eldest sister of the "Angel in the House," was an extremely beautiful girl of seventeen; she sang "Tambourgi, Tambourgi" * with great spirit and a rich voice, went at blackberry time on rambles with us at the Norwood Spa, and made me feel generally that there was something in girls that I did not understand, and that was curiously agreeable. And at last, because I was so fond of the Doctor, and he had the reputation (in Walworth) of being a good scholar, my father thought he might pleasantly initiate me in Greek, such initiation having been already too long deferred. The Doctor, it afterwards turned out, knew little more of Greek than the letters, and declensions of nouns; but he wrote the letters prettily, and had an accurate and sen-

* Hebrew melodies.

sitive ear for rhythm. He began me with the odes of
Anacreon, and made me scan both them and my Virgil
thoroughly, sometimes, by way of interlude, reciting bits
of Shakespeare to me with force and propriety. The
Anacreontic metre entirely pleased me, nor less the Ana-
creontic sentiment. I learned half the odes by heart
merely to please myself, and learned with certainty, what
in later study of Greek art it has proved extremely
advantageous to me to know, that the Greeks liked doves,
swallows, and roses just as well as I did.

82. In the intervals of these unlaborious Greek lessons,
I went on amusing myself—partly in writing English
doggerel, partly in map drawing, or copying Cruikshank's
illustrations to Grimm, which I did with great, and to
most people now incredible, exactness, a sheet of them
being, by good hap, well preserved, done when I was
between ten and eleven. But I never saw any boy's work
in my life showing so little original faculty, or grasp by
memory. I could literally draw nothing, not a cat, not
a mouse, not a boat, not a bush, "out of my head," and
there was, luckily, at present no idea on the part either
of parents or preceptor, of teaching me to draw out of
other people's heads.

Nevertheless, Mary, at her day school, was getting
drawing lessons with the other girls. Her report of the
pleasantness and zeal of the master, and the frank and
somewhat unusual execution of the drawings he gave her
to copy, interested my father, and he was still more pleased
by Mary's copying, for a proof of industry while he was
away on his winter's journey—copying, in pencil so as to
produce the effect of a vigorous engraving, the little water-
colour by Prout of a wayside cottage, which was the
foundation of our future water-colour collection, being
then our only possession in that kind—of other kind, two
miniatures on ivory completed our gallery.

83. I perceive, in thinking over the good work of that patient black and white study, that Mary could have drawn, if she had been well taught and kindly encouraged. But her power of patient copying did not serve her in drawing from nature, and when, that same summer, I between ten and eleven (1829), we went to stay at Matlock in Derbyshire, all that she proved able to accomplish was an outline of Caxton's New Bath Hotel, in which our efforts in the direction of art, for that year, ended.

But, in the glittering white broken spar, specked with galena, by which the walks of the hotel garden were made bright, and in the shops of the pretty village, and in many a happy walk among its cliffs, I pursued my mineralogical studies on fluor, calcite, and the ores of lead, with indescribable rapture when I was allowed to go into a cave. My father and mother showed far more kindness than I knew, in yielding to my subterranean passion; for my mother could not bear dirty places, and my father had a nervous feeling that the ladders would break, or the roof fall, before we got out again. They went with me, nevertheless, wherever I wanted to go,—my father even into the terrible Speedwell mine at Castleton, where, for once, I was a little frightened myself.

From Matlock we must have gone on to Cumberland, for I find in my father's writing the legend, "Begun 28th November, 1830, finished 11th January, 1832," on the fly-leaf of the "Iteriad," a poem in four books, which I indited, between those dates, on the subject of our journey among the Lakes, and of which some little notice may be taken farther on.

84. It must have been in the spring of 1831 that the important step was taken of giving me a drawing master. Mary showed no gift of representing any of the scenes of our travels, and I began to express some wish that I could draw myself. Whereupon, Mary's pleasant drawing

master, to whom my father and mother were equitable enough not to impute Mary's want of genius, was invited to give *me* also an hour in the week.

I suppose a drawing master's business can only become established by his assertion of himself to the public as the possessor of a style; and teaching in that only. Nevertheless, Mr. Runciman's memory sustains disgrace in my mind in that he gave no impulse nor even indulgence to the extraordinary gift I had for drawing delicately with the pen point. Any work of that kind was done thenceforward only to please myself. Mr. Runciman gave me nothing but his own mannered and inefficient drawings to copy, and greatly broke the force both of my mind and hand.

Yet he taught me much, and suggested more. He taught me perspective, at once accurately and simply—an invaluable bit of teaching. He compelled me into a swiftness and facility of hand which I found afterwards extremely useful, though what I have just called the "force," the strong accuracy of my line, was lost. He cultivated in me,—indeed founded,—the habit of looking for the essential points in the things drawn, so as to abstract them decisively, and he explained to me the meaning and importance of composition, though he himself could not compose.

85. A very happy time followed, for about two years.

I was, of course, far behind Mary in touch-skill of pencil drawing, and it was good for her that this superiority was acknowledged, and due honour done her for the steady pains of her unimpulsive practice and unwearied attention. For, as she did not write poems like me, nor collect spars like me, nor exhibit any prevailing vivacity of mind in any direction, she was gradually sinking into far too subordinate a position to my high-mightiness. But I could make no pretence for some time to rival her in freehand copying, and my first attempts from nature were

not felt by my father to be the least flattering to his
vanity.

These were made under the stimulus of a journey to
Dover with the forethought of which my mother com-
forted me through an illness of 1829. I find my quite
first sketchbook, an extremely inconvenient upright small
octavo in mottled and flexible cover, the paper pure white,
and ribbedly gritty, filled with outlines, irregularly defaced
by impulsive efforts at finish, in arbitrary places and
corners, of Dover and Tunbridge Castles and the main
tower of Canterbury Cathedral. These, with a really
good study, supplemented by detached detail, of Battle
Abbey, I have set aside for preservation; the really first
sketch I ever made from nature being No. 1, of a street
in Sevenoaks. I got little satisfaction and less praise by
these works; but the native architectural instinct is in-
stantly developed in these,—highly notable for any one
who cares to note such nativities. Two little pencillings
from Canterbury south porch and central tower, I have
given to Miss Gale, of Burgate House, Canterbury; the
remnants of the book itself to Mrs. Talbot, of Tyn-y-
Ffynon, Barmouth, both very dear friends.

86. But before everything, at this time, came my
pleasure in merely watching the sea. I was not allowed
to row, far less to sail, nor to walk near the harbour alone;
so that I learned nothing of shipping or anything else
worth learning, but spent four or five hours every day in
simply staring and wondering at the sea,—an occupation
which never failed me till I was forty. Whenever I could
get to a beach it was enough for me to have the waves to
look at, and hear, and pursue and fly from. I never took
to natural history of shells, or shrimps, or weeds, or jelly-
fish. Pebbles?—yes if there were any; otherwise, merely
stared all day long at the tumbling and creaming strength
of the sea. Idiotically, it now appears to me, wasting all

that priceless youth in mere dream and trance of admiration; it had a certain strain of Byronesque passion in it, which meant something: but it was a fearful loss of time.

87. The summer of 1832 must, I think, have been passed at home, for my next sketch-book contains only some efforts at tree-drawing in Dulwich, and a view of the bridge over the now bricked-up "Effra," by which the Norwood road then crossed it at the bottom of Herne Hill: the road itself, just at the place where, from the top of the bridge, one looked up and down the streamlet, bridged now into putridly damp shade by the railway, close to Herne Hill Station. This sketch was the first in which I was ever supposed to show any talent for drawing. But on my thirteenth (?) birthday, 8th February, 1832, my father's partner, Mr. Henry Telford, gave me Rogers' Italy, and determined the main tenor of my life.

At that time I had never heard of Turner, except in the well remembered saying of Mr. Runciman's, that "the world had lately been much dazzled and led away by some splendid ideas thrown out by Turner." But I had no sooner cast eyes on the Rogers vignettes than I took them for my only masters, and set myself to imitate them as far as I possibly could by fine pen shading.

88. I have told this story so often that I begin to doubt its time. It is curiously tiresome that Mr. Telford did not himself write my name in the book, and my father who writes in it, "The gift of Henry Telford, Esq.," still more curiously, for him, puts no date: if it was a year later, no matter; there is no doubt however that early in the spring of 1833 Prout published his Sketches in Flanders and Germany. I well remember going with my father into the shop where subscribers entered their names, and being referred to the specimen print, the turreted window over the Moselle, at Coblentz. We got the book home to Herne Hill before the time of our usual annual tour;

and as my mother watched my father's pleasure and mine in looking at the wonderful places, she said, why should not we go and see some of them in reality? My father hesitated a little, then with glittering eyes said—why not? And there were two or three weeks of entirely rapturous and amazed preparation. I recollect that very evening bringing down my big geography book, still most precious to me; (I take it down now, and for the first time put my own initials under my father's name in it)—and looking with Mary at the outline of Mont Blanc, copied from Saussure, at p. 201, and reading some of the very singular information about the Alps which it illustrates. So that Switzerland must have been at once included in the plans, —soon prosperously, and with result of all manner of good, by God's help fulfilled.

89. We went by Calais and Brussels to Cologne; up the Rhine to Strasburg, across the Black Forest to Schaff-hausen, then made a sweep through North Switzerland by Basle, Berne, Interlachen, Lucerne, Zurich, to Constance,—following up the Rhine still to Coire, then over Splugen to Como, Milan, and Genoa; meaning, as I now remember, for Rome. But, it being June already, the heat of Genoa warned us of imprudence: we turned, and came back over the Simplon to Geneva, saw Chamouni, and so home by Lyons and Dijon.

To do all this in the then only possible way, with post-horses, and, on the lakes, with oared boats, needed careful calculation of time each day. My father liked to get to our sleeping place as early as he could, and never would stop the horses for me to draw anything (the extra pence to postillion for waiting being also an item of weight in his mind);—thus I got into the bad habit, yet not without its discipline, of making scrawls as the carriage went along, and working them up "out of my head" in the evening. I produced in this manner, throughout the journey, some

thirty sheets or so of small pen and Indian ink drawings, four or five in a sheet; some not inelegant, all laborious, but for the most part one just like another, and without exception stupid and characterless to the last degree.

90. With these flying scrawls on the road, I made, when staying in towns, some elaborate pencil and pen outlines, of which perhaps half-a-dozen are worth register and preservation. My father's pride in a study of the doubly-towered Renaissance church of Dijon was great. A still more laborious Hôtel de Ville of Brussels remains with it at Brantwood. The drawing of that Hôtel de Ville by me now at Oxford is a copy of Prout's, which I made in illustration of the volume in which I wrote the beginning of a rhymed history of the tour.

For it had excited all the poor little faculties that were in me to their utmost strain, and I had certainly more passionate happiness, of a quality utterly indescribable to people who never felt the like, and more, in solid quantity, in those three months, than most people have in all their lives. The impression of the Alps first seen from Schaff-hausen, of Milan and of Geneva, I will try to give some account of afterwards,—my first business now is to get on.

91. The winter of '33, and what time I could steal to amuse myself in, out of '34, were spent in composing, writing fair, and drawing vignettes for the decoration of the aforesaid poetical account of our tour, in imitation of Rogers' Italy. The drawings were made on separate pieces of paper and pasted into the books; many have since been taken out, others are there for which the verses were never written, for I had spent my fervour before I got up the Rhine. I leave the unfinished folly in Joanie's care, that none but friends may see it.

Meantime, it having been perceived by my father and mother that Dr. Andrews could neither prepare me for the University, nor for the duties of a bishopric, I was

sent as a day scholar to the private school kept by the
Rev. Thomas Dale, in Grove Lane, within walking dis-
tance of Herne Hill. Walking down with my father
after breakfast, carrying my blue bag of books, I came
home to half-past one dinner, and prepared my lessons
in the evening for next day. Under these conditions I
saw little of my fellow-scholars, the two sons of Mr. Dale,
Tom and James; and three boarders, the sons of Colonel
Matson, of Woolwich; of Alderman Key, of Denmark
Hill; and a fine lively boy, Willoughby Jones, afterwards
Sir W., and only lately, to my sorrow, dead.

92. Finding me in all respects what boys could only
look upon as an innocent, they treated me as I suppose
they would have treated a girl; they neither thrashed nor
chaffed me,—finding, indeed, from the first that chaff
had no effect on me. Generally I did not understand it,
nor in the least mind it if I did, the fountain of pure
conceit in my own heart sustaining me serenely against all
deprecation, whether by master or companion. I was
fairly intelligent of books, had a good quick and holding
memory, learned whatever I was bid as fast as I could,
and as well; and since all the other boys learned always
as little as they could, though I was far in retard of them
in real knowledge, I almost always knew the day's lesson
best. I have already described, in the first chapter of
Fiction Fair and Foul, Mr. Dale's rejection of my clearly
known old grammar as a "Scotch thing." In that one
action he rejected himself from being my master; and I
thenceforward learned all he told me only because I had
to do it.

93. While these steps were taken for my classical
advancement, a master was found for me, still in that
unlucky Walworth, to teach me mathematics. Mr. Row-
botham was an extremely industrious, deserving, and fairly
well-informed person in his own branches, who, with his

wife, and various impediments and inconveniences in the way of children, kept a "young gentleman's Academy" near the Elephant and Castle, in one of the first houses which have black plots of grass in front, fenced by iron railings from the Walworth Road.

He knew Latin, German, and French grammar; was able to teach the "use of the globes" as far as needed in a preparatory school, and was, up to far beyond the point needed for me, a really sound mathematician. For the rest, utterly unacquainted with men or their history, with nature and its meanings; stupid and disconsolate, incapable of any manner of mirth or fancy, thinking mathematics the only proper occupation of human intellect, asthmatic to a degree causing often helpless suffering, and hopelessly poor, spending his evenings, after his school-drudgery was over, in writing manuals of arithmetic and algebra, and compiling French and German grammars, which he allowed the booksellers to cheat him out of,—adding perhaps, with all his year's lamp-labour, fifteen or twenty pounds to his income;—a more wretched, innocent, patient, insensible, unadmirable, uncomfortable, intolerable being never was produced in this æra of England by the culture characteristic of her metropolis.

94. Under the tuition, twice a week in the evening, of Mr. Rowbotham, (invited always to substantial tea with us before the lesson as a really efficient help to his hungry science, after the walk up Herne Hill, painful to asthma,) I prospered fairly in 1834, picking up some bits of French grammar, of which I had really felt the want,—I had before got hold, somehow, of words enough to make my way about with,—and I don't know how, but I recollect, at Paris, going to the Louvre under charge of Salvador, (I wanted to make a sketch from Rembrandt's Supper at Emmaus,) and on Salvador's application to the custode for permission, it appeared I was not old enough to have a

ticket,—fifteen was then the earliest admission-age; but
seeing me look woebegone, the good-natured custode said
he thought if I went in to the "Board," or whatever it
was, of authorities, and asked for permission myself, they
would give it me. Whereupon I instantly begged to be
introduced to the Board, and the custode taking me in
under his coat lappets, I did verily, in what broken French
was feasible to me, represent my case to several gentlemen
of an official and impressive aspect, and got my permission,
and outlined the Supper at Emmaus with some real success
in expression, and was extremely proud of myself. But
my narrow knowledge of the language, though thus avail-
able for business, left me sorrowful and ashamed after the
fatal dinner at Mr. Domecq's, when the little Elise, then
just nine, seeing that her elder sisters did not choose to
trouble themselves with me, and being herself of an
entirely benevolent and pitiful temper, came across the
drawing-room to me in my desolation, and leaning an
elbow on my knee, set herself deliberately to chatter to me
mellifluously for an hour and a half by the timepiece,—
requiring no answer, of which she saw I was incapable,
but satisfied with my grateful and respectful attention, and
admiring interest, if not exactly always in what she said,
at least in the way she said it. She gave me the entire
history of her school, and of the objectionable characters
of her teachers, and of the delightful characters of her
companions, and of the mischief she got into, and the
surreptitious enjoyments they devised, and the joys of com-
ing back to the Champs Elysées, and the general likeness
of Paris to the Garden of Eden. And the hour and a half
seemed but too short, and left me resolved, anyhow, to do
my best to learn French.

95. So, as I said, I progressed in this study to the con-
tentment of Mr. Rowbotham, went easily through the
three first books of Euclid, and got as far as quadratics in

Algebra. But there I stopped, virtually, for ever. The
moment I got into sums of series, or symbols expressing
the relations instead of the real magnitudes of things,—
partly in want of faculty, partly in an already well-
developed and healthy hatred of things vainly bothering
and intangible,—I jibbed—or stood stunned. After-
wards at Oxford they dragged me through some conic
sections, of which the facts representable by drawing
became afterwards of extreme value to me; and taught
me as much trigonometry as made my mountain work, in
plan and elevation, unaccusable. In elementary geometry
I was always happy, and, for a boy, strong; and my conceit,
developing now every hour more venomously as I began
to perceive the weaknesses of my masters, led me to spend
nearly every moment I could command for study in my
own way, through the year 1835, in trying to trisect an
angle. For some time afterwards I had the sense to
reproach myself for the waste of thoughtful hours in that
year, little knowing or dreaming how many a year to
come, from that time forth, was to be worse wasted.

While the course of my education was thus daily gather-
ing the growth of me into a stubborn little standard bush,
various frost-stroke was stripping away from me the poor
little flowers—or herbs—of the forest, that had once
grown, happily for me, at my side.

CHAPTER V

PARNASSUS AND PLYNLIMMON

96. I HAVE allowed, in the last chapter, my record of boyish achievements and experiments in art to run on to a date much in advance of the early years which were most seriously eventful for me in good and evil. I resume the general story of them with the less hesitation, because, such as it is, nobody else can tell it; while, in later years, my friends in some respects know me better than I know myself.

The second decade of my life was cut away still more sharply from the perfectly happy time of childhood, by the death of my Croydon aunt; death of "cold" literally, caught in some homely washing operations in an east wind. Her brown and white spaniel, Dash, lay beside her body and on her coffin, till they were taken away from him; then he was brought to Herne Hill, and I think had been my companion some time before Mary came to us.

With the death of my Croydon aunt ended for me all the days by Wandel streams, as at Perth by Tay; and thus when I was ten years old, an exclusively Herne Hill-top life set in (when we were not travelling), of no very beneficial character.

97. My Croydon aunt left four sons—John, William, George, and Charles; and two daughters—Margaret and Bridget. All handsome lads and pretty lasses; but Margaret, in early youth, met with some mischance that twisted her spine, and hopelessly deformed her. She was clever, and witty, like her mother; but never of any interest to me, though I gave a kind of brotherly, rather than cousinly, affection to all my Croydon cousins. But

I never liked invalids, and don't to this day; and Margaret used to wear her hair in ringlets, which I couldn't bear the sight of.

Bridget was a very different creature; a black-eyed, or, with precision, dark hazel-eyed, slim-made, lively girl; a little too sharp in the features to be quite pretty, a little too wiry-jointed to be quite graceful; capricious, and more or less selfish in temper, yet nice enough to be once or twice asked to Perth with us, or to stay for a month or two at Herne Hill; but never attaching herself much to us, neither us to her. I felt her an inconvenience in my nursery arrangements, the nursery having become my child's study as I grew studious; and she had no mind, or, it might be, no leave, to work with me in the garden.

98. The four boys were all of them good, and steadily active. The eldest, John, with wider business habits than the rest, went soon to push his fortune in Australia, and did so; the second, William, prospered also in London.

The third brother, George, was the best of boys and men, but of small wit. He extremely resembled a rural George the Fourth, with an expansive, healthy, benevolent eagerness of simplicity in his face, greatly bettering him as a type of British character. He went into the business in Market Street, with his father, and both were a great joy to all of us in their affectionateness and truth: neither of them in all their lives ever did a dishonest, unkind, or otherwise faultful thing—but still less a clever one! For the present, I leave them happily filling and driving their cart of quartern loaves in morning round from Market Street.

99. The fourth, and youngest, Charles, was like the last-born in a fairy tale, ruddy as the boy David, bright of heart, not wanting in common sense, or even in *good* sense; and affectionate, like all the rest. He took to his schooling kindly, and became grammatical, polite, and presentable

in our high Herne Hill circle. His elder brother, John, had taken care of his education in more important matters: very early in the child's life he put him on a barebacked pony, with the simple elementary instruction that he should be thrashed if he came off. And he stayed on. Similarly, for first lesson in swimming, he pitched the boy like a pebble into the middle of the Croydon Canal, jumping in, of course, after him; but I believe the lad squattered to the bank without help, and became when he was only "that high" a fearless master of horse and wave.

100. My mother used to tell these two stories with the greater satisfaction, because, in her own son's education, she had sacrificed her pride in his heroism to her anxiety for his safety; and never allowed me to go to the edge of a pond, or be in the same field with a pony. As ill-luck also would have it, there was no manner of farm or marsh near us, which might of necessity modify these restrictions; but I have already noted with thankfulness the good I got out of the tadpole-haunted ditch in Croxted Lane; while also, even between us and tutorial Walworth, there was one Elysian field for me in the neglected grass of Camberwell Green. There *was* a pond in the corner of it, of considerable size, and unknown depth,—probably, even in summer, full three feet in the middle; the sable opacity of its waters adding to the mystery of danger. Large, as I said, for a pond, perhaps sixty or seventy yards the long way of the Green, fifty the short; while on its western edge grew a stately elm, from whose boughs, it was currently reported, and conscientiously believed, a wicked boy had fallen into the pond on Sunday, and forthwith the soul of him into a deeper and darker pool.

It was one of the most valued privileges of my early life to be permitted by my nurse to contemplate this judicial pond with awe, from the other side of the way. The loss of it, by the sanitary conversion of Camberwell

Green into a bouquet for Camberwell's button-hole, is to this day matter of perennial lament to me.

101. In the carrying out of the precautionary laws above described I was, of course, never allowed, on my visits to Croydon, to go out with my cousins, lest they should lead me into mischief; and no more adventurous joys were ever possible to me there, than my walks with Anne or my mother where the stream from Scarborough pond ran across the road; or on the crisp turf of Duppas Hill; my watchings of the process of my father's drawings in Indian ink, and my own untired contemplations of the pump and gutter on the other side of the so-called street, but really lane,—not more than twelve feet from wall to wall. So that, when at last it was thought that Charles, with all his good natural gifts and graces, should be brought from Croydon town to London city, and initiated into the lofty life and work of its burgess orders; and when, accordingly, he was, after various taking of counsel and making of enquiry, apprenticed to Messrs. Smith, Elder, & Co., of 65 Cornhill, with the high privilege of coming out to dine at Herne Hill every Sunday, the new and beaming presence of cousin Charles became a vivid excitement, and admirable revelation of the activities of youth to me, and I began to get really attached to him.

I was not myself the sort of creature that a boy could care much for,—or indeed any human being, except papa and mama, and Mrs. Richard Gray (of whom more presently); being indeed nothing more than a conceited and unentertainingly troublesome little monkey. But Charles was always kind to me, and naturally answered with some cousinly or even brotherly tenderness my admiration of him, and delight in him.

102. At Messrs. Smith & Elder's he was an admittedly exemplary apprentice, rapidly becoming a serviceable shopman, taking orders intelligently, and knowing well both

his books and his customers. As all right-minded apprent-
ices and good shopmen do, he took personal pride in every-
thing produced by the firm; and on Sundays always brought
a volume or two in his pocket to show us the character
of its most ambitious publications; especially choosing, on
my behalf, any which chanced to contain good engravings.
In this way I became familiar with Stanfield and Harding
long before I possessed a single engraving myself from
either of them; but the really most precious, and con-
tinuous in deep effect upon me, of all gifts to my childhood,
was from my Croydon aunt, of the Forget-me-not of 1827,
with a beautiful engraving in it of Prout's "Sepulchral
monument at Verona."

Strange, that the true first impulse to the most refined
instincts of my mind should have been given by my totally
uneducated, but entirely good and right-minded, mother's
sister.

103. But more magnificent results came of Charles's
literary connection, through the interest we all took in
the embossed and gilded small octavo which Smith & Elder
published annually, by title "Friendship's Offering."
This was edited by a pious Scotch missionary, and minor
—very much minor—key, poet, Thomas Pringle; men-
tioned once or twice with a sprinkling of honour in
Lockhart's Life of Scott. A strictly conscientious and
earnest, accurately trained, though narrowly learned, man,
with all the Scottish conceit, restlessness for travel, and
petulant courage of the Parks and Livingstones; with also
some pretty tinges of romance and inklings of philosophy
to mellow him, he was an admitted, though little regarded,
member of the best literary circles, and acquainted, in the
course of catering for his little embossed octavo, with
everybody in the outer circles, and lower, down to little
me. He had been patronised by Scott; was on terms of
polite correspondence with Wordsworth and Rogers; of

familiar intercourse with the Ettrick Shepherd; and had
himself written a book of poems on the subject of Africa,
in which antelopes were called springboks, and other
African manners and customs carefully observed.

104. Partly to oblige the good-natured and lively shop-
boy, who told wonderful things of his little student cousin;
—partly in the look-out for thin compositions of tractable
stucco, wherewith to fill interstices in the masonry of
"Friendship's Offering," Mr. Pringle visited us at Herne
Hill, heard the traditions of my literary life, expressed some
interest in its farther progress,—and sometimes took a
copy of verses away in his pocket. He was the first person
who intimated to my father and mother, with some
decision, that there were as yet no wholly trustworthy
indications of my one day occupying a higher place in
English literature than either Milton or Byron; and
accordingly I think none of us attached much importance
to his opinions. But he had the sense to recognise,
through the parental vanity, my father's high natural
powers, and exquisitely romantic sensibility; nor less my
mother's tried sincerity in the evangelical faith, which he
had set himself apart to preach: and he thus became an
honoured, though never quite cordially welcomed, guest
on occasions of state Sunday dinner; and more or less an
adviser thenceforward of the mode of my education. He
himself found interest enough in my real love of nature
and ready faculty of rhyme, to induce him to read and
criticize for me some of my verses with attention; and at
last, as a sacred Elusinian imitation and Delphic pilgrim-
age, to take me in his hand one day when he had a visit
to pay to the poet Rogers.

105. The old man, previously warned of my admissible
claims, in Mr. Pringle's sight, to the beatitude of such
introduction, was sufficiently gracious to me, though the
cultivation of germinating genius was never held by Mr.

Rogers to be an industry altogether delectable to genius in its zenith. Moreover, I was unfortunate in the line of observations by which, in return for his notice, I endeavoured to show myself worthy of it. I congratulated him with enthusiasm on the beauty of the engravings by which his poems were illustrated,—but betrayed, I fear me, at the same time some lack of an equally vivid interest in the composition of the poems themselves. At all events, Mr. Pringle—I thought at the time, somewhat abruptly—diverted the conversation to subjects connected with Africa. These were doubtless more calculated to interest the polished minstrel of St. James's Place; but again I fell into misdemeanours by allowing my own attention, as my wandering eyes too frankly confessed, to determine itself on the pictures glowing from the crimson-silken walls; and accordingly, after we had taken leave, Mr. Pringle took occasion to advise me that, in future, when I was in the company of distinguished men, I should listen more attentively to their conversation.

106. These, and such other—(I have elsewhere related the Ettrick Shepherd's favouring visit to us, also obtained by Mr. Pringle)—glorifications and advancements being the reward of my literary efforts, I was nevertheless not beguiled by them into any abandonment of the scientific studies which were indeed natural and delightful to me. I have above registered their beginnings in the sparry walks at Matlock: but my father's business also took him often to Bristol, where he placed my mother, with Mary and me, at Clifton. Miss Edgeworth's story of Lazy Lawrence, and the visit to Matlock by Harry and Lucy, gave an almost romantic and visionary charm to mineralogy in those dells; and the piece of iron oxide with bright Bristol diamonds,—No. 51 of the Brantwood collection, —was I think the first stone on which I began my studies of silica. The diamonds of it were bright with many

an association besides, since from Clifton we nearly always
crossed to Chepstow,—the rapture of being afloat, for
half-an-hour even, on that muddy sea, concentrating into
these impressive minutes the pleasures of a year of other
boys' boating,—and so round by Tintern and Malvern,
where the hills, extremely delightful in themselves to me
because I was allowed to run free on them, there being no
precipices to fall over nor streams to fall into, were also
classical to me through Mrs. Sherwood's "Henry Milner,"
a book which I loved long, and respect still. So that
there was this of curious and precious in the means of my
education in these years, that my romance was always
ratified to me by the seal of locality—and every charm of
locality spiritualized by the glow and the passion of
romance.

107. There was one district, however, that of the
Cumberland lakes, which needed no charm of association
to deepen the appeal of its realities. I have said some-
where that my first memory in life was of Friar's Crag
on Derwentwater;—meaning, I suppose, my first memory
of things afterwards chiefly precious to me; at all events,
I knew Keswick before I knew Perth, and after the Perth
days were ended, my mother and I stayed either there,
at the Royal Oak, or at Lowwood Inn, or at Coniston
Waterhead, while my father went on his business journeys
to Whitehaven, Lancaster, Newcastle, and other northern
towns. The inn at Coniston was then actually at the
upper end of the lake, the road from Ambleside to the
village passing just between it and the water; and the
view of the long reach of lake, with its softly wooded lateral
hills, had for my father a tender charm which excited the
same feeling as that with which he afterwards regarded
the lakes of Italy. Lowwood Inn also was then little
more than a country cottage,—and Ambleside a rural
village; and the absolute peace and bliss which any one

who cared for grassy hills and for sweet waters might find at every footstep, and at every turn of crag or bend of bay, was totally unlike anything I ever saw, or read of, elsewhere.

108. My first sight of bolder scenery was in Wales; and I have written,—more than it would be wise to print, —about the drive from Hereford to Rhaiadyr, and under Plynlimmon to Pont-y-Monach: the joy of a walk with my father in the Sunday afternoon towards Hafod, dashed only with some alarmed sense of the sin of being so happy among the hills, instead of writing out a sermon at home; —my father's presence and countenance not wholly comforting me, for we both of us had alike a subdued consciousness of being profane and rebellious characters, compared to my mother.

From Pont-y-Monach we went north, gathering pebbles on the beach at Aberystwith, and getting up Cader Idris with help of ponies:—it remained, and rightly, for many a year after, a king of mountains to me. Followed Harlech and its sands, Festiniog, the pass of Aberglaslyn, and marvel of Menai Straits and Bridge, which I looked at, then, as Miss Edgeworth had taught me, with reverence for the mechanical skill of man,—little thinking, poor innocent, what use I should see the creature putting his skill to, in the half century to come.

The Menai *Bridge* it was, remember, good reader, not *tube;*—but the trim plank roadway swinging smooth between its iron cobwebs from tower to tower.

109. And so on to Llanberis and up Snowdon, of which ascent I remember, as the most exciting event, the finding for the first time in my life a real "mineral" for myself, a piece of copper pyrites! But the general impression of Welsh mountain form was so true and clear that subsequent journeys little changed or deepened it.

And if only then my father and mother had seen the real

strengths and weaknesses of their little John;—if they had given me but a shaggy scrap of a Welsh pony, and left me in charge of a good Welsh guide, and of his wife, if I needed any coddling, they would have made a man of me there and then, and afterwards the comfort of their own hearts, and probably the first geologist of my time in Europe.

If only! But they could no more have done it than thrown me like my cousin Charles into Croydon Canal, trusting me to find my way out by the laws of nature.

110. Instead, they took me back to London, and my father spared time from his business hours, once or twice a week, to take me to a four-square, sky-lighted, sawdust-floored prison of a riding-school in Moorfields, the smell of which, as we turned in at the gate of it, was a terror and horror and abomination to me: and there I was put on big horses that jumped, and reared, and circled, and sidled; and fell off them regularly whenever they did any of those things; and was a disgrace to my family, and a burning shame and misery to myself, till at last the riding-school was given up on my spraining my right-hand fore-finger (it has never come straight again since),—and a well-broken Shetland pony bought for me, and the two of us led about the Norwood roads by a riding master with a leading string. I used to do pretty well as long as we went straight, and then get thinking of something and fall off when we turned a corner. I might have got some inkling of a seat in Heaven's good time, if no fuss had been made about me, nor inquiries instituted whether I had been off or on; but as my mother, the moment I got home, made searching scrutiny into the day's disgraces, I merely got more and more nervous and helpless after every tumble; and this branch of my education was at last abandoned, my parents consoling themselves, as best they might, in the conclusion that my not being able to learn to ride was the sign of my being a singular genius.

111. The rest of the year was passed in such home
employment as I have above described;—but, either in
that or the preceding year, my mineralogical taste received
a new and very important impulse from a friend who
entered afterwards intimately into our family life, but of
whom I have not yet spoken.

My illness at Dunkeld, above noticed, was attended by
two physicians,—my mother,—and Dr. Grant. The
Doctor must then have been a youth who had just
obtained his diploma. I do not know the origin of his
acquaintance with my parents; but I know that my father
had almost paternal influence over him; and was of service
to him, to what extent I know not, but certainly continued
and effective, in beginning the world. And as I grew
older I used often to hear expressions of much affection
and respect for Dr. Grant from my father and mother,
coupled with others of regret or blame that he did not
enough bring out his powers, or use his advantages.

Ever after the Dunkeld illness, Dr. Grant's name was
associated in my mind with a brown powder—rhubarb,
or the like—of a gritty and acrid nature, which, by his
orders, I had then to take. The name thenceforward
always sounded to me gr-r-ish and granular; and a certain
dread, not amounting to dislike—but, on the contrary,
affectionate, (for *me*)—made the Doctor's presence some-
what solemnizing to me; the rather as he never jested,
and had a brownish, partly austere, and sere, wrinkled,
and—rhubarby, in fact, sort of a face. For the rest, a
man entirely kind and conscientious, much affectionate to
my father, and acknowledging a sort of ward-to-guardian's
duty to him, together with the responsibility of a medical
adviser, acquainted both with his imagination and his
constitution.

112. I conjecture that it must have been owing to
Dr. Grant's being of fairly good family, and in every sense

and every reality of the word a gentleman, that, soon after
coming up to London, he got a surgeon's appointment in
one of His Majesty's frigates commissioned for a cruise
on the west coast of South America. Fortunately the
health of her company gave the Doctor little to do pro-
fessionally; and he was able to give most of his time to
the study of the natural history of the coast of Chili and
Peru. One of the results of these shore expeditions was
the finding such a stag-beetle as had never before been
seen. It had peculiar or colossal nippers, and—I forget
what "chiasos" means in Greek, but its jaws were chiasoi.
It was brought home beautifully packed in a box of cotton;
and, when the box was opened, excited the admiration of
all beholders, and was called the "Chiasognathos Grantii."
A second result was his collection of a very perfect series
of Valparaiso humming birds, out of which he spared, for
a present to my mother, as many as filled with purple and
golden flutter two glass cases as large as Mr. Gould's at
the British Museum, which became resplendent decorations
of the drawing-room at Herne Hill,—were to me, as I
grew older, conclusive standards of plume texture and
colour,—and are now placed in the best lighted recess of
the parish school at Coniston.

113. The third result was more important still. Dr.
Grant had been presented by the Spanish masters of mines
with characteristic and rich specimens of the most beautiful
vein-stones of Copiapo. It was a mighty fact for me, at
the height of my child's interest in minerals, to see our
own parlour table loaded with foliated silver and arbor-
escent gold. Not only the man of science, but the latent
miser in me, was developed largely in an hour or two! In
the pieces which Dr. Grant gave me, I counted my
treasure grain by grain; and recall to-day, in acute sym-
pathy with it, the indignation I felt at seeing no instantly
reverential change in cousin Charles's countenance, when

I informed him that the film on the surface of an un-presuming specimen, amounting in quantity to about the sixteenth part of a sixpence, was "native silver"!

Soon after his return from this prosperous voyage, Dr. Grant settled himself in a respectable house half-way down Richmond Hill, where gradually he obtained practice and accepted position among the gentry of that town and its parkly neighbourhood. And every now and then, in the summer mornings, or the gaily frost-white winter ones, we used, papa and mamma, and Mary and I, to drive over Clapham and Wandsworth Commons to a breakfast picnic with Dr. Grant at the "Star and Garter." Break-fasts much impressed on my mind, partly by the pretty view from the windows; but more, because while my orthodox breakfast, even in travelling, was of stale baker's bread, at these starry picnics I was allowed new French roll.

114. Leaving Dr. Grant, for the nonce, under these pleasant and dignifiedly crescent circumstances, I must turn to the friends who of all others, not relatives, were most powerfully influential on my child life,—Mr. and Mrs. Richard Gray.

Some considerable time during my father's clerkdom had been passed by him in Spain, in learning to know sherry, and seeing the ways of making and storing it at Xerez, Cadiz, and Lisbon. At Lisbon he became intimate with another young Scotsman of about his own age, also employed, I conceive, as a clerk, in some Spanish house, but himself of no narrow clerkly mind. On the contrary, Richard Gray went far beyond my father in the romantic sentiment, and scholarly love of good literature, which so strangely mingled with my father's steady busi-ness habits. Equally energetic, industrious, and high-principled, Mr. Gray's enthusiasm was nevertheless irregu-larly, and too often uselessly, coruscant; being to my

father's, as Carlyle says of French against English fire at
Dettingen, "faggot against anthracite." Yet, I will not
venture absolutely to maintain that, under Richard's
erratic and effervescent influence, an expedition to Cintra,
or an assistance at a village festa, or even at a bull-fight,
might not sometimes, to that extent, invalidate my former
general assertion that, during nine years, my father never
had a holiday. At all events, the young men became close
and affectionate friends; and the connection had a soften-
ing, cheering, and altogether beneficent effect on my
father's character. Nor was their brotherly friendship
any whit flawed or dimmed, when, a little while before
leaving Spain, Mr. Gray married an extremely good and
beautiful Scotch girl, Mary Monro.

115. Extremely good, and, in the gentlest way;—
entirely simple, meek, loving, and serious; not clever
enough to be any way naughty, but saved from being
stupid by a vivid nature, full of enthusiasm like her hus-
band's. Both of them evangelically pious, in a vivid, not
virulent, way; and each of them sacredly, no less than
passionately, in love with the other, they were the entirely
best-matched pair I have yet seen in this match-making
world and dispensation. Yet, as fate would have it, they
had the one grief of having no children, which caused it,
in years to come, to be Mrs. Gray's principal occupation
in life to spoil *me*. By the time I was old enough to be
spoiled, Mr. Gray, having fairly prospered in business,
and come to London, was established, with his wife, her
mother, and her mother's white French poodle, Petite,
in a dignified house in Camberwell Grove. An entirely
happy family; old Mrs. Monro as sweet as her daughter,
perhaps slightly wiser; Richard rejoicing in them both with
all his heart; and Petite, having, perhaps, as much sense
as any two of them, delighted in, and beloved by all three.

116. Their house was near the top of the Grove,—

which was a real grove in those days, and a grand one,
some three-quarters of a mile long, steepishly down hill,—
beautiful in perspective as an unprecedently "long-drawn
aisle;" trees, elm, wych elm, sycamore and aspen, the
branches meeting at top; the houses on each side with
trim stone pathways up to them, through small plots of
well-mown grass; three or four storied, mostly in grouped
terraces,—well-built, of sober-coloured brick, with high
and steep slated roof—not gabled, but polygonal; all well
to do, well kept, well broomed, dignifiedly and pleasantly
vulgar, and their own Grove-world all in all to them. It
was a pleasant mile and a furlong or two's walk from
Herne Hill to the Grove; and whenever Mrs. Gray and
my mother had anything to say to each other, they walked
—up the hill or down—to say it; and Mr. Gray's house
was always the same to us as our own at any time of day
or night. But our house not at all so to the Grays, having
its formalities inviolable; so that during the whole of
childhood I had the sense that we were, in some way or
other, always above our friends and relations,—more or
less patronizing everybody, favouring them by our advice,
instructing them by our example, and called upon, by
what was due both to ourselves, and the constitution of
society, to keep them at a certain distance.

117. With one exception; which I have deep pleasure
in remembering. In the first chapter of the Antiquary,
the landlord at Queen's Ferry sets down to his esteemed
guest a bottle of Robert Cockburn's best port; with which
Robert Cockburn duly supplied Sir Walter himself, being
at that time, if not the largest, the leading importer of the
finest Portugal wine, as my father of Spanish. But Mr.
Cockburn was primarily an old Edinburgh gentleman, and
only by condescension a wine-merchant; a man of great
power and pleasant sarcastic wit, moving in the first circles
of Edinburgh; attached to my father by many links of

association with the "auld toun," and sincerely respecting
him. He was much the stateliest and truest piece of
character who ever sate at our merchant feasts.

Mrs. Cockburn was even a little higher,—as representa-
tive of the Scottish lady of the old school,—indulgent yet
to the new. She had been Lord Byron's first of first
loves; she was the Mary Duff of Lachin-y-Gair. When
I first remember her, still extremely beautiful in middle
age, full of sense; and, though with some mixture of proud
severity, extremely kind.

118. They had two sons, Alexander and Archibald,
both in business with their father, both clever and ener-
getic, but both distinctly resolute—as indeed their parents
desired—that they would be gentlemen first, salesmen
second: a character much to be honoured and retained
among us; nor in their case the least ambitious or affected:
gentlemen they were,—born so, and more at home on the
hills than in the counting-house, and withal attentive
enough to their business. The house, nevertheless, did
not become all that it might have been in less well-bred
hands.

The two sons, one or other, often dined with us, and
were more distinctly friends than most of our guests.
Alexander had much of his father's humour; Archibald,
a fine, young, dark Highlander, was extremely delightful
to me, and took some pains with me, for the sake of my
love of Scott, telling me anything about fishing or deer-
stalking that I cared to listen to. For, even from earliest
days, I cared to listen to the adventures of other people,
though I never coveted any for myself. I read all
Captain Marryat's novels, without ever wishing to go to
sea; traversed the field of Waterloo without the slightest
inclination to be a soldier; went on ideal fishing with Izaak
Walton without ever casting a fly; and knew Cooper's
'Deerslayer' and 'Pathfinder' almost by heart, without

handling anything but a pop-gun, or having any paths to
find beyond the solitudes of Gipsy-Hill. I used sometimes
to tell myself stories of campaigns in which I was an
ingenious general, or caverns in which I discovered veins
of gold; but these were merely to fill vacancies of fancy,
and had no reference whatever to things actual or feasible.
I already disliked growing older,—never expected to be
wiser, and formed no more plans for the future than a
little black silkworm does in the middle of its first mulberry
leaf.

SCHAFFHAUSEN AND MILAN

119. THE visit to the field of Waterloo, spoken of by chance in last chapter, must have been when I was five years old,—on the occasion of papa and mamma's taking a fancy to see Paris in its festivities following the coronation of Charles X. We stayed several weeks in Paris, in a quiet family inn, and then some days at Brussels,— but I have no memory whatever of intermediate stages. It seems to me, on revision of those matin times, that I was very slow in receiving impressions, and needed to stop two or three days at least in a place, before I began to get a notion of it; but the notion, once got, was, as far as it went, always right; and since I had no occasion afterwards to modify it, other impressions fell away from that principal one, and disappeared altogether. Hence what people call my prejudiced views of things,—which are, in fact, the exact contrary, namely, post-judiced. (I do not mean to introduce this word for general service, but it saves time and print just now.)

120. Another character of my perceptions I find curiously steady—that I was only interested by things near me, or at least clearly visible and present. I suppose this is so with children generally; but it remained—and remains—a part of my grown-up temper. In this visit to Paris, I was extremely taken up with the soft red cushions of the arm-chairs, which it took one half an hour to subside into after sitting down,—with the exquisitely polished floor of the salon, and the good-natured French "Boots" (more properly "Brushes"), who skated over it in the morning till it became as reflective as a mahogany table,—with the pretty court full of flowers

and shrubs in beds and tubs, between our rez-de-chaussée windows and the outer gate,—with a nice black servant belonging to another family, who used to catch the house-cat for me; and with an equally good-natured fille de chambre, who used to catch it back again, for fear I should teaze it, (her experience of English boy-children having made her dubious of my intentions);—all these things and people I remember,—and the Tuileries garden, and the "Tivoli" gardens, where my father took me up and down a "Russian mountain," and I saw fireworks of the finest. But I remember nothing of the Seine, nor of Notre Dame, nor of anything in or even out of the town, except the windmills on Mont Martre.

121. Similarly at Brussels. I recollect no Hôtel de Ville, no stately streets, no surprises, or interests, except only the drive to Waterloo and slow walk over the field. The defacing mound was not then built—it was only nine years since the fight; and each bank and hollow of the ground was still a true exponent of the courses of charge or recoil. Fastened in my mind by later reading, that sight of the slope of battle remains to me entirely distinct, while the results of a later examination of it after the building of the mound, have faded mostly away.

I must also note that the rapture of getting on board a steamer, spoken of in last letter, was of later date; as a child I cared more for a beach on which the waves broke, or sands in which I could dig, than for wide sea. There was no "first sight" of the sea for me. I had gone to Scotland in Captain Spinks' cutter, then a regular passage boat, when I was only three years old; but the weather was fine, and except for the pleasure of tattooing myself with tar among the ropes, I might as well have been ashore; but I grew into the sense of ocean, as the Earth shaker, by the rattling beach, and lisping sand.

122. I had meant, also in this place, to give a word or

two to another poor relative, Nanny Clowsley, an entirely
cheerful old woman, who lived, with a Dutch clock and
some old teacups, in a single room (with small bed in
alcove) on the third storey of a gabled house, part of the
group of old ones lately pulled down on Chelsea side of
Battersea bridge. But I had better keep what I have to
say of Chelsea well together, early and late; only, in
speaking of shingle, I must note the use to me of the view
out of Nanny Clowsley's window right down upon the
Thames tide, with its tossing wherries at the flow, and
stranded barges at ebb.

And now, I must get on, and come to the real first
sights of several things.

123. I said that, for our English tours, Mr. Telford
usually lent us his chariot. But for Switzerland, now
taking Mary, we needed stronger wheels and more room;
and for this, and all following tours abroad, the first pre-
paration and the beginning of delight was the choosing a
carriage to our fancy, from the hireable reserves at Mr.
Hopkinson's, of Long Acre.

The poor modern slaves and simpletons who let them-
selves be dragged like cattle, or felled timber, through the
countries they imagine themselves visiting, can have no
conception whatever of the complex joys, and ingenious
hopes, connected with the choice and arrangement of the
travelling carriage in old times. The mechanical ques-
tions first, of strength—easy rolling—steady and safe poise
of persons and luggage; the general stateliness of effect to
be obtained for the abashing of plebeian beholders; the
cunning design and distribution of store-cellars under the
seats, secret drawers under front windows, invisible pockets
under padded lining, safe from dust, and accessible only by
insidious slits, or necromantic valves like Aladdin's trap-
door; the fitting of cushions where they would not slip,
the rounding of corners for more delicate repose; the

prudent attachments and springs of blinds; the perfect fitting of windows, on which one-half the comfort of a travelling carriage really depends; and the adaptation of all these concentrated luxuries to the probabilities of who would sit where, in the little apartment which was to be virtually one's home for five or six months;—all this was an imaginary journey in itself, with every pleasure, and none of the discomfort, of practical travelling.

124. On the grand occasion of our first continental journey—which was meant to be half a year long—the carriage was chosen with, or in addition fitted with, a front seat outside for my father and Mary, a dickey, unusually large, for Anne and the courier, and four inside seats, though those in front very small, that papa and Mary might be received inside in stress of weather. I recollect, when we had finally settled which carriage we would have, the polite Mr. Hopkinson, advised of my dawning literary reputation, asking me (to the joy of my father) if I could translate the motto of the former possessor, under his painted arms,—*"Vix ea nostra voco,"*—which I accomplishing successfully, farther wittily observed that however by right belonging to the former possessor, the motto was with greater propriety applicable to *us*.

125. For a family carriage of this solid construction, with its luggage, and load of six or more persons, four horses were of course necessary to get any sufficient way on it; and half-a-dozen such teams were kept at every post-house. The modern reader may perhaps have as much difficulty in realizing these savagely and clumsily locomotive periods, though so recent, as any aspects of migratory Saxon or Goth; and may not think me vainly garrulous in their description.

The French horses, and more or less those on all the great lines of European travelling, were properly stout trotting cart-horses, well up to their work and over it;

untrimmed, long-tailed, good-humouredly licentious, whinnying and frolicking with each other when they had a chance; sagaciously steady to their work; obedient to the voice mostly, to the rein only for more explicitness; never touched by the whip, which was used merely to express the driver's exultation in himself and them,—signal obstructive vehicles in front out of the way, and advise all the inhabitants of the villages and towns traversed on the day's journey, that persons of distinction were honouring them by their transitory presence. If everything was right, the four horses were driven by one postillion riding the shaft horse; but if the horses were young, or the riders unpractised, there was a postillion for the leaders also. As a rule, there were four steady horses and a good driver, rarely drunk, often very young, the men of stronger build being more useful for other work, and any clever young rider able to manage the well-trained and merry-minded beasts, besides being lighter on their backs. Half the weight of the cavalier, in such cases, was in his boots, which were often brought out slung from the saddle like two buckets, the postillion, after the horses were harnessed, walking along the pole and getting into them.

126. Scarcely less official, for a travelling carriage of good class than its postillions, was the courier, or properly, avant-courier, whose primary office it was to ride in advance at a steady gallop, and order the horses at each post-house to be harnessed and ready waiting, so that no time might be lost between stages. His higher function was to make all bargains and pay all bills, so as to save the family unbecoming cares and mean anxieties, besides the trouble and disgrace of trying to speak French or any other foreign language. He, farther, knew the good inns in each town, and all the good rooms in each inn, so that he could write beforehand to secure those suited to his family. He was also, if an intelligent man and high-class

courier, well acquainted with the proper sights to be seen in each town, and with all the occult means to be used for getting sight of those that weren't to be seen by the vulgar. Murray, the reader will remember, did not exist in those days; the courier was a private Murray, who knew, if he had any wit, not the things to be seen only, but those you would yourself best like to see, and gave instructions to your valet-de-place accordingly, interfering only as a higher power in cases of difficulty needing to be overcome by money or tact. He invariably attended the ladies in their shopping expeditions, took them to the fashionable shops, and arranged as he thought proper the prices of articles. Lastly, he knew, of course, all the other high-class couriers on the road, and told you, if you wished to know, all the people of consideration who chanced to be with you in the inn.

127. My father would have considered it an insolent and revolutionary trespass on the privileges of the nobility to have mounted his courier to ride in advance of us; besides that, wisely liberal of his money for comfort and pleasure, he never would have paid the cost of an extra horse for show. The horses were, therefore, ordered in advance, when possible, by the postillions of any preceding carriage (or, otherwise, we did not mind waiting till they were harnessed), and we carried our courier behind us in the dickey with Anne, being in all his other functions and accomplishments an indispensable luxury to us. Indispensable, first, because none of us could speak anything but French, and that only enough to ask our way in; for all specialties of bargaining, or details of information, we were helpless, even in France,—and might as well have been migratory sheep, or geese, in Switzerland or Italy. Indispensable, secondly, to my father's peace of mind, because, with perfect liberality of temper, he had a great dislike to being over-reached. He perfectly well knew

that his courier would have his commission, and allowed it without question; but he knew also that his courier would not be cheated by other people, and was content in his representative. Not for ostentation, but for real enjoyment and change of sensation from his suburban life, my father liked large rooms; and my mother, in mere continuance of her ordinary and essential habits, liked clean ones; clean, and large, means a good inn and a first floor. Also my father liked a view from his windows, and reasonably said, "Why should we travel to see less than we may?"—so that meant first floor *front*. Also my father liked delicate cookery, just because he was one of the smallest and rarest eaters; and my mother liked good meat. That meant, dinner without limiting price, in reason. Also, though my father never went into society, he all the more enjoyed getting a glimpse, reverentially, of fashionable people—I mean, people of rank,—he scorned fashion, and it was a great thing to him to feel that Lord and Lady —— were on the opposite landing, and that, at any moment, he might conceivably meet and pass them on the stairs. Salvador, duly advised, or penetratively perceptive of these dispositions of my father, entirely pleasing and admirable to the courier mind, had carte-blanche in all administrative functions and bargains. We found our pleasant rooms always ready, our good horses always waiting, everybody took their hats off when we arrived and departed. Salvador presented his accounts weekly, and they were settled without a word of demur.

128. To all these conditions of luxury and felicity, can the modern steam-puffed tourist conceive the added ruling and culminating one—that we were never in a hurry? coupled with the correlative power of always starting at the hour we chose, and that if we weren't ready, the horses would wait? As a rule, we breakfasted at our own home time—eight; the horses were pawing and neighing

at the door (under the archway, I should have said) by nine. Between nine and three,—reckoning seven miles an hour, including stoppages, for minimum pace,—we had done our forty to fifty miles of journey, sate down to dinner at four,—and I had two hours of delicious exploring by myself in the evening; ordered in punctually at seven to tea, and finishing my sketches till half-past nine,—bedtime.

On longer days of journey we started at six, and did twenty miles before breakfast, coming in for four o'clock dinner as usual. In a quite long day we made a second stop, dining at any nice village hostelry, and coming in for late tea, after doing our eighty or ninety miles. But these pushes were seldom made unless to get to some pleasant cathedral town for Sunday, or pleasant Alpine village. We never travelled on Sunday; my father and I nearly always went—as philosophers—to mass, in the morning, and my mother, in pure good-nature to us, (I scarcely ever saw in her a trace of feminine curiosity,) would join with us in some such profanity as a drive on the Corso, or the like, in the afternoon. But we all, even my father, liked a walk in the fields better, round an Alpine châlet village.

129. At page 71 I threatened more accurate note of my first impressions of Switzerland and Italy in 1833. Of customary Calais I have something to say later on,—here I note only our going up Rhine to Strasburg, where, with all its miracles of building, I was already wise enough to feel the cathedral stiff and iron-worky; but was greatly excited and impressed by the high roofs and rich fronts of the wooden houses, in their sudden indication of nearness to Switzerland; and especially by finding the scene, so admirably expressed by Prout in the 36th plate of his Flanders and Germany, still uninjured. And then, with Salvador was held council in the inn-parlour of Strasburg, whether—it was then the Friday afternoon—we should

push on to-morrow for our Sunday's rest to Basle, or to Schaffhausen.

130. How much depended—if ever anything "depends" on anything else,—on the issue of that debate! Salvador inclined to the straight and level Rhine-side road, with the luxury of the Three Kings attainable by sunset. But at Basle, it had to be admitted, there were no Alps in sight, no cataract within hearing, and Salvador honourably laid before us the splendid alternative possibility of reaching, by traverse of the hilly road of the Black Forest, the gates of Schaffhausen itself, before they closed for the night.

The Black Forest! The fall of Schaffhausen! The chain of the Alps! within one's grasp for Sunday! What a Sunday, instead of customary Walworth and the Dulwich fields! My impassioned petition at last carried it, and the earliest morning saw us trotting over the bridge of boats to Kehl, and in the eastern light I well remember watching the line of the Black Forest hills enlarge and rise, as we crossed the plain of the Rhine. "Gates of the hills"; opening for me to a new life—to cease no more, except at the Gates of the Hills whence one returns not.

131. And so, we reached the base of the Schwartzwald, and entered an ascending dingle; and scarcely, I think, a quarter of an hour after entering, saw our first "Swiss cottage." * How much it meant to all of us,—how much prophesied to me, no modern traveller could the least conceive, if I spent days in trying to tell him. A sort of triumphant shriek—like all the railway whistles going off at once, at Clapham Junction—has gone up from the Fooldom of Europe at the destruction of the myth of William Tell. To us, every word of it was true—but mythically luminous with more than mortal truth; and here, under the black woods, glowed the visible, beautiful,

* Swiss, in character and real habit—the political boundaries are of no moment.

tangible testimony to it in the purple larch timber, carved
to exquisiteness by the joy of peasant life, continuous,
motionless there in the pine shadow on its ancestral turf,—
unassailed and unassailing, in the blessedness of righteous
poverty, of religious peace.

The myth of William Tell is destroyed forsooth? and
you have tunnelled Gothard, and filled, it may be, the
Bay of Uri;—and it was all for you and your sake that
the grapes dropped blood from the press of St. Jacob, and
the pine club struck down horse and helm in Morgarten
Glen?

132. Difficult enough for you to imagine, that old
travellers' time when Switzerland was yet the land of the
Swiss, and the Alps had never been trod by foot of man.
Steam, never heard of yet, but for short fair weather cross-
ing at sea (were there paddle-packets across Atlantic? I
forget). Any way, the roads by land were safe; and
entered once into this mountain Paradise, we wound on
through its balmy glens, past cottage after cottage on their
lawns, still glistering in the dew.

The road got into more barren heights by the mid-day,
the hills arduous; once or twice we had to wait for horses,
and we were still twenty miles from Schaffhausen at sun-
set; it was past midnight when we reached her closed
gates. The disturbed porter had the grace to open them
—not quite wide enough; we carried away one of our
lamps in collision with the slanting bar as we drove through
the arch. How much happier the privilege of dreamily
entering a mediæval city, though with the loss of a lamp,
than the free ingress of being jammed between a dray and
a tramcar at a railroad station!

133. It is strange that I but dimly recollect the follow-
ing morning; I fancy we must have gone to some sort of
church or other; and certainly, part of the day went in
admiring the bow-windows projecting into the clean

streets. None of us seem to have thought the Alps would
be visible without profane exertion in climbing hills. We
dined at four, as usual, and the evening being entirely fine,
went out to walk, all of us,—my father and mother and
Mary and I.

We must have still spent some time in town-seeing, for
it was drawing towards sunset when we got up to some
sort of garden promenade—west of the town, I believe;
and high above the Rhine, so as to command the open
country across it to the south and west. At which open
country of low undulation, far into blue,—gazing as at
one of our own distances from Malvern of Worcester-
shire, or Dorking of Kent,—suddenly—behold—beyond!

134. There was no thought in any of us for a moment
of their being clouds. They were clear as crystal, sharp
on the pure horizon sky, and already tinged with rose by
the sinking sun. Infinitely beyond all that we had ever
thought or dreamed,—the seen walls of lost Eden could
not have been more beautiful to us; not more awful, round
heaven, the walls of sacred Death.

It is not possible to imagine, in any time of the world, a
more blessed entrance into life, for a child of such a tem-
perament as mine. True, the temperament belonged to
the age: a very few years,—within the hundred,—before
that, no child could have been born to care for mountains,
or for the men that lived among them, in that way. Till
Rousseau's time, there had been no "sentimental" love of
nature; and till Scott's, no such apprehensive love of "all
sorts and conditions of men," not in the soul merely, but
in the flesh. St. Bernard of La Fontaine, looking out to
Mont Blanc with his child's eyes, sees above Mont Blanc
the Madonna; St. Bernard of Talloires, not the Lake of
Annecy, but the dead between Martigny and Aosta. But
for me, the Alps and their people were alike beautiful in
their snow, and their humanity; and I wanted, neither

for them nor myself, sight of any thrones in heaven but the rocks, or of any spirits in heaven but the clouds.

135. Thus, in perfect health of life and fire of heart, not wanting to be anything but the boy I was, not wanting to have anything more than I had; knowing of sorrow only just so much as to make life serious to me, not enough to slacken in the least its sinews; and with so much of science mixed with feeling as to make the sight of the Alps not only the revelation of the beauty of the earth, but the opening of the first page of its volume,—I went down that evening from the garden-terrace of Schaffhausen with my destiny fixed in all of it that was to be sacred and useful. To that terrace, and the shore of the Lake of Geneva, my heart and faith return to this day, in every impulse that is yet nobly alive in them, and every thought that has in it help or peace.

136. The morning after that Sunday's eve at Schaffhausen was also cloudless, and we drove early to the falls, seeing again the chain of the Alps by morning light, and learning, at Lauffen, what an Alpine river was. Coming out of the gorge of Balstall, I got another ever memorable sight of the chain of the Alps, and these distant views, never seen by the modern traveller, taught me, and made me feel, more than the close marvels of Thun and Interlachen. It was again fortunate that we took the grandest pass into Italy,—that the first ravine of the main Alps I saw was the Via Mala, and the first lake of Italy, Como.

We took boat on the little recessed lake of Chiavenna, and rowed down the whole way of waters, passing another Sunday at Cadenabbia, and then, from villa to villa, across the lake, and across, to Como, and so to Milan by Monza.

It was then full, though early, summer time; and the first impression of Italy always ought to be in her summer. It was also well that, though my heart was with the Swiss cottager, the artificial taste in me had been mainly formed

by Turner's rendering of those very scenes, in Rogers'
Italy. The "Lake of Como," the two moonlight villas,
and the "Farewell," had prepared me for all that was
beautiful and right in the terraced gardens, proportioned
arcades, and white spaces of sunny wall, which have in
general no honest charm for the English mind. But to
me, they were almost native through Turner,—familiar
at once, and revered. I had no idea then of the Renais-
sance evil in them; they were associated only with what I
had been told of the "divine art" of Raphael and Leonardo,
and, by my ignorance of dates, associated with the stories
of Shakespeare. Portia's villa,—Juliet's palace,—I
thought to have been like these.

Also, as noticed in the preface to reprint of vol. ii. of
Modern Painters, I had always a quite true perception of
size, whether in mountains or buildings, and with the per-
ception, joy in it; so that the vastness of scale in the
Milanese palaces, and the "mount of marble, a hundred
spires," of the duomo, impressed me to the full at once:
and not having yet the taste to discern good Gothic from
bad, the mere richness and fineness of lace-like tracery
against the sky was a consummate rapture to me—how
much more getting up to it and climbing among it, with
the Monte Rosa seen between its pinnacles across the
plain!

137. I had been partly prepared for this view by the
admirable presentment of it in London, a year or two
before, in an exhibition, of which the vanishing has been
in later life a greatly felt loss to me,—Burford's panorama
in Leicester Square, which was an educational institution
of the highest and purest value, and ought to have been
supported by the Government as one of the most beneficial
school instruments in London. There I had seen, ex-
quisitely painted, the view from the roof of Milan Cathe-
dral, when I had no hope of ever seeing the reality, but

with a joy and wonder of the deepest;—and now to be there indeed, made deep wonder become fathomless.

Again, most fortunately, the weather was clear and cloudless all day long, and as the sun drew westward, we were able to drive to the Corso, where, at that time, the higher Milanese were happy and proud as ours in their park, and whence, no railway station intervening, the whole chain of the Alps was visible on one side, and the beautiful city with its dominant frost-crystalline Duomo on the other. Then the drive home in the open carriage through the quiet twilight, up the long streets, and round the base of the Duomo, the smooth pavement under the wheels adding with its silentness to the sense of dream wonder in it all,—the perfect air in absolute calm, the just seen majesty of encompassing Alps, the perfectness—so it seemed to me—and purity, of the sweet, stately, stainless marble against the sky. What more, what else, could be asked of seemingly immutable good, in this mutable world?

138. I wish in general to avoid interference with the reader's judgment on the matters which I endeavour serenely to narrate; but may, I think, here be pardoned for observing to him the advantage, in a certain way, of the contemplative abstraction from the world which, during this early continental travelling, was partly enforced by our ignorance, and partly secured by our love of comfort. There is something peculiarly delightful—nay, delightful inconceivably by the modern German-plated and French-polished tourist, in passing through the streets of a foreign city without understanding a word that anybody says! One's ear for all sound of voices then becomes entirely impartial; one is not diverted by the meaning of syllables from recognizing the absolute guttural, liquid, or honeyed quality of them: while the gesture of the body and the expression of the face have the same value for you that

they have in a pantomime; every scene becomes a melodious opera to you, or a picturesquely inarticulate Punch. Consider, also, the gain in so consistent tranquillity. Most young people nowadays, or even lively old ones, travel more in search of adventures than of information. One of my most valued records of recent wandering is a series of sketches by an amiable and extremely clever girl, of the things that happened to her people and herself every day that they were abroad. Here it is brother Harry, and there it is mamma, and now paterfamilias, and now her little graceful self, and anon her merry or remonstrant sisterhood, who meet with enchanting hardships, and enviable misadventures; bind themselves with fetters of friendship, and glance into sparklings of amourette, with any sort of people in comical hats and fringy caps: and it is all very delightful and condescending; and, of course, things are learnt about the country that way which can be learned in no other way, but only about that part of it which interests itself in you, or which you have pleasure in being acquainted with. Virtually, you are thinking of yourself all the time; you necessarily talk to the cheerful people, not to the sad ones; and your head is for the most part vividly taken up with very little things. I don't say that our isolation was meritorious, or that people in general should know no language but their own. Yet the meek ignorance has these advantages. We did not travel for adventures, nor for company, but to see with our eyes, and to measure with our hearts. If you have sympathy, the aspect of humanity is more true to the depths of it than its words; and even in my own land, the things in which I have been least deceived are those which I have learned as their Spectator.

CHAPTER VII

PAPA AND MAMMA

139. THE work to which, as partly above described, I set
myself during the year 1834 under the excitement remain-
ing from my foreign travels, was in four distinct directions,
in any one of which my strength might at that time have
been fixed by definite encouragement. There was first
the effort to express sentiment in rhyme; the sentiment
being really genuine, under all the superficial vanities of
its display; and the rhymes rhythmic, only without any
ideas in them. It was impossible to explain, either to
myself or other people, why I liked staring at the sea, or
scampering on a moor; but, one had pleasure in making
some sort of melodious noise about it, like the waves
themselves, or the peewits. Then, secondly, there was
the real love of engraving, and of such characters of surface
and shade as it could give. I have never seen drawing, by
a youth, so entirely industrious in delicate line; and there
was really the making of a fine landscape, or figure outline,
engraver in me. But fate having ordered otherwise, I
mourn the loss to engraving less than that before calculated,
or rather incalculable, one, to geology! Then there was,
thirdly, the violent instinct for architecture; but I never
could have built or carved anything, because I was with-
out power of design; and have perhaps done as much in
that direction as it was worth doing with so limited
faculty. And then, fourthly, there was the unabated,
never to be abated, geological instinct, now fastened on
the Alps. My fifteenth birthday gift being left to my
choice, I asked for Saussure's "Voyages dans les Alpes,"
and thenceforward began progressive work, carrying on

my mineralogical dictionary by the help of Jameson's
three-volume Mineralogy, (an entirely clear and service-
able book;) comparing his descriptions with the minerals in
the British Museum, and writing my own more eloquent
and exhaustive accounts in a shorthand of many ingeni-
ously symbolic characters, which it took me much longer
to write my descriptions in, than in common text, and
which neither I nor anybody else could read a word of,
afterwards.

140. Such being the quadrilateral plan of my fortifiable
dispositions, it is time now to explain, with such clue as I
have found to them, the somewhat peculiar character and
genius of both my parents; the influence of which was
more important upon me, then, and far on into life, than
any external conditions, either of friendship or tutorship,
whether at the University, or in the world.

It was, in the first place, a matter of essential weight in
the determination of subsequent lines, not only of labour
but of thought, that while my father, as before told, gave
me the best example of emotional reading,—*reading*,
observe, proper, not recitation, which he disdained and I
disliked,—my mother was both able to teach me, and
resolved that I should learn, absolute accuracy of diction
and precision of accent in prose; and made me know, as
soon as I could speak plain, what I have in all later years
tried to enforce on my readers, that accuracy of diction
means accuracy of sensation, and precision of accent, pre-
cision of feeling. Trained, herself in girlhood, only at
Mrs. Rice's country school, my mother had there learned
severely right principles of truth, charity, and house-
wifery, with punctilious respect for the purity of that
English which in her home surroundings she perceived
to be by no means as undefiled as the ripples of Wandel.
She was the daughter, as aforesaid, of the early widowed
landlady of the King's Head Inn and Tavern, which still

exists, or existed a year or two since, presenting its side to Croydon market-place, its front and entrance door to the narrow alley which descends, steep for pedestrians, impassable to carriages, from the High Street to the lower town.

141. Thus native to the customs and dialect of Croydon Agora, my mother, as I now read her, must have been an extremely intelligent, admirably practical, and naïvely ambitious girl; keeping, without contention, the headship of her class, and availing herself with steady discretion of every advantage the country school and its modest mistress could offer her. I never in her after-life heard her speak with regret, and seldom without respectful praise, of any part of the discipline of Mrs. Rice.

I do not know for what reason, or under what conditions, my mother went to live with my Scottish grandfather and grandmother, first at Edinburgh, and then at the house of Bower's Well, on the slope of the Hill of Kinnoul, above Perth. I was stupidly and heartlessly careless of the past history of my family as long as I could have learnt it; not till after my mother's death did I begin to desire to know what I could never more be told.

But certainly the change, for her, was into a higher sphere of society,—that of real, though sometimes eccentric, and frequently poor, gentlemen and gentlewomen. She must then have been rapidly growing into a tall, handsome, and very finely made girl, with a beautiful mild firmness of expression; a faultless and accomplished housekeeper, and a natural, essential, unassailable, yet inoffensive, prude. I never heard a single word of any sentiment, accident, admiration, or affection disturbing the serene tenor of her Scottish stewardship; yet I noticed that she never spoke without some slight shyness before my father, nor without some pleasure, to other people, of Dr. Thomas Brown.

142. That the Professor of Moral Philosophy was a frequent guest at my grandmother's tea-table, and fond of benignantly arguing with Miss Margaret, is evidence enough of the position she held in Edinburgh circles; her household skills and duties never therefore neglected—rather, if anything, still too scrupulously practised. Once, when she had put her white frock on for dinner, and hurried to the kitchen to give final glance at the state and order of things there, old Mause, having run against the white frock with a black saucepan, and been, it seems, rebuked by her young mistress with too little resignation to the will of Providence in that matter, shook her head sorrowfully, saying, "Ah, Miss Margaret, ye are just like Martha, carefu' and troubled about mony things."

143. When my mother was thus, at twenty, in a Desdemona-like prime of womanhood, intent on highest moral philosophy,—"though still the house affairs would draw her thence"—my father was a dark-eyed, brilliantly active, and sensitive youth of sixteen. Margaret became to him an absolutely respected and admired—mildly liked —governess and confidante. Her sympathy was necessary to him in all his flashingly transient amours; her advice in all domestic business or sorrow, and her encouragement in all his plans of life.

These were already determined for commerce;—yet not to the abandonment of liberal study. He had learned Latin thoroughly, though with no large range of reading, under the noble traditions of Adam at the High School of Edinburgh: while, by the then living and universal influence of Sir Walter, every scene of his native city was exalted in his imagination by the purest poetry, and the proudest history, that ever hallowed or haunted the streets and rocks of a brightly inhabited capital. I have neither space, nor wish, to extend my proposed account of things that have been, by records of correspondence;—it is too

much the habit of modern biographers to confuse epistolary talk with vital fact. But the following letter from Dr. Thomas Brown to my father, at this critical juncture of his life, must be read, in part as a testimony to the position he already held among the youths of Edinburgh, and yet more as explaining some points of his blended character, of the deepest significance afterwards, both to himself and to me.

144. "8, N. ST. DAVID'S STREET,
 "EDINBURGH, *February* 18*th*, 1807.

"MY DEAR SIR,—When I look at the date of the letter which you did me the honour to send me as your adviser in literary matters—an office which a *proficient* like you scarcely requires—I am quite ashamed of the interval which I have suffered to elapse. I can truly assure you, however, that it has been unavoidable, and has not arisen from any want of interest in your intellectual progress. Even when you were a mere boy I was much delighted with your early zeal and attainments; and for your own sake, as well as for your excellent mother's, I have always looked to you with great regard, and with the belief that you would distinguish yourself in whatever profession you might adopt.

"You seem, I think, to repent too much the time you have devoted to the Belles Lettres. I confess I do not regret this for you. You must, I am sure, have felt the effect which such studies have in giving a general refinement to the manners and to the heart, which, to anyone who is not to be strictly a *man of science*, is the most valuable effect of literature. You must remember that there is a great difference between studying *professionally*, and studying for relaxation and ornament. In the society in which you are to mix, the writers in Belles Lettres will

be mentioned fifty times, when more abstract science will
not be mentioned once; and there is this great advantage
in that sort of knowledge, that the display of it, unless very
immoderate indeed, is not counted pedantry, when the
display of other intellectual attainments might run some
risk of the imputation. There is indeed one evil in the
reading of poetry and other light productions, that it is
apt to be indulged in to downright *gluttony*, and to occupy
time which should be given to business; but I am sure I
can rely on *you* that you will not so misapply your time.
There is, however, *one science*, the first and greatest of
sciences to all men, and to merchants particularly—the
science of Political Economy. To this I think your chief
attention should be directed. It is in truth the science of
your own profession, which counteracts the—(word lost
with seal)—and narrow habits which that profession is
sometimes apt to produce; and which is of perpetual appeal
in every discussion on mercantile and financial affairs. A
merchant well instructed in Political Economy must
always be fit to lead the views of his brother merchants—
without it, he is a mere trader. Do not lose a day, there-
fore, without providing yourself with a copy of Adam
Smith's "Wealth of Nations," and read and re-read it with
attention—as I am sure you must read it with delight. In
giving you this advice I consider you as a *merchant*, for as
that is to be your profession in life, your test of the import-
ance of any acquirement should be how far it will tend to
render you an *honourable and distinguished merchant;*—
a character of no small estimation in this commercial
country. I therefore consider the physical sciences as
greatly subordinate in relation to your prospects in life,
and the society in which you will be called to mingle.
All but chemistry require a greater preparation in mathe-
matics than you probably have, and chemistry it is quite
impossible to understand without some opportunity of

seeing experiments systematically carried on. If, however, you have the opportunity to attend any of the lecturers on that science in London, it will be well worth your while, and in that case I think you should purchase either Dr. Thompson's or Mr. Murray's new system of chemistry, so as to keep up constantly with your lecturer. Even of physics in general it is pleasant to have some view, however superficial, and therefore though you cannot expect without mathematics to have anything but a superficial view, you had better try to attain it. With this view you may read Gregory's "Economy of Nature," which though not a good book, and not always accurate, is, I believe, the best popular book we have, and sufficiently accurate for your purposes. Remember, however, that though you may be permitted to be a superficial natural philosopher, no such indulgence is to be given you in Political Economy.

"The only other circumstance remaining for me to request of you is that you will not suffer yourself to lose any of the languages you have acquired. Of the modern languages there is less fear, as your mercantile communications will in some measure keep them alive; but merchants do not correspond in Latin, and you may perhaps lose it unconsciously. Independently, however, of the admirable writers of whom you would thus deprive yourself, and considering the language merely as the accomplishment of a gentleman, it is of too great value to be carelessly resigned.

"Farewell, my dear sir. Accept the regard of all this family, and believe me, with every wish to be of service to you,

"Your sincere friend,
"T. Brown."

145. It may easily be conceived that a youth to whom such a letter as this was addressed by one of the chiefs of

the purely intellectual circles of Edinburgh, would be
regarded with more respect by his Croydon cousin than
is usually rendered by grown young women to their
schoolboy friends.

Their frank, cousinly relation went on, however, with-
out a thought on either side of any closer ties, until my
father, at two or three and twenty, after various apprentice-
ship in London, was going finally to London to begin his
career in his own business. By that time he had made
up his mind that Margaret, though not the least an ideal
heroine to him, was quite the best sort of person he could
have for a wife, the rather as they were already so well
used to each other; and in a quiet, but enough resolute
way, asked her if she were of the same mind, and would
wait until he had an independence to offer her. His early
tutress consented with frankly confessed joy, not indeed
in the Agnes Wickfield way, "I have loved you all my
life," but feeling and admitting that it was great delight
to be allowed to love him now. The relations between
Grace Nugent and Lord Colambre in Miss Edgeworth's
"Absentee" extremely resemble those between my father
and mother, except that Lord Colambre is a more eager
lover. My father chose his wife much with the same kind
of serenity and decision with which afterwards he chose
his clerks.

146. A time of active and hopeful contentment for
both the young people followed, my mother being perhaps
the more deeply in love, while John depended more
absolutely on her sympathy and wise friendship than is
at all usual with young men of the present day in their
relations with admired young ladies. But neither of them
ever permitted their feelings to degenerate into fretful or
impatient passion. My mother showed her affection
chiefly in steady endeavour to cultivate her powers of
mind, and form her manners, so as to fit herself to be the

undespised companion of a man whom she considered much her superior: my father in unremitting attention to the business on the success of which his marriage depended: and in a methodical regularity of conduct and correspondence which never left his mistress a moment of avoidable anxiety, or gave her motive for any serious displeasure.

On these terms the engagement lasted nine years; at the end of which time, my grandfather's debts having been all paid, and my father established in a business gradually increasing, and liable to no grave contingency, the now not very young people were married in Perth one evening after supper, the servants of the house having no suspicion of the event until John and Margaret drove away together next morning to Edinburgh.

147. In looking back to my past thoughts and ways, nothing astonishes me more than my want of curiosity about all these matters; and that, often and often as my mother used to tell with complacency the story of this carefully secret marriage, I never asked, "But, mother, why so secret, when it was just what all the friends of both of you so long expected, and what all your best friends so heartily wished?"

But, until lately, I never thought of writing any more about myself than was set down in diaries, nor of my family at all: and thus too carelessly, and, as I now think, profanely, neglected the traditions of my people. "What does it all matter, now?" I said; "we are what we are, and shall be what we make ourselves."

Also, until very lately, I had accustomed myself to consider all that my parents had done, so far as their own happiness was concerned, entirely wise and exemplary. Yet the reader must not suppose that what I have said in my deliberate writings on the propriety of long engagements had any reference to this singular one in my own

family. Of the heroism and patience with which the
sacrifice was made, on both sides, I cannot judge:—but
that it was greater than I should myself have been capable
of, I know, and I believe that it was unwise. For during
these years of waiting, my father fell gradually into a
state of ill-health, from which he never entirely recovered;
and in close of life, they both had to leave their child,
just when he was beginning to satisfy the hopes they had
formed for him.

148. I have allowed this tale of the little I knew of
their early trials and virtues to be thus chance told, because
I think my history will, in the end, be completest if I
write as its connected subjects occur to me, and not with
formal chronology of plan. My reason for telling it in
this place was chiefly to explain how my mother obtained
her perfect skill in English reading, through the hard effort
which, through the years of waiting, she made to efface
the faults, and supply the defects, of her early education;
effort which was aided and directed unerringly by her
natural—for its intensity I might justly call it supernatural
—purity of heart and conduct, leading her always to take
most delight in the right and clear language which only
can relate lovely things. Her unquestioning evangelical
faith in the literal truth of the Bible placed me, as soon
as I could conceive or think, in the presence of an unseen
world; and set my active analytic power early to work on
the questions of conscience, free will, and responsibility,
which are easily determined in days of innocence; but are
approached too often with prejudice, and always with dis-
advantage, after men become stupified by the opinions, or
tainted by the sins, of the outer world: while the gloom,
and even terror, with which the restrictions of the Sunday,
and the doctrines of the Pilgrim's Progress, the Holy War,
and Quarles' Emblems, oppressed the seventh part of my
time, was useful to me as the only form of vexation which

I was called on to endure; and redeemed by the otherwise
uninterrupted cheerfulness and tranquillity of a household
wherein the common ways were all of pleasantness, and
its single and strait path, of perfect peace.

149. My father's failure of health, following necessarily
on the long years of responsibility and exertion, needed
only this repose to effect its cure. Shy to an extreme
degree in general company, all the more because he had
natural powers which he was unable to his own satisfaction
to express,—his business faculty was entirely superb and
easy: he gave his full energy to counting-house work in
the morning, and his afternoons to domestic rest. With
instant perception and decision in all business questions;
with principles of dealing which admitted of no infraction,
and involved neither anxiety nor concealment, the count-
ing-house work was more of an interest, or even an
amusement, to him, than a care. His capital was either
in the Bank, or in St. Catherine's Docks, in the form of
insured butts of the finest sherry in the world; his partner,
Mr. Domecq, a Spaniard as proud as himself, as honour-
able, and having perfect trust in him,—not only in his
probity, but his judgment,—accurately complying with
all his directions in the preparation of wine for the
English market, and no less anxious than he to make
every variety of it, in its several rank, incomparably
good. The letters to Spain therefore needed only brief
statement that the public of that year wanted their wine
young or old, pale or brown, and the like; and the
letters to customers were as brief in their assurances that
if they found fault with their wine, they did not under-
stand it, and if they wanted an extension of credit, they
could not have it. These Spartan brevities of epistle
were, however, always supported by the utmost care in
executing his correspondents' orders; and by the unusual
attention shown them in travelling for those orders him-

self, instead of sending an agent or a clerk. His domi-
ciliary visits of this kind were always conducted by him
with great *savoir faire* and pleasant courtesy, no less than
the most attentive patience: and they were productive of
the more confidence between him and the country mer-
chant, that he was perfectly just and candid in appraise-
ment of the wine of rival houses, while his fine palate
enabled him always to sustain triumphantly any and every
ordeal of blindfold question which the suspicious customer
might put him to. Also, when correspondents of im-
portance came up to town, my father would put himself
so far out of his way as to ask them to dine at Herne Hill,
and try the contents of his own cellar. These London
visits fell into groups, on any occasions in the metropolis
of interest more than usual to the provincial mind. Our
business dinners were then arranged so as to collect two
or three country visitors together, and the table made
symmetrical by selections from the house's customers in
London, whose conversation might be most instructive
to its rural friends.

Very early in my boy's life I began much to dislike
these commercial feasts, and to form, by carefully attending
to their dialogue, when it chanced to turn on any other
subject than wine, an extremely low estimate of the com-
mercial mind as such;—estimate which I have never had
the slightest reason to alter.

Of our neighbours on Herne Hill we saw nothing, with
one exception only, afterwards to be noticed. They were
for the most part well-to-do London tradesmen of the
better class, who had little sympathy with my mother's
old-fashioned ways, and none with my father's romantic
sentiment.

150. There was probably the farther reason for our
declining the intimacy of our immediate neighbours, that
most of them were far more wealthy than we, and

inclined to demonstrate their wealth by the magnificence of their establishments. My parents lived with strict economy, kept only female servants,* used only tallow candles in plated candlesticks, were content with the lease-hold territory of their front and back gardens,—scarce an acre altogether,—and kept neither horse nor carriage. Our shop-keeping neighbours, on the contrary, had usually great cortège of footmen and glitter of plate, extensive pleasure grounds, costly hot-houses, and carriages driven by coachmen in wigs. It may be perhaps doubted by some of my readers whether the coldness of acquaintance-ship was altogether on our side; but assuredly my father was too proud to join entertainments for which he could give no like return, and my mother did not care to leave her card on foot at the doors of ladies who dashed up to hers in their barouche.

151. Protected by these monastic severities and aristo-cratic dignities, from the snares and disturbances of the outer world, the routine of my childish days became fixed, as of the sunrise and sunset to a nestling. It may seem singular to many of my readers that I remember with most pleasure the time when it was most regular and most solitary. The entrance of my cousin Mary into our household was coincident with the introduction of masters above described, and with other changes in the aims and employments of the day, which, while they often increased its interest, disturbed its tranquillity. The ideas of success at school or college, put before me by my masters, were ignoble and comfortless, in comparison with my mother's regretful blame, or simple praise: and Mary, though of a mildly cheerful and entirely amiable disposition, necessarily touched the household heart with the sadness of her orphanage, and something interrupted its harmony by the

* Thomas left us, I think partly in shame for my permanently injured lip; and we never had another indoor manservant.

difference, which my mother could not help showing, between the feelings with which she regarded her niece and her child.

152. And although I have dwelt with thankfulness on the many joys and advantages of these secluded years, the vigilant reader will not, I hope, have interpreted the accounts rendered of them into general praise of a like home education in the environs of London. But one farther good there was in it, hitherto unspoken; that great part of my acute perception and deep feeling of the beauty of architecture and scenery abroad, was owing to the well-formed habit of narrowing myself to happiness within the four brick walls of our fifty by one hundred yards of garden; and accepting with resignation the æsthetic external surroundings of a London suburb, and, yet more of a London chapel. For Dr. Andrews' was the Londonian chapel in its perfect type, definable as accurately as a Roman basilica,—an oblong, flat-ceiled barn, lighted by windows with semi-circular heads, brick-arched, filled by small-paned glass held by iron bars, like fine threaded halves of cobwebs; galleries propped on iron pipes, up both sides; pews, well shut in, each of them, by partitions of plain deal, and neatly brass-latched deal doors, filling the barn floor, all but its two lateral straw-matted passages; pulpit, sublimely isolated, central from sides and clear of altar rails at end; a stout, four-legged box of well-grained wainscot, high as the level of front galleries, and decorated with a cushion of crimson velvet, padded six inches thick, with gold tassels at the corners; which was a great resource to me when I was tired of the sermon, because I liked watching the rich colour of the folds and creases that came in it when the clergyman thumped it.

153. Imagine the change between one Sunday and the next,—from the morning service in this building, attended by the families of the small shopkeepers of the Walworth

Road, in their Sunday trimmings; (our plumber's wife, fat, good, sensible Mrs. Goad, sat in the next pew in front of us, sternly sensitive to the interruption of her devotion by our late arrivals); fancy the change from this, to high mass in Rouen Cathedral, its nave filled by the white-capped peasantry of half Normandy!

Nor was the contrast less enchanting or marvellous between the street architecture familiar to my eyes, and that of Flanders and Italy, as an exposition of mercantile taste and power. My father's counting-house was in the centre of Billiter Street, some years since effaced from sight and memory of men, but a type, then, of English city state in perfection. We now build house fronts as advertisements, spending a hundred thousand pounds in the lying mask of our bankruptcies. But in my father's time both trade and building were still honest. His counting-house was a room about fifteen feet by twenty, including desks for two clerks, and a small cupboard for sherry samples, on the first floor, with a larger room opposite for private polite receptions of elegant visitors, or the serving of a chop for himself if he had to stay late in town. The ground floor was occupied by friendly Messrs. Wardell and Co., a bottling retail firm, I believe. The only advertisement of the place of business was the brass plate under the bell-handle, inscribed "Ruskin, Telford, and Domecq," brightly scrubbed by the single female servant in charge of the establishment, old Maisie,— abbreviated or tenderly diminished into the "sie," from I know not what Christian name—Marion, I believe, as Mary into Mause. The whole house, three-storied, with garrets, was under her authority, with, doubtless, assistant morning charwoman,—cooking, waiting, and answering the door to distinguished visitors, all done by Maisie, the visitors being expected of course to announce themselves by the knocker with a flourish in proportion to their

eminence in society. The businessmen rang the count-
ing-house bell aforesaid, (round which the many coats of
annual paint were cut into a beautiful slant section by
daily scrubbing, like the coats of an agate;) and were
admitted by lifting of latch, manipulated by the head
clerk's hand in the counting-house, without stirring from
his seat.

154. This unpretending establishment, as I said, formed
part of the western side of Billiter Street, a narrow trench
—it may have been thirty feet wide—admitting, with
careful and precise driving, the passing each other of two
brewers' drays. I am not sure that this was possible at
the ends of the street, but only at a slight enlargement
opposite the brewery in the middle. Effectively a mere
trench between three-storied houses of prodigious brick-
work, thoroughly well laid, and presenting no farther
entertainment whatever to the æsthetic beholder than the
alternation of the ends and sides of their beautifully level
close courses of bricks, and the practised and skilful radia-
tion of those which formed the window lintels.

Typical, I repeat, of the group of London edifices,
east of the Mansion House, and extending to the Tower;
the under-hill picturesquenesses of which, however, were
in early days an entirely forbidden district to me, lest I
should tumble into the docks; but Fenchurch and Leaden-
hall Streets, familiar to me as the perfection of British
mercantile state and grandeur,—the reader may by effort,
though still dimly, conceive the effect on my imagination
of the fantastic gables of Ghent, and orange-scented
cortiles of Genoa.

155. I can scarcely account to myself, on any of the
ordinary principles of resignation, for the undimmed
tranquillity of pleasure with which, after these infinite
excitements in foreign lands, my father would return to
his desk opposite the brick wall of the brewery, and I

to my niche behind the drawing-room chimney piece.
But to both of us, the steady occupations, the beloved
samenesses, and the sacred customs of home were more
precious than all the fervours of wonder in things new to
us, or delight in scenes of incomparable beauty. Very
early, indeed, I had found that novelty was soon
exhausted, and beauty, though inexhaustible, beyond
a certain point or time of enthusiasm, no more to be
enjoyed; but it is not so often observed by philosophers
that home, healthily organized, is always enjoyable; nay,
the sick thrill of pleasure through all the brain and heart
with which, after even so much as a month or two of
absence, I used to catch the first sight of the ridge of Herne
Hill, and watch for every turn of the well-known road
and every branch of the familiar trees, was—though not
so deep or overwhelming—more intimately and vitally
powerful than the brightest passions of joy in strange lands,
or even in the unaccustomed scenery of my own. To
my mother, her ordinary household cares, her reading
with Mary and me, her chance of a chat with Mrs. Gray,
and the unperturbed preparation for my father's return,
and for the quiet evening, were more than all the splend-
ours or wonders of the globe between poles and equator.

156. Thus we returned—full of new thoughts, and
faithful to the old, to this exulting rest of home in the
close of 1833. An unforeseen shadow was in the heaven
of its charmed horizon.

Every day at Cornhill, Charles became more delightful
and satisfactory to everybody who knew him. How a
boy living all day in London could keep so bright a
complexion, and so crisply Achillean curls of hair—and
all the gay spirit of his Croydon mother—was not easily
conceivable; but he became a perfect combination of the
sparkle of Jin Vin with the steadiness of Tunstall, and was
untroubled by the charms of any unattainable Margaret,

for his master had no daughter; but, as worse chance
would have it, a son: so that looking forward to possibilities
as a rising apprentice ought, Charles saw that there were
none in the house for him beyond the place of cashier, or
perhaps only head-clerk. His elder brother, who had
taught him to swim by throwing him into Croydon canal,
was getting on fast as a general trader in Australia, and
naturally longed to have his best-loved brother there for
a partner. Bref, it was resolved that Charles should go
to Australia. The Christmas time of 1833 passed heavily,
for I was very sorry; Mary, a good deal more so: and my
father and mother, though in their hearts caring for
nobody in the world but me, were grave at the thought of
Charles's going so far away; but, honestly and justifiably,
thought it for the lad's good. I think the whole affair
was decided, and Charles's outfit furnished, and ship's
berth settled, and ship's captain interested in his favour, in
something less than a fortnight, and down he went to
Portsmouth to join his ship joyfully, with the world to
win. By due post came the news that he was at anchor
off Cowes, but that the ship could not sail because of the
west wind. And post succeeded post, and still the west
wind blew. We liked the west wind for its own sake,
but it was a prolonging of farewell which teazed us,
though Charles wrote that he was enjoying himself im-
mensely, and the captain, that he had made friends with
every sailor on board, besides the passengers.

157. And still the west wind blew. I do not remember
how long—some ten days or fortnight, I believe. At last,
one day my mother and Mary went with my father into
town on some shopping or sight-seeing business of a cheer-
ful character; and I was left at home, busy also about
something that cheered me greatly, I know not what;
but when I heard the others come in, and upstairs into
the drawing-room, I ran eagerly down and into the room,

beginning to tell them about this felicity that had befallen me, whatever it was. They all stood like statues, my father and mother very grave. Mary was looking out of the window—the farthest of the front three from the door. As I went on, boasting of myself, she turned round suddenly, her face all streaming with tears, and caught hold of me, and put her face close to mine, that I might hear the sobbing whisper, "Charles is gone."

158. The west wind had still blown, clearly and strong, and the day before there had been a fresh breeze of it round the isle, at Spithead, exactly the kind of breeze that drifts the clouds, and ridges the waves, in Turner's Gosport.

The ship was sending her boat on shore for some water, or the like—her little cutter, or somehow sailing, boat. There was a heavy sea running, and the sailors, and, I believe, also a passenger or two, had some difficulty in getting on board. "May I go, too?" said Charles to the captain, as he stood seeing them down the side. "Are you not afraid?" said the captain. "I never was afraid of anything in my life," said Charles, and went down the side and leaped in.

The boat had not got fifty yards from the ship before she went over, but there were other boats sailing all about them, like gnats in midsummer. Two or three scudded to the spot in a minute, and every soul was saved, except Charles, who went down like a stone.

<p style="text-align:center">22nd January, 1834.</p>

All this we knew by little and little. For the first day or two we would not believe it, but thought he must have been taken up by some other boat and carried to sea. At last came word that his body had been thrown ashore at Cowes: and his father went down to see him buried. That done, and all the story heard, for still the ship stayed,

he came to Herne Hill, to tell Charles's "auntie" all about it. (The old man never called my mother anything else than auntie.) It was in the morning, in the front parlour —my mother knitting in her usual place at the fireside, I at my drawing, or the like, in my own place also. My uncle told all the story, in the quiet, steady sort of way that the common English do, till just at the end he broke down into sobbing, saying (I can hear the words now), "They caught the cap off of his head, and yet they couldn't save him."

Chapter VIII

VESTER, CAMENAE

159. The death of Charles closed the doors of my heart again for that time; and the self-engrossed quiet of the Herne Hill life continued for another year, leaving little to be remembered, and less to be told. My parents made one effort, however, to obtain some healthy companionship for me, to which I probably owe more than I knew at the moment.

Some six or seven gates down the hill towards the field, (which I have to return most true thanks to its present owner, Mr. Sopper, for having again opened to the public sight in consequence of the passage above describing the greatness of its loss both to the neighbour and the stranger), some six or seven gates down that way, a pretty lawn, shaded by a low spreading cedar, opened before an extremely neat and carefully kept house, where lived two people, modest in their ways as my father and mother, themselves,—Mr. and Mrs. Fall; happier, however, in having son and daughter instead of an only child. Their son, Richard, was a year younger than I, but already at school at Shrewsbury, and somewhat in advance of me therefore in regular discipline; extremely gentle and good-natured,—his sister, still younger, a clever little girl, her mother's constant companion: and both of them unpretending, but rigid, examples of all Herne Hill proprieties, true religions, and useful learnings. I shudder still at the recollection of Mrs. Fall's raised eyebrows one day at my pronunciation of "naiveté" as "naivette."

160. I think it must have been as early as 1832 that my father, noticing with great respect the conduct of all

matters in this family, wrote to Mr. Fall in courteous request that "the two boys" might be permitted, when Richard was at home, to pursue their holiday tasks, or recreations, so far as it pleased them, together. The proposal was kindly taken: the two boys took stock of each other,—agreed to the arrangement,—and, as I had been promoted by that time to the possession of a study, all to myself, while Richard had only his own room, (and *that* liable to sisterly advice or intrusion,) the course which things fell into was that usually, when Richard was at home, he came up past the seven gates about ten in the morning; did what lessons he had to do at the same table with me, occasionally helping me a little with mine; and then we went together for afternoon walk with Dash, Gipsy, or whatever dog chanced to be dominant.

161. I do not venture to affirm that the snow of those Christmas holidays was whiter than it is now, though I might give some reasons for supposing that it remained longer white. But I affirm decisively that it used to fall deeper in the neighbourhood of London than has been seen for the last twenty or twenty-five years. It was quite usual to find in the hollows of the Norwood Hills the field fences buried under crested waves of snow, while, from the higher ridges, half the counties of Kent and Surrey shone to the horizon like a cloudless and terrorless Arctic sea.

Richard Fall was entirely good-humoured, sensible, and practical; but had no particular tastes; a distaste, if anything, for *my* styles both of art and poetry. He stiffly declined arbitration on the merits of my compositions; and though with pleasant cordiality in daily companionship, took rather the position of putting up with me, than of pride in his privilege of acquaintance with a rising author. He was never unkind or sarcastic; but laughed me inexorably out of writing bad English for rhyme's sake,

or demonstrable nonsense either in prose or rhyme. We got gradually accustomed to be together, and far on into life were glad when any chance brought us together again.

162. The year 1834 passed innocuously enough, but with little profit, in the quadripartite industries before described, followed for my own pleasure;—with minglings of sapless effort in the classics, in which I neither felt, nor foresaw, the least good.

Innocuously *enough*, I say,—meaning, with as little mischief as a well-intentioned boy, virtually masterless, could suffer from having all his own way, and daily confirming himself in the serious impression that his own way was always the best.

I cannot analyse, at least without taking more trouble than I suppose any reader would care to take with me, the mixed good and evil in the third rate literature which I preferred to the Latin classics. My volume of the Forget-me-not, which gave me that precious engraving of Verona, (curiously also another by Prout of St. Mark's at Venice), was somewhat above the general caste of annuals in its quality of letterpress; and contained three stories, "The Red-nosed Lieutenant," by the Rev. George Croly; "Hans in Kelder," by the author of "Chronicles of London Bridge;" and "The Comet," by Henry Neele, Esq., which were in their several ways extremely impressive to me. The partly childish, partly dull, or even, as aforesaid, idiotic, way I had of staring at the same things all day long, carried itself out in reading, so that I could read the same things all the year round. As there was neither advantage nor credit to be got by remembering fictitious circumstances, I was, if anything, rather proud of my skill in forgetting, so as the sooner to recover the zest of the tales; and I suppose these favourites, and a good many less important ones of the sort, were read some twenty times a year, during the earlier epoch of teens.

163. I wonder a little at my having been allowed so long to sit in that drawing-room corner with only my Rogers' Italy, my Forget-me-not, the Continental Annual and Friendship's Offering, for my working library; and I wonder a little more that my father, in his passionate hope that I might one day write like Byron, never noticed that Byron's early power was founded on a course of general reading of the masters in every walk of literature, such as is, I think, utterly unparalleled in any other young life, whether of student or author. But I was entirely incapable of such brain-work, and the real gift I had in drawing involved the use in its practice of the best energy of the day. Hans in Kelder, and The Comet, were my manner of rest.

I do not know when my father first began to read Byron to me, with any expectation of my liking him; all primary training, after the Iliad, having been in Scott; but it must have been about the beginning of the teen period, else I should recollect the first effect of it. Manfred evidently, I had got at, like Macbeth, for the sake of the witches. Various questionable changes were made, however, at that 1831 turning of twelve, in the Hermitage discipline of Herne Hill. I was allowed to taste wine; taken to the theatre; and, on festive days, even dined with my father and mother at four: and it was then generally at dessert that my father would read any otherwise suspected delight: the Noctes Ambrosianæ regularly when they came out—without the least missing of the naughty words; and at last, the shipwreck in Don Juan,—of which, finding me rightly appreciative, my father went on with nearly all the rest. I recollect that he and my mother looked across the table at each other with something of alarm, when, on asking me a few festas afterwards what we should have for after dinner reading, I instantly answered "Juan and Haidée." My selection was not adopted, and,

feeling there was something wrong somewhere, I did not press it, attempting even some stutter of apology which made matters worse. Perhaps I was given a bit of Childe Harold instead, which I liked at that time nearly as well; and, indeed, the story of Haidée soon became too sad for me. But very certainly, by the end of this year 1834, I knew my Byron pretty well all through, all but Cain, Werner, the Deformed Transformed, and Vision of Judgment, none of which I could understand, nor did papa and mamma think it would be well I should try to.

164. The ingenuous reader may perhaps be so much surprised that mamma fell in with all this, that it becomes here needful to mark for him some peculiarities in my mother's prudery which he could not discover for himself, from anything hitherto told of her. He might indeed guess that, after taking me at least six times straight through the Bible, she was not afraid of plain words to, or for, me; but might not feel that in the energy and affectionateness of her character, she had as much sympathy with all that is noble and beautiful in Byron as my father himself; nor that her Puritanism was clear enough in common sense to see that, while Shakespeare and Burns lay open on the table all day, there was no reason for much mystery with Byron (though until later I was not allowed to read him for myself). She had trust in my disposition and education, and was no more afraid of my turning out a Corsair or a Giaour than a Richard III., or a———Solomon. And she was perfectly right, so far. I never got the slightest harm from Byron: what harm came to me was from the facts of life, and from books of a baser kind, including a wide range of the works of authors popularly considered extremely instructive—from Victor Hugo down to Doctor Watts.

165. Farther, I will take leave to explain in this place what I meant by saying that my mother was an "inoffen-

sive" prude. She was herself as strict as Alice Bridge-
north; but she understood the doctrine of the religion she
had learnt, and, without ostentatiously calling herself a
miserable sinner, knew that according to that doctrine,
and probably in fact, Madge Wildfire was no worse a
sinner than she. She was like her sister in universal
charity—had sympathy with every passion, as well as every
virtue, of true womanhood; and, in her heart of hearts,
perhaps liked the real Margherita Cogni quite as well as
the ideal wife of Faliero.

166. And there was one more feature in my mother's
character which must be here asserted at once, to put an
end to the notion of which I see traces in some newspaper
comments on my past descriptions of her, that she was in
any wise like Esther's religious aunt in Bleak House. Far
on the contrary, there was a hearty, frank, and sometimes
even irrepressible, laugh in my mother! Never sardonic,
yet with a very definitely Smollettesque turn in it! so that,
between themselves, she and my father enjoyed their
Humphrey Clinker extremely, long before *I* was able to
understand either the jest or gist of it. Much more, she
could exult in a harmless bit of Smollettesque reality.
Years and years after this time, in one of our crossings
of the Simplon, just at the top, where we had stopped to
look about us, Nurse Anne sat down to rest herself on
the railings at the roadside, just in front of the monastery;
—the off roadside, from which the bank slopes steeply
down outside the fence. Turning to observe the pano-
ramic picturesque, Anne lost her balance, and went
backwards over the railings down the bank. My father
could not help suggesting that she had done it expressly
for the entertainment of the Holy Fathers; and neither
he nor my mother could ever speak of the "performance"
(as they called it) afterwards, without laughing for a quarter
of an hour.

167. If, however, there was the least bitterness or irony in a jest, my mother did not like it; but my father and I liked it all the more, if it were just; and, so far as I could understand it, I rejoiced in all the sarcasm of Don Juan. But my firm decision, as soon as I got well into the later cantos of it, that Byron was to be my master in verse, as Turner in colour, was made of course in that gosling (or say cygnet) epoch of existence, without consciousness of the deeper instincts that prompted it: only two things I consciously recognized, that his truth of observation was the most exact, and his chosen expression the most concentrated, that I had yet found in literature. By that time my father had himself put me through the two first books of Livy, and I knew, therefore, what close-set language was; but I saw then that Livy, as afterwards that Horace and Tacitus, were studiously, often laboriously and sometimes obscurely, concentrated: while Byron wrote, as easily as a hawk flies, and as clearly as a lake reflects, the exact truth in the precisely narrowest terms; nor only the exact truth, but the most central and useful one.

168. Of course I could no more measure Byron's greater powers at that time than I could Turner's; but I saw that both were right in all things that *I* knew right from wrong in; and that they must thenceforth be my masters, each in his own domain. The modern reader, not to say also, modern scholar, is usually so ignorant of the essential qualities of Byron, that I cannot go farther in the story of my own novitiate under him without illustrating, by rapid example, the things which I saw to be unrivalled in his work.

For this purpose I take his common prose, rather than his verse, since his modes of rhythm involve other questions than those with which I am now concerned. Read, for chance-first, the sentence on Sheridan, in his letter to

Thomas Moore, from Venice, June 1st (or dawn of
June 2nd!), 1818. "The Whigs abuse him; however,
he never left them, and such blunderers deserve neither
credit nor compassion. As for his creditors—remember
Sheridan never had a shilling, and was thrown, with great
powers and passions, into the thick of the world, and placed
upon the pinnacle of success, with no other external means
to support him in his elevation. Did Fox pay *his* debts?
or did Sheridan take a subscription? Was ——'s drunken-
ness more excusable than his? Were his intrigues more
notorious than those of all his contemporaries? and is his
memory to be blasted and theirs respected? Don't let
yourself be led away by clamour, but compare him with
the coalitioner Fox, and the pensioner Burke, as a man
of principle; and with ten hundred thousand in personal
views; and with none in talent, for he beat them all out
and out. Without means, without connection, without
character (which might be false at first, and drive him
mad afterwards from desperation), he beat them all, in
all he ever attempted. But, alas poor human nature!
Good-night, or rather morning. It is four, and the dawn
gleams over the Grand Canal, and unshadows the Rialto."

169. Now, observe, that passage is noble, primarily
because it contains the utmost number that will come
together into the space, of absolutely just, wise, and kind
thoughts. But it is more than noble, it is *perfect*, because
the quantity it holds is not artificially or intricately concen-
trated, but with the serene swiftness of a smith's hammer-
strokes on hot iron; and with choice of terms which, each
in its place, will convey far more than they mean in the
dictionary. Thus, "however" is used instead of "yet,"
because it stands for "howsoever," or, in full, for "yet
whatever they did." "Thick" of society, because it
means, not merely the crowd, but the *fog* of it; "ten
hundred thousand" instead of "a million," or "a thousand

thousand," to take the sublimity out of the number, and make us feel that it is a number of nobodies. Then the sentence in parenthesis, "which might be false," etc., is indeed obscure, because it was impossible to clarify it without a regular pause, and much loss of time; and the reader's sense is therefore left to expand it for himself into "it was, perhaps, falsely said of him at first, that he had no character," etc. Finally, the dawn "unshadows"— lessens the shadow on—the Rialto, but does not *gleam* on that, as on the broad water.

170. Next, take the two sentences on poetry, in his letters to Murray of September 15th, 1817, and April 12th, 1818; (for the collected force of these compare the deliberate published statement in the answer to Blackwood in 1820.)

1817. "With regard to poetry in general, I am convinced, the more I think of it, that he (Moore), and *all* of us—Scott, Southey, Wordsworth, Moore, Campbell, I,—are all in the wrong, one as much as another; that we are upon a wrong revolutionary poetical system, or systems, not worth a damn in itself, and from which none but Rogers and Crabbe are free: and that the present and next generations will finally be of this opinion. I am the more confirmed in this by having lately gone over some of our classics, particularly Pope, whom I tried in this way: I took Moore's poems, and my own, and some others, and went over them side by side with Pope's, and I was really astonished (I ought not to have been so) and mortified, at the ineffable distance in point of sense, learning, effect, and even *imagination*, passion, and *invention*, between the little Queen Anne's man, and us of the Lower Empire. Depend upon it, it is all Horace then, and Claudian now, among us; and if I had to begin again, I would mould myself accordingly. Crabbe's the man; but he has got a coarse and impracticable subject, and . . .

is retired upon half-pay, and has done enough, unless he
were to do as he did formerly."

1818. "I thought of a preface, defending Lord Hervey
against Pope's attack, but Pope—quoad Pope, the poet,
—against all the world, in the unjustifiable attempts begun
by Warton, and carried on at this day by the new school
of critics and scribblers, who think themselves poets because
they do *not* write like Pope. I have no patience with such
cursed humbug and bad taste; your whole generation are
not worth a canto of the Rape of the Lock, or the Essay
on Man, or the Dunciad, or 'anything that is his.' "

171. There is nothing which needs explanation in the
brevities and amenities of these two fragments, except, in
the first of them, the distinctive and exhaustive enumera-
tion of the qualities of great poetry,—and note especially
the order in which he puts these.

A. Sense. That is to say, the first thing you have
to think of is whether the would-be poet is a wise man
—so also in the answer to Blackwood, "They call him
(Pope) the poet of reason!—is that any reason why he
should not be a poet?"

B. Learning. The Ayrshire ploughman may have
good gifts, but he is out of court with relation to Homer,
or Dante, or Milton.

C. Effect. Has he *efficiency* in his verse?—does it tell
on the ear and the spirit in an instant? See the "effect"
on her audience of Beatrice's "ottave," in the story at
p. 286 of Miss Alexander's Songs of Tuscany.

D. Imagination. Put thus low because many novelists
and artists have this faculty, yet are not poets, or even
good novelists or painters; because they have not sense to
manage it, nor the art to give it effect.

E. Passion. Lower yet, because all good men and
women have as much as either they or the poet ought
to have.

F. Invention. And this lowest, because one may be a good poet without having this at all. Byron had scarcely any himself, while Scott had any quantity—yet never could write a play.

172. But neither the force and precision, nor the rhythm, of Byron's language, were at all the central reasons for my taking him for master. Knowing the Song of Moses and the Sermon on the Mount by heart, and half the Apocalypse besides, I was in no need of tutorship either in the majesty or simplicity of English words; and for their logical arrangement, I had had Byron's own master, Pope, since I could lisp. But the thing wholly new and precious to me in Byron was his measured and living *truth*—measured, as compared with Homer; and living, as compared with everybody else. My own inexorable measuring wand,—not enchanter's, but clothworker's and builder's,—reduced to mere incredibility all the statements of the poets usually called sublime. It was of no use for Homer to tell me that Pelion was put on the top of Ossa. I knew perfectly well it wouldn't go on the top of Ossa. Of no use for Pope to tell me that trees where his mistress looked would crowd into a shade, because I was satisfied that they would do nothing of the sort. Nay, the whole world, as it was described to me either by poetry or theology, was every hour becoming more and more shadowy and impossible. I rejoiced in all stories of Pallas and Venus, of Achilles and Eneas, of Elijah and St. John: but, without doubting in my heart that there were real spirits of wisdom and beauty, nor that there had been invincible heroes and inspired prophets, I felt already, with fatal and increasing sadness, that there was no clear utterance about any of them—that there were for *me* neither Goddess guides nor prophetic teachers; and that the poetical histories, whether of this world or the next, were to me as the words of Peter to the shut

up disciples—"as idle tales; and they believed them
not."

173. But here at last I had found a man who spoke
only of what he had seen, and known; and spoke without
exaggeration, without mystery, without enmity, and with-
out mercy. "That *is* so;—make what you will of it!"
Shakespeare said the Alps voided their rheum on the
valleys, which indeed is precisely true, with the final truth,
in that matter, of James Forbes,—but it was told in a
mythic manner, and with an unpleasant British bias to
the nasty. But Byron, saying that "the glacier's cold and
restless mass moved onward day by day," said plainly what
he saw and knew,—no more. So also, the Arabian
Nights had told me of thieves who lived in enchanted
caves, and beauties who fought with genii in the air; but
Byron told me of thieves with whom he had ridden on
their own hills, and of the fair Persians or Greeks who
lived and died under the very sun that rose over my visible
Norwood hills.

And in this narrow, but sure, truth, to Byron, as already
to me, it appeared that Love was a transient thing, and
Death a dreadful one. He did not attempt to console
me for Jessie's death, by saying she was happier in Heaven;
or for Charles's, by saying it was a Providential dispensation
to me on Earth. He did not tell me that war was a
just price for the glory of captains, or that the National
command of murder diminished its guilt. Of all things
within range of human thought he felt the facts, and
discerned the natures with accurate justice.

But even all this he might have done, and yet been no
master of mine, had not he sympathized with me in
reverent love of beauty, and indignant recoil from ugliness.
The witch of the Staubbach in her rainbow was a greatly
more pleasant vision than Shakespeare's, like a rat without
a tail, or Burns's, in her cutty sark. The sea-king Conrad

had an immediate advantage with me over Coleridge's long, lank, brown, and ancient, mariner; and whatever Pope might have gracefully said, or honestly felt of Windsor woods and streams, was mere tinkling cymbal to me, compared with Byron's love of Lachin-y-Gair.

174. I must pause here, in tracing the sources of his influence over me, lest the reader should mistake the analysis which I am now able to give them, for a description of the feelings possible to me at fifteen. Most of these, however, were assuredly within the knot of my unfolding mind—as the saffron of the crocus yet beneath the earth; and Byron—though he could not teach me to love mountains or sea more than I did in childhood, first animated them for me with the sense of real human nobleness and grief. He taught me the meaning of Chillon and of Meillerie, and bade me seek first in Venice—the ruined homes of Foscari and Falier.

And observe, the force with which he struck depended again on there being unquestionable reality of person in his stories, as of principle in his thoughts. Romance, enough and to spare, I had learnt from Scott—but his Lady of the Lake was as openly fictitious as his White Maid of Avenel: while Rogers was a mere dilettante, who felt no difference between landing where Tell leaped ashore, or standing where "St. Preux has stood." Even Shakespeare's Venice was visionary; and Portia as impossible as Miranda. But Byron told me of, and re-animated for me, the real people whose feet had worn the marble I trod on.

175. One word only, though it trenches on a future subject, I must permit myself about his rhythm. Its natural flow in almost prosaic simplicity and tranquillity interested me extremely, in opposition alike to the symmetrical clauses of Pope's logical metre, and to the balanced strophes of classic and Hebrew verse. But though I

followed his manner instantly in what verses I wrote for my own amusement, my respect for the structural, as opposed to fluent, force of the classic measures, supported as it was partly by Byron's contempt for his own work, and partly by my own architect's instinct for "the principle of the pyramid," made me long endeavour, in forming my prose style, to keep the cadences of Pope and Johnson for all serious statement. Of Johnson's influence on me I have to give account in the last chapter of this volume; meantime, I must get back to the days of mere rivulet-singing, in my poor little watercress life.

176. I had a sharp attack of pleurisy in the spring of '35, which gave me much gasping pain, and put me in some danger for three or four days, during which our old family physician, Dr. Walshman, and my mother, defended me against the wish of all other scientific people to have me bled. "He wants all the blood he has in him to fight the illness," said the old doctor, and brought me well through, weak enough, however, to claim a fortnight's nursing and petting afterwards, during which I read the "Fair Maid of Perth," learned the song of "Poor Louise," and feasted on Stanfield's drawing of St. Michael's Mount, engraved in the "Coast Scenery," and Turner's Santa Saba, Pool of Bethesda, and Corinth, engraved in the Bible series, lent me by Richard Fall's little sister. I got an immense quantity of useful learning out of those four plates, and am very thankful to possess now the originals of the Bethesda and Corinth.

Moreover, I planned all my proceedings on the journey to Switzerland, which was to begin the moment I was strong enough. I shaded in cobalt a "cyanometer" to measure the blue of the sky with; bought a ruled notebook for geological observations, and a large quarto for architectural sketches, with square rule and foot-rule ingeniously fastened outside. And I determined that the events and

sentiments of this journey should be described in a poetic diary in the style of Don Juan, artfully combined with that of Childe Harold. Two cantos of this work were indeed finished—carrying me across France to Chamouni— where I broke down, finding that I had exhausted on the Jura all the descriptive terms at my disposal, and that none were left for the Alps. I must try to give, in the next chapter, some useful account of the same part of the journey in less exalted language.

Chapter IX

THE COL DE LA FAUCILLE

177. ABOUT the moment in the forenoon when the modern fashionable traveller, intent on Paris, Nice, and Monaco, and started by the morning mail from Charing Cross, has a little recovered himself from the qualms of his crossing, and the irritation of fighting for seats at Boulogne, and begins to look at his watch to see how near he is to the buffet of Amiens, he is apt to be baulked and worried by the train's useless stop at one inconsiderable station, lettered ABBEVILLE. As the carriage gets in motion again, he may see, if he cares to lift his eyes for an instant from his newspaper, two square towers, with a curiously attached bit of traceried arch, dominant over the poplars and osiers of the marshy level he is traversing. Such glimpse is probably all he will ever wish to get of them; and I scarcely know how far I can make even the most sympathetic reader understand their power over my own life.

The country town in which they are central,—once, like Croyland, a mere monk's and peasant's refuge (so for some time called "Refuge"),—among the swamps of Somme, received about the year 650 the name of "Abbatis Villa,"—"Abbot's-ford," I had like to have written: house and village, I suppose we may rightly say,—as the chief dependence of the great monastery founded by St. Riquier at his native place, on the hillside five miles east of the present town. Concerning which saint I translate from the Dict^{re} des Sciences Eccles^{ques}, what it may perhaps be well for the reader, in present political junctures, to remember for more weighty reasons than any

arising out of such interest as he may take in my poor little nascent personality.

178. "St. Riquier, in Latin 'Sanctus Richarius,' born in the village of Centula, at two leagues from Abbeville, was so touched by the piety of two holy priests of Ireland, whom he had hospitably received, that he also embraced 'la pénitence.' Being ordained priest, he devoted himself to preaching, and so passed into England. Then, returning into Ponthieu, he became, by God's help, powerful in work and word in leading the people to repentance. He preached at the court of Dagobert, and, a little while after that prince's death, founded the monastery which bore his name, and another, called Forest-Moutier, in the wood of Crécy, where he ended his life and penitence."

I find further in the Ecclesiastical History of Abbeville, published in 1646 at Paris by François Pelican, "Rue St. Jacques, à l'enseigne du Pelican," that St. Riquier was himself of royal blood, that St. Angilbert, the seventh abbot, had married Charlemagne's second daughter Bertha —"qui se rendit aussi Religieuse de l'ordre de Saint Benoist." Louis, the eleventh abbot, was cousin-german to Charles the Bald; the twelfth was St. Angilbert's son, Charlemagne's grandson. Raoul, the thirteenth abbot, was the brother of the Empress Judith; and Carloman, the sixteenth, was the son of Charles the Bald.

179. Lifting again your eyes, good reader, as the train gets to its speed, you may see gleaming opposite on the hillside the white village and its abbey,—not, indeed, the walls of the home of these princes and princesses, (afterwards again and again ruined,) but the still beautiful abbey built on their foundations by the monks of St. Maur.

In the year when the above quoted history of Abbeville was written (say 1600 for surety), the town, then familiarly called "Faithful Abbeville," contained 40,000 souls, "living in great unity among themselves, of a marvellous

frankness, fearing to do wrong to their neighbour, the women modest, honest, full of faith and charity, and adorned with a goodness and beauty toute innocente: the noblesse numerous, hardy, and adroit in arms, the master-ships (maistrises) of arts and trades, with excellent workers in every profession, under sixty-four Mayor-Bannerets, who are the chiefs of the trades, and elect the mayor of the city, who is an independent Home Ruler, de grande probité, d'authorité, et sans reproche, aided by four eschevins of the present, and four of the past year; having authority of justice, police, and war, and right to keep the weights and measures true and unchanged, and to punish those who abuse them, or sell by false weight or measure, or sell anything without the town's mark on it." Moreover, the town contained, besides the great church of St. Wulfran, thirteen parish churches, six monasteries, eight nunneries, and five hospitals, among which churches I am especially bound to name that of St. George, begun by our own Edward in 1368, on the 10th of January; transferred and reconsecrated in 1469 by the Bishop of Bethlehem, and enlarged by the Marguilliers in 1536, "because the congregation had so increased that numbers had to remain outside on days of solemnity."

These reconstructions took place with so great ease and rapidity at Abbeville, owing partly to the number of unanimous workmen, partly to the easily workable quality of the stone they used, and partly to the uncertainty of a foundation always on piles, that there is now scarce vestige left of any building prior to the fifteenth century. St. Wulfran itself, with St. Riquier, and all that remain of the parish churches (four only, now, I believe, besides St. Wulfran), are of the same flamboyant Gothic,—walls and towers alike coeval with the gabled timber houses of which the busier streets chiefly consisted when first I saw them.

180. I must here, in advance, tell the general reader that there have been, in sum, three centres of my life's thought: Rouen, Geneva, and Pisa. All that I did at Venice was bye-work, because her history had been falsely written before, and not even by any of her own people understood; and because, in the world of painting, Tintoret was virtually unseen, Veronese unfelt, Carpaccio not so much as named, when I began to study them; something also was due to my love of gliding about in gondolas. But Rouen, Geneva, and Pisa have been tutresses of all I know, and were mistresses of all I did, from the first moments I entered their gates.

In this journey of 1835 I first saw Rouen and Venice —Pisa not till 1840; nor could I understand the full power of any of those great scenes till much later. But for Abbeville, which is the preface and interpretation of Rouen, I was ready on that 5th of June, and felt that here was entrance for me into immediately healthy labour and joy.

181. For here I saw that art (of its local kind), religion, and present human life, were yet in perfect harmony. There were no dead six days and dismal seventh in those sculptured churches; there was no beadle to lock me out of them, or pew-shutter to shut me in. I might haunt them, fancying myself a ghost; peep round their pillars, like Rob Roy; kneel in them, and scandalize nobody; draw in them, and disturb none. Outside, the faithful old town gathered itself, and nestled under their buttresses like a brood beneath the mother's wings; the quiet, un-injurious aristocracy of the newer town opened into silent streets, between self-possessed and hidden dignities of dwelling, each with its courtyard and richly trellised garden. The commercial square, with the main street of traverse, consisted of uncompetitive shops, such as were needful, of the native wares: cloth and hosiery spun,

woven, and knitted within the walls; cheese of neighbour-
ing Neuchatel; fruit of their own gardens, bread from the
fields above the green coteaux; meat of their herds,
untainted by American tin; smith's work of sufficient
scythe and ploughshare, hammered on the open anvil;
groceries dainty, the coffee generally roasting odoriferously
in the street, before the door; for the modistes,—well,
perhaps a bonnet or two from Paris, the rest, wholesome
dress for peasant and dame of Ponthieu. Above the
prosperous, serenely busy and beneficent shop, the old
dwelling-house of its ancestral masters; pleasantly carved,
proudly roofed, keeping its place, and order, and recognised
function, unfailing, unenlarging, for centuries. Round
all, the breezy ramparts, with their long waving avenues;
through all, in variously circuiting cleanness and sweetness
of navigable river and active millstream, the green chalk-
water of the Somme.

My most intense happinesses have of course been among
mountains. But for cheerful, unalloyed, unwearying
pleasure, the getting in sight of Abbeville on a fine
summer afternoon, jumping out in the courtyard of the
Hotel de l'Europe, and rushing down the street to see
St. Wulfran again before the sun was off the towers, are
things to cherish the past for,—to the end.

182. Of Rouen, and its Cathedral, my saying remains
yet to be said, if days be given me, in "Our Fathers have
told us." The sight of them, and following journey up
the Seine to Paris, then to Soissons and Rheims, determined
as aforesaid, the first centre and circle of future life-work.
Beyond Rheims, at Bar-le-Duc, I was brought again
within the greater radius of the Alps, and my father was
kind enough to go down by Plombiéres to Dijon, that
I might approach them by the straightest pass of
Jura.

The reader must pardon my relating so much as I

think he may care to hear of this journey of 1835, rather as what *used* to happen, than as limitable to that date; for it is extremely difficult for me now to separate the circumstances of any one journey from those of subsequent days, in which we stayed at the same inns, with variation only from the blue room to the green, saw the same sights, and rejoiced the more in every pleasure—that it was not new.

And this latter part of the road from Paris to Geneva, beautiful without being the least terrific or pathetic, but in the most lovable and cheerful way, became afterwards so dear and so domestic to me, that I will not attempt here to check my gossip of it.

183. We used always to drive out of the yard of La Cloche at Dijon in early morning—seven, after joyful breakfast at half-past six. The small saloon on the first floor to the front had a bedroom across the passage at the west end of it, whose windows commanded the cathedral towers over a low roof on the opposite side of the street. This was always mine, and its bed was in an alcove at the back, separated only by a lath partition from an extremely narrow passage leading from the outer gallery to Anne's room. It was a delight for Anne to which I think she looked forward all across France, to open a little hidden door from this passage, at the back of the alcove exactly above my pillow, and surprise, or wake, me in the morning.

I think I only remember once starting in rain. Usually the morning sun shone through the misty spray and far thrown diamonds of the fountain in the south-eastern suburb, and threw long poplar shadows across the road to Genlis.

Genlis, Auxonne, Dole, Mont-sous-Vaudrey—three stages of 12 or 14 kilometres each, two of 18; in all about 70 kilometres = 42 miles, from Dijon gate to Jura

foot—we went straight for the hills always, lunching on
French plums and bread.

Level plain of little interest to Auxonne. I used
to wonder how any mortal creature could be content to
live within actual sight of Jura, and never go to see
them, all their lives! At Auxonne, cross the Saone,
wide and beautiful in clear shallows of green stream—
little more, yet, than a noble mountain torrent; one saw
in an instant it came from Jura. Another hour of
patience, and from the broken yellow limestone slopes
of Dole—there, at last, they were—the long blue surges
of them fading as far as eye could see to the south, more
abruptly near to the north-east, where the bold outlier,
almost island, of them, rises like a precipitous Wrekin,
above Salins. Beyond Dole, a new wildness comes into
the more undulating country, notable chiefly for its clay-
built cottages with enormously high thatched gables of
roof. Strange, that I never inquired into the special
reason of that form, nor looked into a single cottage to
see the mode of its inhabitation!

184. The village, or rural town, of Poligny, clustered
out of well-built old stone houses, with gardens and
orchards; and gathering at the midst of it into some
pretence or manner of a street, straggles along the roots
of Jura at the opening of a little valley, which in York-
shire or Derbyshire limestone would have been a gorge
between nodding cliffs, with a pretty pattering stream at
the bottom: but, in Jura is a far retiring theatre of rising
terraces, with bits of field and garden getting foot on
them at various heights; a spiry convent in its hollow,
and well-built little nests of husbandry-building set in
corners of meadow, and on juts of rock;—no stream, to
speak of, nor springs in it, nor the smallest conceivable
reason for its being there, but that God made it.

"Far" retiring, I said,—perhaps a mile into the hills

from the outer plain, by half a mile across, permitting the
main road from Paris to Geneva to serpentine and zigzag
capriciously up the cliff terraces with innocent engineer-
ing, finding itself every now and then where it had no
notion of getting to, and looking, in a circumflex of
puzzled level, where it was to go next;—retrospect of the
plain of Burgundy enlarging under its backward sweeps,
till at last, under a broken bit of steep final crag, it got
quite up the side, and out over the edge of the ravine,
where said ravine closes as unreasonably as it had opened,
and the surprised traveller finds himself, magically as if
he were Jack of the Beanstalk, in a new plain of an
upper world. A world of level rock, breaking at the
surface into yellow soil, capable of scanty, but healthy,
turf, and sprinkled copse and thicket; with here and
there, beyond, a blue surge of pines, and over those, if
the evening or morning were clear, always one small
bright silvery likeness of a cloud.

185. These first tracts of Jura differ in many pleasant
ways from the limestone levels round Ingleborough,
which are their English types. The Yorkshire moors
are mostly by a hundred or two feet higher, and exposed
to drift of rain under violent, nearly constant, wind.
They break into wide fields of loose blocks, and rugged
slopes of shale; and are mixed with sands and clay from
the millstone grit, which nourish rank grass, and lodge
in occasional morass: the wild winds also forbidding any
vestige or comfort of tree, except here and there in a
sheltered nook of new plantation. But the Jura sky is
as calm and clear as that of the rest of France; if the
day is bright on the plain, the bounding hills are bright
also; the Jura rock, balanced in the make of it between
chalk and marble, weathers indeed into curious rifts and
furrows, but rarely breaks loose, and has long ago clothed
itself either with forest flowers, or with sweet short grass,

and all blossoms that love sunshine. The pure air, even
on this lower ledge of a thousand feet above sea, cherishes
their sweetest scents and liveliest colours, and the winter
gives them rest under thawless serenity of snow.

186. A still greater and stranger difference exists in
the system of streams. For all their losing themselves
and hiding, and intermitting, their presence is distinctly
felt on a Yorkshire moor; one sees the places they have
been in yesterday, the wells where they will flow after
the next shower, and a tricklet here at the bottom of a
crag, or a tinkle there from the top of it, is always making
one think whether this is one of the sources of Aire, or
rootlets of Ribble, or beginnings of Bolton Strid, or threads
of silver which are to be spun into Tees.

But no whisper, nor murmur, nor patter, nor song, of
streamlet disturbs the enchanted silence of open Jura.
The rain-cloud clasps her cliffs, and floats along her fields;
it passes, and in an hour the rocks are dry, and only beads
of dew left in the Alchemilla leaves,—but of rivulet, or
brook,—no vestige yesterday, or to-day, or to-morrow.
Through unseen fissures and filmy crannies the waters
of cliff and plain have alike vanished, only far down in
the depths of the main valley glides the strong river,
unconscious of change.

187. One is taught thus much for one's earliest lesson,
in the two stages from Poligny to Champagnole, level
over the absolutely crisp turf and sun-bright rock, without
so much water anywhere as a cress could grow in, or a
tadpole wag his tail in,—and then, by a zigzag of shady
road, forming the Park and Boulevard of the wistful little
village, down to the single arched bridge that leaps the
Ain, which pauses underneath in magnificent pools of
clear pale green: the green of spring leaves; then clashes
into foam, half weir, half natural cascade, and into a
confused race of currents beneath hollow overhanging of

crag festooned with leafage. The only marvel is, to anyone knowing Jura structure, that rivers should be visible anywhere at all, and that the rocks should be consistent enough to carry them in open air through the great valleys, without perpetual "pertes" like that of the Rhone. Below the Lac de Joux the Orbe thus loses itself indeed, reappearing seven hundred feet * beneath in a scene of which I permit myself to quote my Papa Saussure's description.

188. "A semicircular rock at least two hundred feet high, composed of great horizontal rocks hewn vertical, and divided † by ranks of pine which grow on their projecting ledges, closes to the west the valley of Valorbe. Mountains yet more elevated and covered with forests, form a circuit round this rock, which opens only to give passage to the Orbe, whose source is at its foot. Its waters, of a perfect limpidity, flow at first with a majestic tranquillity upon a bed tapestried with beautiful green moss (Fontinalis antipyretica), but soon, drawn into a steep slope, the thread of the current breaks itself in foam against the rocks which occupy the middle of its bed, while the borders, less agitated, flowing always on their green ground, set off the whiteness of the midst of the river; and thus it withdraws itself from sight, in following the course of a deep valley covered with pines, whose blackness is rendered more striking by the vivid green of the beeches which are scattered among them.

"Ah, if Petrarch had seen this spring and had found there his Laura, how much would not he have preferred it to that of Vaucluse, more abundant, perhaps, and more rapid, but of which the sterile rocks have neither the greatness of ours, nor the rich parure, which embellishes them."

* Six hundred and eighty French feet. Saussure, §§ 385.
† "Taillés à pic, et entrecoupées."

I have never seen the source of the Orbe, but would commend to the reader's notice the frequent beauty of these great springs in literally *rising* at the base of cliffs, instead of falling, as one would have imagined likely, out of clefts in the front of them. In our own English anti-type of the source of Orbe, Malham Cove, the flow of water is, in like manner, wholly at the base of the rock, and seems to rise to the ledge of its outlet from a deeper interior pool.

189. The old Hotel de la Poste at Champagnole stood just above the bridge of Ain, opposite the town, where the road got level again as it darted away towards Geneva. I think the year 1842 was the first in which we lengthened the day from Dijon by the two stages beyond Poligny; but afterwards, the Hotel de la Poste at Champagnole became a kind of home to us: going out, we had so much delight there, and coming home, so many thoughts, that a great space of life seemed to be passed in its peace. No one was ever in the house but ourselves; if a family stopped every third day or so, it was enough to maintain the inn, which, besides, had its own farm; and those who did stop, rushed away for Geneva early in the morn-ing. We, who were to sleep again at Morez, were in no hurry; and in returning always left Geneva on Friday, to get the Sunday at Champagnole.

190. But my own great joy was in the early June evening, when we had arrived from Dijon, and I got out after the quickly dressed trout and cutlet for the first walk on rock and under pine.

With all my Tory prejudice (I mean, principle), I have to confess that one great joy of Swiss—above all, Jurassic Swiss—ground to me, is in its effectual, not merely theoretic, *liberty*. Among the greater hills, one can't always go just where one chooses,—all around is the too far, or too steep,—one wants to get to this, and climb

that, and can't do either;—but in Jura one can go every way, and be happy everywhere. Generally, if there was time, I used to climb the islet of crag to the north of the village, on which there are a few grey walls of ruined castle, and the yet traceable paths of its "pleasance," whence to look if the likeness of white cloud were still on the horizon. Still there, in the clear evening, and again and again, each year more marvellous to me; the derniers rochers, and calotte of Mont Blanc. Only those; that is to say just as much as may be seen over the Dome du Gouté from St. Martin's. But it looks as large from Champagnole as it does there—glowing in the last light like a harvest moon.

If there were not time to reach the castle rock, at least I could get into the woods above the Ain, and gather my first Alpine flowers. Again and again, I feel the duty of gratitude to the formalities and even vulgarities of Herne Hill, for making me to feel by contrast the divine wildness of Jura forest.

Then came the morning drive into the higher glen of the Ain, where the road began first to wind beside the falling stream. One never understands how those winding roads steal with their tranquil slope from height to height; it was but an hour's walking beside the carriage, —an hour passed like a minute; and one emerged on the high plain of St. Laurent, and the gentians began to gleam among the roadside grass, and the pines swept round the horizon with the dark infinitude of ocean.

191. All Switzerland was there in hope and sensation, and what was less than Switzerland was in some sort better, in its meek simplicity and healthy purity. The Jura cottage is not carved with the stately richness of the Bernese, nor set together with the antique strength of Uri. It is covered with thin slit fine shingles, side-roofed as it were to the ground for mere dryness' sake, a little

crossing of laths here and there underneath the window
its only ornament. It has no daintiness of garden nor
wealth of farm about it,—is indeed little more than a
delicately-built chalet, yet trim and domestic, mildly
intelligent of things other than pastoral, watch-making
and the like, though set in the midst of the meadows,
the gentian at its door, the lily of the valley wild in the
copses hard by.

My delight in these cottages, and in the sense of human
industry and enjoyment through the whole scene, was at
the root of all pleasure in its beauty; see the passage
afterwards written in the "Seven Lamps" insisting on
this as if it were general to human nature thus to admire
through sympathy. I have noticed since, with sorrowful
accuracy, how many people there are who, wherever they
find themselves, think only "of their position." But the
feeling which gave me so much happiness, both then and
through life, differed also curiously, in its impersonal char-
acter, from that of many even of the best and kindest
persons.

192. In the beginning of the Carlyle-Emerson corre-
spondence, edited with too little comment by my dear
friend Charles Norton, I find at page 18 this—to me
entirely disputable, and to my thought, so far as un-
disputed, much blameable and pitiable—exclamation of my
master's: "Not till we can think that here 'and there one
is thinking of us, one is loving us, does this waste earth
become a peopled garden." My training, as the reader
has perhaps enough perceived, produced in me the precisely
opposite sentiment. *My* times of happiness had always
been when *nobody* was thinking of me; and the main
discomfort and drawback to all proceedings and designs,
the attention and interference of the public—represented
by my mother and the gardener. The garden was no
waste place to me, because I did not suppose myself an

object of interest either to the ants or the butterflies; and
the only qualification of the entire delight of my evening
walk at Champagnole or St. Laurent was the sense that
my father and mother *were* thinking of me, and would
be frightened if I was five minutes late for tea.

I don't mean in the least that I could have done without
them. They were, to me, much more than Carlyle's
wife to him; and if Carlyle had written, instead of, that
he wanted Emerson to think of him in America, that he
wanted his father and mother to be thinking of him at
Ecclefechan, it had been well. But that the rest of the
world was waste to him unless he had admirers in it, is a
sorry state of sentiment enough; and I am somewhat
tempted, for once, to admire the exactly opposite temper
of my own solitude. My entire delight was in observing
without being myself noticed,—if I could have been
invisible, all the better. I was absolutely interested in
men and their ways, as I was interested in marmots and
chamois, in tomtits and trout. If only they would stay
still and let me look at them, and not get into their holes
and up their heights! The living inhabitation of the
world—the grazing and nesting in it,—the spiritual power
of the air, the rocks, the waters, to be in the midst of it,
and rejoice and wonder at it, and help it if I could,—
happier if it needed no help of mine,—this was the essential
love *of Nature* in me, this the root of all that I have usefully
become, and the light of all that I have rightly learned.

193. Whether we slept at St. Laurent or Morez, the
morning of the next day was an eventful one. In
ordinarily fine weather, the ascent from Morez to Les
Rousses, walked most of the way, was mere enchantment;
so also breakfast, and fringed-gentian gathering, at Les
Rousses. Then came usually an hour of tortured watch-
ing the increase of the noon clouds; for, however early
we had risen, it was impossible to reach the Col de la

Faucille before two o'clock, or later if we had bad horses, and at two o'clock, if there are clouds above Jura, there will be assuredly clouds on the Alps.

It is worth notice, Saussure himself not having noticed it, that this main pass of Jura, unlike the great passes of the Alps, reaches its traverse-point very nearly under the highest summit of that part of the chain. The col, separating the source of the Bienne, which runs down to Morez and St. Claude, from that of the Valserine, which winds through the midst of Jura to the Rhone at Belle-garde, is a spur of the Dole itself, under whose prolonged masses the road is then carried six miles farther, ascending very slightly to the Col de la Faucille, where the chain opens suddenly, and a sweep of the road, traversed in five minutes at a trot, opens the whole Lake of Geneva, and the chain of the Alps along a hundred miles of horizon.

194. I have never seen that view perfectly but once —in this year 1835; when I drew it carefully in my then fashion, and have been content to look back to it as the confirming sequel of the first view of the Alps from Schaffhausen. Very few travellers, even in old times, saw it at all; tired of the long posting journey from Paris, by the time they got to the col they were mostly thinking only of their dinners and rest at Geneva; the guide books said nothing about it; and though, for everybody, it was an inevitable task to ascend the Righi, nobody ever thought there was anything to be seen from the Dole.

Both mountains have had enormous influence on my whole life;—the Dole continually and calmly; the Righi at sorrowful intervals, as will be seen. But the Col de la Faucille, on that day of 1835, opened to me in distinct vision the Holy Land of my future work and true home in this world. My eyes had been opened, and my heart with them, to see and to possess royally such a kingdom! Far as the eye could reach—that land and its moving or

pausing waters; Arve, and his gates of Cluse, and his glacier fountains; Rhone, and the infinitude of his sapphire lake,—his peace beneath the narcissus meads of Vevay —his cruelty beneath the promontories of Sierre. And all that rose against and melted into the sky, of mountain and mountain snow; and all that living plain, burning with human gladness—studded with white homes,—a milky way of star-dwellings cast across its sunlit blue.

CHAPTER X

QUEM TU, MELPOMENE

195. WHETHER in the biography of a nation, or of a single person, it is alike impossible to trace it steadily through successive years. Some forces are failing while others strengthen, and most act irregularly, or else at uncorresponding periods of renewed enthusiasm after intervals of lassitude. For all clearness of exposition, it is necessary to follow first one, then another, without confusing notices of what is happening in other directions.

I must accordingly cease talk of pictorial and rhythmic efforts of the year 1835, at this point; and go back to give account of another segment of my learning, which might have had better consequence than ever came of it, had the stars so pleased.

196. I cannot, and perhaps the reader will be thankful, remember anything of the Apolline instincts under which I averred to incredulous papa and mamma that, "though I could not speak, I could play upon the fiddle." But even to this day, I look back with starts of sorrow to a lost opportunity of showing what was in me, of that manner of genius, on the occasion of a grand military dinner in the state room of the Sussex, at Tunbridge Wells; where, when I was something about eight or nine years old, we were staying in an unadventurous manner, enjoying the pantiles, the common, the sight, if not the taste, of the lovely fountain, and drives to the High Rocks. After the military dinner there was military music, and by connivance of waiters, Anne and I got in, somehow, mixed up with the dessert. I believe I was rather a pretty boy then, and dressed in a not wholly civilian manner, in a

sort of laced and buttoned surtout. My mind was extremely set on watching the instrumental manœuvres of the band,—with admiration of all, but burning envy of the drummer.

The colonel took notice of my rapt attention, and sent an ensign to bring me round to him; and after getting, I know not how, at my mind in the matter, told me I might go and ask the drummer to give me his lovely round-headed sticks, and he would. I was in two minds to do it, having good confidence in my powers of keeping time. But the dismal shyness conquered:—I shook my head woefully, and my musical career was blighted. No one will ever know what I could then have brought out of that drum, or (if my father had perchance taken me to Spain) out of a tambourine.

197. My mother, busy in graver matters, had never cultivated the little she had been taught of music, though her natural sensibility to it was great. Mrs. Richard Gray used sometimes to play gracefully to me, but if ever she struck a false note, her husband used to put his fingers in his ears, and dance about the room, exclaiming, "O Mary, Mary dear!" and so extinguish her. Our own Perth Mary played dutifully her scales, and little more; but I got useful help, almost unconsciously, from a family of young people who ought, if my chronology had been systematic, to have been affectionately spoken of long ago.

In above describing my father's counting-house, I said the door was opened by a latch pulled by the head clerk. This head clerk, or, putting it more modestly, topmost of two clerks, Henry Watson, was a person of much import in my father's life and mine; import which, I perceive, looking back, to have been as in many respects tender and fortunate, yet in others extremely doleful, both to us and himself.

The chief fault in my father's mind, (I say so reverently,

for its faults were few, but necessarily, for they were very fatal,) was his dislike of being excelled. He knew his own power—felt that he had not nerve to use or display it, in full measure; but all the more, could not bear, in his own sphere, any approach to equality. He chose his clerks first for trustworthiness, secondly for—*in*capacity. I am not sure that he would have sent away a clever one, if he had chanced on such a person; but he assuredly did not look for mercantile genius in them, but rather for subordinates who would be subordinate for ever. Frederick the Great chose his clerks in the same way; but then, his clerks never supposed themselves likely to be king, while a merchant's clerks are apt to hope they may at least become partners, if not successors. Also, Friedrich's clerks were absolutely fit for *their* business; but my father's clerks were, in many ways, utterly unfit for theirs. Of which unfitness my father greatly complaining, nevertheless by no means bestirred himself to find fitter ones. He used to send Henry Watson on business tours, and assure him afterwards that he had done more harm than good: he would now and then leave Henry Ritchie to write a business letter; and, I think, find with some satisfaction that it was needful afterwards to write two, himself, in correction of it. There was scarcely a day when he did not come home in some irritation at something that one or other of them had done, or not done. But they stayed with him till his death.

198. Of the second in command, Mr. Ritchie, I will say what is needful in another place; but the clerk of confidence, Henry Watson, has already been left unnoticed too long. He was, I believe, the principal support of a widowed mother and three grown-up sisters, amiable, well educated, and fairly sensible women, all of them; refined beyond the average tone of their position,—and desirous, not vulgarly, of keeping themselves in the upper-

edge circle of the middle class. Not vulgarly, I say, as caring merely to have carriages stopping at their door, but with real sense of the good that *is* in good London society, in London society's way. They liked, as they did not drop their own h's, to talk with people who did not drop theirs; to hear what was going on in polite circles; and to have *entrée* to a pleasant dance, or rightly given concert. Being themselves both good and pleasing musicians, (the qualities are not united in all musicians,) this was not difficult for them;—nevertheless it meant necessarily having a house in a street of tone, near the Park, and being nicely dressed, and giving now and then a little reception themselves. On the whole, it meant the total absorption of Henry's salary, and of the earnings, in some official, or otherwise plumaged occupations, of two brothers besides, David and William. The latter, now I think of it, was a West-End wine merchant, supplying the nobility with Clos-Vougeot, Hochheimer, dignifiedly still Champagne, and other nectareous drinks, of which the bottom fills up half the bottle, and which are only to be had out of the cellars of Grand Dukes and Counts of the Empire. The family lived, to the edge of their means,—not too narrowly: the young ladies enjoyed themselves, studied German—and at that time it was thought very fine and poetical to study German; —sang extremely well, gracefully and easily; had good taste in dress, the better for being a little matronly and old-fashioned: and the whole family thought themselves extremely *élite*, in a substantial and virtuous manner.

199. When Henry Watson was first taken, (then, I believe, a boy of sixteen,) I know not by what chance, or on what commendation, into my father's counting-house, the opening was thought by his family a magnificent one; they were very thankful and happy, and, of course, in their brother's interest, eager to do all they could to please

my father and mother. They found, however, my mother not very easily pleased; and presently began themselves to be not a little surprised and *dis*pleased by the way things went on, both in the counting-house and at Herne Hill. At the one, there was steady work; at the other, little show: the clerks could by no means venture to leave their desks for a garden-party, and after dark were allowed only tallow candles. That the head of the Firm should live in the half of a party-walled house, beyond the suburb of Camberwell, was a degradation and disgrace to everybody connected with the business! and that Henry should be obliged every morning to take omnibus into the eastern City, and work within scent of Billingsgate, instead of walking elegantly across Piccadilly to an office in St. James's Street, was alike injurious to him, and disparaging to my father's taste and knowledge of the world. Also, to the feminine circle, my mother was a singular, and sorrowfully intractable, phenomenon. Taking herself no interest in German studies, and being little curious as to the events, and little respectful to the opinions, of Mayfair, she was apt to look with some severity, perhaps a tinge of jealousy, on what she thought pretentious in the accomplishments, or affected in the manners, of the young people: while they, on the other hand, though quite sensible of my mother's worth, grateful for her good will, and in time really attached to her, were not disposed to pay much attention to the opinions of a woman who knew only her own language;—and were more restive than responsive under kindnesses which frequently took the form of advice.

200. These differences in feeling, irreconcilable though they were, did not hinder the growth of consistently pleasant and sincerely affectionate relations between my mother and the young housewives. With what best of girl nature was in them, Fanny, Helen, and foolishest, cleverest little Juliet, enjoyed, in spring time, exchanging

for a day or two the dusty dignity of their street of tone
in Mayfair for the lilacs and laburnums of Herne-hill:
and held themselves, with their brother Henry, always
ready at call to come out on any occasion of the hill's
hospitality to some respected correspondent of the House,
and sing to us the prettiest airs from the new opera, with
a due foundation and tonic intermixture of classical
German.

Henry had a singularly beautiful tenor voice; and the
three sisters, though not, any one of them, of special
power, sang their parts with sufficient precision, with
intelligent taste, and with the pretty unison of sisterly
voices. In this way, from early childhood, I was accus-
tomed to hear a great range of good music completely and
rightly rendered, without breakings down, missings out,
affectations of manner, or vulgar prominence of execution.
Had the quartette sung me English glees, or Scotch ballads,
or British salt water ones, or had any one of the girls
had gift enough to render higher music with its proper
splendour, I might easily have been led to spare some
time from my maps and mineralogy for attentive listening.
As it was, the scientific German compositions were simply
tiresome to me, and the pretty modulations of Italian,
which I understood no syllable of, pleasant only as the
trills of the blackbirds, who often listened, and expressed
their satisfaction by joining in the part-songs through the
window that opened to the back garden in the spring
evenings. Yet the education of my ear and taste went on
without trouble of mine. I do not think I ever heard
any masterly professional music, until, as good hap was,
I heard the best, only to *be* heard during a narrow space
of those young days.

201. I too carelessly left without explanation the casual
sentence about "fatal dinner at Mr. Domecq's" when I
was fourteen, above, Chap. IV., p. 74. My father's

Spanish partner was at that time living in the Champs
Elysées, with his English wife and his five daughters;
the eldest, Diana, on the eve of her marriage with one
of Napoleon's officers, Count Maison; the four others,
much younger, chanced to be at home on vacation from
their convent school: and we had happy family dinner
with them, and mamma and the girls and a delightful old
French gentleman, Mr. Badell, played afterwards at "la
toilette de Madame" with me; only I couldn't remember
whether I was the necklace or the garters; and then
Clotilde and Cécile played "les Echos" and other fascina-
tions of dance-melody,—only I couldn't dance; and at
last Elise had to take pity on me as above described. But
the best, if not the largest, part of the conversation among
the elders was of the recent death of Bellini, the sorrow
of all Paris for him, and the power with which his "I
Puritani" was being rendered by the reigning four great
singers for whom it was written.

202. It puzzles me that I have no recollection of any
first sight and hearing of an opera. Not even, for that
matter, of my first going to a theatre, though I was full
twelve, before being taken; and afterwards, it was a matter
of intense rapture, of a common sort, to be taken to a
pantomime. And I greatly enjoy theatre to this day—
it is one of the pleasures that have least worn out; yet,
while I remember Friar's Crag at Derwentwater when
I was four years old, and the courtyard of our Paris inn
at five, I have no memory whatever, and am a little proud
to have none, of my first theatre. To be taken now at
Paris to the feebly dramatic "Puritani" was no great joy
to me; but I then heard, and it will always be a rare,
and only once or twice in a century possible, thing to
hear, four great musicians, all rightly to be called of
genius, singing together, with sincere desire to assist each
other, not eclipse; and to exhibit, not only their own

power of singing, but the beauty of the music they sang.

203. Still more fortunately it happened that a woman of *faultless* genius led the following dances,—Taglioni; a person of the highest natural faculties, and stainlessly simple character, gathered with sincerest ardour and reverence into her art. My mother, though she allowed me without serious remonstrance to be taken to the theatre by my father, had the strictest Puritan prejudice against the stage; yet enjoyed it so much that I think she felt the sacrifice she made in not going with us to be a sort of price accepted by the laws of virtue for what was sinful in her concession to my father and me. She went, however, to hear and see this group of players, renowned, without any rivals, through all the cities of Europe;—and, strange and pretty to say, her instinct of the innocence, beauty, and wonder, in every motion of the Grace of her century, was so strong, that from that time forth my mother would always, at a word, go with us to see Taglioni.

Afterwards, a season did not pass without my hearing twice or thrice, at least, those four singers; and I learned the better because my ear was never jaded the intention of the music written for them, or studied by them; and am extremely glad now that I heard *their* renderings of Mozart and Rossini, neither of whom can be now said ever to be heard at all, owing to the detestable quickening of the time. Grisi and Malibran sang at least one-third slower than any modern cantatrice; * and Patti, the last time I heard her, massacred Zerlina's part in "La ci darem," as if the audience and she had but the one object of getting Mozart's air done with, as soon as possible.

204. Afterwards, (the confession may as well be got

* It is a pretty conceit of musical people to call themselves scientific, when they have not yet fixed their unit of time!

over at once,) when I had got settled in my furrow at
Christ Church, it chanced that the better men of the
college had founded a musical society, under instruction
of the cathedral organist, Mr. Marshall, an extremely
simple, good-natured, and good-humoured person, by
whose encouragement I was brought to the point of trying
to learn to sing, "Come mai posso vivere se Rosina non
m'ascolta," and to play the two lines of prelude to the
"A te o cara," and what notes I could manage to read of
accompaniments to other songs of similarly tender purport.
In which, though never even getting so far as to read with
ease, I nevertheless, between my fine rhythmic ear, and
true lover's sentiment, got to understand some principles
of musical art, which I shall perhaps be able to enforce
with benefit on the musical public mind, even to-day, if
only I can get first done with this autobiography.

What the furrow at Christ Church was to be like, or
where to lead, none of my people seem at this time to
have been thinking. My mother, watching the natural-
istic and methodic bent of me, was, I suppose, tranquil
in the thought of my becoming another White of Selborne,
or Vicar of Wakefield, victorious in Whistonian and every
other controversy. My father perhaps conceived more
cometic or meteoric career for me, but neither of them
put the matter seriously in hand, however deeply laid up
in heart: and I was allowed without remonstrance to go
on measuring the blue of the sky, and watching the flight
of the clouds, till I had forgotten most of the Latin I
ever knew, and all the Greek, except Anacreon's ode to
the rose.

205. Some little effort was made to pull me together
in 1836 by sending me to hear Mr. Dale's lectures at
King's College, where I explained to Mr. Dale, on
meeting him one day in the court of entrance, that
porticoes should not be carried on the top of arches; and

considered myself exalted because I went in at the same
door with boys who had square caps on. The lectures
were on early English literature, of which, though I had
never read a word of any before Pope, I thought myself
already a much better judge than Mr. Dale. His quota-
tion of "Knut the king came sailing by" stayed with me;
and I think that was about all I learnt during the summer.
For, as my adverse stars would have it, that year, my
father's partner, Mr. Domecq, thought it might for once
be expedient that he should himself pay a complimentary
round of visits to his British customers, and asked if mean-
while he might leave his daughters at Herne Hill to see
the lions at the Tower, and so on. How we got them
all into Herne Hill corners and cupboards would be
inexplicable but with a plan of the three stories! The
arrangements were half Noah's ark, half Doll's house,
but we got them all in: Clotilde, a graceful oval-faced
blonde of fifteen; Cécile, a dark, finely-browed, beauti-
fully-featured girl of thirteen; Elise, again fair, round-
faced like an English girl, a treasure of good nature and
good sense; Caroline, a delicately quaint little thing of
eleven. They had all been born abroad, Clotilde at
Cadiz, and of course convent-bred; but lately accustomed
to be much in society during vacation at Paris. Deeper
than any one dreamed, the sight of them in the Champs
Elysées had sealed itself in me, for they were the first
well-bred and well-dressed girls I had ever seen—or at
least spoken to. I mean of course, by well-dressed, per-
fectly simply dressed, with Parisian cutting and fitting.
They were all "bigoted"—as Protestants would say;
quietly firm, as they ought to say—Roman Catholics;
spoke Spanish and French with perfect grace, and English
with broken precision: were all fairly sensible, Clotilde
sternly and accurately so, Elise gaily and kindly, Cécile
serenely, Caroline keenly. A most curious galaxy, or

southern cross, of unconceived stars, floating on a sudden
into my obscure firmament of London suburb.

206. How my parents could allow their young novice
to be cast into the fiery furnace of the outer world in this
helpless manner the reader may wonder, and only the
Fates know; but there was this excuse for them, that they
had never seen me the least interested or anxious about
girls—never caring to stay in the promenades at Chelten-
ham or Bath, or on the parade at Dover; on the contrary,
growling and mewing if I was ever kept there, and off to
the sea or the fields the moment I got leave; and they had
educated me in such extremely orthodox English Toryism
and Evangelicalism that they could not conceive their
scientific, religious, and George the Third revering youth,
wavering in his constitutional balance towards French
Catholics. And I had never *said* anything about the
Champs Elysées! Virtually convent-bred more closely
than the maids themselves, without a single sisterly or
cousinly affection for refuge or lightning rod, and having
no athletic skill or pleasure to check my dreaming, I was
thrown, bound hand and foot, in my unaccomplished
simplicity, into the fiery furnace, or fiery cross, of these
four girls,—who of course reduced me to a mere heap of
white ashes in four days. Four days, at the most, it took
to reduce me to ashes, but the Mercredi des cendres
lasted four years.

Anything more comic in the externals of it, anything
more tragic in the essence, could not have been invented
by the skilfullest designer in either kind. In my social
behaviour and mind I was a curious combination of Mr.
Traddles, Mr. Toots, and Mr. Winkle. I had the real
fidelity and single-mindedness of Mr. Traddles, with the
conversational abilities of Mr. Toots, and the heroic
ambition of Mr. Winkle;—all these illuminated by imagin-
ation like Mr. Copperfield's, at his first Norwood dinner.

207. Clotilde (Adèle Clotilde in full, but her sisters called her Clotilde, after the queen-saint, and I Adèle, because it rhymed to shell, spell, and knell) was only made more resplendent by the circlet of her sisters' beauty; while my own shyness and unpresentableness were farther stiffened, or rather sanded, by a patriotic and Protestant conceit, which was tempered neither by politeness nor sympathy; so that, while in company I sate jealously miserable like a stock fish (in truth, I imagine, looking like nothing so much as a skate in an aquarium trying to get up the glass), on any blessed occasion of tête-à-tête I endeavoured to entertain my Spanish-born, Paris-bred, and Catholic-hearted mistress with my own views upon the subjects of the Spanish Armada, the Battle of Waterloo, and the doctrine of Transubstantiation.

To these modes of recommending myself, however, I did not fail to add what display I could make of the talents I supposed myself to possess. I wrote with great pains, and straining of my invention, a story about Naples (which I had never seen), and "the Bandit Leoni," whom I represented as typical of what my own sanguinary and adventurous disposition would have been had I been brought up a bandit; and "the Maiden Giuletta," in whom I portrayed all the perfections of my mistress. Our connection with Messrs. Smith & Elder enabled me to get this story printed in "Friendship's Offering;" and Adèle laughed over it in rippling ecstasies of derision, of which I bore the pain bravely, for the sake of seeing her thoroughly amused.

I dared not address any sonnets straight to herself; but when she went back to Paris, wrote her a French letter seven quarto pages long, descriptive of the desolations and solitudes of Herne Hill since her departure. This letter, either Elise or Caroline wrote to tell me she had really read, and "laughed immensely at the French of." Both

Caroline and Elise pitied me a little, and did not like to
say she had also laughed at the contents.

208. The old people, meanwhile, saw little harm in all
this. Mr. Domecq, who was extremely good-natured,
and a good judge of character, rather liked me, because he
saw that I was good-natured also, and had some seedling
brains, which would come up in time: in the interests of
the business he was perfectly ready to give me any of his
daughters I liked, who could also be got to like me, but
considered that the time was not come to talk of such
things. My father was entirely of the same mind, besides
being pleased at my getting a story printed in "Friendship's
Offering," glad that I saw something of girls with good
manners, and in hopes that if I wrote poetry about them,
it might be as good as the Hours of Idleness. My
mother, who looked upon the idea of my marrying a
Roman Catholic as too monstrous to be possible in the
decrees of Heaven, and too preposterous to be even
guarded against on earth, was rather annoyed at the whole
business, as she would have been if one of her chimneys
had begun smoking,—but had not the slightest notion her
house was on fire. She saw more, however, than my
father, into the depth of the feeling, but did not, in her
motherly tenderness, like to grieve me by any serious check
to it. She hoped, when the Domecqs went back to Paris,
we might see no more of them, and that Adèle's influence
and memory would pass away—with next winter's snow.

209. Under these indulgent circumstances,—bitterly
ashamed of the figure I had made, but yet not a whit
dashed back out of my daily swelling foam of furious
conceit, supported as it was by real depth of feeling, and
(note it well, good reader) by a true and glorious sense of
the newly revealed miracle of human love, in its exaltation
of the physical beauty of the world I had till then sought
by its own light alone,—I set myself in that my seven-

teenth year, in a state of majestic imbecility, to write a tragedy on a Venetian subject, in which the sorrows of my soul were to be enshrined in immortal verse,—the fair heroine, Bianca, was to be endowed with the perfections of Desdemona and the brightness of Juliet,—and Venice and Love were to be described, as never had been thought of before. I may note in passing, that on my first sight of the Ducal Palace, the year before, I had deliberately announced to my father and mother, and—it seemed to me stupidly incredulous—Mary, that I meant to make such a drawing of the Ducal Palace as never had been made before. This I proceeded to perform by collecting some hasty memoranda on the spot, and finishing my design elaborately out of my head at Treviso. The drawing still exists,—for a wonder, out of perspective, which I had now got too conceited to follow the rules of,—and with the diaper pattern of the red and white marbles represented as a bold panelling in relief. No figure disturbs the solemn tranquillity of the Riva, and the gondolas—each in the shape of a Turkish crescent standing on its back on the water—float about without the aid of gondoliers.

I remember nothing more of that year, 1836, than sitting under the mulberry tree in the back garden, writing my tragedy. I forget whether we went travelling or not, or what I did in the rest of the day. It is all now blank to me, except Venice, Bianca, and looking out over Shooter's Hill, where I could see the last turn of the road to Paris.

Some Greek, though I don't know what, must have been read, and some mathematics, for I certainly knew the difference between a square and cube root when I went to Oxford, and was put by my tutor into Herodotus, out of whom I immediately gathered materials enough to write my Scythian drinking song, in imitation of the Giaour.

210. The reflective reader can scarcely but have begun to doubt, by this time, the accuracy of my statement that I took no harm from Byron. But he need not. The particular form of expression which my folly took was indeed directed by him; but this form was the best it could have taken. I got better practice in English by imitating the Giaour and Bride of Abydos than I could have had under any other master, (the tragedy was of course Shakespearian!) and the state of my mind was—my mind's own fault, and that of surrounding mischance or mismanagement—not Byron's. In that same year, 1836, I took to reading Shelley also, and wasted much time over the Sensitive Plant and Epipsychidion; and I took a good deal of harm from *him*, in trying to write lines like "prickly and pulpous and blistered and blue;" or "it was a little lawny islet by anemone and vi'let,—like mosaic paven," etc.; but in the state of frothy fever I was in, there was little good for me to be got out of anything. The perseverance with which I tried to wade through the Revolt of Islam, and find out (I never did, and don't know to this day) who revolted against whom, or what, was creditable to me; and the Prometheus really made me understand something of Æschylus. I am not sure that, for what I was to turn out, my days of ferment could have been got over much easier: at any rate, it was better than if I had been learning to shoot, or hunt, or smoke, or gamble. The entirely inscrutable thing to me, looking back on myself, is my total want of all reason, will, or design in the business: I had neither the resolution to win Adèle, the courage to do without her, the sense to consider what was at last to come of it all, or the grace to think how disagreeable I was making myself at the time to everybody about me. There was really no more capacity nor intelligence in me than in a just fledged owlet, or just open-eyed puppy, disconsolate at the existence of the moon.

211. Out of my feebly melodious complaints to that luminary, however, I was startled by a letter to my father from Christ Church, advising him that there was room for my residence in the January term of 1837, and that I must come up to matriculate in October of the instant year, 1836.

Strangely enough, my father had never enquired into the nature and manner of matriculation, till he took me up to display in Oxford;—he, very nearly as much a boy as I, for anything we knew of what we were about. He never had any doubt about putting me at the most fashionable college, and of course my name had been down at Christ Church years before I was called up; but it had never dawned on my father's mind that there were two, fashionable and unfashionable, orders, or castes, of undergraduate at Christ Church, one of these being called Gentlemen-Commoners, the other Commoners; and that these last seemed to occupy an almost bisectional point between the Gentlemen-Commoners and the Servitors. All these "invidious" distinctions are now done away with in our Reformed University. Nobody sets up for the special rank of a gentleman, but nobody will be set down as a commoner; and though, of the old people, anybody will beg or canvass for a place for their children in a charity school, everybody would be furious at the thought of his son's wearing, at college, the gown of a Servitor.

212. How far I agree with the modern British citizen in these lofty sentiments, my general writings have enough shown; but I leave the reader to form his own opinions without any contrary comment of mine, on the results of the exploded system of things in my own college life.

My father did not like the word "commoner,"—all the less, because our relationships in general were not uncommon. Also, though himself satisfying his pride enough

in being the head of the sherry trade, he felt and saw in
his son powers which had not their full scope in the sherry
trade. His ideal of my future,—now entirely formed in
conviction of my genius,—was that I should enter at
college into the best society, take all the prizes every year,
and a double first to finish with; marry Lady Clara Vere
de Vere; write poetry as good as Byron's, only pious;
preach sermons as good as Bossuet's, only Protestant; be
made, at forty, Bishop of Winchester, and at fifty, Primate
of England.

213. With all these hopes, and under all these tempta-
tions, my father was yet restrained and embarrassed in no
small degree by his old and steady sense of what was
becoming to his station in life: and he consulted anxiously,
but honestly, the Dean of Christ Church, (Gaisford,) and
my college tutor that was to be, Mr. Walter Brown,
whether a person in his position might without impro-
priety enter his son as a gentleman-commoner. I did not
hear the dialogues, but the old Dean must have answered
with a grunt, that my father had every right to make me a
gentleman-commoner if he liked, and could pay the fees;
the tutor, more attentively laying before him the condi-
tions of the question, may perhaps have said, with courtesy,
that it would be good for the college to have a reading man
among the gentlemen-commoners, who, as a rule, were
not studiously inclined; but he was compelled also to give
my father a hint, that as far as my reading had already
gone, it was not altogether certain I could pass the
entrance examination which had to be sustained by com-
moners. This last suggestion was conclusive. It was
not to be endured that the boy who had been expected to
carry all before him, should get himself jammed in the
first turnstile. I was entered as a Gentleman-Commoner
without farther debate, and remember still, as if it were
yesterday, the pride of first walking out of the Angel

Hotel, and past University College, holding my father's arm, in my velvet cap and silk gown.

214. Yes, good reader, the velvet and silk made a difference, not to my mother only, but to me! Quite one of the telling and weighty points in the home debates concerning this choice of Hercules, had been that the commoner's gown was not only of ugly stuff, but had no flowing lines in it, and was virtually only a black rag tied to one's shoulders. One was thrice a gownsman in a flowing gown.

So little, indeed, am I disposed now in maturer years to deride these unphilosophical feelings, that instead of effacing distinction of dress at the University (except for the boating clubs), I would fain have seen them extended into the entire social order of the country. I think that nobody but duchesses should be allowed to wear diamonds; that lords should be known from common people by their stars, a quarter of a mile off; that every peasant girl should boast her county by some dainty ratification of cap or bodice; and that in the towns a vintner should be known from a fishmonger by the cut of his jerkin.

That walk to the Schools, and the waiting, outside the Divinity School, in comforting admiration of its door, my turn for matriculation, continue still for me, a pleasure. But I remember nothing more that year; nor anything of the first days of the next, until early in January we drove down to Oxford, only my mother and I, by the beautiful Henley road, weary a little as we changed horses for the last stage from Dorchester; solemnized, in spite of velvet and silk, as we entered among the towers in the twilight; and after one more rest under the domestic roof of the Angel, I found myself the next day at evening, alone, by the fireside, entered into command of my own life, in my own college room in Peckwater.

Chapter XI

CHRIST CHURCH CHOIR

215. ALONE, by the fireside of the little back room, which looked into the narrow lane, chiefly then of stabling, I sate collecting my resolution for college life.

I had not much to collect; nor, so far as I knew, much to collect it against. I had about as clear understanding of my whereabouts, or foresight of my fortune, as Davie Gellatly might have had in my place; with these farther inferiorities to Davie, that I could neither dance, sing, nor roast eggs. There was not the slightest fear of my gambling, for I had never touched a card, and looked upon dice as people now do on dynamite. No fear of my being tempted by the strange woman, for was not I in love? and besides, never allowed to be out after half-past nine. No fear of my running in debt, for there were no Turners to be had in Oxford, and I cared for nothing else in the world of material possession. No fear of my breaking my neck out hunting, for I couldn't have ridden a hack down the High Street; and no fear of my ruining myself at a race, for I never had been but at one race in my life, and had not the least wish to win anybody else's money.

I expected some ridicule, indeed, for these my simple ways, but was safe against ridicule in my conceit: the only thing I doubted myself in, and very rightly, was the power of applying for three years to work in which I took not the slightest interest. I resolved, however, to do my parents and myself as much credit as I could, said my prayers very seriously, and went to bed in good hope.

216. And here I must stay, for a minute or two, to give some account of the state of mind I had got into

during the above-described progress of my education, touching religious matters.

As far as I recollect, the steady Bible reading with my mother ended with our first continental journey, when I was fourteen; one could not read three chapters after breakfast while the horses were at the door. For this lesson was substituted my own private reading of a chapter, morning and evening, and, of course, saying the Lord's Prayer after it, and asking for everything that was nice for myself and my family; after which I waked or slept, without much thought of anything but my earthly affairs, whether by night or day.

It had never entered into my head to doubt a word of the Bible, though I saw well enough already that its words were to be understood otherwise than I had been taught; but the more I believed it, the less it did me any good. It was all very well for Abraham to do what angels bid him, —so would I, if any angels bid me; but none had ever appeared to me that I knew of, not even Adèle, who couldn't be an angel because she was a Roman Catholic.

217. Also, if I had lived in Christ's time, of course I would have gone with Him up to the mountain, or sailed with Him on the Lake of Galilee; but that was quite another thing from going to Beresford chapel, Walworth, or St. Bride's, Fleet Street. Also, though I felt myself somehow called to imitate Christian in the Pilgrim's Progress, I couldn't see that either Billiter Street and the Tower Wharf, where my father had his cellars, or the cherry-blossomed garden at Herne Hill, where my mother potted her flowers, could be places I was bound to fly from as in the City of Destruction. Without much reasoning on the matter, I had virtually concluded from my general Bible reading that, never having meant or done any harm that I knew of, I could not be in danger of hell: while I saw also that even the crème de la crême

of religious people seemed to be in no hurry to go to heaven. On the whole, it seemed to me, all that was required of *me* was to say my prayers, go to church, learn my lessons, obey my parents, and enjoy my dinner.

218. Thus minded, in the slowly granted light of the winter morning I looked out upon the view from my college windows, of Christ Church library and the smooth gravelled square of Peckwater, vexed a little because I was not in an oriel window looking out on a Gothic chapel: but quite unconscious of the real condemnation I had fallen under, or of the loss that was involved to me in having nothing but Christ Church library, and a gravelled square, to see out of window during the spring-times of two years of youth.

At the moment I felt that, though dull, it was all very grand; and that the architecture, though Renaissance, was bold, learned, well-proportioned, and variously didactic. In reality, I might just as well have been sent to the dungeon of Chillon, except for the damp; better indeed, if I could have seen the three small trees from the window slit, and good groining and pavement, instead of the modern vulgar upholstery of my room furniture.

Even the first sight of college chapel disappointed me, after the large churches abroad; but its narrow vaults had very different offices.

On the whole, of important places and services for the Christian souls of England, the choir of Christ Church was at that epoch of English history virtually the navel, and seat of life. There remained in it the traditions of Saxon, Norman, Elizabethan, religion unbroken,—the memory of loyalty, the reality of learning, and, in nominal obedience at least, and in the heart of them with true docility, stood every morning, to be animated for the highest duties owed to their country, the noblest of English youth. The greater number of the peers of England, and

as a rule, the best of her squirealty, passed necessarily through Christ Church.

The cathedral itself was an epitome of English history. Every stone, every pane of glass, every panel of woodwork, was true, and of its time,—not an accursed sham of architect's job. The first shrine of St. Frideswide had indeed been destroyed, and her body rent and scattered on the dust by the Puritan; but her second shrine was still beautiful in its kind,—most lovely English work both of heart and hand. The Norman vaults above were true English Norman; bad and rude enough, but the best we could do with our own wits, and no French help. The roof was true Tudor,—grotesque, inventively constructive, delicately carved; it, with the roof of the hall staircase, summing the builder's skill of the fifteenth century. The west window, with its clumsy painting of the Adoration of the Shepherds, a monument of the transition from window to picture which ended in Dutch pictures of the cattle without either shepherds or Christ,—but still, the best men could do of the day; and the plain final woodwork of the stalls represented still the last art of living England in the form of honest and comfortable carpentry.

219. In this choir, written so closely and consecutively with indisputable British history, met every morning a congregation representing the best of what Britain had become,—orderly, as the crew of a man-of-war, in the goodly ship of their temple. Every man in his place, according to his rank, age, and learning; every man of sense or heart there recognizing that he was either fulfilling, or being prepared to fulfil, the gravest duties required of Englishmen. A well-educated foreigner, admitted to that morning service, might have learned and judged more quickly and justly what the country had been and still had power to be, than by months of stay in court or city. There, in his stall, sat the greatest divine of

England,—under his commandant niche, her greatest
scholar,—among the tutors the present Dean Liddell, and
a man of curious intellectual power and simple virtue,
Osborne Gordon. The group of noblemen gave, in the
Marquis of Kildare, Earl of Desart, Earl of Emlyn, and
Francis Charteris, now Lord Wemyss,—the brightest
types of high race and active power. Henry Acland and
Charles Newton among the senior undergraduates, and I
among the freshmen, showed, if one had known it,
elements of curious possibilities in coming days. None
of us then conscious of any need or chance of change,
least of all the stern captain, who with rounded brow and
glittering dark eye, led in his old thunderous Latin the
responses of the morning prayer.

For all that I saw, and was made to think, in that
cathedral choir, I am most thankful to this day.

220. The influence on me of the next goodliest part of
the college buildings,—the hall,—was of a different and
curiously mixed character. Had it only been used, as it
only ought to have been, for festivity and magnificence,—
for the refectory daily, the reception of guests, the delivery
of speeches on state occasions, and the like,—the hall, like
the cathedral, would have had an entirely salutary and
beneficently solemnizing effect on me, hallowing to me
my daily bread, or, if our Dean Abbot had condescended
sometimes to dine with us, our incidental venison. But
with the extremely bad taste (which, to my mind, is our
cardinal modern sin, the staple to the hinge of our taste
for money, and distaste for money's worth, and every other
worthiness)—in that bad taste, I say, the Abbot allowed
our Hall to be used for "collections." The word is
wholly abominable to my mind, whether as expressing
extorted charities in church, or extracted knowledge in
examination. "Collections," in scholastic sense, meant
the college examination at the end of every term, at which

the Abbot had always the worse than bad taste to be present as our inquisitor, though he had never once presided at our table as our host. Of course the collective quantity of Greek possessed by all the undergraduate heads in hall, was to *him*, infinitesimal. Scornful at once, and vindictive, thunderous always, more sullen and threatening as the day went on, he stalked with baleful emanation of Gorgonian cold from dais to door, and door to dais, of the majestic torture chamber,—vast as the great council hall of Venice, but degraded now by the mean terrors, swallow-like under its eaves, of doleful creatures who had no counsel in them, except how to hide their crib in time, at each fateful Abbot's transit. Of course *I* never used a crib, but I believe the Dean would rather I had used fifty, than borne the puzzled and hopeless aspect which I presented towards the afternoon, over whatever I had to do. And as my Latin writing was, I suppose, the worst in the university,—as I never by any chance knew a first from a second future, or, even to the end of my Oxford career, could get into my head where the Pelasgi lived, or where the Heraclidæ returned from,—it may be imagined with what sort of countenance the Dean gave me his first and second fingers to shake at our parting, or with what comfort I met the inquiries of my father and mother as to the extent to which I was, in college opinion, carrying all before me.

221. As time went on, the aspect of my college hall to me meant little more than the fear and shame of those examination days; but even in the first surprise and sublimity of finding myself dining there, were many reasons for the qualification of my pleasure. The change from our front parlour at Herne Hill, some fifteen feet by eighteen, and meat and pudding with my mother and Mary, to a hall about as big as the nave of Canterbury Cathedral, with its extremity lost in mist, its roof in dark-

ness, and its company, an innumerable, immeasurable vision in vanishing perspective, was in itself more appalling to me than appetizing; but also, from first to last, I had the clownish feeling of having no business there.

In the cathedral, however born or bred, I felt myself present by as good a right as its bishop,—nay, that in some of its lessons and uses, the building was less his than mine. But at table, with this learned and lordly perspective of guests, and state of worldly service, I had nothing to do; my own proper style of dining was for ever, I felt, divided from this—impassably. With baked potatoes under the mutton, just out of the oven, into the little parlour off the shop in Market Street, or beside a gipsy's kettle on Addington Hill (not that I had ever been beside a gipsy's kettle, but often wanted to be); or with an oat-cake and butter—for I was always a gourmand—in a Scotch shepherd's cottage, to be divided with his collie, I was myself, and in my place: but at the gentlemen-commoners' table, in Cardinal Wolsey's dining-room, I was, in all sorts of ways at once, less than myself, and in all sorts of wrong places at once, out of my place.

222. I may as well here record a somewhat comic incident, extremely trivial, which took place a little while afterwards; and which, in spite of its triviality, farther contributed to diminish in my own mind the charm of Christ Church hall. I had been received as a good-humoured and inoffensive little cur, contemptuously, yet kindly, among the dogs of race at the gentlemen-commoners' table; and my tutor, and the men who read in class with me, were beginning to recognize that I had some little gift in reading with good accent, thinking of what I read, and even asking troublesome questions about it, to the extent of being one day eagerly and admiringly congratulated by the whole class the moment we got out into quad, on the consummate manner in which I had floored

our tutor. I having had no more intention to floor, or consciousness of flooring, the tutor, than a babe unborn, but had only happened, to the exquisite joy of my companions, to ask him something which he didn't happen to know. But, a good while before attaining this degree of public approval, I had made a direct attempt to bring myself into favourable notice, which had been far less successful.

It was an institution of the college that every week the undergraduates should write an essay on a philosophical subject, explicatory of some brief Latin text of Horace, Juvenal, or other accredited and pithy writer; and, I suppose, as a sort of guarantee to the men that what they wrote was really looked at, the essay pronounced the best was read aloud in hall on Saturday afternoon, with enforced attendance of the other undergraduates. Here, at least, was something in which I felt that my little faculties had some scope, and both conscientiously, and with real interest in the task, I wrote my weekly essay with all the sagacity and eloquence I possessed. And therefore, though much flattered, I was not surprised, when, a few weeks after coming up, my tutor announced to me, with a look of approval, that I was to read my essay in hall next Saturday.

223. Serenely, and on good grounds, confident in my powers of reading rightly, and with a decent gravity which I felt to be becoming on this my first occasion of public distinction, I read my essay, I have reason to believe, not ungracefully; and descended from the rostrum to receive —as I doubted not—the thanks of the gentlemen-commoners for this creditable presentment of the wisdom of that body. But poor Clara, after her first ball, receiving her cousin's compliments in the cloak-room, was less surprised than I by my welcome from my cousins of the long-table. Not in envy, truly, but in fiery disdain,

varied in expression through every form and manner of
English language, from the Olympian sarcasm of Charteris
to the level-delivered volley of Grimston, they explained
to me that I had committed grossest *lèse-majesté* against
the order of gentlemen-commoners; that no gentleman-
commoner's essay ought ever to contain more than twelve
lines, with four words in each; and that even indulging
to my folly, and conceit, and want of *savoir faire*, the
impropriety of writing an essay with any meaning in it,
like vulgar students,—the thoughtlessness and audacity
of writing one that would take at least a quarter of an
hour to read, and then reading it all, might for this once
be forgiven to such a greenhorn, but that Coventry wasn't
the word for the place I should be sent to if ever I did such
a thing again. I am happy at least in remembering that
I bore my fall from the clouds without much hurt, or
even too ridiculous astonishment. I at once admitted the
justice of these representations, yet do not remember that
I modified the style of my future essays materially in
consequence, neither do I remember what line of conduct
I had proposed to myself in the event of again obtaining
the privilege of edifying the Saturday's congregation.
Perhaps my essays really diminished in value, or perhaps
even the tutors had enough of them. All I know is, I
was never asked to.

224. I ought to have noticed that the first introduc-
tions to the men at my table were made easier by the
chance of my having been shut up for two days of storm
at the Hospice of the Grimsel, in 1835, with some thirty
travellers from various countries, among whom a Christ
Church gentleman-commoner, Mr. Strangways, had
played chess with me, and been a little interested in the
way I drew granite among the snow. He at once acknow-
ledged me in Hall for a fellow-creature; and the rest of his
set, finding they could get a good deal out of me in amuse-

ment without my knowing it, and that I did not take upon
myself to reform their manners from any Evangelical, or
otherwise impertinent, point of view, took me up kindly;
so that, in a fortnight or so, I had fair choice of what
companions I liked, out of the whole college.

Fortunately for me—beyond all words, fortunately—
Henry Acland, by about a year and a half my senior, chose
me; saw what helpless possibilities were in me, and took me
affectionately in hand. His rooms, next the gate on the
north side of Canterbury, were within fifty yards of mine,
and became to me the only place where I was happy. He
quietly showed me the manner of life of English youth
of good sense, good family, and enlarged education; we
both of us already lived in elements far external to the
college quadrangle. He told me of the plains of Troy;
a year or two afterwards I showed him, on his marriage
journey, the path up the Montanvert; and the friendship
between us has never changed, but by deepening, to this
day.

225. Of other friends, I had some sensible and many
kind ones; an excellent college tutor; and later on, for a
private one, the entirely right-minded and accomplished
scholar already named, Osborne Gordon. At the corner
of the great quadrangle lived Dr. Buckland, always ready
to help me,—or, a greater favour still, to be helped by me,
in diagram drawing for his lectures. My picture of the
granite veins in Trewavas Head, with a cutter weathering
the point in a squall, in the style of Copley Fielding, still,
I believe, forms part of the resources of the geological
department. Mr. Parker, then first founding the Archi-
tectural Society, and Charles Newton, already notable in
his intense and curious way of looking into things, were
there to sympathize with me, and to teach me more
accurately the study of architecture. Within eight miles
were the pictures of Blenheim. In all ways, opportuni-

ties, and privileges, it was not conceivable that a youth of my age could have been placed more favourably—if only he had had the wit to know them, and the will to use them. Alas! there I stood—or tottered—partly irresolute, partly idiotic, in the midst of them: nothing that I can think of among men, or birds, or beasts, quite the image of me, except poor little Shepherdess Agnes's picture of the "Duckling Astray."

226. I count it is just a little to my credit that I was not ashamed, but pleased, that my mother came to Oxford with me to take such care of me as she could. Through all three years of residence, during term time, she had lodging in the High Street (first in Mr. Adams's pretty house of sixteenth century wood-work), and my father lived alone all through the week at Herne Hill, parting with wife and son at once for the son's sake. On the Saturday, he came down to us, and I went with him and my mother, in the old domestic way, to St. Peter's, for the Sunday morning service: otherwise, they never appeared with me in public, lest my companions should laugh at me, or any one else ask malicious questions concerning vintner papa and his old-fashioned wife.

None of the men, through my whole college career, ever said one word in depreciation of either of them, or in sarcasm at my habitually spending my evenings with my mother. But once, when Adèle's elder sister came with her husband to see Oxford, and I mentioned, somewhat unnecessarily, at dinner, that she was the Countess Diane de Maison, they had no mercy on me for a month afterwards.

The reader will please also note that my mother did not come to Oxford because she could not part with me,—still less, because she distrusted me. She came simply that she might be at hand in case of accident or sudden illness. She had always been my physician as well as my nurse; on

several occasions her timely watchfulness had saved me
from the most serious danger; nor was her caution now,
as will be seen, unjustified by the event. But for the first
two years of my college life I caused her no anxiety; and
my day was always happier because I could tell her at tea
whatever had pleased or profited me in it.

227. The routine of day is perhaps worth telling. I
never missed chapel; and in winter got an hour's reading
before it. Breakfast at nine,—half-an-hour allowed for
it to a second, for Captain Marryat with my roll and
butter. College lectures till one. Lunch, with a little
talk to anybody who cared to come in, or share their own
commons with me. At two, Buckland or other pro-
fessor's lecture. Walk till five, hall dinner, wine either
given or accepted, and quiet chat over it with the reading
men, or a frolic with those of my own table; but I always
got round to the High Street to my mother's tea at seven,
and amused myself till Tom * rang in, and I got with a
run to Canterbury gate, and settled to a steady bit of final
reading till ten. I can't make out more than six hours'
real work in the day, but that was constantly and unflinch-
ingly given.

228. My Herodotean history, at any rate, got well
settled down into me, and remains a greatly precious pos-
session to this day. Also my college tutor, Mr. Walter
Brown, became somewhat loved by me, and with gentle-
ness encouraged me into some small acquaintance with
Greek verbs. My mathematics progressed well under
another tutor whom I liked, Mr. Hill; the natural instinct
in me for pure geometry being keen, and my grasp of it,
as far as I had gone, thorough. At my "little go" in the
spring of '38, the diagrams of Euclid being given me, as

* I try to do without notes, but for the sake of any not English
reader must explain that "Tom" is the name of the great bell of
Oxford, in Christ Church western tower.

was customary with the Euclid examination paper, I
handed the book back to the examiner, saying scornfully,
"I don't want any figures, Sir." "You had better take
them," replied he, mildly; which I did, as he bid me; but
I could then, and can still, dictate blindfold the demon-
stration of any problem, with any letters, at any of its
points. I just scraped through, and no more, with my
Latin writing, came creditably off with what else had to
be done, and my tutor was satisfied with me,—not enough
recognizing that the "little go" had asked, and got out
of me, pretty nearly all I had in me, or was ever likely to
have in that kind.

229. It was extremely unfortunate for me that the two
higher lecturers of the college, Kynaston (afterwards
Master of St. Paul's) in Greek, and Hussey, the censor, in
I don't recollect what of disagreeable, were both to my
own feeling repellent. They both despised me, as a
home-boy, to begin with; Kynaston with justice, for I
had not Greek enough to understand anything he said;
and when good-naturedly one day, in order to bring out
as best he might my supposed peculiar genius and acquire-
ments, he put me on at the ορα δέ γ᾽εἴσω τριγλύφων,
ὅποι κενὸν δέμας καθεῖναι, of the Iphigenia in Tauris,
and found, to his own and all the class's astonishment
and disgust, that I did not know what a triglyph was,
—never spoke to me with any patience again, until long
afterwards at St. Paul's, where he received me, on an
occasion of school ceremony, with affection and respect.

Hussey was, by all except the best men of the college,
felt to be a censorious censor; and the manners of the
college were unhappily such as to make any wise censor
censorious. He had, by the judgment of heaven, a grim
countenance; and was to me accordingly, from first to
last, as a Christ Church Gorgon or Erinnys, whose passing
cast a shadow on the air as well as on the gravel.

I am amused, as I look back, in now perceiving what an æsthetic view I had of all my tutors and companions,—how consistently they took to me the aspect of pictures, and how I from the first declined giving any attention to those which were not well painted enough. My ideal of a tutor was founded on what Holbein or Durer had represented in Erasmus or Melanchthon, or, even more solemnly, on Titian's Magnificoes or Bonifazio's Bishops. No presences of that kind appeared either in Tom or Peckwater; and even Doctor Pusey (who also never spoke to me) was not in the least a picturesque or tremendous figure, but only a sickly and rather ill put together English clerical gentleman, who never looked one in the face, or appeared aware of the state of the weather.

230. My own tutor was a dark-eyed, animated, pleasant, but not in the least impressive person, who walked with an unconscious air of assumption, noticeable by us juniors not to his advantage. Kynaston was ludicrously like a fat schoolboy. Hussey, grim and brown as I said, somewhat lank, incapable of jest, equally incapable of enthusiasm; for the rest, doing his duty thoroughly, and a most estimable member of the college and university, —but to me, a resident calamity far greater than I knew, whose malefic influence I recognize in memory only.

Finally, the Dean himself, though venerable to me, from the first, in his evident honesty, self-respect, and real power of a rough kind, was yet in his general aspect too much like the sign of the Red Pig which I afterwards saw set up in pudding raisins, with black currants for eyes, by an imaginative grocer in Chartres fair; and in the total bodily and ghostly presence of him was to me only a rotundly progressive terror, or sternly enthroned and niched Anathema.

There was one tutor, however, out of my sphere, who

reached my ideal, but disappointed my hope, then,—as perhaps his own, since;—a man sorrowfully under the dominion of the Greek ἀνάγκη—the present Dean. He was, and is, one of the rarest types of nobly-presenced Englishmen, but I fancy it was his adverse star that made him an Englishman at all—the prosaic and practical element in him having prevailed over the sensitive one. He was the only man in Oxford among the masters of my day who knew anything of art; and his keen saying of Turner, that he "had got hold of a false ideal," would have been infinitely helpful to me at that time, had he explained and enforced it. But I suppose he did not see enough in me to make him take trouble with me,—and, what was much more serious, he saw not enough in himself to take trouble, in that field, with himself.

231. There was a more humane and more living spirit, however, inhabitant of the north-west angle of the Cardinal's Square: and a great many of the mischances which were only harmful to me through my own folly may be justly held, and to the full, counterbalanced by that one piece of good fortune, of which I had the wit to take advantage. Dr. Buckland was a Canon of the Cathedral, and he, with his wife and family, were all sensible and good-natured, with originality enough in the sense of them to give sap and savour to the whole college.

Originality—passing slightly into grotesqueness, and a little diminishing their effective power. The Doctor had too much humour ever to follow far enough the dull side of a subject. Frank was too fond of his bear cub to give attention enough to the training of the cubbish element in himself; and a day scarcely passed without Mit's committing herself in some manner disapproved by the statelier college demoiselles. But all were frank, kind, and clever, vital in the highest degree; to me, medicinal and saving.

Dr. Buckland was extremely like Sydney Smith in his staple of character; no rival with him in wit, but like him in humour, common sense, and benevolently cheerful doctrine of Divinity. At his breakfast-table I met the leading scientific men of the day, from Herschel downwards, and often intelligent and courteous foreigners,— with whom my stutter of French, refined by Adèle into some precision of accent, was sometimes useful. Every one was at ease and amused at that breakfast-table,—the menû and service of it usually in themselves interesting. I have always regretted a day of unlucky engagement on which I missed a delicate toast of mice; and remembered, with delight, being waited upon one hot summer morning by two graceful and polite little Carolina lizards, who kept off the flies.

232. I have above noticed the farther and incalculable good it was to me that Acland took me up in my first and foolishest days, and with pretty irony and loving insight,— or, rather, sympathy with what was best, and blindness to what was worst in me,—gave me the good of seeing a noble young English life in its purity, sagacity, honour, reckless daring, and happy piety; its English pride shining prettily through all, like a girl's in her beauty. It is extremely interesting to me to contrast the Englishman's silently conscious pride in what he *is*, with the vexed restlessness and wretchedness of the Frenchman, in his thirst for "gloire," to be gained by agonized effort to become something he is *not*.

One day when the Cherwell was running deep over one of its most slippery weirs, question arising between Acland and me whether it were traversable, and I declaring it too positively to be impassable, Acland instantly took off boot and sock, and walked over and back. He ran no risk but of a sound ducking, being, of course, a strong swimmer: and I suppose him wise enough not to have done it had

there been real danger. But he would certainly have run
the margin fine, and possessed in its quite highest, and in
a certain sense, most laughable degree, the constitutional
English serenity in danger, which, with the foolish of us,
degenerates into delight in it, but with the wise, whether
soldier or physician, is the basis of the most fortunate action
and swiftest decision of deliberate skill. When, thirty years
afterwards, Dr. Acland was wrecked in the steamer *Tyne*,
off the coast of Dorset, the steamer having lain wedged
on the rocks all night,—no one knew what rocks,—and
the dawn breaking on half-a-mile of dangerous surf
between the ship and shore,—the officers, in anxious
debate, the crew, in confusion, the passengers, in hysterics
or at prayers, were all astonished, and many scandalized,
at the appearance of Dr. Acland from the saloon in
punctilious morning dress, with the announcement that
"breakfast was ready." To the impatient clamour of
indignation with which his unsympathetic conduct was
greeted, he replied by pointing out that not a boat could
go on shore, far less come out from it, in that state of the
tide, and that in the meantime, as most of them were wet,
all cold, and at the best must be dragged ashore through
the surf, if not swim for their lives in it, they would be
extremely prudent to begin the day, as usual, with break-
fast. The hysterics ceased, the confusion calmed, what
wits anybody had became available to them again, and
not a life was ultimately lost.

233. In all this playful and proud heroism of his youth,
Henry Acland delighted me as a leopard or a falcon would,
without in the least affecting my own character by his
example. I had been too often adjured and commanded
to take care of myself, ever to think of following him over
slippery weirs, or accompanying him in pilot boats through
white-topped shoal water; but both in art and science he
could pull me on, being years ahead of me, yet glad of my

sympathy, for, till I came, he was literally alone in the university in caring for either. To Dr. Buckland, geology was only the pleasant occupation of his own merry life. To Henry Acland physiology was an entrusted gospel of which he was the solitary and first preacher to the heathen; and already in his undergraduate's room in Canterbury he was designing—a few years later in his professional room in Tom quad, he was realizing,—the introduction of physiological study which has made the university what she has now become.

Indeed, the curious point in Acland's character was its early completeness. Already in these yet boyish days, his judgment was unerring, his aims determined, his powers developed; and had he not, as time went on, been bound to the routine of professional work, and satisfied in the serenity, not to say arrested by the interests, of a beautiful home life,——it is no use thinking or saying what he might have been; those who know him best are the most thankful that he is what he is.

234. Next to Acland, but with a many-feet-thick wall between, in my æsthetic choice of idols, which required primarily of man or woman that they should be comely, before I regarded any of their farther qualities, came Francis Charteris. I have always held Charteris the most ideal Scotsman, and on the whole the grandest type of European Circassian race hitherto visible to me; and his subtle, effortless, inevitable, unmalicious sarcasm, and generally sufficient and available sense, gave a constantly natural, and therefore inoffensive, hauteur to his delicate beauty. He could do what he liked with anyone,—at least with anyone of good humour and sympathy; and when one day, the old sub-dean coming out of Canterbury gate at the instant Charteris was dismounting at it in forbidden pink, and Charteris turned serenely to him as he took his foot out of the stirrup, to inform him that

"he had been out with the Dean's hounds," the old man and the boy were both alike pleased.

Charteris never failed in anything, but never troubled himself about anything. Naturally of high ability and activity, he did all he chose with ease,—neither had falls in hunting, nor toil in reading, nor ambition nor anxiety in examination,—nor disgrace in recklessness of life. He was partly checked, it may be in some measure weakened, by hectic danger in his constitution, possibly the real cause of his never having made his mark in after life.

235. The Earl of Desart, next to Charteris, interested me most of the men at my table. A youth of the same bright promise, and of kind disposition, he had less natural activity, and less—being Irish,—common sense, than the Scot; and the University made no attempt to give him more. It has been the pride of recent days to equalize the position, and disguise the distinction of noble and servitor. Perhaps it might have been wiser, instead of effacing the distinction, to reverse the manner of it. In those days the happy servitor's tenure of his college-room and revenue depended on his industry, while it was the privilege of the noble to support with lavish gifts the college, from which he expected no return, and to buy with sums equivalent to his dignity the privileges of rejecting alike its instruction and its control. It seems to me singular, and little suggestive of sagacity in the common English character, that it had never occurred to either an old dean, or a young duke, that possibly the Church of England and the House of Peers might hold a different position in the country in years to come if the entrance examination had been made severer for the rich than the poor; and the nobility and good breeding of a student expected to be blazoned consistently by the shield on his seal, the tassel on his cap, the grace of his conduct, and the accuracy of his learning.

In the last respect, indeed, Eton and Harrow boys are for ever distinguished,—whether idle or industrious in after life,—from youth of general England; but how much of the best capacity of her noblesse is lost by her carelessness of their university training, she may soon have more serious cause to calculate than I am willing to foretell.

I have little to record of my admired Irish fellow-student than that he gave the supper at which my freshman's initiation into the body of gentlemen-commoners was to be duly and formally ratified. Curious glances were directed to me under the ordeal of the necessary toasts,—but it had not occurred to the hospitality of my entertainers that I probably knew as much about wine as they did. When we broke up at the small hours, I helped to carry the son of the head of my college downstairs, and walked across Peckwater to my own rooms, deliberating, as I went, whether there was any immediately practicable trigonometric method of determining whether I was walking straight towards the lamp over the door.

236. From this time—that is to say, from about the third week after I came into residence—it began to be recognized that, muff or milksop though I might be, I could hold my own on occasion; and in next term, when I had to return civilities, that I gave good wine, and that of curious quality, without any bush; and saw with good-humour the fruit I had sent for from London thrown out of the window to the porter's children: farther, that I could take any quantity of jests, though I could not make one, and could be extremely interested in hearing conversation on topics I knew nothing about,—to that degree that Bob Grimston condescended to take me with him one day to a tavern across Magdalen Bridge, to hear him elucidate from the landlord some points of the horses entered for the Derby, an object only to be properly

accomplished by sitting with indifference on a corner of
the kitchen table, and carrying on the dialogue with care-
ful pauses, and more by winks than words.

The quieter men of the set were also some of them
interested in my drawing; and one or two—Scott Murray,
for instance, and Lord Kildare—were as punctual as I in
chapel, and had some thoughts concerning college life and
its issues, which they were glad to share with me. In
this second year of residence, my position in college was
thus alike pleasant, and satisfactorily to my parents,
eminent: and I was received without demur into the
Christ Church society, which had its quiet club-room at
the corner of Oriel Lane, looking across to the "beautiful
gate" of St. Mary's; and on whose books were entered
the names of most of the good men belonging to the upper
table and its set, who had passed through Christ Church
for the last ten or twelve years.

237. Under these luxurious, and—in the world's sight
—honourable, conditions, my mind gradually recovering
its tranquillity and spring, and making some daily, though
infinitesimal, progress towards the attainment of common
sense, I believe that I did harder and better work in my
college reading than I can at all remember. It seems to
me now as if I had known Thucydides, as I knew Homer
(Pope's!), since I could spell; but the fact was, that for a
youth who had so little Greek to bless himself with at
seventeen, to know every syllable of his Thucydides at
half past eighteen meant some steady sitting at it. The
perfect honesty of the Greek soldier, his high breeding,
his political insight, and the scorn of construction with
which he knotted his meaning into a rhythmic strength
that writhed and wrought every way at once, all interested
me intensely in him as a writer; while his subject, the
central tragedy of all the world, the suicide of Greece, was
felt by me with a sympathy in which the best powers of

my heart and brain were brought up to their fullest, for
my years.

I open, and lay beside me as I write, the perfectly clean
and well-preserved third volume of Arnold, over which
I spent so much toil, and burnt with such sorrow; my
close-written abstracts still dovetailed into its pages; and
read with surprised gratitude the editor's final sentence in
the preface dated "Fox How, Ambleside, January, 1835."

"Not the wildest extravagance of atheistic wickedness
in modern times can go further than the sophists of Greece
went before them. Whatever audacity can dare, and
subtlety contrive, to make the words 'good' and 'evil'
change their meaning, has been already tried in the days
of Plato, and by his eloquence, and wisdom, and faith
unshaken, put to shame."

CHAPTER XII

ROSLYN CHAPEL

238. I MUST yet return, before closing the broken record
of these first twenty years, to one or two scattered days in
1836, when things happened which led forward into
phases of work to be given account of in next volume.

I cannot find the date of my father's buying his first
Copley Fielding,—"Between King's House and In-
veroran, Argyllshire." It cost a tremendous sum, for *us*
—forty-seven guineas; and the day it came home was a
festa, and many a day after, in looking at it, and fancying
the hills and the rain were real.

My father and I were in absolute sympathy about
Copley Fielding, and I could find it in my heart now to
wish I had lived at the Land's End, and never seen any
art but Prout's and his. We were very much set up at
making his acquaintance, and then very happy in it: the
modestest of presidents he was; the simplest of painters,
without a vestige of romance, but the purest love of daily
sunshine and the constant hills. Fancy him, while Stan-
field and Harding and Roberts were grand-touring in
Italy, and Sicily, and Stiria, and Bohemia, and Illyria,
and the Alps, and the Pyrenees, and the Sierra Morena,—
Fielding never crossing to Calais, but year after year
returning to Saddleback and Ben Venue, or, less ambitious
yet, to Sandgate and the Sussex Downs.

239. The drawings I made in 1835 were really inter-
esting even to artists, and appeared promising enough to
my father to justify him in promoting me from Mr.
Runciman's tutelage to the higher privileges of art-
instruction. Lessons from any of the members of the

Water-Colour Society cost a guinea, and six were supposed
to have efficiency for the production of an adequately
skilled water-colour amateur. There was, of course, no
question by what master they should be given; and I know
not whether papa or I most enjoyed the six hours in New-
man Street: my father's intense delight in Fielding's work
making it a real pleasure to the painter that he should stay
chatting while I had my lesson. Nor was my father's
talk (if he could be got to talk) unworthy any painter's
attention, though he never put out his strength but in
writing. I chance in good time on a letter from North-
cote in 1830, showing how much value the old painter
put on my father's judgment of a piece of literary work
which remains classical to this day, and is indeed the best
piece of existing criticism founded on the principles of
Sir Joshua's school:

240. "DEAR SIR,—I received your most kind and
consoling letter, yet I was very sorry to find you had been
so ill, but hope you have now recovered your health. The
praise you are so good as to bestow on me and the Volume
of Conversations gives me more pleasure than perhaps you
apprehend, as the book was published against my consent,
and, in its first appearance in the magazines, totally with-
out my knowledge. I have done all in my power to
prevent its coming before the public, because there are
several hard and cruel opinions of persons that I would
not have them see in a printed book; besides that, Hazlitt,
although a man of real abilities, yet had a desire to give
pain to others, and has also frequently exaggerated that
which I had said in confidence to him. However, I
thank God that this book, which made me tremble at its
coming before the world, is received with unexpected
favour on to my part, and the approbation of a mind like
yours give (*sic*—short for 'cannot but give') me the greatest

consolation I can receive, and sets my mind more at
ease.

"Please to present my respectful compliments to Mrs.
Ruskin, who I hope is well, and kind remembrances to
your son.

<div style="text-align:center">

"I remain always, dear Sir,

"Your most obliged friend *

"And very humble servant,

"JAMES NORTHCOTE.

</div>

"ARGYLL HOUSE,
 "*October 13th*, 1830.
"To John J. Ruskin, Esq."

241. And thus the proposed six lessons in Newman
Street ran on into perhaps eight or nine, during which
Copley Fielding taught me to wash colour smoothly in
successive tints, to shade cobalt through pink madder into
yellow ochre for skies, to use a broken scraggy touch for
the tops of mountains, to represent calm lakes by broad
strips of shade with lines of light between them (usually
at about the distance of the lines of this print), to produce
dark clouds and rain with twelve or twenty successive
washes, and to crumble burnt umber with a dry brush for
foliage and foreground. With these instructions, I suc-
ceeded in copying a drawing which Fielding made before
me, some twelve inches by nine, of Ben Venue and the
Trosachs, with brown cows standing in Loch Achray, so
much to my own satisfaction that I put my work up over
my bedroom chimney-piece the last thing at night, and
woke to its contemplation in the morning with a rapture,
mixed of self-complacency and the sense of new faculty,
in which I floated all that day, as in a newly-discovered
and strongly buoyant species of air.

* In memory of the quiet old man who thus honoured us with his
friendship, and in most true sense of their value, I hope to reprint
the parts of the Conversations which I think he would have wished
to be preserved.

In a very little while, however, I found that this great first step did not mean consistent progress at the same pace. I saw that my washes, however careful or multitudinous, did not in the end look as smooth as Fielding's, and that my crumblings of burnt umber became uninteresting after a certain number of repetitions.

With still greater discouragement, I perceived the Fielding processes to be inapplicable to the Alps. My scraggy touches did not to my satisfaction represent aiguilles, nor my ruled lines of shade, the Lake of Geneva. The water-colour drawing was abandoned, with a dim under-current of feeling that I had no gift for it,—and in truth I had none for colour arrangement,—and the pencil outline returned to with resolute energy.

242. I had never, up to this time, seen a Turner drawing, and scarcely know whether to lay to the score of dulness, or prudence, the tranquillity in which I copied the engravings of the Rogers vignettes, without so much as once asking where the originals were. The facts being that they lay at the bottom of an old drawer in Queen Anne Street, inaccessible to me as the bottom of the sea,—and that, if I had seen them, they would only have destroyed my pleasure in the engravings,—my rest in these was at least fortunate: and the more I consider of this and other such forms of failure in what most people would call laudable curiosity, the more I am disposed to regard with thankfulness, and even respect, the habits which have remained with me during life, of always working resignedly at the thing under my hand till I could do it, and looking exclusively at the thing before my eyes till I could see it.

On the other hand, the Academy Turners were too far beyond all hope of imitation to disturb me, and the impressions they produced before 1836 were confused; many of them, like the Quilleboeuf, or the "Keelmen heaving in coals," being of little charm in colour; and the Fountain

of Indolence, or Golden Bough, perhaps seeming to me already fantastic, beside the naturalism of Landseer, and the human interest and intelligible finish of Wilkie.

243. But in 1836 Turner exhibited three pictures, in which the characteristics of his later manner were developed with his best skill and enthusiasm: Juliet and her Nurse, Rome from Mount Aventine, and Mercury and Argus. His freak in placing Juliet at Venice instead of Verona, and the mysteries of lamplight and rockets with which he had disguised Venice herself, gave occasion to an article in Blackwood's Magazine of sufficiently telling ribaldry, expressing, with some force, and extreme discourtesy, the feelings of the pupils of Sir George Beaumont at the appearance of these unaccredited views of Nature.

The review raised me to the height of "black anger" in which I have remained pretty nearly ever since; and having by that time some confidence in my power of words, and—not merely judgment, but sincere *experience* —of the charm of Turner's work, I wrote an answer to Blackwood, of which I wish I could now find any fragment. But my father thought it right to ask Turner's leave for its publication; it was copied in my best hand, and sent to Queen Anne Street, and the old man returned kindly answer, as follows:—

"47, QUEEN ANN (*sic*) STREET WEST,
"*October 6th*, 1836.

"MY DEAR SIR,—I beg to thank you for your zeal, kindness, and the trouble you have taken in my behalf, in regard of the criticism of Blackwood's Magazine for October, respecting my works; but I never move in these matters, they are of no import save mischief and the meal tub, which Maga fears for by my having invaded the flour tub.

"*P.S.*—If you wish to have the manuscript back, have
the goodness to let me know. If not, with your sanction,
I will send it on to the possessor of the picture of Juliet."

I cannot give the signature of this letter, which has
been cut off for some friend! In later years it used to be,
to my father, "Yours most truly," and to me, "Yours
truly."

The "possessor of the picture" was Mr. Munro of
Novar, who never spoke to me of the first chapter of
"Modern Painters" thus coming into his hands. Nor did
I ever care to ask him about it; and still, for a year or two
longer, I persevered in the study of Turner engravings
only, and the use of Copley Fielding's method for such
efforts at colour as I made on the vacation journeys during
Oxford days.

244. We made three tours in those summers, without
crossing Channel. In 1837, to Yorkshire and the Lakes;
in 1838, to Scotland; in 1839, to Cornwall.

On the journey of 1837, when I was eighteen, I felt,
for the last time, the pure childish love of nature which
Wordsworth so idly takes for an intimation of immortality.
We went down by the North Road, as usual; and on the
fourth day arrived at Catterick Bridge, where there is a
clear pebble-bedded stream, and both west and east some
rising of hills, foretelling the moorlands and dells of
upland Yorkshire; and there the feeling came back to me
—as it could never return more.

It is a feeling only possible to youth, for all care, regret,
or knowledge of evil destroys it; and it requires also the
full sensibility of nerve and blood, the conscious strength
of heart, and hope; not but that I suppose the purity of
youth may feel what is best of it even through sickness
and the waiting for death; but only in thinking death
itself God's sending.

245. In myself, it has always been quite exclusively confined to *wild*, that is to say, wholly natural places, and especially to scenery animated by streams, or by the sea. The sense of the freedom, spontaneous, unpolluted power of nature was essential in it. I enjoyed a lawn, a garden, a daisied field, a quiet pond, as other children do; but by the side of Wandel, or on the downs of Sandgate, or by a Yorkshire stream under a cliff, I was different from other children, that ever I have noticed: but the feeling cannot be described by any of us that have it. Wordsworth's "haunted me like a passion" is no description of it, for it is not *like*, but *is*, a passion; the point is to define how it *differs* from other passions,—what sort of human, pre-eminently human, feeling it is that loves a stone for a stone's sake, and a cloud for a cloud's. A monkey loves a monkey for a monkey's sake, and a nut for the kernel's, but not a stone for a stone's. I took stones for bread, but not certainly at the Devil's bidding.

I was different, be it once more said, from other children even of my own type, not so much in the actual nature of the feeling, but in the mixture of it. I had, in my little clay pitcher, vialfuls, as it were, of Wordsworth's reverence, Shelley's sensitiveness, Turner's accuracy, all in one. A snowdrop was to me, as to Wordsworth, part of the Sermon on the mount; but I never should have written sonnets to the celandine, because it is of a coarse, yellow and imperfect form. With Shelley, I loved blue sky and blue eyes, but never in the least confused the heavens with my own poor little Psychidion. And the reverence and passion were alike kept in their places by the constructive Turnerian element; and I did not weary myself in wishing that a daisy could see the beauty of its shadow, but in trying to draw the shadow rightly, myself.

246. But so stubborn and chemically inalterable the laws of the prescription were, that now, looking back from

1886 to that brook shore of 1837, whence I could see the whole of my youth, I find myself in nothing whatsoever *changed*. Some of me is dead, more of me stronger. I have learned a few things, forgotten many; in the total of me, I am but the same youth, disappointed and rheumatic.

And in illustration of this stubbornness, not by stiffening of the wood with age, but in the structure of the pith, let me insist a minute or two more on the curious joy I felt in 1837 in returning to the haunts of boyhood. No boy could possibly have been more excited than I was by seeing Italy and the Alps; neither boy nor man ever knew better the difference between a Cumberland cottage and Venetian palace, or a Cumberland stream and the Rhone:—my very knowledge of this difference will be found next year expressing itself in the first bit of promising literary work I ever did; but, after all the furious excitement and wild joy of the Continent, the coming back to a Yorkshire streamside felt like returning to heaven. We went on into well known Cumberland; my father took me up Scawfell and Helvellyn, with a clever Keswick guide, who knew mineralogy, Mr. Wright; and the summer passed beneficently and peacefully.

247. A little incident which happened, I fancy in the beginning of '38, shows that I had thus recovered some tranquillity and sense, and might at that time have been settled down to simple and healthy life, easily enough, had my parents seen the chance.

I forgot to say, when speaking of Mr. and Mrs. Richard Gray, that, when I was a child, my mother had another religious friend, who lived just at the top of Camberwell Grove, or between it and the White Gate,—Mrs. Withers; an extremely amiable and charitable person, with whom my mother organized, I imagine, such schemes of almsgiving as her own housekeeping prevented her seeing to herself. Mr. Withers was a coal-merchant,

ultimately not a successful one. Of him I remember
only a reddish and rather vacant face; of Mrs. Withers,
no material aspect, only the above vague but certain facts;
and that she was a familiar element in my mother's life,
dying out of it however without much notice or miss,
before I was old enough to get any clear notion of her.

In this spring of '38, however, the widowed Mr.
Withers, having by that time retired to the rural districts
in reduced circumstances, came up to town on some small
vestige of carboniferous business, bringing his only daughter
with him to show my mother;—who, for a wonder, asked
her to stay with us, while her father visited his umquwhile
clientage at the coal-wharves. Charlotte Withers was a
fragile, fair, freckled, sensitive slip of a girl about sixteen;
graceful in an unfinished and small wild-flower sort of a
way, extremely intelligent, affectionate, wholly right-
minded and mild in piety. An altogether sweet and
delicate creature of ordinary sort, not pretty, but quite
pleasant to see, especially if her eyes were looking your
way, and her mind with them.

248. We got to like each other in a mildly confidential
way in the course of a week. We disputed on the relative
dignities of music and painting; and I wrote an essay
nine foolscap pages long, proposing the entire establish-
ment of my own opinions, and the total discomfiture and
overthrow of hers, according to my usual manner of paying
court to my mistresses. Charlotte Withers, however,
thought I did her great honour, and carried away the
essay as if it had been a school prize.

And, as I said, if my father and mother had chosen to
keep her a month longer, we should have fallen quite
melodiously and quietly in love; and they might have
given me an excellently pleasant little wife, and set me up,
geology and all, in the coal business, without any resistance
or farther trouble on my part. I don't suppose the idea

ever occurred to them; Charlotte was not the kind of
person they proposed for me. So Charlotte went away
at the week's end, when her father was ready for her.
I walked with her to Camberwell Green, and we said
good-bye, rather sorrowfully, at the corner of the New
Road; and that possibility of meek happiness vanished for
ever. A little while afterwards, her father "negotiated"
a marriage for her with a well-to-do Newcastle trader,
whom she took because she was bid. He treated her
pretty much as one of his coal sacks, and in a year or two
she died.

249. Very dimly, and rather against my own will, the
incident showed me what my mother had once or twice
observed to me, to my immense indignation, that Adèle
was not the only girl in the world; and my enjoyment
of our tour in the Trosachs was not described in any more
Byronian heroics; the tragedy also having been given up,
because, when I had described a gondola, a bravo, the
heroine Bianca, and moonlight on the Grand Canal, I
found I had not much more to say.

Scott's country took me at last well out of it all. It
is of little use to the reader now to tell him that still at
that date the shore of Loch Katrine, at the east extremity
of the lake, was exactly as Scott had seen it, and described,

> "Onward, amid the copse 'gan peep,
> A narrow inlet, still and deep."

In literal and lovely truth, that was so:—by the side of
the footpath (it was no more) which wound through the
Trosachs, deep and calm under the blaeberry bushes, a
dark winding clear-brown pool, not five feet wide at first,
reflected the entangled moss of its margin, and arch of
branches above, with scarcely a gleam of sky.

That inlet of Loch Katrine was in itself an extremely
rare thing; I have never myself seen the like of it in lake

shores. A winding recess of deep water, without any
entering stream to account for it—possible only, I imagine,
among rocks of the quite abnormal confusion of the
Trosachs; and besides the natural sweetness and wonder
of it made sacred by the most beautiful poem that Scotland
ever sang by her stream sides. And all that the nineteenth
century conceived of wise and right to do with this piece
of mountain inheritance, was to thrust the nose of a
steamer into it, plank its blaeberries over with a platform,
and drive the populace headlong past it as fast as they can
scuffle.

It had been well for me if I had climbed Ben Venue
and Ben Ledi, hammer in hand, as Scawfell and Helvellyn.
But I had given myself some literary work instead, to
which I was farther urged by the sight of Roslyn and
Melrose.

250. The idea had come into my head in the summer
of '37, and, I imagine, rose immediately out of my sense
of the contrast between the cottages of Westmoreland and
those of Italy. Anyhow, the November number of
Loudon's *Architectural Magazine* for 1837 opens with
"Introduction to the Poetry of Architecture; or, The
Architecture of the Nations of Europe considered in its
Association with Natural Scenery and National Char-
acter," by Kataphusin. I could not have put in fewer,
or more inclusive words, the definition of what half my
future life was to be spent in discoursing of; while the
nom-de-plume I chose, "According to Nature," was
equally expressive of the temper in which I was to discourse
alike on that and every other subject. The adoption of
a nom-de-plume at all, implied (as also the concealment
of name on the first publication of "Modern Painters")
a sense of a power of judgment in myself, which it would
not have been becoming in a youth of eighteen to claim.
Had either my father or tutor then said to me, "Write

as it is becoming in a youth to write,—let the reader
discover what you know, and be persuaded to what you
judge," I perhaps might not now have been ashamed of
my youth's essays. Had they said to me more sternly,
"Hold your tongue till you need not ask the reader's con-
descension in listening to you," I might perhaps have been
satisfied with my work when it was mature.

As it is, these youthful essays, though deformed by
assumption, and shallow in contents, are curiously right
up to the points they reach; and already distinguished
above most of the literature of the time, for the skill of
language which the public at once felt for a pleasant gift
in me.

251. I have above said that had it not been for constant
reading of the Bible, I might probably have taken Johnson
for my model of English. To a useful extent I have
always done so; in these first essays, partly because I could
not help it, partly of set, and well set, purpose.

On our foreign journeys, it being of course desirable to
keep the luggage as light as possible, my father had judged
that four little volumes of Johnson—the Idler and the
Rambler—did, under names wholly appropriate to the
circumstances, contain more substantial literary nourish-
ment than could be, from any other author, packed into
so portable compass. And accordingly, in spare hours,
and on wet days, the turns and returns of reiterated
Rambler and iterated Idler fastened themselves in my ears
and mind; nor was it possible for me, till long afterwards,
to quit myself of Johnsonian symmetry and balance in
sentences intended, either with swordsman's or paviour's
blow, to cleave an enemy's crest, or drive down the oaken
pile of a principle. I never for an instant compared John-
son to Scott, Pope, Byron, or any of the really great writers
whom I loved. But I at once and for ever recognized
in him a man entirely sincere, and infallibly wise in the

view and estimate he gave of the common questions, business, and ways of the world. I valued his sentences not primarily because they were symmetrical, but because they were just, and clear; it is a method of judgment rarely used by the average public, who ask from an author always, in the first place, arguments in favour of their own opinions, in elegant terms; and are just as ready with their applause for a sentence of Macaulay's, which may have no more sense in it than a blot pinched between doubled paper, as to reject one of Johnson's, telling against their own prejudice,—though its symmetry be as of thunder answering from two horizons.

252. I hold it more than happy that, during those continental journeys, in which the vivid excitement of the greater part of the day left me glad to give spare half-hours to the study of a thoughtful book, Johnson was the one author accessible to me. No other writer could have secured me, as he did, against all chance of being misled by my own sanguine and metaphysical temperament. He taught me carefully to measure life, and distrust fortune; and he secured me, by his adamantine common-sense, for ever, from being caught in the cobwebs of German metaphysics, or sloughed in the English drainage of them.

I open, at this moment, the larger of the volumes of the Idler to which I owe so much. After turning over a few leaves, I chance on the closing sentence of No. 65, which transcribing, I may show the reader in sum what it taught me,—in words which, writing this account of myself, I conclusively obey.

"Of these learned men, let those who aspire to the same praise imitate the diligence, and avoid the scrupulosity. Let it be always remembered that life is short, that knowledge is endless, and that many doubts deserve not to be cleared. Let those whom nature and study have qualified to teach mankind, tell us what they have learned

while they are yet able to tell it, and trust their reputation only to themselves."

It is impossible for me now to know how far my own honest desire for truth, and compassionate sense of what is instantly helpful to creatures who are every instant perishing, might have brought me, in their own time, to think and judge as Johnson thought and measured,—even had I never learned of him. He at least set me in the straight path from the beginning, and, whatever time I might waste in vain pleasure, or weak effort, he saved me for ever from false thoughts and futile speculations.

253. Why, I know not, for Mr. Loudon was certainly not tired of me, the Kataphusin papers close abruptly, as if their business was at its natural end, without a word of allusion in any part of them, or apology for the want of allusion, to the higher forms of civil and religious architecture. I find, indeed, a casual indication of some ulterior purpose in a ponderous sentence of the paper on the Westmoreland cottage, announcing that "it will be seen hereafter, when we leave the lowly valley for the torn ravine, and the grassy knoll for the ribbed precipice, that if the continental architects cannot adorn the pasture with the humble roof, they can crest the crag with eternal battlements." But this magnificent promise ends in nothing more tremendous than a "chapter on chimneys," illustrated as I find this morning to my extreme surprise, by a fairly good drawing of the building which is now the principal feature in the view from my study window,—Coniston Hall.

On the whole, however, these papers, written at intervals during 1838, indicate a fairly progressive and rightly consolidated range of thought on these subjects, within the chrysalid torpor of me.

254. From the Trosachs we drove to Edinburgh: and, somewhere on the road near Linlithgow, my father,

reading some letters got by that day's post, coolly announced to my mother and me that Mr. Domecq was going to bring his four daughters to England again, to finish their schooling at New Hall, near Chelmsford.

And I am unconscious of anything more in that journey, or of anything after it, until I found myself driving down to Chelmsford. My mother had no business of course to take *me* with her to pay a visit in a convent; but I suppose felt it would be too cruel to leave me behind. The young ladies were allowed a chat with us in the parlour, and invited (with acceptance) to spend their vacations always at Herne Hill. And so began a second æra of that part of my life which is *not* "worthy of memory," but only of the "Guarda e Passa."

There was some solace during my autumnal studies in thinking that she was really in England, really over *there*,—I could see the sky over Chelmsford from my study window,—and that she was shut up in a convent and couldn't be seen by anybody, or spoken to, but by nuns; and that perhaps she wouldn't quite like it, and would like to come to Herne Hill again, and bear with me a little.

255. I wonder mightily now what sort of a creature I should have turned out, if at this time Love had been with me instead of against me; and instead of the distracting and useless pain, I had had the joy of approved love, and the untellable, incalculable motive of its sympathy and praise.

It seems to me such things are not allowed in this world. The men capable of the highest imaginative passion are always tossed on fiery waves by it: the men who find it smooth water, and not scalding, are of another sort. My father's second clerk, Mr. Ritchie, wrote unfeelingly to his colleague, bachelor Henry, who would not marry for his mother's and sisters' sakes, "If you want to know what

happiness is, get a wife, and half a dozen children, and come to Margate." But Mr. Ritchie remained all his life nothing more than a portly gentleman with gooseberry eyes, of the Irvingite persuasion.

There must be great happiness in the love-matches of the typical English squire. Yet English squires make their happy lives only a portion for foxes.

256. Of course, when Adèle and her sisters came back at Christmas, and stayed with us four or five weeks, every feeling and folly that had been subdued or forgotten, returned in redoubled force. I don't know what would have happened if Adèle had been a perfectly beautiful and amiable girl, and had herself in the least liked me. I suppose then my mother would have been overcome. But though extremely lovely at fifteen, Adèle was not prettier than French girls in general at eighteen; she was firm, and fiery, and high principled; but, as the light traits already noticed of her enough show, not in the least amiable; and although she would have married me, had her father wished it, was always glad to have me out of her way. My love was much too high and fantastic to be diminished by her loss of beauty; but I perfectly well saw and admitted it, having never at any time been in the slightest degree blinded by love, as I perceive other men are, out of my critic nature. And day followed on day, and month to month, of complex absurdity, pain, error, wasted affection, and rewardless semi-virtue, which I am content to sweep out of the way of what better things I can recollect at this time, into the smallest possible size of dust heap, and wish the Dustman Oblivion good clearance of them.

With this one general note, concerning children's conduct to their parents, that a great quantity of external and irksome obedience may be shown them, which virtually is no obedience, because it is not cheerful and total.

The *wish* to disobey is already disobedience; and although at this time I was really doing a great many things I did not like, to please my parents, I have not now *one* self-approving thought or consolation in having done so, so much did its sullenness and maimedness pollute the meagre sacrifice.

257. But, before I quit, for this time, the field of romance, let me write the epitaph of one of its sweet shadows, which some who knew the shadow may be glad I should write. The ground floor, under my father's counting-house at Billiter Street, I have already said was occupied by Messrs. Wardell & Co. The head of this firm was an extremely intelligent and refined elderly gentleman, darkish, with spiritedly curling and projecting dark hair, and bright eyes; good-natured and amiable in a high degree, well educated, not over wise, always well pleased with himself, happy in a sensible wife, and a very beautiful, and entirely gentle and good, only daughter. Not over wise, I repeat, but an excellent man of business; older, and, I suppose, already considerably richer, than my father. He had a handsome house at Hampstead, and spared no pains on his daughter's education.

It must have been some time about this year 1839, or the previous one, that my father having been deploring to Mr. Wardell the discomfortable state of mind I had got into about Adèle, Mr. Wardell proposed to him to try whether some slight diversion of my thoughts might not be effected by a visit to Hampstead. My father's fancy was still set on Lady Clara Vere de Vere; but Miss Wardell was everything that a girl should be, and an heiress,—of perhaps something more than my own fortune was likely to come to. And the two fathers agreed that nothing could be more fit, rational, and desirable, than such an arrangement. So I was sent to pass a summer afternoon, and dine at Hampstead.

258. It would have been an extremely delightful after-
noon for any youth not a simpleton. Miss Wardell had
often enough heard me spoken of by her father as a well-
conducted youth, already of some literary reputation—
author of the "Poetry of Architecture"—winner of the
Newdigate,—First class man in expectation. She herself
had been brought up in a way closely resembling my own,
in severe seclusion by devoted parents, at a suburban villa
with a pretty garden, to skip, and gather flowers, in. The
chief difference was that, from the first, Miss Wardell had
had excellent masters, and was now an extremely accom-
plished, intelligent, and faultless maid of seventeen; fragile
and delicate to a degree enhancing her beauty with some
solemnity of fear, yet in perfect health, as far as a fast-
growing girl could be; a softly moulded slender brunette,
with her father's dark curling hair transfigured into playful
grace round the pretty, modest, not unthoughtful, gray-
eyed face. Of the afternoon at Hampstead, I remember
only that it was a fine day, and that we walked in the
garden; mamma, as her mere duty to me in politeness
at a first visit, superintending,—it would have been wiser
to have left us to get on how we could. I very heartily
and reverently admired the pretty creature, and would
fain have done, or said, anything I could to please her.
Literally to *please* her, for that is, indeed, my hope with
all girls, in spite of what I have above related of my
mistaken ways of recommending myself. My primary
thought is how to serve *them*, and make them happy, and
if they could use me for a plank bridge over a stream, or
set me up for a post to tie a swing to, or anything of the
sort not requiring me to talk, I should be always quite
happy in such promotion. This sincere devotion to them,
with intense delight in whatever beauty or grace they
chance to have, and in most cases, perceptive sympathy,
heightened by faith in their right feelings, for the most

part gives me considerable power with girls: but all this
prevents me from ever being in the least at ease with
them,—and I have no doubt that during the whole after-
noon at Hampstead, I gave little pleasure to my com-
panion. For the rest, though I extremely admired Miss
Wardell, she was not my sort of beauty. I like oval
faces, crystalline blonde, with straightish, at the utmost
wavy, (or, in length, wreathed) hair, and the form elastic,
and foot firm. Miss Wardell's dark and tender grace had
no power over me, except to make me extremely afraid
of being tiresome to her. On the whole, I suppose I
came off pretty well, for she afterwards allowed herself
to be brought out to Herne Hill to see the pictures, and
so on; and I recollect her looking a little frightenedly
pleased at my kneeling down to hold a book for her, or
some such matter.

259. After this second interview, however, my father
and mother asking me seriously what I thought of her,
and I explaining to them that though I saw all her beauty,
and merit, and niceness, she yet was not my sort of girl,
—the negotiations went no farther at that time, and a
little while after, were ended for all time; for at Hamp-
stead they went on teaching the tender creature High
German, and French of Paris, and Kant's Metaphysics,
and Newton's Principia; and then they took her to Paris,
and tired her out with seeing everything every day, all
day long, besides the dazzle and excitement of such a first
outing from Hampstead; and she at last getting too pale
and weak, they brought her back to some English seaside
place, I forget where: and there she fell into nervous
fever and faded away, with the light of death flickering
clearer and clearer in her soft eyes, and never skipped in
Hampstead garden more.

How the parents, especially the father, lived on, I never
could understand; but I suppose they were honestly

religious without talking of it, and they had nothing to blame themselves in, except not having known better. The father, though with grave lines altering his face for ever, went steadily on with his business, and lived to be old.

260. I cannot be sure of the date of either Miss Withers' or Miss Wardell's death; that of Sybilla Dowie (told in Fors), more sad than either, was much later; but the loss of her sweet spirit, following her lover's, had been felt by us before the time of which I am now writing. I had never myself seen Death, nor had any part in the grief or anxiety of a sick chamber; nor had I ever seen, far less conceived, the misery of unaided poverty. But I had been made to think of it; and in the deaths of the creatures whom I had seen joyful, the sense of deep pity, not sorrow for myself, but for them, began to mingle with all the thoughts, which, founded on the Homeric, Æschylean, and Shakespearian tragedy, had now begun to modify the untried faith of childhood. The blue of the mountains became deep to me with the purple of mourning, —the clouds that gather round the setting sun, not subdued, but raised in awe as the harmonies of a Miserere, —and all the strength and framework of my mind, lurid, like the vaults of Roslyn, when weird fire gleamed on its pillars, foliage-bound, and far in the depth of twilight, "blazed every rose-carved buttress fair."

<center>END OF VOL. I</center>

VOLUME II

Chapter I

OF AGE

1. THIS second volume must, I fear, be less pleasing to the general reader, with whom the first has found more favour than I had hoped,—not because I tire of talking, but that the talk must be less of other persons, and more of myself. For as I look deeper into the mirror, I find myself a more curious person than I had thought. I used to fancy that everybody would like clouds and rocks as well as I did, if once told to look at them; whereas, after fifty years of trial, I find that is not so, even in modern days; having long ago known that, in ancient ones, the clouds and mountains which have been life to me, were mere inconvenience and horror to most of mankind.

2. I related, in the first volume, page 82, some small part of my pleasures under St. Vincent's rock at Clifton and the beginning of quartz-study there with the now No. 51 of the Brantwood series. Compare with these childish sentiments, those of the maturely judging John Evelyn, at the same place, 30th June, 1654:—

"The city" (Bristol) "wholly mercantile, as standing neere the famous Severne, commodiously for Ireland and the Western world. Here I first saw the manner of refining suggar, and casting it into loaves, where we had a collation of eggs fried in the suggar furnace,* together with excellent Spanish wine: but what appeared most stupendious to me, was the rock of St. Vincent, a little distance from ye towne, the precipice whereoff is equal

* Note (by Evelyn's editor in 1827): "A kind of entertainment like that we now have of eating beefsteaks drest on the stoker's shovel, and drinking porter at the famous brewhouses in London."

to anything of that nature I have seen in y^e most con-
fragose cataracts of the Alpes, the river gliding between
them at an extraordinary depth. Here we went searching
for diamonds, and to the Hot Wells at its foote. There
is also on the side of this horrid Alp a very romantic seate:
and so we returned to Bathe in the evening."

3. Of course Evelyn uses the word "horrid" only in
its Latin sense; but his mind is evidently relieved by
returning to Bath; and although, farther on, he describes
without alarm the towne and county of Nottingham as
"seeming to be but one entire rock, as it were," he explains
his toleration of that structure in the close of his sentence
—"an exceeding pleasant shire, full of gentry." Of his
impressions of the "stupendious" rocks of Fontainebleau,
and ungentle people of the Simplon, I have to speak in
another place.

In these and many other such particulars I find the
typical English mind, both then and now, so adverse to
my own, as also to those of my fellow companions through
the sorrows of this world, that it becomes for me a matter
of acute Darwinian interest to trace my species from origin
to extinction: and I have, therefore, to warn the reader,
and ask his pardon, that while a modest person writes his
autobiography chiefly by giving accounts of the people
he has met, I find it only possible, within my planned
limits, to take note of those who have had distinct power
in the training or the pruning of little me to any good.

4. I return first to my true master in mathematics, poor
Mr. Rowbotham. Of course he missed his Herne Hill
evenings sadly when I went to Oxford. But always,
when we came home, it was understood that once in the
fortnight, or so, as he felt himself able, he should still toil
up the hill to tea. We were always sorry to see him at
the gate; but felt that it was our clear small duty to put
up with his sighing for an hour or two in such rest as

his woful life could find. Nor were we without some real affection for him. His face had a certain grandeur, from its constancy of patience, bewildered innocence, and firm lines of faculty in geometric sort. Also he brought us news from the mathematical and grammatical world, and told us some interesting details of manufacture, if he had been on a visit to his friend Mr. Crawshay. His own home became yearly more wretched, till one day its little ten-years-old Peepy choked himself with his teetotum. The father told us, with real sorrow, the stages of the child's protracted suffering before he died; but observed, finally, that it was better he should have been taken away, —both for him and his parents. Evidently the poor mathematical mind was relieved from one of its least soluble burdens, and the sad face, that evening, had an expression of more than usual repose.

I never forgot the lesson it taught me of what human life meant in the suburbs of London.

5. The rigidly moral muse of Mr. Pringle had by this time gone to Africa, or, let us hope, Arabia Felix, in the other world; and the reins of my poetical genius had been given into the hand of kindly Mr. W. H. Harrison in the Vauxhall Road, of whom account has already been given in the first chapter of "On the Old Road" enough to carry us on for the present.

I must next bring up to time the history of my father's affectionate physician, Dr. Grant. Increasing steadily in reputation, he married a widowed lady, Mrs. Sidney, of good position in Richmond; and became the guardian of her two extremely nice and clever daughters, Augusta and Emma, who both felt great respect, and soon great regard, for their stepfather, and were every day more dutiful and pleasing children to him. Estimating my mother's character also as they ought, later on, they were familiar visitors to us; the younger, Emma, having good taste for

drawing, and other quiet accomplishments and pursuits. At the time I am now looking back to, however, the Star and Garter breakfasts had become rarer, and were connected mostly with visits to Hampton Court, where the great vine, and the maze, were of thrilling attraction to me; and the Cartoons began to take the aspect of mild nightmare and nuisance which they have ever since retained.

My runs with cousin Mary in the maze, (once, as in Dantesque alleys of lucent verdure in the Moon, with Adèle and Elise,) always had something of an enchanted and Faery-Queen glamour in them: and I went on designing more and more complicated mazes in the blank leaves of my lesson books—wasting, I suppose, nearly as much time that way as in the trisection of the angle. Howbeit, afterwards, the coins of Cnossus, and characters of Dædalus, Theseus, and the Minotaur, became intelligible to me as to few: and I have much unprinted MSS. about them, intended for expansion in "Ariadne Florentina," and other labyrinthine volumes, but which the world must get on now without the benefit of, as it can.

6. Meantime, from the Grove, whitehaired mamma Monro, and silvery-fringed Petite, had gone to their rest. Mrs. Gray cared no longer for the pride of her house, or shade of her avenue; while more and more, Mr. Gray's devotion to Don Quixote, and to my poetry in "Friendship's Offering," interfered with his business habits. At last it was thought that, being true Scots both of them, they might better prosper over the Border. They went to Glasgow, where Mr. Gray took up some sort of a wine business, and read Rob Roy instead of Don Quixote. We went to Glasgow to see them, on our Scottish tour, and sorrowfully perceived them to be going downwards, even in their Scottish world. For a little change, they were asked to Oxford that autumn, to see their spoiled

Johnnie carrying all before him: and the good couple being seated in Christ Church Cathedral under the organ, and seeing me walk in with my companions in our silken sleeves, and with accompanying flourishes by Mr. Marshall on the trumpet stop, and Rembrandtesque effects of candle-light upon the Norman columns, were both of them melted into tears; and remained speechless with reverent delight all the evening afterwards.

7. I have left too long without word the continual benevolence towards us of the family at Widmore, Mr. Telford and his three sisters; the latter absolutely well-educated women—wise, without either severity or ostentation, using all they knew for the good of their neighbours, and exhibiting in their own lives every joy of sisterly love and active homeliness. Mr. Henry Telford's perfectly quiet, slightly melancholy, exquisitely sensitive face, browned by continual riding from Bromley to Billiter Street, remains with me, among the most precious of the pictures which, unseen of any guest, hang on the walls of my refectory.

Mr. and Mrs. Robert Cockburn, as the years drew on, became more and more kindly, but less and less approvingly, interested in our monastic ways at Herne Hill; and in my partly thwarted and uncomfortable, partly singular, development of literary character. Mrs. Cockburn took earnest pains with my mother to get her to send me more into society, that I might be licked a little into shape. But my mother was satisfied with me as I was: and besides, Mrs. Cockburn and she never got quite well on together. My mother, according to her established manner, would no more dine with her than with any one else, and was even careless in returning calls; and Mrs. Cockburn—which was wonderful in a woman of so much sense—instead of being merely sorry for my mother's shyness, and trying to efface her sense of

inferiority in education and position, took this somewhat in pique. But among the fateful chances of my own life in her endeavours to do something for me, and somehow break the shell of me, she one day asked me to dine with Lockhart, and see his little harebell-like daintiness of a daughter. I suppose Mrs. Cockburn must have told him of my love of Scott, yet I do not remember manifesting that sentiment in any wise during dinner: I recollect only, over the wine, making some small effort to display my Oxonian orthodoxy and sound learning, with respect to the principles of Church Establishment; and being surprised, and somewhat discomfited, by finding that Mr. Lockhart knew the Greek for "bishop" and "elder" as well as I did. On going into the drawing-room, however, I made every effort to ingratiate myself with the little dark-eyed, high-foreheaded Charlotte, and was very sorry, —but I don't think the child was,—when she was sent to bed.

8. But the most happy turn of Fortune's wheel for me, in this year '39, was the coming of Osborne Gordon to Herne Hill to be my private tutor, and read with me in our little nursery. Taking up the ravelled ends of yet workable and spinnable flax in me, he began to twist them, at first through much wholesome pain, into such tenor as they were really capable of.

The first thing he did was to stop all pressure in reading. His inaugural sentence was, "When you have got too much to do, don't do it,"—a golden saying which I have often repeated since, but not enough obeyed.

To Gordon himself, his own proverb was less service-able. He was a man of quite exceptional power, and there is no saying what he might have done, with any strong motive. Very early, a keen, though entirely bene-volent, sense of the absurdity of the world took away his heart in working for it:—perhaps I should rather have

said, the density and unmalleability of the world, than
absurdity. He thought there was nothing to be done with
it, and that after all it would get on by itself. Chiefly,
that autumn, in our walks over the Norwood hills, he,
being then an ordained, or on the point of being ordained,
priest, surprised me greatly by avoiding, evidently with
the sense of its being useless bother, my favourite topic
of conversation, namely, the torpor of the Protestant
churches, and their duty, as it to me appeared, before any
thought of missionary work, out of Europe, or comfortable
settling to pastoral work at home, to trample finally out
the smouldering "diabolic fire" of the Papacy, in all Papal-
Catholic lands. For I was then by training, thinking,
and the teaching of such small experience as I had, as
zealous, pugnacious, and self-sure a Protestant as you
please. The first condition of my being so was, of course,
total ignorance of Christian history; the second,—one
for which the Roman Church is indeed guiltily responsible,
—that all the Catholic Cantons of Switzerland, counting
Savoy also as a main point of Alpine territory, are idle and
dirty, and all Protestant ones busy and clean—a most
impressive fact to my evangelical mother, whose first duty
and first luxury of life consisted in purity of person and
surroundings; while she and my father alike looked on
idleness as indisputably Satanic. They failed not, there-
fore, to look carefully on the map for the bridge, or gate,
or vale, or ridge, which marked the separation of Protest-
ant from the benighted Catholic cantons; and it was rare
if the first or second field and cottage, beyond the border,
did not too clearly justify their exulting,—though also
indignant and partly sorrowful,—enforcement upon me
of the natural consequences of Popery.

9. The third reason for my strength of feeling at this
time was a curious one. In proportion to the delight I
felt in the ceremonial of foreign churches, was my convic-

tion of the falseness of religious sentiment founded on these
enjoyments. I had no foolish scorn of them, as the proper
expressions of the Catholic Faith; but infinite scorn of the
lascivious sensibility which could change its beliefs because
it delighted in these, and be "piped into a new creed by
the whine of an organ pipe." So that alike my reason,
and romantic pleasure, on the Continent, combined to
make a bitter Protestant of me;—yet not a malicious nor
ungenerous one. I never suspected Catholic priests of
dishonesty, nor doubted the purity of the former Catholic
Church. I was a Protestant Cavalier, not Protestant
Roundhead,—entirely desirous of keeping all that was
noble and traditional in religious ritual, and reverent to
the existing piety of the Catholic peasantry. So that the
"diabolic fire" which I wanted trampled out, was only
the corrupt Catholicism which rendered the vice of Paris
and the dirt of Savoy possible; and which I was quite
right in thinking it the duty of every Christian priest to
attack, and end the schism and scandal of it.

10. Osborne, on the contrary, was a practical English-
man, of the shrewdest, yet gentlest type; keenly perceptive
of folly, but disposed to pardon most human failings as
little more. His ambition was restricted to the walls of
Christ Church; he was already the chiefly trusted aid of
the old Dean; probably, next to him, the best Greek
scholar in Oxford, and perfectly practised in all the college
routine of business. He thought that the Church of
England had—even in Oxford—enough to do in looking
after her own faults; and addressed himself, in our con-
versations on Forest Hill, mainly to mollify my Protestant
animosities, enlarge my small acquaintance with ecclesi-
astical history, and recall my attention to the immediate
business in hand, of enjoying our walk, and recollecting
what we had read in the morning.

In his proper work with me, no tutor could have been

more diligent or patient. His own scholarly power was
of the highest order; his memory (the necessary instru-
ment of great scholarship) errorless and effortless; his
judgment and feeling in literature sound; his interpreta-
tion of political events always rational, and founded on
wide detail of well-balanced knowledge; and all this
without in the least priding himself on his classic power,
or wishing to check any of my impulses in other directions.
He had taken his double first with the half of his strength,
and would have taken a triple one without priding himself
on it: he was amused by my facility in rhyming, recog-
nized my true instinct in painting, and sympathised with
me in love of country life and picturesque towns, but
always in a quieting and reposeful manner. Once in
after life, provoked at finding myself still unable to read
Greek easily, I intimated to him a half-formed purpose
to throw everything else aside, for a time, and make myself
a sound Greek scholar. "I think it would give you more
trouble than it is worth," said he. Another time, as I
was making the drawing of "Chamouni in afternoon
sunshine" for him, (now at his sister's,) I spoke of the
constant vexation I suffered because I could not draw
better. "And I," he said, simply, "should be very content
if I could draw at all."

11. During Gordon's stay with us, this 1839 autumn,
we got our second Turner drawing. Certainly the most
curious failure of memory—among the many I find—is
that I don't know when I *saw* my first! I feel as if
Mr. Windus's parlour at Tottenham had been familiar
to me since the dawn of existence in Brunswick Square.

Mr. Godfrey Windus was a retired coachmaker, living
in a cheerful little villa, with low rooms on the ground
floor opening pleasantly into each other, like a sort of
grouped conservatory, between his front and back gardens:
their walls beset, but not crowded, with Turner drawings

of the England series; while in his portfolio-stands, coming there straight from the publishers of the books they illustrated, were the entire series of the illustrations to Scott, to Byron, to the South Coast, and to Finden's Bible.

Nobody, in all England, at that time,—and Turner was already sixty,—*cared*, in the true sense of the word, for Turner, but the retired coachmaker of Tottenham, and I.

Nor, indeed, could the public ever see the drawings, so as to begin to care for them. Mr. Fawkes's were shut up at Farnley, Sir Peregrine Acland's, perishing of damp in his passages, and Mr. Windus bought all that were made for engravers as soon as the engraver had done with them. The advantage, however, of seeing them all collected at his house,—he gave an open day each week, and to me the run of his rooms at any time,—was, to the general student, inestimable, and, for me, the means of writing "Modern Painters."

12. It is, I think, noteworthy that, although first attracted to Turner by the mountain truth in Rogers' Italy,—when I saw the drawings, it was almost wholly the pure artistic quality that fascinated me, whatever the subject; so that I was not in the least hindered by the beauty of Mr. Windus's Llanberis or Melrose from being quite happy when my father at last gave me, not for a beginning of Turner collection, but for a specimen of Turner's work, which was all—as it was supposed—I should ever need or aspire to possess, the "Richmond Bridge, Surrey."

The triumphant talk between us over it, when we brought it home, consisted, as I remember, greatly in commendation of the quantity of Turnerian subject and character which this single specimen united:—"it had trees, architecture, water, a lovely sky, and a clustered bouquet of brilliant figures."

And verily the Surrey Richmond remained for at least two years our only Turner possession, and the second we bought, the Gosport, which came home when Gordon was staying with us, had still none of the delicate beauty of Turner except in its sky; nor were either my father or I the least offended by the ill-made bonnets of the lady-passengers in the cutter, nor by the helmsman's head being put on the wrong way.

The reader is not to think, because I speak thus frankly of Turner's faults, that I judge them greater, or know them better, now, than I did then. I knew them at this time of getting Richmond and Gosport just as well as other people; but knew also the power shown through these faults, to a degree quite wonderful for a boy;—it being my chief recreation, after Greek or trigonometry in the nursery-study, to go down and feast on my Gosport.

13. And so, after Christmas, I went back to Oxford for the last push, in January 1840, and did very steady work with Gordon, in St. Aldate's;* the sense that I was coming of age somewhat increasing the feeling of responsibility for one's time. On my twenty-first birthday my father brought me for a present the drawing of Winchelsea, —a curious choice, and an unlucky one. The thundrous sky and broken white light of storm round the distant gate and scarcely visible church, were but too true symbols of the time that was coming upon us; but neither he nor I were given to reading omens, or dreading them. I suppose he had been struck by the power of the drawing, and he always liked soldiers. I was disappointed, and saw for the first time clearly that my father's joy in

* The street, named from its parish church, going down past Christ Church to the river. It was the regular course of a gentleman-commoner's residence to be promoted from Peckwater to Tom Quad, and turned out into the street for his last term. I have no notion at this minute who St. Aldate was;—American visitors may be advised that in Oxford it will be expected of them to call him St. Old.

Rubens and Sir Joshua could never become sentient of
Turner's microscopic touch. But I was entirely grateful
for his purpose, and very thankful to have any new Turner
drawing whatsoever; and as at home the Gosport, so in
St. Aldate's the Winchelsea, was the chief recreation of
my fatigued hours.

14. This Turner gift, however, was only complimen-
tary. The same day my father transferred into my name
in the stocks as much as would bring in at least £200 a
year, and watched with some anxiety the use I should
make of this first command of money. Not that I had
ever been under definite restriction about it: at Oxford I
ran what accounts with the tradesmen I liked, and the
bills were sent in to my mother weekly; there was never
any difficulty or demur on either side, and there was
nothing out of the common way in Oxford I wanted to
buy, except the engraving of Turner's Grand Canal, for
my room wall,—and Monsier Jabot, the first I ever saw
of Topffer's rivalless caricatures, one day when I had a
headache. For anything on which my state or comfort
in the least depended, my father was more disposed to be
extravagant than I; but he had always the most curious
suspicion of my taste for minerals, and only the year before,
in the summer term, was entirely vexed and discomfited
at my giving eleven shillings for a piece of Cornish
chalcedony. That I never thought of buying a mineral
without telling him what I had paid for it, besides advising
him duly of the fact, curiously marks the intimate confi-
dence between us: but alas, my respect for his judgment
was at this time by these littlenesses gradually diminished;
and my confidence in my own painfully manifested to him
a very little while after he had permitted me the above
stated measure of independence. The Turner drawings
hitherto bought,—Richmond, Gosport, Winchelsea,—
were all supplied by Mr. Griffith, an agent in whom

Turner had perfect confidence, and my father none. Both were fatally wrong. Had Turner dealt straight with my father, there is no saying how much happiness might have come of it for all three of us; had my father not been always afraid of being taken in by Mr. Griffith, he might at that time have bought some of the loveliest drawings that Turner ever made, at entirely fair prices. But Mr. Griffith's art-salesmanship entirely offended my father from the first, and the best drawings were always let pass, because Mr. Griffith recommended them, while Winchelsea and Gosport were both bought—among other reasons—because Mr. Griffith said they were not drawings which we ought to have!

15. Among those of purest quality in his folios at this time was one I especially coveted, the Harlech. There had been a good deal of dealers' yea and nay about it, whether it was for sale or not; it was a smaller drawing than most of the England and Wales series, and there were many hints in the market about its being iniquitous in price. The private view day of the Old Water Colour came; and, arm in arm with my father, I met Mr. Griffith in the crowd. After the proper five minutes of how we liked the exhibition, he turned specially to me. "I have some good news for you, the Harlech is ready for sale." "I'll take it then," I replied, without so much as a glance at my father, and without asking the price. Smiling a little ironically, Mr. Griffith went on, "And—seventy," —implying that seventy was a low price, at once told me in answer to my confidence. But it was thirty above the Winchelsea, twenty-four above Gosport, and my father was of course sure that Mr. Griffith had put twenty pounds on at the instant.

The mingled grief and scorn on his face told me what I had done; but I was too happy on pouncing on my Harlech to feel for him. All sorts of blindness and error

on both sides, but, on his side, inevitable,—on mine, more foolish than culpable; fatal every way, beyond words.

16. I can scarcely understand my eagerness and delight in getting the Harlech at this time, because, during the winter, negotiations had been carried on in Paris for Adèle's marriage; and, it does not seem as if I had been really so much crushed by that event as I expected to be. There are expressions, however, in the foolish diaries I began to write, soon after, of general disdain of life, and all that it could in future bestow on me, which seem inconsistent with extreme satisfaction in getting a water-colour drawing, sixteen inches by nine. But whatever germs of better things remained in me, were then all centred in this love of Turner. It was not a piece of painted paper, but a Welsh castle and village, and Snowdon in blue cloud, that I bought for my seventy pounds. This must have been in the Easter holidays;—Harlech was brought home and safely installed in the drawing-room on the other side of the fireplace from my idol-niche: and I went triumphantly back to St. Aldate's and Winchelsea.

In spite of Gordon's wholesome moderatorship, the work had come by that time to high pressure, until twelve at night from six in the morning, with little exercise, no cheerfulness, and no sense of any use in what I read, to myself or anybody else: things progressing also smoothly in Paris, to the abyss. One evening, after Gordon had left me, about ten o'clock, a short tickling cough surprised me, because preceded by a curious sensation in the throat, and followed by a curious taste in the mouth, which I presently perceived to be that of blood. It must have been on a Saturday or Sunday evening, for my father, as well as my mother, was in the High Street lodgings. I walked round to them and told them what had happened.

17. My mother, an entirely skilled physician in all forms of consumptive disease, was not frightened, but sent

round to the Deanery to ask leave for me to sleep out of
my lodgings. Morning consultations ended in our going
up to town, and town consultations in my being forbid
any farther reading under pressure, and in the Dean's
giving me, with many growls, permission to put off taking
my degree for a year. During the month or two follow-
ing, passed at Herne Hill, my father's disappointment at
the end of his hopes of my obtaining distinction in Oxford
was sorrowfully silenced by his anxiety for my life. Once
or twice the short cough, and mouth-taste—it was no
more—of blood, returned; but my mother steadily main-
tained there was nothing serious the matter, and that
I only wanted rest and fresh air. The doctors, almost
unanimously,—Sir James Clark excepted,—gave gloomier
views. Sir James cheerfully, but decidedly, ordered me
abroad before autumn, to be as much in open carriages as
possible, and to winter in Italy.

And Mr. Telford consented to sit in the counting-
house, and the clerks promised to be diligent; and my
father, to whom the business was nothing, but for me, left
his desk, and all other cares of life, but that of nursing me.

18. Of his own feelings, he said little; mine, in the
sickly fermentation of temper I was in, were little deserv-
ing of utterance, describable indeed less as feelings than as
the want of them, in all wholesome directions but one;—
magnetic pointing to all presence of natural beauty, and
to the poles of such art and science as interpreted it. My
preparations for the journey were made with some renewal
of spirit; my mother was steadily, bravely, habitually
cheerful; while my father, capable to the utmost of every
wise enjoyment in travelling, and most of all, of that in
lovely landscape, had some personal joy in the thought of
seeing South Italy. The attacks of the throat cough
seemed to have ceased, and the line of our journey began
to be planned with some of the old exultation.

That we might not go through Paris, the route was arranged by Rouen and the Loire to Tours, then across France by Auvergne, and down the Rhone to Avignon; thence, by the Riviera and Florence, to the South.

19. "And is there to be no more Oxford?" asks Froude, a little reproachfully, in a recent letter concerning these memoranda; for he was at Oriel while I was at Christ Church, and does not think I have given an exhaustive view either of the studies or manners of the University in our day.

No, dear friend. I have no space in this story to describe the advantages I never used; nor does my own failure give me right to blame, even were there any use in blaming, a system now passed away. Oxford taught me as much Greek and Latin as she could; and though I think she might also have told me that fritillaries grew in Iffley meadow, it was better that she left me to find them for myself, than that she should have told me, as nowadays she would, that the painting on them was only to amuse the midges. For the rest, the whole time I was there, my mind was simply in the state of a squash before 'tis a peascod,—and remained so yet a year or two afterwards, I grieve to say;—so that for any account of my real life, the gossip hitherto given to its codling or cocoon condition has brought us but a little way. I must get on to the days of opening sight, and effective labour; and to the scenes of nobler education which all men who keep their hearts open, receive in the End of Days.

CHAPTER II

ROME

20. However dearly bought, the permission to cease reading, and put what strength was left into my sketching again, gave healthy stimulus to all faculties which had been latently progressive in me; and the sketchbooks and rulers were prepared for this journey on hitherto unexampled stateliness of system.

It had chanced, in the spring of the year, that David Roberts had brought home and exhibited his sketches in Egypt and the Holy Land. They were the first studies ever made conscientiously by an English painter, not to exhibit his own skill, or make capital out of his subjects, but to give true portraiture of scenes of historical and religious interest. They were faithful and laborious beyond any outlines from nature I had ever seen, and I felt also that their severely restricted method was within reach of my own skill, and applicable to all my own purposes.

With Roberts' deficiencies or mannerism I have here no concern. He taught me, of absolute good, the use of the fine point instead of the blunt one; attention and indefatigable correctness in detail; and the simplest means of expressing ordinary light and shade on grey ground, flat wash for the full shadows, and heightening of the gradated lights by warm white.

21. I tried these adopted principles first in the courtyard of the Chateau de Blois: and came in to papa and mamma declaring that "Prout would give his ears to make such a drawing as that."

With some truth and modesty, I might have said he

"would have changed eyes with me;" for Prout's manner
was gravely restricted by his nearness of sight.　But also
this Blois sketch showed some dawning notions of grace
in proportion, and largeness of effect, which enabled me
for the first time that year, to render continental subjects
with just expression of their character and scale, and well-
rounded solidification of pillars and sculpture.

22. The last days of the summer were well spent at
Amboise, Tours, Aubusson, Pont Gibaud, and Le Puy;
but as we emerged into the Rhone valley, autumn broke
angrily on us; and the journey by Valence to Avignon
was all made gloomy by the ravage of a just past inundation,
of which the main mass at Montelimar had risen from
six to eight feet in the streets, and the slime remained,
instead of fields, over—I forget in fact, and can scarcely
venture to conceive,—what extent of plain.　The Rhone,
through these vast gravelly levels a mere driving weight
of discoloured water;—the Alps, on the other side, now
in late autumn snowless up to their lower peaks, and
showing few eminent ones;—the bise, now first letting
one feel what malignant wind could be,—might, perhaps,
all be more depressing to me in my then state of temper;
but I have never cared to see the lower Rhone any more;
and to my love of cottage rather than castle, added at this
time another strong moral principle, that if ever one was
metamorphosed into a river, and could choose one's own
size, it would be out of all doubt more prudent and delight-
ful to be Tees or Wharfe than Rhone.

And then, for the first time, at Frejus, and on the
Esterelle and the Western Riviera, I saw some initial
letters of Italy, as distinct from Lombardy,—Italy of the
stone pine and orange and palm, white villa and blue sea;
and saw it with right judgment, as a wreck, and a
viciously neglected one.

23. I don't think the reader has yet been informed

that I inherited to the full my mother's love of tidiness and
cleanliness; so that quite one of the most poetical charms
of Switzerland to me, next to her white snows, was her
white sleeves. Also I had my father's love of solidity
and soundness,—of unveneered, unrouged, and well finished
things; and here on the Riviera there were lemons and
palms, yes,—but the lemons pale, and mostly skin; the
palms not much larger than parasols; the sea—blue, yes,
but its beach nasty; the buildings, pompous, luxurious,
painted like Grimaldi,—usually broken down at the ends,
and in the middle, having sham architraves daubed over
windows with no glass in them; the rocks shaly and
ragged, the people filthy: and over everything, a coat of
plaster dust.

I was in a bad humour? Yes, but everything I have
described is as I say, for all that; and though the last time
I was at Sestri *I* wanted to stay there, the ladies with me
wouldn't and couldn't, because of the filth of the inn;
and the last time I was at Genoa, 1882, my walk round
the ramparts was only to study what uglinesses of plants
liked to grow in dust, and crawl, like the lizards, into clefts
of ruin.

24. At Genoa I saw then for the first time the circular
Pieta by Michael Angelo, which was my initiation in all
Italian art. For at this time I understood no jot of Italian
painting, but only Rubens, Vandyke, and Velasquez.
At Genoa, I did not even hunt down the Vandykes, but
went into the confused frontage of the city at its port,
(no traversing blank quay blocking out the sea, then,) and
drew the crescent of houses round the harbour, borne on
their ancient arches;—a noble subject, and one of the
best sketches I ever made.

From Genoa, more happy journey by the Eastern
Riviera began to restore my spring of heart. I am just in
time, in writing these memories, to catch the vision of

the crossing Magra, in old time, and some of the other mountain streams of the two Rivieras.

It seems unbelievable to myself, as I set it down, but there were then only narrow mule bridges over the greater streams on either side of which were grouped the villages, where the river slackened behind its sea bar. Of course, in the large towns, Albenga, Savona, Ventimiglia, and so on, there were proper bridges; but at the intermediate hamlets (and the torrents round whose embouchures they grew were often formidable), the country people trusted to the slack of the water at the bar, and its frequent failure altogether in summer, for traverse of their own carrioles: and had neither mind nor means to build Waterloo bridges for the convenience of English carriages and four. The English carriage got across the shingle how it could; the boys of the village, if the horses could not pull it through, harnessed themselves in front; and in windy weather, with deep water on the inside of the bar, and blue breakers on the other, one really began sometimes to think of the slackening wheels of Pharaoh.

25. It chanced that there were two days of rain as we passed the Western Riviera; there was a hot night at Albenga before they came on, and my father wrote—which was extremely wrong of him—a parody of "Woe is me, Alhama," the refrain being instead, "Woe is me, Albenga"; the Moorish minarets of the old town and its Saracen legends, I suppose, having brought "the Moorish King rode up and down" into his head. Then the rain, with wild sirocco, came on; and somewhere near Savona there was a pause at the brink of one of the streams, in rather angry flood, and some question if the carriage could get through. Loaded, it could not, and everybody was ordered to get out and be carried across, the carriage to follow, in such shifts as it might. Everybody obeyed these orders, and submitted to the national customs with

great hilarity, except my mother, who absolutely refused to be carried in the arms of an Italian ragged opera hero, more or less resembling the figures whom she had seen carrying off into the mountains the terrified Taglioni, or Cerito. Out of the carriage she would not move, on any solicitation;—if they could pull the carriage through, they could pull her too, she said. My father was alike alarmed and angry, but as the surrounding opera corps de ballet seemed to look on the whole thing rather as a jest and an occasion for bajocco gathering, than any crisis of fate, my mother had her way; a good team of bare-legged youngsters was put to, and she and the carriage entered the stream with shouting. Two-thirds through, the sand was soft, and horses and boys stopped to breathe. There was another, and really now serious, remonstrance with my mother, we being all nervous about quicksands, as if it had been the middle of Lancaster Bay. But stir she would not; the horses got their wind again, and the boys their way, and with much whip cracking and splashing, carriage and dama Inglese were victoriously dragged to dry land, with general promotion of good will between the two nations.

26. Of the passage of Magra, a day or two afterwards, my memory is vague as its own waves. There were all sorts of paths across the tract of troubled shingle, and I was thinking of the Carrara mountains beyond, all the while. Most of the streams fordable easily enough; a plank or two, loosely propped with a heap of stones, for pier and buttress, replaced after every storm, served the foot passenger. The main stream could neither be bridged nor forded, but was clumsily ferried, and at one place my mother had no choice really but between wading or being carried. She suffered the indignity, I think with some feeling of its being a consequence of the French Revolution, and remained cross all the way to Carrara.

We were going on to Massa to sleep, but had time to stop and walk up the dazzling white road to the lower quarry, and even to look into one or two "studios,"— beginnings of my fixed contempt for rooms so called, ever since. Nevertheless, partly in my father's sense of what was kind and proper to be done,—partly by way of buying "a trifle from Matlock,"—and partly because he and I both liked the fancy of the group, we bought a two feet high "Bacchus and Ariadne," copied from I know not what (we supposed classic) original, and with as much art in it as usually goes to a French timepiece. It remained long on a pedestal in the library at Denmark Hill, till it got smoked, and was put out of the way.

With the passage of the Magra, and the purchase of the Bacchus and Ariadne, to remain for a sort of monument of the two-feet high knowledge of classic art then possessed by me, ended the state of mind in which my notions of sculpture lay between Chantrey and Roubilliac. Across Magra I felt that I was in Italy proper; the next day we drove over the bridge of Serchio into Lucca.

27. I am wrong in saying I "felt," *then*, I was in Italy proper. It is only in looking back that I can mark the exact point where the tide began to turn for me; and total ignorance of what early Christian art meant, and of what living sculpture meant, were first pierced by vague wonder and embarrassed awe, at the new mystery round me. The effect of Lucca on me at this time is now quite confused with the far greater one in 1845. Not so that of the first sight of Pisa, where the solemnity and purity of its architecture impressed me deeply;—yet chiefly in connection with Byron and Shelley. A masked brother of the Misericordia first met us in the cathedral of Lucca; but the possible occurrence of the dark figures in the open sunlight of the streets added greatly to the imaginative effect of Pisa on my then nervous and depressed fancy.

I drew the Spina Chapel with the Ponte-a-Mare beyond, very usefully and well; but the languor of the muddy Arno as against Reuss, or Genevoise Rhone, made me suspect all past or future descriptions of Italian rivers. Singularly, I never saw Arno in full flood till 1882, nor understood till then that all the rivers of Italy are mountain torrents. I am ashamed, myself, to read, but feel it an inevitable duty to print, the piece of diary which records my first impression of Florence.

28. "November 13th, 1840. I have just been walking, or sauntering, in the square of the statues, the air perfectly balmy; and I shall not soon forget, I hope, the impression left by this square as it opened from the river, with the enormous mass of tower above,—or of the Duomo itself. I had not expected any mass of a church, rather something graceful, like La Salute at Venice; and, luckily, coming on it at the south-east angle, where the gallery round the dome is complete, got nearly run over before I recovered from the stun of the effect. Not that it is good as architecture even in its own barbarous style. I cannot tell what to think of it; but the wealth of exterior marble is quite overwhelming, and the motion of magnificent figures in marble and bronze about the great square, thrilling.

"Nov. 15th. I still cannot make up my mind about this place, though my present feelings are of grievous disappointment. The galleries, which I walked through yesterday, are impressive enough; but I had as soon be in the British Museum, as far as enjoyment goes, except for the Raphaels. I can understand nothing else, and not much of *them*."

29. At Florence then, this time, the Newgate-like palaces were rightly hateful to me; the old shop and market-streets rightly pleasant; the inside of the Duomo a horror, the outside a Chinese puzzle. All sacred art,—

frescoes, tempera, what not, mere zero, as they were to
the Italians themselves; the country round, dead wall and
dusty olive;—the whole, a provocation and weariness,
except for one master, M. Angelo.

I saw at once in him that there was emotion and human
life, more than in the Greeks; and a severity and meaning
which were not in Rubens. Everybody about me
swearing that Michael Angelo was the finest thing in the
world, I was extremely proud of being pleased with him;
confirmed greatly in my notion of my own infallibility,
and with help of Rogers in the Lorenzo Chapel, and long
sittings and standings about the Bacchus in the Uffizii,
progressed greatly and vitally in Michael-Angelesque
directions. But I at once pronounced the knife grinder
in the Tribune a vulgar nuisance, as I do still; the Venus
de Medicis, an uninteresting little person; Raphael's
St. John, a piece of black bombast; and the Uffizii collec-
tion in general, an unbecoming medley, got together by
people who knew nothing, and cared less than nothing,*
about the arts. On the whole, when I last walked
through the Uffizii in 1882 I was precisely of the same
opinion, and proud of having arrived at it so quickly. It
was not to be expected of me at that time to like either
Angelico or Botticelli; and if I had, the upper corridor of
the Uffizii was an entirely vile and contemptible place
wherein to see the great Madonna of the one, or the Venus
Marina of the other. Both were then in the outer passage
from the entrance to the Tribune.

These conclusions being comfortably arrived at, I sate
myself down in the middle of the Ponte Vecchio, and
made a very true and valuable sketch of the general perspec-
tive of its shops and the buildings beyond, looking towards
the Duomo. I seem to have had time or will for no more

* That is, cared the wrong way,—liked them for their meanest
skills, and worst uses.

in Florence; the Mercato Vecchio was too crowded to
work in, and the carving of the Duomo could not be
disengaged from its colour. Hopeful, but now somewhat
doubtful, of finding things more to our mind in the south,
we drove through the Porta Romana.

30. Siena, Radicofani, Viterbo, and the fourth day,
Rome;—a gloomy journey, with gloomier rests. I had
a bad weary headache at Siena; and the cathedral seemed
to me every way absurd—over-cut, over-striped, over-
crocketed, over-gabled, a piece of costly confectionery,
and faithless vanity. In the main it is so; the power of
Siena was in her old cathedral, *her* Edward the Confessor's
Westminster. Is the ruin of it yet spared?

The volcanic desert of Radicofani, with gathering
storm, and an ominously Æolian keyhole in a vile inn,
remained long to all of us a terrific memory. At Viterbo
I was better, and made a sketch of the convent on one side
of the square, rightly felt and done. On the fourth day
papa and mamma observed with triumph, though much
worried by the jolting, that every mile nearer Rome the
road got worse!

31. My stock of Latin learning, with which to begin
my studies of the city, consisted of the two first books of
Livy, never well known, and the names of places remem-
bered without ever looking where they were on a map;
Juvenal, a page or two of Tacitus, and in Virgil the
burning of Troy, the story of Dido, the episode of Euryalus
and the last battle. Of course, I had nominally read the
whole Æneid, but thought most of it nonsense. Of later
Roman history, I had read English abstracts of the
imperial vices, and supposed the malaria in the Campagna
to be the consequence of the Papacy. I had never heard
of a good Roman emperor, or a good pope; was not quite
sure whether Trajan lived before Christ or after, and
would have thanked, with a sense of relieved satisfaction,

anybody who might have told me that Marcus Antoninus was a Roman philosopher contemporary with Socrates.

32. The first sight of St. Peter's dome, twenty miles away, was little more to any of us than the apparition of a grey milestone, announcing twenty miles yet of stony road before rest. The first sluggish reach of Tiber, with its mud shore and ochreous water, was a quite vile and saddening sight to me,—as compared with breezy tide of Thames, seen from Nanny Clowsley's. The Piazza del Popolo was as familiar to me, from paintings, as Cheapside, and much less interesting. We went, of course, to some hotel in the Piazza di Spagna, and I went to bed tired and sulky at finding myself in a big street of a big modern town, with nothing to draw, and no end of things to be bothered with. Next day, waking refreshed, of course I said, "I am in Rome," after Mr. Rogers; and accompanied papa and mamma, with a tinge of curiosity, to St. Peter's.

Most people and books had told me I should be disappointed in its appearance of size. But I have not vainly boasted my habit and faculty of measuring magnitudes, and there was no question to me how big it was. The characters I was not prepared for were the clumsy dulness of the façade, and the entirely vile taste and vapid design of the interior. We walked round it, saw the mosaic copies of pictures we did not care for, the pompous tombs of people whose names we did not know, got out to the fresh air and fountains again with infinite sense of relief, and never again went near the place, any of us, except to hear music, or see processions and paraphernalia.

33. So we went home to lunch, and of course drove about the town in the afternoon, and saw the Forum, Coliseum, and so on. I had no distinct idea what the Forum was or ever had been, or how the three pillars, or the seven, were connected with it, or the Arch of

Severus, standing without any road underneath, or the
ragged block of buildings above, with their tower of the
commonest possible eighteenth century type. There was,
however, one extreme good in all this, that I saw things,
with whatever faculty was in me, exactly for what they
were; and though my religious instruction, as aforesaid,
led me to suppose the malaria in the Campagna was the
consequence of the Papacy, that did not in the least affect
my clear and invincible perception that the outline of
Soracte was good, and the outlines of tufo and pozzolana
foregrounds bad, whether it was Papal or Protestant
pozzolana. What the Forum or Capitol had been, I did
not in the least care; the pillars of the Forum I saw were
on a small scale, and their capitals rudely carved, and the
houses above them nothing like so interesting as the side
of any close in the "Auld toun" of Edinburgh.

34. Having ascertained these general facts about the
city and its ruins, I had to begin my gallery work. Of
course all the great religious paintings, Perugino's ante-
chamber, Angelico's chapel, and the whole lower story of
the Sistine, were entirely useless to me. No soul ever
bade me look at them, and I had no sense yet to find
them out for myself. Everybody told me to look at the
roof of the Sistine chapel, and I liked it; but everybody
also told me to look at Raphael's Transfiguration, and
Domenichino's St. Jerome; which also I did attentively,
as I was bid, and pronounced—without the smallest
hesitation—Domenichino's a bad picture, and Raphael's
an ugly one; and thenceforward paid no more attention
to what anybody said, (unless I happened to agree with it)
on the subject of painting.

Sir Joshua's verdict on the Stanze was a different matter,
and I studied them long and carefully, admitting at once
that there was more in them than I was the least able to
see or understand, but decisively ascertaining that they

could not give me the least pleasure, and contained a mixture of Paganism and Papacy wholly inconsistent with the religious instruction I had received in Walworth.

Having laid these foundations of future study, I never afterwards had occasion seriously to interfere with them. Domenichino is always spoken of—as long as, in deference to Sir Joshua, I name him at all—as an entirely bad painter; the Stanze, as never giving, or likely to give, anybody in a healthy state of mind,—that is to say, desirous of knowing what sibyls were really like, or how a Greek conceived the Muses,—the slightest pleasure; and the opposition of the Parnassus to the Disputa, shown, in the "Stones of Venice," * to foretell the fall of Catholic Theology.

35. The main wonders of Rome thus taken stock of, and the course of minor sight-seeing begun, we thought it time to present a letter of introduction which Henry Acland had given me to Mr. Joseph Severn.

Although in the large octavo volume containing the works of Coleridge, Shelley, and Keats, which so often lay on my niche-table at Herne Hill, the Keats part had never attracted me, and always puzzled, I had got quite enough perception of his natural power, and felt enough regret for his death, to make me wait with reverence on his guardian friend. I forget exactly where Mr. Severn lived at that time, but his door was at the right of the landing at the top of a long flight of squarely reverting stair,—broad, to about the span of an English lane that would allow two carts to pass; and broad-stepped also, its gentle incline attained by some three inches of fall to a foot of flat. Up this I was advancing slowly,—it being forbidden me ever to strain breath,—and was within

* I have authorized the republication of this book in its original text and form, chiefly for the sake of its clear, and the reader will find, wholly incontrovertible, statement of the deadly influence of Renaissance Theology on the Arts in Italy, and on the religion of the World.

eighteen or twenty steps of Mr. Severn's door, when it opened, and two gentlemen came out, closed it behind them with an expression of excluding the world for evermore from that side of the house, and began to descend the stairs to meet me, holding to my left. One was a rather short, rubicund, serenely beaming person; the other, not much taller, but paler, with a beautifully modelled forehead, and extremely vivid, though kind, dark eyes.

36. They looked hard at me as they passed, but in my usual shyness, and also because I have held it a first principle of manners not to waylay people;—above all, not to stop them when they are going out, I made no sign, and leaving them to descend the reverting stair in peace, climbed, at still slackening pace, the remaining steps to Mr. Severn's door, and left my card and letter of introduction with the servant, who told me he had just gone out. His dark-eyed companion was George Richmond, to whom, also, Acland had given me a letter. Both Mr. Severn and he came immediately to see us. My father and mother's quiet out-of-the-wayness at first interested, soon pleased, and at last won them, so completely, that before Christmas came, out of all people in Rome they chose us to eat their Christmas dinner with. Much more for my father's sake and mother's, than mine; not that they were uninterested in me also, but as *my* ways of out-of-the-wayness were by no means quiet, but perpetually firing up under their feet in little splutters and spitfires of the most appalling heresy; and those not only troublesome in immediate crackle, but carried out into steady, and not always refutable, objection to nearly everything sacred in their sight, of the autocratic masters and authentic splendours of Rome, their dialogues with me were apt to resolve themselves into delicate disguises of necessary reproof; and even with my father and mother, into consultation as to what was best to be done to bring me to anything like a

right mind. The old people's confidence in *them* had been unbounded from the first, in consequence of Mr. Severn's having said to Mr. Richmond when they met me on the stairs, "What a poetical countenance!"—and my recently fanatical misbehaviour in the affair of the Harlech, coupled with my now irrepressible impertinences to Raphael and Domenichino, began to give me in my parents' eyes something of the distant aspect of the Prodigal Son.

37. The weight of adverse authority which I had thus to support was soon increased by the zeal of Mr. Richmond's younger brother, Tom, whom I found, on the first occasion of my visiting them in their common studio, eagerly painting a torso with shadows of smalt blue, which, it was explained to me, were afterwards to be glazed so as to change into the flesh colour of Titian. As I did not at that time see anything particular in the flesh colour of Titian, and did not see the slightest probability—if there were—of its being imitable by that process, here was at once another chasm of separation opened between my friends and me, virtually never closed to the end of time; and in its immediately volcanic effect, decisive of the manner in which I spent the rest of my time in Rome and Italy. For, making up my mind thenceforward that the sentiment of Raphael and tints of Titian were alike beyond me, if not wholly out of my way; and that the sculpture galleries of the Vatican were mere bewilderment and worry, I took the bit in my teeth, and proceeded to sketch what I could find in Rome to represent in my own way, bringing in primarily,—by way of defiance to Raphael, Titian, and the Apollo Belvidere all in one,—a careful study of old clothes hanging out of old windows in the Jews' quarter.

38. The gauntlet being thus thrown, the two Mr. Richmonds and my father had nothing for it but to amuse

themselves as best they could with my unclassical efforts, not, taken on my own terms, without interest. I did the best I could for the Forum, in a careful general view; a study of the aqueducts of the Campagna from St. John Lateran, and of the Aventine from the Ponte Rotto, were extremely pleasant to most beholders; and at last even Mr. Richmond was so far mollified as to ask me to draw the street of the Trinita di Monte for him, with which he had many happy associations. There was another practical chance for me in life at this crisis,—I might have made the most precious records of all the cities in Italy. But all my chances of being anything but what I am were thrown away, or broken short, one after another. An entirely mocking and mirage-coloured one, as it seemed then, yet became, many a year later, a great and beautiful influence on my life.

39. Between my Protestantism and, as Tom Richmond rightly called it, Proutism, I had now abjured Roman shows altogether, and was equally rude and restive, whether I was asked to go to a church, a palace, or a gallery,—when papa and mamma began to perceive some dawn of docility in me about going to hear musical church services. This they naturally attributed to my native taste for Gregorian chants, and my increasing aptitude for musical composition. But the fact was, that at services of this kind there was always a chance of seeing, at intervals, above the bowed heads of the Italian crowd, for an instant or two before she also stooped—or sometimes, eminent in her grace above a stunted group of them,—a fair English girl, who was not only the admitted Queen of beauty in the English circle of that winter in Rome, but was so, in the kind of beauty which I had only hitherto dreamed of as possible, but never yet seen living: statuesque severity with womanly sweetness joined. I don't think I ever succeeded in getting nearer than within fifty yards

of her; but she was the light and solace of all the Roman winter to me, in the mere chance glimpses of her far away, and the hope of them.

40. Meantime, my father, to whom our Roman physician had given an encouraging report of me, recovered some of his natural cheerfulness, and enjoyed, with his niece, who if not an enthusiastic, was an indefatigable and attentive sight-seeker and seer, everything that Rome had to show; the musical festas especially, whenever his cross-grained boy consented, for Miss Tollemache's secret sake, to go with him; while Mr. Severn and George Richmond became every day more kindly—nor, we felt, without real pleasure to themselves—helpful to us all. No *habitué* of the brightest circles of present London Society will doubt the privilege we had in better and better knowing George Richmond. But there is nothing in any circle that ever I saw or heard of, like what Mr. Joseph Severn then was in Rome. He understood everybody, native and foreign, civil and ecclesiastic, in what was nicest in them, and never saw anything else than the nicest; or saw what other people got angry about as only a humorous part of the nature of things. It was the nature of things that the Pope should be at St. Peter's, and the beggars on the Pincian steps. He forgave the Pope his papacy, reverenced the beggar's beard, and felt that alike the steps of the Pincian, and the Araceli, and the Lateran, and the Capitol, led to heaven, and everybody was going up, somehow; but might be happy where they were in the meantime. Lightly sagacious, lovingly humorous, daintily sentimental, he was in council with the cardinals to-day, and at picnic in Campagna with the brightest English belles to-morrow; and caught the hearts of all in the golden net of his good will and good understanding, as if life were but for him the rippling chant of his favourite song,—

"Gente, e qui l'uccellatore."

CUMÆ

41. IN my needful and fixed resolve to set the facts down continuously, leaving the reader to his reflections on them, I am slipping a little too fast over the surfaces of things; and it becomes at this point desirable that I should know, or at least try to guess, something of what the reader's reflections *are!* and whether in the main he is getting at the sense of the facts I tell him.

Does he think me a lucky or unlucky youth, I wonder? Commendable, on the whole, and exemplary—or the reverse? Of promising gifts—or merely glitter of morning, to pass at noon? I ask him at this point, because several letters from pleased acquaintances have announced to me, of late, that they have obtained quite new lights upon my character from these jottings, and like me much better than they ever did before. Which was not the least the effect I intended to produce on them; and which moreover is the exact opposite of the effect on my own mind of meeting myself, by turning back, face to face.

42. On the contrary, I suffer great pain, and shame, in perceiving with better knowledge the little that I was, and the much that I lost—of time, chance, and—duty, (a duty missed is the worst of loss); and I cannot in the least understand what my acquaintances have found, in anything hitherto told them of my childhood, more amiable than they might have guessed of the author of "Time and Tide," or "Unto This Last." The real fact being, whatever they make of it, that hitherto, and for a year or two on, yet, I was simply a little floppy and soppy tadpole, —little more than a stomach with a tail to it, flattening

and wriggling itself up the crystal ripples and in the pure
sands of the springhead of youth.

But there were always good eyes in me, and a good
habit of keeping head up stream; and now the time was
coming when I began to think about helping princesses
by fetching up their balls from the bottom; when I got
a sudden glimpse of myself, in the true shape of me,
extremely startling and discouraging:—here, in Rome it
was, towards the Christmas time.

43. Among the living Roman arts of which polite
travellers were expected to carry specimens home with
them, one of the prettiest used to be the cutting cameos
out of pink shells. We bought, according to custom,
some coquillage of Gods and Graces; but the cameo
cutters were also skilful in mortal portraiture, and papa
and mamma, still expectant of my future greatness,
resolved to have me carved in cameo.

I had always been content enough with my front face
in the glass, and had never thought of contriving vision
of the profile. The cameo finished, I saw at a glance
to be well cut; but the image it gave of me was not to my
mind. I did not analyse its elements at the time, but
should now describe it as a George the Third's penny,
with a halfpenny worth of George the Fourth, the pride
of Amurath the Fifth, and the temper of eight little
Lucifers in a swept lodging.

Now I knew myself proud; yes, and of late, sullen;
but did not in the least recognise pride or sulkiness for
leading faults of my nature. On the contrary, I knew
myself wholly reverent to all real greatness, and wholly
good-humoured—when I got my own way. What
more can you expect of average boy, or beast?

And it seemed hard to me that only the excrescent
faults, and by no means the constant capacities, should be
set forth, carved by the petty justice of the practical

cameo. Concerning which, as also other later portraits of me, I will be thus far proud as to tell the disappointed spectator, once for all, that the main good of my face, as of my life, is in the eyes,—and only in those, seen near; that a very dear and wise French friend also told me, a long while after this, that the lips, though not Apolline, were kind: the George the Third and Fourth character I recognise very definitely among my people, as already noticed in my cousin George of Croydon; and of the shape of head, fore and aft, I have my own opinions, but do not think it time, yet, to tell them.

44. I think it, however, quite time to say a little more fully, not only what happened to me, now of age, but what was *in* me: to which end I permit a passage or two out of my diary, written for the first time this year wholly for my own use, and note of things I saw and thought; and neither to please papa, nor to be printed,—with corrections,—by Mr. Harrison.

I see, indeed, in turning the old leaves, that I have been a little too morose in my record of impressions on the Riviera. Here is a page more pleasant, giving first sight of a place afterwards much important in my life—the promontory of Sestri di Levante.

"Sestri, Nov. 4th (1840). Very wet all morning; merely able to get the four miles to this most lovely village, the clouds drifting like smoke from the hills, and hanging in wreaths about the white churches on their woody slopes. Kept in here till three, then the clouds broke, and we got up the woody promontory that overhangs the village. The clouds were rising gradually from the Apennines, fragments entangled here and there in the ravines catching the level sunlight like so many tongues of fire; the dark blue outline of the hills clear as crystal against a pale distant purity of green sky, the sun touching here and there upon their turfy precipices, and the white,

square villages along the gulph gleaming like silver to the
north-west;—a mass of higher mountain, plunging down
into broad valleys dark with olive, their summits at first
grey with rain, then deep blue with flying showers—the
sun suddenly catching the near woods at their base,
already coloured exquisitely by the autumn, with such a
burst of robing,—penetrating, glow as Turner only could
even imagine, set off by the grey storm behind. To the
south, an expanse of sea, varied by reflection of white
Alpine cloud, and delicate lines of most pure blue, the
low sun sending its line of light—forty miles long—from
the horizon; the surges dashing far below against rocks
of black marble, and lines of foam drifting back with the
current into the open sea. Overhead, a group of dark
Italian pine and evergreen oak, with such lovely ground
about their roots as we have in the best bits of the islands
of Derwentwater. This continued till near sunset, when
a tall double rainbow rose to the east over the fiery woods,
and as the sun sank, the storm of falling rain on the moun-
tains became suddenly purple—nearly crimson; the rain-
bow, its hues scarcely traceable, one broad belt of crimson,
the clouds above all fire. The whole scene such as can
only come once or twice in a lifetime."

45. I see that we got to Rome on a Saturday, Novem-
ber 28th. The actual first entry next morning is, perhaps,
worth keeping:—

"Nov. 29th, Sunday. A great fuss about Pope officiat-
ing in the Sistine Chapel—Advent Sunday. Got into a
crowd, and made myself very uncomfortable for nothing:
no music worth hearing, a little mummery with Pope and
dirty cardinals. Outside and west façade of St. Peter's
certainly very fine: the inside would make a nice ball-
room, but is good for nothing else."

"Nov. 30th. Drove up to the Capitol—a filthy,
melancholy-looking, rubbishy place; and down to the

Forum, which is certainly a very good subject; and then a little further on, amongst quantities of bricks and rubbish, till I was quite sick."

With disgust, I meant; but from December 20th to 25th I had a qualm of real fever, which it was a wonder came to no worse. On the 30th I am afoot again; thus:—

"I have been walking backwards and forwards on the Pincian, being unable to do anything else since this confounded illness, and trying to find out why every imaginable delight palls so very rapidly on even the keenest feelings. I had all Rome before me; towers, cupolas, cypresses, and palaces mingled in every possible grouping; a light Decemberish mist, mixed with the slightest vestige of wood smoke, hovering between the distances, and giving beautiful grey outlines of every form between the eye and the sun; and over the rich evergreen oaks of the Borghese gardens, a range of Apennine, with one principal pyramid of pure snow, like a piece of sudden comet-light fallen on the earth. It was not like moonlight, nor like sunlight, but as soft as the one, and as powerful as the other. And yet, with all this around me, I could not feel it. I was as tired of my walk, and as glad when I thought I had done duty, as ever on the Norwood road."

46. There was a girl walking up and down with some children, her light cap prettily set on very well dressed hair: of whose country I had no doubt; long before I heard her complain to one of her charges, who was jabbering English as fast as the fountain tinkled on the other side of the road, "Qu'elle n'en comprenait pas un mot." This girl after two or three turns sat down beside another *bonne*. There they sate laughing and chattering, with the expression of perfect happiness on their faces, thinking no more of the Alpine heights behind them, or the city beneath them, than of Constantinople; while I, with every feeling raised, I should think to a great degree above

theirs, was in a state of actually severe mental pain, because I could perceive materials of the highest pleasure around me, and felt the time hang heavy on my hands. Here is the pride, you perceive, good reader, and the sullens— dum pituita molestat—both plain enough. But it is no lofty pride in which I say my "*feelings*" were raised above the French *bonne's*. Very solemnly, I did not think myself a better creature than she, nor so good; but only I knew there was a link between far Soracte and me,— nay, even between unseen Voltur and me,—which was not between her and them; and meant a wider, earthly, if not heavenly, horizon, under the birth-star.

47. Meantime, beneath the hill, my mother knitted, as quietly as if she had been at home, in the corner of the great Roman room in which she cared for nothing but the cleanliness, as distinguishing it from the accommodation of provincial inns; and the days turned, and it was time to think of the journey to Naples, before any of us were tired of Rome. And simple cousin Mary, whom I never condescended to ask for either sympathy or opinion, was really making better use of her Roman days than any of us. She was a sound, plain, musician; (having been finished by Moscheles); attended to the church orchestras carefully, read her guide-books accurately, knew always where she was, and in her sincere religion, conquered her early Puritanism to the point of reverently visiting St. Paul's grave and St. Cecilia's house, and at last going up the Scala Santa on her knees, like any good girl of Rome.

48. So passed the days, till there was spring sunshine in the air as we climbed the Alban mount, and went down into the ravine under La Riccia, afterwards described in perhaps the oftenest quoted passage of "Modern Painters." The diary says: "A hollow with another village on the hill opposite, a most elegant and finished group of church

tower and roof, descending by delicate upright sprigs * of tree into a dark rich-toned depth of ravine, out of which rose nearer, and clear against its shade, a grey wall of rock, an absolute miracle for blending of bright lichenous colour."

With a few sentences more, to similar effect, and then a bit of Pontine marsh description, dwelling much on the moving points of the "black cattle, white gulls, black, bristly high-bred swine, and birds of all sorts, waders and dippers innumerable." It is very interesting, at least to myself, to find how, so early as this, while I never drew anything but in pencil outline, I *saw* everything first in colour, as it ought to be seen.

49. I must give room to the detail of the day from Mola to Naples, because it shows, to proof enough, the constant watchfulness upon which the statements in "Modern Painters" were afterwards founded, though neither that nor any other book had yet been dreamed of, and I wrote only to keep memory of things seen, for what good might come of the memory anyhow.

"Naples, January 9th (1841). Dressed yesterday at Mola by a window commanding a misty sunrise over the sea—a grove of oranges sloping down to the beach, flushed with its light; Gaeta opposite, glittering along its promontory. Ran out to terrace at side of the house, a leaden bit of roof, with pots of orange and Indian fig. There was a range of Skiddaw-like mountains rising from the shore, the ravines just like those of Saddleback, or the west side of Skiddaw; the higher parts bright with fresh-fallen snow; the highest, misty with a touch of soft white, swift † cloud. Nearer, they softened into green, bare

* I have substituted this word for a sketch like the end of a broom, which would convey no idea to anybody but myself.

† Note the instant marking the *pace* of the cloud,—the work of "Cœli Enarrant" having been begun practically years before this. See below also of the rain-cloud.

masses of hill, like Malvern, but with their tops covered with olives and lines of vine,—the village of Mola showing its white walls and level roofs above the olives, with a breath of blue smoke floating above them, and a long range of distant hills running out into the sea beyond. The air was fresh, and yet so pure and soft, and so full of perfume from the orange trees below the terrace, that it seemed more like an early summer morning than January. It got soon threatening, however, though the sun kept with us as we drove through the village;—confined streets, but bright and varied, down to the shore, and then under the slopes of the snowy precipice, now thoroughly dazzling with the risen sun, and between hedges of tall myrtle, into the plain of Garigliano. A heavy rain-cloud raced * us the ten miles, and stooped over us, stealing the blue sky inch by inch, till it had left only a strip of amber-blue † behind the Apennines, the near hills thrown into deep dark purple shade, the snow behind them, first blazing— the only strong light in the picture—then in shade, dark against the pure sky; the grey above, warm and lurid—a little washed with rain in parts; below, a copse of willow coming against the dark purples, nearly pure Indian yellow, a little touched with red. Then came a lovely bit of aqueduct, with coats of shattered mosaic, the hills seen through its arches, and pieces of bright green meadow mixing with the yellow of the willows. At Capua, detained by a rascally Dogana,—we had one at Garigliano as well, howling beggars all about (Caffé del Giglio d'Oro), one ape of a creature clinging with its legs about another's neck, and chopping its jaws with its fists. Hence a dead flat of vines hanging from elms, and road perfectly straight,

* This distinct approach, or chase, by rain-cloud is opposed, in my last lectures on sky, to the *gathering* of rain-cloud all through the air, under the influence of plague wind.

† Palest transparent blue passing into gold.

and cut utterly up by a deluge of rain. I was quite tired
as it grew dark, fragments of blue and amber sky showing
through colossal thunder clouds, and two or three pure
stars labouring among the dark masses. It lightened fast
as we got into Naples, and we were stopped again, first by
Dogana, and then at passport office, till I lost temper and
patience, and could have cried like a girl, for I was quite
wearied with the bad roads, and disappointed with the
approach to Naples, and cold. I could not help wonder-
ing at this. How little could I have imagined, sitting
in my home corner, yearning for a glance of the hill snow,
or the orange leaf, that I should, at entering Naples, be
as thoroughly out of humour as ever after a monotonous
day in London. More so!"

50. For full ten years, since earliest geologic reading, I
had thoroughly known the structure and present look of
Vesuvius and Monte Somma; nor had "Friendship's
Offering" and "Forget-me-not," in the days of the Ban-
dit Leoni, left me without useful notions of the Bay of
Naples. But the beautiful forms of Monte St. Angelo
and Capri were new to me, and the first feeling of being
in the presence of the power and mystery of the under
earth, unspeakably solemn; though Vesuvius was virtually
in repose, and the slow changes in the heaped white cloud
above the crater were only like those of a thunder cloud.

The first sight of the Alps had been to me as a direct
revelation of the benevolent will in creation. Long since,
in the volcanic powers of destruction, I had been taught
by Homer, and further forced by my own reason, to see,
if not the personality of an Evil Spirit, at all events the
permitted symbol of evil, unredeemed; wholly distinct
from the conditions of storm, or heat, or frost, on which
the healthy courses of organic life depended. In the same
literal way in which the snows and Alpine roses of Lauter-
brunnen were visible Paradise, here, in the valley of ashes

and throat of lava, were visible Hell. If thus in the
natural, how else should it be in the spiritual world?

I had never yet read a line of Dante. From the
moment when I knew the words,——

> "It now is evening there, where buried lies
> The body in which I cast a shade, removed
> To Naples from Brundusium's wall,"

not Naples only, but Italy, became for ever flushed with
the sacred twilight of them. But even now, what pieces
I knew of Virgil, in that kind, became all at once true,
when I saw the birdless lake; for me also, the voice of
it had teaching which was to be practically a warning
law of future life:——

> "Nec te
> Nequidquam lucis Hecate præfecit Avernis."

The legends became true,——*began* to come true, I
should have said,——trains of thought now first rising
which did not take clear current till forty years afterwards;
and in this first trickling, sorrowful in disappointment.
"There *were* such places then, and Sibyls *did* live in
them!——but is this all?"

Frightful enough, yes, the spasmodic ground——the
boiling sulphur lake——the Dog's grotto with its floor a
foot deep in poisoned air that could be stirred with the
hand. Awful, but also for the Delphi of Italy, ignoble.
And all that was fairest in the whole sweep of isle and sea,
I saw, as was already my wont, with precise note of its
faults.

51. The common English traveller, if he can gather a
black bunch of grapes with his own fingers, and have his
bottle of Falernian brought him by a girl with black eyes,
asks no more of this world, nor the next; and declares
Naples a Paradise. But I knew, from the first moment
when my foot furrowed volcanic ashes, that no mountain

form or colour could exist in perfection when everything
was made of scoria, and that blue sea was to be little
boasted if it broke on black sand. And I saw also, with
really wise anger, the horror of neglect in the governing
power, which Mr. Gladstone found, forsooth, in the
Neapolitan prisons! but which neither he nor any other
Englishman, so far as I know, except Byron and I, saw to
have made the Apennines one prison wall, and all the
modern life of Italy one captivity of shame and crime;
alike against the honour of her ancestors, and the kindness
of her God.

With these strong insights into the faults of others,
there came also at Naples, I am thankful to say, some
stroke of volcanic lightning on my own. The sense of
the uselessness of all Naples and its gulph to me, in my
then state of illness and gloom, was borne in upon me with
reproach: the chrysalid envelope began to tear itself open
here and there to some purpose, and I bade farewell to
the last outlines of Monte St. Angelo as they faded in
the south, with dim notions of bettering my ways in
future.

52. At Mola di Gaeta we stopped a whole day that I
might go back to draw the castle of Itri. It was hinted
darkly to us that Itri was of no good repute; we disdained
all imputations on such a lovely place, and drove back
there for a day's rambling. While I drew, my mother
and Mary went at their own sweet wills up and down;
Mary had by this time, at school and on the road, made
herself mistress of syllables enough to express some sym-
pathy with any contadina who wore a pretty cap, or carried
a pretty baby; and, the appearance of English women
being rare at Itri, the contadine were pleased, and every-
thing that was amiable to mamma and Mary. I made
an excellent sketch, and we returned in exultation to the
orange-groves of Mola. We afterwards heard that the

entire population of Itri consisted of banditti, and never troubled ourselves about banditti any more.

We stopped at Albano for the Sunday, and I went out in the morning for a walk through its ilex groves with my father and mother and Mary. For some time back, the little cough bringing blood had not troubled me, and I had been taking longer walks and otherwise counting on comparative safety, when here suddenly, in the gentle morning saunter through the shade, the cough came back —with a little darker stain on the handkerchief than usual. I sat down on a bank by the roadside, and my father's face was very grave.

We got quietly back to the inn, where he found some sort of light carriole disposable, and set out, himself, to fetch the doctor from Rome.

It has always been one of the great shadows of thought to me, to fancy my father's feelings as he was driven that day those eighteen miles across the Campagna.

Good Dr. Gloag comforted him, and returned with him. But there was nothing new to be done, nor said. Such chance attack was natural in the spring, he said, only I must be cautious for a while. My mother never lost her courage for an instant. Next day we went on to Rome, and it was the last time the cough ever troubled me.

53. The weather was fine at Easter, and I saw the Benediction, and sate in the open air of twilight opposite the castle of St. Angelo, and saw the dome-lines kindle on St. Peter's, and the castle veil the sky with flying fire. Bearing with me from that last sight in Rome many thoughts that ripened slowly afterwards, chiefly convincing me how guiltily and meanly dead the Protestant mind was to the whole meaning and end of mediæval Church splendour; and how meanly and guiltily dead the existing Catholic mind was, to the course by which to reach the Italian soul, instead of its eyes.

Re-opening, but a few days since, the book which my Christ Church official tutor, Walter Brown, recommended to me as the most useful code of English religious wisdom, the "Natural History of Enthusiasm," I chanced on this following passage, which I think must have been one of the first to startle the complacency of my Puritan creed. My since experience in theological writing furnishes me with no more terrific example of the absence alike of charity and understanding in the leading masters of that sect, beyond all others into which the Church has ever been divided:—

"If it be for a moment forgotten that in every bell, and bowl, and vest of the Romish service there is hid a device against the liberty and welfare of mankind, and that its gold, and pearls, and fine linen are the deckings of eternal ruin; and if this apparatus of worship be compared with the impurities and the cruelties of the old Polytheistic rites, great praise may seem due to its contrivers. All the materials of poetic and scenic effect have been elaborated by the genius and taste of the Italian artists until a spectacle has been got up which leaves the most splendid shows of the ancient idol worship of Greece and Rome at a vast distance of inferiority."

Yet I cannot distinctly remember being shocked, even at this passage, and I know there was much in the rest of the book that pleased me; but I had already the advantage over its author, and over all such authors, of knowing, when I saw them, sincere art from lying art, and happy faith from insolent dogmatism. I knew that the voices in the Trinita di Monte did not sing to deceive me; and that the kneeling multitude before the Pontiff were indeed bettered and strengthened by his benediction.

Although I had been able, weather favouring, to see the Easter ceremonies without danger, there was no sign, take all in all, of gain to my health from Roman winter.

My own discouragement was great; and the first cautious journeyings back by Terni and Fuligno were sad enough; the night at Terni very deeply so. For in the evening, when we came back from seeing the falls, the servant of a young Englishman asked to speak with us, saying that he was alone in charge of his master, who had been stopped there by sudden, he feared mortal, illness. Would my father come and see him? My father went, and found a beautifully featured Scottish youth of three or four and twenty, indeed in the last day of decline. He died during the night, and we were of some use to the despairing servant afterwards. I forget now whether we ever knew who the youth was. I find his name in my diary, "Farquharson," but no more.

As we drew northward, however, out of the volcanic country, I recovered heart; the enchanted world of Venice enlarging in front of me. I had only yet once seen her, and that six years ago, when still a child. That the fairy tale should come true now seemed wholly incredible, and the start from the gate of Padua in the morning,—Venice, asserted by people whom we could not but believe, to be really over there, on the horizon, in the sea! How to tell the feeling of it!

54. I have not yet fancied the reader's answer to the first question proposed in outset of this chapter,—does he think me a fortunate or unfortunate youth?

As to preparation for the future world, terrestrial or celestial, or future self in either, there may be two opinions —two or three perhaps—on the matter. But, there is no question that, of absolute happiness, I had the share of about a quarter of a million of average people, all to myself. I say "people," not "boys." I don't know what delight boys take in cricket, or boating, or throwing stones at birds, or learning to shoot them. But of average people in continuity of occupation, shopmen, clerks, Stock Ex-

change people, club and Pall Mall people, certainly there
was no reckoning the quantity of happiness I had in com-
parison, followed indeed by times of reaction, or of
puzzled satiety; and partly avenged by extremes of vexa-
tion at what vexed nobody else; but indisputably and
infinitely precious in itself, every day complete at the end,
as with Sydney Smith's salad: "Fate cannot harm me; I
have dined, to-day."

55. The two chapters closing the first, and beginning
the second volume of the "Stones of Venice" were written,
I see on re-reading, in the melancholy experience of 1852,
with honest effort to tell every traveller what was really
to be seen. They do not attempt to recall my own joys of
1835 and 1841, when there was not even beginning of
railway bridge; when everything, muddy Brenta, vulgar
villa, dusty causeway, sandy beach, was equally rich in
rapture, on the morning that brought us in sight of Venice:
and the black knot of gondolas in the canal of Mestre,
more beautiful to me than a sunrise full of clouds all
scarlet and gold.

But again, how to tell of it? or even explain it to
myself,—the English mind, high or common, being
utterly without trace of the feeling. Sir Philip Sidney
goes to Venice, and seems unconscious that it is in the
sea at all. Elizabeth Lady Craven, in 1789, "expected
to see a gay clean-looking town, with quays on each side
of the canals, but was extremely disappointed; the houses
are in the water, and look dirty and uncomfortable on
the outside; the innumerable quantity of gondolas too,
that look like swimming coffins, added to the dismal scene,
and, I confess, Venice on my arrival struck me with horror
rather than pleasure."

After this, she goes to the Casini, and is happy. It
does not appear she had ever read the Merchant, or
Othello; still less has Evelyn read them, though for him,

as for Sidney, Othello's and Antonio's Venice was still all but living. My Venice, like Turner's, had been chiefly created for us by Byron; but for me, there was also still the pure childish passion of pleasure in seeing boats float in clear water. The beginning of everything was in seeing the gondola-beak come actually inside the door at Danieli's, when the tide was up, and the water two feet deep at the foot of the stairs; and then, all along the canal sides, actual marble walls rising out of the salt sea, with hosts of little brown crabs on them, and Titians inside.

56. Between May 6th and 16th I made notes on effects of light, afterwards greatly useful in "Modern Painters;" and two pencil drawings, Ca' Contarini Fasan, and the Giant's Staircase, of which, with two more made at Bologna in passing, and some half-dozen at Naples and Amalfi, I can say, now forty years later, with certitude, that they could not have been much better done. I knew absolutely nothing of architecture proper, had never drawn a section nor a leaf moulding; but liked, as Turner did to the end of his days, anything that was graceful and rich, whether Gothic or Renaissance; was entirely certain and delicate in pencil-touch; and drew with an acuteness of delight in the thing as it actually stood, which makes the sketch living and like, from corner to corner. Thus much I could do, and *did* do, for the last time. Next year I began trying to do what I could not, and have gone on ever since, spending half of my days in that manner.

57. I find a sentence in diary on 6th May, which seems inconsistent with what I have said of the centres of my life work.

"Thank God I am here; it is the Paradise of cities."

.

"This, and Chamouni, are my two bournes of Earth."

But then, I *knew* neither Rouen nor Pisa, though I

had seen both. (Geneva, when I spoke of it with them, is meant to include Chamouni.) Venice I regard more and more as a temptation. The diary says (where the stars are): "There is moon enough to make half the sanities of the earth lunatic, striking its pure flashes of light on the grey water."

From Venice, by Padua, where St. Antonio,—by Milan, where the Duomo,—were still faultless to me, and each a perfect bliss; to Turin—to Susa; my health still bettering in the sight of Alps, and what breeze came down from them—and over Cenis for the first time. I woke from a sound tired sleep in a little one-windowed room at Lans-le-bourg, at six of the summer morning, June 2nd, 1841; the red aiguilles on the north relieved against pure blue—the great pyramid of snow down the valley in one sheet of eastern light. I dressed in three minutes, ran down the village street, across the stream, and climbed the grassy slope on the south side of the valley, up to the first pines.

I had found my life again;—all the best of it. What good of religion, love, admiration or hope, had ever been taught me, or felt by my best nature, rekindled at once; and my line of work, both by my own will and the aid granted to it by fate in the future, determined for me. I went down thankfully to my father and mother, and told them I was sure I should get well.

As to my mere physical state, the doctors had been entirely mistaken about me. I wanted bracing air, exercise, and rest from all artificial excitement. The air of the Campagna was the worst they could have sent me into—the life of Rome the worst they could have chosen.

58. The three following diary entries, which meant much afterwards, may summarily end what I fear has been a tiresome chapter.

I. "Geneva, June 5th. Yesterday from Chambery,—

a fresh north wind blowing away the dust. Much pleased with the respectable young wife of a confectioner, at one of the mid-towns where I went to get some Savoy biscuits —and asked for 'a pound.' 'Mais, Monsieur, une livre sera un peu—volumineuse! je vous en donnerai la moitié; vous verrez si cela vous suffira;'—'Ah, Louise' (to a little bright-eyed lady in the inner room, who was expressing her disapprobation of some of the affairs of life too loudly), 'si tu n'es pas sage, tu vas savoir'—but so playfully and kindly! Got here on a lovely afternoon near sunset, and the green bastions and bright Salève and rushing Rhone and far Jura, all so lovely that I was nearly vowing never to go into Italy again."

II. "June 6th. Pouring rain all day, and slow extempore sermon from a weak-voiced young man in a white arched small chapel, with a braying organ and doggerel hymns. Several times, about the same hour on Sunday mornings, a fit of self-reproach has come upon me for my idling at present, and I have formed resolutions to be always trying to get knowledge of some kind or other, or bodily strength, or some real available, continuing good, rather than the mere amusement of the time. It came on me to-day very strongly, and I would give anything and everything to keep myself in the temper, for I always slip out of it next day."

III. "Dec. 11th, 1842. Very odd! Exactly the same fit came on me in the same church, next year, and was the origin of Turner's work."

CHAPTER IV

FONTAINEBLEAU

59. WE reached Rochester on the 29th of June, and a
month was spent at home, considering what was to be
done next. My own feeling, ever since the morning at
Lans-le-bourg, was that, if only left free in mountain air,
I should get well, fast enough. After debate with London
doctors, it was thought best to give me my way; and,
stipulating only that Richard Fall should go with me, papa
and mamma sent me, early in August, on my first
independent journey, into Wales.

But they desired me, on my way there, to stop at
Leamington, and show myself to its dominant physician,
Dr. Jephson—called a quack by all the Faculty, yet of
whom they had heard favourably from wise friends.

Jephson was no quack; but a man of the highest general
power, and keenest medical instincts. He had risen, by
stubborn industry and acute observation, from an apothe-
cary's boy to be the first physician in Leamington; and
was the first true physician I ever knew—nor since, till
I knew Sir William Gull, have I met the match of him.

He examined me for ten minutes; then said, "Stay
here, and I'll put you to rights in six weeks." I said I
was not the least disposed to stay there, and was going into
Wales, but would obey any directions and follow any
prescriptions he chose to give me. No, he said, I must
stay, or he could do nothing for me. I thought this did
look a little like quackery, and accordingly made my bow,
and proceeded on my journey into Wales, after writing
a full account of the interview to my father.

60. At Pont-y-Monach lay for me a letter from him,

bidding me go back to Leamington at once, and place
myself under Jephson's care. Richard therefore went on
to Snowdon by himself; and I, returning with what speed
the mail could make, presented myself to the doctor peni-
tently. He sent me into tiny lodgings near the Wells,
where I spent six weeks of life extremely new to me;
much grumbled at in my diary,—not unpleasant, now
remembered.

Salt water from the Wells in the morning, and iron,
visibly glittering in deposit at bottom of glass, twice a day.
Breakfast at eight, with herb tea—dandelion, I think;
dinner at one, supper at six, both of meat, bread, and
water, only;—fish, meat, or fowl, as I chose, but only
one dish of the meat chosen, and no vegetables nor fruit.
Walk, forenoon and afternoon, and early to bed. Such
the regimen suddenly enforced on my luxurious life.

To which discipline I submitted accurately: and found
life still worth having on these terms, and the renewed
hope of its continuance, extremely interesting.

61. Nor wanting in interest, the grotesquely prosaic
position itself. Here I was, in a small square brick lodg-
ing-house, number what you like of its row, looking out
on a bit of suburban paddock, and a broken paling; mean
litter everywhere about; the muddy lingering of Leam,
about three yards broad, at the other side of the paddock;
a ragged brambly bank at the other side of *it*. Down
the row, beginnings of poor people's shops, then an aristo-
cratic grocer and mercer or two, the circulating library,
and the Pump Room.

After the Bay of Naples, Mount Aventine, and St.
Mark's Place, it felt like the first practical scene of a
pantomime, after the transformation, and before the busi-
ness begins. But I had been extremely dull under Mount
Aventine; and did not, to my surprise, feel at all disposed
to be dull here,—but somewhat amused, and with a

pleasant feeling of things being really at last all right, for
me at least; though it wasn't as grand as Peckwater, nor
as pretty as St. Mark's Place. Any how, I was down to
Croydon level again in the world; and might do what I
liked in my own lodgings, and hadn't any Collections to
get ready for.

62. The first thing I did was to go to the library and
choose a book to work at. After due examination, I
bought Agassiz' "Poissons Fossiles"! and set myself to
counting of scales and learning of hard names,—thinking
as some people do still, that in that manner I might best
advance in geology. Also I supplied myself with some
Captain Marryat; and some beautiful new cakes of colour
wherewith to finish a drawing, in Turner's grandest
manner, of the Chateau of Amboise at sunset, with the
moon rising in the distance, and shining through a bridge.

The "Poissons Fossiles" turned out a most useful
purchase, enabling me finally to perceive, after steady
work on them, that Agassiz was a mere blockhead to
have paid for all that good drawing of the nasty ugly things,
and that it didn't matter a stale herring to any mortal
whether they had any names or not.

For any positive or useful purpose, I could not more
utterly have wasted my time; but it was no small gain
to know that time spent in that sort of work *was* wasted;
and that to have caught a chub in the Avon, and learned
how to cook it spicily and herbaceously, so as to have
pleased Izaak Walton, if the odour of it could reach him
in the Anglers' Paradise, would have been a better result
of six weeks' study than to be able to count and call by
their right names every scale stuck in the mud of the
universe.

Also I got a wholesome perception, from that book,
of the true relation between artists and scientific gentle-
men. For I saw that the real genius concerned in the

"Poissons Fossiles" was the lithographer's, and not at all the scientific gentleman's; and that the book ought to have been called after the lithographer, *his* fishes, only with their scales counted and called bad names by subservient Mons. Agassiz.

63. The second thing of specific meaning that went on in Leamington lodgings was the aforesaid highly laboured drawing of the Chateau of Amboise, "out of my head;" representing the castle as about seven hundred feet above the river, (it is perhaps eighty or ninety,) with sunset light on it, in imitation of Turner; and the moon rising behind it, in imitation of Turner; and some steps and balustrades (which are not there) going down to the river, in imitation of Turner; with the fretwork of St. Hubert's Chapel done very carefully in my own way,— I thought perhaps a little better than Turner.

This drawing, and the poem of the "Broken Chain," which it was to illustrate, after being beautifully engraved by Goodall, turned out afterwards equally salutary exercises; proving to me that in those directions of imagination I was even a worse blockhead than Agassiz himself. Meantime, the autumn weather was fine, the corn was ripe, and once out of sight of the paddock, the pump room, and the Parade, the space of surrounding Warwickshire within afternoon walk was extremely impressive to me, in its English way. Warwick towers in sight over the near tree tops; Kenilworth, within an afternoon's walk; Stratford, to be reached by an hour's drive with a trotting pony; and, round them, as far as eye could reach, a space of perfect England, not hill and *dale*,—that might be anywhere,—but hill and *flat*, through which the streams linger, and where the canals wind without lock.

64. Under these peaceful conditions I began to look carefully at cornflowers, thistles, and hollyhocks; and find, by entry on Sept. 15th, that I was writing a bit of

the "King of the Golden River," and reading Alison's "Europe" and Turner's "Chemistry."

Anent the "King of the River," I remorsefully bethink me no word has been said of the dawn and sunrise of Dickens on us; from the first syllable of him in the "Sketches," altogether precious and admirable to my father and me; and the new number of Pickwick and following Nickleby looked to, through whatever laborious or tragic realities might be upon us, as unmixed bliss, for the next day. But Dickens taught us nothing with which we were not familiar,—only painted it perfectly for us. We knew quite as much about coachmen and hostlers as he did; and rather more about Yorkshire. As a caricaturist, both in the studied development of his own manner, and that of the illustrative etchings, he put himself out of the pale of great authors; so that he never became an educational element of my life, but only one of its chief comforts and restoratives.

The "King of the Golden River" was written to amuse a little girl; and being a fairly good imitation of Grimm and Dickens, mixed with a little true Alpine feeling of my own, has been rightly pleasing to nice children, and good for them. But it is totally valueless, for all that. I can no more write a story than compose a picture.

65. Jephson kept his word, and let me go in six weeks, with my health, he told me,—I doubt not, truly,—in my own hands. And indeed, if I had continued to live on mutton and iron, learned to swim in the sea which I loved, and set myself wholly upon my geology and poissons— vivants instead of fossils,——Well, I suppose I should have been drowned like Charles, or lain, within a year or two,

"on a glacier, halfway up to heaven,
Taking my final rest."

What might have been, the mute Fates know. I

myself know only, with certainty, what ought *not* to have been,—that, getting released from Leamington, I took again to brown potatoes and cherry-pie; instead of learning to swim and climb, continued writing pathetic verses, and at this particularly foolish crisis of life, as aforesaid, trying to paint *twilight* like Turner. I was not simpleton enough to think I could follow him in daylight, but I thought I could do something like his Kenilworth Castle at sunset, with the milkmaid and the moon.

66. I have passed without notice what the reader might suppose a principal event of my life,—the being introduced to him by Mr. Griffith, at Norwood dinner, June 22nd, 1840.

The diary says, "Introduced to-day to the man who beyond all doubt is the greatest of the age; greatest in every faculty of the imagination, in every branch of scenic * knowledge; at once the painter and poet of the day, J. M. W. Turner. Everybody had described him to me as coarse, boorish, unintellectual, vulgar. This I knew to be impossible. I found in him a somewhat eccentric, keen-mannered, matter-of-fact, English-minded —gentleman; good-natured evidently, bad-tempered evidently, hating humbug of all sorts, shrewd, perhaps a little selfish, highly intellectual, the powers of the mind not brought out with any delight in their manifestation, or intention of display, but flashing out occasionally in a word or a look."

Pretty close, that, and full, to be seen at a first glimpse, and set down the same evening.

67. Curiously, the drawing of Kenilworth was one of those that came out of Mr. Griffith's folio after dinner; and I believe I must have talked some folly about it, as being "a leading one of the England series"; which would

* Meaning, I suppose, knowledge of what could rightly be represented or composed as a scene.

displease Turner greatly. There were few things he
hated more than hearing people gush about particular
drawings. He knew it merely meant they could not see
the others.

Anyhow, he stood silent; the general talk went on as
if he had not been there. He wished me good-night
kindly, and I did not see him again till I came back from
Rome.

If he had but asked me to come and see him the next
day! shown me a pencil sketch, and let me see him lay
a wash! He would have saved me ten years of life, and
would not have been less happy in the close of his own.
One can only say, Such things are never to be; every
soul of us has to do its fight with the Untoward, and for
itself discover the Unseen.

68. So here I was at Leamington, trying to paint
twilight at Amboise, and meditating over the Poissons
Fossiles, and Michael Angelo. Set free of the Parade,
I went to stay a few days with my college tutor, Walter
Brown, Rector now of "Wendlebury," a village in the
flats, eleven miles north of Oxford. Flats, not marshes:
wholesome pastoral fields, separated by hedges; here and
there a haystack, a gate, or a stile. The village consisted
of twelve or fifteen thatched cottages, and the Rectory.
The Rectory was a square house, with a garden fifty yards
square. The church, close by, about four yards high by
twenty yards long, had a square tower at the end, and a
weather-cock.

Good Mr. Walter Brown had married an entirely
worthy, very plain, somewhat middle-aged wife, and settled
himself down, with all his scholarship and good gifts, to
promote the spiritual welfare of Wendlebury. He
interested himself entirely in that object; dug his garden
himself; took a scholar or two to prepare for Oxford
examinations, with whom in the mornings he read in the

old way; studied the "Natural History of Enthusiasm," and was perfectly happy and contented, to the end of his time.

69. Finding him proud of his little church and its weather-cock, I made a drawing of it for him, in my best manner, at sunset, with a moonrise behind. He objected a little to having the sky upside down, with the darkest blue at the bottom, to bring out the church; but somehow, everybody at this time had begun to believe in me, and think I knew more about drawing than other people: and the meekness with which Mr. Brown would listen to me lecturing on Michael Angelo, from a series of outlines of the Last Judgment which I had brought from Rome, with the muscles engraved all over the bodies like branch railroads, remains wholly phenomenal and mystic in my memory. Nobody is ever the least meek to me now, when I *do* know something about it.

But Mr. Brown and his wife were in all ways extremely kind to me, and seemed to like having me with them. It was perhaps only their politeness: I can neither fancy nor find anything in myself at this time which could have been pleasant to anybody, unless the mere wish to be pleasant, which I had always; seeking to say, so far as I could honestly, what would be agreeable to whomsoever I spoke to.

70. From Wendlebury I went home, and made final preparation, with Gordon's help, for taking my degree in the spring. I find entry on Nov. 16th, 1841, at Herne Hill, "I have got my rooms in order at last; I shall set to work on my reading to-morrow, methodically, but not hard." Setting my rooms in order has, throughout life, been an occasionally complacent recreation to me; but I have never succeeded in keeping them in order three days after they were in it.

On the day following comes this: "Mem., why is hoar-frost formed in larger crystals on the ribs and edges of

leaves than in other places?" (on other parts of the leaf, I meant)—question which I had thought asked for the first time in my ice-study of '79, and which is not answered yet.

The entry next day is also worth copying: "Read the Clementina part of 'Sir Charles Grandison.' I never met with anything which affected me so powerfully; at present I feel disposed to place this work above all other works of fiction I know. It is very, very grand; and has, I think, a greater practical effect on me for good than anything I ever read in my life."

I find my first lessons from Harding were also at this time; very delightful for what they were worth, though I saw well enough his shortcomings. But it was lovely to see him draw, in his own way, and up to a certain point. His knowledge of tree form was true, and entirely won for himself, with an honest original perception. Also, he was a violent hater of the old Dutch school, and I imagine the first who told me that they were "sots, gamblers, and debauchees, delighting in the reality of the alehouse more than in its pictures." All which was awakening and beneficial to no small extent.

71. And so the year 1842 dawned for me, with many things in its morning cloud. In the early spring of it, a change came over Turner's mind. He wanted to make some drawings to please himself; but also to be paid for making them. He gave Mr. Griffith fifteen sketches for choice of subject by any one who would give him a commission. He got commissions for nine, of which my father let me choose at first one, then was coaxed and tricked into letting me have two. Turner got orders, out of all the round world besides, for seven more. With the sketches, four finished drawings were shown for samples of the sort of thing Turner meant to make of them, and for immediate purchase by anybody.

Among them was the Splugen, which I had some hope of obtaining by supplication, when my father, who was travelling, came home. I waited dutifully till he should come. In the meantime it was bought, with the loveliest Lake Lucerne, by Mr. Munro of Novar.

72. The thing became to me grave matter for meditation. In a story by Miss Edgeworth, the father would have come home in the nick of time, effaced Mr. Munro as he hesitated with the Splugen in his hand, and given the dutiful son that, and another. I found, after meditation, that Miss Edgeworth's way was not the world's, nor Providence's. I perceived then, and conclusively, that if you do a foolish thing, you suffer for it exactly the same, whether you do it piously or not. I knew perfectly well that this drawing was the best Swiss landscape yet painted by man; and that it was entirely proper for *me* to have it, and inexpedient that anybody else should. I ought to have secured it instantly, and begged my father's pardon, tenderly. He would have been angry, and surprised, and grieved; but loved me none the less, found in the end I was right, and been entirely pleased. I should have been very uncomfortable and penitent for a while, but loved my father all the more for having hurt him, and, in the good of the thing itself, finally satisfied and triumphant. As it was, the Splugen was a thorn in both our sides, all our lives. My father was always trying to get it; Mr. Munro, aided by dealers, always raising the price on him, till it got up from 80 to 400 guineas. Then we gave it up,—with unspeakable wear and tear of best feelings on both sides.

73. And how about "Thou shalt not covet," etc.? Good reader, if you ask this, please consult my philosophical works. Here, I can only tell you facts, whether of circumstance or law. It is a law that if you do a foolish thing you suffer for it, whatever your motive. I do not

say the motive itself may not be rewarded or punished on its own merits. In this case, nothing but mischief, as far as I know, came of the whole matter.

In the meantime, bearing the disappointment as best I could, I rejoiced in the sight of the sketches, and the hope of the drawings that were to be. And they gave me much more to think of than my mischance. I saw that these sketches were straight impressions from nature, —not artificial designs, like the Carthages and Romes. And it began to occur to me that perhaps even in the artifice of Turner there might be more truth than I had understood. I was by this time very learned in *his* principles of composition; but it seemed to me that in these later subjects Nature herself was composing with him.

Considering of these matters, one day on the road to Norwood, I noticed a bit of ivy round a thorn stem, which seemed, even to my critical judgment, not ill "composed"; and proceeded to make a light and shade pencil study of it in my grey paper pocket-book, carefully, as if it had been a bit of sculpture, liking it more and more as I drew. When it was done, I saw that I had virtually lost all my time since I was twelve years old, because no one had ever told me to draw what was really there! All my time, I mean, given to drawing as an art; of course I had the records of places, but had never seen the beauty of any-thing, not even of a stone—how much less of a leaf!

I was neither so crushed nor so elated by the discovery as I ought to have been, but it ended the chrysalid days. Thenceforward my advance was steady, however slow.

74. This must have been in May, and a week or two afterwards I went up for my degree, but find no entry of it. I only went up for a pass, and still wrote Latin so badly that there was a chance of my *not* passing! but the examiners forgave it because the divinity, philosophy,

and mathematics were all above the average; and they gave me a complimentary double-fourth.

When I was sure I had got through, I went out for a walk in the fields north of New College, (since turned into the Parks,) happy in the sense of recovered freedom, but extremely doubtful to what use I should put it. There I was, at two and twenty, with such and such powers, all second-rate except the analytic ones, which were as much in embryo as the rest, and which I had no means of measuring; such and such likings, hitherto indulged rather against conscience; and a dim sense of duty to myself, my parents, and a daily more vague shadow of Eternal Law.

What should I be, or do? my utterly indulgent father ready to let me do anything; with my room always luxuriously furnished in his house,—my expenses paid if I chose to travel. I was not heartless enough, yet, to choose to do that, alone. Perhaps it may deserve some dim praise that I never seriously thought of leaving my father and mother to explore foreign countries; and certainly the fear of grieving them was intermingled more or less with all my thoughts; but then, I did not much *want* to explore foreign countries. I had not the least love of adventure, but liked to have comfortable rooms always ordered, and a three-course dinner ready by four o'clock. Although no coward under circumstances of accidental danger, I extremely objected to any vestige of danger as a continuous element in one's life. I would not go to India for fear of tigers, nor to Russia for fear of bears, nor to Peru for fear of earthquakes; and finally, though I had no rightly glowing or grateful affection for either father or mother, yet as they could not well do without me, so also I found I was not altogether comfortable without *them*.

75. So for the present, we planned a summer-time

in Switzerland, not of travelling, but chiefly stay in
Chamouni, to give me mountain air, and the long coveted
power of examining the Mont Blanc rocks accurately.
My mother loved Chamouni nearly as much as I; but
this plan was of severe self-denial to my father, who did
not like snow, nor wooden-walled rooms.

But he gave up all his own likings for me, and let me
plan the stages through France as I chose, by Rouen,
Chartres, Fontainebleau, and Auxerre. A pencil-sketch
or two at first show only want of faith in my old manner,
and more endeavour for light and shade, futile enough.
The flat cross-country between Chartres and Fontaine-
bleau, with an oppressive sense of Paris to the north,
fretted me wickedly; when we got to the Fountain of
Fair Water I lay feverishly wakeful through the night,
and was so heavy and ill in the morning that I could not
safely travel, and fancied some bad sickness was coming
on. However, towards twelve o'clock the inn people
brought me a little basket of wild strawberries; and they
refreshed me, and I put my sketch-book in pocket and
tottered out, though still in an extremely languid and woe-
begone condition; and getting into a cart-road among
some young trees, where there was nothing to see but
the blue sky through thin branches, lay down on the bank
by the roadside to see if I could sleep. But I couldn't,
and the branches against the blue sky began to interest
me, motionless as the branches of a tree of Jesse on a
painted window.

Feeling gradually somewhat livelier, and that I wasn't
going to die this time, and be buried in the sand, though
I couldn't for the present walk any farther, I took out
my book, and began to draw a little aspen tree, on the
other side of the cart-road, carefully.

76. How I had managed to get into that utterly dull
cart-road, when there were sandstone rocks to be sought

for, the Fates, as I have so often to observe, only know; but I was never fortunate enough to find at Fontainebleau any of the sublimities which I hear vaunted by French artists, and which disturbed poor Evelyn's mind nearly as much as the "horrid Alp" of Clifton:—

"7th March (1644). I set forwards with some company towards Fontaine Bleau, a sumptuous palace of the King's like ours at Hampton Court. By the way we passe through a forest so prodigiously encompass'd with hideous rocks of whitish hard stone, heaped one on another in mountainous heights, that I think the like is nowhere to be found more horrid and solitary. On the summit of one of these gloomy precipices, intermingled with trees and shrubs, the stones hanging over and menacing ruin, is built an hermitage."

I believe this passage to be accurately characteristic of the pure English mind about rocks. If they are only big enough to look as if they would break your head if they fell on it, it is all an Englishman asks, or can understand, of them. The modern thirst for self-glorification in getting to the top of them is indeed often accompanied with good interest in geographical and other science; and nice boys and girls *do* enjoy their climbing, and lunching in fields of primula. But I never trace a word in one of their journals of sorrow for the destruction of any Swiss scene or Swiss character, so only that they have their own champagne at lunch.

77. The "hideous rocks" of Fontainebleau were, I grieve to say, never hideous enough to please me. They always seemed to me no bigger than I could pack and send home for specimens, had they been worth carriage; and in my savage dislike of palaces and straight gravel walks, I never found out the spring which was the soul of the place. And to-day, I missed rocks, palace, and fountain all alike, and found myself lying on the bank

of a cart-road in the sand, with no prospect whatever
but that small aspen tree against the blue sky.

Languidly, but not idly, I began to draw it; and as
I drew, the languor passed away: the beautiful lines
insisted on being traced,—without weariness. More and
more beautiful they became, as each rose out of the rest,
and took its place in the air. With wonder increasing
every instant, I saw that they "composed" themselves, by
finer laws than any known of men. At last, the tree was
there, and everything that I had thought before about
trees, nowhere.

The Norwood ivy had not abased me in that final
manner, because one had always felt that ivy was an
ornamental creature, and expected it to behave prettily,
on occasion. But that all the trees of the wood (for I
saw surely that my little aspen was only one of their
millions) should be beautiful—more than Gothic tracery,
more than Greek vase-imagery, more than the daintiest
embroiderers of the East could embroider, or the artfullest
painters of the West could limn,—this was indeed an end
to all former thoughts with me, an insight into a new
silvan world.

Not silvan only. The woods, which I had only looked
on as wilderness, fulfilled I then saw, in their beauty, the
same laws which guided the clouds, divided the light, and
balanced the wave. "He hath made everything beautiful,
in his time," became for me thenceforward the interpreta-
tion of the bond between the human mind and all visible
things; and I returned along the wood-road feeling that
it had led me far;—Farther than ever fancy had reached,
or theodolite measured.

78. To my sorrow, and extreme surprise, I find no
diary whatever of the feelings or discoveries of this year.
They were too many, and bewildering, to be written. I
did not even draw much,—the things I now saw were

beyond drawing,—but took to careful botany, while the
month's time set apart for the rocks of Chamouni was
spent in merely finding out what was to be done, and
where. By the chance of guide dispensation, I had only
one of the average standard, Michel Devouassoud, who
knew his way to the show places, and little more; but I
got the fresh air and the climbing; and thought over my
Fontainebleau thoughts, by sweeter springs. The entry
above quoted (p. 270), of Dec. 11th, the only one I can
find of all the year's journeying, is very notable to me,
in showing that the impulse which threw the new thoughts
into the form of "Modern Painters," came to me in the
fulfilment of the one disagreeable duty I persisted in,—
going to church! But it came to me, two years following,
in my true mother-town of Geneva.

We went home in 1842 by the Rhine and Flanders:
and at Cologne and St. Quentin I made the last drawings
ever executed in my old manner. That of the great
square at Cologne was given to Osborne Gordon, and
remains I believe with his sister, Mrs. Pritchard. The
St. Quentin has vanished into space.

79. We returned once more to the house at Herne Hill,
and the lovely drawings Turner had made for me, Ehren-
breitstein and Lucerne, were first hung in its little front
dining-room. But the Herne Hill days, and many joys
with them, were now ended.

Perhaps my mother had sometimes—at Hampton
Court, or Chatsworth, or Isola-Bella—admitted into her
quiet soul the idea that it might be nice to have a larger
garden. Sometimes a gold-tasseled Oxford friend would
come out from Cavendish or Grosvenor Square to see me;
and there was only the little back room opposite the nursery
for him to wash his hands in. As his bank-balance
enlarged, even my father thought it possible that his
country customers might be more impressed by enjoying

their after-dinner sherry with more room for their legs. And, now that I was of age and B.A. and so on—did not *I* also want a larger house?

No, good reader; but ever since first I could drive a spade, I had wanted to dig a canal, and make locks on it, like Harry in "Harry and Lucy." And in the field at the back of the Denmark Hill house, now, in this hour of all our weaknesses, offered in temptation, I saw my way to a canal with any number of locks down towards Dulwich.

It is very wonderful to me, looking back, to remember this, and how entirely boyish—and very young-boyish, too—I was still, in all instincts of personal delight: while yet, looking out of myself, I saw farther than Kings of Naples or Cardinals of Rome.

80. Yet there was much, and very closely balanced, debate, before the house was taken. My mother wisely, though sadly, said it was too late for her; she could not now manage a large garden: and my father, feeling his vanity had more than a word in the matter, besides all that might rightly be alleged of what was now convenient and becoming, hesitated painfully, as he had done about his first Copley Fielding.

But at last the lease of the larger house was bought: and everybody said how wise and proper; and my mother *did* like arranging the rows of pots in the big greenhouse; and the view from the breakfast-room into the field was really very lovely. And we bought three cows, and skimmed our own cream, and churned our own butter. And there was a stable, and a farmyard, and a haystack, and a pigstye, and a porter's lodge, where undesirable visitors could be stopped before startling us with a knock. But, for all these things, we never were so happy again. Never any more "at home."

81. At Champagnole, yes; and in Chamouni,—in La

Cloche, at Dijon,—in La Cygne, at Lucerne. All these
places were of the old time. But though we had many
happy days in the Denmark Hill house, none of our new
ways ever were the same to us as the old: the basketfuls
of peaches had not the flavour of the numbered dozen
or score; nor were all the apples of the great orchard
worth a single dishful of the Siberian crabs of Herne
Hill.

And I never got my canal dug, after all! Harry's
making the lock-gates himself had indeed always seemed
to me too magnificent! inimitable if not incredible: but
also, I had never, till now that the need came, entered
into the statistics of water supply. The gardeners wanted
all that was in the butts for the greenhouse. Nothing
but a dry ditch, incommodious to the cows, I saw to be
possible, and resigned myself to destiny: yet the bewitching
idea never went out of my head, and some water-works,
on the model of Fontainebleau, were verily set aflowing
—twenty years afterwards, as will be told.*

82. The next year, there was travelling enough for
us up and down the new garden walks. Also, the first
volume of "Modern Painters" took the best of the winter's
leisure: the summer was broken by some formal term-
keeping at Oxford. There is nothing in diary worth
noting, except a word about Camberwell church window,
to which I must return in connection with things yet
far ahead.

The said first volume must have been out by my father's
birthday; its success was assured by the end of the year,
and on January 1st, 1844, "my father brought me in the
'Slaver' for a New Year's gift,"—knowing well, this time,
how to please me. I had it at the foot of my bed next
morning like my own "Loch Achray" of old. But the
pleasure of one's own first painting everybody can under-

* See "Joanna's Care."

stand. The pleasure of a new Turner to me, nobody
ever will, and it's no use talking of it.

For the second volume, (not meant to be the least like
what it is,) I wanted more Chamouni. The journey of
1844 was planned entirely for central Alps, and on
June 1st, 1844, we were happy by Lake Leman shore,
again.

Chapter V

THE SIMPLON

83. More and more deeply every hour, in retracing Alpine paths,—by my fireside,—the wonder grows on me, what Heaven made the Alps for, and gave the chamois its foot, and the gentian its blue,—yet gave no one the heart to love them. And in the Alps, why especially that mighty central pass was so divinely planned, yet no one to pass it but against their wills, till Napoleon came, and made a road over it.

Nor often, since, with any joy; though in truth there is no other such piece of beauty and power, full of human interest of the most strangely varied kind, in all the mountain scenery of the globe, as that traverse, with its two terminal cities, Geneva and Milan; its two lovely lakes of approach, Leman and Maggiore; its two tremendous valleys of vestibule, the Valais and Val d'Ossola; and its own, not desolate nor terrible, but wholly beautiful, upper region of rose and snow.

Of my early joy in Milan, I have already told; of Geneva, there is no telling, though I must now give what poor picture I may of the days we spent there, happy to young and old alike, again and again, in '33, '35, '42, and now, with full deliberation, in '44, knowing, and, in their repetitions twice, and thrice, and four times, magnifying, the well-remembered joys. And still I am more thankful, through every year of added life, that I was born in London, near enough to Geneva for me to reach it easily;—and yet a city so contrary to everything Genevoise as best to teach me what the wonders of the little canton were.

84. A little canton, four miles square, and which did
not wish to be six miles square! A little town, composed
of a cluster of watermills, a street of penthouses, two
wooden bridges, two dozen of stone houses on a little hill,
and three or four perpendicular lanes up and down the
hill. The four miles of acreage round, in grass, with
modest gardens, and farm-dwelling houses; the people,
pious, learned, and busy, to a man, to a woman—to a boy,
to a girl, of them; progressing to and fro mostly on their
feet, and only where they had business. And this bird's-
nest of a place, to be the centre of religious and social
thought, and of physical beauty, to all living Europe!
That is to say, thinking and designing Europe,—France,
Germany, and Italy. They, and their pieties, and their
prides, their arts and their insanities, their wraths and
slaughters, springing and flowering, building and fortify-
ing, foaming and thundering round this inconceivable
point of patience: the most lovely spot, and the most
notable, without any possible dispute, of the European
universe; yet the nations do not covet it, do not gravitate
to it,—what is more wonderful, do not make a wilderness
of it. They fight their battles at Chalons and Leipsic;
they build their cotton mills on the Aire, and leave the
Rhone running with a million of Aire power,—all pure.
They build their pleasure houses on Thames shingle, and
Seine mud, to look across to Lambeth, and—whatever *is*
on the other side of the Seine. They found their military
powers in the sand of Berlin, and leave this precipice-
guarded plain in peace. And yet it rules them,—is the
focus of thought to them, and of passion, of science, and
of *contrat sociale;* of rational conduct, and of decent—
and other—manners. Saussure's school and Calvin's,—
Rousseau's and Byron's,—Turner's,—

And of course, I was going to say mine; but I didn't
write all that last page to end so. Yet Geneva had better

have ended with educating me and the likes of me, instead
of the people who have hold of it now, with their polypous
knots of houses, communal with "London, Paris, and New
York."

Beneath which, and on the esplanades of the modern
casino, New York and London now live—no more the
Genevese. What their home once was, I must try to
tell, as I saw it.

85. First, it was a notable town for keeping all its
poor,—inside of it. In the very centre, where an English
town has its biggest square, and its Exchange on the model
of the Parthenon, built for the sake of the builder's com-
mission on the cost; there, on their little pile-propped
island, and by the steep lane-sides, lived the Genevoise
poor; in their garrets,—their laborious upper spinning or
watch-wheel cutting rooms,—their dark niches and angles
of lane: mostly busy; the infirm and old all seen to and
cared for, their porringers filled and their pallet-beds made,
by household care.

But, outside the ramparts, no more poor. A sputter,
perhaps, southward, along the Savoy road; but in all the
champaign round, no mean rows of cubic lodgings with
Doric porches; no squalid fields of mud and thistles; no
deserts of abandoned brickfield and insolvent kitchen
garden. On the instant, outside Geneva gates, perfectly
smooth, clean, trim-hedged or prim-walled country roads;
the main broad one intent on far-away things, its signal-
posts inscribed "Route de Paris;" branching from it, right
and left, a labyrinth of equally well-kept ways for fine
carriage wheels, between the gentlemen's houses with their
farms; each having its own fifteen to twenty to fifty acres
of mostly meadow, rich-waving always (in my time for
being there) with grass and flowers, like a kaleidoscope.
Stately plane trees, aspen and walnut,—sometimes in
avenue,—casting breezy, never gloomy, shade round the

dwelling-house. A dwelling-house indeed, all the year
round; no travelling from it to fairer lands possible; no
shutting up for seasons in town; hay-time and fruit-time,
school-time and play, for generation after generation,
within the cheerful white domicile with its green shutters
and shingle roof,—pinnacled perhaps, humorously, at the
corners, glittering on the edges with silvery tin. "Kept
up" the whole place, and all the neighbours' places, not
ostentatiously, but perfectly: enough gardeners to mow,
enough vintagers to press, enough nurses to nurse; no
foxes to hunt, no birds to shoot; but every household
felicity possible to prudence and honour, felt and fulfilled
from infancy to age.

86. Where the grounds came down to the waterside,
they were mostly built out into it, till the water was four
or five feet deep, lapping up, or lashing, under breeze,
against the terrace wall. Not much boating; fancy
wherries, unmanageable, or too adventurous, upon the
wild blue; and Swiss boating a serious market and trade
business, unfashionable in the high rural empyrean of
Geneva. But between the Hotel des Etrangers, (one of
these country-houses open to the polite stranger, some
half-mile out of the gates, where Salvador took us in '33
and '35) and the town, there were one or two landing-
places for the raft-like flat feluccas; and glimpses of the
open lake and things beyond,—glimpses only, shut off
quickly by garden walls, until one came to the inlet of
lake-water moat which bent itself under the ramparts
back to the city gate. This was crossed, for people afoot
who did not like going round to that main gate, by the
delicatest of filiform suspension bridges; strong enough
it looked to carry a couple of lovers over in safety, or a
nursemaid and children, but nothing heavier. One was
allowed to cross it for a centime, which seemed to me
always a most profitable transaction, the portress receiving

placidly a sort of dirty flattened sixpence, (I forget its name) and returning me a waistcoat-pocketful of the loveliest little clean-struck centimes; and then one might stand on the bridge any time, in perfect quiet. (The Genevese didn't like paying the centime, and went round by the gate.) Two swans, drifting about underneath, over a couple of fathoms of purest green water, and the lake really opening from the moat, exactly where the Chamouni range of aiguilles rose beyond it far away. In our town walks we used always to time getting back to the little bridge at sunset, there to wait and watch.

87. That was the way of things on the north side; on the south, the town is still, in the main buildings of it, as then; the group of officially aristocratic houses round the cathedral and college presenting the same inaccessible sort of family dignity that they do to-day; only, since then, the Geneva Liberals——Well, I will not say what they have done; the main town stands still on its height of pebble-gravel, knit almost into rock; and still the upper terraces look across the variously mischievous Liberal works to the open southern country, rising in steady slope of garden, orchard, and vineyard—sprinkled with pretty farm-houses and bits of chateau, like a sea-shore with shells; rising always steeper and steeper, till the air gets rosy in the distance, then blue, and the great walnut-trees have become dots, and the farmsteads, minikin as if they were the fairy-finest of models made to be packed in a box; and then, instant—above vineyard, above farmstead, above field and wood, leaps up the Salève cliff, two thousand feet into the air.

88. I don't think anybody who goes to Geneva ever sees the Salève. For the most part, no English creature ever *does* see farther than over the way; and the Salève, unless you carefully peer into it, and make out what it is, pretends to be nothing,—a long, low swell like the South

Downs, I fancy most people take it for, and look no more.
Yet there are few rocks in the high Alps more awful than
the "Angle" of the Salève, at its foot—seven Shakespeare's
Cliffs set one on the top of another, and all of
marble.*

On the other side of the high town the houses stand
closer, leaving yet space for a little sycamore-shaded walk,
whence one looks down on the whole southern reach of
lake, opening wide to the horizon, and edged there like
the sea, but in the summer sunshine looking as if it was
the one well of blue which the sunbeams drank to make
the sky of. Beyond it, ghostly ranges of incredible
mountains—the Dent d'Oche, and first cliffs towards
Fribourg; to the west, the long wave of Jura, fading
into the air above Neuchatel.

That was the view for full noon, when the lake was
brightest and bluest. Then you fell down a perpendicular
lane into the lower town again, and you went to Mr.
Bautte's.

89. Virtually there was no other jeweller in Geneva,
in the great times. There were some respectable, un-
competitive shops, not dazzling, in the main street; and
smaller ones, with an average supply of miniature watches,
that would go well for ten years; and uncostly, but honest,
trinketry. But one went to Mr. Bautte's with awe, and
of necessity, as one did to one's bankers. There was
scarcely any external sign of Bautte whatever—a small
brass plate at the side of a narrow arched door, into an alley
—into a secluded alley—leading into a monastic court-
yard, out of which—or rather out of the alley, where it
opened to the court, you ascended a winding stair, wide
enough for two only, and came to a green door, swinging,

* Not Parian, indeed, nor Carrara, but an extremely compact
limestone, in which the compressed faulted veins are of marble indeed,
and polish beautifully.

at the top of it; and there you paused to summon courage to enter.

A not large room, with a single counter at the further side. Nothing shown on the counter. Two confidential attendants behind it, and—it might possibly be Mr. Bautte! —or his son—or his partner—or anyhow the Ruling power—at his desk beside the back window. You told what you wanted: it was necessary to know your mind, and to be sure you *did* want it; there was no showing of things for temptation at Bautte's. You wanted a bracelet, a brooch, a watch—plain or enamelled. Choice of what was wanted was quietly given. There were no big stones, nor blinding galaxies of wealth. Entirely sound work-manship in the purest gold that could be worked; fine enamel for the most part, for colour, rather than jewels; and a certain Bauttesque subtlety of linked and wreathed design, which the experienced eye recognized when worn in Paris or London. Absolutely just and moderate price; wear,—to the end of your days. You came away with a sense of duty fulfilled, of treasure possessed, and of a new foundation to the respectability of your family.

You returned into the light of the open street with a blissful sense of a parcel being made up to be sent after you, and in the consequently calm expatiation of mind, went usually to watch the Rhone.

Bautte's was in the main street, out of which one caught glimpses, down the short cross ones, of the passing water, as at Sandgate, or the like fishing towns, one got peeps of the sea. With twenty steps you were beside it.

90. For all other rivers there is a surface, and an under-neath, and a vaguely displeasing idea of the bottom. But the Rhone flows like one lambent jewel; its surface is nowhere, its ethereal self is everywhere, the iridescent rush and translucent strength of it blue to the shore, and radiant to the depth.

Fifteen feet thick, of not flowing, but flying water; not
water, neither,—melted glacier, rather, one should call it;
the force of the ice is with it, and the wreathing of the
clouds, the gladness of the sky, and the continuance of
Time.

Waves of clear sea are, indeed, lovely to watch, but they
are always coming or gone, never in any taken shape to
be seen for a second. But here was one mighty wave that
was always itself, and every fluted swirl of it, constant as
the wreathing of a shell. No wasting away of the fallen
foam, no pause for gathering of power, no helpless ebb
of discouraged recoil; but alike through bright day and
lulling night, the never-pausing plunge, and never-fading
flash, and never-hushing whisper, and, while the sun was
up, the ever-answering glow of unearthly aquamarine,
ultramarine, violet-blue, gentian-blue, peacock-blue, river-
of-paradise blue, glass of a painted window melted in the
sun and the witch of the Alps flinging the spun tresses of
it for ever from her snow.

91. The innocent way, too, in which the river used
to stop to look into every little corner. Great torrents
always seem angry, and great rivers too often sullen; but
there is no anger, no disdain, in the Rhone. It seemed
as if the mountain stream was in mere bliss at recovering
itself again out of the lake-sleep, and raced because it
rejoiced in racing, fain yet to return and stay. There
were pieces of wave that danced all day as if Perdita were
looking on to learn; there were little streams that skipped
like lambs and leaped like chamois; there were pools that
shook the sunshine all through them, and were rippled
in layers of overlaid ripples, like crystal sand; there were
currents that twisted the light into golden braids, and inlaid
the threads with turquoise enamel; there were strips of
stream that had certainly above the lake been millstreams,
and were looking busily for mills to turn again; there were

shoots of stream that had once shot fearfully into the air, and now sprang up again laughing that they had only fallen a foot or two;—and in the midst of all the gay glittering and eddied lingering, the noble bearing by of the midmost depth, so mighty, yet so terrorless and harmless, with its swallows skimming instead of petrels, and the dear old decrepit town as safe in the embracing sweep of it as if it were set in a brooch of sapphire.

92. And the day went on, as the river; but I never felt that I wasted time in watching the Rhone. One used to get giddy sometimes, or discontentedly envious of the fish. Then one went back for a walk in the penthouse street, long ago gone. There was no such other street anywhere. Penthouses five stories high, not so much for the protection of the people in the street as to keep the plash of heavy rain from the house windows, so that these might be the more safely open. Beam-pillars of squared pine, with one cross-tie beam, the undecorative structural arrangement, Swiss to the very heart and pitch of it, picturesque in comfort, stately and ancient without decay, and rough, here in mid Geneva, more than in the hill solitudes.

93. We arrived at Geneva on 1st June, 1844, with plan of another month at Chamouni; and fine things afterwards, which also came prosperously to pass. I had learned to draw now with great botanical precision; and could colour delicately, to a point of high finish. I was interested in everything, from clouds to lichens. Geneva was more wonderful to me, the Alps more living and mighty, than ever; Chamouni more peaceful.

We reached the Prieure on the 6th June, and found poor Michel Devouassoud's climbing days ended. He had got a chill, and a cough; medicined himself with absinthe, and was now fast dying. The body of guides had just sustained a graver loss, by the superannuation, according

to law, in his sixtieth year, of Joseph Couttet, the Captain
of Mont Blanc, and bravest at once and most sagacious
of the old school of guides. Partly in regard for the old
man, partly in respect for us, now favourably known in
Chamouni, the law was relaxed by the Chef des Guides
in our favour, and Couttet came to us on the morning of
the 7th of June. My father explained to him that he
wanted me taken charge of on the hills, and not permitted
in any ambitious attempts, or taken into any dangerous
places; and that, from what he had heard of Couttet's
trustworthiness, and knowledge of his mountains, he had
no doubt that I should be safe with him, and might learn
more under his tutelage, in safety, than by the most daring
expeditions under inferior masters. Couttet said little,
but accepted the charge with a kindly glitter in his eyes,
and a cheerful word or two, signifying that my father need
not fear for me; and we set out together for the base
of the Buet,—I on muleback, he walking.

For thirty years he remained my tutor and companion.
Had he been my drawing-master also, it would have been
better for me: if my work pleased Couttet, I found after-
wards it was always good; and he knew perfectly when
I was trying vainly to do what I could not, or foolishly
what no one else would care for.

The month at Chamouni, however, passed with his
approval, and to my perfect benefit. I made two fore-
ground studies in colour, of considerable beauty; and,
under his teaching, began to use my alpenstock easily, and
to walk with firmness.

94. Of our habitual Chamouni life—papa's, mamma's,
and mine—I shall give account further on: I take from
this year's diary only the note on first reaching the bases
of the aiguilles.

"At last, on steep inclined planes of snow, reached the
base of the little Charmoz; but was amazed to find that

the size of the aiguilles seemed to diminish with every step
of approach, after a certain point, and that, thus seen (the
aiguille) Blaitière, though still 3,000 feet above us, looked
a mere rock, ascendable in a quarter of an hour. Of
course, after being used to the higher rocks, one begins
to measure them in their own way; but where there is
nothing to test scale—where the air is perfectly mistless,
and the mountain masses are divided into sheets whose
edges are the height of Dover cliffs, it is impossible effectu-
ally to estimate their magnitude but by trying them."

This bit of moonlight is perhaps worth keeping:
"28th June, half-past ten.—I never was dazzled by
moonlight until now; but as it rose from behind the
Mont Blanc du Tacul, the full moon almost blinded me:
it burst forth into the sky like a vast star. For an hour
before, the aiguilles had appeared as dark masses against
a sky looking as transparent as clear sea, edged at their
summits with fleeces of cloud breaking into glorious spray
and foam of white fire. A meteor fell over the Dôme
as the moon rose: now it is so intensely bright that I cannot
see the Mont Blanc underneath it; the form is lost in its
light."

Many and many an hour of precious time and perfect
sight was spent, during these years, in thus watching skies;
much was written which would be useful—if I took a
year to put it together,—to myself; but, in the present
smoky world, to no other creature: and much was learned,
which is of no use now to anybody; for to me it is only
sorrowful memory, and to others, an old man's fantasy.

95. We left Chamouni on 4th July; on the 8th I find
this entry at St. Gingoulph: "We dined late, which kept
me later from my walk than I like, and it was wet with
recent rain; but the glades of greensward under groves
of Spanish chestnut all the greener for it. Such richness
I never saw in Italy; the hay just cut, leaving the grass

crisp and short; the grey trunks and rich leaves mixed
with mossy rock, and the cliffs above, nobler than Amalfi:
the sunset sent down rays of opaque gold between me and
the Jura, bringing out the successive rises of the Pays de
Vaud; the Jura a golden shadow, sharp-edged and baseless
in the sky."

Hence, we crossed the Simplon to Baveno and back,—
for the Simplon's and Lago Maggiore's sake only.

"Baveno, July 12th.—I have more feeling for Italy
than ever, but it makes me deeply sad. The vines and
pasture about this place make it a Paradise; the people are
fine-featured, and singularly graceful in motion; but there
is every appearance of hopeless vice. Four men have been
playing cards and drinking, without stirring, in the inn-
yard since twelve o'clock (noon). I had come in from
an evening walk, and the gardens and enclosed spots of
ground are foul as dunghills. The Isola Bella is fast
going to decay—all the stucco of it green, damp, shattered,
covered with weeds and dead leaves; yet the flowers and
foliage of surpassing beauty."

And to this day, the uselessness of San Carlo's memory
is to me one of the entirely wonderfullest things in Catholic
history;—that Rome should go on sending missionaries
to China, and, within a thousand yards across the water
from St. Carlo's isle, leave the people of her own Italy's
Garden of Eden in guilt and misery. I call the Lago
Maggiore district the Eden of Italy; for there are no
solfataras there, no earthquakes, no pestiferous marsh, no
fever-striking sunshine. Purest air, richest earth, loveliest
wave; and the same noble race that founded the architec-
ture of Italy at Como.

Left to die, like the green lizards, in the blind clefts of
their rocks, whence they see no God.

96. "Village of Simplon, 15th June.—At eight this
evening I was sitting on the highest col of the Simplon,

watching the light die on the Breithorn; nothing round me but rock and lichen, except one purple flower," (coloured and very accurate drawing, at the side, of Linaria Alpina,) "and the forget-me-not, which grows everywhere. My walk home was very lovely, star after star coming out above my head, the white hills gleaming among them; the gulph of pines, with the torrent, black and awful below; lights breaking softly through cottage windows.

"Cassiopeia is rising above a piny mountain, exactly opposite my window."

The linaria must have been brought "home" (the Simplon village inn was already more that to me than ever Denmark Hill), and painted next morning—it could not have been so rightly coloured at night; also the day had been a heavy one. At six, morning, I had visited Signor Zanetti, and reviewed his collection of pictures on Isola Pescatore; walked up most of the defile of Gondo; and the moment we got to the Simplon village, dashed off to catch the sunset from the col; five miles up hill against time, (and walk against time up a regular slope of eight feet in the hundred is the most trying foot-work I know,) five miles back under the stars, with the hills not *under* but *among* them, and careful entry, of which I have only given a sentence, make up a day which shows there was now no farther need to be alarmed about my health. My good father, who was never well in the high air, and hated the chills from patches of melting snow, stayed nevertheless all next day at the village, to let me climb the long-coveted peak west of the Simplon col, which forms the great precipice on the Brieg side. "It commanded the Valais far down, the Bernese Alps in their whole extent, and two great mountains beyond the valley of Saas." These were the Weisshorn, and lower peak nearer Zermatt.

97. That evening James Forbes and his wife were with us in the otherwise untenanted salle-à-manger (see "Deucalion," Chap. X.), and next morning, the 17th, "I set off at six to visit the Père Barras," (formerly Clavendiér of the great St. Bernard, now at the monastery of the Simplon,) "On the Sempione," (I meant the Fletschhorn,) "a field of cirri, bounded by a contour like that of common cirrostrati, convex and fishy, but composed of the most exquisite sandy and silky forms, all in most rapid motion, but forming and vanishing, as usual, exactly at the same point, so that the mass was stationary. Reached the col in two hours of very slow walking, and breakfasted with the Father. He showed me the spot where the green actynolite is found, directly behind the convent. One of his dogs saw him with his hat on, and waited in the passage, barking furiously with delight. He parted from me half a mile down on this side (Brieg side), and I waited at the second gallery for the carriage."

"19th July, Zermatt.—Clouds on the Matterhorn all day till sunset, when there were playing lights over the sky, and the Matterhorn appeared in full ruby, with a wreath of crimson cloud drifting from its top."

That day Gordon was to come up from Chamouni to meet us; he had slept at Visp, and was first at Zermatt. Just as we came in sight of the Matterhorn he met us, with his most settledly practical and constitutional face—

"Yes, the Matterhorn is all very fine; but do you know there's nothing to eat?"

"Nonsense; we can eat anything here."

"Well, the black bread's two months old, and there's nothing else but potatoes."

"There must be milk, anyhow."

Yes, there was milk, he supposed.

"You can sop your bread in it then; what could be nicer?"

But Gordon's downcast mien did not change; and I had to admit myself, when supper-time came, that one might almost as hopelessly have sopped the Matterhorn as the loaf.

98. Thus the Christian peasant had lived in the Alps, unthought of, for two thousand years—since Christ broke bread for His multitude; and lived thus under the direct care of the Catholic Church—for Sion, the capital of the Valais, is one of the grandest of old bishoprics; and just below this valley of black bread, the little mountain towns of Visp and Brieg are more groups of tinkling towers and convent cloisters than civic dwelling-places. As for the Catholic State, for a thousand years, while at every sunset Monte Rosa glowed across the whole Lombard plain, not a Lombard noble knew where the mountain was.

Yet, it may be, I err in my pity. I have many things yet to say of the Valais; meantime this passage from Saussure records a social state in 1796, which, as compared with that of the poor in our great capitals, is one neither of discomfort nor disgrace:—

"La sobriété, compagne ordinaire de l'amour du travail, est encore une qualité remarquable des habitants de ces vallées. Ce pain de seigle, dont j'ai parlé qu'on ne mange que six mois après qu'il est cuit, on le ramollit dans du petit lait ou dans du lait de beurre, et cette espèce de soupe fait leur principale nourriture; le fromage et un peu de vieille vache ou de chèvre salées, se réservent pour les jours de fête ou pour le temps de grands travaux; car pour la viande fraîche, ils n'en mangent jamais, c'est un mets trop dispendieux. Les gens riches du pays vivent avec la même économie; je voyois notre hôte de Macugnaga, qui n'étoit rien moins que pauvre, aller tous les soirs prendre, dans un endroit fermé à clef, une pincée d'aulx dont il distribuoit gravement une gousse à sa femme, et autant à chacun de ses enfants, et cette gousse d'ail étoit l'assaisonnement unique d'un morceau de pain sec qu'ils

brisoient entre deux pierres, & qu'ils mangeoient pour leur souper. Ceux d'entr'eux qui négocient au dehors, viennent au moins une fois tous les deux ans passer quelques mois dans leur village; et quoique hors de chez eux ils prennent l'habitude d'une meilleure nourriture, ils se remettent sans peine à celle de leur pays, et ne le quittent qu'avec un extrême regret; j'ai été témoin d'un ou deux de ces départs, qui m'ont attendri jusqu'aux larmes."

99. By the morning, however, our hosts had found some meat for the over-greedy foreigners, and the wine was good enough; but it was no place for papa and mamma to stay in; and, bravado apart, I liked black bread no better than they. So we went up to the Riffelberg, where I saw that on the north Monte Rosa was only a vast source of glacier, and, as a mountain, existed only for the Italian side: the Matterhorn was too much of an Egyptian obelisk to please me (I trace continually the tacit reference in my Cumberland-built soul to moorish Skiddaw and far-sweeping Saddleback as the proper types of majestic form); and I went down to Visp again next day without lamentation: my mother, sixty-three on next 2nd September, walking with me the ten miles from St. Nicholas to Visp as lightly as a girl. And the old people went back to Brieg with me, that I might climb the Bell Alp (then unknown), whence I drew the panorama of the Simplon and Bernese range, now in Walkley Museum. But the more I got, the more I asked. After drawing the Weisshorn and Aletsch-horn, I wanted to see the Aiguille Verte again, and was given another fortnight for Chamouni; the old people staying at the Trois Couronnes of Vevay. I spent the days usefully, going first up to the base of the Aiguille d'Argentière, which commands the glorious white ocean of the Tours glacier below, and, opposite, the four precipices of the Aiguille Verte on its north-east flank; and that day, 27th July,

we saw a herd of more than thirty chamois on the Argen-
tière. "Pour les voir, faut aller où ils sont," said Couttet;
and he might have added, where other living things are
not; for, whether by shepherd or traveller, the snows
round the Aiguilles of Chardonnet and Argentière are
the least trodden of all the Mont Blanc fields. The herd
was in three groups, twelve in one of them only; and did
not put itself to speed, but retired slowly when we got
within a quarter of a mile of them, each stopping to look
back from the ridge behind which they disappeared.

100. "Iceland moss" (says the diary), "in enormous
quantities amongst the Alpine roses, above the Argentière
glacier—not growing at all, so far as I recollect, but on the
hills on the north-east of the valley. Where we took the
snow, the top of the glacier" (Tours) "was wreathed in
vast surges which took us from twenty minutes to half an
hour (each) to climb,—green lovely lakes in their hollows,
no crevices." On the 29th July I went up the Buet,
and down to Sixt, where I found myself very stiff and
tired, and determined that the Alps were, on the whole,
best seen from below. And after a walk to the Fer-à-
cheval, considering the wild strawberries there to taste of
slate, I went rather penitently down to Geneva again.

Feeling also a little ashamed of myself before papa—in
the consciousness that all his pining in cold air, and dining
on black bread, and waiting, day after day, not without
anxiety, while I rambled he knew not whither, had not
in the least advanced the object nearest his heart,—the
second volume of "Modern Painters." I had, on the
contrary, been acutely and minutely at work in quite other
directions—felt tempted now to write on Alpine botany,
or devote myself to painting myrtilles and mica-slate for
the rest of my days. The Turner charm was indeed as
potent as ever; but I felt that other powers were now
telling on me besides his,—even beyond his; not in delight,

but in vital strength; and that no word more could be written of him, till I had tried the range of these.

101. It surprises me to find, by entries at Paris (which I was reasonable enough now to bear the sight of again), in August of this year, how far I had advanced in picture knowledge since the Roman days; progress which I see no ground for, and remember no steps of,—except only a lesson given me by George Richmond at one of Mr. Rogers' breakfasts (the old man used to ask me, finding me always reverent to him, joyful in his pictures, and sometimes amusing, as an object of curiosity to his guests), —date uncertain, but probably in 1842. Until that year, Rubens had remained the type of colour power to me, and (p. 250 above) Titian's flesh tints of little worth! But that morning, as I was getting talkative over the wild Rubens sketch, (War or Discord, or Victory or the Furies, I forget what,) Richmond said, pointing to the Veronese beneath it, "Why are you not looking at this,—so much greater in manner?" "Greater,—how?" I asked, in surprise; "it seems to me quite tame beside the Rubens." "That may be," said Richmond, "but the Veronese is true, the other violently conventional." "In what way true?" I asked, still not understanding. "Well," said Richmond, "compare the pure shadows on the flesh, in Veronese, and its clear edge, with Rubens's ochre and vermilion, and outline of asphalt."

102. No more was needed. From that moment, I saw what was meant by Venetian colour; yet during 1843, and early 1844, was so occupied with "Modern Painters," degree-getting, and studies of foliage and foreground, that I cannot understand how I had reached, in picture know-ledge, the point shown by these following entries, of which indeed the first shows that the gain surprised me at the time, but foolishly regards it only as a change coming to pass in the Louvre on the instant, and does not recognize

it as the result of growth: the fact being, I suppose, that the habit of looking for true colour in nature had made me sensitive to the modesty and dignity of hues in painting also, before possessing no charm for me.

"Aug. 17th. I have had a change wrought in me, and a strong one, by this visit to the Louvre, and know not how far it may go, chiefly in my full understanding of Titian, John Bellini, and Perugino, and being able to abandon everything for them; or rather, being *un*able to look at anything else."

103. I allow the following technical note only for proof of the length I had got to. There shall be no more of the kind let into PRÆTERITA.

"1252 ('The Entombment') is the finest Titian in the gallery,—glowing, simple, broad, and grand. It is to be opposed to 1251 ('The Flagellation'), in which the shades are brown instead of grey, the outlines strong brown lines, the draperies broken up by folds, the lights very round and vivid, and foiled by deep shades, the flesh forms, the brightest lights, and the draperies subdued.

"In 1252 every one of these conditions is reversed. Even the palest flesh is solemn and dark, in juxtaposition with golden-white drapery; all the masses broad and flat, the shades grey, the outlines chaste and severe. It may be taken as an example of the highest dignity of expression wrought out by mere grandeur of colour and composition.

"I found myself finally in the Louvre, fixed by this Titian, and turning to it, and to the one (picture), exactly opposite, John and Gentile Bellini, by John Bellini. I was a long time hesitating between this and Raphael's dark portrait; but decided for the John Bellini.

"Aug. 18th. To-morrow we leave. I have been watching the twilight on the Tuileries, which was very grand and clear; and planning works. I shall try to paint a Madonna some day, I believe."

CHAPTER VI

THE CAMPO SANTO

104. THE summer's work of 1844, so far from advancing the design of "Modern Painters," had thrown me off it —first into fine botany, then into difficult geology, and lastly, as that entry about the Madonna shows, into a fit of figure study which meant much. It meant, especially, at last some looking into ecclesiastical history,—some notion of the merit of fourteenth century painting, and the total abandonment of Rubens and Rembrandt for the Venetian school. Which, the reader will please observe, signified not merely the advance in sense of colour, but in perception of truth and modesty in light and shade. And on getting home, I felt that in the cyclone of confused new knowledge, this was the thing first to be got firm.

Scarcely any book writing was done that winter,—and there are no diaries; but, for the first time, I took up Turner's "Liber Studiorum" instead of engravings; mastered its principles, practised its method, and by spring-time in 1845 was able to study from nature accurately in full chiaroscuro, with a good frank power over the sepia tinting.

I must have read also, that winter, Rio's "Poésie Chrétienne," and Lord Lindsay's introduction to his "Christian Art." And perceiving thus, in some degree, what a blind bat and puppy I had been, all through Italy, determined that at least I must see Pisa and Florence again before writing another word of "Modern Painters."

105. How papa and mamma took this new vagary, I have no recollection; resignedly, at least: perhaps they also had some notion that I might think differently, and

it was to be hoped in a more orthodox and becoming manner, after another sight of the Tribune. At all events, they concluded to give me my own way entirely this time; and what time I chose. My health caused them no farther anxiety; they could trust my word to take care of myself every day, just the same as if I were coming home to tea: my mother was satisfied of Couttet's skill as a physician, and care, if needed, as a nurse;—he was engaged for the summer in those capacities,—and, about the first week in April, I found myself dining on a trout of the Ain, at Champagnole; with Switzerland and Italy at my feet—for to-morrow.

106. Curiously, the principal opposition to this unprincipled escapade had been made by Turner. He knew that one of my chief objects was to see the motives of his last sketches on the St. Gothard; and he feared my getting into some scrape in the then disturbed state of the cantons. He had probably himself seen some of their doings in 1843, when "la vieille Suisse prit les armes, prévint les Bas Valaisans, qui furent vaincus et massacrés au Pont du Trient, près de Martigny;" * and again an expedition of the Corps Francs of the liberal cantons "pour expulser les Jesuits, et renverser le gouvernement," at Lucerne, had been summarily "renversée" itself by the Lucernois, 8th December, 1844, only three months before my intended start for the Alps. Every time Turner saw me during the winter, he said something to dissuade me from going abroad; when at last I went to say good-bye, he came down with me into the hall in Queen Anne Street, and opening the door just enough for me to pass, laid hold of my arm, gripping it strongly. "Why *will* you go to Switzerland—there'll be such a fidge about you, when you're gone."

* "La Suisse Historique," par E. H. Gaullieur. Genève, 1855, p. 428.

I am never able to collect myself in a moment, and am simply helpless on any sudden need for decision like this; the result being, usually, that I go on doing what I meant to do. If I say anything, it is sure to be wrong. I made no answer, but grasped his hand closely, and went. I believe he made up his mind that I was heartless and selfish; anyhow he took no more pains with me.

107. As it chanced, even while I sat over my trout at Champagnole, there was another expedition of the Francs Corps—M. Gaullieur does not say against whom, but only that it had "une issue encore plus tragique que la première." But there had been no instance of annoyance to English or any other travellers, in all the course of these Swiss squabbles since 1833, in which year—by the way, the first of our journeys—we drove under some posted field-batteries into Basle, just after the fight at Liesthal between the liberal townspeople and Catholic peasants. The landlord of the "Three Kings" had been out; and run—or at least made the best speed he could—three leagues to the town gates.

It was no part of my plan, however, as my parents knew, to enter Switzerland in this spring-time: but to do what I could in Italy first. Geneva itself was quiet enough: Couttet met me there, and next day we drove over the ledges of the Salève, all aglow with primrose and soldanelle, down upon Annecy.

108. I had with me, besides Couttet, a young servant who became of great use to me in succeeding years; with respect to whom I must glance back at some of the past revolutions in our domestic dynasties. The cook and housemaid at Herne Hill, in its mainly characteristic time —1827–1834—were sisters, Mary and Elizabeth Stone. I have never seen a fillet of veal rightly roasted, nor a Yorkshire pudding rightly basted, since Mary Stone left us to be married in 1836. Elizabeth, also not to be

excelled in her line, was yet replaceable, when her career ended in the same catastrophe, by a third younger sister, Hannah; but I can't in the least remember who waited on us, till our perennial parlour-maid, Lucy Tovey, came to us in 1829—remaining with us till 1875. Her sister Harriet replaced Hannah Stone, who must needs be married, like Mary and Elizabeth, in 1834; nor did she leave us till the Denmark Hill household was broken up. But in 1842 another young housemaid came, Anne Hobbs, whose brother John Hobbs, called always at Denmark Hill, George, to distinguish him, in vocal summons, from my father and me, became my body servant in the same year, and only left me to push his higher fortune in 1854. I could not say before, without interrupting graver matters, that the idea of my not being able to dress myself began at Oxford, where it was thought becoming in a gentleman-commoner to have a squire to manage his scout. My good, honest, uninteresting Thomas Hughes, being vigilant that I put my waistcoat on right side outwards, went abroad with us, instead of Salvador; my father, after the first two journeys, being quite able to do his courier's work himself. When we came home in '42, Hughes wanted to promote himself to some honour or other in the public-house line, and George Hobbs, a sensible and merry-minded youth of eighteen, came in his stead. Couttet and he sat in the back seat of the light-hooded barouche which I took for this Italian journey; the hood seldom raised, as I never travelled in bad weather unless surprised by it; and the three of us walked that April morning up the Salève slope, and trotted down to Annecy, in great peace of mind.

109. At Annecy I made the first careful trial of my new way of work. I herewith reproduce the study; it is very pleasant to me still; and certainly any artist who once accustoms himself to the method cannot afterwards

fall into any mean trickery or dull conventionalism. The outline must be made clearly and quietly, conveying as much accurate information as possible respecting the form and structure of the object; then, in washing, the chiaroscuro is lowered from the high lights with extreme care down to the middle tones, and the main masses left in full shade.

A rhyme written to Mont Blanc at Geneva, and another in vituperation of the idle people at Conflans, were, I think, the last serious exertions of my poetical powers. I perceived finally that I could express nothing I had to say, rightly, in that manner; and the "peace of mind" above referred to, which returns to me as the principal character of this opening journey, was perhaps, in part, the result of this extremely wholesome conclusion.

110. But also, the two full years, since the flash of volcanic lightning at Naples, had brought me into a deeper and more rational state of religious temper. I can scarcely yet call it religious thought; but the steadily read chapters, morning and evening, with the continual comparison between the Protestant and Papal services every Sunday abroad, made me feel that all dogmatic teaching was a matter of chance and habit; and that the life of religion depended on the force of faith, not the terms of it. In the sincerity and brightness of his imagination, I saw that George Herbert represented the theology of the Protestant Church in a perfectly central and deeply spiritual manner: his "Church Porch" I recognised to be blamelessly wise as a lesson to youth; and the exquisitely faithful fancy of the other poems (in the "Temple") drew me into learning most of them by heart,—the "Church Porch," the "Dialogue," "Employment," "Submission," "Gratefulness," and, chief favourite, "The Bag,"—deliberately and carefully. The code of feeling and law written in these verses may be always assigned as a standard of the purest

unsectarian Christianity; and whatever has been wisest
in thought or happiest in the course of my following life
was founded at this time on the teaching of Herbert. The
reader will perhaps be glad to see the poem that has been
most useful to me, "Submission," in simpler spelling than
in the grand editions:

> But that Thou art my wisdom, Lord,
> And both mine eyes are Thine,
> My mind would be extremely stirred
> For missing my design.
>
> Were it not better to bestow
> Some place and power on me?
> Then should Thy praises with me grow,
> And share in my degree.
>
> But when I thus dispute and grieve
> I do resume my sight,
> And pilfering what I once did give,
> Disseize Thee of Thy right.
>
> How know I, if Thou shouldst me raise,
> That I should then raise Thee?
> Perhaps great places and Thy praise
> Do not so well agree!
>
> Wherefore, unto my gift I stand,
> I will no more advise;
> Only do Thou lend me Thine hand,
> Since Thou hast both mine eyes.

111. In these, and other such favourite verses, George
Herbert, as aforesaid, was to me at this time, and has been
since, useful beyond every other teacher; not that I ever
attained to any likeness of feeling, but at least knew where
I was myself wrong, or cold, in comparison. A little more
force was also put on Bible study at this time, because I
held myself responsible for George's tenets as well as my
own, and wished to set him a discreet example; he being

well-disposed, and given to my guidance, with no harm
as yet in any of his ways. So I read my chapter with
him morning and evening; and if there were no English
church on Sundays, the Morning Service, Litany and all,
very reverently; after which we enjoyed ourselves, each
in our own way, in the afternoons, George being always
free, and Couttet, if he chose; but he had little taste for
the Sunday promenades in a town, and was glad if I would
take him with me to gather flowers, or carry stones. I
never, until this time, had thought of travelling, climbing,
or sketching on the Sunday: the first infringement of
this rule by climbing the isolated peak above Gap, with
both Couttet and George, after our morning service,
remains a weight on my conscience to this day. But it
was thirteen years later before I made a sketch on Sunday.

112. By Gap and Sisteron to Frejus, along the Riviera
to Sestri, where I gave a day to draw the stone-pines now
at Oxford; and so straight to my first fixed aim, Lucca,
where I settled myself for ten days,—as I supposed. It
turned out forty years.

The town is some thousand paces square; the unbroken
rampart walk round may be a short three miles. There
are upwards of twenty churches in that space, dating
between the sixth and twelfth centuries; a ruined feudal
palace and tower, unmatched except at Verona: the
streets clean—cheerfully inhabited, yet quiet; nor desolate,
even now. Two of the churches representing the per-
fectest phase of round-arched building in Europe, and one
of them containing the loveliest Christian tomb in Italy.

The rampart walk, unbroken except by descents and
ascents at the gates, commands every way the loveliest
ranges of all the Tuscan Apennine: when I was there
in 1845, besides the ruined feudal palace, there was
a maintained Ducal Palace, with a living Duke in it,
whose military band played every evening on the most

floral and peaceful space of rampart. After a well-spent day, and a three-course dinner,—military band,—chains, double braided, of amethyst Apennine linked by golden clouds,—then the mountain air of April still soft as the marble towers grew unsubstantial in the starlight, —such the monastic discipline of Lucca to my novitiate mind.

113. I must stop to think a little how it was that so early as this I could fasten on the tomb of Ilaria di Caretto with certainty of its being a supreme guide to me ever after. If I get tiresome, the reader must skip; I write, for the moment, to amuse myself, and not him. The said reader, duly sagacious, must have felt, long since, that, though very respectable people in our way, we were all of us definitely vulgar people; just as my aunt's dog Towzer was a vulgar dog, though a very good and dear dog. Said reader should have seen also that we had not set ourselves up to have a taste in anything. There was never any question about matching colours in furniture, or having the correct pattern in china. Everything for service in the house was bought plain, and of the best; our toys were what we happened to take a fancy to in pleasant places—a cow in stalactite from Matlock, a fisher-wife doll from Calais, a Swiss farm from Berne, Bacchus and Ariadne from Carrara. But, among these toys, principal on the drawing-room chimney-piece, always put away by my mother at night, and "put out" in the afternoon, were some pieces of Spanish clay, to which, without knowing it, I owed a quantity of strenuous teaching. Native baked clay figures, painted and gilded by untaught persons who had the gift; manufacture mainly practised along the Xeres coast, I believe, and of late much decayed, but then flourishing, and its work as good as the worker could make it. There was a Don Whiskerandos contra-bandista, splendidly handsome and good-natured, on a

magnificent horse at the trot, brightly caparisoned: every-
thing finely finished, his gun loose in his hand. There
was a lemonade seller, a pomegranate seller, a matador
with his bull—animate all, and graceful, the colouring
chiefly ruddy brown. Things of constant interest to me,
and altogether wholesome; vestiges of living sculpture
come down into the Herne Hill times, from the days of
Tanagra.

For loftier admiration, as before told, Chantrey in Lich-
field, Roubilliac in Westminster, were set forth to me,
and honestly felt; a scratched white outline or two from
Greek vases on the black Derbyshire marble did not
interfere with my first general feeling about sculpture,
that it should be living, and emotional; that the flesh
should be like flesh, and the drapery like clothes; and
that, whether trotting contrabandista, dancing girl, or
dying gladiator, the subject should have an interest of its
own, and not consist merely of figures with torches or
garlands standing alternately on their right and left legs.
Of "ideal" form and the like, I fortunately heard and
thought nothing.

114. The point of connoisseurship I had reached, at
sixteen, with these advantages and instincts, is curiously
measured by the criticism of the Cathedral of Rheims in
my Don Juan journal of 1835:

> The carving is not rich,—the Gothic heavy,
> The statues miserable; not a fold
> Of drapery well-disposed in all the bevy
> Of Saints and Bishops and Archbishops old
> That line the porches grey. But in the nave I
> Stared at the windows purple, blue, and gold:
> And the perspective's wonderfully fine
> When you look down the long columnar line.

By the "carving" I meant the niche work, which is
indeed curiously rude at Rheims; by the "Gothic" the

structure and mouldings of arch, which I rightly call
"heavy" as compared with later French types; while the
condemnation of the draperies meant that they were not
the least like those either of Rubens or Roubilliac. And
ten years had to pass over me before I knew better; but
every day between the standing in Rheims porch and by
Ilaria's tomb had done on me some chiselling to the good;
and the discipline from the Fontainebleau time till now
had been severe. The accurate study of tree branches,
growing leaves, and foreground herbage, had more and
more taught me the difference between violent and grace-
ful lines; the beauty of Clotilde and Cécile, essentially
French-Gothic, and the living Egeria of Araceli, had
fixed in my mind and heart, not as an art-ideal, but as
a sacred reality, the purest standards of breathing woman-
hood; and here suddenly, in the sleeping Ilaria, was the
perfectness of these, expressed with harmonies of line
which I saw in an instant were under the same laws as
the river wave, and the aspen branch, and the stars' rising
and setting; but treated with a modesty and severity which
read the laws of nature by the light of virtue.

115. Another influence, no less forcible, and more
instantly effective, was brought to bear on me by my first
quiet walk through Lucca.

Hitherto, all architecture, except fairy-finished Milan,
had depended with me for its delight on being partly in
decay. I revered the sentiment of its age, and I was
accustomed to look for the signs of age in the mouldering
of its traceries, and in the interstices deepening between
the stones of its masonry. This looking for cranny and
joint was mixed with the love of rough stones themselves,
and of country churches built like Westmoreland cottages.

Here in Lucca I found myself suddenly in the presence
of twelfth century buildings, originally set in such balance
of masonry that they could all stand without mortar; and

in material so incorruptible, that after six hundred years of sunshine and rain, a lancet could not now be put between their joints.

Absolutely for the first time I now saw what mediæval builders were, and what they meant. I took the simplest of all façades for analysis, that of Santa Maria Foris-Portam, and thereon literally *began* the study of architecture.

In the third—and, for the reader's relief, last—place in these technical records, Fra Bartolomeo's picture of the Magdalene, with St. Catherine of Siena, gave me a faultless example of the treatment of pure Catholic tradition by the perfect schools of painting.

116. And I never needed lessoning more in the principles of the three great arts. After those summer days of 1845, I advanced only in knowledge of individual character, provincial feeling, and details of construction or execution. Of what was primarily right and ultimately best, there was never more doubt to me, and my art-teaching, necessarily, in its many local or personal interests, partial, has been from that time throughout consistent, and progressing every year to more evident completion.

The full happiness of that time to me cannot be explained except to consistently hard workers; and of those, to the few who can keep their peace and health. For the world appeared to me now exactly right. Hills as high as they should be, rivers as wide, pictures as pretty, and masters and men as wise—as pretty and wise could be. And I expected to bring everybody to be of my opinion, as soon as I could get out my second volume; and drove down to Pisa in much hope and pride, though grave in both.

For now I had read enough of Cary's Dante, and Sismondi's "Italian Republics," and Lord Lindsay, to feel what I had to look for in the Campo Santo. Yet at this moment I pause to think what it was that I found.

Briefly, the entire doctrine of Christianity, painted so that a child could understand it. And what a child cannot understand of Christianity, no one need try to.

117. In these days of the religion of this and that,—briefly let us say, the religion of Stocks and Posts—in order to say a clear word of the Campo Santo, one must first say a firm word concerning Christianity itself. I find numbers, even of the most intelligent and amiable people, not knowing what the word means; because they are always asking how much is true, and how much they like, and never ask, first, what *was* the total meaning of it, whether they like it or not.

The total meaning was, and is, that the God who made earth and its creatures, took at a certain time upon the earth, the flesh and form of man; in that flesh sustained the pain and died the death of the creature He had made; rose again after death into glorious human life, and when the date of the human race is ended, will return in visible human form, and render to every man according to his work. Christianity is the belief in, and love of, God thus manifested. Anything less than this, the mere acceptance of the sayings of Christ, or assertion of any less than divine power in His Being, may be, for aught I know, enough for virtue, peace, and safety; but they do not make people Christians, or enable them to understand the heart of the simplest believer in the old doctrine. One verse more of George Herbert will put the height of that doctrine into less debateable, though figurative, picture than any longer talk of mine:—

> Hast thou not heard that my Lord Jesus died?
> Then let me tell thee a strange story.
> The God of power, as he did ride
> In his majestic robes of glory,
> Resolved to light; and so, one day
> He did descend, undressing all the way.

> The stars his tire of light, and rings, obtained,
> The cloud his bow, the fire his spear,
> The heavens his azure mantle gained,
> And when they asked what he would wear,
> He smiled, and said as he did go,
> "He had new clothes a-making, here, below."

I write from memory; the lines have been my lesson, ever since 1845, of the noblesse of thought which makes the simplest word best.

118. And the Campo Santo of Pisa is absolutely the same in painting as these lines in word. Straight to its purpose, in the clearest and most eager way; the purpose, highest that can be; the expression, the best possible to the workman according to his knowledge. The several parts of the gospel of the Campo Santo are written by different persons; but all the original frescoes are by men of honest genius. No matter for their names; the contents of this wall-scripture are these.

First, the Triumph of Death, as Homer, Virgil, and Horace thought of death. Having been within sight of it myself, since Oxford days; and looking back already over a little Campo Santo of my own people, I was ready for that part of the lesson.

Secondly, the story of the Patriarchs, and of their guidance by the ministries of visible angels; that is to say, the ideal of the life of man in its blessedness, *before* the coming of Christ.

Thirdly, the story of Job, in direct converse with God himself, the God of nature, and without any reference to the work of Christ except in its final surety, "Yet in my flesh I shall see God."

Fourthly, the life of St. Ranier of Pisa, and of the desert saints, showing the ideal of human life in its blessedness *after* the coming of Christ.

Lastly, the return of Christ in glory, and the Last Judgment.

119. Now this code of teaching is absolutely general for the whole Christian world. There is no papal doctrine, nor antipapal; nor any question of sect or schism whatsoever. Kings, bishops, knights, hermits, are there, because the painters saw them, and painted them, naturally, as we paint the nineteenth century · product of common councilmen and engineers. But they did not conceive that a man must be entirely happy in this world and the next because he wore a mitre or helmet, as we do because he has made a fortune or a tunnel.

˙Not only was I prepared at this time for the teaching of the Campo Santo, but it was precisely what at that time I needed.

It realized for me the patriarchal life, showed me what the earlier Bible meant to say; and put into direct and inevitable light the questions I had to deal with, alike in my thoughts and ways, under existing Christian tradition.

Questions clearly not to be all settled in that fortnight. Some, respecting the Last Judgment, such as would have occurred to Professor Huxley,—as for instance, that if Christ came to judgment in St. James's Street, the people couldn't see him from Piccadilly,—had been dealt with by me before now; but there is one fact, and no question at all, concerning the Judgment, which was only at this time beginning to dawn on me, that men had been curiously judging *themselves* by always calling the day they expected, "Dies Iræ," instead of "Dies Amoris."

120. Meantime, my own first business was evidently to read what these Pisans had said of it, and take some record of the sayings; for at that time the old-fashioned ravages were going on, honestly and innocently. Nobody cared for the old plaster, and nobody pretended to. When any dignitary of Pisa was to be buried, they peeled off some Benozzo Gozzoli, or whatever else was in the way,

and put up a nice new tablet to the new defunct; but
what was left was still all Benozzo, (or repainting of old
time, not last year's restoration). I cajoled the Abbé
Rosini into letting me put up a scaffold level with the
frescoes; set steadily to work with what faculty in outline
I had; and being by this time practised in delicate curves,
by having drawn trees and grass rightly, got far better
results than I had hoped, and had an extremely happy
fortnight of it! For as the triumph of Death was no
new thought to me, the life of hermits was no temptation;
but the stories of Abraham, Job, and St. Ranier, well
told, were like three new—Scott's novels, I was going
to say, and will say, for I don't see my way to anything
nearer the fact, and the work on them was pure delight.
I got an outline of Abraham's parting with the last of
the three angels; of the sacrifice of Job; of the three
beggars, and a fiend or two, out of the Triumph of Death;
and of the conversion of St. Ranier, for which I greatly
pitied him.

. For he is playing, evidently with happiest skill, on a
kind of zithern-harp, held upright as he stands, to the
dance of four sweet Pisan maids, in a round, holding each
other only by the bent little fingers of each hand. And
one with graver face, and wearing a purple robe,
approaches him, saying—I knew once what she said, but
forget now; only it meant that his joyful life in that
kind was to be ended. And he obeys her, and follows,
into a nobler life.

I do not know if ever there was a real St. Ranier;
but the story of him remained for truth in the heart of
Pisa as long as Pisa herself lived.

121. I got more than outline of this scene: a coloured
sketch of the whole group, which I destroyed afterwards,
in shame of its faults, all but the purple-robed warning
figure; and that is lost, and the fresco itself now lost also,

all mouldering and ruined by what must indeed be a
cyclical change in the Italian climate; the frescoes exposed
to it of which I made note before 1850, seem to me to
have suffered more in the twenty years since, than they
had since they were painted: those at Verona alone
excepted, where the art of fresco seems to have been
practised in the fifteenth century in absolute perfection,
and the colour to have been injured only by violence, not
by time.

There was another lovely cloister in Pisa, without
fresco, but exquisite in its arched perspective and central
garden, and noble in its unbuttressed height of belfry tower;
—the cloister of San Francesco: in these, and in the
meadow round the baptistery, the routine of my Italian
university life was now fixed for a good many years in
main material points.

122. In summer I have been always at work, or out
walking, by six o'clock, usually awake by half-past four;
but I keep to Pisa for the present, where my monkish
discipline arranged itself thus. Out, anyhow, by six,
quick walk to the field, and as much done as I could, and
back to breakfast at half-past eight. Steady bit of Sis-
mondi over bread and butter, then back to Campo Santo,
draw till twelve; quick walk to look about me and stretch
my legs, in shade if it might be, before lunch, on anything
I chanced to see nice in a fruit shop, and a bit of bread.
Back to lighter work, or merely looking and thinking,
for another hour and a half, and to hotel for dinner at four.
Three courses and a flask of Aleatico (a sweet yet rather
astringent, red, rich for Italian, wine—provincial, and
with lovely basket-work round the bottle). Then out
for saunter with Couttet; he having leave to say anything
he had a mind to, but not generally communicative of his
feelings; he carried my sketch-book, but in the evening
there was too much always to be hunted out, of city; or

watched, of hills, or sunset; and I rarely drew,—to my sorrow, now. I wish I knew less, and had drawn more.

Homewards, from wherever we had got to, the moment the sun was down, and the last clouds had lost their colour. I avoided marshy places, if I could, at all times of the day, because I didn't like them; but I feared neither sun nor moon, dawn nor twilight, malaria nor anything else malefic, in the course of work, except only draughts and ugly people. I never would sit in a draught for half a minute, and fled from some sorts of beggars; but a crowd of the common people round me only made me proud, and try to draw as well as I could; mere rags or dirt I did not care an atom for.

123. As early as 1835, and as late as 1841, I had been accustomed, both in France and Italy, to feel that the crowd behind me was interested in my choice of subjects, and pleasantly applausive of the swift progress under my hand of street perspectives, and richness of surface decoration, such as might be symbolized by dextrous zigzags, emphatic dots, or graceful flourishes. I had the better pleasure, now, of feeling that my really watchful delineation, while still rapid enough to interest any stray student of drawing who might stop by me on his way to the Academy, had a quite unusual power of directing the attention of the general crowd to points of beauty, or subjects of sculpture, in the buildings I was at work on, to which they had never before lifted eyes, and which I had the double pride of first discovering for them, and then imitating—not to their dissatisfaction.

And well might I be proud; but how much more ought I to have been pitiful, in feeling the swift and perfect sympathy which the "common people"—companion-people I should have said, for in Italy there is no commonness—gave me, in Lucca, or Florence, or Venice, for

every touch of true work that I laid in their sight.* How much more, I say, should it have been pitiful to me, to recognize their eager intellect, and delicate senses, open to every lesson and every joy of their ancestral art, far more deeply and vividly than in the days when every spring kindled them into battle, and every autumn was red with their blood: yet left now, alike by the laws and lords set over them, less happy in aimless life than of old in sudden death; never one effort made to teach them, to comfort them, to economize their industries, animate their pleasures, or guard their simplest rights from the continually more fatal oppression of unprincipled avarice, and unmerciful wealth.

124. But all this I have felt and learned, like so much else, too late. The extreme seclusion of my early training left me long careless of sympathy for myself; and that which I gave to others never led me into any hope of being useful to them, till my strength of active life was past. Also, my mind was not yet catholic enough to feel that the Campo Santo belonged to its own people more than to me; and indeed, I had to read its lessons before I could interpret them. The world has for the most part been of opinion that I entered on the task of philanthropy too soon rather than too late: at all events, my conscience remained at rest during all those first times at Pisa, in mere delight in the glory of the past, and in hope for the future of Italy, without need of my becoming one of her

* A letter, received from Miss Alexander as I correct this proof, gives a singular instance of this power in the Italian peasant. She says:—"I have just been drawing a magnificent Lombard shepherd, who sits to me in a waistcoat made from the skin of a yellow cow with the hairy side out, a shirt of homespun linen as coarse as sail-cloth, a scarlet sash, and trousers woven (I should think) from the wool of the black sheep. He astonishes me all the time by the great amount of good advice which he gives me about my work; and always right! Whenever he looks at my unfinished picture, he can always tell me exactly what it wants."

demagogues. And the days that began in the cloister of the Campo Santo usually ended by my getting upon the roof of Santa Maria della Spina, and sitting in the sunlight that transfused the warm marble of its pinnacles, till the unabated brightness went down beyond the arches of the Ponte-a-Mare,—the few footsteps and voices of the twilight fell silent in the streets, and the city and her mountains stood mute as a dream, beyond the soft eddying of Arno.

CHAPTER VII

MACUGNAGA

125. When first I saw Florence, in 1840, the great street leading into the Baptistery square from the south had not been rebuilt, but consisted of irregular ancient houses, with far projecting bracketed roofs. I mourned over their loss bitterly in 1845; but for the rest, Florence was still, then, what no one who sees her now could conceive.

For one great feature, an avenue of magnificent cypress and laurel ascended, unbroken, from the Porta Romana to Bellosguardo, from whose height one could then wander round through lanes of olive, or through small rural vineyards, to San Miniato, which stood deserted, but not ruinous, with a narrow lawn of scented herbage before it, and sweet wild weeds about its steps, all shut in by a hedge of roses. The long ascending causeway between smaller cypresses than those of the Porta Romana, gave every conceivably loveliest view of the Duomo, and Cascine forest, and passing away of Arno towards the sunset.

126. In the city herself, the monasteries were still inhabited, religiously and usefully; and in most of them, as well as among the Franciscans at Fésole, I was soon permitted to go wherever I liked, and draw whatever I chose. But my time was passed chiefly in the sacristy and choir of Santa Maria Novella, the sacristy of Santa Croce, and the upper passage of San Marco. In the Academia I studied the Angelicos only, Lippi and Botticelli being still far beyond me; but the Ghirlandajos in the choir of Santa Maria Novella, in their broad masses of

colour, complied with the laws I had learned in Venice, while yet they swiftly and strictly taught me the fine personalities of the Florentine race and art. At Venice, one only knows a fisherman by his net, and a saint by his nimbus. But at Florence, angel or prophet, knight or hermit, girl or goddess, prince or peasant, cannot but be what they are, masque them how you will.

Nobody ever disturbed me in the Ghirlandajo apse. There were no services behind the high altar; tourists, even the most learned, had never in those days heard Ghirlandajo's name; the sacristan was paid his daily fee regularly whether he looked after me or not. The lovely chapel, with its painted windows and companies of old Florentines, was left for me to do what I liked in, all the forenoon; and I wrote a complete critical and historical account of the frescoes from top to bottom of it, seated mostly astride on the desks, till I tumbled off backwards one day at the gap where the steps went down, but came to no harm, though the fall was really a more dangerous one than any I ever had in the Alps. The inkbottle was upset over the historical account however, and the closing passages a little shortened,—which saved some useful time.

127. When the chief bustle in the small sacristy, (a mere cupboard or ecclesiastical pantry, two steps up out of the transept) was over, with the chapel masses of the morning, I used to be let in there to draw the Angelico Annunciation,—about eleven inches by fourteen as far as I recollect, then one of the chief gems of Florence, seen in the little shrine it was painted for, now carried away by republican pillage, and lost in the general lumber of the great pillage-reservoir galleries. The monks let me sit close to it and work, as long as I liked, and went on with their cup-rinsings and cope-foldings without minding me. If any priest of the higher dignities came in, I was careful always to rise reverently, and get his kind look, or bow,

or perhaps a stray crumb of benediction. When I was tired of drawing, I went into the Spezieria, and learned what ineffable sweetnesses and incenses were in the herbs and leaves that had gathered the sunbeams of Florence into their life; and bought little bundles of bottles, an inch long, and as thick as a moderately sized quill, with Araby the blest and a spice island or two inside each. Then in the afternoon a bit of street or gallery work, and after dinner, always up either to Fésole or San Miniato. In those days, I think it never rained but when one wanted it to, (and not always then); wherever you chanced to be, if you got tired, and had no friends to be bothered with, you lay down on the next bank and went to sleep, to the song of the cicadas, which, with a great deal of making believe, might at last, somehow, be thought nice.

128. I did make one friend in Florence, however, for love of Switzerland, Rudolph Durheim, a Bernese student, of solid bearish gifts and kindly strength. I took to him at first because of a clearly true drawing he had made of his little blue-eyed twelve-years-old simplicity of a goat-herd sister; but found him afterwards a most helpful and didactic friend. He objected especially to my losing time in sentiment or over-hot vaporization, and would have had me draw something every afternoon, whether it suited my fancy or not. "Ça vaut déjà la peine," said he, stopping on the way to the Certosa, under a group of hillside cottages; it was my first serious lesson in Italian backgrounds; and if we had worked on together, so and so might have happened, as so often afore-said. But we separated, to our sorrow then, and harm, afterwards. I went off into higher and vainer vaporization at Venice; he went back to Berne, and under the patronage of its aristocracy, made his black bread by dull portrait-painting to the end of a lost life. I saw the arid remnant of him in

his Bernese painting, or daubing, room, many a year afterwards, and reproached the heartless Alps, for his sake.

129. Of other companionship in Florence, except Couttet's, I had none. I had good letters to Mr. Millingen, and of course a formal one to the British Embassy. I called on Mr. Millingen dutifully, but found he knew nothing after the fourth century B.C., and had as little taste for the Liber Studiorum as the Abbé Rosini. I waited on the Ambassador, and got him to use British influence enough to let me into the convent of the Magdalen, wherein I have always since greatly praised Perugino's fresco, with a pleasant feeling that nobody else could see it. I never went near the Embassy afterwards, nor the Embassy near me, till I sent my P. P. C. card by George, when I was going away, before ten in the morning, which caused Lord ——— s porter to swear fearfully at George and his master both. And it was the last time I ever had anything to do with Embassies, except through the mediation of pitying friends.

There was yet another young draughtsman in Florence, who lessoned me to purpose—a French youth;—his family name Dieudonné; I knew him by no other. He had trained himself to copy Angelico, in pencil tint, wrought with the point, as pure as the down on a butterfly's wing, and with perfect expression: typical engraving in grey, of inconceivable delicacy. I have never seen anything the least approaching it since, but did not then enough know its value. Dieudonné's prices were necessarily beyond those of the water-colour copyists, and he would not always work, even when the price was ready for him. He went back to France, and was effaced in the politeness of Paris, as Rudolph in the rudeness of Berne. Hard homes alike, their native cities, to them both.

130. My own work in Florence, this time, was chiefly thinking and writing—progressive, but much puzzled,

and its Epicurean pieties a little too dependent on enamel and gilding. A study in the rose-garden of San Miniato, and in the cypress avenue of the Porta Romana, remain to me, for memorials of perhaps the best days of early life.

Couttet, however, was ill at ease and out of temper in Florence, little tolerant of Italian manners and customs; and not satisfied that my studies in sacristies and cloisters were wise, or vials of myrrh and myrtle essence as good for me as the breeze over Alpine rose. He solaced himself by making a careful collection of all the Florentine wild-flowers for me exquisitely pressed and dried,—now, to my sorrow, lost or burned with all other herbaria; they fretted me by bulging always in the middle, and crumbling like parcels of tea, over my sketches.

At last the Arno dried up; or, at least, was reduced to the size of the Effra at Dulwich, with muddy shingle to the shore; and the grey "pietra serena" of Fésole was like hot iron in the sun, sprinkled with sand. Also, I had pretty well tired myself out, and, for the present, spent all my pictorial language;—so that we all of us were pleased to trot over the Apennines, and see the gleam of Monte Rosa again from Piacenza and Pavia. Once it was in sight, I went straight for it, and remember nothing more till we were well afoot in the Val Anzasca.

131. The afternoon rambles to Fésole and Bellos-guardo, besides having often to stand for hours together writing notes in church or gallery, had kept me in fair training; and I did the twenty miles up hill from Vogogna to Macugnaga without much trouble, but in ever hotter indignation all the way at the extreme dulness of the Val Anzasca, "the most beautiful valley in the Alps"— according to modern guide books. But tourists who pass their time mostly in looking at black rocks through blue spectacles, cannot be expected to know much about a valley:—on the other hand, ever since the days of Glen-

farg and Matlock, I have been a stream-tracker and cliff-
hunter, and rank mountains more by the beauty of their
glens than the height of their summits: also, it chanced
that our three first journeys abroad had shown me the
unquestionably grandest defiles of the Alps in succession
—first the Via Mala, then the St. Gothard, then the
tremendous granites of the Grimsel; then Rosenlaui and
Lauterbrunnen, Val d'Aosta and Cormayeur; then the
valley of the Inn and precipices of Innsbruck—and at
last the Ortlerspitze and descent from the Stelvio to Como;
with the Simplon and defile of Cluse now as well known
as Gipsy Hill at Norwood: and the Val Anzasca has no
feature whatever in any kind to be matched with any one
of these. It is merely a deep furrow through continuous
masses of shaly rock, blistered by the sun and rough with
juniper, with scattered chestnut-trees and pastures below.
There are no precipices, no defiles, no distinct summits
on either flank; while the Monte Rosa, occasionally seen
at the extremity of the valley, is a mere white heap, with
no more form in it than a haycock after a thunder-
shower.

132. Nor was my mind relieved by arrival at Macug-
naga itself; I did not then, nor do I yet, understand why
the village should have a name at all, more than any other
group of half-a-dozen chalets in a sheltered dip of moor-
lands. There was a little inn, of which the upper floor
was just enough for the landlord, Couttet, George and me;
—once, during a month's stay, I remember seeing two
British persons with knapsacks at the bottom of the
stairs, who must also have slept in the house, I suppose.
My own room was about seven feet wide by ten long;
one window, two-feet-six square, at the side, looked
straight into the green bank at the bottom of the Monte
Moro, and another at the end, looked into vacant sky
down the valley. A clear dashing stream, not ice fed,

but mere fountain and rainfall from the Moro, ran past
the house just under the side window, and was the chief
cause of my stay, and consolation of it. The group of
chalets round had no inhabitants, that ever I saw:—the
little chapel had a belfry, but I never remember hearing its
bell, or seeing anybody go in or come out of it. I don't
think even the goats had bells, so quiet the place was.
The Monte Rosa glacier, a mile higher up, merely choked
the valley; it seemed to come from nowhere and to be
going nowhere; it had no pinnacles, no waves, no crevasses
with action or method of fracture in them; no icefalls at
the top, nor arched source of stream at the bottom; the
sweep of rock above showed neither bedding nor buttress-
ing of the least interest, and gave no impression of having
any particular top, while yet the whole circuit of it was,
to such poor climbing powers as mine, totally inaccessible,
and even unapproachable, but with more trouble than it
was worth.

133. Thus much I made out the first day after arriving,
but thought there must be something to see somewhere,
if I looked properly about; also, I had made solemn vows
and complex postal arrangements for a month under
Monte Rosa, and I stayed my month accordingly, with
variously humiliating and disagreeably surprising results.

The first, namely, that mountain air at this height,
4,000 ft. for sleeping level, varying to 6,000 or 7,000 ft.
in the day's walks, was really not good for me, but quick-
ened pulse and sickened stomach, and saddened one's
notions alike of clouds, stones, and pastoral life.

The second, that my Florentine studies had not taught
me how to draw clouds or stones any better; that the
stream under my window was no more imitable than the
Rhone itself, and that any single boulder in it would take
all the month, or it might be six weeks, to paint the least
to my mind.

The third, that Alpine geology was in these high centres of it as yet wholly inscrutable to me.

The fourth, that I was not, as I used to suppose, born for solitude, like Dr. Zimmermann, and that the whole south side of Monte Rosa did not contain as much real and comfortable entertainment for me as the Market Street of Croydon. Nor do I believe I could have stayed out my month at Macugnaga with any consistency, but that I had brought with me a pocket volume of Shakespeare, and set myself for the first time to read, seriously, Coriolanus, and Julius Cæsar.

134. I see that in the earlier passages of this too dimly explicit narrative, no notice is taken of the uses of Shakespeare at Herne Hill, other than that he used to lie upon the table; nor can I the least trace his influence on my own mind or work, except as a part of the great reality and infinity of the world itself, and its gradually unfolding history and law. To my father, and to Richard Gray, the characters of Shakespearian comedy were all familiar personal friends; my mother's refusal to expose herself to theatric temptation began in her having fallen in love, for some weeks, when she was a girl, with Henry the Fifth at the Battle of Agincourt; nor can I remember in my own childhood any time when the plots of the great plays were unknown to me, or—I write the word now with more than surprise—misunderstood! I thought and felt about all of them then, just as I think and feel now; no character, small or great, has taken a new aspect to me; and the attentive reading which began first at Macugnaga meant only the discovery of a more perfect truth, or a deeper passion, in the words that had before rung in my ears with too little questioned melody. As for the full contents of any passage, or any scene, I never expected, nor expect, to know them, any more than every rock of Skiddaw, or flower of Jura.

135. But by the light of the little window at Macugnaga, and by the murmur of the stream beneath it, began the course of study which led me into fruitful thought, out of the till then passive sensation of merely artistic or naturalist life; and which have made of me—or at least I fain would believe the friends who tell me so—a useful teacher, instead of a vain labourer.

From that time forward, nearly all serious reading was done while I was abroad; the heaviest box in the boot being always full of dictionaries; and my Denmark Hill life resolved itself into the drudgery of authorship and press correction, with infinite waste of time in saying the same things over and over to the people who came to see our Turners.

In calling my authorship, drudgery, I do not mean that writing ever gave me the kind of pain of which Carlyle so wildly complains,—to my total amazement and boundless puzzlement, be it in passing said; for he talked just as vigorously as he wrote, and the book he makes bitterest moan over, Friedrich, bears the outer aspect of richly enjoyed gossip, and lovingly involuntary eloquence of description or praise. My own literary work, on the contrary, was always done as quietly and methodically as a piece of tapestry. I knew exactly what I had got to say, put the words firmly in their places like so many stitches, hemmed the edges of chapters round with what seemed to me graceful flourishes, touched them finally with my cunningest points of colour, and read the work to papa and mamma at breakfast next morning, as a girl shows her sampler.

136. "Drudgery" may be a hard word for this often complacent, and entirely painless occupation; still, the best that could be said for it, was that it gave me no serious trouble; and I should think the pleasure of driving, to a good coachman, of ploughing, to a good farmer, much

more of dressmaking, to an inventive and benevolent
modiste, must be greatly more piquant than the most
proudly ardent hours of book-writing have ever been to
me, or as far as my memory ranges, to any conscientious
author of merely average power. How great work is
done, under what burden of sorrow, or with what expense
of life, has not been told hitherto, nor is likely to be; the
best of late time has been done recklessly or contemp-
tuously. Byron would burn a canto if a friend disliked
it, and Scott spoil a story to please a bookseller.

As I have come on the extremely minor question of
my own work,* I may once for all complete all necessary
account of it by confession of my evermore childish delight
in beginning a drawing; and usually acute misery in
trying to finish one. People sometimes praise me as
industrious, when they count the number of printed
volumes which Mr. Allen can now advertise. But the
biography of the waste pencilling and passionately for-
saken colouring, heaped in the dusty corners of Brantwood,
if I could write it, would be far more pathetically exem-
plary or admonitory.

137. And as I transpose myself back through the forty
years of desultory, yet careful, reading, which began in my
mossy cell of Macugnaga, it becomes a yet more pertinent
question to me how much life has been also wasted in
that manner, and what was not wasted, extremely weak-
ened and saddened. Very certainly, Coriolanus and
Julius Cæsar did not in the least cheer or strengthen my
heart in its Monte-Rosean solitude; and as I try to follow
the clue of Shakespearian power over me since, I cannot
feel that it has been anywise wholesome for me to have
the world represented as a place where, for that best sort
of people, everything always goes wrong; or to have my

* *Manner* of work, I mean. How I learned the things I taught is
the major, and properly, only question regarded in this history.

conceptions of that best sort of people so much confused
by images of the worst. To have kinghood represented,
in the Shakespearian cycle, by Richards II. and III.
instead of I., by Henrys IV. and VIII. instead of II.; by
King John, finished into all truths of baseness and grief,
while Henry V. is only a king of fairy tale; or in the realm
of imagination, by the folly of Lear, the cruelty of Leontes,
the furious and foul guilt of Macbeth and the Dane.
Why must the persons of Iago and Iachimo, of Tybalt
and Edmund, of Isabel's brother and Helena's lord, pollute,
or wither with their shadows, every happy scene in the
loveliest plays; and they, the loveliest, be all mixed and
encumbered with languid and common work,—to one's
best hope spurious, certainly, so far as original, idle and
disgraceful?—and all so inextricably and mysteriously that
the writer himself is not only unknowable, but inconceiv-
able; and his wisdom so useless, that at this time of being
and speaking, among active and purposeful Englishmen,
I know not one who shows a trace of ever having felt a
passion of Shakespeare's, or learnt a lesson from him.

Any way, for good or sorrow, my student's life, instead
of mere instinct of rhythmic mimicry, began thus, not till
I was six-and-twenty. It is so inconvenient to be always
a year behind the Christian date, (and I am really so
young of my age!) that I am going to suppose the reader's
permission to be only a quarter of a century old at Macug-
naga, and to count my years henceforward by the stars
instead of the clock.

138. The month of Rome and Monte Rosa was at
least, compared with the days at Florence, a time of rest;
and when I got down to Domo d'Ossola again, I was
fresh for the expedition in search of Turner's subject at
Dazio Grande.

With Couttet and George, and a baggage mule, I
walked up the Val Formazza, and across to Airolo;

Couttet on this walk first formulating the general principle, "Pour que George aille bien, il faut lui donner à manger souvent; et beaucoup à la fois." I had no objection whatever to this arrangement, and was only sorry my Chamouni tutor could not give the same good report of *me*. But on anything like a hard day's walk, the miles after lunch always seemed to me to become German instead of geographical. And although I much enjoyed the Val Formazza all the way up, Airolo next day was found to be farther off than it appeared on the map, and on the third morning I ordered a post-chaise, and gave up my long-cherished idea of making the pedestrian tour of Europe.

139. The work done at Faido and Dazio Grande is told and illustrated in the fourth volume of "Modern Painters;" it was a little shortened by a letter from J. D. Harding, asking if I would like him to join me at any place I might have chosen for autumn sketching. Very gratefully, I sent word that I would wait for him at Baveno; where, accordingly, towards the close of August, we made fraternal arrangements for an Elysian fortnight's floating round Isola Bella. There was a spacious half of seat vacant in my little hooded carriage, and good room for Harding's folios with mine: so we trotted from Baveno to Arona, and from Arona to Como, and from Como to Bergamo, and Bergamo to Brescia, and Brescia to Verona, and took up our abode in the "Two Towers" for as long as we chose.

I do not remember finding in any artistic biography the history of a happier epoch than it was to us both. I am bold to speak for Harding as for myself. Generally, the restlessness of ambition, or the strain of effort, or anxiety about money matters, taint or disturb the peace of a painter's travels: but Harding did not wish, or perhaps think it possible, to do better than, to his own mind, he

always did; while I had no hope of becoming a second Turner, and no thoughts of becoming a thirtieth Academician. Harding was sure of regular sale for his summer's work, and under no difficulty in dividing the hotel bills with me: we both enjoyed the same scenes, though in different ways, which gave us subjects of surprising but not antagonistic talk: the weather was perfect, the roads smooth, and the inns luxurious.

140. I must not yet say more of Verona, than that, though truly Rouen, Geneva, and Pisa have been the centres of thought and teaching to me, Verona has given the colouring to all they taught. She has virtually represented the fate and the beauty of Italy to me; and whatever concerning Italy I have felt, or been able with any charm or force to say, has been dealt with more deeply, and said more earnestly, for her sake.

It was only for Harding's sake that I went on to Venice that year; and, for the first week there, neither of us thought of anything but the market and fishing boats, and effects of light on the city and the sea; till, in the spare hour of one sunny but luckless day, the fancy took us to look into the Scuola di San Rocco. Hitherto, in hesitating conjectures of what might have been, I have scarcely ventured to wish, gravely, that it *had* been. But, very earnestly, I should have bid myself that day keep *out* of the School of St. Roch, had I known what was to come of my knocking at its door. But for that porter's opening, I should (so far as one can ever know what they should) have written, The Stones of Chamouni, instead of The Stones of Venice; and the Laws of Fésole, in the full code of them, before beginning to teach in Oxford: and I should have brought out in full distinctness and use what faculty I had of drawing the human face and form with true expression of their higher beauty.

But Tintoret swept me away at once into the "mare

maggiore" of the schools of painting which crowned the power and perished in the fall of Venice; so forcing me into the study of the history of Venice herself; and through that into what else I have traced or told of the laws of national strength and virtue. I am happy in having done this so that the truth of it must stand; but it was not my own proper work; and even the sea-born strength of Venetian painting was beyond my granted fields of fruitful exertion. Its continuity and felicity became thenceforward impossible, and the measure of my immediate success irrevocably shortened.

141. Strangely, at the same moment, another adversity first made itself felt to me,—of which the fatality has been great to many and many besides myself.

It must have been during my last days at Oxford that Mr. Liddell, the present Dean of Christ Church, told me of the original experiments of Daguerre. My Parisian friends obtained for me the best examples of his results; and the plates sent to me in Oxford were certainly the first examples of the sun's drawing that were ever seen in Oxford, and, I believe, the first sent to England.

Wholly careless at that time of finished detail, I saw nothing in the Daguerreotype to help, or alarm me; and inquired no more concerning it, until now at Venice I found a French artist producing exquisitely bright small plates, (about four inches square,) which contained, under a lens, the Grand Canal or St. Mark's Place as if a magician had reduced the reality to be carried away into an enchanted land. The little gems of picture cost a napoleon each; but with two hundred francs I bought the Grand Canal from the Salute to the Rialto; and packed it away in thoughtless triumph.

142. I had no time then to think of the new power, or its meanings; my days were over-weighted already. Every morning, at six by the Piazza clock, we were

moored, Harding and I, among the boats in the fruit-market; then, after eight o'clock breakfast, he went on his own quest of full subjects, and I to the Scuola di San Rocco, or wherever else in Venice there were Tintorets. In the afternoon, we lashed our gondola to the stern of a fishing-boat, sailing, as the wind served, within or outside the Lido, and sketching the boat and her sails in their varied action, —or Venice, as she shone far away beyond her islands. Back to Danieli's for six o'clock table d'hote; where, after we had got a bit of fish and fillet of anything, the September days were yet long enough for a sunset walk.

143. A much regarded friend, Mr. Boxall, R.A., came on to Venice at this time, after finishing at Milan the beautiful drawing from Leonardo's Christ, which was afterwards tenderly, though inadequately, engraved. Mrs. Jameson was staying also at Danieli's to complete her notes on Venetian legends: and in the evening walk we were usually together, the four of us; Boxall, Harding, and I extremely embarrassing Mrs. Jameson by looking at everything from our pertinaciously separate corners of an equilateral triangle. Mrs. Jameson was absolutely without knowledge or instinct of painting; and had no sharpness of insight for anything else; but she was candid and industrious, with a pleasant disposition to make the best of all she saw, and to say, compliantly, that a picture was good, if anybody had ever said so before. Her peace of mind was restored in a little while, by observing that the three of us, however separate in our reasons for liking a picture, always fastened on the same pictures to like; and that she was safe, therefore, in saying that, for whatever other reason might be assigned, other people should like them also.

I got some most refined and right teaching from Mr. Boxall; of which I remember as chiefly vital, his swift correction of my misgiven Wordsworth's line—

"So be it when I shall grow old,"

as——

"So shall it be when I grow old."

I read Wordsworth with better care and profit ever after-wards; but there was this much of reason for that particular mistake, that I was perfectly confident in my own heart's love of rainbows to the end, and felt no occasion to wish for what I was so sure would be.

144. But Mr. Boxall's time, and Harding's, were at end before I had counted and described all the Tintorets in Venice, and they left me at that task, besides trying to copy the Adoration of the Magi on four sheets of brown paper. Things had gone fairly well as long as Harding took me out to sea every afternoon; but now, left to my-self, trying to paint the Madonna and Magi in the morn-ing, and peering all the rest of the day into the shadowy corners of chapel and sacristy and palace-corridor, beside every narrow street that was paved with waves, my strength began to fail fast. Couttet got anxious, and looked more gravely every morning into my eyes. "Ç'a ne va pas bien," said he. "Vous ne le sentirez pas à présent, mais vous le sentirez après." I finished my list, however, pasted my brown paper into some rude likeness of the picture,—and packed up colours and note-books finally for a rapid run home; when, as so often happens in the first cessation of an overstrain, the day after leaving Venice I was stopped at Padua by a sharp fit of nervous fever.

145. I call it "nervous," not knowing what else to call it,—for there was no malarian taint or other malignity in it, but only quick pulse, and depressed spirit, and the nameless ailing of overwearied flesh. Couttet put me to bed instantly, and went out to buy some herb medicines,—which Paduan physicians are wise enough yet to keep,—and made me some tisane, and bade me be patient, and all

would be well. And, indeed, next day I was up, in arm-chair; but not allowed to stir out of the extremely small back room of the old inn, which commanded view only of a few deep furrowed tiles and a little sky. I sent out George to see if he could find some scrap of picture to hang on the blank wall; and he brought me a seven-inch-square bit of fifteenth century tempera, a nameless saint with a scarlet cloak and an embossed nimbus, who much comforted me.

I was able to travel in a day or two; but the mental depression, with some weakness of limb, remained, all across Lombardy, as far as Vogogna, where a frosty morning glittered on the distant Simplon; and though I could not walk up the pass of Gondo, there was no more sadness in me, afterwards, than I suffered always in leaving either Italy or the Alps.

146. Which, however, in its own kind, became acute again a day or two afterwards, when I stopped on a cloudless afternoon at Nyon, where the road branches away for Paris. I had to say good-bye to Mont Blanc—there visible in his full cone, through the last gap given by the Chablais mountains as they rise eastward along the lake-shore.

Six months before, I had rhymed to his snows in such hope and delight, and assurance of doing everything I wanted, this year at last; and now, I had only discovered wants that any number of years could not satisfy; and weaknesses, which no ardour of effort or patience of practice could overcome.

Thus, for the first time, measuring some of the outer bastions of the unconquerable world, I opened my English letters; which told me that my eldest Croydon cousin, John, in whose prosperity and upward rounding of fortune's wheel all of us had been confident, was dead in Australia.

So much stronger than I, and so much more dutiful, working for his people in the little valley of Wandel, out in the great opposite desolate country; and now the dust of it laid on him, as on his brother the beach-sand on this side the sea. There was no grief, for me, in his loss, so little had I known, and less remembered, him; but much awe, and wonder, when all the best and kindest of us were thus struck down, what my own selfish life was to come to, or end in.

147. With these thoughts and fears fastening on me, as I lost sight first of Mont Blanc, and then of the lines of Jura, and saw the level road with its aisle of poplars in perspective vista of the five days between Dijon and Calais, the fever returned slightly, with a curious tingling, and yet partly, it seemed to me, deadness of sensation, in the throat, which would not move, for better nor worse, through the long days, and mostly wakeful nights. I do not know if diphtheria had been, in those epochs, known or talked of; but I extremely disliked this feeling in the throat, and passed from dislike into sorrowful alarm, (having no Couttet now to give me tisane,) and wonder if I should ever get home to Denmark Hill again.

Although the poetical states of religious feeling taught me by George Herbert's rhymes, and the reading of formal petition, whether in psalter or litany, at morning and evening and on Sunday forenoon, were sincere enough in their fanciful or formal ways, no occasion of life had yet put me to any serious trial of direct prayer. I never knew of Jessie's or my aunt's sicknesses, or now of my cousin John's, until too late for prayer; in our own household there had been no instantly dangerous illness since my own in 1835; and during the long threatening of 1841 I was throughout more sullen and rebellious than frightened. But now, between the Campo Santo and Santa Maria Novella, I had been brought into some knowledge of the

relations that might truly exist between God and His creatures; and thinking what my father and mother would feel if I did not get home to them through those poplar avenues, I fell gradually into the temper, and more or less tacit offering, of very real prayer.

Which lasted patiently through two long days, and what I knew of the nights, on the road home. On the third day, as I was about coming in sight of Paris, what people who are in the habit of praying know as the consciousness of answer, came to me; and a certainty that the illness, which had all this while increased, if anything, would be taken away.

Certainty in mind, which remained unshaken, through unabated discomfort of body, for another night and day, and then the evil symptoms vanished in an hour or two, on the road beyond Paris; and I found myself in the inn at Beauvais entirely well, with a thrill of conscious happiness altogether new to me.

148. Which, if I had been able to keep!—— Another "had been" this, the gravest of all I lost; the last with which I shall trouble the reader.

That happy sense of direct relation with Heaven is known evidently to multitudes of human souls of all faiths, and in all lands; evidently often a dream,— demonstrably, as I conceive, often a reality; in all cases, dependent on resolution, patience, self-denial, prudence, obedience; of which some pure hearts are capable without effort, and some by constancy. Whether I was capable of holding it or not, I cannot tell; but little by little, and for little, yet it seemed invincible, causes, it passed away from me. I had scarcely reached home in safety before I had sunk back into the faintness and darkness of the Under-World.

CHAPTER VIII

THE STATE OF DENMARK

149. THE house on Denmark Hill, where my father and mother, in the shortening days of 1845, thankfully received back their truant, has been associated, by dated notepaper, with a quarter of a century of my English life; and was indeed to my parents a peaceful, yet cheerful, and pleasantly, in its suburban manner, dignified, abode of their declining years. For my father had no possibilities of real retirement in him; his business was the necessary pride and fixed habit of his soul: his ambition, and what instinct of accumulative gain the mercantile life inevitably begets, were for me only; but involved the fixed desire to see me moving in the western light of London, among its acknowledged literary orders of merit; and were totally inconsistent with the thought, faintly and intermittingly haunting my mother and me, that a rose-covered cottage in the dells of Matlock or the vale of Keswick, might be nearer the heavenly world, for *us*, than all the majesty of Denmark Hill, connected though it was, by the Vauxhall Road and convenient omnibuses, with St. James's Street and Cavendish Square.

But the house itself had every good in it, except nearness to a stream, that could with any reason be coveted by modest mortals. It stood in command of seven acres of healthy ground (a patch of local gravel there overlying the London clay); half of it in meadow sloping to the sunrise, the rest prudently and pleasantly divided into an upper and lower kitchen garden; a fruitful bit of orchard, and chance inlets and outlets of woodwalk, opening to the sunny path by the field, which was gladdened on its other

side in springtime by flushes of almond and double peach blossom. Scarce all the hyacinths and heath of Brant-wood redeem the loss of these to me, and when the summer winds have wrecked the wreaths of our wild roses, I am apt to think sorrowfully of the trailings and climbings of deep purple convolvulus which bloomed full every autumn morning round the trunks of the apple trees in the kitchen garden.

150. The house itself had no specialty, either of comfort or inconvenience, to endear it; the breakfast-room, opening on the lawn and farther field, was extremely pretty when its walls were mostly covered with lakes by Turner * and doves by Hunt; the dining and drawing-rooms were spacious enough for our grandest receptions,—never more than twelve at dinner, with perhaps Henry Watson and his sisters in the evening,—and had decoration enough in our Northcote portraits, Turner's Slave-ship, and, in later years, his Rialto, with our John Lewis, two Copley Fieldings, and every now and then a new Turner drawing. My own work-room, above the breakfast-room, was only distinct, as being such, in its large oblong table, occupying so much of the—say fifteen by five and twenty—feet of available space within book-cases, that the rest of the floor virtually was only a passage round it. I always wrote on the flat of the table,—a bad habit, enforced partly by the frequent need of laying drawings or books for reference beside me. Two windows, forming the sides of a bow blank in the middle, gave me, though rather awkwardly crossed, all the light I needed: partly through laziness and make-shiftiness,

* Namely, Derwentwater; Lake Lucerne, with the Righi, at sunset; the Bay of Uri, with the Rothstock, from above Brunnen; Lucerne itself, seen from the lake; the upper reach of the lake, seen from Lucerne; and the opening of the Lake of Constance, from Constance. Goldau, St. Gothard, Schaffhausen, Coblentz, and Llanthony, raised the total of matchless Turner drawings in this room to eleven.

partly in respect for external symmetry,—for the house
had really something of an architectural air at the back,—
I never opened the midmost blank wall, though it con-
siderably fretted me: the single window of my bed-room
above, looking straight south-east, gave, through the first
ten or twelve winters at Denmark Hill, command of the
morning clouds, inestimable for its aid in all healthy
thought. Papa and mamma took possession of the quiet
western rooms, which looked merely into the branches
of the cedar on the front lawn.

151. In such stateliness of civic domicile, the industry
of midlife now began for me, little disturbed by the mur-
mur of London beyond the bridges, and in no wise by
any enlargement of neighbourly circle on the Hill itself;
one family alone excepted, whose affection has not failed
me from then till now,—having begun in earlier times,
out of which I must yet gather a gleam or two of the
tremulous memory.

In speaking of Mr. Dale's school, I named only my
younger companions there; of whom Willoughby had
gone to Cambridge, and was by this time beyond my ken;
but Edward Matson sometimes came yet to dine with us
at Denmark Hill, and sometimes carried me down to
Woolwich, to spend a day amidst its military displays and
arts, with his father, and mother, and two sweet younger
sisters. Where I saw, in Major Matson, such calm type
of truth, gentleness, and simplicity, as I have myself found
in soldiers or sailors only; and so admirable to me that I
have never been able, since those Woolwich times, to
gather myself up against the national guilt of war, seeing
that such men were made by the discipline of it.

But at Mr. Dale's were also two senior pupils, little
known to me except, Henry Dart by his large hazel eyes,
and Edmund Oldfield by his already almost middle-aged
aspect of serene sagacity. When I went to Oxford, I

found Dart at Exeter College, where we established
poetical friendship, and contended in all honour for the
Newdigate, reading our best passages to each other, for
improving censure. Dart, very deservedly, won it that
year, and gave promise of generous distinction afterwards;
but the hazel eyes were too bright, and closed, in a year
or two, to this world's ambition.

152. I do not know how it chanced that the art im-
pulse which animated Edmund Oldfield's grave sagacity
did not manifest itself to me till much later. He was the
elder brother of a large group of clever lads and lasses,
amiable in the extreme, yet in a slightly severe and
evangelical manner; whose father was in some tangible
relation to mine as one of the leading men of business on
the Hill; their mother known to us by sight only, as a
refined and still beautiful woman,—evangelical *without*
severity; both of them occupying, with such of their
children as were that way minded, the pew before us in
Mr. Burnet's chapel, whereat sometimes in my younger
days we went to hear a gloomier divinity than that of my
beloved and Anacreontic Doctor Andrews.

153. We might never have known more of them,
unless, among the sacred enthusiasms of Camberwell
parish, the fancy had arisen to put a painted window into
the east end of the pretty church, just built for it by Mr.
Gilbert Scott. Edmund Oldfield, already advanced far
beyond me in Gothic art scholarship, was prime mover
in the matter, but such rumour as existed in the village
of my interest in architecture justified him in expecting
some help from me. I had already quite fixed notions
of what the colour of glass should be, and in these Edmund
concurred. The tracery of the east window seemed to
us convertible into no dishonouring likeness of something
at Rheims or Chartres. Hitherto unconscious of my
inability to compose in colour, I offered to design the

entire window head; and did, after some headstrong toil, actually fill the required spaces with a mosaic presenting an orthodox cycle of subjects in purple and scarlet, round a more luminous centre of figures adapted from Michael Angelo. Partly in politeness, partly in curiosity, the committee on the window did verily authorize Edmund Oldfield and me to execute this design; and I having fortunately the sense to admit Edmund's representations that the style of Michael Angelo was not exactly adapted to thirteenth century practice, in construction of a vitrail, the central light was arranged by him on more modest lines; and the result proved on the whole satisfactory to the congregation, who thereupon desired that the five vertical lights might be filled in the same manner. I had felt, however, through the changes made on my Michael Angelesque cinquefoil, that Mr. Oldfield's knowledge of Gothic style, and gift in placing colour, were altogether beyond mine; and prayed him to carry out the rest of the window by himself. Which he did with perfect success, attaining a delicate brilliancy purer than anything I had before seen in modern glass.

154. I should have been more crushed by this result, had I not been already in the habit of feeling worsted in everything I tried of original work; while since 1842, I was more and more sure of my faculty of seeing the beauty and meaning of the work of other minds. At this time, I might assuredly have been led by Edmund Oldfield into a study of all the painted glass in England, if only Edmund had been a little more happy in his own power: but I suppose his immediate success was too easy to divert him from the courses of study which afterwards gave him his high position in the British Museum, not enough recognized by the public, and, I believe, farther obscured by the ill humour or temper of Mr. Panizzi. If only—I may still sometimes indulge in a "might have been," for

my friends—he had kept to Gothic foils and their glass, my belief is that Edmund Oldfield could have done for England great part of what Viollet le Duc did for France, with the same earnestness, and with thrice the sensibility. But the sensibility taking in him the form of reserve, and the restless French energy being absent, he diffused himself in serene scholarship till too late, and retired from the collisions and intrigues of the Museum too early.

Our temporary alliance among the traceries of Camberwell had for immediate consequence to me, an introduction to his family, which broke the monastic laws of Denmark Hill to the extent of tempting me to a Christmas revel or two with his pretty sisters; whereat I failed in my part in every game, and whence I retired in a sackcloth of humiliation, of which the tissue had at once the weight of a wet blanket, and the sting of horsehair.

155. I have only once named, among my Christ Church companions, Charles Newton. He was considerably my senior, besides being a rightly bred scholar, who knew his grammar and his quantities; and, while yet an undergraduate, was doing accurately useful work in the Architectural Society. Without rudely depreciating my Proutesque manner of drawing, he represented to me that it did not meet all the antiquarian purposes of that body; and, always under protest, I drew a Norman door for Newton, (as the granite veins of Trewavas Head for Dr. Buckland,) with distinct endeavour to give the substantial facts in each, apparent to the vulgar mind. And if only—once more pardon, good reader, but this is really an "if" that I cannot resist—if only Newton had learnt Irish instead of Greek, Scotch instead of Egyptian, and preferred, for light reading, the study of the Venerable Bede to that of Victor Hugo,——well, the British Museum might have been still habitable; the effigy, as the bones, of Mausolus would have rested in peace; and

the British public known more than any Idylls of kings
have yet told them, of personages such as Arthur, Alfred,
and Charlemagne.

156. There remained yet some possibilities, even after
Charles Newton became Attic and diplomatic, of some
heroic attachment between us, in the manner of Theseus
and Pirithous. In fact, for some years after my Camber-
well window and Campo Santo entanglements, Theseus
retained, I believe, some hope of delivering me from those
Lethean chains; nor until so late as the year 1850,* when,
as we crossed the Great St. Bernard together, Charles
spoke heresies against the Valley of Chamouni, remarking,
with respect to its glacial moraines, that "he thought more
housemaids were wanted in that establishment," and on
the other hand, I expressed myself respecting the virtues
of diplomatists, and the value of the opinions of the British
Peerage on Art and Science, in a manner which caused
Newton to observe (not without foundation) that "there
was the making of Robespierre in me,"—not till then, I
repeat, did it become clear to either of us that the decisions
of Minos were irrevocable.

We yet examined the castle of Verrex together, as once
the aisles of Dorchester; and compared in peace, at Milan,
the Corinthian graces of St. Lorenzo with the Lombardic
monsters of St. Ambrogio. Early the next morning
Newton left me, in the Albergo Reale, not without inner
tears on both sides, and went eastward I know not where.
Ever since, we have been to each other, he as the Heathen,
and I as the Publican, both of us finding it alike impossible
to hear the Church.

157. The transition to Denmark Hill had, however,
in the first pride of it, an advantage also in giving our
family Puritanism, promotion to a distinguished pew in
Camden Chapel, quite near the pulpit. Henry Melvill,

[* It was 1851. See Letters.]

afterwards Principal of Haileybury, was the only preacher I ever knew whose sermons were at once sincere, orthodox, and oratorical on Ciceronian principles. He wrote them from end to end with polished art, and read them admirably, in his own manner; by which, though the congregation affectionately expected it, they were always deeply impressed. He arranged his sermons under four or five heads, and brought each in its turn to a vigorously pointed climax, delivering the last words of each paragraph with two or three energetic nods of his head, as if he were hammering that much of the subject into the pulpit cushion with a round-headed mallet.* Then all

* The hackneyed couplet of Hudibras respecting clerical use of the fist on the pulpit cushion is scarcely understood by modern readers because of the burlesqued rhythm leaning falsely on the vowel:—

> "The pulpit, drum ecclesiastic,
> Is beat with fist instead of *a* stick."

The couplet, like most of the poem, has been kept in memory more by the humour of its manner than the truth of its wit. I should like myself to expand it into—

> The pulpit, drum ecclesiastic,
> Keeps time to truth politely plastic,
> And wakes the Dead, and lulls the Quick,
> As with a death's-head on a stick.

Or, in the longer rhythm of my old diary—

> Who, despots of the ecclesiastic drum,
> Roll the rogues' muffled march, to the rogues' "kingdom
> come."—

For indeed, since I wrote the paragraph about the pulpit of Torcello, in "The Stones of Venice," Vol. II., Chap. II., it has become hourly more manifest to me how far the false eloquence of the pulpit—whether Kettledrummle's at Drumclog, with whom it is, in Gibbon's scornful terms, "the safe and sacred organ of sedition," or the apology of hired preachers for the abuses of their day—has excited the most dangerous passions of the sects, while it quenched the refiner's fire and betrayed the reproving power of the gospel.

the congregation wiped their eyes, blew their noses, coughed the coughs they had choked over for the last quarter of an hour, and settled themselves to the more devoted acceptance of the next section.

158. It is the habit of many good men—as it was confessedly, for instance, that of the infant, Samuel, Wilberforce, Bishop of Oxford—not to allow themselves to doubt or question any part of Bible teaching. Henry Melvill, being of the same Episcopal school, and dutifully forbidding himself any dangerous fields of enquiry, explained with accuracy all that was explicable in his text, and argued the inexplicable into the plausible with great zeal and feeling;—always thoroughly convincing himself before he attempted to convince his congregation.

(It may be noted in passing that Dean Stanley, on the other hand, used his plausibility to convince his congregation without convincing himself, or committing himself to anything in particular; while Frederic Maurice secured his audiences' religious comfort, by turning their too thorny convictions the other side up, like railroad cushions.)

For the rest, Mr. Melvill was entirely amiable in the Church visitant, though not formidable in the Church militant. There were not many poor in the district to be visited; but he became at once a kindly and esteemed friend to us, as, for the present, serenely feeding lambs of his flock; and I shall always remember gratefully the unoffended smile with which one day, when he had called late, and I became restless during his conversation because my dinner was ready, he broke off his talk, and said, "Go to your dinner."

I was greatly ashamed of myself for having been so rude; but went to my dinner,—attended better to Mr. Melvill's preaching ever afterwards,—and owe to him all sorts of good help in close analysis, but especially, my

habit of always looking, in every quotation from the Bible, what goes before it and after.*

159. But to these particulars I must return by-and-bye; for my business in this chapter is only to give account of the materials and mental resources with which, in my new study at Denmark Hill, looking out on the meadow and the two cows, I settled myself, in the winter of 1845, to write, as my father now justly expected me to do without farther excuse, the second volume of "Modern Painters."

It is extremely difficult to define, much more to explain, the religious temper in which I designed that second volume. Whatever I know or feel, now, of the justice of God, the nobleness of man, and the beauty of nature, I knew and felt then, nor less strongly; but these firm faiths were confused by the continual discovery, day by day, of error or limitation in the doctrines I had been taught, and follies or inconsistencies in their teachers: while for myself, it seemed to me quite sure, since my downfall of heart on last leaving France, that I had no part nor lot in the service or privileges of the saints; but, on the contrary, had such share only in the things of God, as well-conducted beasts and serenely-minded birds had: while, even among the beasts, I had no claim to represent myself figuratively as a lion couchant, or eagle volant, but was, at my best and proudest, only of a doggish and piggish temper, content in my dog's chain, and with my pig's-wash, in spite of Carlyle; and having no mind whatever to win Heaven at the price of conversion like St. Ranier's, or mortification like St. Bruno's.

160. And that my father much concurred with me in

* I have never forgotten his noble sermon, one day, on the folly of reading "Eye hath not seen the things God has prepared for them that love Him," without going on to the end of the verse, "but He hath revealed them unto us by His Spirit."

these, partly stubborn, partly modest, sentiments, appeared
curiously on the occasion of registering his arms at the
Heralds' College for painting, as those of the Bardi, and
no more under the Long Acre limitation, "vix ea nostra,"
on the panel of his own brougham. It appeared, on
enquiry at the Heralds' Office, that there was indeed a
shield appertaining to a family, of whom nothing particular
was known, by the name of Rusk*e*n: Sable, a chevron,
argent, between six lance-heads, argent. This, without
any evidence of our relation to the family, we could not,
of course, be permitted to use without modification: but
the King-at-Arms registered it as ours, with the addition
of three crosses crosslets on the chevron, gules, (in case
of my still becoming a clergyman!); and we carried home,
on loan from the college, a book of crests and mottoes;
crests being open to choice in modern heraldry, (if one
does not by chance win them,) as laconic expressions of
personal character, or achievement.

Over which book, I remember, though too vaguely,
my father's reasoning within himself, that a merchant
could not with any propriety typify himself by Lord
Marmion's falcon, or Lord Dudley's bear; that, though
we were all extremely fond of dogs, any doggish crest
would be taken for an extremely minor dog, or even
puppy, by the public; while vulpine types, whether of
heads or brushes, were wholly out of our way; and at last,
faute de mieux, and with some idea, I fancy, of the beast's
resolution in taking and making its own way through
difficulties, my father, with the assent, if not support, of
my mother and Mary, fixed, forsooth, upon a boar's head,
as reasonably proud, without claim to be patrician; under-
written by the motto "Age quod agis." Some ten or
twelve years, I suppose, after this, beginning to study
heraldry with attention, I apprehended, that, whether a
knight's war-cry, or a peaceful yeoman's saying, the words

on the scroll of a crest could not be a piece of advice to other people, but must be always a declaration of the bearer's own mind. Whereupon I changed, on my own seal, the "Age quod agis" into "To-day," tacitly under-lined to myself with the warning, "The night cometh, when no man can work."

161. But as years went on, and the belief in fortune, and fortune-telling, which is finally confessed in Fors Clavigera, asserted itself more distinctly in my private philosophy, I began to be much exercised in mind as to the fortunate, or otherwise, meaning of my father's choos-ing a pig for my crest; and that the more, because I could not decide whether it was lawful for me to adopt the Greek mode of interpretation, according to which I might con-sider myself an assistant of Hercules in the conquest of the Erymanthian boar, or was restricted to the Gothic reading which would compel me to consider myself a pig in personâ,—(as the aforesaid Marmion a falcon, or Albert of Geierstein a vulture,—) and only take pride in the strength of bristle, and curl of tusk, which occasioned, in my days of serious critical influence, the lament of the Academician in Punch:

> "I paints and paints,
> Hears no complaints,
> And sells before I'm dry,
> Till savage Ruskin
> Sticks his tusk in,
> And nobody will buy."

Inclining, as time went on, more and more to this view of the matter, I rested at last in the conviction that my prototype and patron saint was indeed, not Hercules, but St. Anthony of Padua, and that it might in a measure be recorded also of little me, that "il se retira d'abord dans une solitude peu éloignée du bourg de Côme, puis dans un sépulcre fort éloigné de ce bourg, enfin dans les masures

d'un vieux château au-dessus d'Héraclée, où il vécut
pendant vingt ans. Il n'est pas possible de raconter tout
ce qu'il eut à souffrir dans ces trois retraites, tant par les
rigueurs qu'il exerça sur lui-même que par la malice du
démon, qui mit tout en œuvre pour le tromper par ses
artifices, ou pour l'abattre par ses menaces et ses mauvais
traitements, qui allèrent quelquefois jusqu'à le laisser pour
mort des coups qu'il lui donna. Antoine triompha de
tout; et ce fut pour le récompenser de tant de combats et
de tant de victoires que Dieu le rendit puissant en œuvres
et en paroles pour guérir toutes sortes de maladies spirit-
uelles et corporelles, chasser les démons aussi bien des
corps que des âmes, se faire obéir par les bêtes les plus
cruelles, par les éléments et les autres créatures les moins
soumises à la volonté de l'homme." *

162. I must not, however, anticipate the course of this
eventful history so far as to discuss at present any manner
of the resemblance in my fate, or work, or home com-
panionships, to those of St. Anthony of Padua; but may
record, as immediately significant, the delight which both
my mother and I took in the possession of a really practical
pigstye in our Danish farmyard, (the coach-house and
stables being to us of no importance in comparison); the
success with which my mother directed the nurture, and
fattening, of the piglings; the civil and jovial character of
the piglings so nurtured, indicated especially by their habit
of standing in a row on their hind-legs to look over the
fence, whenever my mother came into the yard: and con-
clusively by the satisfaction with which even our most
refined friends would accept a present of pork—or it
might be, alas! sometimes of sucking pig—from Denmark
Hill.

* "Dictionnaire des Sciences Ecclésiastiques." I assumed, of
course, in adopting this patron saint, that he would have the same
domestic pets as St. Anthony of the Desert.

163. The following example of such acknowledgments, addressed to my father, is farther interesting in its post (or side) script, referring to the civil war in Switzerland, and fixing, therefore, the letter, otherwise without date of year, to 1845, when I was beginning to prepare for my first adventurous journey.

<div style="text-align:right">47, QUEEN ANN (no street!) WEST,

Thursday, 27 *Fe*^y.</div>

"My dear Sir,

"Have the goodness to offer my respectful thanks to Mrs. Ruskin for the kind present of a part of the little fat friends, & its————————*

Portugal onions for stuffing them included, &c., &c. Hoping you are all well,

<div style="text-align:center">"Believe me,

"Most truly obliged,

"J. M. W. TURNER."</div>

J. RUSKIN, ESQ.

Neither do I think it irrelevant, in this place, to foretell that, after twenty years' various study of the piglet char-

*In the *Times*, sad news from Switzerland.*

* Turner always indicates by these long lines the places in his letters where his feelings become inexpressible.

acter, (see, for instance, the account of the comfort given me by the monastic piglet at Assisi,*) I became so resigned to the adoption of my paternally chosen crest as to write my rhymed travelling letters to Joan† most frequently in my heraldic character of "Little Pig"; or, royally plural, "Little Pigs," especially when these letters took the tone of confessions, as for instance, from Keswick, in 1867:—

> When little pigs have muffins hot,
> And take three quarters for their lot,
> Then, little pigs—had better not.

And again, on the occasion of over-lunching myself before ascending Red Pike, in the same year:—

> As readers, for their minds' relief,
> Will sometimes double down a leaf,
> Or rather, as good sailors reef
> Their sails, or jugglers, past belief
> Will con-involve a handkerchief—
> If little pigs, when time is brief
> *Will*, that way, double up their beef,
> Then—little pigs will come to grief.

And here is what may, it seems to me, gracefully conclude this present chapter, as a pretty and pathetic Pigwiggian chaunt, from Abbeville, in 1858.

> If little pigs,—when evening dapples,
> With fading clouds, her autumn sky,—
> Set out in search of Norman Chapels,
> And find, instead, where cliffs are high,
> Half way from Amiens to Etaples,
> A castle, full of pears and apples,

* "In one of my saddest moods, I got some wholesome peace and refreshment by mere sympathy with a Bewickian little pig, in the roundest and conceitedest burst of pig-blossom."—"Fors," Letter XLVIII.

† Now Mrs. Arthur Severn.

On donjon floors laid out to dry;
—Green jargonelles, and apples tenny,—
And find their price is five a penny,
If little pigs, then, buy too many,
Spare to those little pigs a sigh.

CHAPTER IX

THE FEASTS OF THE VANDALS

164. THE reader of "to-day" who has been accustomed to hear me spoken of by the artists of to-day as a super-annuated enthusiast, and by the philosophers of to-day as a delirious visionary, will scarcely believe with what serious interest the appearance of the second volume of "Modern Painters" was looked for, by more people than my father and mother,—by people even belonging to the shrewdest literary circles, and highest artistic schools, of the time.

165. In the literary world, attention was first directed to the book by Sydney Smith, in the hearing of my severest and chiefly antagonist master, the Rev. Thomas Dale, who with candid kindness sent the following note of the matter to my father:—

"You will not be uninterested to hear that Mr. Sydney Smith (no mean authority in such cases) spoke in the highest terms of your son's work, on a public occasion, and in presence of several distinguished literary characters. He said it was a work of transcendent talent, presented the most original views, and the most elegant and powerful language, and would work a complete revolution in the world of taste. He did not know, when he said this, how much I was interested in the author."

166. My father was greatly set up by this note, though the form of British prudence which never specifies occasion or person, for fear of getting itself into a scrape, is provokingly illustrated by its imperfect testimony. But it mattered little who the other ·"literary characters" might have been, for Sydney's verdict was at this time, justly, final, both in general society and among the

363

reviewers; and it was especially fortunate for me that he had been trained in his own youth, first by Dugald Stewart, and then by the same Dr. Thomas Brown who had formed my father's mind and directed his subsequent reading. And, indeed, all the main principles of metaphysics asserted in the opening of "Modern Painters" had been, with conclusive decision and simplicity, laid down by Sydney himself in the lectures he gave on Moral Philosophy at the Royal Institution in the years 1804-5-6, of which he had never enough himself recognized the importance. He amplified and embodied some portions of them afterwards in the Edinburgh Review; but "considering that what remained could be of no farther use, he destroyed several, and was proceeding to destroy the whole, when, entreaty being made by friends that the portions not yet torn up might be spared, their request was granted;" * and these despised fragments, published in 1850 under the title of Elementary Sketches of Moral Philosophy, contain, in the simplest and securest terms, every final truth which any rational mortal needs to learn on that subject.

Had those lectures been printed five years sooner, and then fallen in my way, the second volume of "Modern Painters" would either never have been written at all, or written with thankful deference to the exulting wit and gracious eloquence with which Sydney had discerned and adorned all that I wished to establish, twenty years before.

167. To the modern student, who has heard of Sydney Smith only as a jester, I commend the two following passages, as examples of the most wise, because most noble, thought, and most impressive, because steel-true, language, to be found in English literature of the living, as distinguished from the classic, schools:—

* See note to Introduction, in the edition of 1850.

"But while I am descanting so minutely upon the conduct of the understanding, and the best modes of acquiring knowledge, some men may be disposed to ask, 'Why conduct my understanding with such endless care? and what is the use of so much knowledge?' What is the use of so much knowledge?—what is the use of so much life! What are we to do with the seventy years of existence allotted to us? and how are we to live them out to the last? I solemnly declare that, but for the love of knowledge, I should consider the life of the meanest hedger and ditcher as preferable to that of the greatest and richest man here present: for the fire of our minds is like the fire which the Persians burn in the mountains,—it flames night and day, and is immortal, and not to be quenched! Upon something it *must* act and feed,—upon the pure spirit of knowledge, or upon the foul dregs of polluting passions. Therefore, when I say, in conducting your understanding, love knowledge with a great love, with a vehement love, with a love coeval with life, what do I say, but love innocence, love virtue, love purity of conduct, love that which, if you are rich and great, will sanctify the blind fortune which has made you so, and make men call it justice; love that which, if you are poor, will render your poverty respectable, and make the proudest feel it unjust to laugh at the meanness of your fortunes; love that which will comfort you, adorn you, and never quit you,—which will open to you the kingdom of thought, and all the boundless regions of conception, as an asylum against the cruelty, the injustice, and the pain that may be your lot in the outer world,—that which will make your motives habitually great and honourable, and light up in an instant a thousand noble disdains at the very thought of meanness and of fraud! Therefore, if any young man here have embarked his life in pursuit of knowledge, let him go on without doubting or fearing the event; let him

not be intimidated by the cheerless beginnings of know-
ledge, by the darkness from which she springs, by the
difficulties which hover around her, by the wretched
habitations in which she dwells, by the want and sorrow
which sometimes journey in her train; but let him ever
follow her as the Angel that guards him, and as the Genius
of his life. She will bring him out at last into the light
of day, and exhibit him to the world comprehensive in
acquirements, fertile in resources, rich in imagination,
strong in reasoning, prudent and powerful above his
fellows in all the relations and in all the offices of life."

168. "The history of the world shows us that men
are not to be counted by their numbers, but by the fire
and vigour of their passions; by their deep sense of injury;
by their memory of past glory; by their eagerness for fresh
fame; by their clear and steady resolution of ceasing to
live, or of achieving a particular object, which, when it is
once formed, strikes off a load of manacles and chains, and
gives free space to all heavenly and heroic feelings. All
great and extraordinary actions come from the heart.
There are seasons in human affairs when qualities, fit
enough to conduct the common business of life, are feeble
and useless, and when men must trust to emotion for that
safety which reason at such times can never give. These
are the feelings which led the Ten Thousand over the
Carduchian mountains; these are the feelings by which a
handful of Greeks broke in pieces the power of Persia:
they have, by turns, humbled Austria, reduced Spain; and
in the fens of the Dutch, and in the mountains of the
Swiss, defended the happiness, and revenged the oppres-
sions of man! God calls all the passions out in their
keenness and vigour, for the present safety of mankind.
Anger, and revenge, and the heroic mind, and a readiness
to suffer;—all the secret strength, all the invisible array
of the feelings;—all that nature has reserved for the great

scenes of the world. For the usual hopes, and the common aids of man, are all gone! Kings have perished, armies are subdued, nations mouldered away! Nothing remains, under God, but those passions which have often proved the best ministers of His vengeance, and the surest protectors of the world."

169. These two passages of Sydney's express, more than any others I could have chosen out of what I know of modern literature, the roots of everything I had to learn and teach during my own life; the earnestness with which I followed what was possible to me in science, and the passion with which I was beginning to recognize the nobleness of the arts and range of the powers of men.

It was a natural consequence of this passion that the sympathy of the art-circles, in praise of whose leading members the first volume of "Modern Painters" had been expressly written, was withheld from me much longer than that of the general reader; while, on the other hand, the old Roman feuds with George Richmond were revived by it to the uttermost; and although, with amused interest in my youthful enthusiasm, and real affection for my father, he painted a charming watercolour of me sitting at a picturesque desk in the open air, in a crimson waistcoat and white trousers, with a magnificent port-crayon in my hand, and Mont Blanc, conventionalized to Raphaelesque grace, in the distance, the utmost of serious opinion on my essay which my father could get from him was "that I should know better in time."

170. But the following letter from Samuel Prout, written just at the moment when my father's pride in the success of the book was fast beguiling him into admission of its authorship, at least in our own friendly circle, expresses with old-fashioned courtesy, but with admirable simplicity and firmness, the first impression made by my

impetuous outburst on the most sensible and sincere members of the true fellowship of English artists, who at that time were doing each the best he could in his own quiet way, without thought either of contention with living rivals, or of comparing their modest work to the masterpieces of former time.

"HASTINGS, *July 2nd*, 1843.

"DEAR SIR,

"I beg to apologize for not sooner acknowledging, with my best thanks, your kindness in adding another to many obligations.

"Please to believe that I am ambitious of meriting your many acts of kind consideration, but I am ashamed and vexed to feel a consciousness of apparent rudeness, and a trial of patience which nothing can extenuate. I must fear that my besetting sin of idleness in letter-writing has been displeasing to you, although your note is politely silent on the subject.

"I am sorry to say that for months together my spirits have sunk so low, that every duty and every kindness have been sadly neglected.

"In consequence of this nervous inactivity, the Water Colour Exhibition contains almost all I have been able to accomplish since last year. The drawing of Petrarch's House, which you wished me to make, was finished some time since, but is so unlike what I am sure you expected, that I deferred saying anything about it till another was made. Alas! the things I ought to have done have not been done. I intended bringing it to town with me, and asking the favour that it might remain in your possession till I had made something more worthy. My trip to town has been put off month after month, and I expect the resolution will not awake till the last day of seeing sights.

Should you not be in town, both drawings shall be left at Foord's.*

"Permit me to say that I have been indulged with a hasty perusal of a work on art and artists by 'A Graduate of Oxford.' I read the volume with intense interest, the sentiments and language riveting my attention to every page. But I mourn lest such splendid means of doing eminent service to art should be lost. Had the work been written with the *courteousness* of Sir Joshua Reynolds' lectures, it would have been 'a standard work,' the author held in high estimation for his learning, and the volume recommended for instruction and usefulness. Perhaps nothing helps more certainly to an accession of influence, and an accumulating power of doing good, than the *language* in which we dictate. We approach an unassuming courteous manner with respect, confidence, and satisfaction, but most persons shrink back from sarcasm. Certainly every author who writes to do good will write with firmness and candour, *cleaving to what is right, but cautious of giving pain or offence.*

"I hope some day to give the book a more careful perusal; *it made me think,* and when I lay hold of it again, I will endeavour to test it by my experience and the judgment of others; and as I have a little *cooled* from the *rage* I felt at first to find my 'darlings' set at nought, I trust in spite of its biting bitterness I shall feel more ashamed of myself, and more respect for the opinions of the author.

"Pardon, dear sir, this presuming to tire your patience with my humble opinions; and should it be true what I

* The letters quoted in the text of "Præterita" will always be given without omissions even of trivial passages. Of those arranged in "Dilecta," I give only the portions which seem to me likely to interest the reader; and even take leave to drop superfluous sentences without stars or other note of the omission, but so that the absolute meaning of the writer shall be always kept.

have just heard, that you know the author, I will rely on your goodness to forgive my objection to opinions in which you are so much interested.

"If it is so, you are indeed honoured, and I trust the powerful 'angel-bright talent' will be directed to do much good for art and artists.　Pray give me credit for sincerity in acknowledging that it is art generally I feel for, and as far as I am individually mentioned, I am pleased to find that I have come off beautifully.

"I did not intend to write so much.　Kindly pardon quantity and quality.

　　　　"And believe me to remain, dear Sir,
　　　　　　　"With the greatest respect,
　　　　　"Yours truly and obliged,
　　　　　　　　　　　"S. PROUT.

"J. J. Ruskin, Esq.
　&c. &c. &c."

171. I must guard myself, however, very distinctly in giving this letter as an example of the general feeling about the book among the living painters whom it praised, against attributing to them any such admiration of my "angel-bright talent" as that here expressed by my father's affectionate, and now intimate, friend.　The group of landscapists, headed by Copley Fielding, David Cox, and P. de Wint in the old Water Colour Society, and by David Roberts and Clarkson Stanfield in the Academy (Turner being wholly exceptional, and a wild meteoric pheno- menon in the midst of them, lawless alike and scholarless) —this group of very characteristically English landscape painters had been well grounded, every one of them, more or less, in the orthodox old English faith in Dutch paint- ing; had studied it so as to know the difficulty of doing anything as good in its way; and, whether in painting or literature, had studied very little else.　Of any qualities

or talents "angel bright," past or present, except in the
rather alarming than dignified explosions round the stable
lantern which sometimes take place in a Rembrandt
Nativity, Vision to the Shepherds, or the like, none of
them had ever felt the influence, or attempted the con-
ception: the religious Italian schools were as little known
at that time, to either artist or connoisseur, as the Japanese,
and the highest scholarly criticism with which I had first
come to hand-grips in Blackwood, reached no higher than
a sketching amateur's acquaintance with the manner of
Salvator and Gaspar Poussin. Taken as a body, the total
group of Modern Painters were, therefore, more startled
than flattered by my schismatic praise; the modest ones,
such as Fielding, Prout, and Stansfield, felt that it was
more than they deserved,—and, moreover, a little beside
the mark and out of their way; the conceited ones, such
as Harding and De Wint, were angry at the position given
to Turner; and I am not sure that any of them were
ready even to endorse George Richmond's consoling
assurance to my father, that I should know better in time.

172. But, with all the kindness of heart, and apprecia-
tion of domestic character, partly humorous, partly
pathetic, which gave its prevailing tone to the British
school of the day, led by Wilkie, Leslie, and Mulready,
the entire fellowship of artists with whom we were
acquainted sympathized with the partly quaint, altogether
pure, strong, and always genial, home-life of my father and
mother; nor less with their anxious devotion to their son,
and the hopes they entertained for him. Nor, I suppose,
was my own status at Denmark Hill without something
honourably notable to men of the world, in that, refusing
to enter my father's business, I yet stayed serenely under
his authority, and, in what seemed to me my own proper
line of work, did my utmost to please him. And when (I
anticipate now the progress of the next four or five years)

—when on any, to us, peculiarly festive occasion,—the
return from a journey, publication of a new volume,
anniversary of a birthday, or the like,—we ventured to
ask our artist friends to rejoice with us, most of them
came, I believe with real pleasure. The early six o'clock
dinner allowed them usually a pleasant glance over the
meadow and the Norwood Hills in the evening light; the
table was just short enough to let the talk flow round
without wandering into eddies, or lingering into con-
fidences; there was no guest whom the others did not
honour; there was neither effort, affectation, nor restraint
in the talk. If the painters cared to say anything of pic-
tures, they knew they would be understood; if they chose
rather to talk of sherry, my father could, and would with
delight, tell them more about it than any other person
knew in either England or Spain; and when the candles
came, and the good jests, over the nuts and olives, there
was "frolic wine" in the flask at every right hand, such
as that never Prince Hal nor Jack Falstaff tasted cup of
brighter or mightier.

173. I somewhat admire in myself, at this time, though
I perceive it to have been greatly owing to want of
imagination, the simplicity of affection with which I
kept hold on my Cumberland moors, Calais sands, and
French costumes and streets,—as contrasted with the
peaks of the Sierra Nevada, the surges of Trafalgar, and
the towers of Seville and Granada; of all which I continu-
ally heard as the most beautiful and wonderful scenery
and architecture of the European world; and in the very
midst of which—in the heart of Andalusia, and on the
very battle-field of Xeres de la Frontera which gave the
Arab his dominion in Spain—I might have been adopted
by my father's partner to reign over his golden vineyards,
and write the histories of the first Caliphs of Arabia and
the Catholic Kings of Spain.

It chanced, however,—or mischanced,—for better or worse, that in the meantime I knew no more the histories of either Arabia or Spain than Robinson Crusoe or his boy Xury; that the absolutely careful and faithful work of David Roberts showed me the inconstructive and merely luxurious character of Spanish and Arab buildings; and that the painter of greatest power, next to Turner, in the English school, J. F. Lewis, rendered the facts of existing Andalusian life so vividly, as to leave me no hope of delighting or distinguishing myself in any constant relations either with its gaiety or its pride.

174. Looking back to my notices of these and other contemporary artists in the paragraphs added to the first volume of "Modern Painters," when I corrected its sheets at Sestri di Levante, in 1846, I find the display of my new Italian information, and assertion of critical acumen, prevail sorrowfully over the expressions of gratitude with which I ought to have described the help and delight they had given me. Now, too late, I can only record with more than sorrow the passing away from the entire body of men occupied in the arts, of the temper in which these men worked. It is—I cannot count how many years, since, on all our walls of recklessly ambitious display, I have seen one drawing of any place loved for its own sake, or understood with unselfish intelligence. Whether men themselves, or their buildings, or the scenery in which they live, the only object of the draughtsman, be he great or small, is to overpower the public mind with his greatness, or catch it with his smallness. *My* notions of Rome, says Mr. Alma Tadema; *Mine* of Venice, says Miss Clara Montalba; *Ours* of Belgravia and Brighton, say the public and its Graphics, with unanimous egotism;— and what sensational effects can be wrung out of China or New Zealand, or the miseries and follies of mankind anywhere. Exact knowledge enough—yes, let us have

it to fill our pockets or swell our pride; but the beauty of wild nature or modest life, except for the sake of our own picnics or perquisites, none care to know, or to save.

And it is wholly vain, in this state of the popular mind, to try to explain the phase of art in which I was brought up, and of which—little thinking how soon it was to pass away—I wrote so ungratefully.

175. Absolutely careful and faithful, I said, David Roberts was, though in his own restricted terms; fastening on the constant aspect of any place, and drawing that in grey shade, and so much of what might pass for light as enough showed magnitude, distance, and grace of detail. He was like a kind of grey mirror; he gave the greatness and richness of things, and such height and space, and standing of wall and rock, as one saw to be true; and with unwearied industry, both in Egypt and Spain, brought home records of which the value is now forgotten in the perfect detail of photography, and sensational realism of the effects of light which Holman Hunt first showed to be possible. The minute knowledge and acute sensation throw us back into ourselves; haunting us to the examination of points and enjoyment of moments; but one imagined serenely and joyfully, from the old drawings, the splendour of the aisles of Seville or the strength of the towers of Granada, and forgot oneself, for a time.

176. The work of John Lewis was a mirror of men only—of building and scenery as backgrounds for them; all alike rendered with an intensity of truth to the external life, which nothing has resembled before or since. But it was the external and animal life only. Lewis saw in men and women only the most beautiful of living creatures, and painted them as he did dogs and deer, but with a perception of their nature and race which laughs to scorn all the generic study of the scientific schools. Neither Andalusian nor Arab, Turk nor Circassian, had been

painted before his time, any more than described before
Byron's; and the endeavours at representation of Oriental
character or costume which accompany the travels of even
the best-educated English travellers either during or im-
mediately after the Peninsular war, are without exception
the clumsiest, most vulgar, and most ludicrous pieces of
work that ever disgraced draughtsmen, savage or civil.

No artist that ever I read of was treated with such
injustice by the people of his time as John Lewis. There
was something un-English about him, which separated
him from the good-humoured groups of established fame
whose members abetted or jested with each other; feeling
that every one of them had something to be forgiven, and
that each knew the other's trick of trade. His resolute
industry was inimitable; his colour—founded either on
the frankness of southern sunlight, or on its subtle reflec-
tions and diffusions through latticed tracery and silken
tent—resembled nothing that could be composed in a
London studio; while the absence of bravado, sentiment,
or philosophy in his subjects—the total subjection alike of
the moral and immoral, the heroic and the sensual, to
the mere facts of animal beauty, and grace of decoration,
left him without any power of appeal either to the domestic
simplicity or personal pride of the ordinary English mind.
In artistic power and feeling he had much in common
with Paul Veronese: but Paolo had the existing pomp
and the fading religion of Venice to give his work hold
on the national heart, and epic unity in its design; while
poor Lewis did but render more vividly, with all his
industry, the toy contrabandista or matador of my mother's
chimneypiece.

He never dined with us as our other painter friends did;
but his pictures, as long as he worked in Spain, were an
extremely important element in both my father's life and
mine.

177. I have not yet enough explained the real importance of my father's house, in its command of that Andalusian wine district. Modern maps of Spain, covered with tracks of railroad, show no more the courses either of Guadalquiver or Guadiana; the names of railway stations overwhelm those of the old cities; and every atlas differs from every other in its placing of the masses of the Sierras,—if even the existence of the mountain ranges be acknowledged at all.

But if the reader will take ten minutes of pains, and another ten of time, to extricate, with even the rudest sketch, the facts of value from the chaos of things inscrutably useless, in any fairly trustworthy map of Spain, he will perceive that between the Sierra Morena on the north, and Sierra Nevada on the south, the Guadalquiver flows for two hundred miles through a valley fifty miles wide, in the exact midst of which sits Cordova, and half way between Cordova and the sea, Seville; and on the Royal Harbour, Puerto Real, at the sea shore,—Cadiz; ten miles above which, towards Seville, he will find the "Xeres de la Frontera," to which, as a golden centre of Bacchic commerce, all the vineyards of that great valley of Andalusia, Vandalusia, or, as Mr. Ford puts it, I believe more probably, land of the west, send down their sun-browned juice; the ground of Macharnudo on Mr. Domecq's estate at Xeres itself furnishing the white wine of strongest body in Europe.

178. The power which Mr. Domecq had acknowledged in my father, by making him head partner in his firm, instead of merely his English agent, ruled absolutely at Xeres over the preparation of the wines; and, by insisting always on the maintenance of their purity and quality at the highest attainable standard, gave the house a position which was only in part expressed by its standing, until Mr. Domecq's death, always at the head in the list of

importers. That list gave only the number of butts of wine imported by each firm, but did not specify their price; still less could it specify the relation of price to value. Mr. Domecq's two or three thousand butts were, for the most part, old wine, of which the supply had been secured for half a century by the consistent prudence of putting the new vintages in at one end of cellars some quarter of a mile long, and taking the old vintages out at the other. I do not, of course, mean that such transaction was literally observed; but that the vulgar impatience to "turn over" capital was absolutely forsworn, in the steady purpose of producing the best wine that could be given for the highest price to which the British public would go. As a rule, sherry drinkers are soundly-minded persons, who do not choose to spend a guinea a glass on anything; and the highest normal price for Mr. Domecq's "double-cross" sherry was eighty pounds a butt; rising to two hundred for the older wines, which were only occasionally imported. The highest price ever given was six hundred; but this was at a loss to the house, which only allowed wine to attain the age which such a price represented in order to be able to supply, by the mixture of it with younger vintage, whatever quality the English consumer, in any fit of fashion, might desire.

On the whole, the sales varied little from year to year, virtually representing the quantity of wine annually produced by the estate, and a certain quantity of the drier Amontillado, from the hill districts of Montilla, and some lighter and cheaper sherries,—though always pure,— which were purchased by the house for the supply of the wider London market. No effort was ever made to extend that market by lowering quality; no competition was possible with the wines grown by Mr. Domecq, and little with those purchased on his judgment. My father

used to fret, as I have told, if the orders he expected were not forthcoming, or if there seemed the slightest risk of any other house contesting his position at the head of the list. But he never attempted, or even permitted, the enlargement of the firm's operations beyond the scale at which he was sure that his partner's personal and equal care, or, at least, that of his head cellarman, could be given to the execution of every order.

Mr. Domecq's own habits of life were luxurious, but never extravagant. He had a house in Paris, chiefly for the sake of his daughters' education and establishment; the profits of the estate, though not to be named in any comparison with those of modern mercantile dynasty, were enough to secure annual income to each of his five girls large enough to secure their marriages in the best French circles: they became, each in her turn, baronne or comtesse; their father choosing their baron or count for them with as much discretion as he had shown in the choice of his own partner; and all the marriages turned out well. Elise, Comtesse des Roys, and Caroline, Princess Bethune, once or twice came with their husbands to stay with us; partly to see London, partly to discuss with my father his management of the English market: and the way in which these lords, virtually, of lands both in France and Spain, though men of sense and honour; and their wives, though women of gentle and amiable disposition, (Elise, indeed, one of the kindest I ever have known,) spoke of their Spanish labourers and French tenantry, with no idea whatever respecting them but that, except as producers by their labour of money to be spent in Paris, they were cumberers of the ground, gave me the first clue to the real sources of wrong in the social laws of modern Europe; and led me necessarily into the political work which has been the most earnest of my life. But these visits and warnings were not till seven or

eight years after the time at present rendered account of,
in which, nevertheless, it was already beginning to be, if
not a question, at least a marvel with me, that these
graceful and gay Andalusians, who played guitars, danced
boleros, and fought bulls, should virtually get no good
of their own beautiful country but the bunch of grapes
or stalk of garlic they frugally dined on; that its precious
wine was not for them, still less the money it was sold
for; but the one came to crown our Vandalic feasts, and
the other furnished our Danish walls with pictures, our
Danish gardens with milk and honey, and five noble houses
in Paris with the means of beautiful dominance in its
Elysian fields.

179. Still more seriously, I was now beginning to con-
trast the luxury and continual opportunity of my own
exulting days, with the poverty, and captivity, or, as it
seemed to chance always, fatal issue of any efforts to escape
from these, in which my cousins, the only creatures
whom I had to care for, beyond my home, were
each and all spending, or ending, their laborious
youth.

I must briefly resume their histories, though much
apart from mine; but if my heart was cold to them, my
mind was often sad for them.

By grotesque freak of Fors, both my aunts married a
Mr. Richardson—and each left six children, four boys
and two girls.

The Perth children were Mary and Jessie, James, John,
William, and Andrew; the Croydon children, Margaret
and Bridget, John, William, George, and Charles. None
left now but William of Croydon.

180. The Perth boys were all partly weak in constitu-
tion, and curiously inconsistent in elements of character,
having much of their mother's subtlety and sweetness
mixed with a rather larger measure of their father's tannin.

The eldest, James, was unlike the other three,—more delicate in feature, and more tractable in temper. My father brought him up to London when he was one- or two-and-twenty, and put him into the counting-house to see what could be made of him: but, though perfectly well-behaved, he was undiligent and effectless—chiefly solicitous about his trousers and gloves. I remember him in his little room, the smaller of the two looking west at top of Herne Hill house, a pleasant, gentle, tall figure of a youth. He fell into rapid decline and died.

Nor long after him, the youngest brother, Andrew, who with fewer palpable follies, had less real faculty than the rest. He learnt farming under a good master in Scotland, and went out to Australia to prove his science; but after a short struggle with the earth of the other side of the world, rested beneath it.

181. The second brother, John, thus left the head of the family, was a stumpily made, snub- or rather knob-nosed, red-faced, bright-eyed, good-natured simpleton; with the most curiously subtle shrewdnesses, and obstinate faculties, excrescent through his simplicity. I believe he first tried to carry on his father's business; not prospering in that, after some pause and little-pleased scrutiny of him, he was established by my father as a wine-agent in Glasgow, in which business and town he remained, in a shambling, hand-to-mouth manner, some thirty years, a torment to my father, of an extremely vexatious kind— all the more that he was something of a possession and vestige of his mother all the same. He was a quite first-rate chess-player and whist-player: in business, he had a sort of chess and whist instinct for getting the better of people, as if every dozen of sherry were a hand of cards; and would often, for the mere pleasure of playing a trick, lose a customer without really making a penny by him. Good-natured, as I said, with a rude foundation of

honesty at the bottom which made my father put up with him, (indeed, so far as I can find out, no one of all my relations was ever dishonest at heart, and most of them have been only too simple,) he never lied about his sherry or adulterated it, but tried to get little advantages in bargains, and make the customer himself to choose the worst wine at the money, and so on—trying always to get the most he could out of my father in the same way, yet affectionate in a dumb-doggish sort, and not ungrateful, he went scamble-shambling on, a plague to the end, yet through all, a nephew.

182. William, the third of the Perth boys, had all John's faults of disposition, but greater powers, and, above all, resolution and perseverance, with a rightly foresighted pride, not satisfied in trivial or momentary successes, but knitting itself into steady ambition, with some deep-set notions of duty and principles of conscience farther strengthening it. His character, however, developed slowly, nor ever freed itself from the flaws which ran like a geological cleavage through the whole brotherhood: while his simplicities in youth were even more manifest than theirs, and as a schoolboy, he was certainly the awkwardest, and was thought the foolishest, of the four.

He became, however, a laborious and sagacious medical student, came up to London to walk the hospitals; and on passing his examination for medical practitioner, was established by my father in a small shop in the Bayswater Road, when he began—without purchase of any former favour, but camped there like a gipsy by the roadside,— general practice, chiefly among the poor, and not enough to live upon for a year or two (without supplemental pork and applesauce from Denmark Hill), but conscientious and earnest, paying largely in gathered knowledge and insight. I shall often have occasion to speak of him here-

after; it is enough to say in advance that after a few years of this discipline he took his diploma of M.D. with credit, and became an excellent physician—and the best chess-player I have ever known.

Chapter X

CROSSMOUNT

183. My best readers cannot but be alike astonished and disappointed that I have nothing set down of the conversation, cordial always, and if George Richmond were there, better than brilliant, which flowed at these above described Vandalic feasts. But it seemed to me that all the sap and bloom of it were lost in deliberate narrative, and its power shorn away if one could not record also the expression of the speaker; while of absolutely useful and tenable resulting sense, there was, to my unsympathetic mind, little to be got hold of. Turner resolutely refused to speak on the subject of art at all, and every one of us felt that we must ask him no questions in that direction; while of what any other painter said, I was careless, regarding them all as limited to their own fields, and unable to help me in mine.

I had two distinct instincts to be satisfied, rather than ends in view, as I wrote day by day with higher-kindled feeling the second volume of "Modern Painters." The first, to explain to myself, and then demonstrate to others, the nature of that quality of beauty which I now saw to exist through all the happy conditions of living organism; and down to the minutest detail and finished material structure naturally produced. The second, to explain and illustrate the power of two schools of art unknown to the British public, that of Angelico in Florence, and Tintoret in Venice.

184. I have no knowledge, and can form no conjecture, of the extent to which the book in either direction accomplished its purpose. It is usually read only for its pretty

passages; its theory of beauty is scarcely ever noticed,—
its praise of Tintoret has never obtained the purchase of
any good example of him for the National Gallery. But
I permit myself—perhaps with vain complacency—the
thought that I have had considerable share in the move-
ment which led to the useful work of the Arundel Society
in Italy, and to the enlargement of the National collection
by its now valuable series of fourteenth-century religious
paintings.

The style of the book was formed on a new model,
given me by Osborne Gordon. I was old enough now
to feel that neither Johnsonian balance nor Byronic
alliteration were ultimate virtues in English prose; and
I had been reading with care on Gordon's counsel, both
for its arguments and its English, Richard Hooker's
"Ecclesiastical Polity." I had always a trick of imitating,
more or less, the last book I had read with admiration;
and it farther seemed to me that for the purposes of argu-
ment, (and my own theme was, according to my notion,
to be argued out invincibly,) Hooker's English was the
perfectest existing model. At all events, I did the best
I then knew how, leaving no passage till I had put as
much thought into it as it could be made to carry, and
chosen the words with the utmost precision and tune I
could give them.

For the first time in my life, when I had finished the
last sentence, I was really tired. In too long readings
at Oxford I got stupid and sleepy, but not fatigued: now,
however, I felt distinctly that my head could do no more;
and with much satisfied thankfulness, after the revise of
the last sheet was sent to printer, found myself on the
bows of the little steamer, watching their magical division
of the green waves between Dover and Calais.

185. Little steamers they all were, then; nor in the
least well appointed, nor aspiring to any pride of shape or

press of speed; their bits of sails worn and patched like
those of an old fishing-boat. Here, for modest specimen
of my then proper art style, I give my careful drawing of
the loose lashed jib of one of them, as late as 1854.* The
immeasurable delight to me of being able to loiter and
swing about just over the bowsprit and watch the plunge
of the bows, if there was the least swell or broken sea to
lift them, with the hope of Calais at breakfast, and the
horses' heads set straight for Mont Blanc to-morrow, is
one of the few pleasures I look back to as quite unmixed.
In getting a Turner drawing I always wanted another;
but I didn't want to be in more boats than one at once.

As I had done my second volume greatly to my father's
and mother's delight, (they used both to cry a little, at
least my father generally did, over the pretty passages,
when I read them after breakfast,) it had been agreed
that they should both go with me that summer to see all
the things and pictures spoken of,—Ilaria, and the Campo
Santo, and St. Mary's of the Thorn, and the School of
St. Roch.

Though tired, I was in excellent health, and proud
hope; they also at their best and gladdest. And we had
a happy walk up and down the quiet streets of Calais that
day, before four o'clock dinner.

186. I have dwelt with insistence in last chapter on
my preference of the Hotel de Ville at Calais to the
Alcazar of Seville. Not that I was without love of

* In which year we must have started impatiently, without our
rubrical gooseberry pie, for I find the drawing is dated "10th May,
my father's birthday," and thus elucidated, "Opposite," (*i.e.* on leaf
of diary), "the jib of steamer seen from inside it on the deck. The
double curve at the base of it is curious; in reality the curves were a
good deal broken, the sail being warped like a piece of wetted paper.
The rings by which it holds, being *alternately* round and edge to
the eye, are curious. The *lines* are of course seams, which go to the
bottom of the sail; the brown marks, running short the same way,
are stains."

grandeur in buildings, but in that kind, Rouen front and
Beauvais apse were literally the only pieces that came up
to my mark; ordinary minsters and palaces, however
they might set themselves up for sublime, usually hurt me
by some manner of disproportion or pretence; and my
best joys were in small pieces of provincial building, full
of character, and naturally graceful and right in their given
manner. In this kind the little wooden belfry of Evreux,
of which Prout's drawing is photographed at page 42 of
my "Memoir," * is consummate; but the Calais one,
though of far later and commoner style, is also matchless,
far or near, in that rude way, and has been a perpetual
delight and lesson to me. Prout has a little idealized it
in the distance of the drawing of Calais Harbour, page 40
in the same book; I never tried to draw it myself, the
good of it being not in any sculpturesque detail, but in
the complex placing of its plain, square-cut props and ties,
taking some pretence of pinnacle on them, and being really
as structurally useful, though by their linked circletting
instead of their weight. There was never time in the
happy afternoon to do this carefully enough, though I
got a colour-note once of the church-spire, loved in a
deeper way, ("Modern Painters," Vol. IV., Chap. I.,)
but the belfry beat me. After all, the chief charm of it
was in being seen from my bedroom at Desseins, and
putting me to sleep and waking me with its chimes.

187. Calais is properly a Flemish, not French town
(of course the present town is all, except belfry and church,
built in the seventeenth century, no vestige remaining of
Plantagenet Calais); it has no wooden houses, which mark
the essential French civic style, but only brick or chalk
ones, with, originally, most of them, good indented
Flemish stone gables and tiled roofs. True French roofs
are never tiled, but slated, and have no indented gables,

* Printed by the Fine Art Society, 1880.

but bold dormer windows rising over the front, never, in any pretty street groups of them, without very definite expression of pride. Poor little Calais had indeed nothing to be proud of, but it had a quaint look of contentment with itself on those easy terms; some dignity in its strong ramparts and drawbridge gates; and, better than dignity, real power and service in the half-mile of pier, reaching to the low-tide breakers across its field of sand.

Sunset, then, seen from the pier-head across those whispering fringes; belfry chime at evening and morning; and the new life of that year, 1846, was begun.

188. After our usual rest at Champagnole, we went on over the Cenis to Turin, Verona, and Venice; whereat I began showing my father all my new discoveries in architecture and painting. But there began now to assert itself a difference between us I had not calculated on. For the first time I verily perceived that my father was older than I, and not immediately nor easily to be put out of his way of thinking in anything. We had been entirely of one mind about the carved porches of Abbeville, and living pictures of Vandyck; but when my father now found himself required to admire also flat walls, striped like the striped calico of an American flag, and oval-eyed saints like the figures on a Chinese teacup, he grew restive. Farther, all the fine writing and polite *éclat* of "Modern Painters" had never reconciled him to my total resignation of the art of poetry; and beyond this, he entirely, and with acute sense of loss to himself, doubted and deplored my now constant habit of making little patches and scratches of the sections and fractions of things in a notebook which used to live in my waistcoat pocket, instead of the former Proutesque or Robertsian outline of grand buildings and sublime scenes. And I was the more viciously stubborn in taking my own way, just because everybody was with him in these opinions; and I was more and

more persuaded every day, that everybody was always wrong.

Often in my other books,—and now, once for all, and finally here,—I have to pray my readers to note that this continually increasing arrogance was not founded on vanity in me, but on sorrow. There is a vast difference —there is all the difference—between the vanity of displaying one's own faculties, and the grief that other people do not use their own. Vanity would have led me to continue writing and drawing what every one praised; and disciplining my own already practised hand into finer dexterities. But I had no thought but of learning more, and teaching what truth I knew,—assuredly then, and ever since, for the student's sake, not my own fame's; however sensitive I may be to the fame, also, afterwards.

189. Meantime, my father and I did not get on well in Italy at all, and one of the worst, wasp-barbed, most tingling pangs of my memory is yet of a sunny afternoon at Pisa, when, just as we were driving past my pet La Spina chapel, my father, waking out of a reverie, asked me suddenly, "John, what shall I give the coachman?" Whereupon, I, instead of telling him what he asked me, as I ought to have done with much complacency at being referred to on the matter, took upon me with impatience to reprove, and lament over, my father's hardness of heart, in thinking at that moment of sublunary affairs. And the spectral Spina of the chapel has stayed in my own heart ever since.

Nor did things come right that year till we got to Chamouni, where, having seen enough by this time of the upper snow, I was content to enjoy my morning walks in the valley with papa and mamma; after which, I had more than enough to do among the lower rocks and woods till dinner time, and in watching phases of sunset afterwards from beneath the slopes of the Breven.

190. The last Chamouni entry, with its sequel, is perhaps worth keeping.

"Aug. 23rd.—Rained nearly all day; but I walked to the source of the Arveron—now a mighty fall down the rocks of the Montanvert; * note the intense scarletty purple of the shattered larch stems, wet, opposed with yellow from decomposing turpentine; the alder stems looking much like birch, covered with the white branchy moss that looks like a coral. Went out again in the afternoon towards the Cascade des Peleims; surprised to see the real rain-clouds assume on the Breven, about one-third of its height, the form of cirri,—long, continuous, and delicate; the same tendency showing in the clouds all along the valley, some inclining to the fish-shape, and others to the cobweb-like wavy film."

"Lucerne, Aug. 31st.—The result of the above phenomena was a little lift of the clouds next morning, which gave me some of the finest passages about Mont Blanc I ever beheld; and then, weather continually worse till now. We have had two days' ceaseless rain, this, the third, hardly interrupted, and the lake right into the town."

191. There was great joy in helping my mother from the door of the Cygne along a quarter of a mile of extempore plank bridge in the streets, and in writing a rhymed letter in description of the lifted lake and swirling Reuss, to little Louise Ellis (Mr. Telford's niece, at this time one of the happy presences in Widmore), of which a line or two yet remain in my ears, about a market boat moored above the submerged quay—

"Full of mealy potatoes and marrowfat pease,
And honey, and butter, and Simmenthal cheese,
And a poor little calf, not at all at its ease,
Tied by the neck to a box at its knees.

* The rocks over which the Glacier des Bois descends, I meant.

Don't you agree with me, dear Louise,
It was unjustifiably cruel in
Them to have brought it in all that squeeze
Over the lake from Fluelen?"

And so home, that year by Troyes, with my own calf's
mind also little at its ease, under confused squeeze of Alps,
clouds, and architecture; yet finding room still in the
waistcoat pocket for notes on the external tracery of St.
Urbain, which fixed that church for me as the highest
type of Gothic construction, and took me off all Italian
models for the next four years. The abstraction, how-
ever, though St. Urbain began it, was not altogether that
Saint's fault.

192. The press notices of my second volume had been
either cautious or complimentary,—none, to the best of
my memory, contemptuous. My friends took much
pleasure in it, and the estimate formed of it in the old
Scott and John Murray circle was shown by Lockhart's
asking me that winter to review Lord Lindsay in the
"Quarterly." I was shy of doing this, being well aware
that Lord Lindsay knew much more about Italian paint-
ing than I did; but I thought no one else likely to do it
better, and had another motive to the business,—of an
irresistible nature.

The little high-foreheaded Charlotte had by this time
become a Scottish fairy, White Lady, and witch of the
fatallest sort, looking as if she had just risen out of the
stream in Rhymer's Glen, and could only be seen by
favouring glance of moonlight over the Eildons. I used
to see her, however, sometimes, by the dim lamplight of
this world, at Lady Davy's,—Sir Humphrey's widow,—
whose receptions in Park Street gathered usually, with
others, the literary and scientific men who had once known
Abbotsford. But I never could contrive to come to any
serious speech with her; and at last, with my usual wisdom

in such matters, went away into Cumberland to recommend myself to her by writing a Quarterly Review.

193. I went in the early spring * to the Salutation at Ambleside, then yet a country village, and its inn a country inn. But there, whether it was the grilled salmon for breakfast, or too prolonged reflections on the Celestial Hierarchies, I fell into a state of despondency till then unknown to me, and of which I knew not the like again till fourteen years afterwards. The whole morning was painfully spent in balancing phrases; and from my boat, in the afternoons on Windermere, it appeared to me that the water was leaden, and the hills were low. Lockhart, on the first reception of the laboured MS., asked me to cut out all my best bits, (just as Keble had done before with my prize poem). In both cases I submitted patiently to the loss of my feathers; but was seriously angry and disgusted when Lockhart also intimated to me that a sentence in which I had with perfect justice condemned Mr. Gally Knight's representation "out of his own head" of San Michele at Lucca, could not—Mr. Gally Knight being a *protégé* of Albemarle Street—appear in the "Quarterly." This first clear insight into the arts of bookselling and reviewing made me permanently distrustful of both trades; and hearing no word, neither, of Charlotte's taking the smallest interest in the celestial hierarchies, I returned to town in a temper and state of health in which my father and mother thought that once more the best place for me would be Leamington.

I thought so myself, too; and went penitently again to Jephson, who at once stopped the grilled salmon, and ordered salts and promenade, as before.

194. It chanced that at this time there was staying at Leamington, also under Jephson's care, the son of an old friend, perhaps flame, of my father's, Mrs. Farquharson,

* 1847.

—a youth now of some two or three-and-twenty, but who seemed to me older than myself, being already a man of some position and influence in Perthshire. A few years before he had come into possession, under trustees, of a large Highland estate, on the condition that he should change his name for that of Macdonald, (properly re-duplicate,—Macdonald Macdonald,) considerable sums being reserved in the trustees' hands by the terms of the will, for the purchase of more land. At that time his properties were St. Martin's near Perth, where his mother lived; Rossie Castle, above Montrose; another castle, with much rock and moor round it, name forgotten, just south of Schehallien; and a shooting-lodge, Cross-mount, at the foot of Schehallien, between Lochs Rannoch and Tummel. The young Macdonald had come to see us once or twice with his mother, at Denmark Hill, and, partly I suppose at his mother's instigation, partly, the stars know how, took a true liking to me; which I could not but answer with surprised thankfulness. He was a thin, dark Highlander, with some expression of gloom on his features when at rest, but with quite the sweetest smile for his friends that I have ever seen, except in one friend of later years, of whom in his place.

He was zealous in the Scottish Evangelical Faith, and wholly true and upright in it, so far as any man can be true in any faith, who is bound by the laws, modes, and landed estates of this civilized world.

195. The thoughtful reader must have noted with some displeasure that I have scarcely, whether at college or at home, used the word "friendship" with respect to any of my companions. The fact is, I am a little puzzled by the specialty and singularity of poetical and classic friendship. I get, distinctively, attached to places, to pictures, to dogs, cats, and girls: but I have had, Heaven be thanked, many and true friends, young and old, who

have been of boundless help and good to me,—nor I quite helpless to them; yet for none of whom have I ever obeyed George Herbert's mandate, "Thy friend put in thy bosom; wear his eyes, still in thy heart, that he may see what's there; if cause require, thou art his sacrifice," etc. Without thinking myself particularly wicked, I found nothing in my heart that seemed to me worth anybody's seeing; nor had I any curiosity for insight into those of others; nor had I any notion of being a sacrifice for them, or the least wish that they should exercise for my good any but their most pleasurable accomplishments, —Dawtrey Drewitt, for instance, being farther endeared because he could stand on his head, and catch vipers by the tail; Gershom Collingwood because he could sing French songs about the Earthly Paradise; and Alic Wedderburn, because he could swim into tarns and fetch out water-lilies for me, like a water-spaniel. And I never expected that they should care much for *me*, but only that they should read my books; and looking back, I believe they liked and like me, nearly as well as if I hadn't written any.

196. First then, of this Love's Meinie of my own age, or under it, William Macdonald took to me; and got me to promise, that autumn, to come to him at Crossmount, where it was his evangelical duty to do some shooting in due season.

I went into Scotland by Dunbar; saw again Loch Leven, Glen Farg, Rose Terrace, and the Inch of Perth; and went on, pensive enough, by Killiecrankie, to the clump of pines which sheltered my friend's lodge from the four winds of the wilderness.

After once walking up Schehallien with him and his keepers, with such entertainment as I could find in the mewing and shrieking of some seventy or eighty grey hares, who were brought down in bags and given to the

poorer tenantry; and forming final opinion that the poorer tenantry might better have been permitted to find the stock of their hare-soup for themselves, I forswore further fashionable amusement, and set myself, when the days were fine, to the laborious eradication of a crop of thistles, which had been too successfully grown by northern agriculture in one of the best bits of unboggy ground by the Tummel.

197. I have carelessly omitted noticing till now, that the ambitions in practical gardening, of which the germs, as aforesaid, had been blighted at Herne Hill, nevertheless still prevailed over the contemplative philosophy in me so far as to rekindle the original instinct of liking to dig a hole, whenever I got leave. Sometimes, in the kitchen garden of Denmark Hill, the hole became a useful furrow; but when once the potatoes and beans were set, I got no outlet nor inlet for my excavatory fancy or skill during the rest of the year. The thistle-field at Crossmount was an inheritance of amethystine treasure to me; and the working hours in it are among the few in my life which I remember with entire serenity—as being certain I could have spent them no better. For I had wise—though I say it—thoughts in them, too many to set down here (they are scattered afterwards up and down in "Fors" and "Munera Pulveris"), and wholesome sleep after them, in spite of the owls, who were many, in the clumps of pine by Tummel shore.

Mostly a quiet stream there, through the bogs, with only a bit of step or tumble a foot or two high on occasion; above which I was able practically to ascertain for myself the exact power of level water in a current at the top of a fall. I need not say that on the Cumberland and Swiss lakes, and within and without the Lido, I had learned by this time how to manage a boat—an extremely different thing, be it observed, from steering one in a race; and the

little two-foot steps of Tummel were, for scientific pur-
poses, as good as falls twenty or two hundred feet high.
I found that I could put the stern of my boat full six
inches into the air over the top of one of these little falls,
and hold it there, with very short sculls, against the *level* *
stream, with perfect ease for any time I liked; and any
child of ten years old may do the same. The nonsense
written about the terror of feeling streams quicken as they
approach a mill weir is in a high degree dangerous, in
making giddy water parties lose their presence of mind
if any such chance take them unawares. And (to get this
needful bit of brag, and others connected with it, out of
the way at once), I have to say that half my power of
ascertaining facts of any kind connected with the arts, is
in my stern habit of doing the thing with my own hands
till I know its difficulty; and though I have no time nor
wish to acquire showy skill in anything, I make myself
clear as to what the skill means, and is. Thus, when I
had to direct road-making at Oxford, I sate, myself, with
an iron-masked stone-breaker, on his heap, to break stones
beside the London road, just under Iffley Hill, till I knew
how to advise my too impetuous pupils to effect their
purposes in that matter, instead of breaking the heads of
their hammers off, (a serious item in our daily expenses).
I learned from an Irish street crossing-sweeper what he
could teach me of sweeping; but found myself in that
matter nearly his match, from my boy-gardening; and
again and again I swept bits of St. Giles' foot-pavements,
showing my corps of subordinates how to finish into depths
of gutter. I worked with a carpenter until I could take
an even shaving six feet long off a board; and painted
enough with properly and delightfully soppy green paint
to feel the master's superiority in the use of a blunt brush.
But among all these and other such studentships, the reader

* Distinguish carefully between this and a sloping rapid.

will be surprised, I think, to hear, seriously, that the in-
strument I finally decided to be the most difficult of
management was the trowel. For accumulated months
of my boy's life I watched bricklaying and paving; * but
when I took the trowel into my own hand, abandoned
at once all hope of attaining the least real skill with it,
unless I gave up all thoughts of any future literary or
political career. But the quite happiest bit of manual
work I ever did was for my mother in the old inn at Sixt,
where she alleged the stone staircase to have become
unpleasantly dirty, since last year. Nobody in the inn
appearing to think it possible to wash it, I brought the
necessary buckets of water from the yard myself, poured
them into beautiful image of Versailles waterworks down
the fifteen or twenty steps of the great staircase, and with
the strongest broom I could find, cleaned every step into
its corners. It was quite lovely work to dash the water
and drive the mud, from each, with accumulating splash
down to the next one.

198. I must return for a moment to the clumps of
pine at Crossmount, and their company of owls, because—
whatever wise people may say of them—I at least myself
have found the owl's cry always prophetic of mischief to
me; and though I got wiser, as aforesaid, in my field of
thistles, yet the Scottish Athena put on against me at that
time her closed visor (not that Greek helmets ever have
a visor, but when Athena hides her face, she throws her
casque forward and down, and only looks through the oval
apertures of it). Her adversity to me at this time was
shown by my loss of Miss Lockhart, whom I saw for the

* Of our paviour friends, Mr. and Mrs. Duprez (*we* always spelt
and pronounced Depree), of Langley, near Slough, and Gray's Inn
(pronounced Grazen) Lane, in London (see the seventh number of
"Dilecta"). The laying of the proper quantity of sand under the
pavement stones being a piece of trowel-handling as subtle as spreading
the mortar under a brick.

last time at one of Lady Davy's dinners, where Mr. Hope-Scott took the foot of the table. Lady Davy had given me Miss Lockhart to take down, but I found she didn't care for a word I said; and Mr. Gladstone was on the other side of her—and the precious moments were all thrown away in quarrelling across her, with him, about Neapolitan prisons.* He couldn't see, as I did, that the real prisoners were the people outside.

199. Meantime, restraining the ideals and assuaging the disappointments of my outer-world life, the home-work went on with entirely useful steadiness. The admiration of tree-branches taught me at Fontainebleau, led me now into careful discernment of their species; and while my father, as was his custom, read to my mother and me for half-an-hour after breakfast, I always had a fresh-gathered outer spray of a tree before me, of which the mode of growth, with a single leaf full size, had to be done at that sitting in fine pen outline, filled with the simple colour of the leaf at one wash. On fine days, when the grass was dry, I used to lie down on it and draw the blades as they grew, with the ground herbage of buttercup or hawkweed mixed among them, until every square foot of meadow, or mossy bank, became an infinite picture and possession to me, and the grace and adjustment to each other of growing leaves, a subject of more curious interest to me than the composition of any painter's master-piece. The love of complexity and quantity before noticed as influencing my preference of flamboyant to purer architecture, was here satisfied, without qualifying sense of wasted labour, by what I felt to be the constant working of Omnipotent kindness in the fabric of the food-giving tissues of the earth; nor less, morning after morning, did I rejoice in the traceries and the painted glass of the sky at sunrise.

* *Ante*, p. 263, § 51.

This physical study had, I find, since 1842, when it began, advanced in skill until now in 1847, at Leamington, it had proceeded into botanical detail; and the collection of material for "Proserpina" began then, singularly, with the analysis of a thistle-top, as the foundation of all my political economy was dug down to, through the thistle-field of Crossmount.

200. "Analysis" of thistle-top, I say; not "dissection," nor microscopic poring into.

Flowers, like everything else that is lovely in the visible world, are only to be seen rightly with the eyes which the God who made them gave us; and neither with microscopes nor spectacles. These have their uses for the curious and the aged; as stilts and crutches have for people who want to walk in mud, or cannot safely walk but on three legs anywhere. But in health of mind and body, men should see with their own eyes, hear and speak without trumpets, walk on their feet, not on wheels, and work and war with their arms, not with engine-beams, nor rifles warranted to kill twenty men at a shot before you can see them. The use of the great mechanical powers may indeed sometimes be compatible with the due exercise of our own; but the use of instruments for exaggerating the powers of sight necessarily deprives us of the best pleasures of sight. A flower is to be watched as it grows, in its association with the earth, the air, and the dew; its leaves are to be seen as they expand in sunshine; its colours, as they embroider the field, or illumine the forest. Dissect or magnify them, and all you discover or learn at last will be that oaks, roses, and daisies, are all made of fibres and bubbles; and these again, of charcoal and water; but, for all their peeping and probing, nobody knows how.

201. And far more difficult work than this was on foot in other directions. Too sorrowfully it had now

become plain to me that neither George Herbert, nor Richard Hooker, nor Henry Melvill, nor Thomas Dale, nor the Dean of Christ Church, nor the Bishop of Oxford, could in anywise explain to me what Turner meant by the contest of Apollo with the Python, or by the repose of the great dragon above the Garden of the Hesperides.

For such nearer Python, as might wreathe itself against my own now gathering strength,—for such serpent of Eternity as might reveal its awe to me amidst the sands even of Forest Hill or Addington Heath, I was yet wholly unprepared.

All that I had been taught had to be questioned; all that I had trusted, proved. I cannot enter yet into any account of this trial; but the following fragment of 1847 diary will inform the reader enough of the courses of thought which I was being led into beside the lilies of Avon, and under the mounds, that were once the walls, of Kenilworth.

202. "It was cold and dark and gusty and raining by fits, at two o'clock to-day, and until four; but I went out, determined to have my walk, get wet or no.

"I took the road to the village where I had been the first day with Macdonald, and about a mile and a half out, I was driven by the rain into a little cottage, remarkable outside for two of the most noble groups of hollyhocks I ever saw—one rose-colour passing into purple, and the other rich purple and opposed by a beautiful sulphur yellow one. It was about a quarter to five, and they (the woman and her mother) were taking their tea (pretty strong, and without milk) and white bread. Round the room were hung several prints of the Crucifixion, and some Old Testament subjects, and two bits of tolerable miniature; one in what I thought at first was an uniform, but it was the footman's dress of the woman's second son, who is

with a master in Leamington; the other a portrait of a
more distingué-looking personage, who, I found on
inquiry, was the eldest son, cook in the Bush inn at
Carlisle. Inquiring about the clergyman of the village,
the woman—whose name, I found, was Sabina—said they
had lost their best earthly friend, the late clergyman, a
Mr. Waller, I think, who had been with them upwards
of eleven years, and had got them into that cottage; her
husband having been in his service, and he fretted himself,
she said, too much, about getting them into it, and never
lived to see them in it after all, dying of decline in London.
She spoke of him with tears in her eyes. I looked at the
books lying on the table, well used all of them, and found
three Bibles, three Prayer Books, a treatise on practical
Christianity, another on seriousness in religion, and
Baxter's 'Saint's Rest.' I asked her if they read no books
but religious ones. 'No, sir; I should be very sorry if
there were any others in my house,' said she. As I took
up the largest Bible, she said 'it was a nice print, but sadly
tattered; she wished she could get it bound.' This
I promised to get done for her, and left her much
pleased.

"It had rained hard while I stayed in the cottage, but
had ceased when I went on, and presently appeared such
a bright bar of streaky sky in the west, seen over the
glittering hedges, as made my heart leap again, it put so
much of old feelings into me of far-away hills and foun-
tains of morning light; and the sun came out presently,
and every shake of the trees shook down more light upon
the grass. And so I came to the village and stood leaning
on the churchyard gate, looking at the sheep nibbling and
resting among the graves (newly watered they lay, and
fresh, like a field of precious seed). One narrow stream
of light ran in ups and downs across them, but the shadow
of the church fell over most—the pretty little grey church,

now one dark mass against the intense golden glittering sky; and to make it sweeter still, the churchyard itself rose steeply, so that its own grand line came against this same light at last."

CHAPTER XI

L'HOTEL DU MONT BLANC

203. THE little inn at Samoens, where I washed the stairs down for my mother,* was just behind the group of houses of which I gave a carefully coloured sketch to Mrs. John Simon, who, in my mother's old age, was her most deeply trusted friend. She, with her husband, love Savoy even more than I; were kinder to Joseph Couttet to the last, and are so still to his daughter Judith.

The Samoens inn was, however, a too unfavourable type of the things which—in *my* good old times—one had sometimes to put up with, and rather liked having to put up with, in Savoy. The central example of the sort of house one went there to live in, was the Hotel du Mont Blanc at St. Martin's; to me, certainly, of all my inn homes, the most eventful, pathetic, and sacred. How to begin speaking of it, I do not know; still less how to end; but here are three entries, consecutive, in my diary of 1849, which may lead me a little on my way.

204. "St. Martin's, evening, July 11th. What a strange contrast there is between these lower valleys, with their over-wrought richness mixed with signs of waste and disease, their wild noon-winds shaking their leaves into palsy, and the dark storms folding themselves about their steep mural precipices,—between these and the pastoral green, pure aiguilles, and fleecy rain-clouds of Chamouni; yet nothing could be more divine than (to-day) the great valley of level cornfield; half, smooth

* "I have myself washed a flight of stone stairs all down, with bucket and broom, in a Savoy Inn, where they hadn't washed their stairs since they first went up them; and I never made a better sketch than that afternoon." (Ses. and Lil., § 138.)

close to the ground, yet yellow and warm with stubble;
half, laden with sheaves; the vines in massy green above,
with Indian corn, and the rich brown and white cottages
(in midst of them).

July 13th. I walked with my father last night up to
the vine-covered cottages under the Aiguille de Varens.

July 15th, Samoens. We had a stony road to traverse
in chars from St. Martin's yesterday, and a hot walk
this morning over the ground between this (Samoens)
and Sixt. As I passed through the cornfields, I found
they gave me a pleasant feeling by reminding me of
Leamington."

"We" in this entry means only my father and mother
and I; poor Mary was with us no more. She had got
married, as girls always will,—the foolish creatures!—
however happy they might be at home, or abroad, with
their own people.

Mary heartily loved her aunt and uncle, by this time,
and was sorry to leave them: yet she must needs marry
her brother-in-law, a good, quiet London solicitor, and
was now deep in household cares in a dull street, Pimlico
way, when she might have been gaily helping me to sweep
the stairs at Samoens, and gather bluets * in those Leam-
ington-like cornfields.

205. The sentence about "noon-wind" refers to a
character of the great valleys on the north of the main
Alpine chain, which curiously separates them from those
of the Italian side. These great northern valleys are, in
the main, four,—those of the Rhine (the Grisons), of the
Reuss (Canton Uri), of the Rhone (Canton Valais), and
the Arve (Faucigny),—all of them in ordinarily fine
summer weather oppressed by quiet heat in the early part

* The blue centaury-like five gentians in a level cluster. Among
the corn, it teaches, like the poppy, that everything isn't meant to be
eaten.

of the day, then burst in upon by wild wind blowing up the valley about noon, or later; a diurnal storm which raises the dust in whirlwinds, and wholly prevents the growth of trees in any beautiful forms, their branches being daily tormented into every irregular and fretful curve they can be strained to, and their leaves wrung round on the stalks, so that half their vitality is torn out of them.

Strangely, and, so far as I know, without notice by scientific men of the difference, the Italian valleys are, in the greater number of them, redeemed from this calamitous law. I have not lately been in either Val d'Aosta, or the Valtelline, nor ever stayed in the upper valley of the Adige; but neither in the Val Anzasca, the Val Formazza, the Val d'Isella, or the southern St. Gothard, is there any trace of the action of malignant wind like this northern one, which I suppose to be, in the essence of it, the summer form of the bise. It arises, too fatally, punctual to the noon, in the brightest days of spring all over western Savoy.

Be that as it may, in the fields neighbouring the two villages which mark the eastern and western extremities of the chain of Mont Blanc,—Sallenches, namely, and Martigny, where I have passed many of the most serviceable days of my life,—this noon wind, associated with inundation, is one of the chief agents in producing the character of the whole scene, and in forming the tempers of the inhabitants. Very early my mind became fixed on this their physical distress, issuing finally not in the distortion of growing trees only, but in abortion of human form and mind, while yet the roots of beauty and virtue remained always of the same strength in the race; so that, however decimated by cretinism, the Savoyard and Valaisan retain to this day their vigorous personal character, wherever the conditions of ordinary health are observed for them.

206. So earnestly was my heart set on discovering and

contending with the neglect and error which were the causes of so great evil to so noble a people, that—I must here anticipate the progress of many years—I was in treaty again and again for pieces of land near the chain of Mont Blanc on which I thought to establish my life, and round which to direct its best energies. I first actually bought the piece of meadow in Chamouni above the chalets of Blaitiere; but sold it on perceiving what ruin was inevitable in the valley after it became a tourist rendezvous. Next, I entered into treaty with the Commune of Bonneville for the purchase of the whole top of the Brezon; but this negotiation came to nothing, because the Commune, unable to see why anybody should want to buy a waste of barren rock, with pasturage only for a few goats in the summer, concluded that I had found a gold mine or a coal-bed in it, and raised their price on me till I left the Brezon on their hands: (Osborne Gordon having also walked up with me to my proposed hermitage, and, with his usual sagacity, calculated the daily expense of getting anything to eat, up those 4,000 feet from the plain).

207. Next, I was tempted by a grand, fourteenth century, square-set castle, with walls six feet thick, and four round towers, cone-roofed, at the angles, on the west bank of the Arve, below La Roche: but this baronial residence having been for many years used by the farmer to whom it belonged for his fruit store, and the three floors of it only accessible by ladders through trap doors in them, and soaked through with the juice of rotten apples and plums;—so that the most feasible way of making the place habitable would have been to set fire to the whole, and refit the old masonry with an inner lodging of new wood,—(which might as well have been built inside a mountain cave at once as within those six-feet thick of cemented rock,)—I abandoned also the idea of

this gloomy magnificence, and remained fancy-free till
1870, when I again was about to enter into treaty for a
farm two thousand feet above Martigny, on the ridge
separating the Forclaz from the glen of the Trient, and
commanding view of the whole valley of the Rhone, west-
ward to Sierre, and northward to Bex. Design ended by
my illness at Matlock, and following sorrow; of which
in their due time.

Up to the year with which I am now concerned, how-
ever, 1849, when I was just thirty, no plans of this sort
had dawned on me: but the journeying of the year, mostly
alone, by the Allée Blanche and Col de Ferret round
Mont Blanc and then to Zermatt, for the work chiefly
necessary to the fourth volume of "Modern Painters,"
gave me the melancholy knowledge of the agricultural
condition of the great Alpine chain which was the origin
of the design of St. George's Guild; and that walk with
my father at St. Martin's virtually closed the days of
youthful happiness, and began my true work in the world
—for what it is worth.

208. An entry or two from the beginning of the year
may be permitted, connecting old times with new.

"April 15th, Wednesday. Left home, stayed at Folke-
stone, happy, but with bad cough, and slight feverish
feeling, till Monday. Crossed to Boulogne, with desper-
ate cold coming on. Wrote half letter to Miss Wedder-
burn," (afterwards Mrs. Blackburn,) "in carriage, going
over:" the carriages, of course, in old times being lashed
on the deck, one sat inside, either for dignity or shelter.

"April 24th, Tuesday. To Paris on rail. Next morn-
ing, very thankfully changing horses, by as lovely sunshine
as ever I saw, at Charenton. Slept at Sens. Thursday,
Mont-bard; Friday, Dijon. All these evenings I was
working hard at my last plate of Giotto." (G.'s tower,
I meant; frontispiece to "Seven Lamps," first edition.)

"Stopped behind in the lovely morning at Sens, and went after my father and mother an hour later.* It was very cold, and I was driven out by the fires going out, it being in the large room at the back of the yard, with oil pictures only to be got at through my father's bedroom.†

April 29th, Sunday, was a threatening day at Champagnole. We just walked to the entrance of the wood and back,—I colded and coughing, and generally headachy. In the evening the landlady, who noticed my illness, made me some syrup of violets. Whether by fancy, or chance, or by virtue of violet tea, I got better thenceforward, and have, thank God, had no cold since!" (Diary very slovenly hereabouts; I am obliged to mend a phrase or two.)

209. "Monday, 30th April. To Geneva, through a good deal of snow, by St. Cergues; which frightened my mother, they having a restive horse in their carriage. She got out on a bank near where I saw the first gentians, and got into mine, as far as St. Cergues." (It is deserving of record that at this time just on the point of coming in sight of the Alps—and that for the first time for three years, a moment which I had looked forward to thinking I should be almost fainting with joy, and want to lie down on the earth and take it in my arms;—at this time, I say, I was irrecoverably sulky because George had not got me butter to my bread at Les Rousses.)

"Tuesday, 1st May. Walked about Geneva, went to Bauttes', and drew wood anemones.

Thursday, 3rd May, Chambery. Up the hill that looks towards Aix, with my father and mother; had a chat with an old man, a proprietor of some land on the hillside, who complained bitterly that the priests and the revenue officers

* They had given me a little brougham to myself, like the hunting doctor's in "Punch," so that I could stop behind, and catch them up when I chose.

† The inn is fully and exquisitely described by Dickens in "Mrs. Lirriper's Lodgings."

seized everything, and that nothing but black bread was left for the peasant.*

Friday, 4th May. Half breakfasted at Chambery; started about seven for St. Laurent du Pont, thence up to the Chartreuse, and walked down (all of us); which, however, being done in a hurry, I little enjoyed. But a walk after dinner up to a small chapel, placed on a waving group of mounds, covered with the most smooth and soft sward, over whose sunny gold came the dark piny precipices of the Chartreuse hills, gave me infinite pleasure. I had seen also for the third time, by the Chartreuse torrent, the most wonderful of all Alpine birds—a grey, fluttering stealthy creature, about the size of a sparrow, but of colder grey, and more graceful, which haunts the sides of the fiercest torrents. There is something more strange in it than in the seagull—*that* seems a powerful creature; and the power of the sea, not of a kind so adverse, so hopelessly destructive; but this small creature, silent, tender and light, almost like a moth in its low and irregular flight,—almost touching with its wings the crests of waves that would overthrow a granite wall, and haunting the hollows of the black, cold, herbless rocks that are continually shaken by their spray, has perhaps the nearest approach to the look of a spiritual existence I know in animal life.

210. Saturday, May 5th. Back to Chambery, and up by Rousseau's house to the point where the thunder-shower came down on us three years ago."

I think it was extremely pretty and free-hearted of my mother to make these reverent pilgrimages to Rousseau's house.†

* Complaints of this kind always mean that you are near a luxurious capital or town. In this case, Aix les Bains.

† "Les Charmettes." So also "un détachement de la troupe" (of his schoolboys) "sous la conduite de Mr. Topffer, qui ne sait pas le chemin, entreprend de gravir le coteau des Charmettes, pour atteindre

With whom I must here thankfully name, among my own masters, also St. Pierre: I having shamefully forgotten hitherto the immense influence of "Paul and Virginia" amidst my early readings. Rousseau's effective political power I did not know till much later.

211. Richard Fall arrived that Saturday at Chambery; and by way of amends for our lost Welsh tour, (above, p. 271,) I took him to Vevay and Chamouni, where, on May 14th, the snow was still down to the valley; crisp frost everywhere; the Montanvert path entirely hidden, and clear slopes down all the couloirs perfectly even and smooth—ten to twenty feet deep of good, compact snow; no treacherous surface beds that could slip one over the other.

Couttet and I took Richard up to the cabane of the Montanvert, memory of the long snow walks at Herne Hill now mingling tenderly with the cloudless brightness of the Mer de Glace, in its robe of winter ermine. No venturing on that, however, of course, with every crevasse hidden; and nobody at the cabane yet, so we took Richard back to the first couloir, showed him how to use foot and pole, to check himself if he went too fast, or got head-foremost; and we slid down the two thousand feet to the source of the Arveron, in some seven or eight minutes; * Richard vouchsafing his entire approval of that manner of progression by the single significant epithet, "Pernicious!"

It was the last of our winter walks together. Richard did not die, like Charles, but he went on the Stock

à l'habitation de Jean-Jacques Rousseau"—in the year 1833; and an admirably faithful and vivid drawing of the place, as it then stood (unchanged till 1849, when papa and mamma and their little St. Preux saw it), is given by Mr. Topffer's own hand on p. 17 of his work here quoted, "Voyage à la Grande Chartreuse" (1833).

* Including ecstatic or contemplative rests: of course one goes much faster than 200 feet a minute, on good snow, at an angle of 30°.

Exchange; married a wife, very nice and pretty; then grew rich; held a rich man's faiths in political economy; and bought bad prints of clipper packets in green sea; and so we gradually gave each other up—with all good wishes on both sides. But Richard, having no more winter walks, became too fat and well liking when he was past fifty—and *did* die, then; to his sister's great surprise and mine. The loss of him broke her heart, and she soon followed him.

212. During her forty-five or fifty years of life, Eliza Fall (had she but been named Elizabeth instead, I should have liked her ever so much better,) remained an entirely worthy and unworldly girl and woman, of true service and counsel always to her brother and me; caring for us both much more than she was cared for;—to my mother an affectionate and always acceptable, calling and chatting, friend: capable and intelligent from her earliest youth, nor without graceful fancy and rational poetic power. She wrote far better verses than ever I did, and might have drawn well, but had always what my mother called "perjinketty" ways, which made her typically an old maid in later years. I imagine that, without the least unkind severity, she was yet much of a Puritan at heart, and one rarely heard if ever, of her going to a theatre, or a rout, or a cricket-match; yet she was brilliant at a Christmas party, acted any part—that depended on whalebone— admirably, and was extremely witty in a charade. She felt herself sorrowfully turned out of her own house and place when her brother married, and spent most of her summers in travel with another wise old maid for companion. Then Richard and his wife went to live in Clapham Park; and Eliza stayed, wistfully alone, in her child's home, for a while. The lease expired, I suppose, and she did not care to renew it. The last time I saw her, she was enjoying some sort of town life in New Bond Street.

Little I thought, in clasping Richard's hand on the ridge of the Jaman that spring,—he going down into the Simmenthal, I back to Vevay,—that our companying together was ended: but I never have known anything of what was most seriously happening to me till afterwards; this—unastrological readers will please to note—being one of the leaden influences on me of the planet Saturn.

213. My father and mother were waiting for me at Geneva, and we set out, with short delay, for St. Martin's.

The road from Geneva to Chamouni, passing the extremity of the Salève about five miles south of the city, reaches at that point the sandy plateau of Annemasse, where forms of passport had (anciently) to be transacted, which gave a quarter of an hour for contemplation of what the day had to do.

From the street of the straggling village one saw over the undulations of the nearer, and blue level of the distant, plain, a mass of rocky mountains, presenting for the most part their cliffs to the approaching traveller, and tossing their crests back in careless pride, above the district of well inhabited, but seldom traversed, ravines which wind between the lake of Annecy and vale of Sallenches.

Of these the nearest—yet about twelve miles distant —is the before-named Brezon, a majestic, but unterrific, fortalice of cliff, forest, and meadow, with unseen nests of village, and unexpected balm and honey of garden and orchard nursed in its recesses. The horses have to rest at Bonneville before we reach the foot of it; and the line, of its foundation first, and then of the loftier Mont Vergy, must be followed for seven or eight miles, without hope apparently of gaining access to the inner mountain world, except by footpath.

214. A way is opened at last by the Arve, which, rushing furiously through a cleft affording room only for road and river, grants entrance, when the strait is passed,

to a valley without the like of it among the Alps. In
all other avenues of approach to their central crests the
torrents fall steeply, and in places appear to be still cutting
their channels deeper, while their lateral cliffs have
evidently been in earlier time, at intervals, connected,
and rent or worn asunder by traceable violence or decay.
But the valley of Cluse is in reality a narrow plain between
two chains of mountains which have never been united,
but each independently * raised, shattered, and softened
into their present forms; while the river, instead of
deepening the ravine it descends, has filled it to an
unknown depth with beds of glacial sand, increased
annually, though insensibly, by its wandering floods; but
now practically level, and for the most part tenable,
with a little logwork to fence off the stream at its angles,
in large spaces of cultivable land.

In several turns of the valley the lateral cliffs go plumb
down into these fields as if into a green lake; but usually,
slopes of shale, now forest-hidden, ascend to heights of
six or seven hundred feet before the cliffs begin; then the
mountain above becomes partly a fortress wall, partly
banks of turf ascending around its bastions or between
but always guarded from avalanche by higher woods or
rocks; the snows melting in early spring, and falling in
countless cascades, mostly over the cliffs, and then in
broken threads down the banks. Beautiful always, and
innocent, the higher summits by midsummer are snowless,
and no glacial moraine or torrent defaces or disturbs the
solitude of their pastoral kingdom.

Leaving the carriage at Cluse, I always used to walk,
through this valley, the ten miles to St. Martin's, resting
awhile at the springs of Maglan, where, close under the
cliff, the water thrills imperceptibly through the crannies

* In the same epoch of time, however. See Mr. Collingwood's
"Limestone Alps of Savoy."

of its fallen stones, deeper and deeper every instant; till, within three fathoms of its first trickling thread, it is a deep stream of dazzling brightness, dividing into swift branches eager for their work at the mill, or their ministry to the meadows.

Contrary again to the customs of less enchanted vales, this one opens gradually as it nears the greater mountain, its own lateral cliffs rising also in proportion to its width —those on the left, as one approaches St. Martin's, into the vast towers and promontories of the Aiguille de Varens; those on the right into a mountain scarcely marked in any Alpine chart, yet from which, if one could climb its dangerous turf and mural diadem, there must be commanded precisely the most noble view of Mont Blanc granted by any summit of his sentinel chains.

215. In the only map of Switzerland which has ever been executed with common sense and intelligence ("Original von Keller's Zweiter Reisekarte der Schweitz," 1844), this peak is, nevertheless, left without distinction from that called the "Croix de Fer," of which it is only a satellite. But there are any quantity of iron crosses on the Western Alps, and the proper name of this dominant peak is that given in M. Dajoz's lithographed "Carte des rives du Lac de Genève," *—"Mont Fleury"; though the more usual one with the old Chamouni guides was "Montagne des Fours"; but I never heard any name given to its castellated outwork. In Studer's geological map it is well drawn, but nameless; in the Alpine Club's map of South-Western Alps, it is only a long ridge descending from the Mont Fleury, which, there called "Pointe Percée," bears a star, indicating a view of Mont

* Chez Briquet et Fils, éditeurs, au bas de la Cité à Genève, 1860; extremely careful in its delineation of the lower mountain masses, and on the whole the best existing map for the ordinary traveller. The Alpine Club maps give nothing clearly but the taverns and footpaths.

Blanc, as probably of Geneva also, from that summit. But the vision from the lower promontory, which commands the Chamouni aiguilles with less foreshortening, and looks steep down into the valley of Cluse from end to end, must be infinitely more beautiful.

216. Its highest ridge is just opposite the Nant d'Arpenaz, and might in future descriptions of the Sallenche mountains be conveniently called the "Tower of Arpenaz." After passing the curved rock from which the waterfall leaps into its calm festoons, the cliffs become changed in material, first into thin-bedded blue limestone and then into dark slates and shales, which partly sadden, partly enrich, with their cultivable ruin, all the lower hill-sides henceforward to the very gate of Chamouni. A mile or two beyond the Nant d'Arpenaz, the road ascends over a bank of their crumbling flakes, which the little stream, pendent like a white thread over the mid-cliff of the Aiguille de Varens, drifts down before it in summer rain, lightly as dead leaves. The old people's carriage dips into the trough of the dry bed, descends the gentle embankment on the other side, and turns into the courtyard of the inn under one of the thin arches, raised a foot or two above the gap in the wall, which give honourable distinction either to the greater vineyards or open courts, like this one, of hospitable houses. Stableyard, I should have said, not courtyard; no palatial pride of seclusion, like M. Dessein's, but a mere square of irregular stable, —not even coach-house, though with room for a carriage or two: but built only for shelter of the now unknown char-à-banc, a seat for three between two pairs of wheels, with a plank for footing, at a convenient step from the ground. The fourth side of the yard was formed by the front of the inn, which stood with its side to the road, its back to the neglected garden and incorrigible streamlet: a two-storied building of solid grey stone, with gabled roof

and garrets; a central passage on the second floor giving
access to the three or four bedrooms looking to back and
front, and at the end to an open gallery over the road.
The last room on the left, larger than the rest, and with
a window opening on the gallery, used to be my father's
and mother's; that next it, with one square window in
the solid wall, looking into the yard, mine. Floors and
partitions all of rough-sawn larch; the planks of the
passage floor uncomfortably thin and bending, as if one
might easily fall through; some pretence of papering, I
think, in the old people's state room. A public room,
about the size of my present study, say twelve paces by
six within its cupboards, and usually full of flies, gave us
the end of its table for meals, and was undisturbed through
the day, except during the hour when the diligence dined.

217. I should have said that my square window looked
over, rather than *into* the yard, for one could scarcely
see anything going on there, but by putting one's head
out: the real and prevalent prospect was first into the
leaves of the walnut tree in the corner; then of the mossy
stable roofs behind them; then of the delicately tin-mailed
and glittering spire of the village church; and beyond
these, the creamy, curdling, overflowing seas of snow on
the Mont Blanc de St. Gervais. The Aiguille de Bion-
nassay, the most graceful buttress ridge in all the Alps,
and Mont Blanc himself, above the full fronts of the
Aiguille and Dome du Gouté, followed further to the
left. So much came into the field of that little four-feet-
square casement.

If one had a mind for a stroll, in half a minute's turn
to the left from the yard gate, one came to the aforesaid
village church, the size of a couple of cottages, and one
could lean, stooping, to look at it, on the deeply lichened
stones of its low churchyard wall, which enclosed the
cluster of iron crosses,—floretted with everlastings, or

garlands of fresh flowers if it was just after Sunday,—
on two sides; the cart-path to the upper village branching
off round it from the road to Chamouni. Fifty yards
further, one came to the single-arched bridge by which
the road to Sallenche, again dividing from that of
Chamouni, crosses the Arve, clearing some sixty feet of
strongly-rushing water with a leap of lovely elliptic curve;
lovely, because here traced with the lightest possible sub-
stance of masonry, rising to its ridge without a pebble's
weight to spare,* and then signed for sacred pontifical
work by a cross high above the parapet, seen from as far
as one can see the bridge itself.

218. Neither line, nor word, nor colour, has ever yet
given rendering of the rich confusions of garden and
cottage through which the winding paths ascend above
the church; walled, not with any notion of guarding the
ground, except from passing herds of cattle and goats,
but chiefly to get the stones off the surface into narrowest
compass, and, with the easy principle of horticulture,—
plant everything, and let what can, grow;—the under-
crops of unkempt pease, potatoes, cabbage, hemp, and
maize, content with what sun can get down to them
through luxuriantly-branched apple and plum trees, and
towering shade of walnuts, with trunks eight or ten feet
in girth; a little space left to light the fronts of the cottages
themselves, whose roof and balconies, the vines seem to
think, have been constructed for their pleasure only, and
climb, wreathe, and swing themselves about accordingly
wherever they choose, tossing their young tendrils far up
into the blue sky of spring, and festooning the balconies
in autumn with Correggian fresco of purple, relieved
against the pendent gold of the harvested maize.

* Of course, in modern levelled bridges, with any quantity of over-
charged masonry, the opening for the stream is not essentially an
arch, but a tunnel, and might for that matter be blown through the
solid wall, instead of built to bear it.

The absolute seclusion and independence of this manner of rural life, totally without thought or forethought of any foreign help or parsimonious store, drinking its wine out of the cluster, and saving of the last year's harvest only seed for the next,—the serene laissez faire given to God and nature, with thanks for the good, and submission to the temporary evil of blight or flood, as due to sinful mortality; and the persistence, through better or worse, in their fathers' ways, and use of their fathers' tools, and holding to their fathers' names and fields, faithfully as the trees to their roots, or the rocks to their wild flowers —all this beside us for our Sunday walk, with the grey, inaccessible walls of the Tower of Arpenaz above, dim in their distant height, and all the morning air twice brighter for the glow of the cloudless glaciers, gave me deeper and more wonderful joy than all the careful beauty and disciplined rightness of the Bernese Oberland, or even the stately streets of my dearest cities of Italy.

219. Here is a little bit of diary, five years later, giving a detail or two of the opposite hillside above Sallenche.

"St. Martin's, 26th July, 1854. I was up by the millstream this evening, and climbed to the right of it, up among the sloping waves of grass. I never was so struck by their intense beauty,—the masses of walnut shading them with their broad, cool, clearly-formed leafage; the glossy grey stems of the cherry trees, as if bound round tight with satin, twining and writhing against the shadows; the tall pollards of oak set here and there in the soft banks, as if to show their smoothness by contrast, yet themselves beautiful, rugged, and covered with deep brown and bright silver moss. Here and there a chestnut—sharp, and soft, and starry *; and always the

* I meant—the leaves themselves, sharp, the clustered nuts, soft, the arrangement of leaves, starry.

steep banks, one above another, melting * into terraces of pure velvet, gilded with corn; here and there a black jet-black—crag of slate breaking into a frown above them, and mouldering away down into the gloomy torrent bed, fringed on its opposite edge, a grisly cliff, with delicate birch and pine, rising against the snow light of Mont Blanc. And opposite always the mighty Varens lost in the cloud its ineffable walls of crag."

220. The next following entry is worth keeping, as a sketch of the undisturbed Catholicism among these hills since the days of St. Bernard of Annecy, and Mont Velan.

"Sallenches, Sunday, 10th June (1849). The waitress here, a daughter of the landlord, asked me to-day whether Protestants all said grace before meat, observing me to do so. On this we got into conversation, out of which I have elicited some points worth remembering; to wit, that some of the men only go to confession once a year, and that some of them, to spare their memories, write their sins,—which, however, they cannot deliver on paper to the confessor, but must read them aloud. Louise appeared much horror-struck at the idea which such a procedure admits, of 'losing one's sins;' and of their being found by some one who was not a confessor. She spoke with great pleasure of the Capucins who come sometimes; said they were such delightful confessors, and made 'des morales superbes,' and that they preached so well that everybody listened with all their might, so that you might tap them on the back and they would never turn round. Of the Jesuits she spoke with less affection, saying that in their great general confessions, which took several days, two or three commandments at a time, they would not allow a *single* sin to be committed by the persons coming to them in the meantime, or else they refused them absolution—

* "Melting"—seeming to flow into the levels like lava; not cut sharp down to them.

refusal which takes place sometimes for less cause. They
had a poor old servant, who could only speak patois; the
priest couldn't understand her, nor she him, so that he
could not find out whether she knew her catechism. He
refused absolution, and the poor old creature wept and
raved about it, and was in a passion with all the world.
She was afterwards burnt in the great fire here! I went
to mass, to hear how they preached: the people orderly,
and church perfectly full. The sermon by a fat stuttering
curé, was from the 'Receive not the grace of God in vain,'
on the Sacraments. 'Two of these called Sacramens des
Morts, because they are received by persons in a state of
spiritual death; the five others called Sacramens des
Vivants, because they presume, in those who receive them,
a state of spiritual life. The three sacraments of Baptism,
Confirmation, and Orders, can only be received once;
because they impress an indelible seal, and make men what
they were not; and what, after they are once, they cannot
unmake themselves. Baptism makes people children or
subjects of God; Confirmation makes them soldiers of
God, or soldiers of His Kingdom; and Orders make them
magistrates of the Kingdom. If you have received
baptism, you are therefore an "enfan de Dieu." ' What
being an 'enfan de Dieu' meant was not very clear; for
the ineffaceability of baptism was illustrated by the instance
of Julian the Apostate, who did all he could to efface it
—'Mais la mort,' said the preacher, growing eloquent,
'le poursuivit jusqu'à'—(he stopped, for he did not know
exactly where *to*)—'la tombe; et il est descendu aux enfers,
portant cette marque, qui fera éternellement sa honte et
sa confusion.' "

221. I wonder at the lightness of these entries, now;
but I was too actively, happily, and selfishly busy, to be
thoughtful, except only in scholarly way; but I got one
of the sharpest warnings of my life only a day after leaving

papa and mamma at St. Martin's,—(cruel animal that I
was!—to do geology in the Allée Blanche, and at Zer-
matt.) I got a chill by stopping, when I was hot, in the
breeze of one of the ice streams, in ascending to the Col
de Bon Homme; woke next morning in the châlet of
Chapiù with acute sore throat; crossed the Col de la
Seigne scarcely able to sit my mule, and was put to bed
by Couttet in a little room under the tiles at Courmayeur,
where he nursed me as he did at Padua; gave me hot herb-
tea, and got me on muleback again, and over the Col de
Ferret, in a day or two; but there were some hours of
those feverish nights which ought to have made my
diaries more earnest afterwards. They go off, however,
into mere geology and school divinity for a while, of which
this bit, written the evening after crossing the Col de
Ferret, is important as evidence of my beginning to
recognise what James Forbes had proved of glacier flow:—

"The most magnificent piece of ruin I have yet seen
in the Alps is that opposite the embouchure of the lower
glacier of the Val de Ferret, near Courmayeur; the pines
are small indeed, but they are hurled hither and thither,
twisted and mingled in all conditions of form, and all
phases of expiring life, with the chaos of massy rocks,
which the glacier has gnashed down, or the opposite
mountain hurled. And yet, farther on, at the head of
the valley, there is another, in its way as wonderful; less
picturesque, but wilder still,—the remains of the eboule-
ment of the Glacier de Triolet caused by the fall of an
aiguille near the Petits Jorasses—the most phrenzied
accumulation of moraines I have ever seen; not dropped
one by one into a heap, and pushed forward by the ice
ploughshare, but evidently borne down by some mingled
torrent of ice and rock and flood, with the swiftness of
water and the weight of stone, and thrown along the
mountain-side like pebbles from a stormy sea;—but the

ruins of an Alp instead of the powder of a flint bed. The
glacier torrent of Triolet is almost lost among them, but
that below, coming just from the base of the Jorasses, is
exquisite beyond description in the play of its currents,
narrow eddies of white nevè round islands of rock—falling
in upon each other in deep and eddying pools; flowing
forth again in massy sheets of ice, feeding, not one glacier
stream, but cascade above cascade, far into the mountain
gulph."

And so on, of divers matters, through four hundred
and fifty pages; not all as good as that, but the core of
what I had to learn and teach about gneiss and ice and
clouds;—George indefatigably carrying his little daguer-
reotype box up everywhere, and taking the first image
of the Matterhorn, as also of the aiguilles of Chamouni,
ever drawn by the sun. A thing to be proud of still,
though he is now a justice of peace, somewhere in
Australia.

222. The following entries, in June, of which the
two last come in the midst of busy and otherwise happy
days, are all with which I permit myself to trouble the
reader for this time.

"Chamouni, Sunday, June 17th. Quiet south rain
till twelve o'clock. I have been abstracting the book of
Revelation, (they say the French are beaten again at Rome,
and another revolution in Paris); many signs seem to
multiply around us, and yet my unbelief yields no more
than when all the horizon was clear. I was especially
struck with the general appellation of the system of the
world. As the 'Mystery of God,' Chap. x. 7, compared
with Hebrews xi. 6, which I read this morning in our usual
course.* Theme enough for the day's thought.

* Read the 5th, 6th, and 7th verses in succession:—"AND THE
ANGEL WHICH I SAW STAND UPON THE SEA AND UPON THE EARTH
LIFTED UP HIS HAND TO HEAVEN, AND SWARE BY HIM THAT LIVETH

Halfpast five. Pouring still, but I got out before
dinner during a fine blink, which lasted just long enough
to let me, by almost running, and leaping all the streams,
reach the end of the pine wood next the source of the
Arveron. There I had to turn to the left to the wooden
bridge, when behold a sight new to me; an avalanche
had evidently taken place from the (upper) glacier into
the very bed of the great cataract, and the stream was as
nearly choked as could be with balls and ellipsoids of ice,
from the size of its common stones to that of a portmanteau,
which were rolling down with it wildly, generally swing-
ing out and in of the water as it waved; but when they
came to the shallow parts, tumbled and tossed over one
another, and then plunging back into the deep water like
so many stranded porpoises, spinning as they went down,
and showing their dark backs with wilder swings after their
plunge,—white, as they emerged, black, owing to their
clearness as seen in the water; the stream itself of a pale
clay-colour, opaque, larger by one half than ever I saw
it, and running, as I suppose, not less than ten miles an
hour; the whole mass, water and ice, looking like some
thick paste full of plums, or ill-made pine-apple ice, with
quantities of fruit in it, and the whole looking like a solid
body; for the nodules of ice hardly changed their relative
position during the quarter of a minute they were severally
in sight, going down in a mass, thundering and rumbling
against the piles of the bridge. It made me giddy to look
at it; and the more, because, on raising the eye, there
was always the great cataract itself startling one, as if it

FOR EVER AND EVER, WHO CREATED HEAVEN, AND THE THINGS THAT
THEREIN ARE, AND THE EARTH, AND THE THINGS THAT THEREIN
ARE, AND THE SEA, AND THE THINGS WHICH ARE THEREIN, THAT
THERE SHOULD BE TIME NO LONGER: BUT IN THE DAYS OF THE
VOICE OF THE SEVENTH ANGEL, WHEN HE SHALL BEGIN TO SOUND,
THE MYSTERY OF GOD SHOULD BE FINISHED, AS HE HATH DECLARED
TO HIS SERVANTS THE PROPHETS."

had just begun and seeming to increase every instant, bounding and hurling itself hither and thither, as if it was striving to dash itself to pieces, not falling because it could not help it; and behind there was a fearful storm coming up by the Breven, its grisly clouds warping up, as it seemed, against the river and cataract, with pillars of hail behind. I stayed till it began, and then crept back through the wood, running from one tree to another—there is really now a bit of blue sky over the Pavillon.*

223. June 18th. Evening, nine o'clock. I must not write much, it is past bed-time; went to source of Arveron with my father and mother and Miss Dowie; † never saw it so lovely; drew afterwards near the source, piny sketch, well begun. After tea walked up nearly to my beloved old place on the Breven, and saw a solemn sunset, yet not very bright; the granulated rosy crags of La Cote especially. Thank God for permitting me to sit on that slope once more thus strong in health and limb.

Chamouni, day 13th, Monday, June 25th. Up rather late this morning, and lost time before breakfast over camera-lucida; drove to Argentière with my mother, who enjoyed her drive exceedingly; back at one o'clock to my usual place (Les Tines, till four); out after dinner, rambling about Breven with sketch-book in search of a view of Aiguille du Plan; didn't find one, but found some wild strawberries, which were a consolation. The day has been fine, with scattered clouds; in the evening a most curious case of floating cap cloud, *hooding* the Mont Blanc summit without touching it, like gossamer blown upwards from a field; an awning of slender threads waving like weeds in the blue sky," (as weeds in a brook current, I meant), "and drawn out like floss silk as fine as snow. This cloud, that does not *touch* the snow, but hovers over

* The green mountain at the base of the Aiguille du Gouté.
† Sybilla. See "Fors," Letter 90th, "Lost Jewels," p. 165.

it at a certain height following the convexity of the mountain, has always seemed most unaccountable to me.

224. Chamouni, day 14th, Tuesday, June 26th. Heavy, rounded, somewhat dirty clouds on the Pavillon (halfpast six); but summit bright and clear, and all very promising.

Get following books if possible—'Mémoires de la Société de Physique et d'Histoire Naturelle de Genève' (t. iv., p. 209), on the valley of Val Orsine, by M. Necker; 'Actes de la Société Helvétique des Sc. Nat.,' 1837, p. 28, 1839, p. 47, on Nagelflue pebbles.

Evening. After one of the most heavenly walks I ever took in Chamouni among the woods of the Pèlerins, I come in to hear of my poor cousin Mary's death. How well I recollect sitting with her on the slopes of the Breven, and reasoning about the height of La Cote: she knows it now, better than I, and thinks it less.

Chamouni, day 15th, Wednesday, June 27th. One of the heavenly Alpine mornings, all alight: I have been trying to get some of the effect of sunrise on the Montan-vert, and aerial quality of aiguilles,—in vain. Slanting rays now touch the turf by the châlet of Blaitière, as per-haps they touch poor Mary's grave."

Chapter XII

OTTERBURN

225. In blaming myself, as often I have done, and may have occasion to do again, for my want of affection to other people, I must also express continually, as I think back about it, more and more wonder that ever anybody had any affection for *me*. I thought they might as well have got fond of a camera lucida, or an ivory foot-rule: all my faculty was merely in showing that such and such things were so; I was no orator, no actor, no painter but in a minute and generally invisible manner; and I couldn't bear being interrupted in anything I was about.

Nevertheless, some sensible grown up people *did* get to like me!—the best of them with a protective feeling that I wanted guidance no less than sympathy; and the higher religious souls, hoping to lead me to the golden gates.

226. I have no memory, and no notion, when I first *saw* Pauline, Lady Trevelyan; but she became at once a monitress-friend in whom I wholly trusted,—(not that I ever took her advice!)—and the happiness of her own life was certainly increased by my books and me. Sir Walter, being a thorough botanist, and interested in pure science generally, did not hunt, but was benevolently useful, as a landlord should be, in his county. I had no interests in county business at that time; but used to have happy agricultural or floral chats with Sir Walter, and entirely admired his unambitious, yet dignified stability of rural, and celestial, life, there amidst the Northumbrian winds.

Wallington is in the old Percy country, the broad

descent of main valley leading down by Otterburn from
the Cheviots. An ugly house enough it was; square set,
and somewhat bare walled, looking down a slope of rough
wide field to a burn, the Wansbeck, neither bright nor
rapid, but with a ledge or two of sandstone to drip over,
or lean against in pools; bits of crag in the distance, worth
driving to, for sight of the sweeps of moor round them,
and breaths of breeze from Carter Fell.

There were no children of its own in Wallington, but
Lady Trevelyan's little niece, Constance Hilliard, nine
years old when I first saw her there, glittered about the
place in an extremely quaint and witty way; and took
to me a little, like her aunt. Afterwards her mother and
she, in their little rectory home at Cowley (near Hilling-
don), became important among my feminine friendships,
and gave me, of such petting and teasing as women are
good for, sometimes more than enough.

227. But the dearness of Wallington was founded, as
years went on, more deeply in its having made known to
me the best and truest friend of all my life; *best* for me,
because he was of my father's race, and native town;
truest, because he knew always how to help us both, and
never made any mistakes in doing so—Dr. John Brown.
He was staying at Wallington when I stopped there on
my way to give my Edinburgh lectures; and we walked
together, with little Connie, on the moors: it dawned
on me, so, gradually, what manner of man he was.

This, the reader capable of learning at all—(there are
few now who can understand a good Scotchman of the old
classic breed)—had better learn, straightway, from the
record he gave of his own father's life,* of which I must
give here this one passage of his childhood. His father
was a young pastor, crowned in perfectness of faithful
service, together with his "modest, calm, thrifty, reason-

* Letter to Rev. John Cairns. Edmonston & Douglas, 1861.

able, happy-hearted" wife, his student-love; this their son,
five years old,—just at the age when I looked back to
the creation of the world, for *me*, in Friar's Crag, of
Derwentwater; *my* mother, thrifty and reasonable also,
meantime taking care that not more than two plums
should be in my pie for dinner; my father, also thrifty
and reasonable, triumphing in his travel at Whitehaven,
a "wanderer," like the pedlar in the "Excursion," selling
sherry instead of bobbins;—all of us as happy as cicadas
(and a little more). Now hear Dr. John Brown:—

228. "On the morning of the 28th May, 1816, my
eldest sister Janet and I were sleeping in the kitchen-bed
with Tibbie Meek, our only servant. We were all three
awakened by a cry of pain—sharp, insufferable, as if one
were stung. Years after we two confided to each other,
sitting by the burnside, that we thought that 'great cry'
which arose at midnight in Egypt must have been like it.
We all knew whose voice it was, and, in our nightclothes,
we ran into the passage, and into the little parlour to the
left hand, in which was a closet-bed. We found my
father standing before us, erect, his hands clenched in his
black hair, his eyes full of misery and amazement, his face
white as that of the dead. He frightened us. He saw
this, or else his intense will had mastered his agony, for,
taking his hands from his head, he said, slowly and gently,
'Let us give thanks,' and turned to a little sofa * in the
room; there lay our mother, dead. She had long been
ailing. I remember her sitting in a shawl,—an Indian
one with little dark green spots on a light ground,—and
watching her growing pale with what I afterwards knew
must have been strong pain. She had, being feverish,
slipped out of bed, and 'grandmother,' her mother, seeing

* "This sofa, which was henceforward sacred in the house, he had
always beside him. He used to tell us he set her down upon it when
he brought her home to the manse."

her 'change come,' had called my father, and they two
saw her open her blue, kind, and true eyes, 'comfortable'
to us all 'as the day'—I remember them better than those
of any one I saw yesterday—and, with one faint look of
recognition to him, close them till the time of the restitu-
tion of all things."

He had a precious sister left to him; but his life, as
the noblest Scottish lives are always, was thenceforward
generously sad,—and endlessly pitiful.

229. No one has yet separated, in analyzing the mind
of Scott, the pity from the pride; no one, in the mind of
Carlyle, the pity from the anger.

Lest I should not be spared to write another
"Præterita," I will give, in this place, a few words of
Carlyle's, which throw more lovely light on his character
than any he has written,—as, indeed, his instantly vivid
words always did; and it is a bitter blame and shame to
me that I have not recorded those spoken to myself, often
with trust and affection, always with kindness. But I
find this piece, nearly word for word, in my diary of
25th October, 1874. He had been quoting the last words
of Goethe, "Open the window, let us have more light"
(this about an hour before painless death, his eyes failing
him).

I referred to the "It grows dark, boys, you may go,"
of the great master of the High School of Edinburgh.*
On which Carlyle instantly opened into beautiful account
of Adam's early life, his intense zeal and industry as a
poor boy in a Highland cottage, lying flat on the hearth
to learn his Latin grammar by the light of a peat fire.
Carlyle's own memory is only of Adam's funeral, when
he, Carlyle, was a boy of fourteen, making one of a crowd
waiting near the gate of the High School, of which part

* It was *his* Latin grammar, the best ever composed, which my
Camberwell tutor threw aside, as above told, for a "Scotch thing."

of the old black building of the time of James I. was still
standing—its motto, "Nisi Dominus, frustra," every-
where. A half-holiday had been given, that the boys
might see the coffin carried by,—only about five-and-
twenty people in all, Carlyle thought—"big-bellied per-
sons, sympathetic bailies, relieving each other in carrying
the pall." The boys collected in a group, as it passed
within the railings, uttered a low "Ah me! Ah dear!" or
the like, half sigh or wail—"and he is gone from us then!"

"The sound of the boys' wail is in my ears yet," said
Carlyle.

230. His own first teacher in Latin, an old clergyman.
He had indeed been sent first to a schoolmaster in his own
village, "the joyfullest little mortal, he believed, on earth,"
learning his declensions out of an eighteen-penny book!
giving his whole might and heart to understand. And
the master could teach him nothing, merely involved him
day by day in misery of non-understanding, the boy getting
crushed and sick, till (his mother?) saw it, and then he
was sent to this clergyman, "a perfect sage, on the humblest
scale." Seventy pounds a year, his income at first enter-
ing into life; never more than a hundred. Six daughters
and two sons; the eldest sister, Margaret, "a little bit
lassie,"—then in a lower voice, "the flower of all the
flock to *me*." Returning from her little visitations to
the poor, dressed in her sober prettiest, "the most amiable
of possible objects." Not beautiful in any notable way
afterwards, but "comely in the highest degree." With
dutiful sweetness, "the right hand of her father." Lived
to be seven-and-twenty. "The last time that I wept
aloud in the world, I think was at her death."

Riding down from Craigenputtock to Dumfries,—"a
monstrous precipice of rocks on one hand of you, a merry
brook on the other side. . . . In the night just before
sunrise."

He was riding down, he and his brother, to fetch away her body,—they having just heard of her death.

A surveyor (?), or some scientific and evidently superior kind of person, had been doing work which involved staying near, or in, her father's house, and they got engaged, and then he broke it off. "They said that was the beginning of it." The death had been so sudden, and so unexpected, that Mary's mother, then a girl of twelve or thirteen, rushed out of the house and up to the cart,* shrieking, rather than crying, "Where's Peggy?"

I could not make out, quite, how the two parts of the family were separated, so that his sister expected them to bring her back living, (or even well?). Carlyle was so much affected, and spoke so low, that I could not venture to press him on detail.

This master of his then, the father of Margaret, was entirely kind and wise in teaching him—a Scotch gentleman of old race and feeling, an Andrea Ferrara and some silver-mounted canes hanging in his study, last remnants of the old times.

231. We fell away upon Mill's essay on the substitution of patriotism for religion.

"Actually the most paltry rag of"—a chain of vituperative contempt too fast to note—"it has fallen to my lot to come in with. Among my acquaintance I have not seen a person talking of a thing he so little understood." The point of his indignation was Mill's supposing that, if God did not make everybody "happy," it was because He had no sufficient power, "was not enough supplied with the article." Nothing makes Carlyle more contemptuous than this coveting of "happiness."

Perhaps we had better hear what Polissena and the nun of Florence ("Christ's Folk," IV.) have to say about

* "Rushed at the cart," his words. Ending with his deep "Heigh dear," sigh. "Sunt lachrymæ rerum."

happiness, of *their* sort; and consider what every strong heart feels in the doing of any noble thing, and every good craftsman in making any beautiful one, before we despise any innocent person who looks for happiness in this world, as well as hereafter. But assuredly the strength of Scottish character has always been perfected by suffering; and the types of it given by Scott in Flora MacIvor, Edith Bellenden, Mary of Avenel, and Jeanie Deans,—to name only those which the reader will remember without effort,— are chiefly notable in the way they bear sorrow; as the whole tone of Scottish temper, ballad poetry, and music, which no other school has ever been able to imitate, has arisen out of the sad associations which, one by one, have gathered round every loveliest scene in the border land. Nor is there anything among other beautiful nations to approach the dignity of a true Scotswoman's face, in the tried perfectness of her old age.

232. I have seen them beautiful in the same way earlier, when they had passed through trial; my own Joanie's face owes the calm of its radiance to days of no ordinary sorrow—even before she came, when my father had been laid to his rest under Croydon hills, to keep her faithful watch by my mother's side, while I was seeking selfish happiness far away in work which to-day has come to nought. What I have myself since owed to her,— life certainly, and more than life, for many and many a year,—was meant to have been told long since, had I been able to finish this book in the time I designed it. What Dr. John Brown became to me, is partly shown in the continual references to his sympathy in the letters of "Hortus Inclusus"; but nothing could tell the loss to me in his death, nor the grief to how many greater souls than mine, that had been possessed in patience through his love.

I must give one piece more of his own letter, with the following fragment, written in the earlier part of this year,

and meant to have been carried on into some detail of the impressions received in my father's native Edinburgh, and on the northern coast, from Queen's Ferry round by Prestonpans to Dunbar and Berwick.

Dr. Brown goes on:—"A year ago, I found an elderly countrywoman, a widow, waiting for me. Rising up, she said, 'D' ye mind me?' I looked at her, but could get nothing from her face; but the voice remained in my ear, as if coming from the 'fields of sleep,' and I said by a sort of instinct, 'Tibbie Meek!' I had not seen her or heard her voice for more than forty years."

233. The reader will please note the pure Scotch phrase "D' ye mind me?" and compare Meg Merrilies' use of it. "At length she guided them through the mazes of the wood to a little open glade of about a quarter of an acre, surrounded by trees and bushes, which made a wild and irregular * boundary. Even in winter, it was a sheltered and snugly sequestered spot; but when arrayed in the verdure of spring, the earth sending forth all its wild flowers; the shrubs spreading their waste of blossom around it, and the weeping birches, which towered over the underwood, drooping their long and leafy fibres to intercept the sun, it must have seemed a place for a youthful poet to study his earliest sonnet, or a pair of lovers to exchange their first mutual avowal of affection. Apparently it now awakened very different recollections. Bertram's brow, when he had looked round the spot, became gloomy and embarrassed. Meg, after muttering to herself, 'This is the very spot,' looked at him with a ghastly side glance,—'D'ye mind it?'

" 'Yes,' answered Bertram, 'imperfectly I do.'

* It might have been "irregular," in ground just cut up for building leases, in South Lambeth; wild, yet as regular as a disciplined army, had it been the pines of Uri. It *was* a "waste of blossom," a shade of weeping birches.

" 'Ay,' pursued his guide, 'on this very spot the man fell from his horse—I was behind that bourtree *-bush at the very moment. Now will I show you the further track—*the last time ye travelled it, was in these arms.*' "

That was twenty years before, for Bertram's nurse; (compare Waverley's and Morton's;) Dr. Brown's Tibbie; my own father's Mause; my Anne; all women of the same stamp; my Saxon mother not altogether comprehending them; but when Dr. John Brown first saw my account of my mother and Anne in "Fors," *he* understood both of them, and wrote back to me of "those two blessed women," as he would have spoken of their angels, had he then been beside them, looking on another Face.

234. But my reason for quoting this piece of "Guy Mannering" here is to explain to the reader who cares to know it, the difference between the Scotch "mind" for "remember," and any other phrase of any other tongue, applied to the act of memory.

In order that you may, in the Scottish sense, "mind" anything, first there must be something to "mind"—and then, the "mind" to mind it. In a thousand miles of iron railway, or railway train, there is nothing in one rod or bar to distinguish it from another. You can't "mind" which sleeper is which. Nor, on the other hand, if you drive from Chillon to Vevay, asleep, can you "mind" the characteristics of the lake of Geneva. Meg could not have expected Bertram to "mind" at what corner of a street in Manchester—or in what ditch of the Isle of Dogs—anything had past directly bearing on his own fate. She expected him to "mind" only a beautiful scene, of perfect individual character, and she would not have expected him to "mind" even that, had she not known he

* Elder, in modern Scotch; but in the Douglas glossary, *Bower* bush.

had persevering sense and memorial powers of very high order.

Now it is the peculiar character of Scottish as distinct from all other scenery on a small scale in north Europe, to have these distinctively "mindable" features. One range of coteau by a French river is exactly like another; one turn of glen in the Black Forest is only the last turn re-turned; one sweep of Jura pasture and crag, the mere echo of the fields and crags of ten miles away. But in the whole course of Tweed, Teviot, Gala, Tay, Forth, and Clyde, there is perhaps scarcely a bend of ravine, or nook of valley, which would not be recognisable by its inhabitants from every other. And there is no other country in which the roots of memory are so entwined with the beauty of nature, instead of the pride of men; no other in which the song of "Auld lang syne" could have been written,—or Lady Nairn's ballad of "The Auld House."

* * * * *

235. I did not in last "Præterita" enough explain the reason for my seeking homes on the crests of Alps, in my own special study of cloud and sky; but I have only known too late, within this last month, the absolutely literal truth of Turner's saying that the most beautiful skies in the world known to him were those of the Isle of Thanet.

In a former number of "Præterita" I have told how my mother kept me quiet in a boy's illness by telling me to think of Dash, and Dover; and among the early drawings left for gift to Joanie are all those made—the first ever made from nature—at Sevenoaks, Tunbridge, Canterbury, and Dover. One of the poorest-nothings of these, a mere scrawl in pen and ink, of cumulus cloud crossed by delicate horizontal bars on the horizon, is the first attempt I ever made to draw a sky,—fifty-five years ago. That same

sky I saw again over the same sea horizon at sunset only five weeks ago. And three or four days of sunshine following, I saw, to my amazement, that the skies of Turner were still bright above the foulness of smoke-cloud or the flight of plague-cloud; and that the forms which, in the pure air of Kent and Picardy, the upper cirri were capable of assuming, undisturbed by tornado, un-mingled with volcanic exhalation, and lifted out of the white crests of ever-renewed tidal waves, were infinite, lovely and marvellous beyond any that I had ever seen from moor or alp; while yet on the horizon, if left for as much as an hour undefiled by fuel of fire, there was the azure air I had known of old, alike in the lowland distance and on the Highland hills. What might the coasts of France and England have been now, if from the days of Bertha in Canterbury, and of Godefroy in Boulogne, the Christian faith had been held by both nations in peace, in this pure air of heaven? What might the hills of Cheviot and the vale of Tweed have been now, if from the days of Cuthbert in Holy Isle, and of Edwin in Edinburgh, the Crosses of St. George and St. Andrew had been borne by brethren; and the fiery Percy and true Douglas laid down their lives only for their people?

FOLKESTONE, 11*th October*, 1887.

END OF VOL. II

VOLUME III

THE GRANDE CHARTREUSE

MONT BLANC REVISITED.
(*Written at Nyon in* 1845.)

O Mount beloved, mine eyes again
Behold the twilight's sanguine stain
 Along thy peaks expire.
O Mount beloved, thy frontier waste
I seek with a religious haste
 And reverent desire.

They meet me, 'midst thy shadows cold,—
Such thoughts as holy men of old
 Amid the desert found;—
Such gladness, as in Him they felt
Who with them through the darkness dwelt,
 And compassed all around.

Ah, happy, if His will were so,
To give me manna here for snow,
 And by the torrent side
To lead me as He leads His flocks
Of wild deer through the lonely rocks
 In peace, unterrified;

Since, from the things that trustful rest,
The partridge on her purple nest,
 The marmot in his den,
God wins a worship more resigned,
A purer praise than He can find
 Upon the lips of men.

Alas for man! who hath no sense
Of gratefulness nor confidence,
 But still regrets and raves,
Till all God's love can scarcely win
One soul from taking pride in sin,
 And pleasure over graves.

> Yet teach me, God, a milder thought,
> Lest I, of all Thy blood has bought,
> Least honourable be;
> And this, that leads me to condemn,
> Be rather want of love for them
> Than jealousy for Thee.

1. THESE verses, above noticed (vol. ii. § 109), with one following sonnet, as the last rhymes I attempted in any seriousness, were nevertheless themselves extremely earnest, and express, with more boldness and simplicity than I feel able to use now with my readers, the real temper in which I began the best work of my life. My mother at once found fault with the words "sanguine stain," as painful, and untrue of the rose-colour on snow at sunset; but they had their meaning to myself,—the too common Evangelical phrase, "washed in the blood of Christ," being, it seemed to me, if true at all, true of the earth and her purest snow, as well as of her purest creatures; and the claim of being able to find among the rock-shadows thoughts such as hermits of old found in the desert, whether it seem immodest or not, was wholly true. Whatever might be my common faults or weaknesses, they were rebuked among the hills; and the only days I can look back to as, according to the powers given me, rightly or wisely in entireness spent, have been in sight of Mont Blanc, Monte Rosa, or the Jungfrau.

When I was most strongly under this influence, I tried to trace,—and I think have traced rightly, so far as I was then able,—in the last chapter of "Modern Painters," the power of mountains in solemnizing the thoughts and purifying the hearts of the greatest nations of antiquity and the greatest teachers of Christian faith. But I did not then dwell on what I had only felt, but not ascertained, —the destruction of all sensibility of this high order in the populations of modern Europe, first by the fine luxury of

the fifteenth century, and then by the coarse lusts of the eighteenth and early nineteenth: destruction so total that religious men themselves became incapable of education by any natural beauty or nobleness; and though still useful to others by their ministrations and charities, in the corruption of cities, were themselves lost,—or even degraded, if they ever went up into the mountain to preach, or into the wilderness to pray.

2. There is no word, in the fragment of diary recording, in last "Præterita," * our brief visit to the Grande Chartreuse, of anything we saw or heard there that made impression upon any of us. Yet a word was said, of significance enough to alter the courses of religious thought in me, afterwards for ever.

I had been totally disappointed with the Monastery itself, with the pass of approach to it, with the mountains round it, and with the monk who showed us through it. The building was meanly designed and confusedly grouped; the road up to it nothing like so terrific as most roads in the Alps up to anywhere; the mountains round were simplest commonplace of Savoy cliff, with no peaks, no glaciers, no cascades, nor even any slopes of pine in extent of majesty. And the monk who showed us through the corridors had no cowl worth the wearing, no beard worth the wagging, no expression but of superciliousness without sagacity, and an ungraciously dull manner, showing that he was much tired of the place, more of himself, and altogether of my father and me.

Having followed him for a time about the passages of the scattered building, in which there was nothing to show,—not a picture, not a statue, not a bit of old glass, or well-wrought vestment or jewellery; nor any architectural feature in the least ingenious or lovely, we came to a pause at last in what I suppose was a type of a modern

* This should be "last but one." See vol. ii. § 209.—ED.

Carthusian's cell, wherein, leaning on the window sill, I said something in the style of "Modern Painters," about the effect of the scene outside upon religious minds. Whereupon, with a curl of his lip, "We do not come here," said the monk, "to look at the mountains." Under which rebuke I bent my head silently, thinking however all the same, "What then, by all that's stupid, do you come here for at all?"

3. Which, from that hour to this, I have not conceived; nor, after giving my best attention to the last elaborate account of Carthusian faith, "La Grande Chartreuse, par un Chartreux, Grenoble, 5, Rue Brocherie, 1884," am I the least wiser. I am informed by that author that his fraternity are *Eremite* beyond all other manner of men,—that they delight in solitude, and in that amiable disposition pass lives of an angelic tenor, meditating on the charms of the next world, and the vanities of this one.

I sympathize with them in their love of quiet—to the uttermost; but do not hold that liking to be the least pious or amiable in myself, nor understand why it seems so to them; or why their founder, St. Bruno,—a man of the brightest faculties in teaching, and exhorting, and directing; also, by favour of fortune, made a teacher and governor in the exact centre of European thought and order, the royal city of Rheims,—should think it right to leave all that charge, throw down his rod of rule, his crozier of protection, and come away to enjoy meditation on the next world by himself.

And why meditation among the Alps? He and his disciples might as easily have avoided the rest of mankind by shutting themselves into a penitentiary on a plain, or in whatever kind country they chanced to be born in, without danger to themselves of being buried by avalanches, or trouble to their venerating visitors in coming so far up hill.

Least of all I understand how they could pass their days of meditation without getting interested in plants and stones, whether they would or no; nor how they could go on writing books in scarlet and gold,—(for they were great scribes, and had a beautiful library,)—persisting for centuries in the same patterns, and never trying to draw a bird or a leaf rightly—until the days when books were illuminated no more for religion, but for luxury, and the amusement of sickly fancy.

4. Without endeavouring to explain any of these matters, I will try to set down in this chapter, merely what I have found monks or nuns like, when by chance I was thrown into their company, and of what use they have been to me.

And first let me thank my dear Miss Edgeworth for the ideal character of Sister Frances, in her story of Madame de Fleury, which, read over and over again through all my childhood, fixed in me the knowledge of what a good sister of charity can be, and for the most part is, in France; and, of late, I suppose in Germany and England.

But the first impression from the life of the secluded Sisterhoods* was given me at the Convent of St. Michael, on the summit of the isolated peak of lava at Le Puy, in Auvergne, in 1840. The hostess-sister who showed my father and me what it was permitted to see of chapel or interior buildings, was a cheerful, simple creature, pleased with us at once for our courtesy to her, and admiration of her mountain home, and belief in her sacred life. Protestant visitors being then rare in Auvergne, and still more, reverent and gentle ones, she gave her pretty curiosity

* Of the Brotherhoods, of course the first I knew were those of St. Bernard; but these were not secluded for their own spiritual welfare, any more than our coastguardsmen by the Goodwin sands; and are to be spoken of elsewhere, and in quite other relations to the modern world.

free sway; and enquired earnestly of us, what sort of creatures we were,—how far we believed in God, or tried to be good, or hoped to go to heaven? And our responses under this catechism being in their sum more pleasing to her than she had expected, and manifesting, to her extreme joy and wonder, a Christian spirit, so far as she could judge, in harmony with all she had been herself taught, she proceeded to cross-examine us on closer points of Divinity, to find out, if she could, why we were, or unnecessarily called ourselves, anything else than Catholic? The one flaw in our faith which at last her charity fastened on, was that we were not *sure* of our salvation in Christ, but only hoped to get into heaven,— and were not at all, by that dim hope, relieved from terror of death, when at any time it should come. Whereupon she launched involuntarily into an eager and beautiful little sermon, to every word of which her own perfectly happy and innocent face gave vivid power, and assurance of sincerity,—how "we needed to be *sure* of our safety in Christ, and that every one might be so who came to Him and prayed to Him; and that all good Catholics were as sure of heaven as if they were already there;" and so dismissed us at the gate with true pity, and beseeching that we would prove the goodness of God, and be in peace. Which exhortation of hers I have never forgotten; only it has always seemed to me that there was no entering into that rest of hers but by living on the top of some St. Michael's rock too, which it did not seem to me I was meant to do, by any means.

But in here recording the impression made on my father and me, I must refer to what I said above of our common feeling of being, both of us, as compared with my mother, reprobate and worldly characters, despising our birthright like Esau, or cast out, for our mocking ways, like Ishmael. For my father never ventured to give me

a religious lesson; and though he went to church with a
resigned countenance, I knew very well that he liked going
just as little as I did.

5. The second and fourth summers after that, 1842
and 1844, were spent happily and quietly in the Prieuré *
of Chamouni, and there of course we all of us became
acquainted with the curé, and saw the entire manner of
life in a purely Catholic village and valley,—recognising
it, I hope, all of us, in our hearts, to be quite as Christian
as anything we knew of, and much pleasanter and prettier
than the Sunday services, in England, which exhaust the
little faith we have left.

Wordsworth, in his continental notices of peasant
Catholicism, recognises, also at Chamouni, very grace-
fully this external prettiness—

> "They too, who send so far a holy gleam,
> As they the Church engird with motion slow,
> A product of that awful mountain seem
> Poured from its vaults of everlasting snow.
> Not virgin lilies marshalled in bright row,
> Not swans descending with the stealthy tide,
> A livelier sisterly resemblance show
> Than the fair forms that in long order glide
> Bear to the glacier band, those shapes aloft descried."

But on me, the deeper impression was of a continuous
and serene hold of their happy faith on the life alike of
Sunday and Monday, and through every hour and circum-
stance of youth and age; which yet abides in all the moun-
tain Catholic districts of Savoy, the Waldstetten, and the
Tyrol, to their perpetual honour and peace; and this
without controversy, or malice towards the holders of other
beliefs.

6. Next, in 1845, I saw in Florence, as above told,

* Not in the Priory itself, but the Hotel de l'Union. The whole
village is called "The Priory."

the interior economy of the monasteries at Santa Maria
Novella,—in the Franciscan cloisters of Fésole, and in
Fra Angelico's, both at San Domenico and San Marco.
Which, in whatever they retained of their old thoughts
and ways, were wholly beautiful; and the monks with
whom I had any casual intercourse, always kind, inno-
cently eager in sympathy with my own work, and totally
above men of the "world" in general understanding,
courtesy, and moral sense.

Men of the *outer* world, I mean, of course,—official
and commercial. Afterwards at Venice I had a very
dear and not at all monastic, friend, Rawdon Brown; but
his society were the Venetians of the fifteenth century.
The Counts Minischalchi at Verona, and Borromeo at
Milan, would have been endlessly kind and helpful to me;
but I never could learn Italian enough to speak to them.
Whereas, with my monkish friends, at the Armenian isle
of Venice, and in any churches or cloisters through North
Italy, where I wanted a niche to be quiet in, and chiefly at
last in Assisi, I got on with any broken French or Italian
I could stutter, without minding; and was always happy.

7. But the more I loved or envied the monks, and the
more I despised the modern commercial and fashionable
barbaric tribes, the more acutely also I felt that the
Catholic political hierarchies, and isolated remnants of
celestial enthusiasm, were hopelessly at fault in their
dealing with these adversaries; having also elements of
corruption in themselves, which justly brought on them
the fierce hostility of men like Garibaldi in Italy, and of
the honest and open-hearted liberal leaders in other
countries. Thus, irrespectively of all immediate contest
or progress, I saw in the steady course of the historical
reading by which I prepared myself to write the Stones
of Venice, that, alike in the world and the Church, the
hearts of men were led astray by the same dreams and

desires; and whether in seeking for Divine perfection, or earthly pleasure, were alike disobeying the laws of God when they withdrew from their direct and familiar duties, and ceased, whether in ascetic or self-indulgent lives, to honour and love their neighbour as themselves.

While these convictions prevented me from being ever led into acceptance of Catholic teaching by my reverence for the Catholic art of the great ages,—and the less, because the Catholic art of these small ages can say but little for itself,—I grew also daily more sure that the peace of God rested on all the dutiful and kindly hearts of the laborious poor; and that the only constant form of pure religion was in useful work, faithful love, and stintless charity.

8. In which pure religion neither St. Bruno himself nor any of his true disciples failed: and I perceive it finally notable of them, that, poor by resolute choice of a life of hardship, without any sentimental or fallacious glorifying of "Holy poverty" as if God had never promised full garners for a blessing; and always choosing men of high intellectual power for the heads of their community, they have had more directly wholesome influence on the outer world that any other order of monks so narrow in number, and restricted in habitation. For while the Franciscan and Cistercian monks became everywhere a constant element in European society, the Carthusians, in their active sincerity, remained, in groups of not more than from twelve to twenty monks in any single monastery, the tenants of a few wild valleys of the north-western Alps; the subsequent overflowing of their brotherhood into the Certosas of the Lombard plains being mere waste and wreck of them; and the great Certosa of Pavia one of the worst shames of Italy, associated with the accursed reign of Galeazzo Visconti. But in their strength, from the foundation of the order, at the close of the eleventh

century, to the beginning of the fourteenth, they reared
in their mountain fastnesses, and sent out to minister to
the world, a succession of men of immense mental grasp,
and serenely authoritative innocence; among whom our
own Hugo of Lincoln, in his relations with Henry II.
and Cœur de Lion, is to my mind the most beautiful
sacerdotal figure known to me in history. The great
Pontiffs have a power which in its strength can scarcely be
used without cruelty, nor in its scope without error; the
great Saints are always in some degree incredible or
unintelligible; but Hugo's power is in his own personal
courage and justice only; and his sanctity as clear, frank,
and playful as the waves of his own Chartreuse well.*

9. I must not let myself be led aside from my own
memories into any attempt to trace the effect on Turner's
mind of his visit to the Chartreuse, rendered as it is in the
three subjects of the Liber Studiorum,—from the Char-
treuse itself, from Holy Island, and Dumblane Abbey.
The strength of it was checked by his love and awe of the
sea, and sailor heroism, and confused by his classical
thought and passion; but in my own life, the fading away
of the nobler feelings in which I had worked in the Campo
Santo of Pisa, however much my own fault, was yet
complicated with the inevitable discovery of the falseness
of the religious doctrines in which I had been educated.

10. The events of the ten years 1850—1860, for the
most part wasted in useless work, must be arranged first in
their main order, before I can give clear account of any
thing that happened in them. But this breaking down of
my Puritan faith, being the matter probably most important
to many readers of my later books, shall be traced in this
chapter to the sorrowful end. Note first the main facts
of the successive years of the decade.

* The original building was grouped round a spring in the rock,
from which a runlet was directed through every cell.

1851. Turner dies, while I am at first main work in Venice, for "The Stones of Venice."

1852. Final work in Venice for "Stones of Venice." Book finished that winter. Six hundred quarto pages of notes for it, fairly and closely written, now useless. Drawings as many—of a sort; useless too.

1853. Henry Acland in Glenfinlas with me. Drawing of gneiss rock made; now in the school at Oxford. Two months' work in what fair weather could be gleaned out of that time.

1854. With my father and mother at Vevay and Thun. I take up the history of Switzerland, and propose to engrave a series of drawings of the following Swiss towns: Geneva, Fribourg, Basle, Thun, Baden, and Schaffhausen. I proceed to make drawings for this work, of which the first attempted (of Thun) takes up the whole of the summer, and is only half done then. Definition of Poetry, for "Modern Painters," written at Vevay, looking across lake to Chillon. It leaves out rhythm, which I now consider a defect in said definition; otherwise good,—"The arrangement, by imagination, of noble motive for noble emotion." I forget the exact words, but these others will do as well, perhaps better.

11. 1855. Notes on Royal Academy begun. The spring is so cold that the hawthorns are only in bud on the 5th of June. I get cough, which lasts for two months, till I go down to Tunbridge Wells to my doctor cousin, William Richardson, who puts me to bed, gives me some syrup, cures me in three days, and calls me a fool for not coming to him before, with some rather angry warnings that I had better not keep a cough for two months again. Third volume of "Modern Painters" got done with, somehow, but didn't know what to call it, so called it "Of Many Things." But none of *these* were "done with," as I found afterwards, to my cost.

1856. With my father and mother to Geneva and Fribourg. Two drawings at Fribourg took up the working summer. My father begins to tire of the proposed work on Swiss towns, and to inquire whether the rest of "Modern Painters" will ever be done.

1857. My mother wants me to see the Bay of Cromarty and the Falls of Kilmorock. I consent sulkily to be taken to Scotland with that object. Papa and mamma, wistfully watching the effect on my mind, show their Scotland to me. I see, on my own quest, Craig-Ellachie, and the Lachin-y-Gair forests, and finally reach the Bay of Cromarty and Falls of Kilmorock, doubtless now the extreme point of my northern discoveries on the round earth. I admit, generously, the Bay of Cromarty and the Falls to be worth coming all that way to see; but beg papa and mamma to observe that it is twenty miles' walk, in bogs, to the top of Ben Wyvis, that the town of Dingwall is not like Milan or Venice,—and that I think we have seen enough of Scotland.

12. 1858. Accordingly, after arranging, mounting, framing, and cabinetting, with good help from Richard Williams of Messrs. Foord's, the Turner drawings now in the catacombs of the National Gallery, I determine to add two more Swiss towns to my list, namely, Rheinfelden and Bellinzona, in illustration of Turner's sketches at those places; and get reluctant leave from my father to take Couttet again, and have all my own way. I spend the spring at Rheinfelden, and the summer at Bellinzona. But Couttet being of opinion that these town views will come to no good, and that the time I spend on the roof of "cette baraque" at Bellinzona is wholly wasted, I give the town views all up, and take to Vandyke and Paul Veronese again in the gallery of Turin. But, on returning home, my father is not satisfied with my studies from those masters, and piteously asks for the end of "Modern

Painters," saying "he will be dead before it is done."
Much ashamed of myself, I promise him to do my best
on it without farther subterfuge.

1859. Hard writing and drawing to that end. Fourth
volume got done. My father thinks, himself, I ought
to see Berlin, Dresden, Munich, and Nuremberg, before
the book is finished. He and my mother take their last
continental journey with me to those places. I have my
last happy walk with my father at Konigstein.

1860. I work hard all the winter and early spring—
finish the book, in a sort; my father well pleased with the
last chapter, and the engraved drawings from Nuremberg
and Rheinfelden. On the strength of this piece of filial
duty, I am cruel enough to go away to St. Martin's again,
by myself, to meditate on what is to be done next.
Thence I go up to Chamouni,—where a new epoch of
life and death begins.

13. And here I must trace, as simply and rapidly as may
be, the story of my relations with the Working Men's
College.

I knew of its masters only the Principal, F. D. Maurice,
and my own friend Rossetti. It is to be remembered of
Rossetti with loving honour, that he was the only one of
our modern painters who taught disciples for love of them.
He was really not an Englishman, but a great Italian
tormented in the Inferno of London; doing the best he
could, and teaching the best he could; but the "could"
shortened by the strength of his animal passions, without
any trained control, or guiding faith. Of him, more
hereafter.

I loved Frederick Maurice, as every one did who came
near him; and have no doubt he did all that was in him to
do of good in his day. Which could by no means be said
either of Rossetti or of me: but Maurice was by nature
puzzle-headed, and, though in a beautiful manner, *wrong-*

headed; while his clear conscience and keen affections made him egotistic, and in his Bible-reading, as insolent as any infidel of them all. I only went once to a Bible-lesson of his; and the meeting was significant, and conclusive.

14. The subject of lesson, Jael's slaying of Sisera. Concerning which, Maurice taking an enlightened modern view of what was fit and not, discoursed in passionate indignation; and warned his class, in the most positive and solemn manner, that such dreadful deeds could only have been done in cold blood in the Dark Biblical ages; and that no religious and patriotic English-woman ought ever to think of imitating Jael by nailing a Russian's or Prussian's skull to the ground,—especially after giving him butter in a lordly dish. At the close of the instruction, through which I sate silent, I ventured to enquire, why then had Deborah the prophetess declared of Jael, "Blessed above women shall the wife of Heber the Kenite be"? On which Maurice, with startled and flashing eyes, burst into partly scornful, partly alarmed, denunciation of Deborah the prophetess, as a mere blazing Amazon; and of her Song as a merely rhythmic storm of battle-rage, no more to be listened to with edification or faith than the Norman's sword-song at the battle of Hastings.

Whereupon there remained nothing for *me*,—to whom the Song of Deborah was as sacred as the Magnificat,— but total collapse in sorrow and astonishment; the eyes of all the class being also bent on me in amazed repro-bation of my benighted views, and unchristian sentiments. And I got away how I could, and never went back.

That being the first time in my life that I had fairly met the lifted head of Earnest and Religious Infidelity— in a man neither vain nor ambitious, but instinctively and innocently trusting his own amiable feelings as the

final interpreters of all the possible feelings of men and angels, all the songs of the prophets, and all the ways of God.

15. It followed, of course, logically and necessarily, that every one of Maurice's disciples also took what views *he* chose of the songs of the prophets,—or wrote songs of his own, more adapted to the principles of the College, and the ethics of London. Maurice, in all his addresses to us, dwelt mainly on the simple function of a college as a collection or collation of friendly persons,—not in the least as a place in which such and such things were to be taught, and others denied; such and such conduct vowed, and other such and such abjured. So the College went on,—collecting, carpentering, sketching, Bible criticising, etc., virtually with no head; but only a clasp to the strap of its waist, and as many heads as it had students. The leaven of its affectionate temper has gone far; but how far also the leaven of its pride, and defiance of everything above it, nobody quite knows. I took two special pupils out of its ranks to carry them forward all I could. One I chose; the other chose me—or rather, chose my mother's maid Hannah; for love of whom he came to the College, learned drawing there under Rossetti and me,—and became eventually, Mr. George Allen of Sunnyside; who, I hope, still looks back to his having been an entirely honest and perfect working joiner as the foundation of his prosperity in life. The other student I chose myself, a carpenter of equal skill and great fineness of faculty; but his pride, wilfulness, and certain angular narrownesses of nature, kept him down,—together with the deadly influence of London itself, and of working men's clubs, as well as colleges. And finally, in this case, and many more, I have very clearly ascertained that the only proper school for workmen is of the work their fathers bred them to, under masters able to do better than any of their men,

and with common principles of honesty and the fear of
God, to guide the firm.

16. Somewhat before the date of my farewell to
Maurician free-thinking, I had come into still more
definite collision with the Puritan dogmata which forbid
thinking at all, in a séance to which I was invited, shyly,
by my friend Macdonald,—fashionable séance of Evan-
gelical doctrine, at the Earl of Ducie's; presided over by
Mr. Molyneux, then a divine of celebrity in that sect;
who sate with one leg over his other knee in the attitude
always given to Herod at the massacre of the Innocents
in mediæval sculpture; and discoursed in tones of consum-
mate assurance and satisfaction, and to the entire comfort
and consent of his Belgravian audience, on the beautiful
parable of the Prodigal Son. Which, or how many, of
his hearers he meant to describe as having personally lived
on husks, and devoured their fathers' property, did not of
course appear; but that something of the sort was necessary
to the completeness of the joy in heaven over them, now
in Belgrave Square, at the feet—or one foot—of Mr.
Molyneux, could not be questioned.

Waiting my time, till the raptures of the converted
company had begun to flag a little, I ventured, from a back
seat to enquire of Mr. Molyneux what we were to learn
from the example of the *other* son, not prodigal, who was,
his father said of him, "ever with me, and all that I have,
thine"? A sudden horror, and unanimous feeling of the
serpent having, somehow, got over the wall into their
Garden of Eden, fell on the whole company; and some of
them, I thought, looked at the candles, as if they expected
them to burn blue. After a pause of a minute, gathering
himself into an expression of pity and indulgence, with-
holding latent thunder, Mr. Molyneux explained to me
that the home-staying son was merely a picturesque figure
introduced to fill the background of the parable agreeably,

and contained no instruction or example for the well-disposed scriptural student, but, on the contrary, rather a snare for the unwary, and a temptation to self-righteousness,—which was, of all sins, the most offensive to God.

Under the fulmination of which answer I retired, as from Maurice's, from the séance in silence; nor ever attended another of the kind from that day to this.

17. But neither the Puritanism of Belgravia, nor Liberalism of Red Lion Square, interested, or offended, me, otherwise than as the grotesque conditions of variously typhoid or smoke-dried London life. To my old Scotch shepherd Puritanism, and the correspondent forms of noble French Protestantism, I never for an instant failed in dutiful affection and honour. From John Bunyan and Isaac Ambrose, I had received the religion by which I still myself lived, as far as I had spiritual life at all; and I had again and again proof enough of its truth, within limits, to have served me for all my own need, either in this world or the next. But my ordained business, and mental gifts, were outside of those limits. I saw, as clearly as I saw the sky and its stars, that music in Scotland was not to be studied under a Free Church precentor; nor indeed under any disciples of John Knox, but of Signior David; that, similarly, painting in England was not to be admired in the illuminations of Watts' hymns; nor architecture in the design of Mr. Irons' chapel in the Grove. And here I must take up a thread of my mental history, as yet unfastened.

18. I have spoken several times of the effect given cheaply to my drawings of architecture by dexterous dots and flourishes, doing duty for ornament. Already, in 1845, I had begun to distinguish Corinthian from Norman capitals, and in 1848, drew the niches and sculpture of French Gothic with precision and patience. But I had never cared for ornamental design until in 1850 or '51

I chanced, at a bookseller's in a back alley, on a little
fourteenth century Hours of the Virgin, not of refined
work, but extremely rich, grotesque, and full of pure
colour.

The new worlds which every leaf of this book opened
to me, and the joy I had, counting their letters and un-
ravelling their arabesques as if they had all been of beaten
gold,—as many of them indeed were,—cannot be told,
any more than—everything else, of good, that I wanted
to tell. Not that the worlds thus opening were themselves
new, but only the possession of any part in them; for
long and long ago I had gazed at the illuminated missals
in noblemen's houses (see above, p. 8), with a wonder
and sympathy deeper than I can give now; my love of
toil, and of treasure, alike getting their thirst gratified in
them. For again and again I must repeat it, my nature
is a worker's and a miser's; and I rejoiced, and rejoice
still, in the mere quantity of chiselling in marble, and
stitches in embroidery; and was never tired of number-
ing sacks of gold and caskets of jewels in the Arabian
Nights: and though I am generous too, and love giving,
yet my notion of charity is not at all dividing my last
crust with a beggar, but riding through a town like a
Commander of the Faithful, having any quantity of
sequins and ducats in saddle-bags (where cavalry officers
have holsters for their pistols), and throwing them round
in radiant showers and hailing handfuls; with more bags
to brace on when those were empty.

19. But now that I had a missal of my own, and could
touch its leaves and turn, and even here and there under-
stand the Latin of it, no girl of seven years old with a new
doll is prouder or happier: but the feeling was something
between the girl's with her doll, and Aladdin's in a new
Spirit-slave to build palaces for him with jewel windows. ∴
For truly a well-illuminated missal is a fairy cathedral full

of painted windows, bound together to carry in one's
pocket, with the music and the blessing of all its prayers
besides.

And then followed, of course, the discovery that all
beautiful prayers were Catholic,—all wise interpretations
of the Bible Catholic;—and every manner of Protestant
written services whatsoever either insolently altered
corruptions, or washed-out and ground-down rags and
débris of the great Catholic collects, litanies, and songs of
praise.

"But why did not you become a Catholic at once,
then?"

It might as well be asked, Why did not I become a
fire-worshipper? I *could* become nothing but what I was
or was growing into. I no more believed in the living
Pope than I did in the living Khan of Tartary. I saw
indeed that twelfth century psalters were lovely and right,
and that presbyterian prayers against time, by people who
never expected to be any the better for them, were unlovely
and wrong. But I had never read the Koran, nor
Confucius, nor Plato, nor Hesiod, and was only just
beginning to understand my Virgil and Horace. How
I ever came to understand *them* is a new story, which
must be for next chapter: meantime let me finish the
confessions of this one in the tale of my final apostacy
from Puritan doctrine.

20. The most stern practical precept of that doctrine
still holding me,—it is curiously inbound with all the rest,
—was the Sabbath keeping; the idea that one was not to
seek one's own pleasure on Sunday, nor to do anything
useful. Gradually, in honest Bible reading, I saw that
Christ's first article of teaching was to unbind the yoke of
the Sabbath, while, *as* a Jew, He yet obeyed the Mosaic
law concerning it; but that St. Paul had carefully abolished
it altogether, and that the rejoicing, in memory of the

Resurrection, on the Day of the Sun, the first of the week, was only by misunderstanding, and much wilful obstinacy, confused with the Sabbath of the Jew.

Nevertheless, the great passages in the Old Testament regarding its observance held their power over me, nor have ceased to do so; but the inveterate habit of being unhappy all Sunday did not in any way fulfil the order to call the Sabbath a delight.

I have registered the year 1858 as the next, after 1845, in which I had complete guidance of myself. Couttet met me at Basle, and I went on to Rheinfelden with great joy, and stayed to draw town and bridges completely (two of the studies are engraved in "Modern Painters").

21. I think it was the second Sunday there, and no English church. I had read the service with George, and gone out afterwards alone for a walk up a lovely dingle on the Black Forest side of the Rhine, where every pretty cottage was inscribed, in fair old German characters, with the date of its building, the names of the married pair who had built it, and a prayer that, with God's blessing, their habitation of it, and its possession by their children, might be in righteousness and peace. Not in these set terms, of course, on every house, but in variously quaint verses or mottoes, meaning always as much as this.

Very happy in my Sunday walk, I gathered what wild flowers were in their first springing, and came home with a many-coloured cluster, in which the dark-purple orchis was chief. I had never examined its structure before, and by this afternoon sunlight did so with care; also it seemed to me wholly right to describe it as I examined; and to draw the outlines as I described, though with a dimly alarmed consciousness of its being a new fact in existence for me, that I should draw on Sunday.

22. Which thenceforward I continued to do, if it seemed to me there was due occasion. Nevertheless,

come to pass how it might, the real new fact in existence for me was that my drawings did not prosper that year, and, in deepest sense, never prospered again. They might not have prospered in the course of things,—and indeed, could not without better guidance than my own; nevertheless, the crisis of change is marked at Rheinfelden by my having made there two really pretty colour-vignettes which, had I only gone on doing the like of, the journey would have been visibly successful in everybody's sight. Whereas, what actually followed those vignettes at Rheinfelden was a too ambitious attempt at the cliffs of the Bay of Uri, which crushed the strength down in me; and next, a persistently furious one to draw the entire town, three fortresses, and surrounding mountains of Bellinzona, gradually taming and contracting itself into a meekly obstinate resolve that at least I would draw every stone of the roof right in *one* tower of the vineyards,—"cette baraque," as Couttet called it.

I *did* draw every stone, nearly right, at last in that single roof; and meantime read the Plutus of Aristophanes, three or four times over in two months, with long walks every afternoon, besides. Total result on 1st of August—general desolation, and disgust with Bellinzona, —cette baraque,—and most of all with myself, for not yet knowing Greek enough to translate the Plutus. In this state of mind, a fit took me of hunger for city life again, military bands, nicely-dressed people, and shops with something inside. And I emphasized Couttet's disapproval of the whole tour, by announcing to him suddenly that I was going, of all places in the world, to Turin!

23. I had still some purpose, even in this libertinage, namely, to outline the Alpine chain from Monte Viso to Monte Rosa. Its base was within a drive; and there were Veroneses in the Royal gallery, for wet days. The luxury of the Hôtel de l'Europe was extremely pleasant

after brick floors and bad dinners at Bellinzona;—there was a quiet little opera house, where it was always a kindness to the singers to attend to the stage business; finally, any quantity of marching and manœuvring by the best troops in Italy, with perfect military bands, beautifully tossing plumes, and pretty ladies looking on. So I settled at Turin for the autumn.

There, one Sunday morning, I made my way in the south suburb to a little chapel which, by a dusty roadside, gathered to its unobserved door the few sheep of the old Waldensian faith who had wandered from their own pastures under Monte Viso into the worldly capital of Piedmont.

The assembled congregation numbered in all some three or four and twenty, of whom fifteen or sixteen were grey-haired women. Their solitary and clerkless preacher, a somewhat stunted figure in a plain black coat, with a cracked voice, after leading them through the languid forms of prayer which are all that in truth are possible to people whose present life is dull and its terrestrial future unchangeable, put his utmost zeal into a consolatory discourse on the wickedness of the wide world, more especially of the plain of Piedmont and city of Turin, and on the exclusive favour with God, enjoyed by the between nineteen and twenty-four elect members of his congregation, in the streets of Admah and Zeboim.

Myself neither cheered nor greatly alarmed by this doctrine, I walked back into the condemned city, and up into the gallery where Paul Veronese's Solomon and the Queen of Sheba glowed in full afternoon light. The gallery windows being open, there came in with the warm air, floating swells and falls of military music, from the courtyard before the palace, which seemed to me more devotional, in their perfect art, tune, and discipline, than anything I remembered of evangelical hymns. And as

the perfect colour and sound gradually asserted their power on me, they seemed finally to fasten me in the old article of Jewish faith, that things done delightfully and rightly, were always done by the help and in the Spirit of God.

Of course that hour's meditation in the gallery of Turin only concluded the courses of thought which had been leading me to such end through many years. There was no sudden conversion possible to me, either by preacher, picture, or dulcimer. But that day, my evangelical beliefs were put away, to be debated of no more.

Chapter II

MONT VELAN

24. I was crowded for room at the end of last chapter, and could not give account of one or two bits of investigation of the Vaudois character, which preceded the Queen of Sheba crash. It wasn't the Queen herself,—by the way,—but only one of her maids of honour, on whose gold brocaded dress, (relieved by a black's head, who carried two red and green parrots on a salver,) I worked till I could do no more;—to my father's extreme amazement and disgust, when I brought the petticoat, parrots, and blackamoor, home, as the best fruit of my summer at the Court of Sardinia; together with one lurid thunderstorm on the Rosa Alps, another on the Cenis, and a dream or two of mist on the Viso. But I never could make out the set of the rocks on the peak of Viso; and after I had spent about a hundred pounds at Turin in grapes, partridges, and the opera, my mother sent me five, to make my peace with Heaven in a gift to the Vaudois churches. So I went and passed a Sunday beneath Viso; found he had neither rocks nor glaciers worth mentioning, and that I couldn't get into any pleasant confidences with the shepherds, because their dogs barked and snarled irreconcileably, and seemed to have nothing taught them by their masters but to regard all the rest of mankind as thieves.

I had some pious talk of a mild kind with the person I gave my mother's five pounds to: but an infinitely pleasanter feeling from the gratitude of the overworn ballerina at Turin, for the gift of as many of my own. She was not the least pretty; and depended precariously

on keeping able for her work on small pittance; but did that work well always; and looked nice,—near the footlights.

I noticed also curiously at this time, that while the drawings I did to please myself seemed to please nobody else, the little pen-and-ink sketches made for my father, merely to explain where I was, came always well;—one, of the sunset shining down a long street through a grove of bayonets, which he was to imagine moving to military music, is pleasant to me yet. But, on the whole, Turin began at last to bore me as much as Bellinzona; so I thought it might be as well to get home. I drove to Susa on the last day of August, walked quietly with Couttet over the Cenis to Lans-le-bourg next day; and on 2nd September sent my mother my love, by telegram, for breakfast-time, on her birthday, getting answer of thanks back before twelve o'clock; and began to think there might be something in telegraphs, after all.

25. A number of unpleasant convictions were thus driven into my head, in that 1858 journey, like Jael's nail through Sisera's temples; or Tintoret's arrow between St. Sebastian's eyes:—I must return a moment to Mr. Maurice and Deborah before going on to pleasanter matters. Maurice was not, I suppose, in the habit of keeping a skull on his chimney-piece, and looking at it before he went to sleep, as I had been, for a long while before that talk; or he would have felt that whether it was by nail, bullet, or little pin, mattered little when it was ordained that the crowned forehead should sink in slumber. And he would have known that Jael was only one of the forms of "Dira Necessitas"—she, Delilah, and Judith, all the three of them; only we haven't any record of Delilah's hymn when she first fastened Samson's hair to the beam: and of Judith nobody says any harm;—I

suppose because she gave Holofernes wine, instead of milk
and butter. It was Byron, however, not Deborah, who
made *me* understand the thing; the passage he paraphrased
from her, in the Giaour, having rung in my ears ever
since I wrote the Scythian banquet-song—

> "The browsing camels' bells are tinkling,*
> His mother looked from her lattice high," etc.

And I felt now that I had myself driven nails enough into
my mother's heart, if not into my father's coffin; and
would thankfully have taken her home a shawl of divers
colours on both sides, and a pretty damsel or two, in
imitation of Sisera: but she always liked to choose her
damsels for herself.

It was lucky, in her last choosing, she chanced on Joan
Agnew; but we are a far way yet from Joanie's time,
I don't quite know how far. Turner died, as I said, in
1851: Prout had left us still earlier; there could be no
more sharing of festivities on my birthday with *him*. He
went home to De-Crespigny Terrace from Denmark Hill
one evening, seeming perfectly well and happy;—and we
saw him no more.

26. And my dog Wisie, was he dead too? It seems
wholly wonderful to me at this moment that he should
ever have died. He was a white Spitz, exactly like
Carpaccio's dog in the picture of St. Jerome; and he came
to me from a young Austrian officer, who had got tired
of him,—the Count Thun, who fell afterwards at Sol-
ferino. Before the dog was used enough to us, George
and I took him to Lido to give him a little sea bath.
George was holding him by his forepaws upright among
the little crisp breakers. Wisie snatched them out of his

* Misprinted in the first (8vo) edition "The drowsy camel-bells."
—ED.

hands, and ran at full speed—into Fairyland, like
Frederick the Great at Mollwitz. He was lost on Lido
for three days and nights, living by petty larceny, the
fishermen and cottagers doing all they could to catch him;
but they told me he "ran like a hare and leaped like a
horse."

At last, either overcome by hunger, or having made up
his mind that even *my* service was preferable to liberty
on Lido, he took the deep water in broad daylight, and
swam straight for Venice. A fisherman saw him from
a distance, rowed after him, took him, tired among the
weeds, and brought him to me—the Madonna della Salute
having been propitious to his repentant striving with the
sea.

From that time he became an obedient and affectionate
dog, though of extremely self-willed and self-possessed
character. I was then living on the north side of St.
Mark's Place, and he used to sit outside the window on
the ledge at the base of its pillars greater part of the day,
observant of the manners and customs of Venice.
Returning to England, I took him over the St. Gothard,
but found him entirely unappalled by any of the work
of Devils on it—big or little. He saw nothing to trouble
himself about in precipices, if they were wide enough to
put his paws on; and the dog who had fled madly from
a crisp sea wave, trotted beside the fall of the Reuss just
as if it had been another White Dog, a little bigger, created
out of foam.

27. Reaching Paris, he considered it incumbent upon
him to appear unconscious of the existence of that city,
or of the Tuileries gardens and Rue Rivoli, since they were
not St. Mark's Place; but, half asleep one evening, on
a sofa in the entresol at Meurice's, and hearing a bark in
the street which sounded Venetian,—sprang through the
window in expectation of finding himself on the usual

ledge—and fell fifteen feet * to the pavement. As I ran down, I met him rushing up the hotel stairs, (he had gathered himself from the stones in an instant), bleeding and giddy; he staggered round and round two or three times, and fell helpless on the floor. I don't know if young ladies' dogs faint, really, when they are hurt. He, Wisie, did not faint, nor even moan, but he could not stir, except in cramped starts and shivers. I sent for what veterinary help was within reach, and heard that the dog might recover, if he could be kept quiet for a day or two in a dog-hospital. But my omnibus was at the door—for the London train. In the very turn and niche of time I heard that Macdonald of St. Martin's was in the hotel, and would take charge of Wisie for the time necessary. The poor little speechless, luckless, wistfully gazing doggie was tenderly put in a pretty basket, (going to be taken where? thinks the beating heart,) looks at his master to read what he can in the sad face—can make out nothing; is hurried out of the inexorable door, downstairs; finds himself more nearly dead next day, and among strangers. (*Two miles* away from Meurice's, along the Boulevard, it was.)

He takes and keeps counsel with himself on that matter. Drinks and eats what he is given, gratefully; swallows his medicine obediently; stretches his limbs from time to time. There was only a wicket gate, he saw, between the Boulevard and him. Silently, in the early dawn of the fourth or fifth day—I think—he leaped it, and along two miles of Parisian Boulevard came back to Meurice's.

I do not believe there was ever a more wonderful piece of instinct certified. For Macdonald received him, in astonishment,—and Wisie trusted Macdonald to bring

* Thirteen feet nine, I find, on exact measurement—coming back to Meurice's to make sure. It is the height of the capitals of the piers in the Rue Rivoli.

him to his lost master again. The Schehallien chief
brought him to Denmark Hill; where of course Wisie
did not know whether something still worse might not
befall him, or whether he would be allowed to stay. But
he was allowed, and became a bright part of my mother's
day, as well as of mine, from 1852 to 1858, or perhaps
longer. But I must go back now to 1854–6.

28. 1854. The success of the first volume of
"Modern Painters" of course gave me entrance to the
polite circles of London; but at that time, even more
than now, it was a mere torment and horror to me to
have to talk to big people whom I didn't care about.
Sometimes, indeed, an incident happened that was amusing
or useful to me;—I heard Macaulay spout the first chapter
of Isaiah, without understanding a syllable of it;—saw
the Bishop of Oxford taught by Sir Robert Inglis to drink
sherry-cobbler through a straw;—and formed one of the
worshipful concourse invited by the Bunsen family, to
hear them "talk Bunsenese" (Lady Trevelyan), and *see*
them making presents to—each other—from their family
Christmas tree, and private manger of German Magi.
But, as a rule, the hours given to the polite circles were
an angering penance to me,—until, after I don't know
how many, a good chance came, worth all the penitentiary
time endured before.

I had been introduced one evening, with a little more
circumstance than usual, to a seated lady, beside whom it
was evidently supposed I should hold it a privilege to stand
for a minute or two, with leave to speak to her. I entirely
concurred in that view of the matter; but, having ascer-
tained in a moment that she was too pretty to be looked
at, and yet keep one's wits about one, I followed, in what
talk she led me to, with my eyes on the ground. Presently,
in some reference to Raphael or Michael Angelo, or the
musical glasses, the word "Rome" occurred; and a minute

afterwards, something about "Christmas in 1840." I
looked up with a start; and saw that the face was oval,
—fair,—the hair, light-brown. After a pause, I was
rude enough to repeat her words, "Christmas in 1840!
—were you in Rome *then?*" "Yes," she said, a little
surprised, and now meeting my eyes with hers, inquiringly.

Another tenth of a minute passed before I spoke again.
"Why, I lost all that winter in Rome in hunting
you!"

It was Egeria herself! then Mrs. Cowper-Temple.
She was not angry; and became from that time forward
a tutelary power,—of the brightest and happiest; differing
from Lady Trevelyan's, in that Lady Trevelyan hadn't
all her own way at home; and taught me, therefore, to
look upon life as a "Spiritual combat;" but Egeria always
had her own way everywhere,—thought that I also should
have mine,—and generally got it for me.

29. She was able to get a good deal of it for me, almost
immediately, at Broadlands, because Mr. Cowper-Temple
was at that time Lord Palmerston's private secretary: and
it had chanced that in 1845 I had some correspondence
with the government about Tintoret's Crucifixion;—not
the great Crucifixion in the Scuola di San Rocco, but the
bright one with the grove of lances in the Church of St.
Cassan, which I wanted to get for the National Gallery.
I wrote to Lord Palmerston about it, and believe we should
have got it, but for Mr. Edward Cheney's putting a spoke
in the wheel for pure spite. However, Lord Palmerston
was, I believe, satisfied with what I had done; and, now
perhaps thinking there might be some trustworthy official
qualities in me, allowed Mr. Cowper-Temple to bring
me, one Saturday evening, to go down with him to Broad-
lands. It was dark when we reached the South-Western
station. Lord Palmerston received me much as Lord
Oldborough receives Mr. Temple in "Patronage;"—gave

me the seat opposite his own, he with his back to the
engine, Mr. Cowper-Temple beside me;—Lord Palmer-
ston's box of business papers on the seat beside *him*. He
unlocked it, and looked over a few,—said some hospitable
words, enough to put me at ease, and went to sleep, or at
least remained quiet, till we got to Romsey. I forget
the dinner, that Saturday; but I certainly had to take in
Lady Palmerston; and must have pleased her more or less,
for on the Sunday morning, Lord Palmerston took me
himself to the service in Romsey Abbey: drawing me out
a little in the drive through the village; and *that* day at
dinner he put me on his right hand, and led the conversa-
tion distinctly to the wildest political theories I was
credited with,* cross-examining me playfully, but attend-
ing quite seriously to my points; and kindly and clearly
showing me where I should fail, in practice. He dis-
puted no principle with me, (being, I fancied, partly of
the same mind with me about principles,) but only feasibili-
ties; whereas in every talk permitted me more recently
by Mr. Gladstone, *he* disputes *all* the principles before
their application; and the application of all that get past
the dispute. D'Israeli differed from both in making a
jest alike of principle and practice; but I never came into
full collision with him but once. It is a long story, about
little matters; but they had more influence in the end
than many greater ones,—so I will write them.

30. I never went to official dinners in Oxford if I
could help it; not that I was ever really wanted at them,
but sometimes it became my duty to go, as an Art Pro-

* The reader will please remember that the "Life of the Workman"
in the "Stones of Venice," the long note on Education at the end of
first volume of "Modern Painters," and the fierce vituperation of the
Renaissance schools in all my historical teaching, were at this time
attracting far more attention, because part of my architectural and
pictorial work, than ever afterwards the commercial and social
analyses of "Unto This Last."

fessor; and when the Princess of Wales came, one winter, to look over the Art Galleries, I had of course to attend, and be of what use I could: and then came commands to the dinner at the Deanery,—where I knew no more how to behave than a marmot pup! However, my place was next but one to D'Israeli's, whose head, seen close, interested me; the Princess, in the centre of the opposite side of the table, might be glanced at now and then,—to the forgetfulness of the evils of life. Nobody wanted *me* to talk about anything; and I recovered peace of mind enough, in a little while, to hear D'Israeli talk, which was nice; I think we even said something to each other, once, about the salmon. Well—then, presently I was aware of a little ripple of brighter converse going round the table, and saw it had got at the Princess, and a glance of D'Israeli's made me think it must have something to do with *me*. And so it had, thus:—It had chanced either the day before, or the day before that, that the Planet Saturn had treated me with his usual adversity in the carrying out of a plot with Alice in Wonderland. For, that evening, the Dean and Mrs. Liddell dined by command at Blenheim: but the girls were not commanded; and as I had been complaining of never getting a sight of them lately, after knowing them from the nursery, Alice said that she thought, perhaps, if I would come round after papa and mamma were safe off to Blenheim, Edith and she might give me a cup of tea and a little singing, and Rhoda show me how she was getting on with her drawing and geometry, or the like. And so it was arranged. The night was wild with snow, and no one likely to come round to the Deanery after dark. I think Alice must have sent me a little note, when the eastern coast of Tom Quad was clear. I slipped round from Corpus through Peckwater, shook the snow off my gown, and found an armchair ready for me, and a bright fireside,

and a laugh or two, and some pretty music looked out, and tea coming up.

31. Well, I think Edith had got the tea made, and Alice was just bringing the muffins to perfection—I don't recollect that Rhoda was there; (I never did, that anybody else was there, if Edith was; but it is all so like a dream now, I'm not sure)—when there was a sudden sense of some stars having been blown out by the wind, round the corner; and then a crushing of the snow outside the house, and a drifting of it inside; and the children all scampered out to see what was wrong, and I followed slowly;—and there were the Dean and Mrs. Liddell standing just in the middle of the hall, and the footmen in consternation, and a silence,—and—

"How sorry you must be to see us, Mr. Ruskin!" began at last Mrs. Liddell.

"I never was more so," I replied. "But what's the matter?"

"Well," said the Dean, "we couldn't even get past the parks; the snow's a fathom deep in the Woodstock Road. But never mind; we'll be very good and quiet, and keep out of the way. Go back to your tea, and we'll have our dinner downstairs."

And so we did; but we couldn't keep papa and mamma out of the drawing-room when they had done dinner, and I went back to Corpus, disconsolate.

Now, whether the Dean told the Princess himself, or whether Mrs. Liddell told, or the girls themselves, *somehow* this story got all round the dinner-table, and D'Israeli was perfect in every detail, in ten minutes, nobody knew how. When the Princess rose, there was clearly a feeling on her part of some kindness to me; and she came very soon, in the drawing-room, to receive the report of the Slade Professor.

32. Now, in the Deanery drawing-room, everybody in

Oxford who hadn't been at the dinner was waiting to have their slice of Princess—due officially—and to be certified in the papers next day. The Princess,—knowing whom she had to speak to,—*might* speak to, or mightn't, without setting the whole of Oxford by the ears next day, simply walked to the people she chose to honour with audience, and stopped, to hear if they had anything to say. I saw my turn had come, and the revolving zodiac brought its fairest sign to me: she paused, and the attendant stars and terrestrial beings round, listened, to hear what the marmot-pup had to say for itself.

In the space of, say, a minute and a half, I told the Princess that Landscape-painting had been little cultivated by the Heads of Colleges,—that it had been still less cultivated by the Undergraduates, and that my young-lady pupils always expected me to teach them how to paint like Turner, in six lessons. Finding myself getting into difficulties, I stopped: the Princess, I suppose, felt I was getting *her* into difficulties too; so she bowed courteously, and went on—to the next Professor, in silence.

33. The crowd, which had expected a compliment to Her Royal Highness of best Modern Painter quality, was extremely disappointed: and a blank space seemed at once to form itself round me, when the door from the nurseries opened; and—enter Rhoda—in full dress!

Very beautiful! But just a snip too short in the petticoats,—a trip too dainty in the ankles, a dip too deep of sweetbriar-red in the ribands. Not the damsel who came to hearken, named Rhoda,—by any means;—but as exquisite a little spray of rhododendron ferrugineum as ever sparkled in Alpine dew.

D'Israeli saw his opening in an instant. Drawing himself to his full height, he advanced to meet Rhoda. The whole room became all eyes and ears. Bowing with kindly reverence, he waved his hand, and introduced her

to—the world. "*This* is, I understand, the young lady in whose art-education Professor Ruskin is so deeply interested!"

And there was nothing for *me* but simple extinction; for I had never given Rhoda a lesson in my life, (no such luck!); yet I could not disclaim the interest,—nor disown Mr. Macdonald's geometry! I *could* only bow as well as a marmot might, in imitation of the Minister; and get at once away to Corpus, out of human ken.

34. This gossip has beguiled me till I have no time left to tell what in proper sequence should have been chiefly dwelt on in this number,—the effect on my mind of the Hospice of St. Bernard, as opposed to the Hermitage of St. Bruno. I must pass at once to the outline of some scenes in early Swiss history, of which the reader must be reminded before he can understand why I had set my heart so earnestly upon drawing the ruined towers of Fribourg, Thun, and Rheinfelden.

In the mountain kingdom of which I claimed possession by the law of love, in first seeing it from the Col de la Faucille, the ranges of entirely celestial mountain, the "everlasting clouds" whose glory does not fade, are arranged in clusters of summits definitely distinct in form, and always recognizable, each in its own beauty, by any careful observer who has once seen them on the south and north. Of these, the most beautiful in Switzerland, and as far as I can read, or learn, the most beautiful mountain in the world, is the Jungfrau of Lauterbrunnen. Next to her, the double peaks of the Wetterhorn and Wellhorn, with their glacier of Rosenlaui; next to these, the Aiguille de Bionnassay, the buttress of Mont Blanc on the south-west; and after these loveliest, the various summits of the Bernese, Chamouni, and Zermatt Alps, according to their relative power, and the advantage of their place for the general observer. Thus

the Blumlis Alp, though only ten thousand feet high, has far greater general influence than the Mont Combin, which is nearly as high as Mont Blanc, but can only be seen with difficulty, and in no association with the lowlands.

35. Among subordinate peaks, five,—the Tournette of Annecy, the Dent du Midi of Bex, the Stockhorn, south of Thun, Mont Pilate at Lucerne, and the High Sentis of Appenzell,—are notable as outlying masses, of extreme importance in their effect on the approaches to the greater chain. But in that chain itself, no mountain of subordinate magnitude can assert any rivalship with Mont Velan, the ruling alp of the Great St. Bernard.

For Mont Velan signals down the valley of the Rhone, past St. Maurice, to Vevay, the line of the true natural pass of the Great St. Bernard, from France into Italy by the valley of Martigny and Val d'Aosta; a perfectly easy and accessible pass for horse and foot, through all the summer; not dangerous even in winter, except in storm; and from the earliest ages, down to Napoleon's, the pass chosen by the greatest kings, and wisest missionaries. The defiles of the Simplon were still impassable in the twelfth century, and the Episcopate of the Valais was therefore an isolated territory branching up from Martigny; unassailable from above, but in connection with the Monastery of St. Bernard and Abbey of St. Maurice, holding alike Burgundian, Swiss, and Saracen powers at bay, beyond the Castle of Chillon.

And I must remind the reader that at the time when Swiss history opens, there was no such country as France, in her existing strength. There was a sacred "Isle of France," and a group of cities,—Amiens, Paris, Soissons, Rheims, Chartres, Sens, and Troyes,—essentially French, in arts, and faith. But round this Frank central province lay Picardy, Normandy, Brittany, Anjou, Aquitaine, Languedoc, and Provence, all of them independent

national powers: and on the east of the Côte d'Or,* the
strong and true *king*dom of Burgundy, which for centuries
contended with Germany for the dominion of Switzerland,
and, from *her* Alpine throne, of Europe.

36. This was, I have said, at the time "when Swiss
history opens"—*as such*. It opens a century earlier, in
773, as a part of all Christian history, when Charlemagne
convoked his Franks at Geneva to invade Italy, and divid-
ing them there into two bodies, placed Swiss mountaineers
at the head of each, and sending one division by the Great
St. Bernard, under his own uncle, Bernard,† the son of
Charles Martel, led the other himself over the Cenis. It
was for this march over the Great St. Bernard that Charle-
magne is said to have given the foresters of the central
Alps their three trumpets—the Bull of Uri, the Cow of
Unterwald, and the Horn of Lucerne; and, without
question, after his Italian victories, Switzerland became
the organic centre of civilization to his whole empire.
"It is thus," says M. Gaullieur, "that the heroic history
of old Zurich, and the annals of Thurgovie and Rhétie,
are full of the memorable acts of the Emperor of the West,
and among other traditions the foundation of the Water-
church, (Wasserkirche,) at Zurich, attaches itself to the
sight of a marvellous serpent who came to ask justice of
the Emperor, in a place where he gave it to all his subjects,
by the Limmat shore."

37. I pause here a moment to note that there used to
be indeed harmless water serpents in the Swiss waters,
when perfectly pure. I myself saw those of the Lac de
Chêde, in the year 1833, and had one of them drawn out
of the water by the char-a-banc driver with his whip,

* The eastern boundary of France proper is formed by the masses of
the Vosges, Côte d'Or, and Monts de la Madeleine.

† Don't confuse *him* with St. Bernard of Annecy, from whom the
pass is named; nor St. Bernard of Annecy with St. Bernard of Dijon,
the Madonna's chosen servant.

that I might see the yellow ring round its neck. The colour of the body was dark green. If the reader will compare the account given in "Eagle's Nest" * of one of the serpents of the Giesbach, he will understand at once how easily the myths of antiquity would attach themselves among the Alps, as much to the living serpent as to the living eagle.

Also, let the reader note that the *beryl*-coloured water of the Lake of Zurich and the Limmat gave, in old days, the perfectest type of purity, of all the Alpine streams. The deeper blue of the Reuss and Rhone grew dark at less depth, and always gave some idea of the presence of a mineral element, causing the colour; while the Aar had soiled itself with clay even before reaching Berne. But the pale aquamarine crystal of the Lake of Zurich, with the fish set in it, some score of them—small and great—to a cube fathom, and the rapid fall and stainless ripple of the Limmat, through the whole of its course under the rocks of Baden to the Reuss, remained, summer and winter, of a constant, sacred, inviolable, supernatural loveliness.

By the shore of the Limmat then, sate Charlemagne to do justice, as Canute by the sea:—the first "Water church" of the beginning river is his building; and never was St. Jerome's rendering of the twenty-third Psalm sung in any church more truly: "In loco pascue, ibi collocavit me, *super aquam refectionis educavit*." But the Cathedral Minister of Zurich dates from days no longer questionable or fabulous.

38. During the first years of the tenth century, Switzerland was disputed between Rodolph II., King of Burgundy, and Bourcard, Duke of Swabia. The German duke at last defeated Rodolph, near Winterthur; but with so much difficulty, that he chose rather thenceforward to

* Large edition, p. 106; small edition, § 101.—ED.

have him for ally rather than enemy; and gave him, for pledge of peace, his daughter BERTHA, to be Burgundian queen.

Bertha, the daughter of the Duke Bourcard and Regilinda, was at this time only thirteen or fourteen. The marriage was not celebrated till 921—and let the reader remember that marriage,—though there was no Wedding March played at it, but many a wedding prayer said,—for the beginning of all happiness to *Burgundy*, *Switzerland*, and *Germany*. Her husband, in the first ten years after their marriage, in alliance with Henry the Fowler of Germany, drove the Saracen and Hungarian nomad armies out of the Alps: and then Bertha set herself to efface the traces of their ravages; building, everywhere through her territories, castles, monasteries, walled towns, and towers of refuge; restoring the town and church of Soleure in 930, of Moutiers in the Jura, in 932; in the same year endowing the canons of Amsoldingen at Thun, and then the church of Neuchâtel; finally, towards 935, the church and convent of Zurich, of which her mother Regilinda became abbess in 949, and remained abbess till her death; —the Queen Bertha herself residing chiefly near her, in a tower on Mont Albis.

39. In 950 Bertha had to mourn the death of her son-in-law Lothaire, and the imprisonment of her daughter Adelaide on the Lake of Garda. But Otho the Great, of Germany, avenged Lothaire, drove Berenger out of Italy, and himself married Adelaide, reinstating Conrad of Burgundy on the throne of Burgundy and Switzerland: and then Bertha, strong at once under the protection of the king her son, and the emperor her son-in-law, and with her mother beside her, Abbess of the Convent des Dames Nobles of Zurich, began her work of perfect beneficence to the whole of Switzerland.

In the summer times, spinning from her distaff as she

rode, she traversed—the legends say, with only a country
guide to lead her horse, (when such a queen's horse would
need leading!)—all the now peaceful fields of her wide
dominion, from Jura to the Alps. My own notion is
thàt an Anne-of-Geierstein-like maid of honour or two
must have gleamed here and there up and down the hills
beside her; and a couple of old knights, perhaps, followed
at their own pace. Howsoever, the queen verily *did*
know her peasants, and their cottages and fields, from
Zurich to Geneva, and ministered to them for full twelve
years.

40. In 962, her son Conrad gave authority almost
monarchic, to her Abbey of Payerne, which could strike
a coinage of its own. Not much after that time, her
cousin Ulrich, Bishop of Strasbourg, came to visit her;
and with him and the king her son, she revisited all the
religious institutions she had founded, and finally, with
them both, consecrated the Church of Neuchâtel to the
Virgin. The Monastery of the Great St. Bernard was
founded at the same time.

I cannot find the year of her death, but her son Conrad
died in 993, and was buried beside his mother at Payerne.

And during the whole of the 11th century, and more
than half of the 12th, the power of Bertha's institutions,
and of the Church generally, increased in Switzerland; but
gradually corrupted by its wealth of territory into a feudal
hierarchy, against which, together with that of the nobles
who were always at war with each other, Duke Bert-
hold IV., of Zæhringen, undertook in 1178, the founding
of FRIBOURG in Uchtland.

The culminating point of the new city above the scarped
rocks which border the Sarine (on the eastern bank?) was
occupied by the Château de Tyre (Tyrensis), ancient home
of the Counts of that country, and cradle, it is believed,
of the house of Thierstein. Berthold called his new town

Freyburg, as well as that which existed already in his states
of Breisgau, because he granted it in effect the same
liberties, the same franchises, and the same communal
charter (Handfeste) which had been given to the other
Fribourg. A territory of nine leagues in circumference
was given to Fribourg in Uchtland, a piece which they
still call "the old lands." Part of the new colonists came
from Breisgau, Black Forest people; part from the Roman
Pays de Vaud. The Germans lived in the valley, the
others on the heights. Built on the confines of France
and Germany, Fribourg served for the point of contact
to two nations until then hostile; and the Handfeste of
Fribourg served for a model to all the municipal constitu-
tions of Switzerland. Still, at this day, the town is divided
into two parts, and into two languages.

41. This was in 1178. Twelve years later, Bert-
hold V., the greatest and the best of the Dukes of Zæhrin-
gen, made, of the village of Burgdorf in the Emmenthal,
the town of Berthoud, the name given probably from his
own; and then, in the year 1191, laid the foundations of
the town of BERNE.

He chose for its site a spot in the royal domain, for
he intended the new city to be called the Imperial city;
and the place he chose was near a manor which had
served in the preceding century for occasional residence
to the Rodolphian kings. It was a long high promontory,
nearly an island, whose cliff sides were washed by
the Aar. The Duke of Zæhringen's Marshal, Cuno
of Babenberg, received orders to surround with walls the
little island on which stood the simple hamlet of Berne,
now become the powerful city of Berne, praiseworthy at
first in the democratic spirit of its bourgeois, and after-
wards in its aristocracy, whose policy, at once elevated,
firm, consistent, and ambitious, mingled itself in all the
great affairs of the neighbouring countries, and became a

true power, upon which the sovereigns of the first order had sometimes to count.

Lastly, Berthold built the Castle of Thun, where the Aar issues out of its lake; castle which, as may be seen at the present day, commanded the whole level plain, opening to Berne, and the pass into the Oberland.

42. Thus the three towns Fribourg, Berne, and Thun, form, at the close of the twelfth century, the triple fortress of the Dukes of Zæhringen, strengthened by a body of burghers to whom the Dukes have granted privileges till then unknown; this Ducal and Civic allied power asserting itself in entire command of Switzerland proper, against the Counts of Savoy in the south, the Burgundian princes in the east, and the ecclesiastical power of Italy, vested in the Bishops of Sion, in the Valais,—thence extending from the mouth of the Rhone into the Pays de Vaud, and enthroned there at Payerne by the bequests of Queen Bertha. The monks of her royal abbey at Payerne, seeing that all the rights they possessed over the Pays de Vaud were endangered by the existence of Fribourg, opposed the building of the Church of St. Nicholas there, asserting that the ground assigned to it and its monastery belonged to the Abbey of Payerne. Berthold IV. was on the point of attacking the monks on their own rock when the nobles of the Vaud interfered, as mediators.

Four of them—Amé, Count of Geneva, Vauthier of Blonay, Conrad of Estaveyar, and Rodolph of Montagny —compelled Berthold to ratify the privileges, and resign the lands, of the monks of Payerne, by a deed signed in 1178; the church and monastery of St. Nicholas being founded at Fribourg under their rule. And this constitution of Fribourg, whether the Dukes of Zæhringen foresaw it or not, became the fecund germ of a new social order. The "Commune" was the origin of the "Canton," "and the beneficent æra of communal liberty served for

acheminement to the constitutional liberties and legislative codes of modern society."

43. Thus far M. Gaullieur, from whose widow I leased my own chalet at Mornex, and whose son I instructed, to the best of my power, in clearing land of useless stones on the slope of the Salève,—under the ruins of the old Château de Savoie, the central castle, once, of all Savoy; on the site of which, and summit of its conical hill-throne, seated himself, in his pleasure villa, all the summer long, my very dear friend and physician, old Dr. Gosse of Geneva; whose mountain garden, about three hundred feet above mine, was indeed enclosed by the remaining walls and angle towers of the Castle of Savoy, of which the Doctor had repaired the lowest tower so as to serve for a reservoir to the rain rushing down the steep garden slopes in storm,—and to let none of it be wasted afterwards in the golden Salève sunshine.

"C'était une tour de guerre," said the Doctor to me triumphantly, as he first led me round the confines of his estate. "Voyez. C'était une tour de guerre. J'en ai fait une bouteille!"

44. But that walk by the castle wall was long after the Mont Velan times of which I am now telling;—in returning to which, will the reader please note the homes of the four Vaudois knights who stood for Queen Bertha's monastery: Amé of Geneva, Vauthier of Blonay, Conrad of Estaveyer, and Rodolph of Montagny?

Amé's castle of Geneva stood on the island, where the clock tower is now; and has long been destroyed: of Estaveyer and Montagny I know nothing; but the Castle of Blonay still stands above Vevay, as Chillon still at the head of her lake; but the château of Blonay has been modified gradually into comfort of sweet habitation, the war towers of it sustaining timber-latticed walls, and crowned by pretty turrets and pinnacles in cheerful noble-

ness—trellised all with fruitage or climbing flowers; its moats now all garden; its surrounding fields all lily and meadowsweet, with blue gleamings, it may be of violet, it may be of gentian; its heritage of human life guarded still in the peacefully scattered village, or farmhouse, here and there half hidden in apple-blossom, or white with fallen cherry-blossom, as if with snow.

45. I have already told how fond my father was of staying at the Trois Couronnes of Vevay, when I was up among the aiguilles of Chamouni. In later years, I acknowledged his better taste, and would contentedly stay with him at Vevay, as long as he liked,—myself always perfectly happy in the fields and on the hillsides round the Château Blonay. Also, my father and mother were quite able at any time to get up as far as Blonay themselves; and usually walked so far with me when I was intent on the higher hills,—waiting, they, and our old servant, Lucy Tovey, (whom we took abroad with us sometimes that she might see the places we were always talking of), until I had done my bit of drawing or hammering, and we all went down together, through the vineyards, to four o'clock dinner; then the evening was left free for me to study the Dent d'Oche and chains of crag declining southwards to Geneva, by sunset.

Thus Vevay, year after year, became the most domestic of all our foreign homes. At Venice, my mother always thought the gondola would upset; at Chamouni, my father, that I should fall into the Mer de Glace; at Pisa, he would ask me, "What shall I give the coachman?" and at Florence, dispute the delightfulness of Cimabue. But at Vevay, we were all of a mind. My father was professionally at home in the vineyards,—sentimentally in the Bosquet de Julie; my mother liked apple orchards and narcissus meads as much as I did; and for me, there was the Dent du Midi, for eternal snow, in the distance;

the Rochers de Naye, for climbing, accessibly near;
Chillon for history and poetry; and the lake, in the whole
breadth of it from Lausanne to Meillerie, for Turnerian
mist effects of morning, and Turnerian sunsets at evening;
and moonlights,—as if the moon were one radiant glacier
of frozen gold. Then if one wanted to go to Geneva
for anything, there were little steamers,—no mortal would
believe, now, how little; one used to be afraid an extra
basket of apples would be too much for them, when the
pier was full of market people. They called at all the
places along the north shore, mostly for country folks;
and often their little cabins were quite empty. English
people thought the lake of Geneva too dull, if they had
ever more than an hour of it.

46. It chanced so, one day, when we were going from
Vevay to Geneva. It was hot on the deck, and we all
went down into the little cabin, which the waves from
the paddle wheels rushed past the windows of, in lovely
wild masses of green and silver. There was no one in
the cabin but ourselves (that is to say, papa, mamma, old
Anne, and me), and a family whom we supposed, rightly,
to be American, of the best sort. A mother with three
daughters, and her son,—he in charge of them all, perhaps
of five or six and twenty; his sisters younger; the mother
just old enough to *be* their mother; all of them quietly
and gracefully cheerful. There was the cabin table
between us, covered with the usual Swiss news about
nothing, and an old caricature book or two. The waves
went on rushing by; neither of the groups talked, but I
noticed that from time to time the young American cast
somewhat keen, though entirely courteous, looks of
scrutiny at my father and mother.

In a few minutes after I had begun to notice these looks,
he rose, with the sweetest quiet smile I ever saw on any
face (unless, perhaps, a nun's, when she has some grave

kindness to do), crossed to our side of the cabin, and addressing himself to my father, said, with a true expression of great gladness, and of frank trust that his joy would be understood, that he knew who we were, was most thankful to have met us, and that he prayed permission to introduce his mother and sisters to us.

The bright eyes, the melodious voice, the perfect manner, the simple, but acutely flattering, words, won my father in an instant. The New Englander sat down beside us, his mother and sisters seeming at once also to change the steamer's cabin into a reception room in their own home. The rest of the time till we reached Geneva passed too quickly; we arranged to meet in a day or two again, at St. Martin's.

And thus I became possessed of my second friend, after Dr. John Brown; and of my first real tutor, Charles Eliot Norton.

L'ESTERELLE

47. The meeting at St. Martin's with Norton and his family was a very happy one. Entirely sensible and amiable, all of them; with the farther elasticity and acuteness of the American intellect, and no taint of American ways. Charles himself, a man of the highest natural gifts, in their kind; observant and critical rather than imaginative, but with an all-pervading sympathy and sensibility, absolutely free from envy, ambition, or covetousness: * a scholar from his cradle, nor only now a *man* of the world, but a *gentleman* of the world, whom the highest born and best bred of every nation, from the Red Indian to the White Austrian, would recognize in a moment, as of their caste.

In every branch of classical literature he was my superior; knew old English writers better than I,—much more, old French; and had active fellowship and close friendship with the then really progressive leaders of thought in his own country, Longfellow, Lowell, and Emerson.

All the sympathy, and all the critical subtlety, of his mind had been given, not only to the reading, but to the trial and following out of the whole theory of "Modern Painters;" so that, as I said, it was a real joy for him to meet me, and a very bright and singular one for both

* I mean, covetousness of beautiful things, the only sort that is possible to people like Charles Norton or me. He gave me his best Greek "Fortune," a precious little piece of flying marble, with her feet on the world, engraved with hexagonal tracery like a honeycomb. We both love its honey—but best, given by each other.

of us, when I knocked at his door in the Hôtel du Mont Blanc at five in the morning; and led him, as the roselight flushed the highest snow, up the winding path among the mountain meadows of Sallenches.

I can see them at this moment, those mountain meadows, if I rise from my writing-table, and open the old barred valves of the corner window of the Hotel Bellevue;—yes, and there is the very path we climbed that day together, apparently unchanged. But on what seemed then the everlasting hills, beyond which the dawn rose cloudless, and on the heaven in which it rose, and on all that we that day knew, of human mind and virtue, —how great the change, and sorrowful, I cannot measure, and, in this place, I will not speak.

48. That morning gave to me, I said my first tutor; * for Dr. John Brown, however, far above me in general power, and in the knowledge proper to his own profession, yet in the simplicity of his affection liked everything I wrote, for what was true in it, however imperfectly or faultfully expressed: but Norton saw all my weaknesses, measured all my narrownesses, and, from the first, took serenely, and as it seemed of necessity, a kind of paternal authority over me, and a right of guidance; —though the younger of the two,—and always admitting my full power in its own kind; nor only admitting, but in the prettiest way praising and stimulating. It was almost impossible for him to speak to any one he cared for, without some side-flash of witty compliment; and to me, his infinitely varied and loving praise became a constant motive to exertion, and aid in effort: yet he never allowed me in the slightest violation of the laws, either of good writing, or social prudence, without instant blame, or warning.

* Gordon was only my master in Greek, and in common sense; he never criticized my books, and, I suppose, rarely read them.

I was entirely conscious of his rectorial power, and affectionately submissive to it; so that he might have done anything with me, but for the unhappy difference in our innate, and unchangeable, political faiths.

49. Since that day at Sallenches it has become a matter of the most curious speculation to me, what sort of soul Charles Norton would have become, if he had had the blessing to be born an English Tory, or a Scotch Jacobite, or a French Gentilhomme, or a Savoyard Count. I think I should have liked him best to have been a Savoyard Count; say, Lord of the very Tower of Sallenches, a quarter of a mile above me at the opening of the glen, —habitable yet and inhabited; it is half hidden by its climbing grapes. Then, to have read the "Fioretti di San Francesco," (which *he* found out, New Englander though he was, before I did,) in earliest boyhood; then to have been brought into instructively grievous collision with Commerce, Liberty, and Evangelicalism at Geneva; then to have learned Political Economy from Carlyle and me; and finally devoted himself to write the History of the Bishops of Sion! What a grand happy, consistent creature he would have been,—while now he is as hopelessly out of gear and place, over in the States there, as a runaway star dropped into Purgatory; and twenty times more a slave than the blackest nigger he ever set his white scholars to fight the South for; because all the faculties a black has may be fully developed by a good master (see Miss Edgeworth's story of the grateful Negro),*—while only about the thirtieth or fortieth part of Charles Norton's

* I showed the valley of Chamouni, and the "Pierre-a-Bot" above Neuchâtel, to Mrs. Beecher Stowe and her pretty little daughter Georgie—when Georgie was about sixteen, and wouldn't let me say a word against Uncle Tom: howbeit, that story of the Grateful Negro, Robinson Crusoe, and Othello, contain, any of the three, more alike worldly and heavenly, wisdom than would furnish three "Uncle Tom's Cabins."

effective contents and capacity are beneficially spent in
the dilution of the hot lava, and fructification of the hot
ashes, of American character;—which are overwhelming,
borne now on volcanic air,—the life of Scotland, England,
France, and Italy. I name Scotland first, for reasons
which will be told in next "Præterita,"—"Joanna's
Care." Meantime, here is the last letter I have from
Norton, showing how we have held hands since that first
day on Geneva lake.

"SHADY HILL, *April 9th*, 1887.

50. "It is very good of you, my dearest Ruskin, to send
me such a long, pleasant letter, not punishing me for my
silence, but trusting to—

> 'My thought, whose love for you,
> Though words come hindmost, holds his rank before.'

You are doing too much, and your letter gives me a fear
lest, out of care for me, you added a half-hour of effort
to the work of a too busy day. How long it is since
I first began to preach prudence to you! and my preaching
has availed about as much as the sermons in stones avail
to convert the hard-hearted. Well, we are glad to take
each other as we are, you ever imprudent, I ever——
(I leave the word to your mercy).

"The last number of 'Præterita' pleased me greatly.
There was a sweet tone in it, such as becomes the retro-
spect of a wise man as he summons the scenes of past life
before his eyes; the clearness, the sharp-cut outline of
your memories is a wonder, and their fulness of light and
colour. My own are very different. I find the outlines
of many of them blurred, and their colours faint. The
loss that came to me fifteen years ago included the loss of
vividness of memory of much of my youth.

"The winter has been long and hard with us. Even

yet there are snowbanks in shady places, and not yet is there a sign of a leaf. Even the snowdrops are hardly venturing out of the earth. But the birds have come back, and to-day I hear the woodpeckers knocking at the doors of the old trees to find a shelter and home for the summer. We have had the usual winter pleasures, and all my children have been well, though Lily is always too delicate, and ten days hence I part with her that she may go to England and try there to escape her summer cold. She goes out under Lowell's charge, and will be with her mother's sister and cousins in England. My three girls have just come to beg me to go out with them for a walk. So, good-bye. I will write soon again. Don't you write to me when you are tired. I let my eyes rest for an instant on Turner's sunset, and your sunrise from Herne Hill, which hang before me; and with a heart full of loving thanks to you,—I am ever your affectionate

"C. E. N.

"My best love to Joan,—to whom I mean to write."

Somewhat more of Joan (and Charles also) I have to tell, as I said, in next "Præterita."

51. I cannot go on, here, to tell the further tale of our peace and war; for the Fates wove for me, but a little while after they brought me that friend to Sallenches glen, another net of Love; in which alike the warp and woof were of deeper colours.

Soon after I returned home, in the eventful year 1858, a lady wrote to me from—somewhere near Green Street, W.,—saying, as people sometimes did, in those days, that she saw I was the only sound teacher in Art; but this farther, very seriously, that she wanted her children— two girls and a boy—taught the beginnings of Art rightly;

especially the younger girl, in whom she thought I might find some power worth developing:—would I come and see her? I thought I should rather like to; so I went, to near Green Street; and found the mother—the sort of person I expected, but a good deal more than I expected, and in all sorts of ways. Extremely pretty still, herself, nor at all too old to learn many things; but mainly anxious for her children. Emily, the elder daughter, wasn't in; but Rosie was,—should she be sent for to the nursery? Yes, I said, if it wouldn't tease the child, she might be sent for. So presently the drawing-room door opened, and Rosie came in, quietly taking stock of me with her blue eyes as she walked across the room; gave me her hand, as a good dog gives its paw, and then stood a little back. Nine years old, on 3rd January, 1858, thus now rising towards ten; neither tall nor short for her age; a little stiff in her way of standing. The eyes rather deep blue at that time, and fuller and softer than afterwards. Lips perfectly lovely in profile;—a little too wide, and hard in edge, seen in front; the rest of the features what a fair, well-bred Irish girl's usually are; the hair, perhaps, more graceful in short curl round the forehead, and softer than one sees often, in the close-bound tresses above the neck.

52. I thought it likely she *might* be taught to draw a little, if she would take time; I did not expect her to take *pains*, and told her mother so, at once. Rosie says never a word, but we continue to take stock of each other. "I thought you *so* ugly," she told me, afterwards. She didn't quite mean that; but only, her mother having talked much of my "greatness" to her, she had expected me to be something like Garibaldi, or the Elgin Theseus; and was extremely disappointed.

I expressed myself as ready to try what I could make of Rosie; only I couldn't come every other day all the way

in to Green Street. Mamma asked what sort of a road
there was to Denmark Hill? I explained the simplicity
and beauty of its ramifications round the Elephant and
Castle, and how one was quite in the country as soon as one
got past the triangular field at Champion Hill. And
the wildernesses of the Obelisk having been mapped out,
and determined to be passable, the day was really appointed
for first lesson at Denmark Hill—and Emily came with
her sister.

53. Emily was a perfectly sweet, serene, delicately-
chiselled marble nymph of fourteen, softly dark-eyed,
rightly tender and graceful in all she did and said. I
never saw such a faculty for the arrangement of things
beautifully, in any other human being. If she took up a
handful of flowers, they fell out of her hand in wreathed
jewellery of colour and form, as if they had been sown,
and had blossomed, to live together so, and no otherwise.
Her mother had the same gift, but in its more witty,
thoughtful, and scientific range; in Emily it was pure
wild instinct. For an Irish girl, she was not witty, for
she could not make a mistake; one never laughed at what
she said, but the room was brighter for it. To Rose and
me she soon became no more Emily, but "Wisie," named
after my dead Wisie. All the children, and their father,
loved animals;—my first sight of papa was as he caressed
a green popinjay which was almost hiding itself in his
waistcoat. Emily's pony, Swallow, and Rosie's dog,
Bruno, will have their day in these memoirs; but Emily's
"Bully" was the perfectest pet of all;—he used to pass
half his day in the air, above her head, or behind her
shoulders, holding a little tress of her long hair as far out
as he could, on the wing.

54. That first day, when they came to Denmark Hill,
there was much for them to see;—my mother, to begin
with, and she also had to see them; on both sides the sight

was thought good. Then there were thirty Turners, including the great Rialto; half-a-dozen Hunts; a beautiful Tintoret; my minerals in the study; the loaded apple trees in the orchard; the glowing peaches on the old red garden wall. The lesson lost itself that day in pomiferous talk, with rustic interludes in the stables and pigsty. The pigs especially, it was observed, were highly educated, and spoke excellent Irish.

When next they came, lessons began duly, with perspective, and the analysis of the essential qualities of triangles! I must state here, generally, that ever since the year I lost in efforts to trisect an angle myself, education, both in drawing and ethics, has been founded by me on the *pleasant* and pretty mysteries of trigonometry! the more resolutely, because I always found ignorance of magnitudes at the root of modern bad taste and frivolity; and farther, because all the grace, and much of the sentiment, both of plant and mountain form, depends on the angle of the cone they fill with their branches, or rise into with their cliffs.

These geometrical lessons are always accompanied, when I have girls to teach, by the most careful pencil study of the forms of leaves as they grow, whether on ground or branch.

55. In botanical knowledge, and perception of plant-character, my eldest Irish pupil, mamma, was miles and miles my superior; and in powers of design, both the children were so; but the fine methods of measurement and delineation were new to all of them; nor less the charm of faithfully represented colour, in full daylight, and in the open air. Having Turner's mountain drawings of his best time beside us, and any quantity of convolvuluses, hollyhocks, plums, peaches, and apples, to bring in from the garden, the afternoon hours went fast: but so much more in talk than work, that I soon found, if either

triangles or bindweeds were to come to anything, it must
be under the governess's superintendence, not mamma's:
and that I should have to make my way to Green Street,
and up to the schoolroom, after all, on at least two out
of three of the lesson days. Both the children, to my
extreme satisfaction, approved of this arrangement, and
the final order was that whenever I happened to go
through Green Street, I should pay them a visit in the
nursery. Somehow, from that time, most of my London
avocations led me through Green Street.

It chanced above all things well for me that their
governess was a woman of great sense and power, whom
the children entirely loved, and under whom mamma
put herself, in the schoolroom, no less meekly than they;
partly in play, but really also a little subdued by the clear
insight of the fearlessly frank preceptress into her own
faults. I cannot call them "foibles," for her native wit
and strength of character admitted none.

56. Rosie had shortly expressed her sense of her
governess's niceness by calling her "Bun;" and I had not
been long free of the schoolroom before she wanted a
name for me also, significant of like approval. After
some deliberation, she christened me "Crumpet"; then,
impressed by seeing my gentleness to beggars, canonized
me as "Saint Crumpet," or, shortly and practically,
"St. C.,"—which I remained ever afterwards; only
Emily said one day to her sister that the C. did in truth
stand for "Chrysostom."

The drawing, and very soon painting, lessons went on
meantime quite effectively, both the girls working with
quick intelligence and perfect feeling; so that I was soon
able, with their mother's strong help, to make them
understand the essential qualities both of good painting
and sculpture. Rose went on into geology; but only far
enough to find another play-name for me—"Archego-

saurus." This was meant partly to indicate my scientific knowledge of Depths and Ages; partly to admit me more into family relations, her mother having been named, by her cleverest and fondest friend, "Lacerta,"—to signify that she had the grace and wisdom of the serpent, without its poison.

And things went on,—as good girls will know how, through all that winter;—in the spring, the Fates brought the first whirlpool into the current of them, in that (I forget exactly why) it was resolved that they should live by the Cascine of Florence in the spring, and on the Lung' Arno, instead of in the park by the Serpentine. But there was the comfort for me that Rosie was really a little sorry to go away; and that she understood in the most curious way how sorry *I* was.

Some wise, and prettily mannered, people have told me I shouldn't say anything about Rosie at all. But I am too old now to take advice, and I won't have this following letter—the first she ever wrote me—moulder away, when I can read it no more, lost to all loving hearts.

NICE, *Monday, March* 18*th.*

57. DEAREST S^T. CRUMPET—I am so sorry—I couldn't write before, there wasn't one bit of time—I am so sorry you were di_ssap^Pointed—I only got yr letter yesterday (Sunday), & we only got to Nice late on Saturday afternoon—So I have got up so early this morning to try & get a clear hour before breakfast to write to you, which you see I'm doing—So you thought of us, dear S^t. Crumpet, & we too thought so much of you—Thank you very much for the Diary letter; it was so nice of you to write so long a one—I have so much to tell you too Arichigosaurus so I will begin from Dover, & tell what befel us up to Nice—Emily asks me to say that she

did a picture at Dover of Dover Castle in a fog—I think it was to please you—Well we had a roughish passage, but we *

sat on deck & didn't mind—We thought & talked about you—Every great wave that came we called a ninth wave and we thought how pleasant it wd be to sit in a storm and draw them, but I think if you had wanted it done I'd have tryed to do it St. Crumpet—There was what do you think at the prow of our steamer—yr brother Archigosaurus, an alligator, and we said it was you— Well so we got to Calais, breakfasted at the Table d'Hôte there, and then began that weary railroad journey from Calais to Paris—The scenery was just the same all the way—I suppose you know it—Those long straight rows of poplars cut even at the tops & flat uninteresting country. I drew the poPlars in perspective for you St. Crumpet— We got to Paris on

Friday evening & stayed till Wednesday—No, I couldn't I tell you, there wasn't one bit of time or do you think I would not have seized it directly for I know yr thinking why didn't she write—Its too long to say all we did & didn't do in Paris, so I'll only tell about the Louvre and Notre Dame. We went to the Louvre. Oh St. Crumpet how we thought of you there—How we looked and talked about the Titians you told us to look at particu- larly the glass ball one & the white Rabbit—Yes we looked so much at them and we did, all of us, think them so very beautiful—I liked two portraits of Titian's of two dark gentlemen with earnest eyes better than any I think. We thought his skins (I mean the skins he made his picture- people have) so very beautifully done & we looked at the

* I leave pauses where the old pages end.—J. R.

pinks at the corners of the eyes & thought of the Portrait
of Lord Bute's & you again St. Crumpet.

58. We liked the picture of Paul Veronese of the children
playing with the dog very much I think one of them the
most prominent with dark eyes & not looking at the dog is
very beautiful. Why does Paul Veronese put his own
family in the pictures of sacred subjects, I wonder? I
liked the little puppy in the boys arms trying to get away—
The statues in the Louvre I think most beautiful. Is it
wrong St. Crumpet to 'like that noble Venus Victrix as
well as Titian. If it is, am I a hardened little tinner?
Oh but they are so beautiful those statues there's one of
a Venus leaning against a tree with a Lacerta running up
it—Notre Dame they are spoiling as quick as they can
by colouring those grand old pillars with ugly daubs of
green and yellow etc. Is not that "light" in the French?*
It's a bore saying all we thought of Paris, I must get on
to the mountains not to say Alps—Don't be Kinfishery †
dear St. Crumpet; how good it was of you to give yr
Turners that you love so much to the Oxford Museum
From Paris we started early on Wednesday morning &
travelled all day & all the night in the train—Yes you
would have said "Poor Posie" I was bored But we got
over it very well—It was so pleasant to be running after
the sun to the south (Dont be Kingfishery) & awaking at
about 5 in the morning to see long plains of greyheaded
silvery olives and here and there pink perky peach trees
dancing among them—And there were groups of dark
cool cypress trees pointing upwards, & hills & grey rocks
sloping to the sea—the Mediterranean So we shook off

* Referring to a debate over Mrs. Browning's poem in defence of
them; the one in which she says, rightly, that they are no more
"light" than a rifle-ball is.

† *King*fishery. Sitting sulkily on a branch.

our sleepiness, at least Papa Mama and I did for Emily
& Adèle still slept; & saw behind those peaks of craggy
hills a pink smile coming in the sky telling us that the
morning had come really at last So we watched &
suddenly there rose (popped wd be a better word for it
really rose in one instant)

such a sun—"nor dim, nor red" (you know the verse)
& then dipped back again below the hills It was so
beautiful—But I shocked Mama by saying "Jack in the
box" which awoke Emily who declared of course she had
been wide awake and had seen it all. Why do people
always do that, St. Crumpet? This was just before we
came to Marseilles. It had been snowing the day before
& it was nice to go to sleep & wake up in the summer—
We got to Toulon and there we spent the day & oh Archi-
gosaurus we saw so many Lacertas there; again we thought
of you—How can you wish to be a parrot *—are you not
our saint—You wouldn't look a bit nice in a gold laced
cap; don't you know blue is the colour you should wear.
At Toulon it was like July—I don't like such heat—
Transplantation & scorching is too much for an Irish
rose—But I sat with

Mama and Emily on a rock & sketched Toulon Harbour,
(or rather tried to) for you St. Crumpet. Then the next
we posted, the country was so beautiful some of it &
towards evening we saw snowy peaks, they were the
mountains of Savoy. I was pretty tired that night & we
had to sleep at Frejus such a disagreeable place. The
next day we had six horses to our carriage for it was a hilly
road. We walked about two hours of the way over the

* I suppose I had not expressed this farther condition, of being
her father's parrot.

hills* You know what sort of a view there was at the top,
St. Crumpet & how one stands & stares & says nothing
because the words of Grand, Glorious, Beautiful etc
cannot in one quarter express what one thinks. You
the author of M-Ps cd describe it Irish roses can't. But I
can tell you how my cousins the moorland roses nodded at
me as I passed and how they couldn't understand why
Irish hedge roses bloomed in July instead of March

59. I can tell you how the fields were white with Narcissi,
how the roads were edged with mauve-coloured anemones
& how the scarlet anemones stood up in the meadows
tantalizing me in the carriage so much because I wanted
to feel them And there were myrtles (wild) growing
close to the blue Mediterranean & Mama lay down on
them by the seaside at Cannes while Papa and I were
talking to a perfectly deaf old French fisherman who gave
his† to me as he caught them putting them half alive into
my hands, oh, you wd have been alive there Archigosaurus.
How I wish you had been there. Well we got here
(Nice) on Saturday evening & we climbed up an old
Roman Ampitheatre and saw of all sunsets the most
glorious. We said it was like Light in the West,
Beauvais, and again we thought of you Oh St. Crumpet
I think of you so much & of all your dearnesses to me

I wish so very much that you were happy—God can
make you so—We will try not to forget all you taught
us—It was so nice of you. Thank you so much from
both of us.—Mama is very glad you went to Dr. Ferguson

* The Pass of the Esterelle, between Frejus and Nice; more beautiful,
always, to me, than all the groves and cliffs of the Riviera.—J. R.,
1889.

† "Fish" to be understood; also that the fisherman was not
"perfectly" deaf, for papa could not have talked with his eyes only,
as Rose could.

She says you must not give him up. How very kind of you to see & talk to our old man Certainly the name is not beautiful We have all read your letter & we all care for it That was indeed a "dear Irish labourer." I like him so much; such a nice letter. I hope Mr & Mrs Ruskin are well now. Will you give them our love please & take for yourself as much as ever you please. It will be a great deal if you deign to take all we send you. I like Nice but I don't much like being transplanted except going home. I am ever your rose.

Postscript.

Yes, write packets—trunks, & we shall like them so much. Indeed I couldn't write before, I'll try to write again. You must see how we think of you & talk of you —rose posie.

CHAPTER IV

JOANNA'S CARE

60. THE mischances which have delayed the sequence of "Præterita" must modify somewhat also its intended order. I leave Rosie's letter to tell what it can of the beginning of happiest days; but omit, for a little while, the further record of them,—of the shadows which gathered around them, and increased, in my father's illness; and of the lightning which struck him down in death—so sudden, that I find it extremely difficult, in looking back, to realize the state of mind in which it left either my mother or me. My own principal feeling was certainly anxiety for her, who had been for so many years in every thought dependent on my father's wishes, and withdrawn from all other social pleasure as long as she could be *his* companion. I scarcely felt the power I had over her, myself; and was at first amazed to find my own life suddenly becoming to her another ideal; and that new hope and pride were possible to her, in seeing me take command of my father's fortune, permitted by him, from his grave, to carry out the theories I had formed for my political work, with unrestricted and deliberate energy.

My mother's perfect health of mind, and vital religious faith, enabled her to take all the good that was left to her, in the world, while she looked in secure patience for the heavenly future: but there was immediate need for some companionship which might lighten the burden of the days to her.

61. I have never yet spoken of the members of my

grandmother's family, who either remained in Galloway,*
or were associated with my early days in London. Quite
one of the dearest of them at this time, was Mrs. Agnew,
born Catherine Tweddale, and named Catherine after her
aunt, my father's mother. She had now for some years
been living in widowhood; her little daughter, Joan,
only five years old when her father died, having grown
up in their pretty old house at Wigtown,† in the simplicity
of entirely natural and contented life; and, though again
and again under the stress of domestic sorrow, untellable
in the depth of the cup which the death-angels filled for
the child, yet in such daily happiness as her own bright
and loving nature secured in her relations with all those
around her; and in the habits of childish play, or education
then common in the rural towns of South Scotland: of
which, let me say at once that there was greater refine-
ment in them, and more honourable pride, than probably,
at that time, in any other district of Europe; ‡ a certain

* See *Ante*, pp. 61, 62.
† Now pulled down and the site taken for the new county buildings.
The house as it once stood is seen in the centre of the wood-cut at
page 6 of Gordon Fraser's Guide, with the Stewartry hills in the
distance. I have seldom seen a truer rendering of the look of an old
Scottish town.
‡ The following couple of pages, from "Redgauntlet," put in
very few words the points of difference between them and the fatally
progressive follies and vanities of Edinburgh:—
 " 'Come away, Mr. Fairford; the Edinburgh time is later than
ours,' said the Provost.
 " 'And come away, young gentleman,' said the Laird; 'I remember
your father weel, at the Cross, thirty years ago. I reckon you are
as late in Edinburgh as at London; *four* o'clock hours, eh?'
 " 'Not quite so degenerate,' replied Fairford; 'but certainly many
Edinburgh people are so ill-advised as to *postpone their dinner* till
three, that they may have full time to answer their London corre-
spondents.'
 " 'London correspondents!' said Mr. Maxwell; 'and pray, what the
devil have the people of Auld Reekie to do with London correspond-
ents?'
 " 'The tradesmen must have their goods,' said Fairford.

pathetic melody and power of tradition consecrating nearly every scene with some past light, either of heroism or religion.

62. And so it chanced, providentially, that at this moment, when my mother's thoughts dwelt constantly on the past there should be this child near us,—still truly a child, in her powers of innocent pleasure, but already so accustomed to sorrow, that there was nothing that could farther depress her in my mother's solitude. I have not time to tell of the pretty little ways in which it came about, but they all ended in my driving to No. 1, Cambridge Street, on the 19th April, 1864: where her uncle (my cousin, John Tweddale) brought her up to the drawing-room to me, saying, "This is Joan."

I had seen her three years before, but not long enough to remember her distinctly: only I had a notion that she would be "nice," * and saw at once that she *was* entirely nice, both in my mother's way and mine; being now seventeen years and some—well, for example of accuracy and conscience—forty-five days, old. And I very thankfully took her hand out of her uncle's, and received her in trust, saying—I do not remember just what,—

"'Can they not buy our own Scottish manufactures, and pick their customers' pockets in a more patriotic manner?'

"'Then the ladies must have fashions,' said Fairford.

"'Can they not busk the plaid over their heads, as their mothers did? A tartan screen, and once a year a new cockernony from Paris, should serve a countess; but ye have not many of *them* left, I think. Mareschal, Airley, Winton, Wemyss, Balmerino—ay, ay, the countesses and ladies of quality will scarce take up too much of your ballroom floor with their quality hoops nowadays.'

"'There is no want of crowding, however, sir,' said Fairford; 'they begin to talk of a new Assembly Room.'

"'A new Assembly Room!' said the old Jacobite Laird. 'Umph —I mind quartering three hundred men in the Assembly Room you *have*. But, come, come: I'll ask no more questions—the answers all smell of new lords, new lands.' "

* And the word means more, with me, than with Sydney Smith (see his Memoirs); but it means *all* that *he* does, to begin with.

but certainly *feeling* much more strongly than either her uncle or she did, that the gift, both to my mother and me, was one which we should not easily bear to be again withdrawn. I put her into my father's carriage at the door, and drove her out to Denmark Hill. Here is her own account of what followed between my mother and her:—

63. "I was received with great kindness by the dear old lady, who did not inspire *me*, as she did so many other people, with a feeling of awe! We were the best of friends, from the first. She, ever most considerate of what would please *me*, and make me happy; and I, (ever a lover of old ladies!) delighted to find it so easily possible to please *her*.

"Next morning she said, 'Now tell me frankly, child, what you like best to eat, and you shall have it. Don't hesitate; say what you'd really like,—for luncheon to-day, for instance.' I said, truthfully, 'Cold mutton, and oysters'; and this became a sort of standing order (in months with the letter *r!*)—greatly to the cook's amusement.

"Of course I respectfully called the old lady '*Mrs. Ruskin*'; but in a day or two, she told me she didn't like it, and would I call her 'Aunt' or 'Auntie'? I readily did so.

"The days flew in that lovely garden, and as I had only been invited to stay a week, until Mr. Ruskin should return home,* I felt miserable when he did come, thinking I must go back to London streets, and noise; (though I was always very happy with my good uncle and aunts).

"So, when the last evening came, of my week, I said, with some hesitation, 'Auntie, I had better go back to my uncle's to-morrow?'

"She flung down her netting, and turned sharply

* I must have been going away somewhere the day after I brought her to Denmark Hill.

round, saying, 'Are you unhappy, child?' 'Oh no!' said I, 'only my week is up, and I thought it was time——'

"I was not allowed to finish my sentence. She said, 'Never let me hear you say anything again about going; as long as you are happy here, stay, and we'll send for your clothes, and make arrangements about lessons, and everything else here.'

"And thus it came about that I stayed *seven years!*— till I married; going home now and then to Scotland, but always getting pathetic little letters there, telling me to 'come back as soon as my mother could spare me, that I was much missed, and nobody could ever fill my place.' And Auntie was very old then (not that she ever could bear being called *old*, at ninety!), and I could not ever bear the thought of leaving her!"

64. Thus far Joanie; nor virtually have she and I ever parted since. I do not care to count how long it is since her marriage to Arthur Severn; only I think her a great deal prettier now than I did then: but other people thought her extremely pretty then, and I am certain that everybody *felt* the guileless and melodious sweetness of the face. Her first conquest was almost on our threshold; for half an hour or so after we had reached Denmark Hill, Carlyle rode up the front garden, joyfully and reverently received as always; and stayed the whole afternoon; even, (Joan says) sitting with us during our early dinner at five. Many a day after that, he used to come; and one evening, "in describing with some rapture how he had once as a young man had a delightful trip into Galloway, 'where he was most hospitably entertained in the town of Wigtown by a Mr. Tweddale,' I (Joan) said quietly, 'I *am* so glad! That was my grandfather, and Wigtown is my native place!' He turned in a startled, sudden way, saying, 'Bless the child, is that so?' adding some very pretty compliments to my

place and its people, which filled my heart with great pride.
And, on another occasion, after he had been to meet the
Queen at Dean Stanley's, in describing to us some of the
conversation, he made us laugh by telling how, in describ-
ing to Her Majesty the beauty of Galloway, that 'he
believed there was no finer or more beautiful drive in
her kingdom than the one round the shore of the Stewartry,
by Gatehouse of Fleet,' he got so absorbed in his subject
that, in drawing his chair closer to the Queen, he at last
became aware he had fixed it on her dress, and that she
could not move till he withdrew it! Do you think I
may say farther" (Of course, Joanie), "that Carlyle as
a young man often went to my great aunt's (Mrs. Church)
in Dumfriesshire; and he has several times told me that he
considered *her* one of the most remarkable and kindest
women he had ever known. On one occasion while
there, he went to the little Cummertrees Church, where
the then minister (as a joke sometimes called 'Daft Davie
Gillespie') used to speak his mind very plainly from the
pulpit, and while preaching a sermon on 'Youth and
Beauty being laid in the grave,' something tickled Carlyle,
and he was seen to smile; upon which Mr. Gillespie
stopped suddenly, looked with a frown at Carlyle (who
was sitting in my aunt's pew), and said, 'Mistake me not,
young man; it is *youth alone* that *you* possess.' This was
told to me, (Joan,) by an old cousin of mine who heard it,
and was sitting next Carlyle at the time."

65. I am so glad to be led back by Joanie to the
thoughts of Carlyle, as he showed himself to her, and to
me, in those spring days, when he used to take pleasure
in the quiet of the Denmark Hill garden, and to use all
his influence with me to make me contented in my duty
to my mother; which he, as, with even greater insistance,
Turner, always told me was my first;—both of them
seeing, with equal clearness, the happiness of the life that

was possible to me in merely meeting my father's affection and hers, with the tranquil exertion of my own natural powers, in the place where God had set me.

Both at the time, and ever since, I have felt bitter remorse that I did not make Carlyle free of the garden, and his horse of the stables, whether we were at home or not; for the fresh air, and bright view of the Norwood hills, were entirely grateful and healing to him, when the little back garden at Cheyne Row was too hot, or the neighbourhood of it too noisy, for his comfort.

66. And at this time, nearly every opportunity of good, and peace, was granted in Joan's coming to help me to take care of my mother. She was perfectly happy herself, in the seclusion of Denmark Hill; while yet the occasional evenings spent at George Richmond's, or with others of her London friends, (whose circle rapidly widened,) enabled her to bring back to my mother little bits of gossip which were entirely refreshing to both of us; for I used to leave my study whenever Joanie came back from these expeditions, to watch my mother's face in its glittering sympathy. I think I have said of her before, that although not witty herself, her strong sense gave her the keenest enjoyment of kindly humour, whether in saying or incident; and I have seen her laughing, partly *at* Joanie and partly *with* her, till the tears ran down her still brightly flushing cheeks. Joan was never tired of telling her whatever gave her pleasure, nor of reading to her, in quieter time, the books she delighted in, against which, girls less serenely—nay, less religiously, bred, would assuredly have rebelled,—any quantity, for instance, of Miss Edgeworth and Richardson.

(I interrupt myself for a moment to express, at this latter time of life, the deep admiration I still feel for Richardson. The follies of modern novel writing render it impossible for young people to understand the perfection

of the human nature in his conception, and delicacy of
finish in his dialogue, rendering all his greater scenes
unsurpassable in their own manner of art. They belong
to a time of the English language in which it could express
with precision the most delicate phases of sentiment,
necessarily now lost under American, Cockney, or
scholastic slang.)

67. Joanie herself had real faculty and genius in all
rightly girlish directions. She had an extremely sweet
voice, whether in reading or singing; inventive wit,
which was softly satirical, but never malicious; and quite
a peculiar, and perfect, sense of clownish humour, which
never for an instant diminished her refinement, but enabled
her to sing either humorous Scotch, or the brightest
Christy Minstrel carols, with a grace and animation
which, within their gentle limits, could not be surpassed.
She had a good natural faculty for drawing also, not
inventive, but realistic; so that she answered my *first*
lessons with serviceable care and patience; and was soon
able to draw and paint flowers which were a great deal
liker the flowers themselves than my own elaborate
studies;—no one said of them, "What wonderful draw-
ing!" but everybody said, "How like a violet, or a butter-
cup!" At that point, however, she stayed, and yet stays,
to my sorrow, never having advanced into landscape
drawing.

But very soon, also, she was able to help me in arranging
my crystals; and the day divided itself between my
mother's room, the mineral room, the garden, and the
drawing-room, with busy pleasures for every hour.

68. Then, in my favourite readings, the deep interest
which, in his period of entirely central power, Scott had
taken in the scenery of the Solway, rendered everything
that Joanie could tell me of her native bay and its hills,
of the most living interest to me; and although, from my

father's unerring tutorship, I had learned Scott's own
Edinburgh accent with a precision which made the turn
of every sentence precious to me, (and, I believe, my own
rendering of it thoroughly interesting, even to a Scottish
listener,)—yet every now and then Joanie could tell me
something of old, classic, Galloway Scotch, which was
no less valuable to me than a sudden light thrown on a
chorus in Æschylus would be to a Greek scholar;—nay,
only the other day I was entirely crushed by her interpret-
ing to me, for the first time, the meaning of the name of
the village of Captain Clutterbuck's residence,—Kenna-
quhair.*

69. And it has chiefly been owing to Joan's help,—
and even so, only within the last five or six years,—that
I have fully understood the power, not on Sir Walter's
mind merely, but on the character of all good Scotchmen,
(much more, good Scotchwomen,) of the two lines of
coast from Holy Island to Edinburgh, and from Annan
to the Mull of Galloway. Between them, if the reader
will glance at any old map which gives rivers and moun-
tains, instead of railroads and factories, he will find that
all the highest intellectual and moral powers of Scotland

* "Ken na' where"! Note the cunning with which Scott himself
throws his reader off the scent, in the first sentence of "The Monas-
tery," by quoting the learned Chalmers "for the derivation of the
word '*Quhair*,' from the winding course of the stream; a definition
which coincides in a remarkable degree with the serpentine turns of
the Tweed"! ("It's a *serpentine turn* of his own, I think!" says
Joanie, as I show her the sentence,) while in the next paragraph he
gives an apparently historical existence to "the village of which we
speak," by associating it with Melrose, Jedburgh, and Kelso, in the
"splendour of foundation by David I.," and concludes, respecting the
lands with which the king endowed these wealthy fraternities, with a
grave sentence, perhaps the most candid ever written by a Scotsman,
of the centuries preceding the Reformation: "In fact, for several ages
the possessions of these Abbies were each sort of Goshen, enjoying
the calm light of peace and immunity, while the rest of the country,
occupied by wild clans and marauding barons, was one dark scene
of confusion, blood, and unremitted outrage."

were developed, from the days of the Douglases at Loch-
maben, to those of Scott in Edinburgh,—Burns in Ayr,
—and Carlyle at Ecclefechan, by the *pastoral* country,
everywhere habitable, but only by hardihood under suffer-
ing, and patience in poverty; defending themselves always
against the northern Pictish war of the Highlands, and
the southern, of the English Edwards and Percys, in the
days when whatever was loveliest and best of the Catholic
religion haunted still the—then *not* ruins,—of Melrose,
Jedburgh, Dryburgh, Kelso, Dumblane, Dundrennan,
New Abbey of Dumfries, and, above all, the most ancient
Cave of Whithorn,—the Candida Casa of St. Ninian;
while perfectly sincere and passionate forms of Evangeli-
calism purified and brightened the later characters of
shepherd Cameronian life, being won, like all the great
victories of Christianity, by martyrdoms, of which the
memory remains most vivid by those very shores where
Christianity was first planted in Scotland,—Whithorn is
I think, only ten miles south of Wigtown Bay; and in
the churchyard of Wigtown, close to the old Agnew
burying-ground, (where most of Joanie's family are laid,)
are the graves of Margaret MacLachlan, and Margaret
Wilson, over which in rhythm is recorded on little square
tombstones the story of their martyrdom.

70. It was only, I repeat, since what became practically
my farewell journey in Italy in 1882, that I recovered
the train of old associations by re-visiting Tweedside, from
Coldstream up to Ashestiel; and the Solway shores from
Dumfries to Whithorn; and while what knowledge I
had of southern and foreign history then arranged itself
for final review, it seemed to me that this space of low
mountain ground, with the eternal sublimity of its rocky
seashores, of its stormy seas and dangerous sands; its
strange and mighty crags, Ailsa and the Bass, and its
pathless moorlands, haunted by the driving cloud, had

been of more import in the true world's history than all
the lovely countries of the South, except only Palestine.
In my quite last journey to Venice I was, I think, justly
and finally impressed with the sadness and even *weakness*
of the Mediterranean coasts; and the temptation to human
nature, there, to solace itself with debasing pleasures;
while the very impossibility of either accumulating the
treasures, or multiplying the dreams, of art, among those
northern waves and rocks, left the spirit of man strong
to bear the hardships of the world, and faithful to obey
the precepts of Heaven.

71. It is farther strange to me, even now, on reflection
—to find how great the influence of this double ocean
coast and Cheviot mountain border was upon Scott's
imagination; and how salutary they were in withdrawing
him from the morbid German fancies which proved so
fatal to Carlyle: but there was this grand original differ-
ence between the two, that, with Scott, his story-telling
and singing were all in the joyful admiration of that past
with which he could re-people the scenery he gave the
working part of his day to traverse, and all the sensibility
of his soul to love; * while Carlyle's mind, fixed anxiously
on the future, and besides embarrassed by the practical
pinching, as well as the unconfessed shame, of poverty,
saw and felt from his earliest childhood nothing but the
faultfulness and gloom of the Present.

* Yet, remember, so just and intense is his perception, and so stern
his condemnation, of whatever is *corrupt* in the Scottish character,
that while of distinctly evil natures—Varney, Rashleigh, or Lord
Dalgarno—he takes world-wide examples,—the unpardonable base-
ness of so-called respectable or religious persons, and the cruelties of
entirely selfish soldiers, are always Scotch. Take for the highest
type the Lord Lindsay of "The Abbot," and for the worst, Morton
in "The Monastery," then the terrible, *because* at first sincere,
Balfour of Burleigh in "Old Mortality"; and in lower kind, the
Andrew Fairservice and MacVittie of "Rob Roy," the Peter Peebles
of "Redgauntlet," the Glossin of "Guy Mannering," and the
Saddletree of the "Heart of Midlothian."

It has been impossible, hitherto, to make the modern reader understand the vastness of Scott's true historical knowledge, underneath its romantic colouring, nor the concentration of it in the production of his eternally great poems and romances. English ignorance of the Scottish dialect is at present nearly total; nor can it be without very earnest effort, that the melody of Scott's verse, or the meaning of his dialogue, can ever again be estimated. He must now be read with the care which we give to Chaucer; but with the greater reward, that what is only a dream in Chaucer, becomes to us, understood from Scott, a consummate historical morality and truth.

72. The first two of his great poems, "The Lay of the Last Minstrel" and "Marmion," are the re-animation of Border legends, closing with the truest and grandest battle-piece that, so far as I know, exists in the whole compass of literature *;—the absolutely fairest in justice to both contending nations, the absolutely most beautiful in its conceptions of both. And that the palm in that conception remains with the Scotch, through the sorrow of their defeat, is no more than accurate justice to the national character, which rose from the fraternal branches of the Douglas of Tantallon and the Douglas of Dunkeld. But,—between Tantallon and Dunkeld,—what moor or mountain is there over which the purple cloud of Scott's imagination has not wrapt its light, in those two great poems?—followed by the entirely heroic enchantment of "The Lady of the Lake," dwelling on the Highland virtue which gives the strength of clanship, and the Lowland honour of knighthood, founded on the Catholic religion. Then came the series of novels, in which, as

* I include the literature of all foreign languages, so far as known to me: there is nothing to approach the finished delineation and flawless majesty of conduct in Scott's Flodden.

I have stated elsewhere,* those which dealt with the
history of other nations, such as "Ivanhoe," "Kenil-
worth," "Woodstock," "Quentin Durward," "Peveril of
the Peak," "The Betrothed," and "The Crusaders,"
however attractive to the general world, were continually
weak in fancy, and false in prejudice; but the literally
Scotch novels, "Waverley," "Guy Mannering," "The
Antiquary," "Old Mortality," "The Heart of Mid-
lothian," "The Abbot," "Redgauntlet," and "The For-
tunes of Nigel," *are*, whatever the modern world may
think of them, as faultless, throughout, as human work
can be: and eternal examples of the ineffable art which
is taught by the loveliest nature to her truest children.

Now of these, observe, "Guy Mannering," "Red-
gauntlet," a great part of "Waverley," and the beautiful
close of "The Abbot," pass on the two coasts of Solway.
The entire power of "Old Mortality" rises out of them,
and their influence on Scott is curiously shown by his
adoption of the name "Ochiltree" for his bedesman of
Montrose, coming, not from the near hills, as one at first
fancies, but from the Ochiltree Castle, which in Mer-
cator's old map of 1637 I find in the centre of the arch-
bishopric, then extending from Glasgow to Wigtown, and
correspondent to that of St. Andrew's on the east,—the
subordinate bishopric of Candida Casa, answering to that
of Dunkeld, with the bishoprics of the isles Sura, Mura,
and Isla. It is also, Mercator adds in his note, called
the "bishopric of Galloway."

73. "Even I," says Joanie, again, "remember old people
who knew the real 'Old Mortality.' He used to come
through all the Galloway district to clean and re-cut the
old worn gravestones of the martyrs; sometimes, I have
been told, to the long since disused kirkyard of Kirkchrist,
the place where my great aunt, Mrs. Church (Carlyle's

* "On the Old Road," Fiction—Fair and Foul.—Ed.

friend, of whom I have spoken) began her married life. Kirkchrist is just on the opposite side from Kirkcudbright, overlooking the River Dee."

I must go back to a middle-aged map of 1773, to find the noble river rightly traced from its source above Kenmure Castle to the winding bay which opens into Solway, by St. Mary's Isle; where Kirkchrist is marked as Christ K, with a cross, indicating the church then existing.

I was staying with Arthur and Joan, at Kenmure Castle itself in the year 1876, and remember much of its dear people: and, among the prettiest scenes of Scottish gardens, the beautiful trees on the north of that lawn on which the last muster met for King James; "and you know," says Joanie, "the famous song that used to inspire them all, of 'Kenmure's on and awa, Willie!' " * The thoughts come too fast upon me, for before Joanie said this, I was trying to recollect on what height above Solway, Darsie Latimer pauses with Wandering Willie, in whom Scott records for ever the glory,—not of Scottish music only, but of all *Music*, rightly so called,—which is a part of God's own creation, becoming an expression of the purest hearts.

74. I cannot pause now to find the spot,† and still less the churchyard in which, at the end of Wandering Willie's tale, his grandsire wakes: but, to the living reader, I have this to say very earnestly, that the whole glory and blessing of these sacred coasts depended on the rise and fall of their eternal sea, over sands which the sunset gilded with its

* "Lady Huntley plays Scotch tunes like a Highland angel. She ran a set of variations on 'Kenmure's on and awa',' which I told her were enough to raise a whole countryside. I never in my life heard such fire thrown into that sort of music."—*Sir Walter writing to his daughter Sophia. Lockhart's "Life,"* vol. iv., page 371.

† It is on the highest bit of moor between Dumfries and Annan. Wandering Willie's "parishine" is only thus defined in "Redgauntlet" —"They ca' the place Primrose Knowe."

withdrawing glow, from the measureless distances of the
west, on the ocean horizon, or veiled in silvery mists, or
shadowed with fast-flying storm, of which nevertheless
every cloud was pure, and the winter snows blanched in
the starlight. For myself, the impressions of the Solway
sands are a part of the greatest teaching that ever I received
during the joy of youth:—for Turner, they became the
most pathetic that formed his character in the prime of
life, and the five Liber Studiorum subjects, "Solway
Moss," "Peat Bog, Scotland," "The Falls of Clyde,"
"Ben Arthur," and "Dumblane Abbey," remain more
complete expressions of his intellect, and more noble
monuments of his art, than all his mightiest after work,
until the days of sunset in the west came for *it* also.

75. As "Redgauntlet" is, in its easily readable form,
inaccessible, nowadays, I quote at once the two passages
which prove Scott's knowledge of music, and the strong
impression made on him by the scenery between Dumfries
and Annan. Hear, first, of Darsie Latimer's escape from
the simplicity of his Quaker friends to the open downs of
the coast which had formerly seemed so waste and dreary.
"The air I breathed felt purer and more bracing; the
clouds, riding high upon a summer breeze, drove in gay
succession over my head, now obscuring the sun, now
letting its rays stream in transient flashes upon various parts
of the landscape, and especially upon the broad mirror of
the distant Frith of Solway."

A moment afterwards he catches the tune of "Old Sir
Thom a Lyne," sung by three musicians cosily niched
into what you might call a *bunker*,* a little sandpit, dry
and snug, surrounded by its banks, and a screen of furze
in full bloom. Of whom the youngest, Benjie, "at first
somewhat dismayed at my appearance, but calculating on

* This is a modern word, meaning, first, a large chest; then, a
recess scooped in soft rock.

my placability, almost in one breath assured the itinerants
that I was a grand gentleman, and had plenty of money,
and was very kind to poor folk, and informed *me* that this
was Willie Steenson, 'Wandering Willie, the best fiddler
that ever kittled thairm (cat-gut) with horsehair.' I asked
him if he was of this country. '*This* country!' replied
the blind man, 'I am of every country in broad Scotland,
and a wee bit of England to the boot. But yet I am in
some sense of this country, *for I was born within hearing
of the roar of Solway.*' "

76. I must pause again to tell the modern reader that
no word is ever used by Scott in a hackneyed sense. For
three hundred years of English commonplace, *roar* has
rhymed to *shore*, as *breeze* to *trees;* yet in this sentence
the word is as powerful as if it had never been written till
now! for no other sound of the sea is for an instant com-
parable to the breaking of deep ocean, as it rises over great
spaces of sand. In its rise and fall on a rocky coast, it is
either perfectly silent, or, if it strike, it is with a crash, or
a blow like that of a heavy gun. Therefore, under
ordinary conditions, there may be either *splash*, or *crash*,
or *sigh*, or *boom;* but not *roar*. But the hollow sound of
the countless ranks of surfy breakers, rolling mile after
mile in ceaseless following, every one of them with the
apparent anger and threatening of a fate which is assured
death unless fled from,—the sound of this approach, over
quicksands, and into inextricable gulfs of mountain bay,
this, heard far out at sea, or heard far inland, through the
peace of secure night—or stormless day, is still an eternal
voice, with the harmony in it of a mighty law, and the
gloom of a mortal warning.

77. "The old man preluded as he spoke, and then
taking the old tune of 'Galashiels' for his theme, he graced
it with a wildness of complicated and beautiful variations;
during which it was wonderful to observe how his sightless

face was lighted up under the conscious pride and heartfelt delight in the exercise of his own very considerable powers.

" 'What think you of that now, for threescore and twa?' "

I pause again to distinguish this noble pride of a man of unerring genius, in the power which all his life has been too short to attain, up to the point he conceives of, —from the base complacency of the narrow brain and dull heart, in their own chosen ways of indolence or error.

The feeling comes out more distinctly still, three pages forward, when his wife tells him, "The gentleman is a gentleman, Willie; ye maunna speak that gate to him, hinnie." "The deevil I maunna!" said Willie,* "and what for maunna I? If he was ten gentles, he *canna draw a bow like me, can he?*"

78. I need to insist upon this distinction, at this time in England especially, when the names of artists, whose birth was an epoch in the world's history, are dragged through the gutters of Paris, Manchester, and New York, to decorate the last puffs written for a morning concert, or a monthly exhibition. I have just turned out of the house a book in which I am told by the modern picture dealer that Mr. A., B., C., D., or F. is "the Mozart of the nineteenth century"; the fact being that Mozart's

* Joanie tells me she has often heard the fame of the *real* Wandering Willie spoken of: he was well known in travel from the Border right into Galloway, stopping to play in villages and at all sorts of out-of-the-way houses, and, strangely, succeeded by a *blind woman* fiddler, who used to come led by a sister; and the chief singing lessons in Joanie's young days were given through Galloway by a *blind man*, who played the fiddle to perfection; and his ear was so correct that if in a class of fifty voices one note was discordant, he would stop instantly, tap loudly on the fiddle with the back of his bow, fly to the spot where the wrong note came from, pounce on the person, and say, 'It was *you*, and it's no use denying it; if I can't *see*, I can *hear!*' and he'd make the culprit go over and over the phrase till it was conquered. He always opened the class with a sweeping scale, dividing off so many voices to each note, to follow in succession.

birth wrote the laws of melody for all the world as irrevoc-
ably as if they had been set down by the waves of Solway;
and as widely as the birth of St. Gregory in the sixth
century fixed to *its* date for ever the establishment of the
laws of musical expression. Men of perfect genius are
known in all centuries by their perfect respect to all law,
and love of past tradition; their work in the world is
never innovation, but new creation; without disturbing
for an instant the foundations which were laid of old
time. One would have imagined—at least, any one but
Scott would have imagined—that a Scottish blind fiddler
would have been only the exponent of Scottish feeling
and Scottish art; it was even with astonishment that I
myself read the conclusion of his dialogue with Darsie
Latimer: " 'Are ye in the wont of drawing up wi' all
the gangrel bodies that ye meet on the high road, or find
cowering in a sand-bunker upon the links?' demanded
Willie.

" 'Oh, no! only with honest folks like yourself, Willie,'
was my reply.

" 'Honest folks like me! How do ye ken whether I
am honest, or what I am? I may be the deevil himsell
for what ye ken; for he has power to come disguised like
an angel of light; and besides, he is a prime fiddler. He
played a sonata to *Corelli*, ye ken.' "

79. This reference to the simplest and purest writer
of Italian melody being not for the sake of the story, but
because Willie's own art had been truly founded upon him,
so that he had been really an angel of music, as well as
light to him. See the beginning of the dialogue in the
previous page. " 'Do you ken the Laird?' said Willie,
interrupting an overture of Corelli, of which he had
whistled several bars with great precision."

I must pause again, to crowd together one or two
explanations of the references to music in my own writings

hitherto, which I can here sum by asking the reader to compare the use of the voice in war, beginning with the cry of Achilles on the Greek wall, down to what may be named as the two great instances of modern choral war-song: the singing of the known Church-hymn * at the Battle of Leuthen ("Friedrich," vol. ii., p. 259), in which "five-and-twenty thousand victor voices joined":

> "Now thank God one and all,
> With heart, with voice, with hands,
> Who wonders great hath done
> To us and to all lands;"—

and, on the counter side, the song of the Marseillaise on the march to Paris, which began the conquests of the French Revolution, in turning the tide of its enemies. Compare these, I say, with the debased use of modern military bands at dinners and dances, which inaugurate such victory as *we* had at the Battle of Balaclava, and the modern no-Battle of the Baltic, when our entire war fleet, a vast job of ironmongers, retreated, under Sir C. Napier, from before the Russian fortress of Cronstadt.

80. I preface with this question the repetition of what I have always taught, that the Voice is the eternal musical instrument of heaven and earth, from angels down to birds. Half way between them, my little Joanie sang me yesterday, 13th May, 1889, "Farewell, Manchester," and "Golden Slumbers," two pieces of consummate melody, which can only be expressed by the voice, and belonging to the group of like melodies which have been, not invented, but inspired, to all nations in the days of their loyalty to God, to their prince, and to themselves. That Manchester has since become the funnel of a volcano, which, not content with vomiting pestilence, gorges the

* *Psalm*, I believe, rather; but see my separate notes on St. Louis' Psalter (now in preparation).

whole rain of heaven, that falls over a district as distant
as the ancient Scottish border,—is not indeed wholly
Manchester's fault, nor altogether Charles Stuart's fault;
the beginning of both faults is in the substitution of
mercenary armies for the troops of nations *led* by their
kings. Had Queen Mary led, like Zenobia, at Langside;
had Charles I. charged instead of Prince Rupert at Naseby;
and Prince Edward bade Lochiel follow *him* at Culloden,
we should not to-day have been debating who was to be
our king at Birmingham or Glasgow. For the rest I
take the bye-help that Fors gives me in this record of the
power of a bird's voice only.*

81. But the distinction of the music of Scotland from
every other is in its association with sweeter natural
sounds, and filling a deeper silence. As Fors also ordered
it, yesterday afternoon, before Joanie sang these songs to
me, I had been, for the first time since my return from
Venice, down to the shore of my own lake, with her and
her two youngest children, at the little promontory of
shingle thrown out into it by the only mountain brook on
this eastern side, (Beck Leven,) which commands the
windings of its wooded shore under Furness Fells, and the
calm of its fairest expanse of mirror wave,—a scene which
is in general almost melancholy in its perfect solitude; but,

* "An extraordinary scene is to be witnessed every evening at
Leicester in the freemen's allotment gardens, where a nightingale has
established itself. The midnight songster was first heard a week ago,
and every evening hundreds of people line the roads near the trees
where the bird has his haunt. The crowds patiently wait till the
music begins, and the bulk of the listeners remain till midnight, while
a number of enthusiasts linger till one and two o'clock in the morning.
Strange to say, the bird usually sings in a large thorn bush just over
the mouth of the tunnel of the Midland main line, but the songster
is heedless of noise, and smoke, and steam, his stream of song being
uninterrupted for four or five hours every night. So large has been
the throng of listeners that the chief constable has drafted a number
of policemen to maintain order and prevent damage."—*Pall Mall
Gazette,* May 11th, 1889.

when the woods are in their gladness, and the green—
how much purer, how much softer than ever emerald!—
of their unsullied spring, and the light of dawning summer,
possessing alike the clouds and mountains of the west,—
it is, literally, one of the most beautiful and strange
remnants of all that was once most sacred in this British
land,—all to which we owe, whether the heart, or the
voice, of the Douglas "tender and true," or the minstrel
of the Eildons, or the bard of Plynlimmon, or the Ellen
of the lonely Isle,—to whose lips Scott has entrusted the
most beautiful Ave Maria that was ever sung, and which
can never be sung rightly again until it is remembered that
the harp is the true ancient instrument of Scotland, as
well as of Ireland.*

I am afraid of being diverted too far from Solway
Moss, and must ask the reader to look back to my des-
cription of the Spirit of music in the Spanish chapel at

* Although the violin was known as early as 1270, and occurs
again and again in French and Italian sculpture and illumination,
its introduction, in superseding both the voice, the golden bell, and
the silver trumpet, was entirely owing to the demoralization of the
Spanish kingdom in Naples, of which Evelyn writes in 1644, "The
building of the city is, for the size, the most magnificent in Europe.
To it belongeth three thousand churches and monasteries, and those
best built and adorned of any in Italy. They greatly affect the
Spanish gravity in their habit, delight in good horses, the streets are
full of gallants on horseback, and in coaches and sedans, from hence
first brought into England by Sir Sanders Duncomb; the country
people so jovial, and addicted to music, that the very husbandmen
almost universally play on the guitar, singing and composing songs
in praise of their sweethearts, and will commonly go to the field with
their fiddle,—they are merry, witty, and genial, all which I attribute
to the excellent quality of the air."

What Evelyn means by the *fiddle* is not quite certain, since he
himself, going to study "in Padua, far beyond the sea," there learned
to play on "ye theorba, taught by Signior Dominico Bassano, who
had a daughter married to a doctor of laws, that played and sung *to
nine* several instruments, with that skill and addresse as few masters
in Italy exceeded her; she likewise composed divers excellent pieces.
I had never seen any play on the *Naples viol* before."

Florence ("The Strait Gate," pages 134 and 135), re-
membering only this passage at the beginning of it, "After
learning to reason, you will learn to sing: for you will
want to. There is much reason for singing in the
sweet world, when one thinks rightly of it. None for
grumbling, provided always you *have* entered in at the
strait gate. You will sing all along the road, then,
in a little while, in a manner pleasant for other people
to hear."

82. I will only return to Scott for one half page more,
in which he has contrasted with his utmost masterhood
the impressions of English and Scottish landscape. Few
scenes of the world have been oftener described, with the
utmost skill and sincerity of authors, than the view from
Richmond Hill sixty years since; but none can be com-
pared with the ten lines in "The Heart of Midlothian,"
edition of 1830, page 374. "A huge sea of verdure,
with crossing and intersecting promontories of massive
and tufted groves, was tenanted by numberless flocks and
herds, which seemed to wander unrestrained, and un-
bounded, through the rich pastures. The Thames,
here turreted with villas, and there garlanded with forests,
moved on slowly and placidly, like the mighty monarch
of the scene, to whom all its other beauties were but
accessories, and bore on his bosom a hundred barks and
skiffs, whose white sails and gaily fluttering pennons gave
life to the whole.

"As the Duke of Argyle looked on this inimitable
landscape, his thoughts naturally reverted to his own more
grand and scarce less beautiful domains of Inverary.
'This is a fine scene,' he said to his companion, curious
perhaps to draw out her sentiments; 'we have nothing
like it in Scotland.' 'It's braw rich feeding for the cows,
and they have a fine breed o' cattle here,' replied Jeanie;
'but I like just as weel to look at the craigs of Arthur's

Seat, and the sea coming in ayont them, as at a' thae muckle trees.'"

83. I do not know how often I have already vainly dwelt on the vulgarity and vainness of the pride in mere magnitude of timber which began in Evelyn's "Sylva," and now is endlessly measuring, whether Californian pines or Parisian towers,—of which, though they could darken continents, and hide the stars, the entire substance, cost, and pleasure are not worth one gleam of leafage in Kelvin Grove, or glow of rowan tree by the banks of Earn, or branch of wild rose of Hazeldean;—but I may forget, unless I speak of it here, a walk in Scott's own haunt of Rhymer's Glen,* where the brook is narrowest in its sandstone bed, and Mary Ker stopped to gather a wild rose for me. Her brother, then the youngest captain in the English navy, afterwards gave his pure soul up to his Captain, Christ,—not like banished Norfolk, but becoming a monk in the Jesuits' College, Hampton.

84. And still I have not room enough to say what I should like of Joanie's rarest, if not chiefest merit, her beautiful dancing. *Real* dancing, not jumping, or whirl-

* "Captain Adam Ferguson, who had written, from the lines of Torres Vedras, his hopes of finding, when the war should be over, some sheltering cottage upon the Tweed, within a walk of Abbotsford, was delighted to see his dreams realized; and the family took up their residence next spring at the new house of Toftfield, on which Scott then bestowed, at the ladies' request, the name of *Huntley Burn;*— this more harmonious designation being taken from the mountain brook which passes through its grounds and garden,—the same famous in tradition as the scene of Thomas the Rhymer's interviews with the Queen of Fairy.

"On completing this purchase, Scott writes to John Ballantyne: —'Dear John,—I have closed with Usher for his beautiful patrimony, which makes me a great laird. I am afraid the people will take me up for coining. Indeed these novels, while their attractions last, are something like it. I am very glad of *your* good prospects. Still I cry, *Prudence! Prudence!* Yours truly, W. S.'"—*Lockhart's "Life,"* vol. iv., page 82.

ing, or trotting, or jigging, but dancing,—like Green
Mantle's in "Redgauntlet," winning applause from men
and gods, whether the fishermen and ocean Gods of
Solway, or the marchmen and mountain Gods of
Cheviot.* Rarest, nowadays, of all the gifts of cultivated

* I must here once for all explain distinctly to the most matter-of-
fact reader, the sense in which throughout all my earnest writing of
the last twenty years I use the plural word "gods." I mean by it,
the totality of spiritual powers, delegated by the Lord of the universe
to do, in their several heights, or offices, parts of His will respecting
men, or the world that man is imprisoned in;—not as myself knowing,
or in security believing, that there are such, but in meekness accepting
the testimony and belief of all ages, to the presence, in heaven and
earth, of angels, principalities, powers, thrones, and the like,—with
genii, fairies, or spirits ministering and guardian, or destroying or
tempting; or aiding good work and inspiring the mightiest. For all
these, I take the general word "gods," as the best understood in all
languages, and the truest and widest in meaning, including the minor
ones of seraph, cherub, ghost, wraith, and the like; and myself know-
ing for an indisputable fact, that no true happiness exists, nor is any
good work ever done by human creatures, but in the sense or imagina-
tion of such presences. The following passage from the first volume
of "Fors Clavigera" gives example of the sense in which I most
literally and earnestly refer to them:—
"You think it a great triumph to make the sun draw brown
landscapes for you! That was also a discovery and some day may
be useful. But the sun had drawn landscapes before for you, not
in brown, but in green, and blue, and all imaginable colours, here in
England. Not one of you ever looked at them, then; not one of you
cares for the loss of them, now, when you have shut the sun out with
smoke, so that he can draw nothing more, except brown blots through
a hole in a box. There was a rocky valley between Buxton and
Bakewell, once upon a time, divine as the vale of Tempe; you might
have seen the gods there morning and evening,—Apollo and all the
sweet Muses of the Light, walking in fair procession on the lawns of
it, and to and fro among the pinnacles of its crags. You cared neither
for gods nor grass, but for cash (which you did not know the way to
get). You thought you could get it by what the *Times* calls 'Railroad
Enterprise.' You enterprised a railroad through the valley, you
blasted its rocks away, heaped thousands of tons of shale into its
lovely stream. The valley is gone, and the gods with it; and now,
every fool in Buxton can be at Bakewell in half-an-hour, and every
fool in Bakewell at Buxton; which you think a lucrative process of
exchange, you Fools everywhere!"

womankind. It *used* to be said of a Swiss girl, in terms
of commendation, she "prays well and dances well;" but
now, no human creature can pray at the pace of our
common prayers, or dance at the pace of popular gavottes,
—more especially the last; for however fast the clergyman
may gabble, or the choir-boys yowl, their psalms, an
earnest reader can always *think* his prayer, to the end of
the verse; but no mortal footing can give either the right
accent, or the due pause, in any beautiful step, at the pace
of modern waltz or polka music. Nay, even the last
quadrille I ever saw well danced, (and would have given
half my wits to have joined hands in,) by Jessie and Vicky
Vokes, with Fred and Rosina, was in truth *not* a quadrille,
or four-square dance, but a beautifully flying romp. But
Joanie could always dance everything *rightly*,* having not
only the brightest light and warmth of heart, but a faultless
foot; faultless in freedom—never narrowed, or lifted into
point or arch by its boot or heel, but level, and at ease;
small, *almost* to a fault, and in its swiftest steps rising and

* Of *right* dancing, in its use on the stage, see the repeated notices
in "Time and Tide." Here is the most careful one:—"She did it
beautifully and simply, as a child ought to dance. She was not an
infant prodigy; there was no evidence, in the finish or strength of her
motion, that she had been put to continual torture through half her
eight or nine years. She did nothing more than any child, well
taught, but painlessly, might do. She caricatured no older person,—
attempted no curious or fantastic skill. She was dressed decently,—
she moved decently,—she looked and behaved innocently,—and she
danced her joyful dance with perfect grace, spirit, sweetness, and
self-forgetfulness. And through all the vast theatre, full of English
fathers and mothers and children, there was not one hand lifted to give
her sign of praise but mine.

"Presently after this came on the forty thieves, who, as I told you,
were girls; and there being no thieving to be presently done, and time
hanging heavy on their hands, arms, and legs, the forty thief-girls
proceeded to light forty cigars. Whereupon the British public gave
them a round of applause.

"Whereupon I fell a-thinking; and saw little more of the piece,
except as an ugly and disturbing dream."

falling with the gentleness which only Byron has found
words for—

> "Naked foot,
> That shines like snow—and falls on earth as mute."

The modern artificial ideal being, on the contrary, ex-
pressed by the manner of stamp or tap, as in the Laureate's
line—

> "She tapped her tiny silken-sandalled foot."

From which type the way is short, and has since been
traversed quickly, to the conditions of patten, clog, golosh,
and high-heeled bottines, with the real back of the foot
thrown behind the ankle like a negress's, which have dis-
tressed alike, and disgraced, all feminine motion for the
last quarter of a century,—the slight harebell having little
chance enough of raising its head, once well under the
hoofs of our proud maidenhood, decorate with dead robins,
transfixed humming birds, and hot-house flowers,—for its
"Wedding March by Mendelssohn." To think that
there is not enough love or praise in all Europe and
America to invent one other tune for the poor things to
strut to!

85. I draw back to my own home, twenty years ago,
permitted to thank Heaven once more for the peace, and
hope, and loveliness of it, and the Elysian walks with
Joanie, and Paradisiacal with Rosie, under the peach-
blossom branches by the little glittering stream which I
had paved with crystal for them. I had built behind the
highest cluster of laurels a reservoir, from which, on
sunny afternoons, I could let a quite rippling film of water
run for a couple of hours down behind the hayfield, where
the grass in spring still grew fresh and deep. There used
to be always a corncrake or two in it. Twilight after
twilight I have hunted that bird, and never once got

glimpse of it: the voice was always at the other side of
the field, or in the inscrutable air or earth. And the little
stream had its falls, and pools, and imaginary lakes. Here
and there it laid for itself lines of graceful sand; there
and here it lost itself under beads of chalcedony. It
wasn't the Liffey, nor the Nith, nor the Wandel; but
the two girls were surely a little cruel to call it "The
Gutter"! Happiest times, for all of us, that ever were
to be; not but that Joanie and her Arthur are giddy
enough, both of them yet, with their five little ones, but
they have been sorely anxious about me, and I have been
sorrowful enough for myself, since ever I lost sight of
that peach-blossom avenue. "Eden-land" Rosie calls it
sometimes in her letters. Whether its tiny river were
of the waters of Abana, or Euphrates, or Thamesis, I
know not, but they were sweeter to my thirst than the
fountains of Trevi or Branda.

86. How things bind and blend themselves together!
The last time I saw the Fountain of Trevi, it was from
Arthur's father's room—Joseph Severn's, where we both
took Joanie to see him in 1872, and the old man made
a sweet drawing of his pretty daughter-in-law, now in
her schoolroom; he himself then eager in finishing his
last picture of the Marriage in Cana, which he had caused
to take place under a vine trellis, and delighted himself
by painting the crystal and ruby glittering of the changing
rivulet of water out of the Greek vase, glowing into wine.
Fonte Branda I last saw with Charles Norton,* under

* I must here say of Joanna and Charles Norton this much farther,
that they were mostly of a mind in the advice they gave me about my
books; and though Joan was, as it must have been already enough
seen, a true-bred Jacobite, she curiously objected to my early Catholic
opinions as roundly as either Norton or John P. Robinson. The
three of them—not counting Lady Trevelyan or little Connie, (all
together *five* opponent powers)—may be held practically answerable
for my having never followed up the historic study begun in Val
d'Arno, for it chanced that, alike in Florence, Siena, and Rome, all

the same arches where Dante saw it. We drank of it
together, and walked together that evening on the hills
above, where the fireflies among the scented thickets
shone fitfully in the still undarkened air. *How* they
shone! moving like fine-broken starlight through the
purple leaves. How they shone! through the sunset that
faded into thunderous night as I entered Siena three days
before, the white edges of the mountainous clouds still
lighted from the west, and the openly golden sky calm
behind the Gate of Siena's heart, with its still golden words,
"Cor magis tibi Sena pandit," and the fireflies everywhere
in sky and cloud rising and falling, mixed with the light-
ning, and more intense than the stars.

 BRANTWOOD,
 June 19th, 1889.

these friends, tutors, or enchantresses were at different times amusing
themselves when I was at my hardest work; and many happy days
were spent by all of us in somewhat luxurious hotel life, when by rights
I should have been still under Padre Tino in the sacristy of Assisi,
or Cardinal Agostini at Venice, or the Pope himself at Rome, with
my much older friend than any of these, Mr. Rawdon Brown's per-
fectly faithful and loving servant Antonio. Of Joanna's and
Connie's care of *me* some further history will certainly, if I live, be
given in No. VII, "The Rainbows of Giesbach"; of Charles Norton's
visit to me there also.

DILECTA

CORRESPONDENCE, DIARY NOTES, AND
EXTRACTS FROM BOOKS,

ILLUSTRATING

PRÆTERITA

ARRANGED BY
JOHN RUSKIN

PREFACE

THE readers of PRÆTERITA must by this time have seen that the limits of its design do not allow the insertion of any but cardinal correspondence. They will, of course, also know that during a life like mine, I must have received many letters of general interest, while those of my best-regarded friends are often much more valuable than my own sayings. Of these I will choose what I think should not be lost, which, with a few excerpts of books referred to, I can arrange at odd times for the illustration of PRÆTERITA, while yet the subscribers to that work need not buy the supplemental one unless they like. But, for the convenience of those who wish to have both, their form and type will be the same.

The letters will not be arranged chronologically, but as they happen, at any time, to bear on the incidents related in the main text. Thus I begin with some of comparatively recent date, from my very dear friend Robert Leslie, George Leslie's brother, of extreme importance in illustration of points in the character of Turner to which I have myself too slightly referred. The pretty scene first related in them, however, took place before I had heard Turner's name. The too brief notes of autobiography left by the quietly skilful and modest painter, the "father who was staying at Lord Egremont's," C. R. Leslie, contain the truest and best-written sketches of the leading men of his time that, so far as I know, exist in domestic literature.

J. RUSKIN.

BRANTWOOD, 26th *June*, 1886.

531

DILECTA

CHAPTER I

"6, MOIRA PLACE, SOUTHAMPTON.
"*June 7th*, 1884.

1. "My father was staying at Lord Egremont's; it was in September, I believe, of 1832. The sun had set beyond the trees at the end of the little lake in Petworth Park; at the other end of this lake was a solitary man, pacing to and fro, watching five or six lines or trimmers, that floated outside the water lilies near the bank. 'There,' said my father, 'is Mr. Turner, the great *sea* * painter.' He was smoking a cigar, and on the grass, near him, lay a fine pike. As we came up, another fish had just taken one of the baits, but, by some mischance, this line got foul of a stump or tree root in the water, and Turner was excited and very fussy in his efforts to clear it, knotting together bits of twine, with a large stone at the end, which he threw over the line several times with no effect. 'He did not care,' he said, 'so much about losing the fish as his tackle.' My father hacked off a long slender branch of a tree and tried to poke the line clear. This also failed, and Turner told him that nothing but a boat would enable him to get his line. Now it chanced that, the very day before, Chantrey, the sculptor, had been trolling for jack, rowed about by a man in a boat nearly all day; and my father, thinking it hard that Turner should lose his fish and a valuable line, started across the park to a keeper's cottage, where the key of

* I have put "sea" in italics, because it is a new idea to me that at this time Turner's fame rested on his marine paintings—all the early drawings passing virtually without notice from the Art world.

533

the boathouse was kept. When we returned, and while waiting for the boat, Turner became quite chatty, rigging me a little ship, cut out of a chip, sticking masts into it, and making her sails from a leaf or two torn from a small sketch-book, in which I recollect seeing a memorandum in colour that he had made of the sky and sunset. The ship was hardly ready for sea before the man and boat came lumbering up to the bank, and Turner was busy directing and helping him to recover the line, and, if possible, the fish. This, however, escaped in the confusion. When the line was got in, my father gave the man a couple of shillings for bringing the boat; while Turner, remarking that it was no use fishing any more after the water had been so much disturbed, reeled up his other lines, and, slipping a finger through the pike's gills, walked off with us toward Petworth House. Walking behind, admiring the great fish, I noticed as Turner carried it how the tail dragged on the grass, while his own coat-tails were but little further from the ground; also that a roll of sketches, which I picked up, fell from a pocket in one of these coat-tails, and Turner, after letting my father have a peep at them, tied the bundle up tightly with a bit of the sacred line. I think he had taken some twine off this bundle of sketches when making his stone rocket apparatus, and that this led to the roll working out of his pocket. My father knew little about fishing or fishing-tackle, and asked Turner, as a matter of curiosity, what the line he had nearly lost was worth. Turner answered that it was an expensive one, worth quite half a crown.

"Turner's fish was served for dinner that evening; and, though I was not there to hear it, my father told me how old Lord Egremont joked Chantrey much about his having trolled the whole of the day without even a single run, while Turner had only come down by coach that after-

noon, gone out for an hour, and brought in this big fish.
Sir Francis was a scientific fisherman, and president of
the Stockbridge Fishing Club, and, no doubt, looked upon
Turner, with his trimmers, as little better than a poacher.
Still there was the fish, and Lord Egremont's banter of
Chantrey must have been an intense delight to Turner
as a fisherman.

2. "It was about this time that I first went with my
father to the Royal Academy upon varnishing days, and,
wandering about watching the artists at work, there was
no one, next to Stanfield and his boats, that I liked to
get near so much as Turner, as he stood working upon
those, to my eyes, nearly blank white canvases in their old
academy frames. There were always a number of
mysterious little gallipots and cups of colour ranged upon
drawing stools in front of his pictures; and, among other
bright colours, I recollect one that must have been simple
red-lead. He used short brushes, some of them like the
writers used by house decorators, working with thin
colour over the white ground, and using the brush end
on, dapping and writing with it those wonderfully fretted
cloud forms and the ripplings and filmy surface curves
upon his near water. I have seen Turner at work upon
many varnishing days, *but never remember his using a
maul-stick*.* He came, they said, with the carpenters at
six in the morning, and worked standing all day. He
always had on an old, tall beaver hat, worn rather off his
forehead, which added much to his look of a North Sea
pilot.

(Parenthetic.) "Have you noticed the sky lately in
the north-west when the sun is about a hand's breadth
above the horizon; also just after sunset, when your

* Italics mine. I have often told my pupils, and, I hope, printed
for them somewhere, that all fine painting involves the play, or sweep,
of the arm from the shoulder.

'storm cloud' has been very marked, remaining like a painted sky, so still, that it might have been photographed over and over again by the slowest of processes?"

(From a following letter):—

3. "The only thing I am not certain about is the exact date of that first sight of Turner. I know that in 1833 I did not go to Petworth, as my father took us all to America in the autumn of that year, returning again in the spring of '34; and I am inclined to think that the scene in the park, which I tried to describe, must have taken place in the September of '34. I remember it all as though it were yesterday; I must then have been eight years old. I was always with my father, and we spent every autumn at Petworth for many years, both before and after then. I did not think it worth mentioning, but I had been allowed to spend the whole of the day before with Sir Francis Chantrey in that boat, and recollect his damning the man very much, once during the day, for pulling ahead rather suddenly, whereby Sir Francis, who was standing up in the boat, was thrown upon his back in the bottom of her—no joke for such a heavy man.

"I think the foundation of *the ship* was a mere flat bit of board or chip, cut out for me by my father, and that Constable, the artist, had stuck a sail in it for me some days before (he was also at Petworth). I must have mentioned this to Turner, as I have a recollection of his saying, as he rigged it, 'Oh, he don't know anything about ships,' or 'What does he know about ships? this is how it ought to be,' sticking up some sails which looked to my eyes really quite ship-shape at that time.

4. "I saw Turner painting at the R.A. on more than one varnishing day, as my father took me with him for several years in succession. Every academician, in those good old times of *many* varnishing days, was allowed to

take an assistant or servant with him, to carry about and clean his brushes, etc.; and my father and others always took their sons. This went on for some years, and I recollect my disappointment when my father told me he could not take me any more, as there had been a resolution passed at a council meeting against the custom. I know that most of the pictures which I saw Turner working upon, just as I have described to you, were the Venetian subjects. Mr. Turner was always rather pleasant and friendly with me, on account, I think, of my love of the sea. I have been to his house in Queen Anne Street many times with my father, and recollect once that he took us into his dining-room and uncorked a very fine old bottle of port for us. I was much older then, perhaps fifteen or sixteen. I can never of course forget a few kind words which he spoke to me when I was myself an exhibitor at the R.A. My picture was a scene on the deck of a ship of two sailors chaffing a passenger, called 'A Sailor's Yarn.' Turner came up to the picture, and after looking at it for a minute, said, 'I like your colour.' I have the picture now, and always think of him when I look at it.

"I have written all this in great haste to answer your questions, dear Mr. Ruskin; and am sorry I have so little to tell, and that I am obliged to bring myself forward so much in the matter.

5. "I have often thought that Turner went out to catch that pike because he knew that Chantrey had been unsuccessful the day before.

"I don't know whether you were ever a fisherman; if you were, you would understand the strange fascination that the water has from which you snatched your first fish, after feeling the tug and sweep of it upon the line. Now the lake in Petworth Park had that fascination for my early fishy mind. Most boys' minds are very fishy,

and shooty too,* as you have pointed out, and I was no
exception; but I was always intensely boaty as well,
caring less for rowing than sailing; and when I could not
get afloat myself, I was never tired, even as a big boy, of
doing so in imagination in any form of toy sailing-boat I
could devise or get hold of. Hence it was that when I
saw Turner's fish upon the grass, and was told that he
was a sea painter, I looked upon him at once as something
to fall down and worship—a man who could catch a big
fish, and paint sea and boats! My father, though he had
much of the back-woodsman in his nature, and could
make himself a bootjack in five minutes when he had
mislaid or lost his own, was no sportsman, and cared
little for boating beyond taking a shilling fare sometimes
from Hungerford Stairs in a wherry.

 6. "As to my recollections of Turner upon the varnish-
ing days, you must bear in mind that, as I had been used
to spend from a child many hours a day in a painting-room,
I never recollect a time when I was not well up in all
matters relating to paint and brushes; and the first thing
that struck me about Turner, as he worked at the R.A.,
was, that his way of work was quite unlike that of the
other artists; and it had at once a great interest for me, so
that I believe I watched him often for long spells at a time.
I noticed, as I think I told you, that his brushes were few,
looked old, and that among them were some of those
common little soft brushes in white quill used by house-
painters for painting letters, etc., with. His colours were
mostly in powder, and he mixed them with turpentine,
sometimes with size, and water, and perhaps even with
stale beer, as the grainers do their umber when using it

* Dear Leslie, might we not as well say they were bird's-nesty or
dog-fighty? Really useful fishing is not play; and to watch a trout
is indeed, whether for boy or girl, greater pleasure than to catch it,
if they did but know!

upon an oil ground, binding it in with varnish afterwards; this way of painting is fairly permanent, as one knows by the work known to them as wainscotting or oak-graining. Besides red-lead, he had a blue which looked very like ordinary smalt; this, I think, tempered with crimson or scarlet lake, he worked over his near waters in the darker lines. I am almost sure that I saw him at work on the *Téméraire*, and that he altered the effect after I first saw it. In fact, I believe he worked again on this picture in his house long after I first saw it in the R.A. I remember Stanfield at work too, and what a contrast his brushes and whole manner of work presented to that of Turner.

7. "My brother George tells me to-day that he too has seen Turner at work, once at the R.A., and describes him as seeming to work almost with his nose close to the picture. He says that the picture was that one of the railway engine coming towards us at full speed. But my brother is nearly ten years younger than I am. Turner was always full of little mysterious jokes and fun with his brother artists upon these varnishing days; and my father used to say that Turner looked upon them as one of the greatest privileges of the Academy. It is such a pleasure to me to think that I can be of *any* use to *you*, that I have risked sending this after my other letters. I have always been a man more or less of lost opportunities, and when living some fifteen years ago at Deal one occurred to me that I have never ceased to regret. My next-door neighbour was an old lady of the name of Cato; her maiden name was White; and she told me that she knew Turner well as a young man, also the young lady he was in love with. She spoke of him as being very delicate, and said that he often came to Margate for health. She seemed to know little of Turner as the artist. I cannot tell you how much I regret now not having pushed my inquiries further at that time; but twenty years ago I was more or less an

unregenerate ruffian in such matters; and though I have always felt the same for Turner as the artist, I cared little to know much more than I remembered myself of him as a man.

"Trusting you will forgive the haste again of this letter,

"Believe me, dear Mr. Ruskin,
"Yours faithfully,
"ROBT. LESLIE."

8. "Out of many visits to the house in Queen Anne Street, I never saw or was admitted to Turner's working studio, though he used to pop out of it upon us, in a mysterious way, during our stay in his gallery, and then leave us again for a while. In fact, I think my father had leave to go there when he pleased. I particularly remember one visit, in company with my father and a Yankee sea captain, to whom Turner was very polite, evidently looking up to the sailor capacity, and making many little apologies for the want of ropes and other details about certain vessels in a picture. No one knew or felt, I think, better than Turner the want of these mechanical details, and while the sea captain was there he paid no attention to any one else, but followed him about the gallery, bent upon hearing all he said. As it turned out, this captain and he became good friends, for the Yankee skipper's eyes were sharp enough to see through all the fog and mystery of Turner, how much of real sea feeling there was in him and his work. Captain Morgan, who was a great friend of Dickens, my father, and many other artists, used to send Turner a box of cigars almost every voyage after that visit to Queen Anne Street.

9. "Nothing I can ever do or write for you would repay the good you have done for me and mine in your books; and will you allow me to say, that in reading

them I am not (much as I admire it) carried actually off my legs by your style, but that I feel more and more, each day I live, the plain *practical truth* of *all* you tell us. I cannot bear to hear people talk and write as they do of your style, and your being the greatest master of it, etc., while they sneer at the matter, etc. Nothing lowers the present generation of what are called clever men more to me than this" (nay, is not their abuse of Carlyle's manner worse than their praise of mine?). "I am rather thankful, even, that my best friends here do not belong to this class, being mostly pilots, sea captains, boat-builders, fishermen, and the like.

"I shall, in a day or two, be with my mother at Henley-on-Thames, and if I learn anything more from her about Turner, will let you know. She is now eighty-four, but writes a better letter, in a finer hand, without glasses, than I can with them."

10. "6, MOIRA PLACE, SOUTHAMPTON,
 "*June 25th,* 1884.

"DEAR MR. RUSKIN,

"I have before me the engraving by Wilmore of the *Téméraire.* I think it was Stanfield who told me that the rigging of the ship in this engraving was trimmed up and generally made intelligible to the engraver by some mechanical marine artist or other. I am not sure now who, but think it was Duncan; whether or no, the rigging is certainly not as Turner painted it; while the black funnel of the tug in the engraving is placed abaft her mast or flagpole, instead of before it, as in Turner's picture; his first, strong, almost prophetic idea of smoke, soot, iron, and steam, coming to the front in all naval matters, being thus changed and, I venture to think, weakened by this alteration. You most truly told us years ago that 'Take it all in all, a ship of the line is the most honourable thing

that man, as a gregarious animal, has ever produced.'
I shall not therefore hesitate to ask you to put on your
best spectacles and look for a moment at the enclosed
photograph, which I have had taken for you from a model
of the *Téméraire*, which we have here now in a sort of
museum. The model is nearly three feet long, and
belonged to an old naval man; it was made years ago by
the French prisoners in the hulks at Portsmouth out of
their beef-bones! Even if we were at war with France,
and had the men and ships likely to do it, it would be
impossible to catch any prisoners now who could make
such a ship as this out of anything, much less of beef-bones;
and as I foresee that this lovely little ship must soon, in
the nature of things, pass away (some unfeeling brute has
already robbed her of all her boats), and that there will be
no one living able to restore a rope or spar rightly once
they are broken or displaced in her, I felt it almost a duty
to have this record taken and to send you a copy of it. I
focussed the camera myself, but there is, unavoidably,
some exaggeration of the length of her jibboom and flying-
jibboom. These spars, however, in old ships really
measured, together with the bowsprit, nearly the length
of the foremast from deck to truck. In fact, the bowsprit,
with its spritsail and spritsail-topsailyards, formed a sort
of fourth mast.

11. "I have just returned from a visit to my dear old
mother at Henley, and she told me of how Turner came
up to our house one evening by special appointment to
sup upon Welsh rabbit (toasted cheese). This must have
been about the year 1840 or '41, as it was at the time my
father was engaged upon a portrait of Lord Chancellor
Cottenham; and during the evening Turner went into
the painting-room, where the robes, wig, etc., of the
Chancellor were arranged upon a lay-figure; and, after
a little joking, he was persuaded to put on the Lord

Chancellor's wig, in which, my mother says, Turner looked splendid, so joyous and happy, too, in the idea that the Chancellor's wig became him better than any one else of the party.

"I must have been away from home then, I think in America, for I never should have forgotten Turner being at our house; and this, I believe, is the only time he ever was there.

"Turner, my father, and the Yankee captain were excellent friends about this time, as the captain took a picture of Turner's to New York which my father had been commissioned to buy for Mr. Lenox. There used to be a story, which I daresay you have heard, of how Turner was one day showing some great man or other round his gallery, and Turner's father looked in through a half-open door and said, in a low voice, 'That 'ere's done,' and that Turner taking no *apparent* notice, but continuing to attend his visitor, the old man's head appeared again, after an interval of five or six minutes, and said, in a louder tone, 'That 'ere will be spiled.' I think Landseer used to tell this story as having happened when he and one of his many noble friends were going the round of Turner's gallery about the time that Turner's chop or steak was being cooked."

12. "6, MOIRA PLACE, SOUTHAMPTON,
 "*June 30th*, 1884.

"MY DEAR MR. RUSKIN,

 "After sending you that photograph of the *Téméraire*, it occurred to me to see if I could find out anything about the ship or her building in an old book I have (Charnock's 'Marine Architecture'), and I was surprised to find there, in a list of ships in our navy between the years 1700 and 1800, TWO ships of that name—one a seventy-four, taken from the French in 1759, the other a ninety-eight gun

ship, built at Chatham in 1798. This made me look
again at Mr. Thornbury's account of the ship and her
title, and leads me to doubt three things he has stated:
first, that the ship (if she was the French *Téméraire*) 'had
no history in our navy before Trafalgar;' secondly, that
'she was taken at the battle of the Nile;' and, thirdly,
that the *Téméraire* which fought at Trafalgar was French
at all.

"The model we have here, and which has the name
Téméraire carved upon her stern, is a ninety-eight gun ship,
and would be the one built at Chatham in 1798. But
what I am driving at, and *the point* to which all this
confusion leads, is, that after all, perhaps, dear old Turner
was perfectly right in his first title for his picture of 'The
Fighting *Téméraire*,' for if she was the old seventy-four
gun ship (and in the engraving she looks like a two-decker)
that he saw being towed to the ship-breaker's yard, she,
having been in our navy for years, may have been distin-
guished among sailors from the other and newer *Téméraire*
by that name; while it is significant (*if true*) that Turner,
when he reluctantly gave up his title, said, 'Well, then,
call her the *Old Téméraire*.'

13. "Thornbury's book, which I have not seen since
it was published until I borrowed it a few days back,
appears to me a sort of hashed-up life of Brown, Jones,
and Robinson, with badly done bits of Turner floating
about in it. I have copied the passage from it referring
to the *Téméraire* upon a separate sheet, also the history
of the capture of the *French Téméraire* from the *Gentle-
man's Magazine*.

"I have only now to add, in answer to your last and
kindest of notes, that I read French in a bumbly sort of
way, like a French yoke of oxen dragging a load of stone
uphill upon a cross road, but that my wife reads it easily.
Twice, dear Mr. Ruskin, you have said, 'Is it not strange

you should have sent me something about Turner just as I was employing a French critic to write his life? Now, I believe that nothing is really strange between those where on the one side there is perfect truth and honesty of purpose, and on the other faith in, and love and reverence for, that purpose.

"Forgive me if I have said too much; and believe me, yours faithfully and affectionately,

"ROBT. C. LESLIE."

14. EXTRACT FROM A LIST OF SHIPS IN OUR NAVY BETWEEN THE YEARS 1700 AND 1800.

"*Téméraire*, 1,685 tons, 74 guns, taken from the French, 1759.

"*Téméraire*, 2,121 tons, 98 guns, *built* at *Chatham*, 1798."

Charnock's "Marine Architecture" (1802).

"Saturday, Sept. 15th, 1759, Admiral Boscawen arrived at Spithead with His Majestie's ships, *Namur*, etc., and the *Modeste* and *Téméraire*, prizes. The *Téméraire* is a fine seventy-four gun ship, forty-two-pounders below, eight fine brass guns abaft her mainmast, ten brass guns on her quarter, very little hurt."

Gentleman's Magazine, September, 1759.

HOW THE OLD *TÉMÉRAIRE* WAS TAKEN

Extract of a letter from Admiral Boscawen to Mr. Cleveland, Secretary of the Admiralty, dated off Cape St. Vincent, August 20th, 1759:—

"I acquainted you in my last of my return to Gibraltar to refit. As soon as the ships were near ready, I ordered the *Lyme* and *Gibraltar* frigates, the first to cruise off Malaga, and the last from Estepona to Ceuta Point, to look out, and give me timely notice of the enemy's

approach. On the 17th, at 8 P.M., the *Gibraltar* made
the signal of their appearance, fourteen sail, on the
Barbary shore. . . . I got under sail as fast as possible,
and was out of the bay before 10 P.M., with fourteen sail
of the line. At daylight I saw the *Gibraltar*, and soon
after seven sail of large ships lying to; but on our not
answering their signals they made sail from us. We had
a fresh gale, and came up with them fast till about noon,
when it fell little wind. About half an hour past two
some of the headmost ships began to engage, but I could
not get up to the *Ocean* till near four. In about half an
hour my ship the *Namur's* mizen-mast and both topsail-
yards were shot away; the enemy then made all the sail
they could. I shifted my flag to the *Newark*, and soon
after the *Centaur*, of seventy-four guns, struck.

15. "I pursued all night, and in the morning of the
19th saw only four sail of the line standing in for the
land. . . . We were not above three miles from them,
and not above five leagues from the shore, but very little
wind. About nine the *Ocean* ran amongst the breakers,
and the three others anchored. I sent the *Intrepid* and
America to destroy the *Ocean*. Capt. Pratten, having
anchored, could not get in; but Capt. Kirk performed that
service alone. On his first firing at the *Ocean* she struck.
Capt. Kirk sent his officers on board. M. de la Clue,
having one leg broke, and the other wounded, had been
landed about half an hour; but they found the captain,
M. le Comte de Carne, and several officers and men on
board; Capt. Kirk, after taking them out, finding it
impossible to bring the ship off, set her on fire. Capt.
Bentley, of the *Warspite*, was ordered against the *Téméraire*
of seventy-four guns, and brought her off with little
damage, the officers and men all on board. At the same
time, Vice-Admiral Broderick, with his division, burnt
the *Redoubtable*, her officers and men having quitted her,

being bulged; and brought the *Modeste*, of sixty-four guns, off very little damaged. I have the pleasure to acquaint their Lordships, that most of His Majestie's ships under my command sailed better than those of the enemy."...

From the *Gentleman's Magazine* for September, 1759.

"I could not resist copying this letter in full.—R. L."

16. "I have just read the appendix to your 'Art of England,' and was particularly interested in the account of how you felt that cold south-west wind up in Lancashire. This is the second, if not third season, that we have remarked them here in the south of England, though I think the south-westers of this spring were more bitter than usual. I told you, I believe, that my wife and I started away for Spain this April. Now, on all this journey, down the west coast of France, across the north of Spain, to Barcelona, in lat. 41°, and up through Central France again, I watched and noted day by day the same strange sky that we have with us, the same white sun, with that opaque sheet about him, or else covered by dark dull vapours, from which now and then something fell in unexpected drops, followed by still more unexpected clearing-ups. There were one or two days of intense sunshine, followed always by bad pale sunsets, and often accompanied by driving storms of wind and dust. But, returning to the cold south-westers, I don't suppose you care much for the why of them, even if I am right, which is, that I think we owe them to the very great and early break-up for the last year or two of the northern ice,* which in the western ocean was met with before March this year, several steamers being in collision with it, while one report from Newfoundland spoke of an iceberg

* Yes; but what makes the ice break up? I think the plague-wind blows every way, everywhere, all round the world.—J. R.

aground there I am afraid to say how many miles long and over a hundred feet high. Now, when I was young (I am fifty-eight), and a good deal upon that sea, it was always thought that there was no chance of falling in with ice earlier than quite the *end* of May, and this was exceptional, the months of July and August being the iceberg months. (I have seen a large one off the Banks in September.) This early arrival of the northern ice seems to show that the mild winters have extended up even into the Arctic Circle, and points to some real increase in the power or heat of the sun.*

"I have many things I should like to talk over with you, but fear that will never be, unless you are able to come some time and have a few days' rest and boating with me."

* I don't believe it a bit. I think the sun's going out.—J. R.

Chapter II

17. Mr. Leslie's notes on the *Téméraire* and her double have led to some farther correspondence respecting both this ship and Nelson's own, which must still take precedence of any connected with the early numbers of "Præterita."

"Dearest Mr. Ruskin,

"Mr. W. Hale White, of the Admiralty, has, as you will see, written to me about the *Téméraires*, and I thought you ought to know what he has to say on the subject, especially that postscript to his note about placing some short history of the ship under Turner's picture. Also the fact of the old French ship being *sold* in the year 1784, when there could have been no tugs on the river, and when Turner was only nine years old, seems to settle the point as to which of the two ships it was, in favour of 'the English *Téméraire*.' Still, as boyish impressions in a mind like Turner's must have been *very strong*, it is just possible that he may have seen the last of both ships when knocking about the Thames below London.

"In the *picture*, as I said before, the ship is a *two-decker*, and her having her spars and sails bent to the yards looks very like a time before steam, when a hulk without some kind of jury-rig would be almost useless, even to a ship-breaker, if he had to *move her* at all.

"Ever affectionately,
"Robt. C. Leslie."

18. "Admiralty, Whitehall, S.W.,
 "*20th November,* 1886.

"Dear Sir,

"I see in Mr. Ruskin's 'Dilecta' a letter of yours

549

about the *Téméraire*. Perhaps you will like to know
the facts about the two vessels you name.

"The *Téméraire* taken by Admiral Boscawen from
the French in 1759 was sold in June 1784.

"The *Téméraire* which Turner saw was consequently
the second *Téméraire*. She was fitted for a prison ship
at Plymouth in 1812. In 1819 she became a receiving
ship, and was sent to Sheerness. There she remained till
she was sold in 1838.

"What Mr. Thornbury means by 'the grand old
vessel that had been taken prisoner at the Nile' I do not
know. I may add that it cannot be ascertained now, at
any rate without prolonged search amongst documents in
the Record Office, whether the second *Téméraire* was
sold 'all standing,' that is to say, with masts and yards as
painted; but it is very improbable, as she had been a
receiving ship, that her masts and yards were in her when
she left the service.

<div align="right">"Truly yours,
"W. HALE WHITE.</div>

"R. C. Leslie, Esq.

"It seems to me a pity, considering the importance of
the picture, that the truth about the subject of it should
not somewhere be easily accessible to everybody who
cares to know it—say upon the picture-frame. I would
undertake to put down in tabular form the principal
points in the vessel's biography, if it were thought worth
while."

I should at all events be most grateful if Mr. Hale
White would furnish me with such abstract, as, whether
used in the National Gallery or not, many people would
like to have it put beneath the engraving.

19. In a subsequent note from Mr. Leslie about the

pike fishing at Lord Egremont's, he gives me this little sketch of the way Turner rigged his ship for him with leaves torn out of his sketch book.

20. The following note, also from Mr. Leslie, with its cutting from *St. James's Gazette;* and the next one, for which I am extremely grateful, on the words "dickey" and "deck," bear further on Turner's meaning in the little black steamer which guides the funeral march of the line of battle ship,—and foretell the time now come when ships have neither masts, sails, nor decks, but are driven under water with their crews under hatches.

"DEAREST MR. RUSKIN,

"I have just finished 'The State of Denmark,' which is delightful, especially the story of the row of expectant little pigs. They are wonderful animals— our English elephant I think as to mental capacity. But they always have an interest to me above other edible live stock, in the way they make the best of life on shipboard; and when you can spare time to look at the enclosed little paper of mine, you will find that others have found their society cheerful.

"I have been reading all the old sea voyages I can get hold of lately, with a view to learn all I can about the way

they handled their canvas in the days of sails (for my 'Sea-Wings'), and I come constantly across the pig on board ship in such books. For some reason or other, sailors don't care to have parsons on board ship. This perhaps dates back to time of Jonah; and your passages in this 'Præterita,' in which you describe and dispose of the teaching of some modern ones, are quite perfect, and in your 'making short work' best style.

"Ever yours affectionately,
"ROBT. C. LESLIE."

21. "In smaller vessels, carrying no passengers, pigs and goats were seldom home-fed; but were turned loose to cater for themselves among the odds and ends in the waist or deck between the poop and forecastle. Some of the poultry, too, soon became tame enough to be allowed the run of this part of a ship; the ducks and geese finding a particular pleasure in paddling in the wash about the lee scuppers. Pigs have always proved a thriving stock on a ship-farm, and the one that pays the best. Some old skippers assert, indeed, that, like Madeira, pig is improved greatly by a voyage to India and back round the Cape; and that none but those who have tasted boiled leg of pork on board a homeward bound Indiaman know much about the matter. But here also, as in so many other things, there was a drawback. Pigs are such cheerful creatures at sea that, as an old soft-hearted seaman once remarked, you get too partial towards them, and feel after dinner sometimes as though you had eaten an old messmate. Next to the pig the goat was the most useful stock on a sea-farm. This animal soon makes itself at home on shipboard; it has good sea-legs, and is blessed with an appetite that nothing in the shape of vegetable fibre comes amiss to, from an armful of shavings from the carpenter's berth to an old newspaper. Preserved milk was, of course, unknown in

those times, and the officers of a large passenger-ship would rather have gone to sea without a doctor (to say nothing of a parson) than without a cow or some nanny-goats. Even on board a man-of-war the admiral or captain generally had at least one goat for his own use, while space was found for live stock for other ward-room officers. But model-farming and home-feeding was the rule then as now in a King's ship; and it is related that, on board one of these vessels, the first lieutenant ordered the ship's painter to give the feet and bills of the admiral's geese that were stowed in coops upon the quarter-deck a coat of black once a week, so that the nautical eye might not be offended by any intrusion of colour not allowed in the service.

"The general absence of colour among real sea-fowl is very marked; and when, as it sometimes happened, a gay rooster escaped overboard after an exciting chase round the decks with Jemmy Ducks, and fluttered help-lessly down upon the bosom of the sea, his glowing plumage looked strangely out of harmony with things as he sat drifting away upon the waste of waters."

22. "BERKELEY, GLOUCESTERSHIRE,
 "*Oct.* 29*th*, 1886.

"MY DEAR SIR,

 "I notice in the first chapter of 'Præterita' that you profess yourself unable to find out the derivation of the word 'dickey' as applied to the rumble of a carriage.

 "At the risk of being the hundredth or so who has volunteered the information, I send you an extract from Dr. Brewer's 'Dictionary of Phrase and Fable':—

 " 'Dickey.—The rumble behind a carriage; also a leather apron, a child's bib, and a false shirt or front. Dutch *dekken*, Germ. *decken*, Sax. *thecan*, Lat. *tego*, to cover.'

"I suppose that the word 'deck' has its derivation from the same source.

"Sincerely hoping that you may be speedily restored to health,

"I am, dear Sir,
"Yours very faithfully,
"HERBERT E. COOKE."

23. The following extract from a letter written to his sister by a young surgeon on board the *Victory*, gives more interesting lights on Nelson's character than I caught from all Southey's Life of him:—

"On my coming on board I found that the recommendation which my former services in the Navy had procured for me from several friends, had conciliated towards me the good opinion of his lordship and his officers, and I immediately became one of the family. It may amuse you, my dear sister, to read the brief journal of a day such as we here pass it at sea in this fine climate and in these smooth seas, on board one of the largest ships in the Navy, as she mounts 110 guns, one of which, carrying a 24lb shot, occupies a very distinguished station in my apartment.

"Jan. 12.—Off the Straits of Bonifacio, a narrow arm of the sea between Corsica and Sardinia.—We have been baffled in our progress towards the rendezvous of the squadron at the Madeline Islands for some days past by variable and contrary winds, but we expect to arrive at our destination to-night or to-morrow morning. To resume, my dear sister, the journal of a day. At 6 o'clock my servant brings a light and informs me of the hour, wind, weather, and course of the ship, when I immediately dress and generally repair to the deck, the dawn of day at this season and latitude being apparent at about half or

three-quarters of an hour past six. Breakfast is announced
in the Admiral's cabin, where Lord Nelson,—Rear-
Admiral Murray, the Captain of the Fleet,—Captain
Hardy, Commander of the *Victory*, the chaplain, secretary,
one or two officers of the ship, and your humble servant,
assemble and breakfast on tea, hot rolls, toast, cold tongue,
etc., which when finished we repair upon deck to enjoy
the majestic sight of the rising sun (scarcely ever obscured
by clouds in this fine climate) surmounting the smooth
and placid waves of the Mediterranean which supports the
lofty and tremendous bulwarks of Britain, following in
regular train their Admiral in the *Victory*. Between
the hours of seven and two there is plenty of time for
business, study, writing, and exercise, which different
occupations, together with that of occasionally visiting
the hospital of the ship when required by the surgeon, I
endeavour to vary in such a manner as to afford me
sufficient employment. At two o'clock a band of music
plays till within a quarter of three, when the drum beats
the tune called 'The Roast Beef of Old England' to
announce the Admiral's dinner, which is served up
exactly at three o'clock, and which generally consists of
three courses and a dessert of the choicest fruit, together
with three or four of the best wines, champagne and
claret not excepted; and—what exceeds the relish of the
best viands and most exquisite wines,—if a person does
not feel himself perfectly at his ease it must be his own
fault, such is the urbanity and hospitality which reign here,
notwithstanding the numerous titles, the four orders of
knighthood, worn by Lord Nelson, and the well-earned
laurels which he has acquired. Coffee and liqueurs close
the dinner about half-past four or five o'clock, after which
the company generally walk the deck, where the band of
music plays for near an hour. At six o'clock tea is
announced, when the company again assemble in the

Admiral's cabin, where tea is served up before seven
o'clock, and, as we are inclined, the party continue to
converse with his lordship, who at this time generally
unbends himself, though he is at all times as free from
stiffness and pomp as a regard to proper dignity will admit,
and is very communicative. At eight o'clock a rummer of
punch with cake or biscuit is served up, soon after which
we wish the Admiral a good night (who is generally in bed
before nine o'clock). For my own part, not having been
accustomed to go to bed quite so early, I generally read an
hour, or spend one with the officers of the ship, several
of whom are old acquaintances, or to whom I have been
known by character. Such, my dear sister, is the journal
of a day at sea in fine or at least moderate weather, in
which this floating castle goes through the water with the
greatest imaginable steadiness, and I have not yet been
long enough on board to experience bad weather."

24. I must find room for a word or two more of Mr.
Leslie's, for the old floating castles as against steam; and
then pass to matters more personal to me.

"MOIRA PLACE, *Sept. 20th,* 1886.

"I believe that the whole of the present depression in
what is called trade is entirely due to the exaggerated
estimate of the economy of steam, especially when applied
to the production of real wealth upon the land; also to the
idea that the wealth of the world is in any way increased
by making a lawn tennis court of it, the world, and
knocking goods to and fro as fast as possible across it by
steam. No doubt I shall be told that I am quite out of
my depth in this matter, and that France (a really self-
supporting country) is at least five hundred years behind the
times. I won't apologize for sending you enclosed,
which, for the animal's sake alone, I fear is true. The
cutting is from the *Times* of the 18th:—

"A writer in the *Revue Scientifique* affirms that, from a comparison of animal and steam power, the former is the cheaper power in France, whatever may be the case in other countries. In the conversion of chemical to mechanical energy, 90 per cent is lost in the machine, against 68 in the animal. M. Sanson, the writer above referred to, finds that the steam horse-power, contrary to what is generally believed, is often materially exceeded by the horse. The cost of traction on the Mount Parnasse-Bastille line of railway he found to be for each car, daily, 57 f., while the same work done by the horse cost only 47 f.; and he believes that for moderate powers the conversion of chemical into mechanical energy is more economically effected through animals than through steam engines."

25. The following two letters from Turner to Mr. W. B. Cooke, which I find among various papers relating to his work given to me at various times, are of great interest in showing the number of points Turner used to take into consideration before determining on anything, and his strict sense of duty and courtesy. The blank line, of which we are left to conjecture the meaning, is much longer in the real letter:—

"Wednesday morning.

"DEAR SIR,

"I have taken the earliest opportunity to return you the touched proof and corrected St. Michael's Mount. I lament that your brother could not forward the Poole, or Mr. Bulmer the proof sheets, for if the two cannot be sent so as to arrive here before *Tuesday next*, I shall be upon the wing for London again, where I hope to be in about a fortnight from this time; therefore, you'll judge how practicable you can make the sending the parcel in time, or waiting until I get to Queen Ann Street, N.W.

Your number coming out on the 10th of December I think impossible; but to this I offer only an opinion (what difference would it make if the two numbers of the Coast, Daniel's and yours, came out on the same day?). All I can say, I'll not hinder you, if I can avoid it, one moment. Therefore employ Mr. Pye if you think proper, but, as you know, there should be some objection on my part as to co-operation with him without————; yet to forego the assistance of his abilities for any feeling of mine is by no means proper to the majority of subscribers to the work.

<div align="center">

"Yours most truly,

"J. M. W. TURNER.

</div>

"P.S.—I am not surprised at Mr. Ellis writing such a note about his signature. Be so good as put the enclosed into the Two-penny Post Box. The book which I now send be kind enough to keep for me until I return, and expect it to be useful in the descriptions of Cornwall."

26. *"Thursday Eg. Decr. 16, 1813.*

"DEAR SIR,

"From your letter of this morning I expected the pleasure of seeing you, but being disappointed, I feel the necessity of requesting you will, under the peculiar case in which the MSS. of St. Michael and Poole are placed, desire Mr. Coombe to deviate wholly from them; and if he has introduced anything which seems to approximate, to be so good as to remove the same, as any likeness in the descriptions (though highly complimentary to my endeavours) must compel me to claim them—by an immediate appeal as to their originality. Moreover, as I now shall not charge or will receive any remuneration whatever for them, they are consequently at my disposal,

and ultimately subject only to my use—in vindication; never do I hope they will be called upon to appear, but if ever offer'd that they will be looked upon with liberality and candour, and not considered in any way detrimental to the interests of the Proprietors of the Southern Coast work.

"Have the goodness to return the corrected proof of St. Michael, which I sent from Yorkshire with the MS. of Poole; and desire Mr. Bulmer either to send me all the proof sheets, or in your seeing them destroyed you will much oblige.

<div style="text-align:center">"Yours most truly,
"J. M. W. TURNER."</div>

27. I find in my father's diary of the journey of 1833 some notes on the state of Basle city and its environs at the time of our passing through them, which are extremely interesting to me in their coolness, especially in connection with the general caution which influenced my father in all other kinds of danger. No man could be more prudent in guarding against ordinary chances of harm, and in what may be shortly expressed as look-ing to the girths of life. But here he is travelling with his wife and son through a district in dispute between not only military forces but political factions, without appearing for an instant to have contemplated changing his route, or felt the slightest uneasiness in passing through the area of most active warfare. My mother seems to have been exactly of the same mind,—which is more curious still, for indeed I never once saw the expression of fear on my father's face, through all his life, at anything; but my mother was easily frightened if postillions drove too fast, or the carriage leaned threateningly aside; while here she passes through the midst of bands of angry and armed villages without a word of objection.

28. "Baden (Swiss Baden, 5th August, 1833).—We heard here of the Basle people fighting with peasantry and burning their villages; and of a battle betwixt Liechstal and Basle soldiers on Saturday; the latter were driven into the town; 80 killed and 400 prisoners. We came to Stein to dine; a single house on the borders of the Rhine, commanding a beautiful view of that river and plains beyond it, and Black Forest in the distance. We had eighteen miles to go to Basle, but, hearing Swiss gates were shut, we crossed into Baden state at Rheinfeld, where there are some very old buildings and two wooden bridges; the river rolls like a troubled sea. Coming towards Basle we saw soldiers with several large brass cannon, in a field which the peasants were ploughing, on an eminence commanding the road. We arrived at 7 o'clock at Three Kings, Basle, and early next morning I walked to cathedral; found many of the first houses with windows entirely closed, in mourning for officers lost in battle of Saturday; and a report prevailed of there being a plot to admit the peasantry into the town to fire it in the night. The people were much alarmed.

29. "Tuesday, 6th August, we left by a gate just opened to let us pass, being sent from another gate we tried, and which we saw, after we got out, had its drawbridge entirely cut away. The guns were placed with twigs and basketwork in embrasures, soldiers stood on the walls ready, and looking out over the country with glasses. The road lay through Liechstal, where the strife was. It is a fine road, as the best in England, generally much frequented, and the country is beautiful and rich in cultivation; but on twenty-seven miles of this fine road we met neither carriage, diligence, gig, nor waggon. The land seemed deserted, only a peasant occasionally in the fields. We soon met a small band of armed peasants in the act of stopping a small market-cart which had preceded

us. The man, when released, went quickly off. They
let us pass. We then met two bands of armed peasants,
very Irish-like in costume, and having guns swung behind
or in their hands, about fifteen or twenty in each body,—
part, we suppose, of the Liberals who had defeated the
Tories of Basle.* They looked, and lifted their hats,
and said nothing to us. Approaching Liechstal, we met
a Swiss car with eight or ten gentlemen in plain clothes,
well armed; also cars filled with armed peasants, and a few
soldiers at their side. We entered Liechstal, and found
every street barricaded breast high with pine logs, except
at entrance, where an opening was left just wide enough
for cart or carriage, and a gate at the other end. These
gentlemen, I was afterwards told, were Polish refugees,
who served the artillery of the peasantry against the Basle
people, who had refused to shelter them, whilst the
Liechstal people had received them kindly."

30. And so all notice of states of siege, whether at
Liechstal or anywhere else, ends in my father's diary;
and he continues in perfect tranquillity to give account of
his notes on the roads, inns, and agriculture of Switzerland.

Of which, however, the reader will, I think, have
pleasure in seeing some further passages, representing, not
through any gilded mists of memory, but with mercantile
precision of entering day by day, the aspect of Switzerland
at the time when we first saw it, half a century ago.

"18th July. We left Berne early, and went eighteen
miles to Thun. The road is one of the best possible,
beginning through an avenue of trees, large and fine, and
proceeding to Thun through fields of amazing beauty,

* Papa cannot bring himself to think of anybody in Irish-like
costume as Conservative. It was Basle that was liberally and Pro-
testantially endeavouring to make the men of Liechstal abjure their
Catholic errors.

bordered with fruit trees; the corn sometimes bordering the road without enclosure. The cottages, houses, farms, inns, all the way, each and all remarkable for neatness, largeness, and beauty. We left our carriage at the Freyenhof Inn, and took boat, three hours' rowing, to Neuhaus, then one league in char-à-banc; through Unterseen to Interlachen, a sweet watering-place sort of a village, with one hotel and many very elegant boarding-houses, where persons stop to take excursions to neighbouring hills. We took boat down lake Brienz as far as waterfall of Giesbach, the finest fall next to those of Rhine I have yet seen; but the best thing was the Swiss family in the small inn up the hill opposite to the fall. The old man, his son, and two daughters, sung Swiss songs in the sweetest and most affecting manner, infinitely finer than opera singing, because true alike to Nature and to music;* no grimace nor affectation, nor strained efforts to produce effect. The tunes were well chosen, and the whole very delightful; more so than any singing I remember. We returned to Interlachen, where the Justice condemned Salvador to pay twelve francs for a carriage not used, which he had hired to go to the Staubbach. Next morning we returned by water to Thun to breakfast, and again to Berne, where we had very nice rooms, with fine prospect.

31. "The portico walks in almost every street in Berne are very convenient for rain or sun: it is in this like Chester, though the one appearing a very new town, and the other very old. We left Berne 22nd July by a narrow but not bad road through Summiswald: dined at Hutwyl; slept at Sursee, in the Catholic canton of Lucerne. The hill and dale country we passed through to the very end

* I shall make this sentence the text of what I have to say, when I have made a few more experiments in our schools here, of the use of music in peasant education.

of the Berne canton was a scene of unequalled loveliness
out of this canton. The face of the country was varied,
but the richness of cultivation the same, and the houses so
large, and yet so neat and comfortable. This is, indeed,
a country for which a man might sigh, and almost die,
of ⌐ ⌐ , to be exiled from. I have seen nothing at all
approaching to it in the neatest parts of England. The
town of Berne is equally remarkable for good though not
lofty buildings, and for cleanliness and neatness. The
street-sweepers were women; and I never saw a city or
town so beautifully kept. I walked up many back streets
and lanes, all in the most perfect order; and the country
seen from the cathedral terrace and ramparts is just suited
to such a town. There is no formed, squared, or trimmed
neatness, but every field, and hedge, and tree, and garden,
seem to be tended and kept in the finest state possible.
The variety of scenery on the grandest scale,—the snowy
Alps, the lower Alps, the woods on undulating grounds,
or sloping down from the mountain tops; the fine river
passing round the town; the rich cornfields, meadows, and
fruit trees, abounding over all; nature doing so much, and
man just bestowing the care and culture required, and
applying art only where it seems to improve nature.

32. "If any country on earth can be deemed perfect
as far as nature and art can make it, the canton of Berne
is that country. The farm houses are each a picture,
and the peasantry are as beautiful and healthy as the
country. They express contentment. Their costume
is handsome, excepting the black, stiff, whalebone-lace
ears of immense size from the women's heads; when they
wear black lace over their heads partially, the rest of their
dress is extremely becoming. On Wednesday, July
17th, we rode to Hofwyl Farm, Mr Fellenberg's Institu-
tion, combining a large fine boarding-house for eighty to
ninety young gentlemen of fortune, where all branches of

education are taught, and agriculture added if they choose; and a school for poor boys and girls, and for masters of country schools to learn.

"Some Russian princes have attended the boarding school. The expense, about three thousand francs yearly. Everything is made on the farm—bread, butter, clothes, shoes, etc. There are from two hundred and eighty to three hundred acres of land in cultivation, lying in a sort of basin sloping gently away from house towards a piece of water. It is impossible to conceive anything so beautiful for a farm as this. There being four hundred people about it there is no want of labour; and added to the usual Swiss neatness, there is the completeness of an amateur farmer possessing ample means. There were fifty-four milk cows kept on hay and potatoes under cover. (The want of cattle in the field is always a drawback to a foreign landscape.) The oxen very handsome. The system of farming same as Scotch, only one new product seen by a Scotch amateur whom we met. Italian rye grass, very fine. The poorer young men cutting hay, all very happy. The workshops, the washing-houses, the outhouses all very perfect, but in implements or machinery nothing new. It was the beauty of the situation on a fine day, and the fulness and apparent comfort, that struck the observer particularly."

CHAPTER III

33. I MUST leave the chronology of "Dilecta" to be arranged by its final index, for the choice of the letters printed in the course of it must depend more on topic than date; and, besides, it will be needful sometimes to let it supply the place of my ceased "Fors," and answer in the parts of it under my hand, any questions that occur in an irritating manner to the readers of "Præterita."

For instance, my morning post-bag has been lately filled with reproaches, or anxious advice, from pious persons of Evangelical persuasion, who accuse me of speaking of their faith thoughtlessly, or without sufficient knowledge. Whereas there is probably no European writer now dealing with the history of Christianity, who is either by hereditary ties more closely connected, or by personal enquiry more variously familiar, with the characteristic and vitally earnest bodies of the Puritan Church.

34. The following letter from her uncle to Mrs. Arthur Severn,—(for whose sake the complexities of our ancient and ramifying cousinships have long since been generalized into the brief family name for me, the Coz,)—contains, with as much added genealogy as the most patient reader will be likely to ask for, evidence of the position held by my great grandfather among the persecuted Scottish Puritans.

"1, CAMBRIDGE STREET, HYDE PARK, W.
"*August 25th,* 1885.

"MY DEAR JOANNA,
"The only thing that I can think of that has historical interest for the Coz, in connection with his father's relations, is that his great grandfather, the Rev. J. Tweddale, of Glenluce, had in his possession during his

ministry the National Covenant of the Scotch Covenanters.
It was given to him by his aunt, who received it from
Baillie of Jarviswood, who was suspected of having it in
his possession, and was executed. I suppose it was given
to my grandfather's aunt, because, being a lady, it would
be assumed that she would not be suspected of having it.

"My father was left an orphan when ten years of age,
and when he became of age, the trustees had parted
with the 'Covenant'; at all events, he could not trace it.
However, he then inherited his parental property, 'Glen-
laggan,' which is rather a picturesque place situated
between New Galloway and Castle Douglas, in the
county of Kirkcudbright. When his uncle, Dr. Adair,
died, he left him £10,000. He then sold Glenlaggan
to enable him to buy a larger estate in Wigtownshire. In
this he made a mistake, for it was during the war in the
time of the first Napoleon, when land was very dear; and
when the peace came it became very cheap, and fearing
complete ruin, he sold at an immense loss; but this latter
part of my father's history is not worth recording.

"The 'National Covenant' is now in the Glasgow
museum. Perhaps these particulars may be interesting
to the Coz, who, I hope, is progressing favourably towards
recovery.

"With kind love,
"Your affectionate uncle,
"J. R. (John Ruskin) TWEDDALE."

"The accompanying note" (on page 568) "contains
the particulars of the relationship that exists between our
family and the Professor. My father's sister was his
grandmother, and mother to the late Mr. Ruskin; so
that my father was full uncle to the late Mr. Ruskin, and
grand uncle to the Professor. The father of the Pro-
fessor's grandmother was minister of Glenluce, but that

is a long time back, for if my father had been living, he would have been *one hundred and seventeen* years old.

"The Rev. J. Garlies Maitland's son was the late Rev. Dr. James Maitland, minister of New Galloway, and husband of the heiress of Kenmure, by his second marriage with the eldest daughter of the Hon. Mrs. Bellamy Gordon, whose son now inherits that property. Dr. Maitland was, some years before his death, Moderator of the General Assembly, and was otherwise a man of mark."

35. As for my own knowledge of the Evangelical character and doctrine, what I have related already of my mother, my Scottish aunt, and her servant Mause, ought to have been guarantee enough to attentive persons; the inattentive I would beg at least not to trouble me with letters till the sequels of "Præterita" and "Dilecta" are in their hands.

36. For the present I return to the documents in my possession respecting Turner; of which the following, signed by Turner the day after I was born, must, I think, take priority in point of date, and has this much of peculiar interest in it, that the drawings of which it disposes the destiny with so much care, were never made. Turner's intention that they should be all of equal value is prettily intimated by his submitting the decision of his property in them to cast of lots.

37. "Agreement between J. M. W. Turner, Esq., W. B. Cooke, and J. C. Allen, February the Ninth, One Thousand Eight Hundred and Nineteen.

"Mr. Turner agrees to make Thirty Six Drawings on the Rhine, between Cologne and Mayence, at the Price of Seventeen Guineas each Drawing.—The first Two Drawings to be made in advance, which are to be paid out of the Profits of the Work.—The Second Two Drawings to be paid by W. B. Cooke in June 1819, and the rest to be paid on delivery.

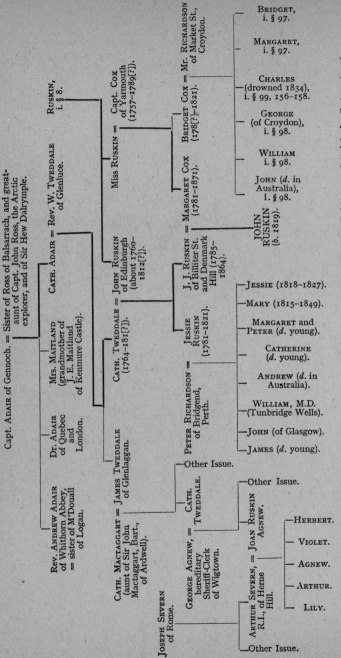

ADAIR of Gennoch. = Sister of Sir Andrew Agnew of Lochnaw,
hereditary Sheriff of Wigtownshire.

Capt. ADAIR of Gennoch. = Sister of Ross of Balsarrach, and great-
aunt of Capt. John Ross, the Arctic
explorer, and of Sir Hew Dalrymple.

RUSKIN,
i. § 8.

CATH. ADAIR = Rev. W. TWEDDALE
of Glenluce.

Miss RUSKIN = Capt. COX
of Yarmouth
(1757–1789[?]).

BRIDGET,
i. § 97.

MARGARET,
i. § 97.

CHARLES
(drowned 1834),
i. § 99, 156–158.

GEORGE
(of Croydon),
i. § 98.

WILLIAM
i. § 98.

JOHN (d. in
Australia),
i. § 98.

BRIDGET COX = Mr. RICHARDSON
(178[?]–1821). of Market St.,
Croydon.

Rev. ANDREW ADAIR
of Whithorn Abbey,
= sister of M'Douall
of Logan.

Dr. ADAIR
of Quebec
and
London.

Mrs. MAITLAND
(grandmother of
J. E. Maitland
of Kennure Castle).

CATH. TWEDDALE = JOHN RUSKIN
(1764–181[?]). of Edinburgh
(about 1760–
1812[?]).

MARGARET COX = J. J. RUSKIN
(1781–1871). of Billiter St.
and Denmark
Hill (1785–
1864).

JESSIE
RUSKIN
(1781–1821).

JOHN
RUSKIN
(b. 1819).

CATH. MACTAGGART = JAMES TWEDDALE
(aunt of Sir John of Glenlaggan.
Mactaggart, Bart.,
of Ardwell).

PETER RICHARDSON =
of Bridgend,
Perth.

JESSIE (1818–1827).

MARY (1815–1849).

MARGARET and
PETER (d. young).

CATHERINE
(d. young).

ANDREW (d. in
Australia).

WILLIAM, M.D.
(Tunbridge Wells).

JOHN (of Glasgow).

JAMES (d. young).

—Other Issue.

JOSEPH SEVERN
of Rome.

GEORGE AGNEW, =
hereditary
Sheriff-Clerk
of Wigtown.

CATH.
TWEDDALE.

—Other Issue.

JOAN RUSKIN
AGNEW.

ARTHUR SEVERN, =
R.I., of Herne
Hill.

HERBERT.

VIOLET.

AGNEW.

ARTHUR.

LILY.

—Other Issue.

(N.B.—The "note" referred to in the text is now (1899) missing, and its place is therefore supplied by a reprint of the family tree given in
W. G. Collingwood's "Life of Ruskin," vol. i, p. 8, with the addition of a few references to passages in "Præterita.")

"It is agreed that none of the Drawings shall be sold for less than Thirty-four Guineas each under the Penalty of One Hundred Guineas. Mr. Turner to be paid Two Pounds on the Sale of every Five Hundred Numbers. The Plates to be estimated at Fifty Guineas each—they are to be the Size of Eleven Inches and a half by Eight Inches and a Quarter.

"The Work to be divided as follows,—Mr. Turner to hold one Eighth Share, W. B. Cooke to hold Five Eighths of the Work, T. C. Allen to hold Two Eighths. The Work to pay its Expenses by its returns before any Dividend is made between the parties.

"Mr. Turner to have a best Copy of the Work, with Etchings.

"A Settlement for all Numbers and Copies sold, to be made at regular half Yearly periods within a Week after Mr. Murray settles his half Yearly Accounts on the Work.

"When Seven Drawings are made for the Work, Mr. Turner to have one of them by casting lots. When the second Seven are made, a like casting of Lots to take Place for one of them. The Third Seven the same. The fourth Seven the same, and Mr. Turner to have the casting of lots for one out of the remaining Eight.

"No other Engraver to be employed in the Work than W. B. Cooke, and J. C. Allen, without the Consent of Mr. Turner. It is agreed that three Numbers containing Two Plates each shall be published in a Year, and that the Proofs shall be printed in Imperial Folio. The Prints in Quarto Grand Eagle French Paper. The first Number, which is to contain Two Plates, to be published during the Year 1819.

"Jos. Mallord W. Turner.
"W. B. Cooke.
"J. C. Allen."

38. Next to this piece of shrewd business, I have great delight in giving an exhaustive delineation of Turner's character, written by an able phrenologist and physiognomist from the cast of his head taken after death. No one person was ever intimately enough acquainted with him to form such estimate by experience, so that the document bears internal evidence of its honesty:—

"He is of the motive mental temperament, and is of an earnest, industrious disposition. He possesses great activity and energy, and works with both mind and body at the same time. He would not give up until he had accomplished his object, especially if principle or if right and justice were at stake.

"According to the development indicated, he must have been compelled to cut out a road of his own. He has developed a character peculiar to himself, his individuality is very marked.

"He inherited a sound constitution, is tough and wiry, and has long life in him. This gives him promptness of action, determination of purpose, firmness and resolution in all his undertakings.

"He is a man who will not use half measures; he works to the full extent of his powers, and is resolved to surmount all obstacles and remove all difficulties that may be in his path.

39. "He is ever ready to defend friends, or to oppose enemies; so far as his physical organization is concerned, he is very fervently constituted, and has not suffered much except from the strain imposed upon himself by overwork. There is not an idle bone in his whole organization. A man with his development cannot possibly have led an idle life, or have indulged himself much in luxury and ease. His life cannot have been a life of holidays. If there is work to do, it must be done, in his opinion, without any faltering or hesitancy.

"He is descended from an old-fashioned family that care more for the useful and real than for the merely ornamental or theoretical.

"He has a large social brain, which gives him an ardent and loving nature. He forms strong attachments to those around him; to his wife, to his children, and friends.

40. "He is most constant in his friendship, and faithful in fulfilling his promises. Once a friend, always a friend, in his case. Friends he will defend to the uttermost of his powers. He is willing to do anything which would render them assistance; but once deceived by a friend, although he bears no malice, he shakes him off for ever, and will have no further dealings with him.

"His love of home, which is fully developed, gives him a patriotic spirit; and as his veracity, force of character, and executiveness are large, he is ready to defend his country and his homestead should defence be required.

"He cannot bear abrupt changes, and although he would travel, if it were necessary to further his studies, and enable him to gain certain information, he will return with feelings of delight to his old home and old friends.

"He is a man who cannot adapt himself to new ways and fashions.

"He is rather impatient with slow people, and especially with idle ones.

"Opposition only serves to call his talents and powers into activity, and the more opposed he is, the more determined he becomes to have his own way.

"His word is his bond; he is reliable and trustworthy in all things.

41. "There are two directly opposite elements in his character; the one contradicts the other. His large acquisitiveness leads him to acquire and to accumulate, to have things of his own, to look out for a rainy day, and store up for the future.

"Yet when help is required, his large benevolence urges him to do all in his power to assist those in need. He requires, however, a complete explanation before he will give his support, and a cause must be a good one to receive support from him. Once convinced of the truth of a cause, he is most earnest in its advocacy.

"He is cautious in his plans and undertakings; slow to decide, but once his plans are formed, quick in carrying them out. If he fails the first time, he tries again until he has attained his object, or accomplished his task. Conquer he must.

"He does not aim after self-glorification, but for the benefit of others; and is prompted not so much by selfish motives as by a desire to raise and elevate his fellow men. Having large veneration, he must be an earnest worker in a religious cause.

42. "Hope appears so largely developed,* that it will stimulate him to undertake tasks which few men have the courage to take in hand. Hope, it may be said, carries him through life. Hope has enabled him to go on when the difficulties in his path appeared well-nigh insurmountable.

"He must have had many struggles, battles, and difficulties to encounter, else he could never have attained his present development. He would never allow himself to be beaten, and having large hope, he clings tenaciously to life.

"He never overrates his talents; he is rather inclined to underrate them. He has been unassuming, unpretentious, and undemonstrative. In the social circle he is quite the reverse of what he is when working in opposition. Among homely people he is social and agreeable, but once roused, he becomes very severe and determined.

* This is a very interesting piece of penetrative science. Turner's chief mental emotion was always striving to express itself in the broken poem which he called the "Fallacies of Hope."

"He cannot tolerate nonsense or foolishness, and must out with the facts and realities of life. Although he enjoys a hearty laugh and joke, they must be caused by genuine wit.

43. "Having a nude head in the front, he is constructive and skilful; can plan, arrange, and invent. He is more of a utilitarian than a poet. Yet he loves the beautiful and sublime in nature, the pure and refined.

"Having remarkably large observant powers, he is keen of discernment, and quick in noticing details. Very few things escape his eyes. He is most practical, methodical, and regular. It is not everybody who can please him.

"He can judge of distances, proportions, lengths, breadths, etc., by the eye. He likes a place for everything, and everything in the right place; a time for everything, and everything purposed to time.

"His calculating powers are large; he will not enter into rash undertakings; he can generally see right ahead, and is therefore successful in his undertakings.

"His memory is good for incidents, events, etc., and he would make a good descriptive speaker. As a speaker, he would be to the point, and easily understood. If success depends upon work, he must be a successful man, for he has a hardworking element in him that will never allow him to remain idle.

"Having large causality, comparison, intuition, he is an excellent reasoner, and is subtle in a debate. If his talents have been directed into the right channel, he must have made his mark, and have accomplished a marvellous work, to the astonishment of all beholders either in a mercantile or professional sphere of labour. Men of his tribe are very rare nowadays.

"GUSTAVUS COHENS."

44. Next to this mental chart of him, I place a sketch

from the life, written for me by my mother's friend, named in "Præterita," vol. ii., § 203, Mrs. John Simon:—

"In the spring of the year 1843, I went to Plymouth, and remained until Midsummer; when, on a certain day of June, it was arranged that I should return to London viâ Southampton; I being then very fond of the sea. John (to whom I was not then married) was to meet me at Southampton, and see me home.

"Accordingly, on the day fixed, I was duly ready, my boxes packed, and I, chatting with my hostess, Mrs. Snow Harris, and her daughters, awaiting the arrival of Mr. Harris, who was (as we fondly believed) securing my berth, and coming to fetch me to the boat. Time passed on,—no Mr. H.! At last at half-past one he appeared.

" 'Oh, papa, how late you are; Miss —— will lose the boat!'

" 'She *has* lost it,' (in Devon accent, and with a loud laugh.)

"Miss ——. 'Oh! Mr. Harris.'

" 'Yes, it's blowing up for such a storm as we haven't had for long, and I'm not going to let you go up Channel to-night. Why, the boats in Catwater are bouncing about already.'

" 'But the boat's gone,—the Captain,—the other passengers,——oh, you *should* have let me go!'

" 'No, no, I shouldn't, and I wouldn't.'

" 'But I *must* go somehow. I can't let my friends' (admire the plural!) 'come to Southampton for nothing!' (Now be it remembered, that in those days was no electric telegraph, the mails were closed and just starting, and the Great Western Railway itself only finished as far as Beam Bridge, a small outlying station.) 'I must go. So please send to tell the coach to come for me.'

"And I had my way. Just saved the coach, which started at 2 p.m., with strong injunctions from Mrs. H. *not* to get out at Exeter, as it might there become crowded.

45. "I had had nothing since eight o'clock breakfast. The coachman was charged to stop and get me buns; he promised, but did not. The guard was charged to be most careful of me; he promised, and *was*.

"As we drove on to Exeter, the hitherto bright, breezy day began to justify Mr. Harris, as it was pretty sure to do, he being *the* great electrician, as well as a first-rate sailor and judge of the weather. (He is well known as Sir W. Snow Harris, the inventor of the conductors which are the safeguards of our ships from lightning.) The clouds gathered, distant low whistlings of wind came from all around, and in a threatening evening, at eight, we reached Exeter; and waited for an hour. I had thus far been alone, and keeping in view Mrs. H.'s advice, stuck firmly to my place, resisting all the blandishments of waiter and chambermaid, and continuing fasting, but in good heart, and not at all hungry.

46. "Some gentlemen got up outside and one young man inside. Of this I could say something which might amuse you, but it has nothing to do with the main point, so I pass it over. The weather after Exeter got worse and worse;—the wind began to bluster, the lightning changed from summer gleams to spiteful forks, and the roll of thunder was almost continuous; and by the time we reached Beam Bridge the storm was at such terrible purpose, that the faithful guard wrapped me up in his waterproof and lifted me, literally, into the shed which served as a station. In like manner, when the train was ready, he lifted me high and dry into a first-class carriage, in which were two elderly, cosy, friendly-looking gentlemen, evidently fellows in friendship as well as in travel. The old Great Western carriages were double, held eight

persons, four in each compartment, and there was a glass door between; which was on this occasion left open. One old gentleman sate with his face to the horses (so to speak) on my side, and one in the inside corner, opposite to me exactly. When I had taken off my cloak and smoothed my plumes, and generally settled myself, I looked up to see the most wonderful eyes I ever saw, steadily, luminously, clairvoyantly, kindly, paternally looking at me. The hat was over the forehead, the mouth and chin buried in the brown velvet coat collar of the brown greatcoat. I looked at him, wondering if my grandfather's eyes had been like those. I should have described them as the most 'seeing' eyes I had ever seen. My father had often spoken of my grandfather's eyes, as being capable of making a hundred ugly faces handsome; and the peasants used to say, 'Divil a sowl could tell a lie to his Riverence's Worship's *eyes*.' (He was a magistrate as well as a parson.) My opposite neighbour's seemed much of this sort.

47. Well, we went on, and the storm went on more and more, until we reached Bristol; to wait ten minutes. My old gentleman rubbed the side window with his coat cuff, in vain; attacked the centre window, again in vain, so blurred and blotted was it with the torrents of rain! A moment's hesitation, and then:

" 'Young lady, would you mind my putting down this window?'

" 'Oh no, not at all?'

" 'You may be drenched, you know.'

" 'Never mind, sir.'

"Immediately, down goes the window, out go the old gentleman's head and shoulders, and there they stay for I suppose nearly nine minutes. Then he drew them in, and I said:

" 'Oh please let me look.'

" 'Now you *will* be drenched;' but he half opened the window for me to see. Such a sight, such a chaos of elemental and artificial lights and noises, I never saw or heard, or expect to see or hear. He drew up the window as we moved on, and then leant back with closed eyes for I dare say ten minutes, then opened them and said:

" 'Well?'

"I said, 'I've been "drenched," but it's worth it.'

"He nodded and smiled, and again took to his steady but quite inoffensive perusing of my face, and presently said it was a bad night for one so young and alone. He had not seen me at Exeter.

" 'No, I got in at Plymouth.'

" 'Plymouth! !'

" 'Yes.' I then said I could only save my friends trouble and anxiety by travelling up that night, and told simply the how it came to pass. Then, except a little joke when we were going through a long tunnel (*then* the terror of 'elegant females'), silence until Swindon, but always the speculative steady look. There we all got out and I got some tea and biscuits. When we were getting in (the storm by then over,) they asked me if I had got some refreshment, and when I said tea, my friend with the eyes said:

" 'Tea! poor stuff; you should have had soup.'

"I said tea was more refreshing, as I had not had anything since eight the previous morning. We all laughed, and I found the two cosy friends had had something more 'comfortable' than tea, and speedily fell into slumber, while I watched the dawn and oncoming brightness of one of the loveliest June mornings that have ever visited the earth.

48. "At six o'clock we steamed into Paddington station, and I had signalled a porter before my friends roused themselves. They were very kind,—could they

do anything to help me?—where had I to go to? 'Hammersmith: that was a long drive.' Then they took off their hats, and went off arm in arm.

"I reached North End, where Georgie* now lives, as I hoped I should, *just* as our baker was opening his shop at seven o'clock; wrote on rough baker's bill-paper a note to John, and sent it off by the baker's boy on the cab, begging John to let my sister know; and then leaving my luggage at the baker's, walked on the short way to our dear friend's house, where I knew my mother had had no sleep for the storm and thinking Jane was in it at sea. 'Jane, how d'ye do?' to the astonished servant, and walked straight up to mamma's room, opened the door, to meet, as I expected, her wide-open, anxious, patient eyes, and to hear '*Jane!*—Oh, thank God!'

49. "The next year, I think, going to the Academy, I turned at once, as I always did, to see what Turners there were.

"Imagine my feelings:—

" 'RAIN, STEAM, AND SPEED,

GREAT WESTERN RAILWAY, JUNE THE —, 1843.'

"I had found out who the 'seeing' eyes belonged to! As I stood looking at the picture, I heard a mawkish voice behind me say:

" 'There now, just look at that; ain't it *just* like Turner?—whoever saw such a ridiculous conglomeration?'

"I turned very quietly round and said:

" '*I* did; I was in the train that night, and it is perfectly and wonderfully true;' and walked quietly away.

"When I saw your *young* portrait of Turner, I saw

* Mrs. Edward Burne-Jones.

that some of it was left in the 43 face,—enough to make me feel it always delightful to look at the picture.

"There, my dearest Mr. John, I've scribbled (for I can no longer *write*) as you wished. Best love to you, and love to all. I send it to Joan to read to you.

"Ever yours, with John's truest love,

"J. S."

GLOSSARY OF PROPER NAMES

THIS Glossary has been compiled for the present edition in order to assist the reader to identify some of the leading characters, who are possibly less well known today than they were sixty years ago.

ACLAND, Sir Henry Wentworth (1815–1900)
Fellow of All Souls, Honorary Student of Christ Church, and from 1858 to 1894 Regius Professor of Medicine in the University of Oxford. He was largely responsible for the modern medical school in the University and founded the Oxford Museum and Science Library.

BOXALL, W. (1800–1879)
Portrait-painter and Royal Academician. He gained particular note for his portraits of women (one of which is now in the National Gallery). From 1865 to 1874 he was Director of the National Gallery.

BROWN, Dr John (1810–1882)
Edinburgh physician and author of *Horæ Subsecivæ* and *Rab and his friends.* He was a man of great personal charm and humour. His books, which deal chiefly with medical subjects, enjoyed a wide success because of the intimate and delightful picture they give of their author.

BROWN, Rawdon Lubbock (1803–1883)
Visited Venice on holiday in 1833 and remained there till his death. He acquired unique knowledge of its history and antiquities and spent most of his life studying its archives. He was the first person to appreciate the value to English history of the sixteenth- and seventeenth-century despatches from Venetian Ambassadors to the Court of St. James's. Palmerston commissioned him in 1862 to index all Venetian state-papers dealing with England. Browning wrote a sonnet on his death.

BUCKLAND, Dr (1784–1856)
Geologist and Dean of Westminster, Fellow of Corpus Christi, Oxford, and Professor of Mineralogy. His chief work was on the geological evidence of the Flood and on glacial erosion. He was an amusing and popular lecturer.

EDGEWORTH, Maria (1767–1849)
Irish novelist and writer of edifying stories for children. Her
novels enjoyed wide popularity in her life-time and brought
her the friendship of most of the celebrated people of her day,
including Scott who acknowledged in his preface to *Waverley*
that her descriptions of Irish character encouraged him to
attempt a similar thing with Scottish character in the Waverley
novels.

FIELDING, Anthony Vandyke Copley (1787–1855)
Water-colourist. Born of a family of painters, as his Christian
names suggest, he quickly gained a reputation both as a
painter and a fashionable teacher of water colours. From
1831 to 1855 he was President of the (Royal) Society of
Painters in Water Colour. He was very thrifty and, for some-
one whose work was so slight, left a surprisingly large fortune.

HOGG, James (1770–1835)
"The Ettrick Shepherd." Born of a Scottish border farming
family and almost entirely self-educated, he discovered a gift
for writing lyrics and ballads which took the fancy of Scott.
In 1810 after financial failure as a sheep-farmer he settled in
Edinburgh and embarked on a literary career. His work
includes volumes of ballads and tales, and an autobiography.
He enjoyed the friendship of Wordsworth, Scott, and Southey.

JAMESON, Mrs (1794–1860)
Essayist and writer on the history of Art and iconography.
Her *Sacred and Legendary Art* (1848) was of much use to
Ruskin. She contributed articles, some of great merit, on
Italian painting.

LEWIS, J. F. (1805–1876)
Painter. The son of an engraver, he gained early recognition
as a painter of animals, and subsequently of pictures on Italian
and Spanish subjects. Between 1838 and 1850 he lived as
a native in the Middle East, exhibiting nothing. When he
returned to England he astonished a public that had almost
forgotten him with a series of brilliant paintings of Oriental
subjects.

LIDDELL, Henry George (1811–1898)
Fellow (1836) and Censor (1845) of Christ Church, Head-
master of Westminster (1846–55), Dean of Christ Church

(1855–91), Vice-Chancellor of Oxford University (1870–4). His great work was the Greek-English Lexicon which he compiled with Robert Scott and which was first published in 1843. He revised it continually throughout his life and prepared the 7th Edition alone in 1897.

LINDSAY, Lord (1812–1880)
Subsequently Earl of Crawford and Balcarres. A lifelong bibliophile and collector, he amassed an enormous library of rare books in all languages. He was the author of the first book in English to deal with early Italian art, the *History of Christian Art*, published in 1847, and reviewed by Ruskin in the *Quarterly*.

LOCKHART, John Gibson (1794–1854)
Intimate friend, son-in-law and biographer of Scott. After a distinguished career at Oxford, he settled in Edinburgh, contributed regularly to *Blackwoods*, and wrote novels of little merit. In 1825 he became editor in succession to Gifford of the *Quarterly Review*, retiring in 1853. As Scott died bankrupt, he handed over the profits from his *Life* to the creditors of the Scott estate.

MAURICE, Frederick Denison (1805–1872)
An original writer and thinker on religious matters, he had to endure throughout his life attacks on his orthodoxy. Although he was able to clear himself of stain, he never gained the preferment which his talents deserved. Apart from a substantial body of work on points of the faith, his greatest interests were in trade associations and in the education of the working class. He founded the Working Men's College, in which he took an active teaching part.

NEWTON, Sir Charles Thomas (1816–1894)
Archæologist. Sometime Keeper of Greek and Roman Antiquities at the British Museum and at the end of his life, 1880–8, Yates Professor of Archæology at the University of London. His chief work was the identification and recovery of the remains of the Mausoleum at Helicarnassus. He also served in the Consular Service.

NORTHCOTE, James (1746–1831)
Achieved his greatest success as a painter of portraits. He learned painting in the studio of Sir Joshua Reynolds, about

whom he subsequently published a memoir. He was an able
and prolific painter but is best remembered for his conversa-
tion, recorded by his friend Hazlitt.

NORTON, Charles Eliot (1827–1908)
Editor, author and Harvard professor. He travelled widely
in Europe and gained the friendship of the Brownings,
Thackeray, Mrs Gaskell and A. H. Clough. His work
includes editions of Emerson, Carlyle and Donne, and a prose
translation of Dante. He was co-editor with Lowell of the
North American Review and one of the first people to recognise
the merit of Whitman.

PROUT, S. (1796–1852)
Water-colourist. Although he was exhibiting drawings and
paintings regularly from 1811, it was not until he went abroad
in 1819 that he discovered his peculiar talent: the portraying
of the picturesque in domestic continental architecture.

RICHMOND, George (1809–1896)
Portrait painter. Studied at the Royal Academy under Henry
Fuseli through whom he came into contact with William
Blake. Blake exerted a great influence over his early work.
In 1831 he eloped with the sister of Frederick Tatham,
Blake's executor, and married her at Gretna Green. From
then onward he took to portraiture, beginning with a water
colour of Wilberforce which founded his reputation. In
1846 he began to work in oils and a list of his sitters would be
little less than a survey of the whole Victorian era.

ROBERTS, David (1796–1864)
Painter. Began to practise art as a scene painter to a com-
pany of travelling players, subsequently coming to London
and securing appointments at Drury Lane and Covent Garden.
He began to exhibit at the Royal Academy in 1826. He
travelled extensively and painted landscapes of all parts of
Europe, as well as of Syria and the Holy Land.

SEVERN, Joseph (1793–1879)
Painter. An early friend of Keats, he accompanied him to
Italy and attended him at his death. Except for a period of
twenty years between 1841 and 1860 he resided at Rome
and from 1860 to 1872 was the British Consul there.

SMITH, Sydney (1771–1845)

Canon of St Paul's. Founder of and lifelong contributor to the *Edinburgh Review*. Though he wrote prolifically on ecclesiastical and political matters, his success was chiefly a social one. All the leading figures of his time have left accounts of his enormous personal charm and wit. He was throughout his life an extremely popular preacher, but like Swift his very brilliance stood in the way of his chances of preferment.

STANLEY, Arthur Penrhyn (1815–1881)

Dean of Westminster. Educated at Rugby, he conceived as a schoolboy a lifelong hero-worship for Arnold, whose biography he subsequently wrote. His character as a boy is portrayed as "Arthur" in *Tom Brown's Schooldays*. A great traveller, his most successful and best remembered book is his account of *Sinai and Palestine*, a copy of which was presented to every member of Allenby's army.

TOLLEMACHE, Georgiana (–)

Second wife of William Francis Cowper-Temple, Lord Mount Temple (married 1848). Mount Temple was the nephew of Melbourne and the stepson of Palmerston, and through the influence of these two prominent relatives he was able to pursue a worthy political career. His wife was hostess to a large circle of friends at Broadlands, Melbourne's former home. When *Sesame & Lilies* was reissued in 1871, Ruskin dedicated it to her.

TREVELYAN, Lady (1816–1866)

Wife of Sir William Calverley Trevelyan, naturalist and editor of the Trevelyan Papers. Travelled in Greece, 1842. Contributed over a long period reviews and stories to the *Scotsman*, including a review of Ruskin's *Pre-Raphælitism*.

INDEX

The Index to the 1899 Edition was a very full one, running to 95 pages, but it is felt that the needs of the reader of today will be met by the shorter index which follows. In addition will be found on p. 581 a brief Glossary concerning many of the leading characters of the book, who were familiar to Ruskin's contemporaries but are perhaps not so well known today.